Exploratory
Image Databases:
Content-Based Retrieval

Academic Press Series in Communications, Networking, and Multimedia

EDITOR-IN-CHIEF

Jerry D. Gibson
Southern Methodist University

This series has been established to bring together a variety of publications that represent the latest in cutting-edge research, theory, and applications of modern communication systems. All traditional and modern aspects of communications as well as all methods of computer communications are to be included. The series will include professional handbooks, books on communication methods and standards, and research books for engineers and managers in the world-wide communications industry.

Books in the Series:
Handbook of Image and Video Processing, Al Bovik, editor
The E-Commerce Book, Second Edition, Steffano Korper and Juanita Ellis
Multimedia Communications, Jerry Gibson, editor
Nonlinear Image Processing, Sanjit K. Mitra and Giovanni L. Sicuranza, editors
Introduction to Multimedia Systems, Guarav Bhatnager, Shika Mehta, and Sugata Mitra
Exploratory Image Databases, Simone Santini

Exploratory Image Databases:
Content-Based Retrieval

SIMONE SANTINI
University of California
La Jolla, California

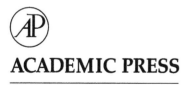

ACADEMIC PRESS

A Harcourt Science and Technology Company

SAN DIEGO / SAN FRANCISCO / NEW YORK / BOSTON / LONDON / SYDNEY / TOKYO

This book is printed on acid-free paper. ⊗

Copyright © 2001 by Academic Press

ACADEMIC PRESS
A Harcourt Science and Technology Company
525 B Street, Suite 1900, San Diego, CA 92101-4495, USA
http://www.academicpress.com

Academic Press
Harcourt Place, 32 Jamestown Road, London, NW1 7BY, UK

Library of Congress Catalog Number: 2001088197

ISBN: 0-12-619261-8

Printed and bound by CPI Group (UK) Ltd, Croydon, CR0 4YY
Transferred to Digital Print 2012

Per ogni problema complesso c'è una soluzione semplice, ed è sbagliata
(For every complex problem there is a simple solution, and it's wrong)
Umberto Eco, Il Pendolo di Foucault

Contents

Preface

Prelude in C (++, of course)

Cui dono lepidum novo libellum?
C. Valerius Catullus

The scene is represented in an ink print that I have seen so many times I almost feel as though I was there. It is a quiet street on the outskirts of Paris; I like to imagine that the events took place a little bit out of the city, maybe on the other bank of the Seine, in the area that is now known as *la Defense*. Nowadays, looking east, one would have a magnificent view of the Champs Elysées, with the Arc de Triomphe and, in the background, the Parisian skyline stamped against the French sky. Looking a bit south, you could see the metallic shape of the Eiffel tower, and, a bit north, you could maybe have a glimpse of the top of the Beaubourg, the machine/building. At the time of my ink print, though, you would not have seen any of those, because the events took place in the year 1769 and Napoleon Bonaparte, Georges Eiffel, and Renzo Piano were still dim possibilities of the future.

The boiler is hot. Assistants have been working on it the whole morning, and now it is full of eager steam; looking at it in the print, you can almost feel the pressure building inside. Nicholas Cugnot takes care of the final details, then climbs to the control post of the vehicle. It is a few tons of steel, wood and fire, mounted on four robust wheels, a carriage not unlike those that peasants and masons use for heavy loads, attached to a pair of oxen. But there are no oxen today—the machine is going to be pushed by the force of steam and the will of Nicholas Cugnot.

The machine starts. At first it moves very slowly; then, with the pure and naïve faith in progress that only an Eighteenth Century machine or inventor could have, it moves faster. And faster, and faster. Now I choose to think (the writer is a benign demiurge) that in that moment Cugnot felt very happy and that, at the same time, he felt a shadow of sadness: in a few minutes the great intellectual achievement of his life would be accomplished

and nothing he would do in the years to come could reach the intensity of these moments.

Of course, we know now that things would go very differently and that there would be no "years to come." Cugnot probably had the time to realize it, in a glimpse of the wall of a country house growing closer and closer, before the impact and the explosion of the boiler would precipitate him into oblivion.

Nicholas Cugnot built the first working steam car, but not the first working pair of brakes.

Let me go back for a moment to Cougnot riding his engine (which actually he did many times before the accident, and not only once as I, with a slightly Gothic melodramatic penchant have chosen to imagine). Now I choose to imagine him looking at his machine with satisfaction, and thinking of the future. One day, he thought, machines like his, or better, would be all around France, doing the work of many animals; people could move faster, and more reliably. The streets of the city would not be full of the smell of horses, and the air would be clear (little did he know...).

I suppose that, even in their wildest dreams, people like Cugnot, Benz, and Diesel never imagined anything even remotely close to the consequences of their inventions. It would have been possible for them (maybe while sitting in front of a fireplace, after dinner, with a few friends, a glass of V.S.O.P. and a cigar, when the fantasy can run loose without worrying about details like plausibility) to imagine endless technological developments of their inventions. Why, one day you will have an engine so small that it will fit in your pocket, and that will drive you to 200 Km/h. What they could not do, what was beyond their foresight, and beyond that of everybody else, were the cultural and social consequences of the new technology.

Most of these pioneers imagined a society more or less like the one in which they lived, with maybe a few things that you could do better than before because of their inventions. They could probably have imagined that the food could have reached the grocery store down the block more quickly, at a lower price, and in greater variety. They could not have imagined that, with the advent of massive road transportation, the grocery store down the corner would disappear, driven out of business by the chain of big supermarkets on the outskirts of the city. A marvel made possible by the car.

Dreamers could have imagined people moving faster inside the cities thanks to the new cars, but they could not have imagined the emergence of the suburban society in America—people *voluntarily* leaving the cities to go and live on the periphery. They were used to a society in which the rich and the poor lived close to each other; it would have been hard for them to imagine that, thanks to the car, the difference between the rich and the poor would become geographic—in America, the rich living in the suburbs, the poor living in the inner cities, in Europe the other way around.

Every researcher working on information technology today is, in a very real sense, the modern counterpart of Cugnot or Benz; it is equally difficult today

for them to fully understand the consequences of their actions. Like Cugnot's machine, today's computers and communication networks are technological devices, and like Cugnot machines, they have just started to leave a faint mark on our social and cultural fabric; a mark that—there is no doubt—will deepen and radicalize in the decades to come.

If trying to understand and predict technological developments beyond the limited horizon of a few years is a hazardous enterprise, to try and understand the cultural changes that this technology will spark beyond the same limited horizon is nothing short of titanic.

This book is concerned with a very small and technical fragment of the current evolution of information technology, the study of computer systems for access and retrieval of images from large databases, with particular interest in retrieval based on the content of the images. Its limited scope notwithstanding, content-based image retrieval can unveil and clarify some crucial aspects of the current and future modalities of human communication. It may seem a sign of hubris for a researcher in a field to state that his field will be the "Otto cycle" of information technology, and it probably would be an overstatement to say it of content-based image retrieval with respect to the overall cultural impact of information technologies. The statement may be true, however, if one considers the potential impact of technical disciplines on the modalities of visual communication, and on their relation with linguistic discourse.

Thanks in part to the ease of image production, transmission and reproduction, we live in a very visual age. The *iconosphere*[1] is around us, and is not going to lift anytime soon; the Twentieth Century started with the centrality of language as an object of philosophical study (with names like Saussure, Peirce, Wittgenstein), and is drawing to a close posing more and more insistently the question of images[2]. From Barthes's unforgettable analysis of the *Pasta Pinzani* advertisement, to the emergence of the field of pictorial semiotics, the cultural debate on the semiosis of image has characterized the second half of the century.

Information technology has remained largely oblivious of this debate. The reasons are many including, in part, a traditional division of intellectual activity in disciplines of analysis (study of the existent, e.g., science, linguistics, ...) and disciplines of synthesis (modification of the existent, e.g., all technological disciplines). More immediately, the traditional problems of computer vision considered images as data from a "sensor" that could be used to solve a specific problem; human perception and culture can be used as a guide and an inspiration but, strictly speaking, there is no reason why a robot or an automatic quality control system should use the data from a camera the same way people use their eyes to "see." The only thing that matters is that enough information be extracted from the sensor to

[1] I borrowed this term from Göran Sonesson (1997).
[2] I write these lines in June 2000, and I categorically refuse, in spite of the confusing numerology of an easy populism, to consider the century closed until midnight Sunday, December 31st, 2000.

allow solution of the problem. Social and cultural considerations on the semiotic status of images have little to do with the metier of computer vision because, *ex hypothesis*, an automaton is not a social participant in human activities, but a mere tool—little more than a smart hammer.

The social and cultural preoccupation of the role of images as a communication medium cannot be discarded, not even provisionally, once one starts working in image retrieval. Here, the relation between the image and its recipient (be it the user of the retrieval system, or the recipient of a message that the user is putting together) is of primary importance, and it is impossible to ignore it.

It is in the sense of recognition of this special relation that the statement that content-based image retrieval as a discipline is independent of image analysis and computer vision is not only defensible, but unavoidable. The recognition of this independence is important because it entails, despite all the points of contact and the many common methods, a different consideration and role for the entity that represents the starting point of both: the image.

Because of this "eye opening" relation between the user and the image, content-based image retrieval has, much more than computer vision, the potential to change our relation with and our understanding of images, their language, their meaning, and their social role as much, maybe, as the invention of the car changed our understanding of the city and of its relation with the countryside. One of the points this book is trying to make (maybe *the* point this book is trying to make) is that the relation between retrieval technology and image signification is a two-way street: Technology will help us gain a new understanding of image signification, and the semiotic study of images is necessary for anybody who wants to work in this area.

In this day and age, it is impossible to write a book like this without accounting for the presence of the Internet. In image databases, the Internet plays a double role. On one hand, it has the very technical function of giving many people access to a virtually unlimited supply of images, and forces database designers to consider the implications of a distributed reservoir of images and a distributed usership. More fundamentally, the Internet constitutes a large context in which images are placed. The Internet is not a sterile collection of mute and anonymous images: It is a complete, self-contained discourse in which images are embedded and, by virtue of this embedding, given meaning[3]. This, I believe, is the real role of the Internet and the basis of its tremendous significance, much more than its convenience as a medium for accessing far-away images.

[3] There are, to be sure, bubbles of anonymous collections of images on the Internet. For one thing, all stock photographs companies now make their collections available "online." These collections, while technically useful, are, from my point of view, the least interesting part of the Internet, as they represent only a translation of an old imaging model into a new technology. As useful and exciting as this translation can be technologically, it does not significantly increase our understanding of image signification.

Acknowledgments

Deciding to write a book is a sign of hubris, and actually writing the book is a fit punishment for such a sin. So long and grudging is this work that no book is really the work of an author, as much as the work of a network of friends, acquaintances, colleagues, of which the author is the lucky one who gets to put his name on the cover. Many people were responsible for this book, many more than I can thank here.

I want to thank Ramesh Jain, my Ph.D. advisor, who introduced me to the study of image databases although at the time, I must confess, I was not always sure of what he was talking about. Our morning discussions in front of a cup of coffee always provided me with great inspiration, as well as a significant contribution to the balance sheet of *Espresso Roma*, the UCSD coffee joint.

I thank Alberto Del Bimbo of the University of Florence, with whom I graduated many years ago in Italy. His insightful, witty, cultured and incredibly cynical remarks are indirectly responsible for some of the best pages of this book.

Amarnath Gupta, of the San Diego Supercomputer Center was the first to make me realize that the word "database" in the expression "image database" is not a useless appendix, but an endless source of technological possibilities. The chapters on query algebras and indexing owe a lot to his contribution.

Joel Claypool, of Academic Press, always showed—for some reason that is still partially obscure to me—a great enthusiasm about this book and, during our first meeting, made me discover the best *ossobuco* in San Diego. For an Italian like me, to be led to great *ossobuco* by an American like him is a source of great shame, but tastebuds are stronger than pride.

A lot of people with which I have interacted during the years have helped me focus on some ideas, or opened new possibilities to me, sometimes without even realizing that they were doing so: they probably attributed the sudden veil over my eyes and the fact that they started to wonder around rather than looking, as good manner would require, at the interlocutor to the aftereffects of wine rather than to a technical epiphany. For these insight I thank (and, at the same time, reaffirm that, no, it was not the wine) Arnold Smeulders, Marcel Worring, Shailendra Bhonsle, Yannis Papaconstantinou, David Kirsh, Adam Hoover, Jeff Boyd, and Valentina Koustzenova.

The biggest thank of all goes to my wife Tania, who endured a lot during the preparation of this book. I silently pledged with myself that I would not resort to corniness, and I take pledges with myself very seriously, so I will not do it. Yet, the temptation is, in this case, rather strong. She helped me maintain a social life, going out as a good boy when the little nasty voice inside me was yelling to go back to my room and start tapping furiously. She helped me escape the horrors of frozen food and TV dinners, reminding me that, as an Italian, everything that goes through the freezer-microwave oven route is not worthy of my table.

Finally (just in case somebody was curious), the titles of the three parts of this book derive from the following sources: Part I is the first verse of St. John's gospel (in the beginning it was the word)…with an apocryphal incidental; Part II is a concoction in Latin somewhere between Newton's *Principia Matematica Philosophiae Naturalis* and Lucretius's *De Rerum Natura*; and Part III is a verse from Dante's *Divine Comedy* (Purgatorio, XII:131).

I

$\epsilon\nu$ $\alpha\rho\chi\eta$ $\eta\nu$ o $\lambda o\gamma o\varsigma$
(Math Came Later)

ἐν ἀρχῇ ἦν ὁ λόγος
(Math Came Later)

1

An Eerie Sense of Deja Vu

...les rédacteurs de Life *refusérent les photos de Kertész, à son arrivée aux États-Unis, en 1937, parce que, dirent-ils, ses images "parlaient trop"; elles faisaient réfléchir, suggéraient un sens—un autre sense que la lettre. Au fond la Photographie est subversive, non lorsqu'elle effraie, révulse ou même stigmatise, mais lorsqu'elle est* pensive.

Roland Barthes, *La Chambre Claire*

Where were you the day Robert Kennedy was shot? I was in kindergarten, and that day is one of the best preserved memories of my childhood. I remember very vividly the classroom: I was sitting in one of the last rows, on the left side of the class; I remember my little desk with the surface of greenish formica, of a model very common in those years. On the left wall large windows overlooked the yard where we played. On the right wall, resting on some piece of furniture, one of those cheap luminescent plastic madonnas. Sister Maria was at her desk facing us (she was young and funny; need I say that we were all madly in love with her?), a small transistor radio in her hand, and held to her ear. I remember distinctly her saying: "Keep quiet for a moment, kids. The radio just said that somebody shot this good and important man. It's a very sad thing."

You will agree that, at a distance of more than 30 years, this is quite an impressive memory. But how real is it? I am pretty confident that the overall scene is reasonably accurate, but what about the details? I am sure that if that day somebody had taken a picture of the scene and now, 30 years later, I could see it, I would find many similarities in the general lines and many differences in the details.

As a matter of fact, if I try to pin down the details, my memory fails me. I could not tell you how many windows there were or what they looked like, although I

seem to remember green venetian blinds on them; as to the fluorescent Madonna, I have no idea what it was standing on. I do not remember anything about any of the kids who were in the room. You see, I can remember the *overall* picture with stunning clarity, yet I am at a loss when I try to remember any detail. Many visual memories of my childhood (the Florence flood in 1966; the first day of school) have these characteristics.

These memories are very different from the way I remember the first verses of Giacomo Leopardi's "L'infinito," which I learned at about the same time. I only remember the first three verses:

> Sempre caro mi fù quest'ermo colle
> E questa siepe che da tanta parte
> dell'ultimo orizzonte il guardo esclude[1]

and the last:

> e naufragar m'è dolce in questo mare[2]

I remember these three verses with absolute clarity, and I remember absolutely nothing of the rest. The characteristics of this memory are very different from those of the memory of my kindergarten scene. My visual memory of the scene is blurred in its details but, in a sense, complete. My memory of the poem is complete in the details, but fragmentary. Both these memories entail some loss of information, but with very different modalities. Imagine a piece of paper on which you have written or drawn something. In the case of my visual kindergarten memory, it is as if you had forgotten the paper in your pants' pocket before laundry and the water had faded the print. You can still make out the general look of the page, tell the drawings from the printed text, distinguish the paragraphs, and so on; but as you try to make out the words, you cannot quite see them, except for a few fortunate ones. My memory of the poem is analogous to having the paper shredded into pieces and finding only a few of them; you have no problem whatsoever in reading the words that you have, but there is nothing you can do about the missing parts.

This difference is not limited to this scene from a long time ago: the same thing can happen for something experienced very recently, or even for something we are experiencing just now. There was, in fact, some factual (symbolic) information in my visual kindergarten memory, namely that I witnessed a nun saying that a man had been shot; I remember this as crisply as I remember the few verses of Leopardi.

[1] In the translation of Jean-Pierre Barricelli (Cypress, 1963): *This lonely knoll was ever dear to me/ and this hedgerow that hides from view/ so large a part of the remote horizon.*
[2] (ibid.) *and in this sea is foundering sweet to me.*

Two different ways of performing the act generically known as "remembering" are at play here. On one hand, there is the somehow "holistic" way of remembering visual scenes[3]: one can have a very vivid and emotionally rich memory but remember practically no detail—the whole can stand by itself without being supported by its parts. On the other hand, one finds a clear but fragmented memory of disconnected details which stand without being connected to a whole.

Why are these considerations important for image databases? Because users look for images based on some imagined (and this is not a lexical coincidence or a careless alliteration) referent. The modalities with which these referents are built in the mind of the user are similar to those with which images are remembered: The holistic aspects of the referent are invariant to considerable change in its details. A search in traditional databases, on the other hand, is a business of details—we ask for certain values in well-defined fields and certain relations between fields. The "overall" or holistic aspect of a record never enters a query specification. A number of problems in image databases derive from failing to acknowledge this difference. The same dichotomy can be seen inside the field of image databases, embodied in the difference between what might be called the *sensorial perception* of a scene (holistic) and the *interpretation* of the same scene (linguistic). Details are important in the interpretation: remembering that Robert Kennedy was shot is not the same as remembering that Abraham Lincoln was shot[4], but a sensorial impression can maintain its semantic connotation more or less intact in the face of considerable loss or misinterpretation of details.

These brief notes identify the two broad classes of meaning that will be present in the rest of the book. The next chapter will analyze image semantics in greater detail, and will place it in relation with the semantics of language. This relation will generate three query modalities, which will form a framework for the rest of the book.

In the remainder of this chapter, I will outline some generic characteristics of visual information systems, and make a brief analysis of their users.

1.1 Characteristics of Visual Information Systems

Image databases are, well,..., databases. In a certain sense, this statement is a truism but in an equally important sense it is incorrect. There is reason to believe that all the familiar concepts in database research will have to be revised in some measure to adapt to images and (more in general) multimedia data. The nature of the image data and the relation between information and its carrier are of a completely different nature and as databases are essentially machines to extract

[3] I am using the word "holistic" in its technical sense here, as I will in the rest of the book. The reader can be reassured that I am not advocating fumigation as an alternative medical practice.

[4] That is, when the visual memory is interpreted—translated from images to language—details matter.

information from collections of data, it is natural that this ontological difference should generate differences in methods and principles.

There are a number of characteristics of images that contribute to the peculiar nature and methods of image databases; among these, a broad (and somewhat arbitrary) distinction can be made between *semiotic* and *technical* characteristics. Correspondingly, one can talk about semiotic and technical characteristics of image databases and of semiotic and technical requirements. The semiotic characteristics of an image are given by the forms of the signification relation between the image data and the possible meanings of the image as interpreted by the user. In other words, semiotic characteristics have to do with the interpretation of an image as a *sign*, a message directed from the creator of the image to its user. Semiosis has by far the most far reaching and deep consequences on image databases. I will introduce the problem of semiosis in the next chapter. In this section, I will consider the technical characteristics of images, and how they have shaped the field of image databases so far.

Image databases are a land of comixture and interaction between the computer vision and database communities. The field of visual information systems borrows techniques from both its well developed neighbors.

Despite its strong cultural heritage, however, image databases constitute an autonomous discipline through the development of original points of view and techniques that derive from the unique characteristics of the problems they try to solve. Although image databases operate on the same data as computer vision and have an ultimate goal affine to databases, this group of characteristics makes them into an autonomous discipline.

Similarity. Image databases do not match symbolic representations of the meaning of images, but rely on a more loosely defined notion of similarity between images. This choice is connected (as I will argue more extensively in Chapter **2**) to intrinsic characteristics of images, and is not merely a consequence of technological limitations in extracting a symbolic meaning from the image data.

Generality. Although there is a large field of applicability for restricted domain databases (for which a symbolic description of all the relevant meanings—possibly with uncertainty—is possible), there is a great interest in methods that can be applied to a large (theoretically unlimited) class of images. This marks a relevant departure from mainstream computer vision and, together with the use of similarity and the rejection of an "object-oriented" approach to semiosis, defines the boundary between visual information retrieval and computer vision.

Interaction. By and large, image databases are not autonomous systems, but work in strict interaction with a user sitting in front of them. This apparently trivial fact is the most important difference between image databases on one hand and traditional databases and computer vision systems on the other. Most computer vision systems (from robotics to quality control and face recognition) are designed to perform all or most of their activity in an unsupervised manner.

Even databases, which are apparently interactive, consider interaction as an essentially peripheral activity, relegated to receiving a problem specification from the user (the query) and providing the problem solution (the answer to the query). In image databases, interaction is a necessary characteristic of the system, and a direct consequence of generality. There cannot be a noninteractive general image database and, the more the generality, the more important the interaction. As for similarity, the importance of interaction derives from characteristics of the image data, and not from technological limitations.

Data complexity. I am not referring here to the semantic complexity of the meaning of an image (which I will consider in the next chapter), but to the sheer complexity of providing and managing an adequate representation of the image data (this does not imply, of course, that the two complexities are not related). Images are represented by feature vectors in high dimensional spaces, or by complex structures like graphs, which are hard to manage efficiently. To make things worse, image databases require operations like nearest neighbor searches, which are considerably more complex than the simple matching typical of symbolic databases. The juxtaposition of a high dimensional feature space and of more complex operations typical of similarity databases create a challenging problem of data management and indexing.

Images are described in high dimensional *feature spaces*, while records are described by a small set of partially independent keys. An elementary search in a database consists of matching a query against the keys. This reduces the problem to a combination of single dimensional problems, in which keys are naturally ordered, thereby allowing the designer to use indexing techniques based on ordered trees. In high dimensional feature spaces, it is impossible to define a total order and, consequently, it is impossible to use the same indexing techniques.

The importance of these problems and characteristics has been recognized to varying degrees. Quite surprisingly, the least recognized (or the least actively pursued) characteristic is the interactive nature of the image search problem. Part of the reason for this state of affairs might be the hastily made assumption that something resembling the traditional query process could be created for image databases. Since the interface has an all-in-all secondary role in a query process, it is a natural consequence of such an assumption to think that it should also have an all-in-all secondary role in visual queries. The most successful embodiment of this point of view is the *query by example* model, to which I will now turn.

1.2 Query by Example and the Semantic Gap

Query by example (the acronym QBE is de rigeur) is the first operating model specifically developed for content-based image retrieval. As is often the case for many good ideas, it originated in several places at the same time; its success, however, came with its adoption in IBM's query by image content (QBIC) [Flicker *et al.,* 1995]. Systems based on similar principles were developed in universities

[Jacobs *et al.,* 1995; Smith and Chang, 1995; Faloutsos *et al.,* 1994; Manjunath and Ma, 1996; Bach *et al.,* 1993] and companies [Gupta, 1995].

Query by example is based on similarity, and uses similarity criteria determined by the user. The details of this determination depend on the specific system. Query by image content only allows the user to select among four fixed similarity criteria: global color; local color; layout; and texture. Other systems, like the Virage [Gupta, 1995] and the Excalibur [Excalibur Technologies, 1995] search engines let the user specify a similarity criterion as the weighted sum of similarity criteria much like those in QBIC. Other systems [Smith and Chang, 1997] allow the definition of regions and the specification of the desired spatial relations between those regions. Once the similarity measure is determined, the user gives the database an *example* of what he is looking for. The database will use the similarity criterion to rank the images by similarity with the example, and will display the top ranking images to the user (usually between 10 and 50 images are displayed).

This interaction model is appealing mainly for its simplicity and because it is a natural extension of the traditional computer vision problem of matching models and data into the more general realm of feature vector similarity. There are, however, endemic problems with QBE, and they are related more or less directly to semantics. The first problem that users of QBE systems find is the selection of the right example to start the query. There are two aspects to this problem, that of judging what kind of image would be a good example, and that of obtaining such an image. The latter aspects have been solved either by letting the user draw a sketch of the image she is looking for or by providing facilities to browse "representative" portions of the database. The first method (sketch) is not easy to use for "artistically challenged" users. Very simple drawing tools do not give the user enough power to create good examples, but increasing the power of the tools requires a correspondingly higher user sophistication. More fundamentally, a sketch is always a simplified or schematic representation of the image that the user desires, and is created through a process of filtering out details from a mental image, or through a process of construction from a linguistic description. None of these processes can be adequately formalized without a heavy epistemological investment in "context" (more on this in the next chapter). Consequently, the translation of a sketch into an image sample for QBE (which is, in a way, the inverse of the process of sketch creation) is a problematic and error-prone activity.

Browsing, on the other hand, requires the selection of a manageably small "representative" set which, by itself, it is a problem no simpler than image retrieval, and more plagued by the problems that come with generality, its definition requiring an a priori categorization that escapes the confines of QBE.

The other aspect of the problem of example selection is the judgment of the quality of the given image when used as the example or, in other words, the judgment of the representativity of the image as a tentative (but not final, for otherwise the search problem would already have been solved) solution for the user problem. The requirements of a user are usually complex and imprecise, especially at the beginning of an interaction, and are not easy to synthesize in one "just right"

example. In most applications, the problem of finding the right example to pose the query is as hard as answering the query.

An additional problem of query by example (QBE) databases is more specifically semantic, and is related to the difference in the semantic field in which features are defined and that in which the user is thinking of the query.

At insertion time, the database engine analyzes an image and extracts a number of features to describe it. Because of the generality requirements, and the notorious unreliability of object recognition systems, most databases use simple perceptual quantities, drawn from what I call a "low level" semantic field. Typical features include color histograms, local color histograms (which give indications on the spatial distribution of color), local density of edge elements and their direction (this feature is sometimes called "structure" or "layout," and is a simple and robust substitute for shape), texture descriptors, and so on. These descriptors are collected in a feature vector, and the similarity between two images is determined as the inverse of the distance of the respective feature vectors.[5]

A similarity query using features like these will give results more or less like those in Fig. 1.1. (The image in the top left corner of the figure is the query.) If you look at this answer you may at first be a little baffled. You were looking for something that was obviously a door, and the result contained a couple of doors, some women, a kid, a city, a corridor. What is going on? The similarity criterion I had specified for this query was a combination of color distribution and structure. With this similarity in mind, consider the woman in the third image. Note that the curve of her forehead has almost the same shape and size of the arch on top of the door in the query. Also, there are other superficial similarities—in both the query and the image of the woman's face the arch encloses a section of the image with many edges, while outside the arch there are not as many edges. This similarity in structure was obviously strong enough to give the image a high score, and make it appear in the third position.

Similar considerations apply to the image of the woman appearing in the fourth position. In this case the color, position, and size of the vest she is wearing make the image relatively similar to the query. Most of the images returned by the engine can be explained this way—the child, the door, and the doorway all have similar structure. Some images are not so easy to explain. For instance, it is not easy to justify the presence of the image of the city. I suspect, however, that the general layout, with a prominent tall structure in the center is responsible for the similarity.

This finding can be expressed informally as follows. The database does not know that I am looking for a door. I specified an image and gave the database certain similarity criteria that I thought were relevant. These similarity criteria form a framework into which the database works or, in other terms, they give the database a logic to which to conform. The database, in general (one does not

[5] This model of similarity requires some hypotheses about the vector space. For one thing, it must be a metric space. This and other, stronger assumptions, are usually tacitly slipped into the description of the system. Metric and metric spaces will play a very important role in the approach proposed in this book.

Figure 1.1. A query (the image in the top-left corner of the figure) and the eight images closer to it in an image database. Image courtesy of Virage, Inc.

expect it to give the exact answer 100% of the time), comes up with an answer that makes sense within this framework.

Therefore, the problem is not that the database is wrong according to the semantic induced by the similarity criterion. The problem is that the similarity criterion does not successfully capture the semantics intended by the user. The problem lies in the different semantic planes in which the user and the database operate. To put it simply, the database operates in an environment whose objects are colors, edge fragments, texture patches, and so on. Colors can be bright or dark, edges have direction, and textures have a number of complex characteristics. The user operates in an environment of old doors, funny hats, friendly faces, and so on. It seems obvious that the semantic of the latter should somehow be based on that of the former, but image database systems are not very good at doing this derivation nor, as I will argue in the following chapter, is this derivation possible based only on image data. I call this problem the *semantic gap*.

Although the fact is not acknowledged in the literature, it is noteworthy that QBE is a (possibly accidental) attempt to a new solution for the semantic gap. Traditional computer vision systems rely on a very explicit semantics. After processing, each unit element in the image is assigned a symbolic descriptor, and meaning is inferred through syntactic manipulation of the descriptors and their relations. In QBE, on the other hand, it is assumed that commonality of meaning is induced by similarity. Images are never explicitly assigned a meaning, but they are ranked by similarity with a referent, under the assumption that similarity will also induce a categorization (possibly a fuzzy one). This is a very important insight of QBE, and will be one of the cornerstones of this book.

Problems start to appear (conceptual problems too) when the model of similarity induced of meaning is cast into the specifics of QBE. Since similarity can only induce a categorization based on the meaning of the referent, it is necessary that the referent embody the meaning intended by the user. However, the process of attaching the meaning to an image is by no means simple, or even well-determined. You decide that an image has a certain meaning based not only on the image data, but also on the situation at hand. The image in the query of Fig. 1.1 can be used by people looking for a door, an old door, a blue door, or an arch. An image of people on a beach can signify "people," "a beach," "the ocean," or "pictures of San Diego."

A final issue for QBE is the choice of the right similarity measure. Receiving an answer like that of Fig. 1.1 is not a terribly negative result if the result can give indications as to how the similarity measure should be changed in order to improve things. In order to cast the problem in more precise terms, assume that the user has a certain meaning m in mind and that there exists a similarity measure S_m that, based on the features used by the database, can create a categorization that reflects exactly (or, at least, optimally) the meaning m. The database, however, uses a similarity measure $S' \neq S_m$. The *similarity mismatch* $S' - S_m$ results in the curious answer of Fig. 1.1. The problem now is: How directly can one use the result of a query (like that of Fig. 1.1) to reduce the similarity mismatch? In pure QBE systems, the connection between the result displayed and the similarity measure is very indirect, as one can only operate on a number of parameters θ on which the similarity S' depends as $S'(\theta)$. Schematically, the situation in Fig. 1.2 is one in which the input interface is a panel with a number of knobs that operate on the parameters θ. The output interface is a list of images (the results of the query). The input obviously has an effect on the output, but the output gives no indication as to how the input should change to make it closer to the user's *desiderata*. What should one do, for instance, in the case of Fig. 1.1? Add more color? Use less texture? The output does not tell.

A related problem concerns whether the measure S_m is in the range of the similarities $S'(\theta)$, at least with reasonable approximation. Alternatively, one can look for the minimum possible error $\|S_m - S'(\theta)\|$ (for some suitable norm $\| \cdot \|$) that can be attained by varying θ. This value decreases (and hence the performance of the system improves) as new parameters are added, that is, as the dimension of the

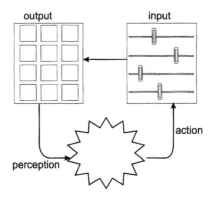

Figure 1.2. The relation between the user, the controls, and the output of the database.

manifold $S'(\Theta)$ is increased. However, practical considerations make it impossible to use more than a few knobs in the interface, lest the interface itself become extremely confusing. This limits the span of $S'(\Theta)$.

These limitations should not shadow the great innovation of the QBE model: the use of similarity as a way to express meaning. Query by example represents the first realization that the usual symbolic ways of assigning meaning to an item in a database may not be applicable to images. In query by example, commonality of meaning is induced by similarity and, as similarity can be manipulated, it depends on the query: Consequently, two images can have the same meaning for a given query and very different meanings if another query is posed. The recognition that the meaning is dependent on the query will also bring the realization that it is context dependent, because queries are made in a certain context.

Context itself is a complex issue and an open concept, so that one will never be able to circumscribe it completely. Before attempting a deeper analysis of meaning and context, however, it is opportune to start classifying, at least superficially, the different needs that may bring a user to an image database.

1.3 What Do Users Really Need?

A study of image databases cannot be made without questioning the application scenarios and modalities of usage that typical databases encounter. Many decisions in the development of a database system (and, more in general, of a technological artifact) depend on the application scenarios it will face, and a successful deployment of a new technology depends in large part on a successful characterization of the social and organizational context in which the technology will be employed. The possibility of such a characterization rests on the constraints that this context poses on the user's personal search strategy. These constraints are maximal for professional users, who use image search as part of their role in some professional organization, and minimal for casual users. The following is a loose list of fields in which, at this time, it is possible to envision an application

of image databases and content-based image retrieval. It goes without saying that such a list is far from exhaustive.

Entertainment. Entertainment, or recreation, is probably the most common reason for the casual user to retrieve images[6]. The advent of commercial TV and video games caused the explosion of entertainment into a constellation of loosely related activities. Today the term "entertainment" covers very diverse activities, ranging from the passive assimilation of video images, to a highly elaborate and interactive game of chess played over the internet against an opponent from a different continent. Entertaining images can be produced to convey information (as is the case of thematic maps), create an emotive state (that is, to create disinformation, as is the case of direct or indirect advertising), be associated with other signs (as is the case of the web sites that place at one's fingertips images with which to compose birthday cards), or enjoyed for the sheer pleasure of it (as is the case of images of paintings, or artistic photography). The boundaries between these categories are blurred. There are many ways in which, say, a weather map can be rendered, with some more attractive that others. At what point does the search for a "better looking" map cease to be a search for clarity (i.e., for more information), and begin to be a search for a more attractive image independent of the clarity with which it can deliver information (i.e., a form of self-referential advertising)?

Document preparation. All word processors today give the user the possibility of inserting images in a document. No word processor, however, is very sophisticated in helping the user find the right image. The assistance is usually limited to browsing a categorized list of images and drawing, an insufficient solution now that the web places potentially millions of images at the fingertips of every word processor user. Content-based image retrieval can help greatly in this. Using

[6] I am taking here a rather general, and considerably Americancentric, sense of the word entertainment. In the current American pop culture the term entertainment has established a firm grasp over domains not traditionally under its umbrella, which used to be limited to children's games and similar activities. In particular, entertainment is extending into the realm of what was once called "culture": In July 2000, the web search service "Yahoo," had the category *music* listed under the heading *Art and Entertainment* (and do not tell me that the association itself is not significant). At the same time, the category *musique* was listed under the heading *culture* in the French version of the same service. A CD brought to me by a Chilean friend carries the label "El disco es cultura"; a label unthinkable in an American release. The (etymologically horrendous) neologism *infotainment* has been created to describe the comixture—mostly for commercial purposes—of information and entertainment; two terms that other cultures tend to keep separated.

However, if the term *entertainment* has such strong cultural connotations, it may be hard to define it in such objective terms to make it a taxonomic subdivision of any technical utility. There are, however, two characteristics of what is commonly classified as entertainment that appear to cut across cultural divides: Entertainment is ahistorical and unskilled. It is ahistorical in the sense that sheer entertainment does not create a prolonged and articulated experience, but its action terminates when the stimulus does. It is unskilled in the sense that entertainment presupposes no particular skill or cultural background of its users (these characteristics have of course a lot to do with the commercial interest to extend entertainment to as many fields as possible). Ahistoricity and unskilled users define entertainment applications in a technical sense.

the techniques developed in Chapter 7, for instance, it is easy to imagine a word processor in which a user highlights a portion of text and, at the click of a button, a database starts searching for images that might illustrate the highlighted text. The database can return a list of candidates from which the user will choose.

A similar scenario can be visualized for other activities in which images illustrate or are somehow subordinate to text, like designing a web page, or preparing a pamphlet.

Learning. The availability of powerful computers and fast data transmission channels has the potential to open interesting opportunities in all areas of learning. The current focus is mostly on *distance learning*, mostly because of the economic advantages it can provide for colleges, schools, and other organizations for which personnel training is a significant activity. The possibility of high-quality learning reaching remote communities that would otherwise be cut off from the stream of sophisticated culture seems at this time more a theoretical than a practical possibility because, *ex hypothesis*, such communities seldom have access to the computing power and the data bandwidth necessary for distance learning application. It is generally believed that images and other media alternative to text will play an important role in distance learning, although, so far, the culture and art of multimedia teaching seems rather immature, and the evidence of benefit from access to media other than a book is scanty. To top this off, the current learning scenario presents a worrisome confusion between *learning* and *training*, with an even more worrisome tendency to move learning in the direction of training, rather than vice versa.

All this said, however, images (and other media) can undoubtedly provide a didactic tool of formidable power, and there is no doubt that learning can greatly benefit from the availability of large databases of images. From the technical point of view, the most interesting aspect of learning applications is the complex relation between images and text, especially if learning will abandon the traditional schemes and become a more exploratory activity in the sense of Piaget. Experiments in this sense were attempted by Papert in the mid-80's in Boston's Hennigan School [Brand, 1987]. Learning, in this case, requires the free manipulation of images and their association to texts in different modalities: explication, contrast, metaphor, pastiche, ..., all in a more complex and multiform relation than anything seen in document preparation.

Graphics and advertising. Many graphic design problems have to do with finding the right image for the right application in cases in which the concept of "right image" is extremely elusive. When a designer is creating, say, a brochure for a new product, he typically starts with a more or less imprecise idea of the thematic content of the final brochure, and then dives into a pile of catalogs from some stock images provider to look for inspiration.

My friend Sergio—a graphic designer—was explaining this to me a few months ago. The case in point was a brochure for a new model of German washing machine that was being imported to Italy. The main selling point of the new washing machine was that it used comparatively little electric power and water. His idea was to find some imagery that would put this environmentally friendly aspect (to which the upscale Italian consumers to whom the machine was directed are very sensitive) in evidence. Due to the obvious connection with water, his idea was to look for some kind of ocean or sea image. The question was not much the search for a particular theme, as the search for an image in which he could fit a picture of the washing machine in order to create a pleasant composition with the right connotation. He started browsing his catalogs of stock images and in the process he realized that an image of a river with salmon fighting the current might be more appropriate for what he had in mind.

First, in this kind of problem the concept of the "right answer" must be abandoned. The designer will start looking for a certain class of images but, while browsing through the catalogs, he migh refocus his choice, or maybe completely change his mind. This may be due to a perceived deficiency in the catalog ("there is nothing better in the catalog; this one will have to do") or because the act of exploring the catalog unveiled a new possibility not thought of until that moment ("hey, this idea looks good; I might search for something like this").

Second, the graphic design activity involves a mix of searching and browsing. The designer does not just search for images satisfying a certain query; he needs to explore the database to see what it has to offer and to look for new ideas. The necessity of browsing highlights another interesting aspect of this problem; although all stock images companies provide CDs with a low resolution version of their images (which can be used for the first test before the designer buys the image), all browsing is done with paper catalogs. Computer browsing is still not good enough to substitute for the paper catalog. The low resolution of the computer screens creates a disadvantage that adequate browsing technologies will have to overcome in order to make this medium successful.

Finally, the "query" in this case is not just about the things contained in the image—the right image must have a space in which the image of the washing machine could fit. The search is no longer just for a presence (an image with such and such objects) but for an absence (an area at least this size without any object).

Trademark search. Searching for trademarks is an important problem that, in a sense, is the opposite of graphic design. In a trademark application, one is given a tentative logo and searches a database to be sure that the logo is not too similar to some already existing trademark.

Unlike the graphic design case, there is here a very specific query, and the user is not going to change his mind in the middle of the search. Moreover, in the graphic design case, one is just interested in finding *one* good image. The number

of potentially good images that are not seen is not terribly important, as long as the designer is happy with his selection (there should always be, of course, the possibility of further exploration). In the case of the trademarks, the user wants to be sure to see *all* the images reasonably similar to our query, in order to be able to make an informed judgment.

Medicine. The medical profession has traditionally relied on a complex of signs, the "look" of a patient being one of the most important[7]. Two phenomena are changing and expanding the role of recorded images in medicine: the diffusion of mechanical devices that produce images as outputs (X-ray, MRI, retinoscopy, etc. . . .), and the fragmentation and specialization of modern western medicine. The increased use of mechanical devices in medicine results in an unprecedented production of images per patient, and the fragmentation of the care of a single patient creates a special emphasis on the storage and maintenance of these images as part of the "patient record." In addition to this, in many countries the law requires that all the data relative to a patient be preserved, at least for the duration of the patient's life (and, in many cases, several years after the patient's death). This means that, for the average person, several decades worth of X-rays and other medical images will have to be preserved. These requirements have generated a tremendous pressure for the development of databases of high-quality images (there are rather strict legal requirements on the quality of the images that should be stored).

Content-based retrieval typically enters into play when images from a uniform domain (e.g., retinoscopy images) relative to many patients are collected in a database. The typical application is that of "clinical cases" databases, in which, given an image relative to a patient, the database retrieves the most similar images, so that the clinician can compare them together with the associated diagnoses.

Medical applications are usually based on very specialized features. The diagnostic semantics is preponderant to the trained eye of the physician (although it is often completely undetectable to the untrained eye) so that images are *perceived* as similar to the degree in which they share the same diagnosis. A great challenge of medical systems is the design of the right feature set on which indexing will be based. This often requires the use of rather sophisticated computer vision and image processing techniques.

Security and law enforcement. The main application of content-based retrieval in this area is for the retrieval of faces. In the law enforcement area applications go from the retrieval of faces of suspects based on witness description (all pictures of middle-aged men with light skin, dark hair, and a round face), to the integration of a photographic database with an interactive system for the compilation of

[7] The medical sign was, in fact, one of the early subjects of semiotic investigation, centuries before the term "semiotic" was created—its appearance dates at least to the debates between the Stoics and the Epicureans in the Third Century B.C.

sketches of suspects by eye witnesses (which, in this case, would be a system for contemporary sketch compilation and image retrieval). As in document preparation and learning these applications put a great emphasis on the relation between images and the linguistic practices that are used to describe them.

In the area of security, applications include searching faces or fingerprints in a database of authorized personnel for access control, or tracking the movements of particular individuals. Other applications include *configuration recognition*, the comparison of a configuration of people or equipment with known configurations to identify the activity that is taking place.

1.3.1 User Interaction with Image Archives

There are as many modalities of interaction with a repository of image data as there are users. One of the most limiting and unfounded assumptions in content-based retrieval is that for each query there is *a* target image (or a finite group of target images, which amounts to the same assumption). Images, especially in professional fields, are searched for a reason, and the search for an image takes place in a certain social and organizational environment. This environment, as well as the personal inclinations of the user, determine the type of search that will take place and, to a large degree, what the user will be willing to take as an acceptable result: The goal and modality of a search made by a police officer will be very different from the goal and modality of a search by a graphic designer.

Understanding the user's culture and organization is a necessary prerequisite for the successful design and deployment of a content-based image retrieval system and for any other computerized cognitive aid. In a sense, this cultural analysis is the cognitive system analog of the *analysis* phase in the design of generic software systems. Just like the analysis of a software system, the study of user needs is exposed to the risk of *gadgetry*. Gadgetry is the name I give to a certain attitude that sees the application of technology as a more or less neutral addition to an existing organization. The new technology will add some convenience (in other words, it will be a useful gadget), but it will leave the structure of the organization and the relation between its people more or less the way they were.

It is not necessary to look too far to find examples of gadgetry. Consider a person who buys a cell phone thinking that the net result of such a purchase will be a greater convenience in placing and receiving calls. Let us also assume that the same person loves to spend his Sundays fishing on the pier. Suddenly, on Sundays, that person will be reachable even in his last sanctuary. He might think all that is necessary is to turn off the phone when he goes fishing, but this opinion reveals a misunderstanding of the real change brought about by the cell phone. The *relationships* between himself and his environment and the *expectations* of his environment have changed. Suddenly, he is expected to be reachable on the weekend before an important deadline at work, or by his wife in case something goes wrong at home. The mere possibility of reachability generates a new set of

expectations and social commitments that were not even contemplated before the availability of the cell phone.

The same is true for the introduction of any significant technology into a social structure. The very presence of the technology, or even in some cases the mere *possibility* of the presence of the technology, will change the organization, and the commitments on which it rests. It is important to understand that, as one studies certain user behaviors of users of image repositories (or, for that matter, of any other aspect of a social structure) in order to automate them, one is *ipso facto* changing them. With this point in mind (and I will return to this point in a short while), the results of user research, although limited to specific types of data or users, give an open and variegated view of the possible requirements imposed on a content-based image retrieval system.

Ornager (1997) and Markkula and Sormounen (1998) studied the habits of journalists in their search for images to associate to their stories. The results were obtained by analyzing the requests that journalists sent to the photo archivists of the newspaper. Ornager derived a user taxonomy based on five types:

The specific enquirer has a specific picture in mind (I need the—very famous— picture of the summary execution by General Loan, the chief of the South Vietnamese National Police, of a Viet Cong Prisoner with a shot to the head in Saigon) and sometimes has specific information about the picture, like the author (I need Rodcenko's portrait of Stepanova). Requests not limited to a single picture, but to a small, very identifiable group of pictures, also fall into this category (I need a picture of Ataturk addressing the Turkish parliament).

The general enquirer asks rather broad questions because he likes to make his own choice (Send upstairs 10 or 20 pictures of Jacques Chirac at home engaged in everyday activities). Typically this enquirer wants to receive a few dozen images among which he will browse looking for the one that is "just right."

The story teller enquirer goes to the archive and talks about the story that the picture will illustrate, is open to suggestions on the type of pictures that will illustrate the story and cooperates with the archive staff to find a good one.

The story giver enquirer, unlike the previous type, hands the story, more or less complete, to the archive staff and lets them choose the photographs.

The space-filler enquirer, finally, only cares about the size of the photograph in order to fill an empty space on the page. [Ornager (1997)]

Markkula and Sormounen also found a similar division of the spectrum of journalistic searches. According to their study, requests for specific photographs

(in which an individual object, person, or place was named) were the majority. One aspect of great interest in their research is the analysis of the desirability of mediation as a function of the type of research. By and large, they found that when the request was for a specific object or person, the search was usually mediated, that is, journalists sent the request to the central photo archive and received back a photograph that they used, often without further interaction. When the request was for a broader domain or for pictures that should convey a symbolic value or a feeling, journalists preferred to search for the picture themselves. In the mediated world of the central archive this amounted to asking the archivist to return a relatively large number of photographs (10 to 100 usually) among which the journalist could browse. It is not known whether the preponderance of object specific searches is due in part to the greater convenience of these searches in a mediated environment. In other words, there is, to this day, no study to indicate how the types of search could be influenced by a different structure and a different set of commitments consequent to the introduction of an automated system, just like it is not known whether the relative independence—and, in any case, subordination—of the picture to the text could change once an image search and browsing tool were integrated into the tool that the journalists use for creating an article[8].

Similar taxonomies (with a somewhat different terminology) were derived from studies in other domains. Partially similar search classes were derived from a study of a large and very general picture archive at the British Library [Enser and McGregor, 1992; Armitage and Enser, 1997]. In this case, narrow queries included the author and origin of paintings[9] as well as the contents of the painting (show me some *maestà* paintings), or its type (show me mannerist portraits).

More complex queries can arise in technical domains. Hastings (1995), for instance, studied the art historians' patterns of access to an archive of digitized art images. Most common queries were found to be identification, subject, text, style, artist, and category, and color. More complex queries included "meaning" and "why" queries. Often these queries could not be answered using just the image and the textual information available in the database, and the researchers

[8] The latter tool is known as a word processor, but I have intentionally avoided the term, as it tends to focus attention on the words and, consequently, to make images subordinate to words. The tool that I believe is possible today is an integrated "story teller" that will allow an author to put together a story using whatever media are available, from words, to images, to video, games, puzzles ... anything.

[9] The author is a much more likely search criterion in paintings than in photographs. While it is quite usual for people to talk about a "Rubens" or an "El Greco," it is much less common to hear somebody refer to a photograph as a "Capa" or a "Doisenau" (despite the fact that, in both cases, what one really gets is a reproduction (possibly a digital one) of the original). Yet, the status of the original seems to be different in the two cases. In the case of paintings, the original preserves its uniqueness and "aura" in the presence of a possibly unlimited reproducibility, and its connection with the hand that made it seems indissoluble. In the case of photographs, the inherent reproducibility of the work seems to detach it somehow from the author and give it an autonomous life. I wonder what Walter Benjamin would have thought of this.

had to access the full text of the secondary resources from which the pictures were derived.

Toy sociology of image databases. Research in content-based image retrieval owes a substantial fraction of its inspiration to the first of the Ornager user types—the specific inquirer. In the image retrieval literature one often finds the concept of "image query," directly derived from that of traditional databases. There is, in the database, an image, or a group of images, which is "the" answer (or, at least, a good answer) to the user desiderata, the underlying unspoken assumption being that the user desires something rather specific or, at least, something specific enough to be the subject of a query. This stance has consequences on the semantic plane (i.e., it entails a certain view of how an image "means" something) and on the consideration of the role of a database system in an organization that is, to use a terminology derived from Winograd and Flores (1987), in the linguistic game of relations and commitments.

The semantic (and, more broadly, semiotic) problems raised by this assumption will form a major part of the next chapter. In this section I will touch in very simple terms on the problem of the role of a database system in an organization.

The introduction of a computer system (especially highly automated cognitive systems) to an organization is sometimes based on a misunderstanding of the nature, the functioning, and the roles of the organization. Many stories of failures can be reduced to wrong presuppositions about organizations and the possible role of "intelligent" machines in them. The basis of every organization is a network of conversations and commitments. Winograd and Flores (1987) summarize the work of an organization with these three points:

1. Organizations exist as networks of directives and commissives. Directives include orders, requests, consultations and offers; commissives include promises, acceptances, and rejections.

2. Breakdowns will inevitably occur, and the organization needs to be prepared. In coping with breakdowns, further networks of directives and commissives are generated.

3. People in an organization (included, but not limited to managers) issue utterances, by speaking or writing, to develop the conversation required in the organizational network. They participate in the creation and maintenance of a process of communication. At the core of this process is the performance of linguistic acts that bring forth different kinds of commitments. [Winograd and Flores, 1987, p. 157]

Winograd and Flores go on to outline the role of a computer system as a communication tool whose goal is to facilitate conversation and commitment inside the organization. This is sometimes the opposite of what a system is ostensibly designed to do. Consider the following passage, which appeared in the popular press and was cited by Winograd and Flores (1987):

Artificial intelligence could produce powerful assistants who manage information for us, reading books, newspapers, magazines, reports; preparing summaries, avoiding those things the computer knows won't interest us, keeping abreast of everything that happens in the world, seeing that nothing we really should know escapes us. [Stockton, 1980, p. 41]

This passage demonstrates a rather serious (but very diffused) misunderstanding of how people (let alone societies) operate. The process of reading in its "utilitarian"—as opposed to "passionate"—component (and I will not even go into the problem of whether this division makes any sense at all) is considered an activity consisting of two parts. When one reads, there is supposed to be a filtering stage, which decides what is "worth knowing" and what is not. After this stage, the "important" things are passed to some other gizmo inside one's head that will assimilate the important information into some kind of unspecified mental structure—whatever that may be. In this model, filtering is a dispensable time-consuming part of processing, since the material that is filtered out will be excluded from memory and consciousness and will have no influence on intellectual activities. I will not comment on the rather evident dehumanizing aspects of a world in which we read only what is "important" to us. I will just comment that such a simplified model of reading and understanding should not even be considered as a first rough approximation of the way people read. Everybody who has spent a pleasant afternoon sifting idly through a bookstore and finding the perfect book for a problem that had occupied his mind for days or finding a book that stimulated a completely new line of thought knows that.

Consequences of this mechanical model are the arbitrary division between "important" and "nonimportant" information (up to the rather limiting use of the word "information") and the assumption that the introduction that the insertion of automated systems in an organization will help people concentrate on the "important" stuff. This simplification leads to an undue restriction of the field of operation of the interested people. In the example of the journalists as already discussed here, such an attitude would materialize in the elimination (or drastic reduction) of the archival team, and in the installation of a terminal of the image database on the desk of every journalist, so that the journalist herself could search for the right image to illustrate a story. Such an approach, as appealing as it may be to the accounting department, would diminish or downright ignore the important role of the interaction between the journalist and the archivist, and, in a rather oblique way, would redefine, rather than help, the activity for which the system was introduced. Once the hypothetical image database of this example is installed, in fact, the activity becomes "choose the right image for the article," which is quite different from the original problem, which is "present this story in the best possible way." The result of the conversation between the journalist and the archivist can be the selection of a good picture to illustrate the story, but this is only one of the possible outcomes. The conversation could result in the decision to publish the story without a picture, to publish it with a drawing prepared expressly for the story, or even to change the story to accommodate a

picture that does not fit with the original version. This process, and the existence of these possibilities, are essential for the solution of the real problem, and the role of a computer system should be to facilitate the exploration of these and other alternatives, not to restrict them.

The ultimate result of the installation of a database system is the enlargement of the original conversation to include the designer of the database. It is important that the participation of the designer (via the computer system) not impose the terms of the conversation. This happens, in the previous example, when the computer system forces the conversation about presenting a story in the best possible way to become a conversation about finding an image for an article. The reductionist temptation to fragment a problem into pieces in such a way that one of the fragments will fit certain prejudices about the use of computer technology, and to call this fragment *the* problem is very strong it should be resisted. It is, in many cases, a consequence of a misguided analytical zeal, and a common determining factor in many failures of the application of advanced computer technology to everyday problems. Successful application of computer technology to complex human activities requires understanding the social nature of the activity, the role of the computer system (and, indirectly, of the designer of the system), and the changes in the organizational pattern of the activity caused by its participation.

It is useful, if a little simplistic, to divide the discussion on the impact of image databases into three scenarios. The first scenario is that in which the user of the photograph is the same person who searches for it. This is the case, for example, of a graphic designer browsing catalogs in search of the right image for an advertising campaign and of the trademark examiner searching the archives for a trademark similar to that for which validation is sought. The second scenario is that in which the journalists in the fore-mentioned user studies work. The choice of the right picture derives from an interaction between the user of the archive and its managers. The interaction can result in the choice of the right picture but also in redefinition of the problem (e.g., a solution in which the article is published without pictures). The third scenario is that of a doctor looking at an X-ray and then at similar X-rays that can lead to a diagnosis. In this case, the image is a connection between two diagnostic situations, and the retrieval of similar images is connected to a similarity that makes sense in the specific field of application of the database.

Traditionally, automation aims at reducing the second situation to the first, that is, to enable a user to do for himself something that used to require the assistance of expert personnel. This attempt embodies a misunderstanding of the role of interpersonal relations in an organization, for the reasons I have already outlined. Rather, the goal of the introduction of a database system should be to transfer as much as possible of the conversational content of the second scenario to the first, that is, to transform the first scenario into the second.

The distinction between the two scenarios (and, consequently, between the two directions of reduction) is more than an intellectual exercise. In the first case, one is looking for a solution to a preestablished and largely unchangeable problem; in the second case, one is looking for a satisfactory situation, which can be obtained

by solving the image database problem, redefining it, or eliminating it through alternative means (e.g., changing the story so that it does not require an image). Therefore, every exposition of image databases is necessarily incomplete because such is the case of an image database taken in isolation—a complete description can only be given of a problem that, in a given social context, gives rise to a requirement to interact with images.

This observation marks a limitation of this book, and I will make no effort to hide it. While recognizing that this limitation will always be present in a general technical book on image databases, however, one should also learn some lessons from it. In particular, I have tried to pay due attention to the interaction between an image database and its surroundings, whether these surroundings are a user, a family of users, another system, or an organization.

2

The Mysterious Case of the Disappearing Semantics

it is not so much our judgments as it is our prejudices that constitute our being.

Hans-Georg Gadamer, *Philosophical Hermeneutics*

Bertrand Russell, in his *A History of Western Philosophy*, wrote:

> One of the curious things about the Middle Ages is that they were original and creative without knowing it. All parties justified their policies by antiquarian and archaistic arguments. [...] The scholastics appealed wither to the Scriptures or at first to Plato and then to Aristotle; when they were original, they tried to conceal the fact. [...]

> We must not be deceived by this literary archaism. [...] The scholastics, however they might revere Aristotle, showed more originality than any of the Arabs— more, indeed, than any one since Plotinus, or at any rate since Augustine [Russell, 1967].

An analogous observation could be done about researchers in content-based image retrieval. One sees very often methodological and epistemological justifications of methods based on computer vision. There is a widespread consensus that content-based image retrieval is a subfield of *object recognition*, and there is a more or less veiled attempt to justify retrieval techniques based on the philosophical presuppositions of object recognition. Just like the scholastic

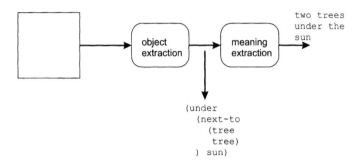

Figure 2.1. Extraction of meaning under compositionality assumptions.

philosopher, however, content-based image retrieval researchers are *de facto* engaged in an original and creative endeavor that goes well beyond the theoretical assumptions of object recognition. Unlike the scholastics, who were restrained by the cumbersome necessity to agree with the scripture and therefore condemned to philosophical sterility, we do not have to excuse ourselves for our originality, but we can embrace it wholeheartedly.

Unbeknownst to theorists and practitioners of image retrieval, new concepts are arising (sometimes unintentionally) that bring into the scope of the discipline some ancient philological and semiotic debates: Image retrieval researchers are tapping into areas concerned with the meaning of images and their relation with the interpretant that are far beyond the traditional philosophical endowment of computer vision.

In this chapter, I will consider the problem of image meaning from the point of view of image databases. I am particularly interested in the analysis of the proposition that the meaning of the image is a compositional function of the objects contained in the image. This hypothesis, if valid, would make a scheme like that of Fig. 2.1 possible. In this scheme, objects are extracted from the image using some suitable computer vision algorithm, resulting in a symbolic description of the objects in the image and their relationship (supplemented by whatever ancillary information about the objects one considers necessary). This symbolic description is then manipulated compositionally to obtain a formal description of the meaning of the image, which is stored in a database and used for the subsequent query process. This scheme, if implemented, would culturally make content-based image retrieval a special case of traditional databases, in which the data are obtained automatically from the images, rather than entered manually[1].

[1] The adverb "culturally" is placed there to remind us that, even if the compositional hypothesis were verified, image databases would still be technically different from traditional databases; the technical difference being due to the surviving imprecision and possibility of error that symbolic data coming from an automatic processing algorithm would have. However, were the hypothesis true, more sophisticated processing algorithms would imply a lesser relevance of uncertainty and error so that, in the limit of an unreachable ideal case, content-based image retrieval would become a chapter of database retrieval.

It is common belief that this scheme would be fully implementable were it not for the incredible difficulty of designing a good object recognition algorithm. Unconstrained object recognition (especially from a static monocular image) is an unsolved problem, and even severe constraints on the nature of the image afford only marginal improvements. Had the problem been solved, however, the conventional wisdom is that the scheme of Fig. 2.1 could be successfully implemented.

This assumption is, I believe, a methodological legacy of computer vision, where it was believed necessary for the purpose of building an anthropomorphic visual machine, but its epistemological foundation and justification have always been somewhat murky.

In this book, I will take a different approach. Meaning is not a datum that is present in the image data (however implicitly) and that can be computed and encoded prior to the query process, but it is the results of the user activity *during* the query process. I like to talk, in this case, of *emergent semantics*: the meaning of an image is given by its relations with all the other images in the database as it emerges during the query interaction. It is no longer a property of a single image but of the whole system, which consists of the image, all the other images, the user, and her cultural presuppositions.

Before taking on the problem of image meaning, I will spend a few words on the fundamentals of the discipline that studies the process of mentioning and signification; semiotics.

2.1 Signs and Meanings

Semiotics (from the Greek σεμηιον, sign) is the discipline that studies *signs*, that is, things that stand for something else, and the general process of *signification*, that is, the process by which things stand for something else.

It is not surprising that a book on image databases should contain a section on semiotics; if anything, it is surprising that it should contain *just* a section on the argument. Although the philosophical interest in signs is as old as Plato, and the debate on the nature of signs as old as the discussions between Stoics and Epicureans, and although modern semiotics was first developed within a linguistic framework, the contemporary world with its copious multi-modal messages—specifically including visual messages—gave semiotics an unprecedented importance and an endless source of new material.

Modern semiotics begins with Ferdinand de Saussure's *Cours de Linguistique Générale* (1960). Saussure was interested in an analysis of the linguistic structures common to all languages. He began by making two distinctions. On one hand, he distinguished between *la parole*, that is, the individual speech acts, and *la langue*, that is, the sign system underlying such speech acts. His interest is in the latter. He also undertook a *synchronic* analysis of language, that is, an analysis of the state of language in general at any particular moment in time, as opposed to a *diachronic* analysis, that is, the historical analysis of the evolution of a language.

The focus of the *Cours* is the nature of linguistic signs, which Saussure considers a dyad composed of a *signifier* and a *signified*. The signifier is the material aspect of the sign: the acoustic waves that stimulate one's ear while listening to a speech, or the light that stimulates one's eye while reading these words, and so on. The signified is the *mental concept* generated by the signifier. The signified is always mental, and it is *not* an object in the real world to which the sign might refer. If I hear the word "dog" in English (generated by the signifiers /d/ /o/ /g/), the signified is not a real dog, but the general concept of "dogness" that is forming in my mind. It should be noticed that the signifier and the signified are not two distinct entities, but two inseparable components of the dyadic sign. There can be no signifier without a signified: a physical stimulus that does not generate a mental concept is not a signifier, but a mere stimulus (this idea will be analyzed in greater detail by Peirce), and a mental concept that is not caused by a physical stimulus is not a signified, but an idea. Saussure illustrated the relation between sign, signifier, and signified with the following diagram:

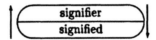

Saussure recognized that the relation between signifier and signified is conventional. There is no reason why the signifier *dog* should be connected to the "dogness" signified. In fact, different languages use different signifiers to express the same signified (or a similar one): *chien, cane, perro, hund*, and so on. However, if the sign contains no natural reference to its signified, it can only function by virtue of its *differences* with other signs. The signifier *dog* does not signify "dogness" by virtue of some connection with the signified of dogness, but by its differential relation with other signifiers, like *cat, cow, house*, and so on.

This system of differences and oppositions (la langue) is the only vehicle of signification. There is no such thing as an isolated sign. The fact that the sign is conventional does not mean that, at the level of a single speaker, it is arbitrary. The single speaker does not have the possibility of suddenly starting to use the word "qlek" or any other sound to indicate a dog. Language is conventional at the level of a collectivity—there can be no language unless there is a collectivity of speakers.

The cofounder of modern semiotics is the American philosopher Charles Sanders Peirce. Unlike Saussure, Peirce considers a sign a triadic system whose elements he called the *representamen*, the *object*, and the *interpretant*. These are often represented in Peirce's *semiotic triangle*:

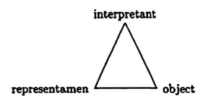

The *representamen* is the form that the sign takes. One can think of it as the "syntactic" characteristics of the sign.

The *object* is the entity to which the sign refers (also, sometimes, called *referent*). The object is not (as the name would lead one to believe) an actual state of the world, but it is a purely cultural reference, or, more precisely, a cultural unit. This fact is highlighted very well by Umberto Eco's famous observation that every time there is signification it can be used to lie: "The possibility of lying is the *proprium* of semiosis just like (for the Schoolmen) the possibility of laughing is the *proprium* of Man as *animal rationale*" [Eco, 1976]. Every time there is a lie, there is signification, and every time there is signification it can be used to lie. The *possibility* of using signification to lie implies that the Peircean object *necessarily* has the capability of supporting a lie and therefore cannot be anchored to objects in the world, for otherwise there would be no sign and no signification in a lie. This observation also implies that Peircean semantics is intensional rather than extensional, at least as long as one considers the sign as part of a code, without analyzing the conditions of its production.

Just like Saussure's, Peirce's semiotics is a theory of a system of differences and oppositions which does not posit (with the exception of the iconic sign—see in what follows) the existence of a real reference. The codes, as far as they are socially accepted, form a world of cultural semantics which supplies objects to the sign relation. To continue with Eco's examples, in order to understand the history of Christian theology, it is not necessary to know whether there exists a specific phenomenon corresponding to the word "transubstantiation," but it is necessary to know which cultural units corresponds to that word.

The interpretant is the most complex part of Peirce's sign. The interpretant is not the interpreter of the sign, but it is that which makes the connection between the representamen and the object, even in the absence of an interpreter. It is the "sense" that is made of the sign. More accurately, the interpretant is another sign (possibly formed in the mind of the interpreter), which refers to the same object, and mediates between it and the representamen. However, if the interpretant is another sign, it will itself need another interpretant, which will need another one, and so on *ad infinitum*. This infinite regression of interpretants creates a process that Peirce called *unlimited semiosis*. As Peirce puts it: "the meaning of a representation can be nothing but a representation. In fact it is nothing but the representation itself conceived as stripped of irrelevant clothing. But this clothing never can be completely stripped off; it is only changed for something more diaphanous. So there is an infinite regression here. Finally, the interpretant is nothing but another representation to which the torch of truth is handed along; and as representation, it has representation again. Lo, another infinite series." [Peirce, 1958]

To give an idea of the vastity of the concept of interpretant, Eco lists a few of the forms it can take:

- an equivalent sign in another sign system (e.g., a drawing of a horse corresponding to the utterance "horse");

- an index directed to an individual object;

- a definition in terms of the same semiotic system (like the definitions in a dictionary);

- an emotive association that acquires the value of an established rule (e.g., "rock," meaning solidity and stability);

- a response of behavioral habit elicited by the sign; and

- all the denotations and connotations of the sign. (Eco, 1976, p. 70–71)

The vastity of the interpretant, and the phenomenon of unlimited semiosis continuously shifts meaning among *cultural units* which, alone, are the ultimate components of a semiotic system. There is never any need to replace an interpretant with anything outside of a sign system. Thanks to this unlimited chain of interpretants, every sign bounces and reverberates throughout the whole semiotic system and, so to speak, the new "equilibrium" of the system is the sole indicator of the meaning of the sign. It is, indeed, the meaning of the sign. The general idea is not too different from that of a connectionist model (with feedback) in which influences propagate and the whole system relaxes to a stable state (a connection evidenced by Paul Cillier in relation to Derrida's notion of *differánce* [Cilliers, 1998]). Just as in a connectionist model, individual cultural units have no interpretation, but meaning is a property of the whole configuration of the system.

A cultural unit is only defined inasmuch as it is embedded in a system of similar cultural units that are opposed to it. This concept of meaning in a semantic system as a function of the differences between concepts is made particularly clear in this example by Hjelmslev (1961). The following diagram shows the distinction between different groups of trees as they are named in German and French:

Baum	arbre
Holz	
	bois
Wald	forêt

The French word *arbre* covers the same semantic domain as the German word *Baum*. The word *bois*, on the other hand, can be used to indicate what Germans call a *Holz* and some entities that Germans call *Wald*. The other portion of the semantic field of *Wald* is covered by the French word *forêt*. The words correspond to cultural units, but they are defined as pure differences; they are not defined in terms of their extensional content, but in terms of the way in which they relate to each other. In terms of Hjelmslev, an empty diagram like

represents the content-form, while units like *Baum* and *bois* represent the content-substance. The difference between different semantic systems (i.e., different languages) is not only in the different extension of the field of the individual cultural units, but the structure itself can be affected. For instance, in English, the word *woods* is defined both by its positioning between *grove* and *forest*, and by its opposition to, say *metals*. In Spanish, the word with a similar (but not identical) positioning among tree groups is *bosque*, while the word opposed to metal is *madera*[2].

In Peirce, orthogonal to the tripartite division of the sign into representamen, interpretant, and object is another one, indicating three general categories of phenomena of signification, which Peirce called *Firstness*, *Secondness*, and *Thirdness*. In very general terms, Firstness is the realm of general, uninterpreted feelings. To illustrate this point, there is a story told of the composer, Schubert, who played a piece on the piano and was then asked what it meant. He said nothing but, as an answer, returned to the piano and played the piece again. The pure feeling of the music (its Firstness) was the meaning that he wanted to convey[3].

Secondness is the realm of brute facts, which derives from an immediate relationship, for example, the feeling that one gets when in trying to close the door, one finds that an object is in the way. A very specific relation is discovered. Finally, Thirdness is the realm of general laws.

The three elements of Peirce's sign can act according to these three categories, giving rise to the schema of Table 2.1 (derived from Merrel (1995, p. 93)). A sign is characterized by the modality in which its three components (representamen, object, interpretant) act. For example, a 2-2-1 sign is one in which the representamen acts as second (qualisign), the object acts as second (index), and the interpretant acts as a first (rheme). Such a sign is called a *rhematic indexical sinsign.* An example of this type of sign is a cry of pain. The representamen in this sign is a sinsign inasmuch as cries are always taken as individual expression, and not categorized in a syntactic system. The object is an index in that the relation between the pain and the cry is automatic and, therefore, indexical. The interpretant is a rheme because the cry is a disconnected term and not part of a richer sentence structure. Three modes of operation in each of the three components of the sign give rise to up to 27 different classes of signs. Peirce considered the 10 classes in Table 2.2.

The same 10 classes of sign are represented in a more graphic manner in the "Peircean cube" of Fig. 2.2. Signs are in general more complex entities, which can belong to several of these classes at once. Consider as an example (from Cobley and Jansz, 1997) a football referee showing a red card to a football player who just

[2] An interesting way to pass some idle moments—very good while waiting at the dentist's office—is to take a common word and its translation in some known language, and look for ways in which the two take different meanings (through polysemy or cultural extension) and different connotations. Take the English word "light," which in the sense of "the light of the day" corresponds to the Italian word "luce," but in the sense of "give me that light," corresponds to the Italian word "lampada." Not to mention the sense of "light" as opposed to "heavy" which, in Italian, explodes in a completely different constellation of words.

[3] The story is reported in Cobley and Jansz (1997).

Table 2.1.

	Representamen *The sign stands syntactically as:*	Object *The relation between the sign and its object is:*	Interpretant *The sign representation is:*
Firstness	Qualisign *A sensation, before there is conscious-ness of it*	Icon *Some property shared by the sign and the object*	Rheme *A single term*
Secondness	Sinsign *An individual object, act, or event*	Index *An actual physical relation with its object*	Dicisign *A proposition*
Thirdness	Legisign *A law, habit, or convention*	Symbol *a conventional relation to its interpretant*	Argument *a sentence*

committed a professional foul[4]. The red card invokes a defined set of football rules (a number of normatively specified behaviors are classified as professional fouls, and the perpetrator is punished) and is, therefore, an Argument. It is also Symbolic (the red card signifies the professional foul by convention), and, therefore, it is a Legisign. But the red card has been used by referees before. This particular extraction of the card acts as a specific fact: a specific statement of the rules of the game; it is therefore a Dicent Indexical Sinsign.

2.2 Can Images Lie?

Many image searches are characterized by a "tension" between their visual and a linguistic aspects. Image searches of the types done by the users examined in the previous chapter are defined by linguistic requirements, either a narrative or a situational description. The counterpart of this linguistic specification is the content of a particular image (or a set of images) *designated* by the description. Before considering in the second part of the book the technical problem of describing the contents of an image, it is necessary to take on the problem of the linguistic designation of images.

The issue is particularly important in consideration of the fact that a number of techniques in image databases are derived or inspired by similar techniques in information retrieval. Information retrieval deals with the storage and retrieval of

[4] The example refers to the sport known as football in Europe and in almost all other countries, and known as "soccer" in the US.

Table 2.2.

1-1-1	Qualisign	A sensation of blue
2-1-1	Iconic Sinsign	A self-contained diagram
2-2-1	Rhematic Indexical Sinsign	A cry of pain
2-2-2	Dicent Sinsign	A weathervane
3-1-1	Iconic Sinsign	A nonself-contained diagram
3-2-1	Rhematic Indexical Legisign	A demonstrative pronoun
3-2-2	Dicent Indexical Legisign	A commonplace expression
3-3-1	Rhematic Symbol	A term
3-3-2	Dicent Symbol	A proposition
3-3-3	Argument	A syllogism

text documents based on their being *about* something. Its "aboutness" makes a document a set of representamen in the sense of Peirce and, therefore, a collection of signs. In making a parallel between textual information retrieval and content-based image retrieval, it is necessary to understand the semiotic status of images as messages, and to relate it to the status of text.

Pictures in a database satisfy the first criterion for being a message or, more specifically, a sign: far from being *natural* objects they are man-made artifacts. The traditional distinction between "artificial" images (e.g., a reproduction of Magritte's *Ceci nes pas une pipe*) and "natural" images (e.g., a picture of a giraffe in the savannah), is based on the idea that the latter is a mechanical (and therefore faithful) reproduction of reality. But the reality is much more multiform than a picture can capture, and, had we been in the savannah that day at that precise

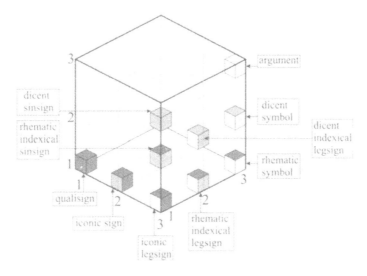

Figure 2.2.

moment, our impression of the scene would have been different from the impression we derive from the picture. This difference is due to two classes of reasons— the first derived from the nature of the photographic process, the second from the presence of the photographer. The nature of the photographic process operates in the sense of inhibiting the natural exploration of the gaze and partially inhibiting the attentional mechanism.

This phenomenon is probably familiar to any amateur photographer. Let us say that, during a visit to the World Famous San Diego Zoo[5] you see a pond with a rock in the middle on which you see a turtle in an interesting pose. You do not have your telephoto lens with you, but take a picture anyway, albeit with an angle wider than optimal. At first you think that it does not really matter: you see very clearly through the lens that the turtle is clearly at the center of the scene. After you develop the film, however, you are startled—the turtle is not prominent as you thought and, in fact, it is barely noticeable. The whole photograph appears like a rather dull scene of a pond of no particular interest, with a little speck in the middle.

A good photographer does not take a picture of the reality in front of him, but somehow filters the scene through the eyes of the camera, and attempts to see the "virtual" image that the camera will create. Considerations like framing, lighting, and the position of the subject enter in the creation of a picture. A picture is always an interpretation, and requires interpretation in order to be understood. At the moment at which the conscious decision is made to create a picture available for public consumption, it takes on some of the characteristics of a man-made message.

The potential of pictures as man-made artifacts to manipulate and deceive the masses was recognized as early as 1895 [LeBon, 1895]. The question of interest in this chapter, however, is more specific than a generic redirection of certain emotional responses, and it is the determination of the semiotic potential of pictures. Can pictures express meanings that correspond to verbal messages, as the old saying "a picture is worth a thousand words" suggests, or is the semiotic potential of pictures inferior or of a different nature, in that they are unable to express truths about the world? In the context of image databases, the question is more than academic. Image databases draw their methodological inspiration from databases and information retrieval systems, which are based on the evaluation of predicates expressed in their data elements (this evaluation is direct in the case of traditional databases, while in information retrieval it is based on a statistical relation between the predicates expressed and the distribution of the elementary components of the linguistic discourse: that is, words). If images do not convey messages in the sense in which text does, then

[5] The name of the San Diego Zoo is traditionally prefixed by the words "World Famous." As there is no need to distinguish it from such hypothetical entities as the "Relatively Unknown San Diego Zoo," or the "Locally known-only San Diego Zoo," I do not completely appreciate the need for such a prefix. I will, however, follow the tradition in this respect.

these methodological foundations must be revised or, at least, independently justified.

If images do convey messages in the textual sense, then they should be able to predicate something about their subject or, to put it in terms of Umberto Eco's definition of semiotic signs, they should be able to *lie* [Eco, 1976]. The question of whether a picture is capable of telling a truth (or, of course, a lie), has syntactic, semantic and pragmatic aspects. Syntactically, a picture capable of telling the truth must represent an object and convey a predication about it. Semantically, a true picture must correspond to the facts it depicts. Pragmatically, a false picture must be the result of an intention to deceive the receiver of the picture itself.

The first question one has to consider is, if pictures are signs, what kind of signs are they? To which one of the three modes defined by Pierce does the relationship between an image and its representamen belong? Are images icons, indices, or symbols?

The iconicity of pictures has been attacked by Eco (1976) in his argument in favor of the conventionality and cultural motivation of iconic signs. Although Eco's dismissal of iconic sign has been attacked [Sonesson, 1998], this attack does not hinge on Eco's analysis of pictures. Rather, it denies that pictures are typical icons.

The essence of Eco's argument is that iconicity—intended as a relation whereby an image points to its referent by virtue of "similarity"—is that such a relation is, without cultural intervention, too generic to be useful.

Unless the similarity relation is qualified, it is always possible to find some aspect in which anything is similar to anything else. Therefore, it is always possible to take anything as a sign of anything else, and signification would dissolve in an orgy of allegories, in the hermetic tradition. The qualification of the similarity relation in such a way that only certain relations give rise to a sign is, for Eco, a cultural operation.

Sonesson (1994, 1997) argues that similarity provides the "raw material" for the construction of an *iconic ground*, on which a sign may or may not be formed. An iconic ground is the possibility of a sign, on which a sign relation *can* be built, but it does not automatically generate a sign. In this model, pure iconicity (that is, pure similarity) may or may not form an iconic ground. The iconic ground, on the other hand, may or may not contribute to the formation of a sign. As an example, consider the picture of a red Ferrari, on one hand, and, on the other hand, a cartoon, a red apple, and a red Ferrari. The picture of the Ferrari and the cartoon are similar because they are composed of the same material but, under normal circumstances, this relation is not enough to constitute an iconic ground. Under normal circumstance a sign relation cannot be built based on the fact that the signifier and the signified are made of paper. There are, of course, exceptions. The study of the *Me* population by Deregowski [Sonesson, 1997] reported that a group of Me was unable to recognize a picture as such. The group had never seen paper and, when shown a picture, was led to concentrate on the material *per se*. The unknown material acquired such prominence that it was hard for the people

to see it as a vehicle for something else. If the same picture was printed on cloth, the Me immediately recognized it as a sign[6].

The similarity between the photograph of the Ferrari and the apple (the red color) is usually sufficient to constitute an iconic ground (as when the color red comes iconically to represent blood) but, in this case, the iconic ground constituted by the color fails to generate a sign relation—the picture of the red Ferrari does not stand for the apple. Finally, the iconic ground materializes in a sign relation between the picture of the car and the car itself.

The choice of which similarity can be used as iconic grounds, and of which iconic grounds are relevant in a particular case is a cultural convention. Therefore, at least in the case of certain signs (e.g., pictures), a conventional sign function must be superimposed on the iconic ground for it to become a sign relation. Iconicity, in this case, is not needed to define the sign relation, but as a taxonomical division within the sign categories. Sonesson uses the term *secondary iconicity* to designate an iconic relation between an expression and its content, which comes into play only after the sign function is known to apply, and only as a classification of such sign function.

The question of the indexicality of pictures is also more complex than it would appear. At first sight, the indexicality of a photograph is easily established. After all, there was, at least at some point in time, a direct physical connection between the object that is depicted and the photographic film. Note, however, that this relation is not exactly the same that goes, for instance, between the smoke and the fire that caused it. In the case of the smoke, the relation between signifier and signified is one of spatial and temporal contiguity while in the case of a picture its only value as a sign comes from the fact that it was recorded somewhere and remained visible even after the object to which it refers has disappeared.

In this case, the only physical relation that we can identify between a photograph and its object is the mechanical process that led to its creation and, if the photograph is an index, it is so by virtue of the causal chain described by the mechanical reproduction process. To say that a picture is indexical while a painting is not implies a fundamental and insurmountable distinction between the processes of algorithmic and creative manipulation. This distinction is required if we want to say that no algorithmic or mechanical manipulation of a picture will let it lose its indexical character, while preserving the nonindexicality of artifacts.

Even admitting all that, the question of the indexicality of a picture has to do with the way the picture was produced, and there is no trace of it in the use of a picture as a code.

[6] This seems to be a common rule for the sign relation. The sign per se (that is, the *object* that is used as a sign, independently of its function) must not be more prominent than its referent for the sign relation to work. Thus, letters of the alphabet carved out of precious materials, or within an artistic setting (like Japanese characters used as an ornament in the west) are not immediately recognized as signs, but taken as objects, independent of signification.

Assuming that photographs are indexical also implies the recognition of their character as signs of reality—more specifically, it assumes a direct causal connection between an external independent reality and the photograph. This assumption, however, ignores the role of the photographer as *interpreter* and manipulator of reality through the photograph. An image is not a slice of reality, but a message (or better yet, an infinite series of overlapping connotations) from the photographer to the viewer. An image conjured up to connote a happy couple does not change just because the two people in the picture do not know each other or cannot stand each other. Even a documentary photograph, which is supposed to document reality, is subject to the filtering function of the author. Without this filtering function there can be no documentary photograph, but only the direct experience of the world.

Photographic and filmic images can also be symbolic, such as certain conventions like "dissolves" that, in the filmic language, mark the passage of a relatively long period of time. This language is very explicit in cartoons—cartoon characters start running in place and only when their legs are moving at high speed do they start to move very rapidly, leaving behind a dust cloud. When they fall from a high rock, the whole rock shakes, and so on.

An image, therefore, can be at one time in an iconic, indexical and symbolic relationship with its referent. Whether an image is an icon, an index, or a symbol depends on the way in which the sign is used. A simple image like the picture of a woman can stand for the general idea of womanhood, or for the particular woman depicted. The balances between these modes is dependent on social and cultural conventions. It is very unlikely that a picture of the actress Eleonora Duse would be used to anonymously stand for all women, given the relevance of the subject, unless the symbolic relation also relates iconically to the subject, as would be the case if the picture were to signify women's achievements in the performing arts.

We return therefore to the original question about the value of an image as a message. What kind of message is it? Is it a predicate? Roland Barthes's answer (1980) is yes. According to Barthes, a photographic message carries its referent with itself, and the message of a photographic image (more: the *noema* of Photography) is: *Ça-a-été* (this-has-been):

> In Latin (a pedantry necessary because it illuminates certain nuances), this would doubtless be said: *interfuit*: what I see has been here, in this place which extends between infinity and the subject (*operator* or *spectator*); it has been here, and yet immediately separated; it has been absolutely, irrefutably present, and yet already deferred. (Barthes, 1980, emphasis in the original)

But what is this *Ça-a-été*, or *la chose a été là* to which Barthes refers? Apart from the obvious possibility of photographic manipulation (like the famous example in which Stalin had the figure of Trotsky removed from a picture of Lenin talking to the workers), which I will consider later, one has to consider the elements of

staging involved in the creation of a picture-message, and which are designed to control and direct the connotations of the picture. Consider a picture from the scene from Stanley Kubrick's *2001: A Space Odyssey* in which Dave Bowman enters the monolith. The "literal meaning" of the scene (if one does indeed exist) is a person in a sound studio, acting from a script. Its more evident connotation is that of a man in a small spacecraft entering a large black monolith in orbit at the Lagrange 1 point between Jupiter and Io. Other important connotations include the myth of the Earth as mother, and the recognition that all children must sooner or later abandon their mother[7]. The denotation can be true in the Barthes's sense (at some point in the past Keir Dullea was actually in a sound studio acting out the scene as the character Dave Bowman, going through the motions and saying the words that are now captured on film), while the connotation is, in the same sense, false (there was never any Dave Bowman on Jupiter). Yet, one can't deny that the "Bowman on Jupiter" meaning is more relevant than the "Dullea in the sound studio" meaning. The message of the picture includes all these possible modes of signification, some of which are true, some of which are false.

There is then the question of photographic manipulation. For Barthes, manipulation is a (rare) exception. In its most common form, the photograph is a sign of the things that have been, a fact that depends crucially on the chemical process of photography:

> For the *noeme* "That-has-been" was possible only on the day when a scientific circumstance (the discovery that silver halogens were sensitive to light) made it possible to recover and print directly the luminous rays emitted by variously lighted objects. The photograph is literally an emanation of the referent. From a real body, which was there, proceed radiations which ultimately touch me, who am here. [Barthes, 1980]

But photographs stored in image databases have an additional characteristic, they are digital; this fact changes the factors of the problem greatly, for the mediation between the referent and the spectator (which grounds the "that-has-been" noema) is now mediated by a process so complex, open, flexible, and abstract that its nature can no longer be sure. The consequences of this changed relation are widespread and important; so important, in fact, that pictures are no longer accepted as evidence in courts of law.

Barthes again writes:

> Perhaps we have an invincible resistance to believing in the past, in History, except in the form of the myth. The *Photograph*, for the first time, puts an end to this

[7] This, and other important connotations of the scene and of the whole film cannot be made independently of the political and cultural climate of the late 1960s. Consider, for instance, the opposite and very gloomy connotations of another famous science fiction movie: Ridley Scott's *Blade Runner*, shot 20 years later. It would be interesting to analyze image meaning in light of all these connotations, but this kind of research goes well beyond the scope of this chapter.

resistance: henceforth the past is as certain as the present, what we see on paper is as certain as what we touch. It is the advent of the Photograph—and not, as has been said, of the cinema—which divides the history of the world. (Barthes, 1980, p. 87–88)

This division turned out not to be permanent, but just the beginning of an interlude that has now come to a close. Even if it was true for a while (and I doubt that it has ever been) that a photograph was a guarantee of presence in the past, a sure and self-referential testimony of what has been, it is no longer so. And this is not because all photographs, or even the majority of them, are falsified, but because the possibility of manipulation comes to be a necessary part of the photograph: some photographs are perfectly falsified, therefore all photographs are necessarily falsifiable; once the photograph is falsifiable, then the possibility of falsification is *necessarily* part of its semiotic structure; if falsifiability is possible, then it is inscribed—at least under the rubric of possibility—in all pictures, whether they are falsified or not.

Even if photographs were for some time self-referential witnesses (physis instead of thesis), the digital divide has changed their status back to that of a text, whose authenticity and interpretation can only be determined as part of a cultural discourse and the social role of the photographer.

2.2.1 What Kind of Signs are Pictures?

In terms of the Peircean sign categories introduced in the previous section, a question can be phrased. Can pictures work as autonomous dicent signs, or do they consist only of rhematic signs? Can pictures predicate the state of affairs they represent? I will consider three types of arguments that deny the predicative power of pictures, that is, which deny that pictures are autonomous dicent signs [Nöth, 1998]: *contextual incompleteness, nonsegmentability*, and *pragmatic indeterminacy*.

The first argument [Gombrich, 1965] is that pictures cannot by themselves, serve as true and false statements, unless the statement is made explicit by a caption or some accompanying text. Only the compound text+picture has the capacity of conveying a statement, that is, of expressing a predicate. The picture alone provides only the material on which the text forms the proposition [Bennet, 1974]. The real predication always involves an index or some other verbal shifter, like "this" or "that" (the most celebrated of which is the *ceci* in Magritte's *ceci nes pas une pipe*). In this text-picture complex, the picture does not work as a predicate but rather as the argument of a proposition [Muckenhaupt, 1986]. However, in this case too the text-picture complex must deal with the complexities of connotation. At a first analysis, it might look like an example of lying— a text-picture complex would be Magritte's *le Table, l'Océan, le Fruit* (1927), in which the label "table" is attached to the picture of a green leaf, and the label "fruit" to the picture of a jug. If the denotation of this picture is, in a sense false

(like the denotation of the scene in 2001 was, in a sense, true), its connotations are perfectly in line with the purposes of the surrealist movement to which Magritte belonged.

The second argument that denies the predicative power of pictures, which I have called *nonsegmentability*, has been advanced in its simpler and most direct terms by Fodor (1981). The argument is illustrated by the following example: "Suppose that [...] the word 'John' is replaced by a picture of John and the word 'Green' is replaced by a green patch. Then the sentence 'John is Green' comes out as, say, a picture of John followed by a green picture. But that does not look like John being green, it doesn't look like anything." As Nöth (1998) rightly notes, in this passage Fodor is trying to push the analogy too far by projecting the linear structure of written language into the structure of the picture, and assuming that combination by juxtaposition can be the only principle by which rhematic components can be assembled into a dicentic sign. Nöth notes that the structural principles in pictures are different from those in language, and that the illustration of the proposition "John is Green" is not the juxtaposition of John and a green patch, but simply a picture of a green-skinned John. The question should be posed in slightly different terms, namely, what are the characteristics of a language that make it capable of expressing propositions, and does the pictorial language possess these characteristics?

Finally, the third argument against the predicative power of pictures is that of "pragmatic indeterminacy." Consider two examples of pictures; in the first, Umberto Eco is having a conversation with Thomas Aquinas about æstethics; the second represents a Marilyn Monroe impersonator. Are these pictures lies? They certainly are if printed on a magazine and disseminated as a depiction of reality (much like the "Elvis still alive" pictures in the tabloid press); but what if the first picture came from an art exhibit called "possible conversations" and the second from the catalogue of an impersonators' agency? In this case, the conventions regarding artistic expression and the business practice of impersonators and their agents would make the pictures true in any sense one would care to consider.

Pragmatic indeterminacy is the property of pictures by which their pragmatic assertive function (and, therefore, their status as a lie) is indeterminate, and non-pictorial signs are required as indicators of the claim to truth that a picture is making in a given circumstance. In this sense, the comments of Peirce on indexicality apply very well to pictures: *The index asssserts nothing; it only says 'There!' It takes hold of your eyes, as it were, and forcibly directs them to a particular object, and there it stops* [Peirce, 1958].

But, one might object, the same is true for most sentences taken in isolation! A sentence like "Julius Cæsar was born in England" is not a lie unless the context indicates that the sentence is intended to convey as true a fact about the birthplace of Julius Cæsar; in a grammar book in wich the sentence is used as an example of usage of the locution "to be born," it would not be false. The difference is that, in the case of language, the contextual indicators of the assertive function

of a sentence can be expressed in the same sign system (language), while this possibility does not exist for images.

Pictures, taken in isolation, cannot lie because they cannot establish their own assertive function. Pictures need a context in the form of a different sign system in which they are embedded. The forms that this alternative sign system can take will be the subject of the next section.

2.2.2 The Association Between Text and Pictures

The previous arguments, in particular that of pragmatic indeterminacy, make the point that pictures taken by themselves have no assertive function, but inherit it only when placed in relation with another sign system. In terms closer to the database language, images cannot be the object of a query because they lack an adequate *schema* to determine their meaning.

It is possible to draw a parallel (although imperfect) between the lack of assertive function in images and in traditional database data. Consider, in a database, a series of records such as:

Berkowitz	368419219	90000
O'Connor	536213888	80000
Fitzpatrick	341889312	95000

These records are neither true or false, since they lack an adequate schema that can transform them into a predicate. It is only when we add a schema to the database, such as:

| Name | SSN | Salary |

that the previous table becomes a series of predicates such as "Fitzpatrick's Social Security number is 341889312, and his salary is $95,000 per year." Note that the schema provides, in a certain sense, an interpretant of the previous table, but this interpretation is still partial, and its necessity is modulated by social conventions. For instance, most people would have realized that "Fitzpatrick" is somebody's name. Realizing that 90,000 is a salary requires familiarity with certain social conventions, and this fact is not substantially changed by the label "Salary": the example refers to the United States, and it relies on certain social conventions and situations that are true for that country, namely that the salary is customarily specified as amount per year (as opposed to amount per month, which is common, e.g., in Italy), and that 90,000 is a reasonable value for a year salary (as opposed to Italy, for instance, in which 90,000 lira corresponds to about $50 and, given the level of industrialization and development of the country, would be far too low for a monthly salary). On the other hand, the label SSN is perfectly clear for a US citizen and, being a normative concept, captures completely the essence of the number. For a non-US citizen, the label SSN is as obscure as the number itself,

but the normative value of the convention is established by the fact that every person in the world can have the same concept of Social Security number as an American once the relevant legal facts about Social Security are known[8].

The schema is only the first step of an interpretation process that must perforce include aspects of the data that are not captured by the database, but which are a common heritage of the people and organizations that are intended to use the database. Up to a certain extent (and this is what data description models do) it is possible to capture the semantics of the data by purely algebraic means, that is, by specifying certain operations that are possible on the different types of data. In the case of a salary, for instance, it makes sense to add together all the salaries relative to the same individual (for tax calculations, for instance), while it does not make sense to add together the Social Security numbers of the same individual. Social Security numbers, on the other hand, are subject to a constraint: a person can only have one. Therefore, if several database tables contain Social Security numbers for the same individual, all these numbers must coincide. The same is not true, obviously, for salaries. The algebraic specification of a data model can be considered as another *interpretant* of the data, which rests on the interpretation given by the schema (or by some other suitable data typing model).

At this point, it is necessary to consider the exact nature of the textual component of the text-picture complex. In particular, should it be restricted to a piece of text or an illocutionary label attached to the image (possibly by physical contiguity, as in captions and labels), or can it be extended to other discourses and, in this case, what sign system should surround an image in order to make it a predicate? Limiting the possibility of interpretation to illocutionary text is an unreasonable restriction. It is possible to have rather successful characterization of the content of images without resorting to any explicit text, for instance, in trademark identification for intellectual property enforcement [Kato, 1992; Wu *et al.*, 1996; Eakins *et al.*, 1998], or on medical applications[9] [Liu *et al.*, 1998; Petrakis and Faloutsos, 1997].

Certain techniques work well in these cases because for certain narrow domains, the social discourse is sufficiently fixed to provide the necessary interpretant for the image data. The predication part of the text-picture complex is not necessarily explicit, but can be constituted by a shared social text (or context) or, more or less explicitly, by the user's interaction with the images. Starting from the general principle that an image can be predicated only in the presence of a text

[8] There are, as usual, political implications of a normative concept like Social Security that cannot be fully understood by a simple normative definition, and that require a deeper cultural understanding of the society in which the concept emerged. These considerations, however, go beyond the limits of this simple example.

[9] I am talking, of course, about the availability of research results, and on how these make it theoretically feasible to imagine certain applications. Not all these theoretical possibilities have, or even will, translate into actual commercially available systems due to factors often beyond the control of theory. In the case of medical images, complex legal issues tied to malpractice litigation and attribution of liability still stand in the way of practical application of the technology.

and, therefore, that an image database is searchable only in terms of text/image contexts, this qualification gives rise to three possible modalities:

Linguistic modality. The image is part of a coherent whole including a self-contained textual universe. It will argue in the following that the World Wide Web provides a typical model of this situation. In a linguistic scenario, the database operates in the territory between text and image, as a *trait d'union* between the two.

Closed world modality. The text is implicit in the social discourse, and fixes and reduces the possible interpretations of the images even before the database is designed. Certain limited domains provide close world scenarios, and here the image database can operate in its most traditional way, as a search engine based on automatically extracted content features.

User modality. The text (or better, the linguistic discourse) is provided by the user. This is the case of strong feedback and highly interactive systems. The database in this case is a *writing tool* for the user, in which linguistic concepts are associated to the images in the repository.

The situation, in the realm of image databases, is therefore complicated by the fact that what we usually call *query* is an activity belonging to one of at least three different categories. The fact that the enclosed world scenario resembles in certain structural aspects the functions of a traditional database should not be taken as a basis for undue generalizations and translations.

It is worth noticing that in most of the literature the uniqueness of image databases is thought to be connected either with technical differences (images are large objects), or with the operating mode of the object component of the image sign, that is, with the fact that records in a database are symbol, while images are icons or indices. This is not the case or, at least, it is not the principal cause for differentiation. While images can to a significant degree be symbolic (thereby reducing the differentiation based on the object to a mere matter of degree), they are rhematic signs, while records in a database, with the addition of the appropriate schema, are dicentic signs. The real root of the difference, therefore, is in the interpretant, rather than in the object.

Moreover, while in databases the schema can be formalized and expressed in the same textual language as the database and therefore a complete database is dicentic per se, containing the signs and their schema component, in the case of images the schema is not expressed in the same sign system, and there are three possible scenarios in which this can happen, only one of which makes the database dicentic per se. The other two scenarios represent two modes of accessing data, and one can expect that the techniques used for accessing data in these two scenarios will be equally new and independent of the similar techniques in traditional databases.

Connotative nature of images. Access to images is complicated by the fact that often the pictorial message speaks by connotations, thus requiring consideration of the connotative power of pictures, upon which I have already touched in the example from *2001: A Space Odyssey* a few pages back. Semioticians are not always clear in their use of the terms denotation and connotation, and the difference between the two appears as a matter of degree and breadth of consensus. Denotation tends to be described as the "literal," "obvious," or "commonsense" meaning of a sign, while connotation refers to its sociocultural, personal and conventional associations:

> Regardless of the multitude of angles from which a photograph can be taken, different pictures of a man wearing a suit and sitting in a desert will generally signify the same first-order meanings. Higher-order significations or connotative meanings, such as the suit and setting, suggest that the man is a hardy executive, and more variable and less predeterminable. [Mick and Buhl, 1992, p. 320]

The notion of denotation in opposition to connotation is hardly universally accepted. Social semioticians, who emphasize diversity of interpretation and the importance of cultural and historical context are more or less at odds with the notion of a literal meaning.

The traditional semiotic distinction between denotation and connotation acquires a new level of problematicity when applied to images. Semioticians always recognized that denotation, that is, literal meaning, or whatever one might want to call it, is a normative issue. When words are used, this normative constraint is a very elastic one, giving rise to metaphors, figurative speech, and ultimately the possibility of interpersonal communication beyond the difference in personal semantic networks (communication would be impossible if the meaning of words were too rigidly fixed). The elasticity of the normative constraint is so necessary for the success of communication that there is a more than legitimate doubt whether the constraint exists at all [Derrida *et al.*, 1988]. The question, as thorny and essential as it is, need not concern the present discussion. The pertinent question is, can the distinction between denotation and connotation (as problematic as it may be) be applied to images? To make things more specific, what is the denotation of a photograph of a town in the French Alps? One simple answer would be: the literal meaning of this photograph is "mountains on a clear day, a lawn with cows in the foreground, and the periphery of a city in the background." But this denotation already presupposes a certain abstraction, a generalization of the picture, which does not represent a generic mountain but, say, Mont Blanc as it appeared looking from an imaginary peephole at a given spot near Chamonix on July 16, 1985 at 6:15 pm. The cow is not just a cow, but nothing less than the famous "Bessie" (who, for all we know, could well be the intended subject of the photograph), and so on. Even without knowing names and places, the picture represents a particular, unique, and irrepeatable situation—it lacks duplicability. Like Schubert's piece

of music, the only determination possible of an image denotation is the image itself.

This is a consequence, in part, of the fact that images do not give access to the underlying reality, as made very explicit in staged images (as in the 2001 example), less explicit in "documentary" images in which, nonetheless, it is true due to the filtering and selecting presence of the photographer.

Consider the picture of a young man, driving a sport car along an elegant street in Paris, with a beautiful young woman at his side. The explicit connotations of this picture are rather evident—wealth, elegance, success, etc. The additional connotation might be that one will join this group of people who possess all these things by buying a certain perfume or brand of clothes. Just as evident are the cultural presuppositions on which these connotations rest. Only in a society that recognizes Paris as an elegant and fashionable city could this picture represent elegance (more specifically, only in a society in which a city can predicate the term "elegant" so that we have fashionable cities but not fashionable railroad crossings). Only in a culture in which fast cars are basically useless, and in which the purchase of useless things is recognized as a symbol of wealth could this picture connote wealth. Only in a culture that objectifies women (and, in other occasions, men too) and considers them as exchangeable and precious commodity for men of success will the presence of a woman satisfying certain cultural criteria of sexual desirability connote success.

But, one might wonder, do these connotations rest on the simple denotation of a sports car with a man and a woman cruising the streets of Paris? Only to a certain extent. The fact that the car is a sports car is, for one thing, as connotative as the success of the man, depending on the cultural recognition of sports and competition. Even the woman (unless she is completely naked) is recognized as such through certain signs of cultural origin, and is recognized as desirable through signs whose origin has been directed by social evolution. The very fact that a woman is there (as opposed to a cardboard cutout as in the amusement park pictures of famous people) and, therefore, the fact that a man *and* a woman are there together relies on a conventional understanding of how pictures *ought* to be taken, not on the content of the picture itself.

Consider now a typical documentary photograph, say the famous death of a republican soldier taken by Robert Capa. The picture shows an entity that might be a man (the face is not very clear) with outstretched arms and bent legs. The belief that such an entity is: (a) a person; (b) a Spanish soldier; and (c) dying, rests only on the authority of the photographer, which is guaranteed by a network of social relations in which the photographer is placed, and not by the contents of the picture.

To make things more explicit: how does the meaning of Doisenau's famous *Les Amants de l'Hotel de ville* change now that we know that the picture was staged and, therefore, that the two *amants* were not lovers at all? The car manufacturer Peugeot used the (disproved) authenticity of the picture for a TV advertisement that works very well (the falsity of the picture notwithstanding) because the

connotation of the photograph rests on its *history* and not on its questionable denotation.

2.3 The Three Modalities of Signification

The schematic analysis of the last two sections revealed that image retrieval can operate according to three modalities: a *linguistic modality*; a *closed world modality*; and a *user modality*. The modality in which a specific database works will determine many aspects of its design, from image features, to indexing algorithms, to query languages and user interfaces. The different techniques that can be used to implement these modalities will be analyzed in the following chapters but, for the remainder of this chapter, I should like to have a rather generic and comprehensive view of the *modus operandi* of a database in these different modalities.

In its most general form, a database implements an inverse semiotic function. While a direct semiotic function maps systems of stimuli into the components of a semantic field of cultural units, an inverse semiotic function maps the semantic desiderata of a particular user in a particular situation into a set of signifiers (images, in this case). The simple use of the verb "maps" here should not lead one to believe that a single sign can be mapped to a well-defined meaning in a semantic field. As argued in the previous sections, the process of signification can only map complete systems—of signifiers—into complete systems—of signifieds. Similarly, an inverse function can only map a complete system of signifieds (concepts that the user is trying to express) into a complete system of signifiers (the images that the database proposes). In principle, the only possible mapping is between a complete system of signifiers and a complete system of signified, and even this mapping will be rather fluid and fuzzy.

Put in this terms, the situation can rapidly become absurd. An old joke talks of a person who is having difficulties explaining to a shopkeeper that he needs a notebook, because the shopkeeper keeps asking more and more details. As the two are talking, a man with a desperate face enters the store with a lamp, a rug, and other things, and says: "Look, Tom: this is the lamp; this is the rug on which it rests; this is the carpet I have in the room; this is a picture of my wife, the kids and the dog, and this is a picture of what I see looking out of the window. Can I have that lightbulb, now?" A database cannot ask the user to reveal the more minute details of his semantic system in order to answer a query: only a part of the semantic system of the user—the part more closely connected with the meaning of the image that the user wants to retrieve—will be available. The extent of this part depends on the modality in which the database is working.

Therefore, the generic term "database" will logically divide into at least three different (and, to an extent, independent) functional entities, depending on the modality in which the system operates. Correspondingly, an analysis of the process of querying a system should be undertaken independently for each of the three modes of signification.

2.3.1 Linguistic Modality

An image database operates in a linguistic modality when (and to the extent to which) images are connected to a universe of text that is capable, by itself, of supporting signification. This definition does not require that the relation between an image and the text be univocal, nor that the signification process of the text be compositional, with units of signification attached to words or phrases. Quite the contrary, the meaning of the text itself is not fixed or determinable by a compositional analysis, but depends on the whole context in which the text is produced and read, and the relation between images and their meaning is even more indirect, since it is built on textual signification.

The distinguishing condition of the linguistic modality is that the textual universe is wide enough to allow the definition of a context purely by restriction and particularization. In other words, the textual universe is large enough to represent a multitude of contexts in which images can acquire multiple meanings, and the restriction of this universe—that is, the selection of a portion of the words and of the relations between them—is sufficient to identify a context in which images can be interpreted.

A requirement for this to be true is that the text form a self-contained unit of signification of its own. Therefore, the distinguishing characteristic of the linguistic modality is the independence and self-completeness of the text; this makes the text an autonomous source of meaning that, by association, is transferred to the images. This requirement rules out immediately the possibility of placing a database in a linguistic modality merely by attaching labels to images, since labels are only a device to provide a symbolic description of the contents of an image within the confines of a given context. Labels always presuppose a context, but cannot create it; labels and simple captions are not a discourse, but merely markers in a pre-existing discourse.

In addition, if the text must be self-complete, it must be—in large part, if not completely—self-referential. A text too rich in external references, such as a paragraph or a standard length article, still needs a context, represented by whatever object, topic, or discipline encapsulates it. In order for the text to generate the multiplicity of context that will be used to endow images with meaning, the only referent of the text must be text itself. The Peircean chain of representamen and object must be completely contained within the text.

The perfect example of a corpus of text with the required characteristics to support an image database in a linguistic modality is the World Wide Web (www). The discourse on the web is largely textual, with images almost always dependent on text, while the opposite situation is much less frequent; the text on the web is a large and heterogeneous corpus, which can support many contexts (is is not too far off to assert that, at this time, every context of social discourse in the western civilization is replicated somewhere on the www); the text is largely self-referent, because pages refer to information that can be found in other pages, and directly to the other pages through links.

The web also has an interesting structure because of its linked setup. Because links can be created so easily, the whole web text is connected much more tightly than the components of a typical corpus, even a highly interconnected one by traditional standards such as those of an encyclopédia. Links create the connectedness between the different texts that in other media is created by cross referencing, catalogues, critics, academic analysis, and so on. The presence of links is essential for making the web text self-contained. With a certain degree of simplification, one can consider different "levels" of linguistic reference in text collections. Call "primary texts" the texts that only talk about things outside the collection, for example a treatise on the life of birds in the Greek islands, a treatise on the economics of oil commerce, or a glamor piece on the life of the rich and famous in Hollywood. Secondary texts are those that talk about primary texts, such as a review of the treatise about the life of birds, an analysis of the theses about the economics of oil commerce showing how the first analysis was only pandering to the interests of multinational corporations, or a glamor piece saying that whatever the first glamor piece said was false. Further, catalogues defining taxonomies of primary texts and associative texts belonging to the same category are secondary texts. Tertiary texts, of course, will do the same about secondary texts, and so on.

Of course, no text is completely primary, secondary, tertiary, or *n*-ary. Each text refers to other texts, and each text refers to something outside the realm of texts. The web, with its massive use of reference, is the first place in which the division of text into levels, as attempted in the preceding, does not even make sense as a provisional or schematic model; on the web, everything is referred to anything else, and everything talks about everything else. Once images are immersed in this whirl of inter-referencing texts, the stage is set for the perfect example of linguistic modality.

2.3.2 Closed World Modality

To some extent, the closed world modality is the most straightforward of the three—certainly the one for which the parallel with traditional databases can be carried out further. In a closed world, context, and the restriction of the semantic field induced by context, is given by a series of conventions and assumptions that will tacitly hold for all users in the system. The most immediate consequence of this restriction is to reduce polysemy both in words and images. In a medical domain, then, the spleen, vascular organ located near the stomach, destroys red blood cells and produces lymphocytes, and has nothing to do with melancholia or the French poet Baudelaire. In a trademark recognition application, the shape of, say, a sword, will be taken prima facie, and will have meaning only for its purely visual aspects; it will not acquire connotations of war and conquest and, as such, it will not be associated to a rifle, the courtier Damocles, or a pen (which, as we all know, is mightier than the sword).

A closed world provides a framework to characterize which aspects of an image or a word are relevant, and to isolate them from all the other possible connotations

that the symbol can have. In a closed word, there is only denotation. The existence of connotations rests on a network of connections and associations more complex and fluid than a closed world allows.

The differentiation between closed world and more open modalities of interaction is somehow related to a problem that researchers in artificial intelligence (AI) know very well; the *frame problem*. Dennett (1984), introduces the frame problem using a tricky and almost impossible task—getting a midnight snack. The task is deceptively simple. You know that you have some sliced turkey, a jar of mustard, and some bread in the cupboard, and a bottle of beer somewhere. You decide to go down, spread some mustard on the bread, add some turkey, and make yourself a great sandwich that you can take to the couch and eat, washing it down with a beer, while reading Simone Santini's book.

Now, in order to do this, there are a number of things you must know. You must know something about spreading mustard; for instance, that a knife will not bend but a piece of paper will. You must know that adding the mustard to the bread will not dig a hole in it, that when you carry the plate to the couch the sandwich (and all its contents) will also come with you, that if the turkey did not taste bad in the kitchen it will not taste bad in the living room, and so on. Solving the frame problem implies finding, in a vast network of actions and consequences, the right place for the immediate actions necessary for the preparation of the midnight snack, without having explicitly to analyze the whole network[10].

While the problem that one is trying to solve in image retrieval is not that of the midnight snack, the problematicity of defining context is the same. Jacques Derrida went further, denying that context is determinable:

> Is there a rigorous and scientific concept of *context*? Or does the notion of context not conceal, behind a certain confusion, philosophical presuppositions of a very determinate nature? Stating it in the most summary manner possible, I shall try to demonstrate why a context is never absolutely determinable, or rather, why its determination can never be certain or saturated. [Derrida *et al.*, 1988]

This, then, seems to be the crucial difference between the closed world modality and the other modalities of interaction; in a closed world the context is indeed determined by the habits and restrictions of a particular domain (at least to the extent to which a database system would need to use such determination), and the frame in which the perceptual and signification problems must be solved is established.

[10] Allow me two observations. First, the frame problem was introduced by McCarthy and Hayes in 1969 in a much more narrow context and with a much more narrow definition. Dennett's published research (1981), from which I am deriving the midnight snack problem, extends and enlarges the problem to what, according to Dennett, Hayes calls "the whole pudding."

Second, the use of the term *information* in the context of the frame problem is bound to have many critics of AI up in arms. They might argue that talking of information in this case is a *petitio principii* because it implicitly assumes that the frame problem can be solved by encoding information in a suitable way, which is precisely the point they context. I am using the term "information" here as a shorthand.

As an aside, I should remind the reader that the case of a labeled database has been excluded from the linguistic modality on grounds of the inadequacy of labels to provide a context because labels can only be used once a context is given. In the closed world modality, the database domain provides this context. Therefore, labeled databases properly belong to the closed world modality.

2.3.3 The User Modality

Of the three modalities, the user modality is the more open and undetermined, but also the most general; to the extent to which the textual universe in the linguistic modality is not closed, and to the extent to which the context in the closed world modality is not determined by the conventions of a certain environment, these modalities also participate in the user modality.

In the user modality, no context is imposed a priori on the database; the context is a product of the interaction between the user and the database and, in a very real sense, the answer to the query is but a byproduct of this context-defining interaction. The way a context is determined is through conversation, and in this sense every interface between a user and a database must allow the two to engage in a conversation during which the boundaries of context will be established at least to the extent of making the query process possible (but, of course, the act of establishing the boundaries of context *is* the query process).

Conversation, however, can only take place on a background of shared assumption and prejudices (this is the sense of the citation of Gadamer that opened this chapter). A language for conversation is learned through interactions, but interactions are only possible using the conversation language. We are right in the middle of the *hermeneutic circle*: the meaning of an individual conversation is contextual, depending on the moment of interpretation and on the context brought to it by the interpreters. However, the context itself is the product of conversations and interactions. As Heidegger points out (1962); the implicit beliefs and assumptions on which our context is based cannot all be made explicit. To do so would require an act of interpretation from outside these beliefs and assumptions, which in turn would require beliefs and assumptions, and so on *ad infinitum*.

To this, we should add the observation that, since interpretation (which is contextual) derives ultimately from interaction, meaning is a social phenomenon, and cannot be reduced to a simple function either of a stimulus or datum, or of the interaction of a single person with a datum. Eco's *cultural unit* requires a culture in which it can arise and be sustained[11].

[11] I should like to make a diversion here to analyze the relativistic implication of such a position. All positions not based on the strictest objectivism have, one time or the other, been accused of relativism: since meaning and interpretation are social constructs, no interpretation is more valuable than any other, and "anything goes."

Some analyses deserve this judgment more than others. One of the main reasons for contention seems to be a certain confusion between the *synchronic* and *diachronic* views of sign systems. Under the impulse of Saussure, semioticians are keen at looking at problems of signification from a synchronic

Interaction with the database must be more than just conversational, it must be *historical* and *social*. Historical interaction entails taking into account the whole history of interaction between a given person and the database. Social interaction considers that the interaction is not between a system and a user, but between a system and a community. The interaction between any particular person and a database must be part of the diffused conversation between users, which establishes the context in which the database will be required to intervene. From a technical point of view, this implies that an image database working in a user mode is not a database in the proper sense of the word, but should be part of a system through which conversation within a certain environment is initiated and maintained.

2.4 The Quest for Formalization

This chapter has revealed a very complicated process focused on the notion of signification, which is at the basis of the operations of an image database. It is so complicated, in fact, that the question of whether and to what extent it can be formalized is very pressing, and methodologically fundamental.

The notion that some kind of reductionist and formalist approach can be applied to phenomena involving perception, cognition, or culture is denied today by most analyses. The idea that some kind of reductionist, logicist program could lead us to cover the whole human experience has an obvious appeal, and is the obvious outcome of a western tradition going back at least to Pythagoras. At the moment of its greatest success, however, this program found itself facing insurmountable difficulties and today, at least in the fields of humanities, few would support an all-out formalist and reductionist position. In the area of computer science, this position is best embodied in traditional artificial intelligence, which tried for a long time to represent cognition with a set of rules, that is, to reduce cognition to the syntactic manipulation of symbols. The debate on the feasibility of traditional AI is too complex and well known to report it here. The various sides of it can be observed in Dreyfus (1992) and McCarthy (1996).

point of view. From this point of view, many cultural units can certainly appear arbitrary, leaving the field open to the most outspoken relativism. Looking at things from a diachronic point of view, one finds a serious limitation to such an all-encompassing relativism, given by evolution. Cultures, languages, and interpretations evolve with the society of which they are part, and flourish only to the extent to which they are, if not advantageous, at least not disadvantageous for the society that creates them. In a trivial example, a society in which it is believed that bodies will not fall if thrown off a cliff, or one with gross misunderstandings in matters of reproduction will not be very successful. Languages and interpretations are social constructs, but there is a way in which the physical or cultural reality constrain what we will and will not think. A point similar to this was made very well—in regard to the coevolution of language, culture, and the brain—by Terrence Deacon in his *The Symbolic Species* (1997). This is also a reason (there are others much more poignant) why I cannot accept the very fashionable postmodernist idea that science is but another grand narrative, not dissimilar from religion or other mythologies: Science is the first attempt to consider the process in which physical reality drives out conjectures, and to try to formalize it and to use it as an exploratory tool.

Most of the problems of symbolic artificial intelligence come from what in this chapter I have identified as context and that often goes under the name *frame problem* in AI.

The frame problem is very pervasive. It pops up every time one tries to explain how we think, and every time we try to extend the usual approaches to intelligence to domains that, in principle or in practice, cannot be completely formalized.

Attempts to formalize domain knowledge have been made for a long time. All eventually hit the wall of the sheer number of facts that must be encoded to represent commonsense knowledge, and the fact that, in regular first-order logic, the number of consequences grows monotonically with the number of premises.

Consider again the midnight snack problem, and assume that you have added a (large) number of predicates to your intelligent system. One of these predicates can state, for instance, that if object A is placed on top of object B, and object B is moved from x to y, object A will also be in y afterwards. You must also add predicates that say that if object A was red (or soft, or edible, or ...), it will still be red (soft, edible, ...) once in y. A predicate like this adds a huge number of possible inferences to the domain of the intelligent agent, inferences that have to be examined and duly discarded. Now we will have to consider other predicates, like the fact that the refrigerator, being on the floor, will be dragged in the bathroom in case the kitchen floor is also taken to the bathroom. With a reasonable basis of commonsense knowledge, our intelligent system will pretty soon grind to a halt trying to determine whether adding pickles to a sandwich will cause the French government to increase taxes.

This kind of monotonic inference is not a very likely model of human reasoning. More recent research in artificial intelligence proposes the use of *nonmonotonic logic* as a better tool for solving the frame problem [Ginzberg, 1987]. I will not consider nonmonotonic logic here because the difference between it and monotonic reasoning is immaterial for the point I am trying to make, which is that context cannot be fully formalized, or even defined.

The AI approach is to try to formalize as many problems as possible and to refrain from intervening in those problems that cannot be formalized. This is has been a reasonably productive approach for the solution of some problems of practical interest but, in the long run, it is condemned to sterility; more and more problems of interest turn out to belong to that part of the world that cannot be fully formalized, and every approach based on full formalization is doomed to steer away from the most interesting problems that will present themselves in the future.

A second approach to face the impossibility of a complete formalization of the problem of signification (in the specific case, of the problem of image signification) is to reject formalization *in toto*, and to rely on intuitive and nonformalized descriptions. This view can be carried to the extreme and always carries with it the temptation to escape problems by refusing to be pinned down to any proposition that can be criticized. This carries with it the uncomfortable position of trying to clarify one of these positions only to be told that "the plurivocal ambiguities of the

(non)meaning inherent in [your] question obviously subverts the possibility of delivering the kind of low-down, phallocratic, and logocentric patriarchial logwallow of an answer which [you] are capable of understanding" [Powell, 1989][12].

In this book, I will try to take a rather pragmatic and, I would say, ethnomethodological approach. Rather than trying to formalize the forms of reasoning of (human) users and replicate them in a cognitive system, I will try to look at the society of users and see how certain phenomena such as language and categorization are negotiated among the users. The interest is therefore shifted from categories of discourse (either linguistic or visual) as mentalistic constructs of a user to categories of discourse as shared and negotiated components of a social conversation. This approach entails a much reduced ontological commitment, as the only requirement for the categories of interest is that they be achieved and communicated in some way at some time during the users' interaction.

In this sense, the approach I am advocating here (and that I will try to use, I do not know how consistently, absolute consistency not being a human trait) is not that of designing a cognitive system as much as a *semiotic* one. A semiotic system does not try to model, or even to postulate, the cognitive processes that take place in the mind of a user. More simply, it tries to participate in the conversation and in the exchange of signs between users (or, in the limit, between one user and the system) and in the definition and negotiation of the categories that will emerge from this conversation—categorization is not a given but a common creation of the system and the society of its users.

In this framework, I will use formal methods rather liberally, recognizing and embracing their limitations, but also the essential insight that they can bring to the structure of communication processes. These analyses will invariably be incomplete and not self-contained. I will try as much as possible to avoid the reification of these formal constructs; they will represent only a picture of a partially understood portion of a problem—in the same way as describing a house in writing would not require that the assumption be made that house is made of the letters used to describe it.

[12] I should point out that Powell uses the sentence that I quoted with the same ironic connotation that I am using here, and not as part of his normal style.

3

How You Can Know You Are Right

Technical and practical knowledge are not forces that steer cognition and should be turned off for the sake of objective knowledge; rather, to a much greater extent, they determine the aspect by which reality is objectivated.

Jürgen Habermas, *Knowledge and Human Interests*

Carl Sagan, in his book *Broca's Brain, Reflections on the Romance of Science*, talks about an obituary that appeared in 1899 in the *Monthly Notices* of the Royal Astronomical Society. The obituary was about a Mr. Henry Perigal, and notes " 'the remarkable way in which the charm of Mr. Perigal's personality won him a place which might have seemed impossible of attainment for a man of his views; for there is no masking the fact that he was a paradoxer pure and simple, his main conviction being that the Moon did not rotate, and his main astronomical aim in life being to convince others, and especially young men not hardened in the opposite belief, of their grave error. To this end he made diagrams, constructed models, and wrote poems; bearing with heroic cheerfulness the continued disappointment of finding none of them of any avail. He has, however, done excellent work, apart from his unfortunate misunderstanding.' "

(I cannot help but notice that in 1899 the style of scientific writing had a certain Faulknerian flavor that no journal editor would allow today.) Style considerations apart, Mr. Perigal must have been a very interesting man. Unfortunately, his academic career would have been certainly more brilliant had he realized that the world is not always as one would like it to be.

As appealing as a theory or an hypothesis might be, one is always confronted with the rude awakening of checking whether a brilliant hypothesis also happens to be true, and whether a theory presents an accurate picture of reality.

The argument of evaluation creates an interesting conundrum that, if followed to its extreme consequences, would elucidate the differences between the practice of science and that of technology. I will not try to follow the forementioned conundrum to its extreme consequences but, before delving into the technical aspects of this chapter, I should like to spend a few words on the role and the scope of evaluation in technological endeavors (with an eye on the technological endeavor that I am undertaking here, namely, the design of image databases). In case you are not interested in epistemological questions, you can safely skip the next section and proceed directly to Section 3.2.

3.1 The Role of Evaluation

In common parlance one talks about "science and technology" as if they were the same or, at least, very related areas of human culture. This is, at best, an over-statement and, at worst, a serious misunderstanding. Science and technology are, indeed, very different things. One should not be fooled by the fact that technology uses a number of byproducts of science. Just consider some facts.

First, technology is much older than science, at least if science is identified with anything resembling the modern scientific method. Technology is as old as man (technological capabilities are used in order to classify the hominids that preceded homo sapiens) and, in fact, is not entirely restricted to man. Other primates use tools in order to get things done and can fabricate tools. This is a full-fledged technological capability. Science, at least as a method resembling the current scientific practice, was fully in place by the mid-Seventeenth Century, although traces of the same attitudes were present in Roger Bacon's writings as early as the Thirteenth Century.

Second, the purpose, philosophical foundations, and modus operandi of technology are different from those of science. A scientist studies nature essentially to understand it better, and is not primarily interested in intervening in nature or in creating devices to aid human activities. There is an inherent social component in technology that is missing in science. A scientist can lock himself in an inaccessible room and still do meaningful science (although probably we would never know it). Technology has value only if it has an impact upon the social structure in which it is developed.

Third (and related to the previous point), it is true that technology uses, as a matter of convenience, some scientific results, but the results that technology employs can be peripheral to the scientific enterprise, and can continue to be used even after they have been dismissed as viable science. For instance, construction technology still consider bodies as continua, although scientific atomism is a century old. The concept of the elemental particle has almost disappeared from

science, but it is still a cornerstone in industrial chemistry and semiconductor development.

It should come as no surprise that evaluation will have in technology a different role than it has in science. From the point of view of evaluation, the most important aspect of the technologocal endeavor is the one highlighted in the second point given here, technology is concerned with the creation of manufactured goods to answer to some perceived social need (or, alas too often, to create some social need in order to sell the technology). One obvious way to evaluate technological manufactured goods is to evaluate their impact on the organization that is using them.

These considerations on the difference between "hard" science and technology (albeit very superficial) highlight the need to shift the focus of evaluation. One is no longer evaluating a certain system or device, but a system or device *in the context of a specific problem*. For instance, while developing a visual information system for use by a graphic designer, one should evaluate quantities like the time necessary to prepare an advertising campaign before and after the introduction of the Content-Based Image Retrieval system, but also quantities like the number of iterations necessary before the client accepts the campaign, the percentage of customers who return to the same designer for new campaigns, the percentage of clients who reject the campaign and hire a new designer, and so on. In the vast majority of the problems it is of course out of the question to measure all the variables directly or marginally relevant to an activity, and it will be necessary to do some approximation and a good deal of simplification. The basic idea, however, stands: one should measure the impact of a system (or of a number of systems, for comparison) on a pre-existing human activity.[1]

[1] As an aside, I will note that actual evaluation of a computer system is even more complex because, like everything that intervenes on a social structure, it poses the problem of social values and goals. The introduction of a system in a complex organization will cause a number of changes in all the aspects of the product cycle, and will have an impact on the final quality of the product, its cost, its availability, the relation of the company with the customer, and so on. It will also change certain relations inside the company (certain people will have more social prestige as a consequence of the introduction of the system, and other people less) and relations between the company and its environment (providers, competition, the government, . . .). How should one evaluate such changes? On the basis of which scale of values? The neocapitalist mantra that the only important value is the profit of the shareholders (as opposed to the traditional capitalist value of the profit of the company) provides, if not an ethically spotless criterion, at least a measurable one. This criterion, however, cannot be applied to systems designed for individual use: How does a given system "improve" the life of the individual using it? Lacking an acceptable definition of quality of life, such a question cannot be answered. The problems are particularly well exposed in disciplines that operate in areas of human activity that we conventionally call "cultural" and that, *qua intellectual*, are not easily quantifiable. To make a superficial parallel, the fact of growing more corn, per se, is positive. When evaluating a new growing technique, one is concerned with the possible side effects of many types—health (pesticides), the environment (the use of polluting diesel engines, genetically modified organisms), social (loss of jobs, degraded working conditions in the fields)—that can outweight the advantages of the growing method but, in any case, there is no doubt that the ultimate goal of growing more corn is a positive one. In the case of cultural or creative activity, this is not true: Quantity is not the whole story, and the modality of access to the material is as important as the quantity of material accessed. Otherwise, the readers of the *Reader's Digest* would be the leading intellectuals of our age.

This type of evaluation is (*mutatis mutandi*) essentially the same as that done by social scientists[2]: the designer is interested in measuring the effect of certain external circumstances (the introduction of an image retrieval system) in an activity involving human subjects.

In addition to the inherent problems of complication and high cost, evaluation of human activities has the disadvantage of being inapplicable to parts of a complete system because only a complete system can have a measurable impact on the activity. A module or a subsystem cannot be evaluated in this way unless it is complex enough to be used to aid an activity (possibly a different one from that for which the whole system is designed) or can be included in some complete system that satisfies some suitable neutrality conditions.

The essential problem in the previous statement is in the expression "suitable neutrality conditions." Although systems are decomposed into subsystems as a matter of engineering practice, there are many and complex interactions between the subsystems, which makes satisfaction of the neutrality condition a myth.

Consider, for instance, the evaluation of a similarity measure. There are n different similarity measures, and the ith similarity, s_i is determined by m_i parameters $\{\theta_{i,1}, \ldots, \theta_{i,m_i}\}$. The experimenter selects an activity or two (let us say, to fix the ideas, certification of the uniqueness of trademarks, and retrieval of patterns of textiles), and incorporates the similarity into a system that looks more or less like that of Fig. 3.1. The first observation one can make is that the feature extractor will either be different for the two applications, or will create a large feature vector that includes the features necessary for both applications. The first case represents a serious violation of the neutrality assumption, since the interaction between the similarity measure (that is being evaluated) and the feature extraction process (which constitutes an experimental circumstance) would vary depending on the application. The second solution, however, is of limited practical relevance. In practice, a system for the certification of trademarks would *not* include features for textiles, and vice versa. Some similarity measures can take advantage of features that, in a more realistic scenario, just would not be there. In other words, one has no control over the features that are not necessary for

The message I want to convey with these notes is that when one is engaged in evaluation, one is necessarily engaging in a partial activity that requires circumscribing a certain area around the system and evaluating within this area, lest one should solve impossible eschatological questions. One can, for instance, formalize the work of a system as the solution of a problem, and evaluate how the system solves the problem, assuming, *ex hypothesis*, that the solution of the problem will be positive for the organization and the individual. It should always be very clear, however, that the problem is nothing but a useful modeling tool, and has no social reality outside of this modeling function. In particular, the assumption that the solution of the problem will always be beneficial to the organization should always be analyzed critically, because once it is accepted, it tends to make the designer "blind" to solutions involving a change, rather than a solution, of the problem.

[2] I should probably add a caveat. So far I purposely avoided placing the adjective *experimental* in front of the noun *evaluation*. Although a good deal of the evaluation that I will consider is indeed experimental (as this parallel with social sciences suggests), this is not always the case. As an example, proving that an algorithm is *NP*-complete is an evaluation of its time complexity (as long as $P \neq NP$, as most mathematicians suspect and all engineers know).

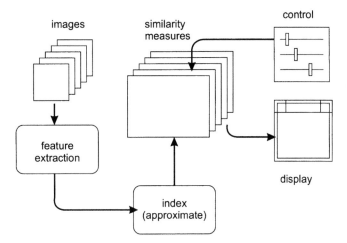

Figure 3.1. Evaluation of similarity measures by incorporating them into a system designed for a specific application.

the example application. The problem disappears in systems that use the general ontological features discussed in Chapter 6.

Problems also arise from the interaction between the similarity measure and the indexing system. If the indexing system is approximate (see Chapter 9), the results returned can contain errors, and the number and nature of errors can depend on the interaction between indexing and similarity measures. Finally, one should always consider the importance of the interface in image databases. Different applications require different interfaces, and there is no reason to believe that the choice of interface will be neutral with respect to the choice of the similarity measure. For instance, some interfaces work well with similarity controlled by very few parameters, while others work well with similarity measures controlled by many parameters.

These observations seem to preclude the possibility of modularizing a system in such a way that one of its components (in this example it was the similarity measure) can be replaced and evaluated. On the other hand, much research work is concerned with the design of methods and algorithms for solving specific problems or implementing specific functions within a complete system. In order to have this research produce meaningful and reproducible results, it is necessary to find an alternative way to evaluate, at least partially, the components of a system. There are, roughly speaking, two types of modules in a system like that of Fig. 3.1. Some, like the indexing box in the figure, have a purely computational specification. Others, like the similarity measures, have a specification that is given by comparison with a cognitive capability. This distinction is a bit rough, and not all subsystems fit nicely into it. In some cases, such as the feature extractor subsystem, the determination of which cognitive capability is being modeled is not immediate. In the case of the interface, the capability that is being modeled is not trivially recognizable as human. These problems are important but,

for the time being, this classification will help me make the first broad distinction of evaluation into three modalities: *physical evaluation; contextual evaluation;* and *noncontextual evaluation.* The three modalities are defined as follows.

Physical evaluation. This modality refers to the evaluation of a computational property of the system, specified without reference to a cognitive capability. Typical examples are the speed of retrieval of a given image from a database, or the storage occupation of a given set of images. These measures, although sometimes the experimentation process can be technically arduous, are conceptually simple to obtain, and do not require the presence of human subjects. I will present some techniques of interest for image databases in the following sections.

Contextual evaluation. I call this modality "holistic evaluation," since it can only evaluate systems in their entirety. Its modus operandi is the measurement of the performance of a certain human activity with and without the assistance of the system (or with the assistance of different systems). This is the most epistemologically sound modality of measurement for an interactive system, because it measures its "bottom line" efficacy (i.e., the effect on the activity that was supposed to be improved) and does not depend, like the next mode, on additional methodological assumptions. It is, however, an often expensive and scarcely practical mode of experimentation, as it involves a large number of human subjects proficient in the activity that the system is supposed to aid. In addition to the difficulties already highlighted for the extension of the evaluation to subsystems, this methodology suffers from excessive particularization. Every experimental assessment has to be relative to a specific activity, and it is very difficult to reach conclusions of general theoretical applicability. Contextual evaluation entails essentially a social experiment, and should be carried out with the methods and tools of the social sciences. I will consider some of the more relevant issues in Section 3.4.

Noncontextual evaluation. This is the measure of the performance of a method or an algorithm isolated from the complete system, and with respect to some ideal functional specification that (at least in the cases that concern image retrieval) involves a comparison with human performance. This mode of evaluation is perforce quite common in visual information systems although, epistemologically, it is weaker than the previous one because of the analytical decomposability assumption it implicitly makes. In order to perform a decontextual evaluation one must assume that the system under evaluation can be decomposed into a number of subsystems whose behavior can be specified, modeled, and evaluated in isolation from their environment. The more complex a system is—and the simpler the subsystem that one needs to evaluate—the more problematic the assumption becomes. As an extreme case, one can think of evaluating a neuron in a neural network without reference to the other neurons, an obviously illusory goal. Nevertheless, at least at the highest levels of a system, modularization is forced by engineering practice, and noncontextual evaluation can be a useful measurement tool.

The main advantage of noncontextual evaluation is that it does not make any assumption on the final application in which the system will be deployed, but tries to measure whether a subsystem implements a certain cognitive function compatibly with the human referent. From a methodological point of view, both contextual and noncontextual evaluations require the presence of human subjects, but with a crucial difference. In the case of contextual evaluation, the human subject is part of the activity that is being evaluated. The experimenter will use suitable instruments (questionnaires, time measurements, ...) in order to assess the efficiency *of the person* in performing a certain activity. In the case of noncontextual evaluation, the human subject is used as a referent, which performs the activity under evaluation in parallel with the method that is being evaluated. The subject is, in this case, outside the activity—there will be no human performing such activity in the final situation.

In a sense, the expectations on the human activity are opposite in the two scenarios. In contextual evaluation, the system is supposed to improve a certain activity and, if things work as expected, the unaided human activity is a lowest reference point, and the experiment will measure the improvement of the system over this reference. In noncontextual evaluation, the human cognitive activity is the optimal model, that is, the highest reference point; the experiment measures the degree by which the system fails to achieve this level of performance.

3.2 Inadequacy of Traditional Evaluation Models

Before considering an evaluation methodology for image retrieval, it is opportune to spend a few words on the evaluation techniques of disciplines close to it, the opportunities for extension of these techniques, and the limitations of such an extension. Three established fields impinge enough on image retrieval systems to provide potentially useful evaluation methods: databases; computer vision; and information retrieval.

Databases. Certain database evaluation methods have an obvious interest for image retrieval. The most immediate example is that of indexing systems for fast access to database entries. It is a well-known result, for instance, that if the entries of a database can be totally ordered, and two entries can be compared in constant time, then there are methods for accessing an entry in $\log_B N$ disk accesses, where N is the number of entries in a database and B the *block size*, that is, the number of database entries that fit in a disk block. In the case of an image database, the situation is complicated by the fact that the entries in a high dimensional feature space cannot be given a total order compatible with the space topology, and many indexing methods exhibit a rapid degradation of performance when the dimensionality of the feature space is high (this phenomenon is commonly known as "curse of dimensionality," and will be analyzed in Chapter 9).

Database theory is also concerned with the properties of query algebra, in particular with the class of queries that can be expressed and implemented efficiently in a given algebra. In an image database, the definition of a query language is a lot more complicated, but the algebraic techniques developed for databases can, in part, be used for the analysis of query algebras in image databases.

Computer vision. Computer vision techniques are of course very important for image retrieval, since they pertain to essential feature extraction and analysis methodologies of great importance for the description of image content. Computer vision, however, has a distinctively separate orientation from image retrieval, and this somehow limits the extensibility of computer vision evaluation techniques. In very general terms, computer vision is interested in detection problems. From the recognition of an object in a cluttered scene, to the recognition of a face; from the identification of a particular gesture, to the identification of a defect in a manufactured item, computer vision is in the business of detection of absence and presence. Image retrieval, as I have already pointed out, deals with categorization by way of similarity.

From the point of view of evaluation, the difference is that in computer vision it is often possible to define precisely a ground truth to which results can be referred, while in visual information systems this definition is more problematic. In very general and superficial terms, the evaluation of a computer vision algorithm entails two steps. The first is the definition of a ground truth, or the result that an ideal algorithm would give on a dataset of interest. The second is the definition of a measure of the deviation between the output of the actual algorithm and that of an ideal algorithm on the same data. In computer vision evaluation, the real challenge lies in the latter activity, while the former is a conceptually easy problem. In image retrieval, the former activity poses the hardest challenge.

Relatively easy availability of a ground truth also makes computer vision methodologies relatively independent of the presence of human beings in the evaluation process. An observer may be necessary to provide the experimental ground truth, but the ground truth itself is objective, in the sense that all observers will agree on it. This relieves computer vision of the burden of a "statistical" ground truth, and of the necessity of analyzing the differences between observers.

Information retrieval. Information retrieval is, in spirit at least, very close to visual information retrieval and it bears a very direct influence on it. Traditionally, information retrieval is concerned with search in free text (unstructured) documents. Information retrieval has to deal with the same problems as image retrieval for the definition of a suitable semantics. Quite unsurprisingly, a number of measures of performance used in information retrieval can be extended to visual information.

There are some possible problems of which one should be aware. The most common measures of performance in information retrieval are *precision* and

recall.[3] Given a database D and a query, define a subset R of *relevant* documents for that query. The *answer* of the system for the same query is a (generally different) *returned set* of documents A. The *recall* measure is the fraction of the relevant documents returned by the system:

$$R = \frac{|A \cap R|}{|R|} \in [0, 1] \tag{3.1}$$

This measure alone is not sufficient to determine the quality of the system. As a simple example, a system that returns D (the whole database) as an answer to every query would always have $r = 1$. The *precision* measure is the fraction of the returned documents that are relevant:

$$P = \frac{|A \cap R|}{|A|} \in [0, 1] \tag{3.2}$$

Usually one of the two parameters can grow at the expense of the other simply by increasing or reducing the size of A.

The epistemologically problematic assumption in this scheme is the existence of, and the possibility of individuating, the set R. In particular, two assumptions are open to challenge: (1) the assumption that a document can only be in two states (*relevant* and *irrelevant*); and (2) the assumption that the relevance of a document is independent of the presence or absence of other documents. The second assumption is essential for the use of the set size function $| \cdot |$ as a measure. Regardless of the validity of these assumptions in textual information retrieval, there are quite pressing reasons to believe that they are not valid in image retrieval. Having to abandon the concept of "relevant set," it is necessary to develop new evaluation techniques that will necessarily have to rely more on the presence and information provided by the users of the systems.

3.3 Basic Techniques

When evaluating an image database, or any other manufactured item or procedures involving human subjects, the basic procedure is to have subjects sitting in front of the system perform a certain activity that yields measurable results, and is correlated with the aspect of the system being measured. One will usually employ a certain experimental protocol (that I will consider in the following sections) to determine how many *trials* should be done, with which subject, and what results should be compared. A trial, in the present scenario, is constituted of a single activity, performed by one subject using one system or one configuration of the system. A trial is the atomic unit of experimentation. In an experiment, one is interested in the evaluation of a number of systems or of a number of variants

[3] Similar measures have been developed in a number of fields, with slightly different definitions and wildly different denominations. For example, in medical research, measures based on the same ideas and (almost) the same definition are called *specificity* and *sensitivity*.

of the same system. Each one of the variants or the systems under evaluation is called a *treatment*[4] (see Section 3.3.2 for a more rigorous definition of treatment).

Regardless of the experimental protocol used, two problems will appear. The first is the measurement of the results of a trial. This problem is easily solved if the result of a trial consists of a response time, a percentage of correct answers, or another easily quantifiable result. In an image database experiment, unfortunately, things seldom go so smoothly, and special trial measurement techniques need to be developed. The nature of the techniques that will be developed depends on the nature of the system under evaluation.

The second problem is the evaluation of the difference between different scenarios. All the protocols that I will present in the following entail the execution of a number of trials (either by the same subject or by different subjects) for each treatment. For instance, the protocol might dictate a comparison of two systems A and B by making 10 measurements for each system (i.e., executing 10 trials). These measurements will show two kinds of variability—the results of different trials will be different even when using the same system due to differences between the subjects (*within-treatment* variability), and there will be differences in the results obtained with different systems (*between-treatments* variability). The experiment is successful (it reveals a difference between the two systems) if the between-treatments differences are statistically more significant than the within-treatment differences. Due to the presence of within-treatment variability, it will in general be impossible to say for sure that there is a difference between the two systems, but it will only be possible to say so with a certain probability.

The first subsection of this section considers methods for solving the first problem, while the second subsection reviews well-established statistical techniques for solving the second problem.

3.3.1 Measurements of Trial Results

All evaluation techniques I will consider are based on comparison of the results of searches. In many cases, comparison is between two results, a result obtained by the system under evaluation and a result obtained by a subject that acts as a referent.

Comparing results in the case of an image database presents some peculiar problems because there is no relevant set, and it will be necessary to generalize some notions in use for information retrieval systems. A retrieval system divides a database D into two sets of documents, a *returned set A*, and a *discarded set* $D - A$. The comparison is made with an ideal system that, similarly, divides the database D into two sets, a *relevant set R* and an *irrelevant set* $D - R$.

[4] I have struggled quite a bit to decide whether to retain the name "treatment" or to substitute it with something closer to the practice of image database evaluation. The term "treatment" refers to an actual drug or other medical treatment under experimentation. I decided to retain it because it is the term that one is more likely to encounter in the statistical literature.

Apart from the different name, the response of a system (ideal or under test) is given by an *answer configuration* which, in this case, can be represented as the pair of sets $\{R, D - R\}$. The evaluation of a system is made by comparing its answer configuration with that of an ideal system.

The question then is to determine what constitutes a valid answer configuration for an image database system and how to measure the similarity between two configurations. I will consider two possible choices:

1. An answer configuration of an image database given a query q is an ordered set of images $\{I_1, \ldots, I_n\}$ such that, if S_q is a scoring function measuring the relevance of an image for the query q, we have $S_q(I_i) \geq S_q(I_{i+1})$.

2. An answer configuration is a set of images $\{I_1, \ldots, I_n\}$ and a function d such that $d(I_i, I_j)$ is the difference between images I_i and I_j relative to the query q.

I call the first case the *ranked list* evaluation and the second the *spatial configuration* evaluation.

Ranked list evaluation. Ranked list evaluation applies to the case in which the answer configuration of the database is an ordered list of images I_1, \ldots, I_n. The measures that will be derived in the following evaluate the difference between the answer configuration of two databases in a completely symmetric way but, for the sake of clarity, I will assume that one of the two responses is the *ideal response* and the other is the *test response*. In the experimental practice, the ideal response is given by a human subject or by some reference system, while the test response is given by the system under evaluation.

Let the ideal answer configuration to the query q be given by

$$C^\iota = (I_1, \ldots, I_N) \tag{3.3}$$

(the superscript ι stands for "ideal") where N is the size of the database. Assume that each image I_i has associated a significance value $s_i^\iota \in [0, 1]$, where $s_i^\iota = 1$ if image I_i matches completely the meaning of the query, and $s_i^\iota = 0$ if image I_i is completely irrelevant for the query. The ordering of the images is such that $s_i^\iota \geq s_{i+1}^\iota$.

Because configurations contain the whole database, the test response consists of the same set of images in a different order (I will consider in a moment—as a simple extension—the case in which the configurations do not contain the whole database and, therefore, the two ordered sets can be different):

$$C^t = (I_{\pi_1}, \ldots, I_{\pi_N}) \tag{3.4}$$

where (π_1, \ldots, π_N) is a permutation of $(1, \ldots, N)$. The *displacement* of image I_i between the two orderings is given by $|i - \pi_i|$, and it is a measure of how far from its ideal rank the tested database placed the image I_i. A suitable combination of such displacements over all images can be used to determine the difference between the two orders and therefore the quality of the database under test. Note,

however, that misplacing an image by a given offset does not always result in the same loss of quality. If a very relevant image is misplaced, the difference in the answer configuration of the two databases is relevant. If, on the other hand, only images of scarce relevance are misplaced, the difference in the answer configuration of the two databases is much less. This suggests weighting the displacement of an image I_i by its relevance, thereby obtaining the *weighted displacement* [Desai Narasimhalu *et al.*, 1997]

$$\omega = \sum_i s_i^t |i - \pi_i| \tag{3.5}$$

If necessary, the weighted displacement can be transformed into a normalized measure of similarity between the two answer configurations using a monotonically decreasing function $g: \mathbb{R} \to [0, 1]$. The *g-weighted concordance* of the two systems is

$$c = g\left(\sum_i s_i^t |i - \pi_i|\right) \tag{3.6}$$

Typical functions used for establishing concordance include the rational functions $g(x) = 1/(1 + x)^p$ and the exponential $g(x) = \exp(-\lambda x)$.

The situation is slightly more complicated if the answer configuration of the systems does not contain the whole database, but only a subset that, for the ideal response, will be denoted with

$$C_m^t = (I_1, \ldots, I_m) \tag{3.7}$$

Again, the images in the answer configuration have associated a significance value $s_i^t \in [0, 1]$, and the significance value for all images not in the answer configuration can be assumed to be zero: $i > m \Rightarrow s_i^t = 0$. The test system will also give a configuration

$$C_m^t = (I_{\pi_1}, \ldots, I_{\pi_m}) \tag{3.8}$$

but, in this case, (π_1, \ldots, π_m) is not a permutation of $(1, \ldots, m)$, because some images that appear in C_m^t may fail to appear in C_m^t and vice versa. The configuration can be analyzed by reference to three sets: the set $A = C_m^t \cap C_m^t$ of images that appear in both configurations; the set $B = C_m^t - C_m^t$ of images that appear in the ideal answer configuration but not in the test answer configuration; and the set $C = C_m^t - C_m^t$ of images that appear in the test answer configuration but not in the ideal answer configuration. Note that the three sets are ordered with the ordering induced by that of C_m^t.

The displacement between the two systems is the sum of the displacements in the set A, B, and C. The set A can be analyzed using the same weighted displacement measure used in the previous case:

$$\omega^A = \sum_{I_i \in A} s_i^t |i - \pi_i| \tag{3.9}$$

The set C is irrelevant because the images in C do not belong to C_m^l and, by construction, their significance is zero. The evaluation of the set B is more problematic. Each image in the set B is a significant image that has been placed by the test system beyond the range of available results. Consider an image $I_j \in B$, j being its position in the ideal answer configuration. Had the test system returned the whole database as a configuration, image I_j would have been placed in a position $\pi_j > m$, and its contribution to the displacement would have been $s_j^t|j - \pi_j|$. Unfortunately, as the test database returns only m images, there is no way of knowing the value π_j.

If the databases allow some form of incremental request to obtain more images after the first m has been examined, one can keep increasing the set C_m^t until it includes all the images in C_m^l. In this case, $A = C_m^l$ and $B = \emptyset$. As C is not relevant, one can use the measure

$$\omega^A = \sum_{I_i \in C_m^l} s_i^t|i - \pi_i| \tag{3.10}$$

If the set C_m^t cannot be augmented, then it is necessary to make some hypothesis about where the images of B have been displaced. There are several hypotheses possible:

The optimistic hypothesis consists of assuming that the database is as good as it can possibly be, compatibly with the fact that the images in B were not returned as part of the set C_m^t. This means that the first image in B (which, by the induced order is the image of B with highest rank in C_m^l), is in position $m + 1$, the second image in B is in position $m + 2$, and so on. Let β_i be the position of the ith image of B inside the set C_m^l, then

$$\omega_o^B = \sum_{I_i \in B} s_i^t|\beta_i - (m + i)| \tag{3.11}$$

The pessimistic hypothesis consists of assuming that, as the images in B are inaccessible to us, the situation is no better than that in which all the images that are not in C_m^l were relegated at the end of the list, that is, the last image in B is in position N, the next to last in position $N - 1$, and so on. In practice, because $N \gg m$, it makes little difference where the images are exactly placed at the bottom of the whole database, and one can consider the displacement to be equal to N for all images in B:

$$\omega_p^B = \sum_{I_i \in B} s_i^t N \tag{3.12}$$

As displacements are additive, the total weighted displacement for the database under test is obtained simply by adding the two displacements relative to A and B (C, as I have already noted, does not contribute any displacement):

$$\omega = \omega^A + \omega^B \tag{3.13}$$

where ω^B can be either in the optimistic or the pessimistic version. In the case in

which the displacement is pessimistic, the previous expression can be simplified. Unless there are wild variations in the values of the significance values s_i^t, ω^A is of the order of magnitude of m and ω^B is of the order of magnitude of N; as $N \gg m$, it is $\omega \approx \omega_B$, or $\omega \approx \sum_{I_i \in B} s_i^t N$. That is, apart from the multiplicative factor N, in the pessimistic interpretation the weighted displacement is equal to the sum of the significances of all the images that are returned by the ideal system but not by the system under test.

Spatial configuration evaluation. Some of the interfaces that will be considered in the book give the user a result based on the placement of images in a suitable display space. In this case, the configuration is given by the set of images represented in the display space and by a function $d(I_i, I_j)$ that gives the distances between image I_i and I_j. Rather than working directly with the distance function d, it will be useful to consider a monotonically decreasing function $g : \mathbb{R} \to [0, 1]$ and define the similarity between two images as $s(I_i, I_j) = g(d(I_i, I_j))$[5]. The function g will be chosen with the additional requirement that the resulting function s be square integrable, that is, $s \in L^2(\mathcal{F} \times \mathcal{F})$, where \mathcal{F} is the feature space in which the images are represented.

As in the previous section, I will compare an *ideal answer configuration* with a *test answer configuration*, beginning with the case in which the configurations contain all the images in the database. The ideal configuration consists of the set D (the whole database) and the similarity function s^t such that $s^t(I_i, I_j)$ represents the similarity between images I_i and I_j with respect to the current query. The test configuration consists of the same set D and the similarity function s^t such that $s^t(I_i, I_j)$ is the similarity between images I_i and I_j that can be inferred from their position on the interface of the system under test. The comparison between the two configurations is therefore limited to the comparison between the two functions s^t and s^t. Such distance can be obtained using any of the many distances on function spaces defined in literature (see, e.g., Riesz and Sz.-Nagy, 1990). The functions s are, of course, only known at the points corresponding to the images in the configuration, so the function distance measures will also be sampled. For example, one can define the *uniform distance* between two configurations as

$$D_\infty(s^t, s^t) = \max_{i,j} |s^t(I_i, I_j) - s^t(I_i, I_j)| \qquad (3.14)$$

and the L_p distance as

$$D_p(s^t, s^t) = \left[\sum_{i,j} |s^t(I_i, I_j) - s^t(I_i, I_j)|^p \right]^{1/p} \qquad (3.15)$$

[5] There is no need to derive any specific property of such distance function for the moment. In the next chapter the transformation from a distance function to a similarity function will be considered more extensively.

Each of these distance functions will provide a suitable measure of the discrepancy between the output of the system and the ideal configuration in the case in which the two configurations contain the same set of images.

In most cases, the sets of images composing the two answer configurations do not coincide. The composition of the answer configurations depends on a certain *stopping criterion* employed by the database. Displaying a configuration is usually a two-step process:

1. Using a selection criterion, determine the set of images that will be displayed in the user interface.

2. Arrange the images in the user interface in such a way that the distance between two images in the interface reflects the dissimilarity between the two.

In order to derive an evaluation criterion, some assumptions about the selection process are necessary. In the remainder of this section, I will assume that the query for the experiment is one of the images in the database, which is returned by both the ideal and the tested database, and that will be indicated as I_1 in the following. Each database takes the closest images to I_1 (the number of images returned is the result of a different criterion that is not relevant for evaluation) and uses them to create the answer configuration.

The experiment with the ideal database returns a set of image $\mathcal{I} = \{I_1, \ldots, I_m\}$ and a set of distances between pairs of images in \mathcal{I}: $\{\delta_{ij} : I_i, I_j \in \mathcal{I}\}$. The values δ_{ij} come from an underlying distance function, and they must satisfy the distance axioms: $\delta_{ii} = 0$, $\delta_{ij} = \delta_{ji}$, and $\delta_{ij} \le \delta_{ik} + \delta_{jk}$.

The experiment with the test database returns a set of images $\mathcal{T} = \{I_i, \ldots, I_q, I_{m+1}, \ldots, I_{m+p}\}$, with $q \le m$, and a set of distances $\{\hat{\delta}_{ij} : I_i, I_j \in \mathcal{T}\}$. The values $\hat{\delta}_{ij}$ also satisfy the distance axioms. Define the sets

$$A = \mathcal{I} \cap \mathcal{T} = \{I_1, \ldots, I_q\}$$
$$B = \mathcal{I} - \mathcal{T} = \{I_{q+1}, \ldots, I_m\}$$
$$C = \mathcal{T} - \mathcal{I} = \{I_{m+1}, \ldots, I_{m+p}\} \tag{3.16}$$

Note that, for the sake of convenience, the indices have been rearranged so that the images of A come before those in B, and these come before those in C. This can be done without loss of generality because in this case the sets are unordered. The only constraint is that, as $I_1 \in A$, the query image is assumed to be returned by both the databases, which is a fairly reasonable assumption.

Considering the L_p distance between the two configurations, one is interested in a measure of the form

$$\Delta(\delta, \hat{\delta}) = \left[\sum_{i<j} |\delta_{ij} - \hat{\delta}_{ij}|^p \right]^{1/p} \tag{3.17}$$

where the summation is extended to $i < j$ because of symmetry and the fact that $\delta_{ii} = 0 = \hat{\delta}_{ii}$. In order to compute the measure Δ, it is necessary to consider the

following cases:

1. $I_i \in A, I_j \in A$

2. $I_i \in A, I_j \in B$

3. $I_i \in A, I_j \in C$

4. $I_i \in B, I_j \in B$

5. $I_i \in B, I_j \in C$

6. $I_i \in C, I_j \in C$

I will consider the cases one by one.

$I_i \in A$, $I_j \in A$. This is the simplest case because both δ_{ij} and $\hat{\delta}_{ij}$ are available among the values returned by the databases, and the difference $|\delta_{ij} - \hat{\delta}_{ij}|$ can be computed directly.

$I_i \in A, I_j \in B$. In this case, $I_j \in \mathcal{I}$, so one can determine δ_{ij}, but $I_j \notin \mathcal{T}$, so it is not possible to determine the value $\hat{\delta}_{ij}$. Let $\hat{M} = \max_{I_k \in \mathcal{T}} \hat{\delta}_{1k}$. Then, obviously, $\delta_{1j} \geq \hat{M}$ (if it were $\delta_{1j} < \hat{M}$, then I_j would be included in \mathcal{T}, and would not be in B). In addition, the triangle inequality must be satisfied. This gives the set of conditions

$$\hat{\delta}_{1i} \geq \hat{M} \qquad (3.18)$$
$$\hat{\delta}_{1i} \leq \hat{\delta}_{1i} + \hat{\delta}_{ij} \quad \forall i : I_i \in A$$

The second inequality implies $\hat{\delta}_{ij} \geq \hat{M} - \hat{\delta}_{1i}$. As in the previous section, one can take an optimistic or a pessimistic attitude. The pessimistic case assumes that the test database placed all the images in B "very far" from their intended position, that is, it assumes that $\hat{\delta}_{ij} \gg \hat{\delta}_{ik}$ for all $I_k \in A$. In this case, reasoning as in the previous section, one finds that the measure Δ depends only on $|B| + |C|$. The optimistic attitude is in this case more interesting, and it entails making the terms $|\delta_{ij} - \hat{\delta}_{ij}|$ as small as possible consistently with the conditions equation (3.19). Consider distances of the type $\hat{\delta}_{ij} = \hat{M} - \alpha \hat{\delta}_{1i}$. It is necessary to verify whether distances of this type satisfy the triangle inequality. For $i, k \in A$, it must be

$$\hat{\delta}_{ij} \leq \hat{\delta}_{ik} + \hat{\delta}_{kj} \qquad (3.19)$$

that is

$$\hat{M} - \alpha \hat{\delta}_{1i} \leq \hat{\delta}_{ik} + \hat{M} - \alpha \hat{\delta}_{1k} \qquad (3.20)$$

or

$$\hat{\delta}_{ik} \geq \alpha(\hat{\delta}_{1k} + \hat{\delta}_1) \qquad (3.21)$$

If $\alpha \leq 1$, the inequality is verified as a consequence of the triangle inequality that $\hat{\delta}_{ik}$ satisfies for $I_i, I_k \in A$. Leaving the value α undetermined for the

moment, this results in a term of the type

$$|\delta_{ij} - \hat{\delta}_{ij}| \approx |\delta_{ij} + \alpha \hat{\delta}_{1i} - \hat{M}| \tag{3.22}$$

Note that this condition requires that the value $\hat{\delta}_{ij}$ satisfy the triangle inequality when considering the distances between I_j and two images $I_i, I_k \in A$. There is no guarantee that the distances thus determined are internally consistent and that, taking three images $I_j, I_r, I_s \in B$, there is no guarantee that $\hat{\delta}_{js} \leq \hat{\delta}_{jr} + \hat{\delta}_{rs}$. I call this condition *first-order consistency*.

$I_i \in A$, $I_j \in C$. In this case, the value $\hat{\delta}_{ij}$ is directly available, while the value δ_{ij} is not. Proceeding as in the previous point, with the optimistic interpretation, and $M = \max_{I_k \in I} \delta_{1k}$, one obtains

$$|\delta_{ij} - \hat{\delta}_{ij}| \approx |M - \beta \delta_{1i} - \hat{\delta}_{ij}| \tag{3.23}$$

$I_i \in B$, $I_j \in B$. As in the first case, δ_{ij} is available, while $\hat{\delta}_{ij}$ is not. However, unlike in the first case, $I_i \notin \mathcal{T}$, so that the value $\hat{\delta}_{1i}$ is also not available, and the relation equation 3.22 does not apply. In this case, there is no first-order constraint to limit our choice of $\hat{\delta}_{ij}$ and, keeping it with the optimistic attitude, one can chose it so that $|\delta_{ij} - \hat{\delta}_{ij}| = 0$.

$I_i \in B$, $I_j \in C$. In this case, neither δ_{ij} nor $\hat{\delta}_{ij}$ is available, and there is no first-order constraint between them. One can therefore choose the values so that $|\delta_{ij} - \hat{\delta}_{ij}| = 0$.

$I_i \in C$, $I_j \in C$. This case is symmetric to case 4, and, as in that case, one can choose δ_{ij} (which is unavailable) so that $|\delta_{ij} - \hat{\delta}_{ij}| = 0$.

The measure of the difference between the two configurations depends on the two parameters α and β, and is given by

$$\Delta(\delta, \hat{\delta}; \alpha, \beta) = \left[\sum_{i=1}^{q} \left(\sum_{j=i+1}^{q} |\delta_{ij} - \hat{\delta}_{ij}|^p + \sum_{j=q+1}^{m} |\delta_{ij} + \alpha \hat{\delta}_{1i} - \hat{M}|^p \right. \right.$$
$$\left. \left. + \sum_{j=m+1}^{m+p} |M - \beta \delta_{1i} - \hat{\delta}_{ij}|^p \right) \right]^{1/p} \tag{3.24}$$

The two parameters α and β should be chosen in a way that minimizes $\Delta(\delta, \hat{\delta}; \alpha, \beta)$. The resulting value

$$\Delta(\delta, \hat{\delta}) = \min_{\alpha, \beta \leq 1} \Delta(\delta, \hat{\delta}; \alpha, \beta) \tag{3.25}$$

is the desired measure of the difference between the two configurations. In many cases, it is not necessary to minimize the function $\Delta(\delta, \hat{\delta}; \alpha, \beta)$, since the measure of interest is the relative performance. In these cases, a sensible choice like $\alpha = \beta = 1$ will be sufficient.

3.3.2 Does the Difference Make a Difference?

The measures introduced in the previous section will result in a numeric value of each trial, which can be either a measure of quality (the higher the number the better) or of discrepancy (the lower the number the better). During a session of experiments, the experimenter will test a certain number of treatments, each one on a number of subjects. I will assume that all treatments have been tested the same number of times.[6] To fix the ideas, consider an experiment in which there are three treatments (e.g., we are evaluating three different similarity measures), and they are evaluated by letting each system answer 5 user queries (the details of how many users should be employed and how the users should be assigned to every single treatment are part of the experimental protocol, which I will introduce in the following sections). Each of the 15 trials gives a measure of quality. The results of this hypothetical experiment are given in Table 3.1. The data relative to each treatment are samples from a certain, unknown, probability distribution, which, if known, would give a good deal of information about the performance of the treatment (that is, in the specific example, about the performance of the similarity measure that is being evaluated). In particular, it would be interesting to know for, say, treatment T_1, what are the most reliable estimates of the average score that a user will obtain, and of the variance of that score.

Some definitions. During an experiment, one can be interested in evaluating a single system, comparing the performance of a number of systems, comparing the performances of a system with a manual version of a certain operation, or comparing the performance of different variants of the same system. Before starting the experiment, it is necessary to set once and for all the number of things that are being compared, whether they are different systems, variants of a system, or manual operations. Each one of the fixed entities that is being evaluated is called a *treatment*.

Table 3.1. Summarization of the results of a hypothetical experiment for the evaluation of three database systems

User	Treatment T_1	T_2	T_3
u_1	10	0.2	10.96
u_2	10.3	0.5	11.1
u_3	9.5	51.7	10.85
u_4	9.7	1	11.04
u_5	10.5	1.6	11.05

[6] In the case in which the number of trials is different for the different treatments, the statistical techniques are more complicated but conceptually similar. A good introduction to these techniques is in Mandal (1964).

The *population* is the class about which certain conclusions have to be made. In the case of image databases, the population is the set of all possible users of the database. The decision as to which population the results should be referred to is not always easy, and should be undertaken with care, as I will show in the following. For instance, in the case of a highly technical image database system for paintings whose interface uses concepts and terminology typical of art theory, one can expect very different results depending on whether the population comprises art critics or the general public.

In most cases, it is impossible to measure the performance of the system based on the whole population. In these cases, the experimenter will draw a *sample* from the population, and do the experiments based on the sample only. The choice of a good sample is an experiment design question but, for the time being, I will just assume that the population is given, and that a suitable sample of *n subjects* is made available. A measurement carried out using one of the subjects and one of the treatments is a *trial*.

In Table 3.1, for instance, there are three treatments and 15 (3×5) trials have been performed. The number of subjects depends on the experimental protocol. If the same subjects were used for the three treatments, then 5 subjects would be necessary, each of which would participate in three trials. If different trials use different subjects, then there would be a total of 15 subjects, each of which would participate in only one trial. By convention, the number of subjects that participate in the experiment for a single treatment is called the *sample size*. In both cases, then, the sample size would be 5 but in the first case one would only draw a sample from the population and use it three times, while in the second case one would draw three samples. In the case of multiple samples, it is important that the samples be *independent*, that is, the selection of a sample should have no influence whatsoever on the selection of the other samples.

The same system will yield different results with different members of the population. Because individual differences, in addition to being practically impossible to track, are quite meaningless, the best way to characterize the behavior of the system in a given population is statistical. If a measure m is used for the characterization of the system, and $m(s, x)$ is the result that one obtains when using the system s with the individual x, then the statistical characterization of the system is given by the probability distribution

$$F_s(v) = \mathbb{P}\{m(s, x) \le v\} \tag{3.26}$$

where \mathbb{P} is a unitary measure defined on a σ-algebra of the subsets of individuals in the population. Two observations should be made about definition:

1. One should not confuse the description of the system in terms of the population with the description of the system in terms of samples, which I will consider shortly. If one collects data about the whole population, and assumes that the response of a certain individual to the system is always the same (see the next point), then one obtains the actual probability that a trial with the system will yield a measure less than v. On the other hand, when

doing actual experiments (with the sample), one obtains only a statistical estimate of this probability whose quality must be evaluated.

2. As mentioned in the previous point, true probabilities could be obtained in the hypothetical situation in which the response of a user to a system is always the same. This is very seldom the case, thus creating a new source of variability to account for. Because of this, Eq. (3.26) is not an actual probability distribution, because the response distribution of any single subject could be characterized only in the limit of an infinite number of trials involving that subject. This variability, however, is usually much less than the intersubject variability that is estimated using the statistical sample and, in most circumstances, it is reasonable to assume that Eq. (3.26) is the true probability distribution of the measurement.

Often, in lieu of the probability distribution, one uses the probability density function

$$f_s(v) = \frac{d}{dw}F(w)\bigg|_v \tag{3.27}$$

In general, it is not necessary to know the whole probability distribution of the measure m in order to characterize a system. Synthesized descriptions of the probability distribution are often much more informative and efficient to compute. The descriptors most often used are the following.

Mean. The mean of the probability density function f is defined as

$$\mu = \int_{-\infty}^{\infty} uf(u)\,du \tag{3.28}$$

Median. The median of the probability density function f is that number $\tilde{\mu}$ such that

$$\int_{-\infty}^{\tilde{\mu}} f(u)\,du = \frac{1}{2} \tag{3.29}$$

That is, the median is that value $\tilde{\mu}$ such that half of the area of f is on the right of $\tilde{\mu}$ and half is on the left. If f is symmetric, that is, if there is a such that $f(a+x) = f(a-x)$ for all x, then the mean and the median coincide, and $\tilde{\mu} = \mu = a$.

Variance. The variance (and the associated standard deviation) is a measure of the dispersion of the distribution around its mean. The variance is defined as

$$\sigma^2 = \int_{-\infty}^{\infty} (u - \mu)^2 f(u)\,du \tag{3.30}$$

If $\sigma^2 = 0$, the distribution is concentrated on its mean, that is, the only value that is possible to obtain in experiments if $m(s,x) = \mu$. As the variance increases,

values more and more different from the mean become more and more probable. The positive square root of the variance σ is the *standard deviation*.

Higher-order moments of the type

$$\left[\int_{-\infty}^{\infty} (u - \mu)^p f(u)\, du\right]^{1/p} \tag{3.31}$$

are used much less frequently for the characterization of population distribution.

The true mean and variance of a distribution are very seldom known. One has to rely on measuring the *sampled mean* and the *sampled variance* that can be obtained from the sample. For a sample of n subjects x_i, giving rise to n measurements $m(s, x_i)$, the sample mean is

$$\bar{m} = \frac{1}{n} \sum_{i=1}^{n} m(s, x_i) \tag{3.32}$$

The sample mean is in most cases the optimal estimate of the true mean μ given the sample. The sample variance is

$$s^2 = \frac{1}{n-1} \sum_{i=1}^{n} (m(s, x_i) - \bar{m})^2 \tag{3.33}$$

The use of the factor $n - 1$, rather than n, at the denominator is necessary to make s^2 an unbiased estimate of σ^2. This means that, if one took all possible samples of size n from the population, computed the sampled variance for all the samples, and averaged the results, one would obtain the true variance σ^2. In the case of a normal population, the sample variance s^2 is the optimal estimate of the variance σ^2. (As an estimate of σ, s is slightly biased [Mandel, 1964].) The sample variance to also be computed with the alternate formula:

$$s^2 = \frac{1}{n(n-1)} \left[n \sum_{i=1}^{n} x_i^2 - \left(\sum_{i=1}^{n} x_i \right)^2 \right] \tag{3.34}$$

which is often more practical because using this formula allows both the sample mean and the sample variance to be computed with a single pass on the data.

Experimental variables. Experiments are made in order to assess the influence of certain variables on other variables that can be measured. If there were no external influences, then every experiment would be perfectly replicable, that is, every time it is repeated, it would give exactly the same result. Alas, this is usually not the case. In experiments involving human subjects, factors like age, fatigue, education, attitude, and so on influence the outcome of the experiment. Because of these factors, measurements are never exactly replicable, and it is necessary to replicate the experiment many times in order to reach statistically valid conclusions.

These uncontrollable factors, the factors that can be controlled, and the quantities that are measured as part of the experiment are expressed as *experimental variables*, divided into the following classes:

Controlled variables. The controlled variables are controllable by the experimenter. In some cases, these variables coincide with the quantities whose influence one wants to assess, but not necessarily so. Consider the evaluation of a number of feature extractors for certain applications of image databases. The feature extractor used and the application selected are controlled variables although, say, for this particular experiment one might only be interested in the evaluation of the feature extractor. The controlled variables whose influence the experiment must ascertain are called *factors*. In some cases (like in the example of the different feature extractors), a factor assumes a discrete set of values, and the experiment may test all possible values. In other cases the factor of interest can be a continuous variable, and it will be tested at several *levels*. Each combination of the factors used for testing is a *treatment*.

Observed variables. The observed variables are quantities that depend on the factors and that can be measured. The measurement of the observed variables is assumed to be a deterministic process, that is, if in two experiments the observed variables have the same value, the same value will be measured twice. Typical measured variables are the response time for a certain operation, the score on questionnaires, and so on.

Background variables. Aside from the factors under investigation, there are a number of conditions that can affect the outcome of the experiments. Some of them can be taken explicitly into account in the design, thereby becoming controlled variables. Others are uncontrollable, and their existence can even be unknown to the experimenter. In some cases, the effect of the background variables can be made manifest by a *control experiment*, in which the factors whose effects are being measured are not present, but all the other background variables are present. In most cases, the effect of the background variables can be countered by repeating the experiment, and scheduling it so that this effect will be as random and unsystematic as possible. The statistical technique of the *analysis of variance* can be used to estimate the relative effects of the factors and the random variables on the observed variables.

Test of statistical hypotheses. Very often, the evaluation problem can be cast in the form of testing of an initial hypothesis, called the *null hypothesis* about the population. Consider, for instance, an experiment in which two different systems S_1 and S_2 are being tested, using a sample from a population P, and using a given performance measure m. The most immediate question that can be asked about the experiment is whether there is a difference at all between the two systems. In terms of the performance measure used, one is interested in determining whether

the two population means μ_1 and μ_2 are the same (i.e., there is no difference between the two systems) or not (i.e., there is a measurable difference between the two systems). The *null hypothesis* is that in which there is *no* difference between the two systems,[7] which is written:

$$H_0 : \mu_1 = \mu_2 \qquad (3.35)$$

The *alternative hypothesis* H_1 is that the two means are different. Note that, in the majority of experiments, one is interested in detecting differences between the systems, that is, in showing that the null hypothesis is false and the alternative hypothesis is true.

As I mentioned earlier, there is in general no access to the entire population. This means that the validity of the null hypothesis must be verified based on measurements on the sample only. As the available information on the means is incomplete, one must accept the possibility of making mistakes, that is, the null hypothesis can be rejected only in a statistical sense. There are two possible ways in which the wrong conclusion can be reached. If H_0 is rejected when it is true, one commits a *type I* error, while if H_0 is accepted when it is false one commits a *type II* error. Thus, a type I error corresponds to concluding that the two systems S_1 and S_2 are different, while in reality they are the same, and the observed difference is only a byproduct of random variability inside the sample. A type II error corresponds to concluding that there is no difference between the two systems, while in reality there is a difference, but the difference is hidden by random variability within the sample. Traditionally, when doing experiments, the probability α of making a type I error is fixed a priori. This value is also called the *level of significance*. Once the value α is set, the experiment is performed and, if the null hypothesis can be rejected with a probability less than α of committing a type I error, the experiment is concluded to have revealed a difference. That is, if given the experimental data, the probability that the null hypothesis is true is less than α, the null hypothesis is rejected. On the other hand, if the probability that the null hypothesis is true is greater than α, the experiment didn't provide enough evidence to reach a decision. Typically, in the social sciences, researchers use $\alpha = 0.05$ or $\alpha = 0.01$, which corresponds to rejecting the null hypothesis if the probability of making a type I error is less than 5% or 1%, respectively. These values are expressed by saying that the results are significant at 5% or 1%, respectively. Two things should be noticed:

1. It is methodologically very important that the value α is set a priori, that is, *before* the experiment starts. As I will note in the following, statistical analysis can be used to derive the value of α from the experimental results.

[7] This use of the null hypothesis can be at first sight a bit confusing. In general one is interested in determining whether there *is* a difference between the two systems. It turns out, however, that it is simpler to do this by rejecting the hypothesis that there is no difference than by positive confirmation of the hypothesis that a difference exists.

There is a strong temptation to perform an experiment, determine the value α, and then conclude that "α is low enough" to reject the null hypothesis. This is incorrect experimental methodology.

2. When the results state that the probability of committing a type I error is greater than α, all that can be concluded is that, given the level of significance, the null hypothesis cannot be rejected. *This does not imply that the null hypothesis can be accepted.* Doing so would give no guarantee as to the probability of committing a type II error.

Degrees of freedom. A final important concept in statistical analysis is that of *degrees of freedoms.* In physics, the number of degrees of freedoms of a system is the number of coordinates that must *independently* be set in order to completely determine a configuration of the system. For instance, a point in space has three degrees of freedom, but if we are constrained to move on a plane, then it has two degrees of freedom, the third coordinate being determined by the constraint.

Similarly, in statistics, the sample mean equation (3.32) for a sample of size n is said to have n degrees of freedom, since n values can be independently set to obtain the value \bar{x}. On the other hand, once the value \bar{x} is given, the sample variance equation (3.34) has only $n - 1$ degrees of freedom, as only $n - 1$ values can be choosen freely, the nth being determined by the requirement that the mean be \bar{x}.

Tests for means and variances. Statistical hypothesis verification can be applied to the problem of determining whether the sample mean and variance obtained from an experiment are an accurate prediction of the actual population mean and variance.

The *t*-test for the mean. Given the sampled mean \bar{m}, one would like to conclude, on the basis of the measurement, that the true population mean is between the value $\mu - \delta$ and $\mu + \delta$ for a suitable δ. As there are no data about the whole populaton, this can only be determined with a certain level of significance α, set a priori. Once α has been selected, one computes the value t defined as

$$t = \frac{\sqrt{n}}{s}\delta \tag{3.36}$$

where s^2 is the sample variance computed as in Eq. (3.34). Consider now the null hypothesis $|\bar{x} - \mu| > \delta$. If, given the significance α, this hypothesis can be rejected, it can be concluded that the true mean is in the interval $[\bar{x} - \delta, \bar{x} + \delta]$.

Intuitively, if t is big, it means either that there are many samples (\sqrt{n} is large), or the variance (s) is very small, or the interval in which the mean is allowed to vary (δ) is large. All these cases favor the rejection of the null hypothesis, since they tend to place the real mean in the interval $[\bar{x} - \delta, \bar{x} + \delta]$, either because

the sampled mean is very significant (\sqrt{n} large and/or s small) or because the acceptable interval is large (δ large). In other words, given the significance level α, if the measured value t is greater than a certain threshold (depending on α), it can be assumed, with significance α, that the null hypothesis is false, and that the real mean is in the interval $[\bar{x} - \delta, \bar{x} + \delta]$.

In order to determine such a threshold, it is necessary to know the probability distribution of the variable t. Another useful characteristic of the variable t defined in Eq. (3.36) is that it is *distribution-free*, in the sense that it does not depend on the mean and variance of the population distribution (μ, σ^2), but only on the degrees of freedom of the sample.

The probability density function of t for a sample with f degrees of freedom (where $f = n - 1$) is

$$p_{t,n}(u) = \frac{\Gamma(f-1)/2}{\Gamma(f-2)/2\sqrt{\pi n}} \left(1 + \frac{u^2}{2}\right)^{-(f+1)/2} \qquad (3.37)$$

where Γ is Euler's function with the characteristics that, if n is an integer number, then $\Gamma(n) = (n-1)!$.

For a given value of t, computed according to Eq. (3.36, the probability of committing a type I error (rejecting the null hypothesis when it is valid) is given

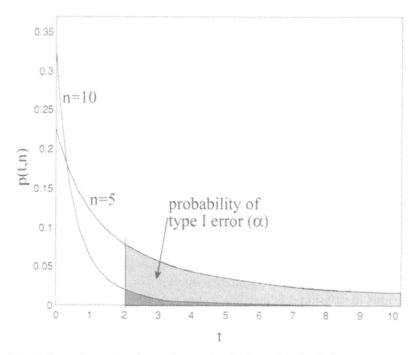

Figure 3.2. If the value t has been determined, then the shaded area measures the probability of committing a type I error.

by the shaded area of Fig. 3.2. The null hypothesis is rejected if the area is less than α or, given the symmetry of the figure, if the left portion of the area is less than $\alpha/2$. For a given number f of degrees of freedom, the area included in the portion $u > t$ of the curve of Fig. 3.2 is given by the function

$$A_f(t) = \frac{\Gamma(f-1)/2}{\Gamma(f-2)/2\sqrt{\pi n}} \int_t^\infty \left(1 + \frac{u^2}{2}\right)^{-(n+1)/2} du \qquad (3.38)$$

Therefore, for a given number of degrees of freedom, and a significance level α, the null hypothesis should be rejected—that is, it should be concluded that the true mean is in the interval $[\bar{x} - \delta, \bar{x} + \delta]$—if

$$A_{n-1}(t) < \frac{\alpha}{2} \qquad (3.39)$$

This equation is valid in the common case of the *two tails test*. In the case in which there is some a priori information that guarantees that the population mean is being either underestimated or overestimated, it is only necessary to check one of the two tails of Fig. 3.2, as the other is excluded by our a priori information. In this case, the value $\alpha/2$ in Eq. (3.39) should be replaced with α.

 This method is the simplest one if the experimenter has access to an algorithm to compute the function A_f. Traditionally, the test is decided using a table of values of t. For a given α and f degrees of freedom, define $t_{\alpha,f}$ as the value of t such that

$$\frac{\Gamma(f-1)/2}{\Gamma(f-2)/2\sqrt{\pi n}} \int_{t_{\alpha,f}}^\infty \left(1 + \frac{u^2}{2}\right)^{-(n+1)/2} du = \alpha \qquad (3.40)$$

(see Fig. 3.2). Given its independence on the distribution of the experiment, the values of t resulting from Eq. (3.40) can be tabulated for various values of f and α. Table 3.2 shows some of the values of t. Using this table, for a sample of size n and a measured value t, the null hypothesis is rejected if $|t| > t_{\alpha/2,n-1}$.

 Checking whether the actual population mean differs from the sample mean by a specific value is not particularly useful, as there is no a priori reason to choose a specific value of δ over another. The main application of the t test is to determine the *confidence interval* of a computation of the mean. Given the sample mean \bar{x} and a significance level α, it would be interesting to know the value δ such that the population average μ belongs to $C_\alpha = [\bar{x} - \delta, \bar{x} + \delta]$ with probability $1 - \alpha$. Here, C_α is called the *confidence interval* for a significance level α. From the previous discussion it is possible to see that it is

$$\delta = t_{\alpha/2,n-1} \frac{s}{\sqrt{n}} \qquad (3.41)$$

 Consider, for instance, the first column of Table 3.1. In this case, it is $n = 5$, $\bar{x} = 10$, and $s = 0.579$. Suppose one wants to determine the confidence interval

Table 3.2. Upper percentage points of the t distribution[a]

	0.2	0.1	0.05	0.025	0.01	0.005
2	1.061	1.886	2.920	4.303	6.965	9.925
3	0.978	1.638	2.353	3.182	4.541	5.841
4	0.941	1.533	2.132	2.776	3.747	4.604
5	0.920	1.476	2.015	2.571	3.365	4.032
6	0.906	1.440	1.943	2.447	3.143	3.707
7	0.896	1.415	1.895	2.365	2.998	3.499
8	0.889	1.397	1.860	2.306	2.896	3.355
9	0.883	1.383	1.833	2.262	2.821	3.250
10	0.879	1.372	1.812	2.228	2.764	3.169
12	0.873	1.356	1.782	2.179	2.681	3.055
14	0.868	1.345	1.761	2.145	2.624	2.977
16	0.865	1.337	1.746	2.120	2.583	2.921
18	0.862	1.330	1.734	2.101	2.552	2.878
20	0.860	1.325	1.725	2.086	2.528	2.845
22	0.858	1.321	1.717	2.074	2.508	2.819
24	0.857	1.318	1.711	2.064	2.492	2.797
26	0.856	1.315	1.706	2.056	2.479	2.779
28	0.855	1.313	1.701	2.048	2.467	2.763
30	0.854	1.310	1.697	2.042	2.457	2.750
40	0.851	1.303	1.684	2.021	2.423	2.704
50	0.849	1.299	1.676	2.009	2.403	2.678
60	0.848	1.296	1.671	2.000	2.390	2.660
70	0.847	1.294	1.667	1.994	2.381	2.648
80	0.846	1.292	1.664	1.990	2.374	2.639
90	0.846	1.291	1.662	1.987	2.368	2.632
100	0.845	1.290	1.660	1.984	2.364	2.626

[a] For two-sided tests, the significance levels are twice those of the column headings. Interpolation between the values reported should be done using the reciprocals of the numbers rather than the numbers themselves.

for $\alpha = 0.05$. Then it is $t_{0.05,4} = 2.132$, so

$$\delta = 2.132\frac{0.579}{\sqrt{5}} = 0.55 \tag{3.42}$$

With probability 0.95 (95%), the population mean is $> 10 - 0.55 = 9.45$ and $< 10 + 0.55 = 10.55$.

Test for $\mu_1 - \mu_2$. In many experiments, the experimenter wants to evaluate two different systems by comparing certain performance measures obtained by one system with those obtained by the other. For a given measure of the quality of a system, one performs a number n_1 of experiments with the first system, obtaining an average measure μ_1, and a number n_2 of experiments with the second system, obtaining an average measure μ_2. Then one is interested in testing statistical hypotheses about $\mu_1 - \mu_2$ and, in particular, in evaluating the statistical hypothesis $\mu_1 - \mu_2 = d$ based on the sample averages \bar{x}_1 and \bar{x}_2. I will assume here that the population distribution of the results is Gaussian.

There are two ways to evaluate the two systems. One way is to select a random sample of subjects from the population, organize the measurements so that each

subject tests both systems, and pair up the measurements relative to the same subject. In other words, for subject j, the experiment determines the values x_{1j} and x_{2j} relative to the two systems, and the experimenter will use the value $x_{1j} - x_{2j}$ as a single measurement for the determination of $\bar{x}_1 - \bar{x}_2$. The second method is to draw from the population two random samples of n_1 and n_2 subjects (usually $n_1 = n_2 = n$) and test each system using a different sample.

In the first case, the hypothesis can be tested simply by applying the t-test in the previous paragraph to $\bar{x} = \bar{x}_1 - \bar{x}_2$. In the second case one computes

$$t = \frac{\bar{x}_1 - \bar{x}_2 - d}{s \, (1/n_1 + 1/n_2)^{1/2}} \qquad (3.43)$$

where

$$s^2 = \frac{1}{n_1 + n_2 - 2} \left[\sum_{j=1}^{n_1} (x_{1j} - \bar{x}_1)^2 + \sum_{j=1}^{n_1} (x_{2j} - \bar{x}_2)^2 \right] \qquad (3.44)$$

Given the significance level α, the null hypothesis is accepted if $A_{n_1+n_2-2}(t) < \alpha/2$. Alternatively, using the values in Table 3.2, the value t given by Eq. (3.43) can be compared with the value $t_{\alpha/2,n_1+n_2-2}$ with the null hypothesis rejected if $|t| > t_{\alpha/2,n_1+n_2-2}$.

As in the previous case, the one tail test uses the condition $A_{n_1+n_2-2}(t) < \alpha$, or $|t| > t_{\alpha,n_1+n_2-2}$. The confidence interval for $\mu_1 - \mu_2$ with significance α is $[\bar{x}_1 - \bar{x}_2 - \delta, \bar{x}_1 - \bar{x}_2 + \delta]$, with

$$\delta = t_{\alpha/2,n_1+n_2-2} s \left(\frac{1}{n_1} + \frac{1}{n_2} \right)^{1/2} \qquad (3.45)$$

Consider, as an example, the confidence interval of the differences between the second and the first column of Table 3.1 and between the third and the first column of the same table using a paired experiment. The differences can be written as in Table 3.3.

The average difference between T_2 and T_1, as well as the average difference between T_3 and T_1 is equal to 1. What is the confidence interval of the difference with significance $\alpha = 0.05$? The sample standard deviations for the two columns

Table 3.3.

$T_2 - T_1$	$T_3 - T_1$
−9.8	0.96
−9.8	0.8
42.2	1.35
−8.7	1.34
−8.9	0.55

μ	1	1

are $\sigma_1 = 23.037$ and $\sigma_2 = 0.347$ and Eq. (3.41) yields $\delta_1 = 10.302$ and $\delta_2 = 0.155$, that is,

$$-9.302 \leq \mu_2 - \mu_1 \leq 11.302$$
$$0.844 \leq \mu_3 - \mu_1 \leq 1.155 \tag{3.46}$$

Note that, within the limits of the accepted significance, the difference $\mu_3 - \mu_1$ is always positive, so that it is possible to conclude that the values of the third column are greater than those of the first column. A similar conclusion cannot be reached for the difference $\mu_2 - \mu_1$.

χ^2 test for standard deviation. The standard deviation σ (or its square, the variance σ^2) is a measure of the dispersion of the data around the mean. If the standard deviation is small, the mean is a faithful indication of the measurements derived from the population, while if the standard deviation is high, the measurements obtained from the population are dispersed over a wide area around the mean.

The following test for the determination of the error in the estimation of the variance assumes that the population distribution is normal. The sampled variance s^2 [Eq. (3.34)] is an optimal estimator of the population variance σ^2; its average over the population of all possible samples of size n is the population variance σ^2, but its distribution is not normal. The quantity

$$\chi^2 = (n-1)\frac{s^2}{\sigma^2} \tag{3.47}$$

is distribution free (it does not depend on the population variance σ^2). Its probability density function depends on the number of degrees of freedom $n - 1$, and it is given by

$$p_{\chi^2}(u^2; f) = \frac{1}{\Gamma(f-2)/2^{f/2}}(u^2)^{(f-2)/2} \exp\left(-\frac{u^2}{2}\right) \tag{3.48}$$

(see Fig. 3.3). Note that in the case of the estimation of variance, the relevant statistics do not involve differences, as it did in the case of the means, but ratios. In this case, a two-tail evaluation will involve a null hypothesis

$$\frac{s^2}{\sigma^2} > \rho \quad \text{or} \quad \frac{s^2}{\sigma^2} < \frac{1}{\rho} \tag{3.49}$$

with $\rho > 1$.

Consider first the statistical hypothesis $s^2/\sigma^2 > \rho$. If this is true, then, by Eq. (3.47), it must be $\chi^2 > (n-1)\rho$. The probability of this happening, given the probability density of χ^2, is $P_{\chi^2}((n-1)\rho; n-1)$, with

$$P_{\chi^2}(t; f) = \int_t^\infty p_{\chi^2}(u; f)\,du \tag{3.50}$$

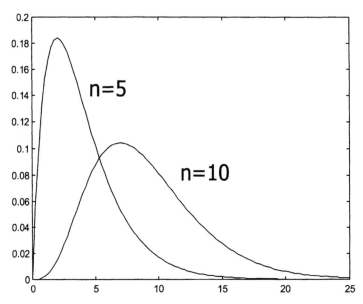

Figure 3.3. The χ^2 distribution. The values marked are those relevant for the determination of the null hypothesis in the following, that is, the values χ_α^2 such that the area under the curve for $\chi > \chi_\alpha$ is $>\alpha$, and the value $\chi_{1-\alpha}^2$ such that the area is $>1-\alpha$.

If this value is less than the significance, the null hypothesis is rejected. Just like in the case of the mean, given the significance α, one uses the value α for the one-tail test, and the significance $\alpha/2$ for the two-tail test. Thus, the null hypothesis $s^2/\sigma^2 > \rho$ is rejected if $P_{\chi^2}((n-1)\rho; n-1) < \alpha/2$.

Consider now the symmetric hypothesis $s^2/\sigma^2 < 1/\rho$. If this is true, then it is $\chi^2 < (n-1)/\rho$, and the probability of this happening is:

$$Q = \int_0^{(n-1)/\rho} p_{\chi^2}(u; f)\, du \qquad (3.51)$$

and, given that the total area under the function p_{χ^2} is unitary, it is

$$\int_0^{(n-1)/\rho} p_{\chi^2}(u; f)\, du = 1 - \int_{(n-1)/\rho}^\infty p_{\chi^2}(u; f)\, du = 1 - P_{\chi^2}\left(\frac{n-1}{\rho}; n-1\right) \qquad (3.52)$$

The null hypothesis is rejected if $Q < \alpha/2$, that is, if $P_{\chi^2}((n-1)/\rho; n-1) > 1-\alpha/2$. Therefore, if both the conditions

$$P_{\chi^2}((n-1)\rho; n-1) < \frac{\alpha}{2} \qquad (3.53)$$

$$P_{\chi^2}\left(\frac{n-1}{\rho}; n-1\right) > 1 - \frac{\alpha}{2} \qquad (3.54)$$

are satisfied, the null hypothesis is rejected, and one can conclude that, to the

Table 3.4.

	0.995	0.99	0.975	0.95	0.9	0.1	0.05	0.025	0.01	0.005
2	0.0100	0.0201	0.0506	0.1026	0.2107	4.6052	5.9915	7.3778	9.2104	10.5965
3	0.0717	0.1148	0.2158	0.3518	0.5844	6.2514	7.8147	9.3484	11.3449	12.8381
4	0.2070	0.2971	0.4844	0.7107	1.0636	7.7794	9.4877	11.1433	13.2767	14.8602
5	0.4118	0.5543	0.8312	1.1455	1.6103	9.2363	11.0705	12.8325	15.0863	16.7496
6	0.6757	0.8721	1.2373	1.6354	2.2041	10.6446	12.5916	14.4494	16.8119	18.5475
7	0.9893	1.2390	1.6899	2.1673	2.8331	12.0170	14.0671	16.0128	18.4753	20.2777
8	1.3444	1.6465	2.1797	2.7326	3.4895	13.3616	15.5073	17.5345	20.0902	21.9549
9	1.7349	2.0879	2.7004	3.3251	4.1682	14.6837	16.9190	19.0228	21.6660	23.5893
10	2.1558	2.5582	3.2470	3.9403	4.8652	15.9872	18.3070	20.4832	23.2093	25.1881
12	3.0738	3.5706	4.4038	5.2260	6.3038	18.5493	21.0261	23.3367	26.2170	28.2997
14	4.0747	4.6604	5.6287	6.5706	7.7895	21.0641	23.6848	26.1189	29.1412	31.3194
16	5.1422	5.8122	6.9077	7.9616	9.3122	23.5418	26.2962	28.8453	31.9999	34.2671
18	6.2648	7.0149	8.2307	9.3904	10.8649	25.9894	28.8693	31.5264	34.8052	37.1564
20	7.4338	8.2604	9.5908	10.8508	12.4426	28.4120	31.4104	34.1696	37.5663	39.9969
22	8.6427	9.5425	10.9823	12.3380	14.0415	30.8133	33.9245	36.7807	40.2894	42.7957
24	9.8862	10.8563	12.4011	13.8484	15.6587	33.1962	36.4150	39.3641	42.9798	45.5584
26	11.1602	12.1982	13.8439	15.3792	17.2919	35.5632	38.8851	41.9231	45.6416	48.2898
28	12.4613	13.5647	15.3079	16.9279	18.9392	37.9159	41.3372	44.4608	48.2782	50.9936
30	13.7867	14.9535	16.7908	18.4927	20.5992	40.2560	43.7730	46.9792	50.8922	53.6719
40	20.7066	22.1642	24.4331	26.5093	29.0505	51.8050	55.7585	59.3417	63.6908	66.7660
50	27.9908	29.7067	32.3574	34.7642	37.6886	63.1671	67.5048	71.4202	76.1538	79.4898
60	35.5344	37.4848	40.4817	43.1880	46.4589	74.3970	79.0820	83.2977	88.3794	91.9518
70	43.2753	45.4417	48.7575	51.7393	55.3289	85.5270	90.5313	95.0231	100.4251	104.2148
80	51.1719	53.5400	57.1532	60.3915	64.2778	96.5782	101.8795	106.6285	112.3288	116.3209
90	59.1963	61.7540	65.6466	69.1260	73.2911	107.5650	113.1452	118.1359	124.1162	128.2987
100	67.3275	70.0650	74.2219	77.9294	82.3581	118.4980	124.3421	129.5613	135.8069	140.1697

significance level α, it is

$$\frac{1}{\rho} \leq \frac{s^2}{\sigma^2} \leq \rho \tag{3.55}$$

The values of χ^2 are tabulated in Table 3.4 for several values of the significance α and the degrees of freedom $f = n - 1$. When using the table, the null hypothesis is rejected if

$$(n-1)\rho > \chi^2_{\alpha/2, n-1} \quad \text{and} \quad \frac{n-1}{\rho} < \chi^2_{1-\alpha/2, n-1} \tag{3.56}$$

The same method can be (and usually is) applied to find the confidence interval for the population variance, given the significance level α, which is given by

$$\frac{\chi^2_{1-\alpha/2, n-1}}{n-1} \leq \frac{s^2}{\sigma^2} \leq \frac{\chi^2_{\alpha/2, n-1}}{n-1} \tag{3.57}$$

that is

$$\frac{(n-1)s^2}{\chi^2_{\alpha/2, n-1}} \leq \sigma^2 \leq \frac{(n-1)s^2}{\chi^2_{1-\alpha/2, n-1}} \tag{3.58}$$

As an example, consider the first column of Table 3.1 with a significance level

$\alpha = 0.05$, and $n - 1 = 4$. Table 3.4 gives

$$\chi^2_{0.975,4} = 0.4844 \quad \chi^2_{0.025,4} = 11.14 \tag{3.59}$$

The sample variance is $s^2 = 0.17$. Thus, from Eq. (3.58) it follows that $1.4 \geq \sigma^2 \geq 0.06$.

Analysis of variance. When performing an experiment, one is interested in determining the influence of a certain factor on a measurable variable. For instance, one may be interested in determining the influence of the feature set on the performance of users engaged in a given task. In addition to the factor under control, a number of different factors may have an influence on the outcome of the experiment. In the feature set measurement example, for instance, the ability of the subject, his/her fatigue, and a number of other factors can influence the outcome. These factors form the background variables of the experiment, and appear in the evaluation as experimental error. In order for an experiment to be declared successful, it is not sufficient to reveal a difference in the observed variables between different treatments; it is necessary to ensure that the difference is due to the factors under control, and not a byproduct of the experimental errors. The technique of the *analysis of variance* allows this determination.

The problem can be cast as *hypothesis verification*. If μ_i is the average score obtained with the ith treatment, one tests a *null hypothesis* (H_0), which states that all the averages μ_i are the same (i.e., that the differences are due only to random variations). The *alternate hypothesis* (H_1) is that the means are not equal, that is, that the experiment actually revealed a difference between treatments.

The technique works by breaking down the variance in the experimental results in a portion caused by the several factors under control, and a portion caused by the experimental errors. In this section I will only consider single factor experiments, in which only one quantity changes between treatments. The application of the analysis of variance to multifactor experiments (including the determination of interactions between factors) can be found, for instance, in Crow et al. (1960). Let r be the number of treatments, and n the number of repetitions of each treatment, so that $m = nr$ is the total number of observations. Further, let x_{it} be the result obtained during the tth replication of the ith treatment. Define the ith *treatment mean* as:

$$\bar{x}_i = \frac{1}{n} \sum_{t=1}^{m} x_{it} \tag{3.60}$$

and the *grand mean* as

$$\bar{x} = \frac{1}{r} \sum_{i=1}^{r} \bar{x}_i = \frac{1}{m} \sum_{t=1}^{n} \sum_{i=1}^{r} x_{it} \tag{3.61}$$

Consider the *squares of deviations* from the grand mean

$$\sum_{t=1}^{n}\sum_{i=1}^{r}(x_{it} - \bar{x})^2 = n\sum_{i=1}^{r}(\bar{x}_i - \bar{x})^2 + \sum_{t=1}^{n}\sum_{i=1}^{r}(x_{it} - \bar{x}_i)^2 \qquad (3.62)$$

If the null hypothesis (all treatment means are the same) is true, then it is possible to obtain three unbiased estimates of the common variance σ_0^2 by dividing the preceding three terms by their degrees of freedom:

$$s_1^2 = \frac{1}{rn - 1}\sum_{t=1}^{n}\sum_{i=1}^{r}(x_{it} - \bar{x})^2 \qquad (3.63)$$

$$s_2^2 = \frac{n}{r - 1}\sum_{i=1}^{r}(\bar{x}_i - \bar{x})^2 \qquad (3.64)$$

$$s_3^2 = \frac{1}{r(n - 1)}\sum_{t=1}^{n}\sum_{i=1}^{r}(x_{it} - \bar{x}_i)^2 \qquad (3.65)$$

In particular, if the null hypothesis is true, the last two quantities will be about the same, and their ratio will be near one. The value s_2^2 is the *between-treatments variances*, which measures the dispersion of the treatment means around the grand mean. A high value of s_2^2 implies that the means of the various treatments are very different from each other. In this sense, a high value of s_2^2 tends to indicate that the experiment did indeed reveal a difference. The value s_3^2 is the *within-treatment variance*. It measures the spread of results between repetitions of the same treatment. If the value s_3^2 is high, the results of a treatment are subject to a great variability. A high value of s_3^2 means that the difference between the treatment means might be due to random variations, and not to actual differences between treatments.

The key value to determine whether the null hypothesis about the equality of the treatment means can be accepted is the so-called *F ratio*:

$$F = \frac{s_2^2}{s_3^2} \qquad (3.66)$$

If $F \leq 1$, the within-treatment variance is greater than the between-treatment variance, and the null hypothesis (that all the means are equal) should be accepted. If $F > 1$, the null hypothesis is accepted or rejected based on the probability of committing a type I error, α. As in the previous paragraph, the value F is distribution-free, and the probability density of F depends only on the values n and r:

$$f_{n,r}(x) = \frac{\Gamma(r + n - 2)/2}{\Gamma(r - 2)/2\Gamma(n - 2)/2}r^{r/2}n^{n/2}x^{(r-2)/2}(n + rx)^{-(n+r)/2} \qquad (3.67)$$

As in the previous examples, given the computed value F, the probability of committing a type I error is given by the area under the upper tail of the F

distribution; therefore, given the significance level α, the null hypothesis will be rejected if

$$P_{n,r}(F) = \int_f^\infty f_{n,r}(x)\,dx < \alpha \qquad (3.68)$$

As in the previous case, the value of α depends on the relative cost of a type I error versus that of a type II error. A low value of α guarantees a low probability of type I errors. In this case, if H_0 is rejected (concluding that the experiment revealed a difference among the treatments), it is very unlikely that this difference was only apparent (due to random variations). On the other hand, this makes one more likely to commit a type II error, that is, to dismiss a perfectly valid difference as a random effect. Most social science experiments use values of $\alpha = 0.05$, or $\alpha = 0.1$.

If the relation Eq. (3.68) cannot be computed directly, the null hypothesis can be verified with the help of tables such as Tables 3.5, 3.6, and 3.7.

Given the selected significance level α, and the degrees of freedom $f_r = r - 1$ and $f_n = n-1$, the table gives the *critical value F_0*. If the computed ratio F is greater

Table 3.5. Table of the critical values for the F ratio for various values of the degrees of freedom on the treatments (columns, $f_r = r - 1$) and on the number of repetitions for each treatment (rows, $f_n = n - 1$) for $\alpha = 0.1$.

$f_n = n - 1$	$\alpha = 0.1$ $f_r = r - 1$										
	1	2	3	4	5	6	8	10	15	20	50
1	39.86	49.50	53.59	55.83	57.24	58.20	59.44	60.19	61.22	61.74	62.69
2	8.526	9.000	9.162	9.243	9.293	9.326	9.367	9.392	9.425	9.441	9.471
3	5.538	5.462	5.391	5.343	5.309	5.285	5.252	5.230	5.200	5.184	5.155
4	4.545	4.325	4.191	4.107	4.051	4.010	3.955	3.920	3.870	3.844	3.795
5	4.060	3.780	3.619	3.520	3.453	3.405	3.339	3.297	3.238	3.207	3.147
6	3.776	3.463	3.289	3.181	3.108	3.055	2.983	2.937	2.871	2.836	2.770
7	3.589	3.257	3.074	2.961	2.883	2.827	2.752	2.703	2.632	2.595	2.523
8	3.458	3.113	2.924	2.806	2.726	2.668	2.589	2.538	2.464	2.425	2.348
9	3.360	3.006	2.813	2.693	2.611	2.551	2.469	2.416	2.340	2.298	2.218
10	3.285	2.924	2.728	2.605	2.522	2.461	2.377	2.323	2.244	2.201	2.117
12	3.177	2.807	2.606	2.480	2.394	2.331	2.245	2.188	2.105	2.060	1.970
14	3.102	2.726	2.522	2.395	2.307	2.243	2.154	2.095	2.010	1.962	1.869
16	3.048	2.668	2.462	2.333	2.244	2.178	2.088	2.028	1.940	1.891	1.793
18	3.007	2.624	2.416	2.286	2.196	2.130	2.038	1.977	1.887	1.837	1.736
20	2.975	2.589	2.380	2.249	2.158	2.091	1.999	1.937	1.845	1.794	1.690
22	2.949	2.561	2.351	2.219	2.128	2.060	1.967	1.904	1.811	1.759	1.652
24	2.927	2.538	2.327	2.195	2.103	2.035	1.941	1.877	1.783	1.730	1.621
26	2.909	2.519	2.307	2.174	2.082	2.014	1.919	1.855	1.760	1.706	1.594
28	2.894	2.503	2.291	2.157	2.064	1.996	1.900	1.836	1.740	1.685	1.572
30	2.881	2.489	2.276	2.142	2.049	1.980	1.884	1.819	1.722	1.667	1.552
40	2.835	2.440	2.226	2.091	1.997	1.927	1.829	1.763	1.662	1.605	1.483
50	2.809	2.412	2.197	2.061	1.966	1.895	1.796	1.729	1.627	1.568	1.441
60	2.791	2.393	2.177	2.041	1.946	1.875	1.775	1.707	1.603	1.543	1.413
80	2.769	2.370	2.154	2.016	1.921	1.849	1.748	1.680	1.574	1.513	1.377
100	2.756	2.356	2.139	2.002	1.906	1.834	1.732	1.663	1.557	1.494	1.355
200	2.731	2.329	2.111	1.973	1.876	1.804	1.701	1.631	1.522	1.458	1.310

Table 3.6. Table of the critical values for the F ratio for various values of the degrees of freedom on the treatments (columns, $f_r = r - 1$) and on the number of repetitions for each treatment (rows, $f_n = n - 1$) for $\alpha = 0.05$.

$f_n = n - 1$	$\alpha = 0.05$ $f_r = r - 1$										
	1	2	3	4	5	6	8	10	15	20	50
1	161.4	199.5	215.7	224.6	230.2	234.0	238.8	241.9	245.9	248.0	251.8
2	18.51	19.00	19.16	19.25	19.30	19.33	19.37	19.40	19.43	19.45	19.48
3	10.13	9.552	9.277	9.117	9.013	8.941	8.845	8.785	8.703	8.660	8.581
4	7.709	6.944	6.591	6.388	6.256	6.163	6.041	5.964	5.858	5.803	5.699
5	6.608	5.786	5.409	5.192	5.050	4.950	4.818	4.735	4.619	4.558	4.444
6	5.987	5.143	4.757	4.534	4.387	4.284	4.147	4.060	3.938	3.874	3.754
7	5.591	4.737	4.347	4.120	3.972	3.866	3.726	3.637	3.511	3.445	3.319
8	5.318	4.459	4.066	3.838	3.688	3.581	3.438	3.347	3.218	3.150	3.020
9	5.117	4.256	3.863	3.633	3.482	3.374	3.230	3.137	3.006	2.936	2.803
10	4.965	4.103	3.708	3.478	3.326	3.217	3.072	2.978	2.845	2.774	2.637
12	4.747	3.885	3.490	3.259	3.106	2.996	2.849	2.753	2.617	2.544	2.401
14	4.600	3.739	3.344	3.112	2.958	2.848	2.699	2.602	2.463	2.388	2.241
16	4.494	3.634	3.239	3.007	2.852	2.741	2.591	2.494	2.352	2.276	2.124
18	4.414	3.555	3.160	2.928	2.773	2.661	2.510	2.412	2.269	2.191	2.035
20	4.351	3.493	3.098	2.866	2.711	2.599	2.447	2.348	2.203	2.124	1.966
22	4.301	3.443	3.049	2.817	2.661	2.549	2.397	2.297	2.151	2.071	1.909
24	4.260	3.403	3.009	2.776	2.621	2.508	2.355	2.255	2.108	2.027	1.863
26	4.225	3.369	2.975	2.743	2.587	2.474	2.321	2.220	2.072	1.990	1.823
28	4.196	3.340	2.947	2.714	2.558	2.445	2.291	2.190	2.041	1.959	1.790
30	4.171	3.316	2.922	2.690	2.534	2.421	2.266	2.165	2.015	1.932	1.761
40	4.085	3.232	2.839	2.606	2.449	2.336	2.180	2.077	1.924	1.839	1.660
50	4.034	3.183	2.790	2.557	2.400	2.286	2.130	2.026	1.871	1.784	1.599
60	4.001	3.150	2.758	2.525	2.368	2.254	2.097	1.993	1.836	1.748	1.559
80	3.960	3.111	2.719	2.486	2.329	2.214	2.056	1.951	1.793	1.703	1.508
100	3.936	3.087	2.696	2.463	2.305	2.191	2.032	1.927	1.768	1.676	1.477
200	3.888	3.041	2.650	2.417	2.259	2.144	1.985	1.878	1.717	1.623	1.415

than F_0, then the null hypothesis is rejected, and the existence of a difference between the treatment is recognized. Otherwise the null hypothesis is accepted.

A summary of the quantities to be computed for the determination of the F ratio is as follows:

$$\mu_i = \frac{1}{n} \sum_{j=1}^{n} w_{ij} \quad \text{Average for treatment } i$$

$$\mu = \frac{1}{m} \sum_{i=1}^{m} \mu_i = \frac{1}{nm} \sum_{i=1}^{m} \sum_{j=1}^{n} w_{ij} \quad \text{Total average}$$

$$\sigma_A^2 = \frac{n}{m-1} \sum_{i=1}^{m} (\mu_i - \mu)^2 \quad \text{Between-treatments variance}$$

$$\sigma_W^2 = \frac{1}{m(n-1)} \sum_{i=1}^{m} \sum_{j=1}^{n} (w_{ij} - \mu_i)^2 \quad \text{Within-treatment variance}$$

$$F = \frac{\sigma_A^2}{\sigma_W^2} \quad \text{The } F \text{ ratio}$$

Table 3.7. Table of the critical values for the F ratio for various values of the degrees of freedom on the treatments (columns, $f_r = r - 1$) and on the number of repetitions for each treatment (rows, $f_n = n - 1$) for $\alpha = 0.01$.

$f_n = n - 1$					$\alpha = 0.01$ $f_r = r - 1$						
	1	2	3	4	5	6	8	10	15	20	50
1	4052	4999	5403	5624	5764	5859	5981	6056	6157	6209	6302
2	98.50	99.00	99.16	99.25	99.30	99.33	99.37	99.40	99.43	99.45	99.48
3	34.12	30.82	29.46	28.71	28.24	27.91	27.49	27.23	26.87	26.69	26.35
4	21.20	18.00	16.69	15.98	15.52	15.21	14.80	14.55	14.20	14.02	13.69
5	16.26	13.27	12.06	11.39	10.97	10.67	10.29	10.05	9.722	9.553	9.238
6	13.74	10.92	9.780	9.148	8.746	8.466	8.102	7.874	7.559	7.396	7.091
7	12.25	9.547	8.451	7.847	7.460	7.191	6.840	6.620	6.314	6.155	5.858
8	11.26	8.649	7.591	7.006	6.632	6.371	6.029	5.814	5.515	5.359	5.065
9	10.56	8.022	6.992	6.422	6.057	5.802	5.467	5.257	4.962	4.808	4.517
10	10.04	7.559	6.552	5.994	5.636	5.386	5.057	4.849	4.558	4.405	4.115
12	9.330	6.927	5.953	5.412	5.064	4.821	4.499	4.296	4.010	3.858	3.569
14	8.862	6.515	5.564	5.035	4.695	4.456	4.140	3.939	3.656	3.505	3.215
16	8.531	6.226	5.292	4.773	4.437	4.202	3.890	3.691	3.409	3.259	2.967
18	8.285	6.013	5.092	4.579	4.248	4.015	3.705	3.508	3.227	3.077	2.784
20	8.096	5.849	4.938	4.431	4.103	3.871	3.564	3.368	3.088	2.938	2.643
22	7.945	5.719	4.817	4.313	3.988	3.758	3.453	3.258	2.978	2.827	2.531
24	7.823	5.614	4.718	4.218	3.895	3.667	3.363	3.168	2.889	2.738	2.440
26	7.721	5.526	4.637	4.140	3.818	3.591	3.288	3.094	2.815	2.664	2.364
28	7.636	5.453	4.568	4.074	3.754	3.528	3.226	3.032	2.753	2.602	2.300
30	7.562	5.390	4.510	4.018	3.699	3.473	3.173	2.979	2.700	2.549	2.245
40	7.314	5.178	4.313	3.828	3.514	3.291	2.993	2.801	2.522	2.369	2.058
50	7.171	5.057	4.199	3.720	3.408	3.186	2.890	2.698	2.419	2.265	1.949
60	7.077	4.977	4.126	3.649	3.339	3.119	2.823	2.632	2.352	2.198	1.877
80	6.963	4.881	4.036	3.563	3.255	3.036	2.742	2.551	2.271	2.115	1.788
100	6.895	4.824	3.984	3.513	3.206	2.988	2.694	2.503	2.223	2.067	1.735
200	6.763	4.713	3.881	3.414	3.110	2.893	2.601	2.411	2.129	1.971	1.629

Consider as an example the data in Table 3.1. Based on these data, is it possible to conclude that there is a difference between the treatments T_1, T_2, and T_3? I will compare treatment T_1 first with treatment T_2 and then with treatment T_3, to see if the experiment reveals some difference. Note that the mean for the first treatment is 10, and the mean for both the second and the third treatment is 11. As I am comparing pairs of treatments it is, for both tests, $r = 2$, that is $f_r = 1$, and $n = 5$, that is, $f_n = 4$. The significance level can be set to $\alpha = 0.05$. From Table 3.6 one obtains, for $f_r = 1$ and $f_n = 4$, a critical F value of 7.709. For the treatments T_1 and T_2, the test gives a value $F = 0.006$. As this value is <1, it can be concluded immediately (even without comparison with the critical value) that the experiment does not reveal any difference between the two treatments. For the treatments T_1 and T_3, the test gives $F = 18.8$, which is greater than the critical value. Therefore one can conclude that, at the given level of significance, the null hypothesis can be rejected, and that the experiment does, indeed, reveal a difference between T_1 and T_3. This difference can be quantified using the technique seen in the foregoing for the analysis of the difference between two means.

3.4 Contextual Evaluation

Contextual evaluation is the evaluation of a whole system in the context of a well-specified human activity (or, alternatively, in a group of human activities). In this sense, contextual evaluation is an analysis of the effects that certain tools have on the selected activity. In the terms of the preceding section, in contextual evaluation the systems under evaluation play the role of a *treatment*, and the people who undertake the activity play the role of experimental subjects.

Experiments of this kind aim at detecting differences in human performace caused by the introduction of a database system, or differences in human performance corresponding to the adoption of one of a number of different systems. It is necessary to assume that there is a way of measuring the performance of a human operator in the execution of a given task. The ways in which this performance can be measured vary from case to case. In some experiments, an objective evaluation can be obtained by measuring the time required to execute a certain activity. This applies to activities whose outcome is fixed or, at least, can be easily categorized as exact or inexact. In most cases, however, the performance of an image search depends on the *quality* of the result and, in order to determine which one of two trials gave the best result, it is necessary to resort to the opinion of an impartial observer who, completely unaware of the measurement procedure, will work in this case as a *measurement instrument*.

The *experimental design* is the plan according to which the test trials are carried out. These include trials with the system under evaluation, trials without any systems, trials with different versions of the same system, and so on. A careful experimental design is necessary in order to ensure that the results obtained by the experiment have both *internal* and *external validity*.

Internal validity is the basic *sine qua non* without which the experiment is not interpretable. An experiment is internally valid if the differences it reveals are indeed due to the different treatments, and not to some other factor not under the control of the experimenter. External validity is concerned with the question of generalizability. All the results are obtained using a (small) sample of subjects extracted from the population that will actually use the system. Are the results obtained with the small sample generalizable to the whole population? External validity, just like inductive inference, is never guaranteed, although experimental design should strive to obtain it in whatever degree possible.

A number of uncontrolled variables can affect internal validity, and experimental designs should provide some safeguard against these influences. The following are the most evident and easily controllable. There may be some more subtle effects that I do not consider here. Their discussion can be found in literature on experimental design, for example, see Campbell and Stanley (1963).

Maturation. The events that occur between two instances of a measurement in addition to the changes in the experimental variable. For instance, if a subject

doing a certain activity is tested without the system and, after a week, is tested again, this time while using the system, there may have been events in that week (taking a new class in his discipline, learning a new technique ...) that caused his response to change independently of the use or nonuse of the system. Similarly, effects completely unrelated to the particular skill of the subject, like growing tired, hungry, bored, ... can have an effect on the measurement.

Testing. The effects of earlier tests on the current measurement, including increased familiarity with a system, better expectations of what will constitute the test, and so on. Note that the familiarity with the system is an uncontrolled variable only if measuring the *synchronic* performance of the system. If the experiment is designed to evaluate the *diachronic* performance (change in performance as a function of the practice with the system), this is a controlled variable.

Instrumentation. The changes in the calibration of the measuring instruments that introduce a bias in the measurement process. In a number of experiments, the "measuring instrument" can be the experimenter himself, who evaluates the reactions and responses of the subjects. Habit and adaptation in the execution of the experiment, as well as the historical changes deriving from knowing the previous history of the experiment can cause such a bias. For example, if a certain activity turns out to be very hard for the subjects of the experiment, the experimenter (who is evaluating it) may become progressively more "lenient" as the accumulating results reveal the difficulty of the activity.

Experimental mortality. The fact that certain subjects can fail to execute all the tests, and abandon the experiment before its end. This mortality is in general nonrandom, but it depends on certain interactions between the subjects and the experiments. For instance, subjects less familiar with the use of automatic tools can find the experiment too demanding, and can decide to leave before its natural end. This constitutes a bias towards certain classes of users, which decreases the representativity of the population sample.

The main factors I will consider as having a possible impact on the external validity of an experiment are the poor randomization of the population of subjects and the interaction effect in testing, in which a pretest procedure, or the mere fact that the subject knows that she is participating in a test can increase of decrease her responsiveness to the experimental variable.

In presenting the experimental designs, I will use a simple graph notation. Nodes in the graph represent activities, and edges represent the logical connections and transmission of results between these activities. Typically, time will flow from left to right, and symbols placed one on top of the other represent activities occurring in parallel. In the nodes, the symbol X represents a test performed on a subject or on a group of subjects using one of the treatments under evaluation; G

represents a reference measure that does not use any of the systems under test; R represent the randomization of a group of subjects; the symbol O represents the observation or measurement of the results of an experiment. Symbols connected by an edge refer to measurements performed on a single subject or on a specific group of subjects.

Consider, for instance, the pre-experimental design that Campbell and Stanley (1963) call the *one-group pretest-post-test design*, which in the notation I am using here is represented as follows:

$$G \longrightarrow O_0 \quad X \longrightarrow O_1 \qquad (3.69)$$

In this experimental design, the performance of a subject is first measured on a given test without the aid of the system under evaluation, then the system under evaluation is used, the same measurement is performed, and the results are compared.

This type of experimental design, although relatively common, is flawed from several points of view. Maturation is essentially uncontrolled in this experiment. Between the observation O_0 and O_1 a number of things can happen that change the responsiveness of the subjects. The likelihood that some undesired effect can intervene increases with the time lapse between the two observations O_0 and O_1. In the other hand, making the observations O_0 and O_1 in the same session can cause other maturation effects due to the subjects getting tired, bored, and so on. Similarly, testing effects can influence the results. These effects are more pronounced if the experimenter is trying to evaluate a number of systems using a scheme like

$$G \longrightarrow O_0 \quad X_1 \longrightarrow O_1 \quad X_2 \longrightarrow O_2 \cdots X_n \longrightarrow O_n \qquad (3.70)$$

Similarly, problems of habituation and fatigue for the experimenter will cause instrumentation effects that will introduce spurious differences between the different observations.

A better experimental design, one which permits a better control over the factor impairing internal validity, is the *post-test-only control group design*, represented by the following scheme:

$$
R \Bigg\langle
\begin{array}{l}
G \longrightarrow O_0 \\
X_1 \longrightarrow O_1 \\
X_2 \longrightarrow O_2 \\
\quad \vdots \\
\quad \vdots \\
X_n \longrightarrow O_n
\end{array}
\qquad (3.71)
$$

In this design, $n + 1$ *equivalent* groups of subjects are created by randomization. One of the groups (the *control group*) is tested without having it use any of the systems under analysis, while the other groups are tested using the systems under

analysis, one system per group. The common case in which only one system is evaluated against the unaided activity is represented as

$$R \begin{array}{c} \nearrow G \longrightarrow O_0 \\ \searrow X_1 \longrightarrow O_1 \end{array}$$

$$(3.72)$$

In this case, testing and maturation effects are neutralized because the experimental and the control groups are tested at the same time. Instrumentation effects can be neutralized by randomizing the observation for the experimental and the control group in such a way that the person collecting observation data is unaware of who belonged to which group. This is particularly important if the data collection is obtained by some nonobjective method, like an interview.

Randomization is the essential component in this design. The arrows that go from the R symbol to all the experiments express the concept that it is a unique operation performed before all the experiments and all the experimental groups are the result of this single randomization operation. Not using randomization would result in a design like the following:

$$\begin{array}{c} G \longrightarrow O_0 \\ X_1 \longrightarrow O_1 \\ X_2 \longrightarrow O_2 \\ \vdots \\ X_n \longrightarrow O_n \end{array}$$

$$(3.73)$$

This is the case, for instance, when the experimenter considers several groups of people that, on their own account, have chosen different systems to perform similar tasks, and measures and compares their performaces. The obvious problem with this group is that there is no guarantee that the observed differences would not have been observed anyway, even in the absence of the system under analysis.

Consider, as an example, the experimental evaluation of commercial database systems for, say, a museum application. Data are collected from museum A, which does not use any database system, and museum B, which uses a given database system. Assume that the analysis of a suitable performance measure reveals that museum B is much more effective than museum A. One might be tempted to conclude that the database system is effective, but, in reality, there are a number of factors that can contribute to the difference. The museum that uses the database system may be more open to innovation and more inventive in its operation so that, even in the absence of any database system, it would have found ways to improve its performace that would have escaped museum A.

Conversely, had it turned out that museum A was more efficient than museum B, one might have argued that museum B had adopted a database system as an attempt to improve a performance that, even during manual operations, was considered insufficient, while museum A had an excellent manual system and did not need to use a database system. Thus the fact that the museum without a database is better than that with a database does not necessarily mean that the adoption of the database is deleterious. In both cases, it is impossible to determine whether an observed difference in performance is a consequence of the adoption of the database system or of a further cause that is at the origin both of the difference in performance and of the different attitude of the two museums towards the adoption of a computerized database.

The very fact that one of the two museums decided to adopt a database system and one did not implies a difference between the two that, alone, may explain the experimental data. Randomization guarantees that the various experimental groups are, indeed, equivalent. In the case in which the effects of randomization were somehow in doubt, a more robust way to proceed is through the following *pretest-post-test control group design*:

$$R \begin{cases} O_{00} & G \longrightarrow O_{01} \\ O_{10} & X_1 \longrightarrow O_{11} \\ O_{20} & X_2 \longrightarrow O_{21} \\ \quad & \vdots \\ O_{n0} & X_n \longrightarrow O_{n1} \end{cases}$$

(3.74)

The pretest observations $O_{00}, \ldots O_{n0}$ guarantee that the performance for all groups is, in the absence of the experimental variables, the same. The main concern for this type of design is the possible presence of maturation effects, as there is a time lapse (which, depending on the experiment, can be considerable) between the first and the second series of observations. Maturation is controlled because whatever effect other than the presence of the system which may have caused a change between, say, O_{10} and O_{11}, would also have caused a change between O_{00} and O_{01}. Note, however, that this experimental design does not compensate for maturation effects specific to one session.

Here, as in all experimental design, the instrumentation effect can be controlled by random assignment of experimenters to the evaluation of the various experimental outcomes, with the additional provision that whoever performs the observation should be ignorant of the particular system to which the observation is referred, or whether the observation is relative to an experimental group or to the control group.

Mortality is also a concern for this experimental design. Specific characteristics of the experimental sessions with the systems could cause a pattern of mortality

different from that of the control group. For instance, if a database system under experimentation requires a user relatively familiar with technological tools, and the application for which the system is tested is not traditionally technological, the least technologically savvy subjects are more likely to drop out of the experimental group than out of the control group.

The advantage of the use of the pretest-post-test design is the possibility of using powerful statistical techniques for the assessment of the experimental results. An obvious possibility is the computation of the pretest-post-test gain for both the experimental and the control group followed by an analysis of variance to guarantee that a difference is present.

3.5 Noncontextual Evaluation

Noncontextual evaluation is the evaluation of portions of a database system without direct reference to any specific activity. This kind of evaluation is not possible for all modules in a database system, but only for those that implement a specific *cognitive* function which replicates a human cognitive ability or can be evaluated by comparison with a human cognitive ability. The archetypal example of such a function is the similarity measure. Similarity measures are used in a variety of contexts. In first generation systems, like QBIC, a similarity measure is used to return a list of results. In more complex systems it would be hard to evaluate the performance of the similarity measures in isolation, as it can only be seen in the context of a complex system composed of the feature extractor, the interface that presents the results to the user, and so on. There is, however, a simple cognitive function that relies on similarity measures and is relatively insensitive to the systems with which the similarity module interact (with the exception of the feature extraction system)—the *ordering* function. When asking a person to order images with respect to some prespecified similarity and a sample image, the effects of the similarity measure are so preponderant over those of the presentation system that the similarity measure can be considered in isolation or, in other words, decontextualized.

The same general considerations on the validity of an experimental design that were made for contextual evaluation can be repeated in this case. Noncontextual evaluation has the additional complication that some of the data that the observers are required to analyze are not generated a priori, but are the result of previous experimental steps. This introduces the potential for additional biases against which the experiment must be robust.

I will begin again by establishing some notational conventions. I indicate with D a data set on which experiments are performed, with X_i an experiment conducted using the ith treatment, with A a reference human activity, and with C a statistical comparison. In the following diagrams, time runs from left to right, and activities placed in vertical stacks are executed (conceptually) in parallel. Activities enclosed in square brackets are considered as a unit, and are processed using the same data.

For example, the following diagram:

$$D \longrightarrow \begin{bmatrix} X_1 \\ X_2 \\ \vdots \\ X_n \\ A \end{bmatrix} \longrightarrow C$$

(3.75)

describes a *simple comparison* experiment. A data set is prepared and processed by the systems X_1, \ldots, X_n as well as by the human referent A. The results are then analyzed statistically (in C) in order to reveal the similarity of the results obtained by X_1, \ldots, X_n with those obtained by A.

This scheme is the noncontextual equivalent of the contextual post-test only design:

$$\begin{array}{l} G \longrightarrow O_0 \\ X_1 \longrightarrow O_1 \\ X_2 \longrightarrow O_2 \\ \quad \vdots \\ X_n \longrightarrow O_n \end{array}$$

(3.76)

Before analyzing the experimental procedures that were used in the previous section, I will briefly consider the general problem of determining the validity of an experiment, distinguishing between the two classes that have already been introduced—*internal validity* and *external validity*.

In a noncontextual measurement, the main factor that can negatively affect internal validity is the subject's *learning curve*. Consider the following experimental scheme in which data are processed by a number of engines and then judged by a subject for each engine individually:

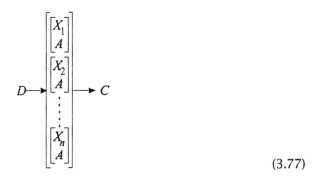

(3.77)

As the experimentation goes, the subject will be exposed to the various images in the data set D and, by the time the last treatments are tested, it is very likely that this knowledge will distort the measurement. Differences in the experimental results might be caused not by the different treatments, but by the *history* of the subject.

An issue connected with distortion caused by history and maturation is that of previous knowledge of the systems under evaluation. It could seem a trivial point that subjects should always be chosen among people who have no knowledge of the systems (or even of the existence of the systems) under evaluation, but it is not rare to see this rule violated. If this rule is not followed, even if the results have internal validity (which, in itself, is doubtful), their external validity is certainly jeopardized.

The previous experimental design had the disadvantage of requiring that the human subject used for comparison examine and evaluate all the data used for the experiment. This requires that the data set on which the experiment is based be rather small, which represents a more severe restriction for noncontextual evaluation than it does for contextual evaluation. In contextual evaluation (as well as in all the experiments in the social sciences), the comparison is done between certain human activities performed using the system under evaluation and the same activity performed using a reference system or no system at all. Human activity is involved in all the trials, and the cost of the experiment with the control group is comparable to that of the experiments with the system under evaluation.

In noncontextual evaluation, the experiments consist in a simulation of a human cognitive activity by an automatic system, while the control group entails the repetition of the same cognitive activity by a human subject. It is therefore feasible to use a very large database for the system experiments, while it is in many cases unfeasible to use the same database for the human referent: it is relatively easy to test a system asking it to sort 10,000 images by similarity with a given one; it is a wholly different story to ask a human subject to do the same thing! There is an evident asymmetry in the "reasonable" size of the data set that makes a direct comparison difficult. The difficulty could be overcome by artificially restricting the system to use a limited data set, of a size manageable by the human referent. This solution gives rise to the previous experimental design, but in some cases it represents an excessive simplification. For some systems, a complete characterization of certain phenomena and characteristics can only be obtained by testing on extended databases containing many exemplars of several different classes of images. Limiting the size of the test database to what can be managed by the human reference can be an intolerable constraint.

The following experimental design allows the experimenter to use large databases for the system measurements while limiting the size of the dataset that the human referent has to handle. Schematically, this design can be expressed as

follows:

$$D \longrightarrow \begin{bmatrix} X_1 \\ X_2 \\ \vdots \\ \vdots \\ X_n \end{bmatrix} \begin{array}{c} \longrightarrow D_l \longrightarrow A \searrow \\ \\ \nearrow \searrow C \end{array}$$

(3.78)

The relevant aspect of the experimental design is that the data set used by the human referent is generated using the result of the experimental sessions with treatments $X_1, \ldots X_n$. This is done in order to reduce the amount of work required from the subject.

Take, as an example, an experiment in which a number of similarity measures are tested over a database of textures. Let D be the whole database. The experiment consists of ordering the textures by similarity with a given texture query, and determining which of the systems provides an ordering closest to that given by the subject. If the simple experimental design of the previous example were used, each of the databases, as well as the subject, would have to order D, and the orderings would be compared, requiring a subject treatment of the form $D \rightarrow A$. This is unfeasible if D contains hundreds or thousands of images. In practice the ordering of images very different from the query is very sensitive to minor variation of the similarity measure and, in general, irrelevant. Thus, only the first q images (with $q \ll |D|$) need to be considered for the measurement of the quality of the ordering.

In this experimental design, each one of the systems orders the whole database D and generates an ordering of the database with respect to the given query. Given the premises of the measurement procedure, one can assume that only the top q images of each one of these orderings are significant. These q images form the *significant set* for each of the n systems D_i with $|D_i| = q$. The results returned by all the systems are pooled together in the *subject set* $D_s = \bigcup_i D_i$, with $|D_s| \leq nq \ll |D|$. This data set is used as the basis for the human referent assessment. The subject orders the set D_s by similarity with the query, and this ordering is compared with those of D_1, \ldots, D_n.

The limitation of this experimental scheme is that it cannot be used to derive an absolute assessment of the performance of any of the systems X_i, but only to derive the *relative* performance of the system with respect to each other. Each system, in fact, produces a result based on the scheme $D \rightarrow X_i$. A comparison like that of the first similarity experiment requires a subject treatment of the form $D \rightarrow A$, as opposed to the $D_s \rightarrow A$ that is required here. All the X_i could perform very poorly when compared with $D \rightarrow A$; none of the results of $D \rightarrow A$ might be present in the results of $D \rightarrow X_i$. This scheme, however, allows one to measure the *relative* performance of the treatments. Note that the unification of all the

outputs into a single set D_1 is essential. The scheme

$$D \longrightarrow \begin{bmatrix} X_1 \longrightarrow D_1 \\ X_2 \longrightarrow D_2 \\ \vdots \\ X_n \longrightarrow D_n \end{bmatrix} \begin{array}{c} \rightarrow A \searrow \\ \rightarrow C \end{array}$$

(3.79)

does not grant drawing any conclusion about the treatments

A final experimental design involves the use of human subjects for the prepa-
ration of the dataset on which the systems will be tested. This is necessary when
the cognitive function being tested is preceded by other cognitive functions but,
in order to minimize the possibility of interaction, it is decided not to perform
the latter automatically. The schema is as follows:

$$A_1 \longrightarrow D \longrightarrow \begin{bmatrix} X_1 \\ X_2 \\ \vdots \\ \vdots \\ X_n \\ A \end{bmatrix} \longrightarrow C$$

(3.80)

The main issue here is whether subjects A_1 and A_2 should be the same person.
Both alternatives present potential risks.

In case two subjects are used, the preprocessing determined by the first subject
might be incompatible with the judgments of the second.

If one subject is used, it is necessary to guard against maturation effects—
during the analysis, the subject is already familiar with the dataset, having con-
tributed to its creation.

3.6 Additional Pointers

It is obviously impossible, in a book like this, even to scratch the surface of the
study of the design and evaluation of experimental procedure, for the perfectly
good reason that the field itself is much larger and has a much longer history than
the whole subject of this book. The notes of this chapter were designed to be a
quick introduction to the most common statistical techniques and experimental
practices, with some additional material (most notably section 3.5) dictated by
the peculiar problems of image databases. Given the importance of evaluation in
image databases as a discipline, I urge the reader to consult additional bibliogra-
phy on the subject. The following paragraphs are a partial list, dictated more by

logistic reasons (I mention the books and articles that I happen to have available at this time) than by any completeness criterion.

The "statistical" Section (3.3) is composed of two parts: techniques for measuring the results of a test and statistical techniques proper, to evaluate the results of an experiment. The material on weighted displacement for rank list is derived from a 1997 paper by Desai Narasimhalu, Kankanhalli and Wu (1997)expanded here to include the case in which the lists to compare do not contain the same elements; the part on the comparison of configurations is, to the best of my knowledge, original.

The statistics presented in the chapter is really basic, and most of it comes from two introductory books: Mandel (1964) and Crow *et al.* (1960). Both books are quite old but have recently been republished in a paperback edition by Dover and should, therefore, be fairly available. Any manual of elementary statistics, however, should cover the arguments presented in the chapter.

My greatest regret in this chapter is not having been able to introduce the concept of power of an experiment, which allows the experimenter to estimate whether the number of subjects used is sufficient to reach reliable conclusions. The topic is considered in Kappel (1991).

The section on experimental design is largely inspired and derived, *mutatis mutandis*, to Campbell and Stanley (1963), whose work is, a classic in its area. As far as I know, there are no recent reprints of this monograph, but it should be reasonably available in any good university library.

II

De Re Visiva Principia Geometrica

II

De Re Visiva Principia Geometrica

4

Similarity

Mein Großvater pflegte zu sagen: "Das Leben ist erstaunlich kurz. Jetzt in der Erinnerung drängt es sich mir so zusammen, daß ich zum Beispiel kaum begreife, wie ein junger Mensch sich entschließen kann ins nächste Dorf zu reiten, ohne zu fürchten, daß—von unglücklichen Zufllen ganz abgesehen—schon die Zeit des gewöhnlichen, glücklich ablaufenden Lebens für einen solchen Ritt bei weitem nicht hinreicht."

Franz Kafka, *Das nächste Dorf*

This morning I was looking for a paper that I wanted to cite in another section of this book. My work room in my apartment in Italy—where I am writing the first draft of this chapter—has a desk, a support with an old computer, and a Spartan metallic bookshelf, which is almost empty because most of my papers and books are laying here and there in stacks on the floor, and the whole room seems almost to float on this increasingly thick layer of paper.

Because of this situation, as you can probably imagine, chances of an easy retrieval of the paper I was looking for were slim at the best. However, for all the time I was conducting my search I was sure that there would have been only one of two possible outcomes: Either the paper was in the room—and if I was patient and thorough enough I was bound to find it sooner or later—or I had left it in San Diego before leaving and, of course, I would not find it (fortunately, I found it in a few minutes).

I also remember another search I did not too long ago on the Internet. I was looking for a picture of a face to create a figure that you will see in a few pages. The figure contains two copies of the same face turned upside down. For reasons that will be only too clear when you see the figure, I needed a photograph taken from the front, with the face reasonably straight (that is, not tilted on either side),

and with a reasonably neutral facial expression. I had decided that, preferably, the face was to be of a woman and that, to make the figure more interesting, it should be of a reasonably well-known person.

I started looking at several World Wide Web sites that I knew contained pictures of celebrities. In this case, I was fairly sure I would find something appropriate but, probably, not exactly the face I had in mind, which I had seen in a similar figure on another book (I even had to give up my celebrity requirement).

In this case, while looking on the Internet for my face sample, I had a specific request in mind, but I was willing to accept anything sufficiently *similar* to my idea. While I was reasonably sure that I would eventually find something appropriate, I could not say how close the photograph I would actually choose would be to the model I had in mind (it turned out to be quite different). The search I was doing this morning in my apartment was, in some respect, quite the opposite of this; while I was not sure whether the thing I was looking for was in the room I knew that, if it was in the room, it would have been exactly the one that I had in mind.

My little Internet adventure is a typical example of a similarity search of the open and exploratory type in which I am interested in this book. In this case, the similarity criterion I was using had a pretty obvious semantics—an image was "similar" to my query if it was the upright straight face of a female celebrity. In other cases the criterion may be more fuzzy and even change during the search. In any case, a similarity search rests on two pillars, a mechanism to encode relevant information about an image and a mechanism to determine whether two images are similar in the semantic space of our query.

Note that I did not use the word "semantics" in the context of the extraction of information, but only in the context of similarity measurement. This is consistent with the ideas of Chapter 2. Features constitute a system of syntactic markers, a semiotic system to which a variety of semantics can be attached. The association with a semantic system begins by endowing the (syntactic) feature space with a metric that can induce semiosis and categorization. In the same line of thought, I will begin the analysis of similarity engines by considering, in this chapter, similarity measures and leaving to the following chapters the study of the feature spaces on which these measures operate.

This is a fairly convoluted chapter, and its convolutions revolve around the concept of metric space. The model that I will develop, in fact, is that images are expressable as elements in a suitable metric space, and similarity (or, rather, dissimilarity) is a distance function in this space. I will begin with a review of similarity measures proposed in the psychological literature, with results somewhat disappointing—the most successful models (in the sense of explanation of observable properties) assume that similarity does not depend on a distance function. Taking note of this conclusion, I will then set out to salvage the geometric approach, showing that a slight extension of the concept of distance can be used to explain most of the psychological findings by purely geometric means.

Finally, I will expand the considerations about geometric similarity to a more complete theory, which will include the characterization of the similarity

measures derived from distance functions as well as the definition of suitable operations on them, which will be useful in the following chapters for the definition of query algebras for image databases.

4.1 Preattentive Similarity

It is quite opportune to start by making an important distinction—between *preattentive* and *attentive* similarity. An alternative way to refer to these things—with almost exactly the same meaning—is, similarity *without interpretation* and similarity *with interpretation.*

Preattentive similarity is determined by early vision mechanisms that operate on the whole image at once (i.e., by mechanisms that operate before the focus of attention) [Malik and Perona, 1990]. Attentive similarity is determined by mechanisms that operate after attention has been focused. The identification between preattentive similarity and similarity without interpretation can be ascribed to the fact that interpretation requires foveation on the relevant parts of the scene and, therefore, takes place after attention has been focused. It is easy to be convinced that this is indeed the case with a simple experiment. Consider the following sequence of letters:

<div align="center">X W C F O J G T Q S D P O J</div>

Stare at the final "J" and, without moving your eyes, try to read as many letters as you can. It is in general impossible to read more than two or three. Beyond that limit, peripheral vision—with its source mainly rods—takes over the cone-based foveal vision, and resolution decreases dramatically. Because of this, and because it is so easy for us to move our eyes; recognition operates on high-definition visual maps built by the attentional mechanism with successive foveations.

One famous example of the difference between preattentive and attentive similarity is replicated in Fig. 4.1. If you look at the two faces of Fig. 4.1, you will notice that they are very similar. As a matter of fact, if you look at them quickly you might be unable to notice any difference between them.

Now, turn the page upside down and look at the two images again. You should see a striking difference between the two! The first time you were looking at two unfamiliar images (or, which is the same thing, at two familiar images in a very unfamiliar setting). The fact that you are seeing the face images in such an unfamiliar setting effectively prevents your face recognition mechanisms from operating correctly. The various parts of the image are not integrated correctly into a coherent face picture. That is, you are measuring and integrating the preattentive similarity of the different parts of the image. When looking at straight faces, the interpretative mechanisms take over. These mechanisms attach great importance to the correct placement and orientation of the mouth and the eyes. The little asymmetries that were barely noticeable in the upside-down images are now preponderant over the overall similarity of the images. Note that even now that

Figure 4.1. If you think these faces are similar, turn the page upside down!

the difference is known, the upside-down faces look very similar. By now you can probably see very easily that the eyes and the mouth are different even when the figure is upside down but, although these parts are manifestly different, the difference does not seem to be that important—the images are still very similar. In a sense, in preattentive mode one is trying to determine the similarity between the two images, while in the second case one is misled by trying to determine the similarity of the two faces evoked by the two images. The dissimilarity of the two faces in several important areas obfuscated the overall similarity of the images.

Preattentive similarity is based on different features than recognition and categorization processes. Julesz (1975) pointed out that *perceptual grouping* is largely based on preattentive features. If this is true, then the study of perceptual grouping could provide some valuable insight into the work of preattentive similarity.

Olson and Attneave (1970) showed their subjects a series of displays like those in Fig. 4.2 and asked them to identify the "odd" quadrant. The difficulty with which people do this can be taken as a measure of the preattentive similarity between the "normal" and the "odd" stimuli. The results turned out to be quite different from what one might expect in an experiment based on identification. For instance, the stimuli L and ∨ are judged more similar than the stimuli L and T when looked at attentively. Yet, in the Olson and Attneave experiment, L and ∨ produce an odd quadrant that is spotted much more easily than that produced by L and T—preattentively L and T are more similar than L and ∨.

Physiologically, this could indicate that the features used for preattentive similarity are computed by early vision areas of brain, possibly as early as the striate cortex. For the purpose of image retrieval, however, a functional description of similarity is more appropriate. For the moment then, we will try to see what people do perceive as similar, and what are the characteristics of this perception. This leads into the rich field of *psychological* models of similarity.

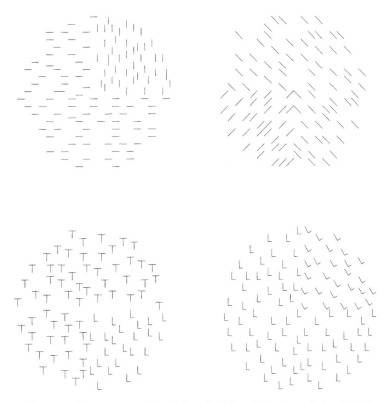

Figure 4.2. Olson and Attneave stimuli for the identification of the "odd" quadrant.

4.2 Psychological Models of Similarity

Psychologists have been studying human similarity perception for at least 70 years. During this time, they have collected an impressive amount of experimental data, and a number of theories to explain the experimental findings. Although a completely satisfactory theory is still elusive, several proposals exhibit interesting properties.

In this section, I will introduce a few of the many ideas that have appeared in the psychological literature, and discuss the merits and flaws of various approaches. I will try to put all these theories in perspective, and collect them in a unified framework. For most of these theories it will be impossible to give more than a brief sketch; the interested reader is urged to consult the primary literature cited in this section for a more comprehensive discussion.

Given the orientation of this book, it will not come as a surprise that the most important taxonomic gauge will be the concept of *geometric distance* and the related distance axioms. Many theories differ in the way they deal with the properties of geometric distance, and by the number and nature of distance axioms they accept or refuse. The first subsection, therefore, discusses the distance axioms from the perspective of similarity measurement.

4.2.1 The Metric Axioms

A number of theories proposed in the literature model similarity (or, more properly, *dissimilarity*) as a distance in some suitable feature[1] space, which is assumed to be metric.

A distinction is made between *perceived dissimilarity* (usually denoted by d), and *judged dissimilarity* (denoted by δ) [Ashby and Perrin, 1988]. If S_A and S_B are the representations of the stimuli A and B in the perceptual space, then $d(S_A, S_B)$ is the perceived dissimilarity (sometimes called perceptual distance) between the two, while the judged dissimilarity is

$$\delta(S_A, S_B) = g[d(S_A, S_B)] \qquad (4.1)$$

g being a suitable monotonically nondecreasing function of its argument. Note that in this model the judged similarity δ is the only quantity actually measured in the experiments, while the perceptual similarity d is a purely mentalistic construct whose existence is postulated but cannot, *ex hypothesis*, be observed. The epistemological ground for the definition of d is therefore rather uncertain, a fact which will have some repercussions on the considerations to follow.

Stimuli are represented as elements of a metric space, and $d(S_A, S_B)$ is the distance function of this space [Shepard, 1962a,b; Torgerson, 1965; Carroll and Arabie, 1980]. As such, the function d is expected to satisfy the distance axioms. Note that a similar requirement is not imposed on the judged similarity δ. This poses a problem for the verification of the distance nature of the function d, since lack of compliance of δ with one of the axioms does not necessarily imply lack of compliance of d. In all the cases in which compliance can be tested, however, experiments have revealed evidence against it.

The first requirement for a distance function is that

$$d(S_A, S_A) = d(S_B, S_B) \qquad (4.2)$$

for all stimuli (constancy of self-similarity). Compliance with this axiom can be tested experimentally using the judged similarity, as it implies $\delta(S_A, S_A) = \delta(S_B, S_B)$. The constancy of self-similarity has been refuted by Krumhansl (1978), who proposed a modification to the distance model to explain its violation. The Krumhansl model will be discussed later in this section.

A second axiom of the distance model is minimality:

$$d(S_A, S_B) \geq d(S_A, S_A) \qquad (4.3)$$

Again, compliance with this axiom is open to experimental investigation because, due to the monotonicity of the relation between d and δ, it implies

[1] The space in which stimuli are represented and spaces connected to it are called in a variety of ways in the psychological literature, depending on the particular orientation of the research, the directedness of the connection between the sensorial variables and the space under consideration, and so on. Common names are *perceptual* and *psychological* space. I will adhere to the computer science terminology and call all the instances of such spaces *feature spaces*.

$\delta(S_A, S_B) \geq \delta(S_A, S_A)$. Tversky (1977) argued that this assumption may sometimes be inappropriate. He noted, for instance, that in recognition experiments, "... the off-diagonal entries often exceed the diagonal entries; that is, an object is identified as another object more frequently than it is identified as itself."

A third axiom states that the distance between stimuli is symmetric:

$$d(S_A, S_B) = d(S_B, S_A) \tag{4.4}$$

Just as in the previous cases, this axiom is subject to experimental investigation because it implies $\delta(S_A, S_B) = \delta(S_B, S_A)$. A number of investigators have attacked this assumption. Tversky (1977) demonstrated violation of symmetry by having subjects assess the similarity between cultural entities such as countries. Other researchers obtained similar results for perceptual stimuli [Rosh, 1975] and observed asymmetries in confusion matrices [Rothkopf, 1957].

Asymmetry has often been attributed to the different "saliency" or "goodness of form" of the stimuli. In general, the less salient stimulus is more similar to the more salient (more prototypical) than the more salient stimulus is similar to the less salient [Tversky, 1977].

The situation here is quite intriguing since it brings to the arena the concept of *goodness of form* (which is more or less what the German-speaking Gestaltists called *prägnanz*) whose meaning is not at all clear. To try and make things somewhat clearer, I will report on one of Tversky's experiments [Tversky, 1977]. Subjects were shown pairs of geometric figures. Each pair had a figure drawn from a set *p* (for "prototypical") and a figure drawn from a set *q*. Subjects, of course, did not know anything about the sets and had no indication of which figure of each pair was supposed to be "prototypical" and which one was not (e.g., the *p* figure was placed on the left or the right of the other figure randomly). The *p* figure had either "better" form than the *q* figure, or the two had the same goodness of form but the *p* figure was "simpler" than the *q* figure. Figure 4.3 shows two pairs from the experiment. The *p* figures are on the left and the *q* figures are on the right. In the first pair the *p* figure has better form, and in the second pair the *p* figure is simpler.

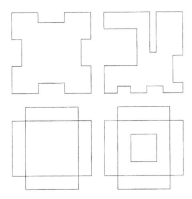

Figure 4.3. Pairs from Tversky's experiments on how prägnanz affects similarity.

For each pair, subjects were asked to indicate which of the following statements they preferred to use: *the left figure is similar to the right figure*, or *the right figure is similar to the left figure*. Analysis of the results showed that in each pair the majority of subjects selected the statement of the form *q is similar to p*. Thus, the more "salient" stimulus (either simpler or with better form) was generally chosen as the referent rather than the subject of similarity. The same pairs were used for a second experiment: one group of subjects was asked to estimate the degree to which the left figure was similar to the right figure, and the second group was asked to estimate the degree to which the right figure was similar to the left figure. The results showed that $s(q, p)$ was on average significantly higher than $s(p, q)$.

This experiment establishes quite conclusively that similarity is asymmetrical, but it does not clarify the concept of "goodness" of form. Given the artificial nature of the stimuli used by Tversky, it is not clear what stimuli with a good ecological validity could be called salient. Moreover, saliency appears to be influenced by context. In another experiment, Tversky asked subjects to rate similarities, much like he did in the previous experiment. In this case, though, stimuli were comparable in complexity and goodness of form but one stimulus had been shown to the subjects in advance and appeared always in the same position. It turns out that these circumstances affected (increased) the saliency of that stimulus.

There is one interesting property of goodness of form: Garner (1962, 1966) showed that the estimated goodness correlates negatively with the number of different patterns that could be generated by rotating and reflecting the stimulus. Rotations and mirror reflections form the orthogonal group $O(2)$. This group is compact and contains an infinite number of finite subgroups. Let $O_n(2)$ be the class of subgroups with n elements. The stimulus x—which belongs to a space X on which $O(2)$ acts—is $O_n(2)$-invariant if there is a subgroup $G_n \in O_n(2)$ such that $gx = x$ for all $g \in G_n$. This is expressed with the notation $G_n x = x$. If one defines

$$m(x) = \max\{n : \exists G_n \in O_n(2)\ G_n x = x\} \tag{4.5}$$

then $m(x)$ can be taken as a measure of the goodness of form of the stimulus x.

The final distance axiom that translates into similarity theory is the triangle inequality:

$$d(S_A, S_B) + d(S_B, S_C) \geq d(S_A, S_C) \tag{4.6}$$

This is the most troublesome of all the axioms. The functional relation between d and δ does not guarantee that satisfaction or violation of the triangular inequality for d will translate into a similar property for δ. In other words, it may well be that the triangular inequality holds for d but not for δ or vice versa. Psychologists have gathered evidence pointing to a violation of the triangle inequality, at least for certain types of stimuli.

Some care is needed here because some of the evidence of violation of the triangle inequality does not apply directly to perception. Consider the following example from Tversky (1977): Jamaica is similar to Cuba (because of geographical

proximity), Cuba is similar to Russia (because of the political system[2]), but Jamaica is definitely not similar to Russia. Ergo, the triangle inequality does not hold. It is difficult to dissipate the impression that something is wrong, that somebody did some sleight of hand and deceived us. Torgerson (1965) made a distinction between similarity as a basic perceptual relation between stimuli, and similarity as a derivative cognitive judgment. The Jamaica-Cuba-Russia experiment is clearly an example of the latter and therefore is irrelevant for perceptual theories. It reveals, however, some important facts applicable to perception. A cognitive stimulus, like Cuba, is described by a number of different features which, in this case, include location, political system, and maybe history, art, industrial products, and so on. When people are asked to judge similarity, they tend to focus on some features and express a judgment based mainly on those. In the experiment reported by Tversky, the subjects concentrated on the political system and the geographical location.

One of the reason why cognitive experiments do not bear immediate relevance to perception is their focus shifting pattern. The cognitive identity of an entity like "Cuba" is made of many different elements. In other words, a sign like ⟨*cuba*⟩ has correspondences, on the plane of the signified, to many different semantic systems. The similarity and dissimilarity of the elements depends on the semantic space on which one decides to focus. It is possible to represent a (partial) compositional analysis of these entities, using Eco's (1976) notation, as:

$$(politics) \rightarrow capitalism$$
$$\nearrow$$
$$//Jamaica// = \langle\langle jamaica \rangle\rangle \rightarrow d_{country} \rightarrow (geography) \rightarrow caribbean$$

$$(politics) \rightarrow communism$$
$$\nearrow$$
$$//Cuba// = \langle\langle cuba \rangle\rangle \rightarrow d_{country} \rightarrow (geography) \rightarrow caribbean$$

$$(politics) \rightarrow communism$$
$$\nearrow$$
$$//Russia// = \langle\langle russia \rangle\rangle \rightarrow d_{country} \rightarrow (geography) \rightarrow europe$$

The relation between these entities can be specified as in Fig. 4.4. No conclusion on the relative closeness of the three entities can be reached from the topology of the complete semantic graph. Only when focusing on a specific semantic axis is it possible to determine the similarity. Thus, the "trick" that caused the violation of the triangle inequality is that the two judgments (Russia vs Cuba and Cuba vs Jamaica) were obtained by focusing on two different oppositional axes of the semantic system, that is, endowing the semantic space with two different

[2] Tversky wrote his paper in 1977 and, at the time, the assertion was certainly true. The political institutions established by human societies, though, can be much more volatile than the facts debated in the scientific literature.

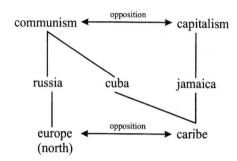

Figure 4.4. Part of the relational graph between Cuba, Jamaica, and Russia.

topologies. This is the first of the properties that, later in the chapter, will permit the reconciliation of the geometric approach with the observed violation of the distance axioms: The distance function in the space is changed depending on the specific comparison that we are doing. More precisely, the presence of the referent deforms the feature space.

What is it possible to say about the occurrence of similar effects in perceptual similarity? Gravetter and Lockhead (1973) and Parducci (1965) have demonstrated contextual effects of the type that lead to the violation of triangle inequality in domains like loudness of tones and size of squares. These experiments, if nothing else, suggest that violation of triangle inequality can be a characteristic of perceptual similarity and is not relegated to the realm of cognitive judgment.

The fact that the triangle inequality does not translate into a similar property for δ that can be checked experimentally creates a curious situation. According to most geometrical theories, in fact, the *perceptual space*, in which d is measured, is inaccessible, and its properties are revealed only through experiments based on the measurement of δ. One wonders whether it is epistemologically correct to consider properties, like the triangle inequality, that experiments cannot either prove or disprove. Talking about the triangle inequality for the metric d makes sense only if a specific form for the function g can be established through independent means. The determination of such a function is undertaken by the Thurstone-Shepard models that I will consider in the next section.

Note also that the ordinal relation between distances is invariant with respect to all the transformations of Eq. (4.1) if g is monotonically increasing. A consequence of this is that the triangular inequality cannot be tested based on ordinal measurements only.

Tversky and Krantz (1970) proved that, if the distance axioms are verified, and the distance is additive along straight lines in the feature space, then d is a Minkowski distance:

$$d(S_A, S_B) = \left[\sum_i (a_i - b_i)^p \right]^{1/p} \tag{4.7}$$

for some $p \geq 1$.

From these notes, it seems like the situation for geometric models is quite desperate: Of the four basic axioms of the distance function, two are questionable, one is untenable, and the fourth is not ascertainable. Yet, these problems notwithstanding, metric models are widely used in psychology, with some adjustment to adapt to the failure of the distance axioms.

Thurstone-Shepard similarity models. An important class of metric models was studied by Shepard (1957, 1962a,b, 1987), based on some ideas that can be traced back to a paper by Thurstone (1927).

Shepard's model is based on *generalization* data[3]: Given a series of stimuli S_i and a corresponding series of learned responses R_i, the similarity between S_i and S_j (in the absence of any bias) is related to the probability that the stimulus S_i elicits the response associated with stimulus S_j:

$$p_{ij} = P[R_j | S_i] \qquad (4.8)$$

In other words, the similarity between S_i and S_j is given by the probability that S_i will be mistaken for S_j. Note that with definition similarity is not necessarily symmetric. In general it is $p_{ij} \neq p_{ji}$. Shepard does not work directly with these quantities, but uses normalized and symmetric *generalization data*, defined as

$$g_{ij} = \left[\frac{p_{ij} p_{ji}}{p_{ii} p_{jj}} \right]^{1/2} \qquad (4.9)$$

The model assumes that the generalization data are obtained as a function of the distance in the perceptual space,

$$g_{ij} = g(d(S_i, S_j)) \qquad (4.10)$$

where g is the *generalization function*, and d is a suitable *perceptual distance* between the two stimuli.

If the stimuli are expressed in terms of physical variables (e.g., hue or brightness for color, geometric parameters for a shape), the experiments predict a number of different behaviors for the generalization data. Shepard assumed that there exists, for each type of stimulus, a suitable underlying *psychological space* such that: (1) the function g is universal (it has the same form for all the types of stimuli); and (2) the function d is a metric. Note that, without the second requirement, the condition can be trivially satisfied for any function $g : \mathbb{R} \to [0, 1]$. The requirement that the psychological space, on which the physical stimuli are mapped, have a metric structure, and that the similarity derived from the generalization data be a function of the distance in this space make the problem nontrivial. Shepard's model is quite fascinating since it would imply that there is really *one* mechanism

[3] The term *generalization* is used here in a slightly different way than in most artificial intelligence papers. In AI, generalization usually means a correct inference whereby the response appropriate in a given situation is extended to cover similar situations for which that response is suitable. In Shepard's papers, generalization refers to the extension of a response from the stimulus for which it was intended to other similar stimuli.

that measures similarity (the mechanism that implements the function g) and that the difference in the various similarity judgments is given only by the different metric of the spaces where the physical features are mapped.

If one assumes that the function g is monotonic, then from the generalization data g_{ij} it is possible to derive the ordering of the stimuli in the perceptual space with respect to any arbitrary reference. For instance, if S_1 is taken as a reference, it is possible to establish the proper order of $\{S_2, \ldots, S_n\}$ with respect to their distance from S_1 based only on the generalization data. Shepard uses these data, and the technique of nonmetric multidimensional scaling ([Carroll and Arabie, 1980; Torgerson, 1965; Beals *et al.*, 1968], see also section 9.2.2) to determine the lowest dimensional metric space that can explain the data. He assumes this space as the psychological space for the model. There is good agreement with the experimental data if the psychological space has a Minkowski metric (defined in Eq. (4.7)), and that the similarity function is exponential:

$$g(d) = \exp(-d^\alpha) \qquad (4.11)$$

One important observation at the core of Shepard's 1987 paper is that, given the right psychological space, the function g is universal, that is, the same exponential behavior (with different values of the parameter α in Eq. (4.11)) can be found in the most diverse situations, ranging from visual stimuli to similarity of pitch in sounds. Given the wide scope of this conclusion, one naturally wonders whether the universality of g is real or an artifact of the creation of the psychological space. It should be pointed out that the psychological space is an ad hoc creation—no independent evidence of its existence has been found apart from the generalization data. The soundness of the hypothesis of the psychological space rests on the validity of multidimensional scaling; as long as this technique can be trusted to reveal structures hidden in the data, by projecting them into a lower dimensional space without creating structures that were not there, the hypothesis of the psychological space holds.

Shepard recognized that the exponential form of the function g must be adjusted in some cases. For some generalization data, the Gaussian-like shape of Fig. 4.5b is a better approximation than the exponential of Fig. 4.5a. The qualitative difference between the two curves is that in Fig. 4.5a the second derivative does not change its sign, while it does so in the curve of Fig. 4.5b.

Another relevant qualitative characteristic is modeled by both the forementioned functions. As two stimuli grow apart in the psychological space, the similarity does not decrease indefinitely, but it flattens out to a finite limit. This behavior occurs because the similarity is based on probability data and, therefore, it has to be bounded from above and below, because its domain must be diffeomorphic to $D \subseteq [0, 1]$ [Ennis *et al.*, 1988; Ennis and Johnson, 1993].

A similar conclusion about the saturation behavior and, more in general, the nonlinear variation of the distance along any axis in the feature space had been observed before Shepard's model. In the middle of the Nineteenth Century, the very first application of the experimental method to the then largely speculative discipline of psychology showed that the human sensorial system has a logarithmic

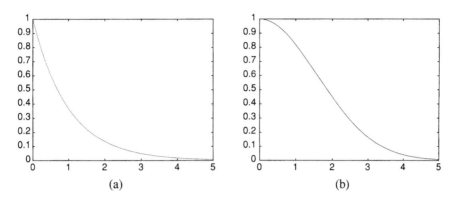

Figure 4.5. One of Shepard's universal similarity functions.

response [Link, 1992]. Therefore similarity of perceptual quantities like brightness or volume of sound is not linear with the variation of the physical stimulus.

Attneave (1950) found similarly nonlinear effects in his experiments on the similarity of rectangles of different area and tilt. These findings are interesting because none of them are based on the probability of mistaking one stimulus for another and, therefore, they provide independent support to the nonadditivity of similarity along the axes of the feature space, and the saturation of the perceived dissimilarity as stimuli become more and more distant.

Quasi-distance models. Krumhansl (1978) proposed a modification to the geometric distance model to account for some violations of the distance axioms that had been determined experimentally. Her idea is that the dissimilarity between two stimuli A, B depends not only on their distance in the psychological space, but also on the spatial density of the stimuli around the representations S_A, S_B. If $\phi(S_A, S_B)$ is some kind of geometrical distance between the representations S_A and S_B, and $h(S)$ is the density of stimuli around the stimulus S, then Krumhansl defined the function d as:

$$d(S_A, S_B) = \phi(S_A, S_B) + \alpha h(S_A) + \beta h(S_B) \tag{4.12}$$

This model accounts for violation of two distance axioms. Assuming $\phi(S, S) = 0$, one obtains

$$d(S_A, S_A) = (\alpha + \beta)h(S_A) \tag{4.13}$$

that is, self-similarity is not constant across the stimuli. Moreover, if $\alpha \neq \beta$, then $d(S_A, S_B) \neq d(S_B, S_A)$. The triangle inequality continues to hold.

If $\alpha < \beta$, then $d(S_B, S_A) < d(S_A, S_B)$ whenever $d(S_A, S_A) < d(S_B, S_B)$. This is in agreement with two experimental observations:

- Self-similarity is higher for more "prototypical" stimuli

- The asymmetry in the similarity assessment is such that the "variant" is more similar to the "prototype" than vice versa.

Krumhansl distance is consistent with these results if one assumes that the density of stimuli is higher around more "prototypical" stimuli. This hypothesis fits nicely with several theories on self-organization of stimuli maps [Kohonen, 1990; Ritter and Schulten, 1988; Ritter, 1991] and automatic determination of categories [Burke, 1991; Carpenter and Grossberg, 1987].

Stochastic models. The Thurstone-Shepard model is based on identification and generalization data, that is, ultimately, on the probability that the response learned for a stimulus S_i be elicited by a different stimulus S_j, and places great emphasis on the determination of a suitable psychological space via multidimensional scaling. An approach based on similar premises but with more emphasis on the manipulation of probability spaces was proposed by Ashby and Perrin (1988). Let $P(R_j|S_i)$ be the probability of having a response R_j when the stimulus S_i is presented (assume that R_i is the correct answer for S_i). Assume that the stimuli are not represented deterministically in the perceptual space but, due to uncertainty, are represented as multivariate probability distributions, and let $f_i : \mathbb{R}^n \to \mathbb{R}^+$ be the probability distribution of stimulus S_i.

Suppose that the task at hand is to discriminate between two responses R_A and R_B to the stimuli S_A and S_B based on the value of the instantaneous perceptual effect $x \in \mathbb{R}^n$. If the decision is based on maximum likelihood, then the answer is R_A whenever x is such that

$$f_A(x) > f_B(x) \tag{4.14}$$

The decision boundary is the set of points such that

$$l(x) = \frac{f_A(x)}{f_B(x)} = 1 \tag{4.15}$$

This model contains the Euclidean model as a special case in which the f_i are multivariate normal distribution with the same variances [Ashby and Perrin, 1988].

Let ρ_B be the region of the perceptual space corresponding to the response R_B. The probability of confusing S_B with S_A is:

$$P(R_B|S_A) = \int_{\rho_b} f_A(x)\,dx \tag{4.16}$$

Ashby and Perrin assume that in the absence of a response bias the similarity between S_A and S_B is proportional to their confusability:

$$s(S_A, S_B) = k \int_{\rho_b} f_A(x)\,dx \tag{4.17}$$

In other words, the perceived similarity of stimulus S_A to stimulus S_B is defined as the proportion of the S_A perceptual distribution that falls in the response region assigned to S_B in an optimal unbiased two-choice decision.

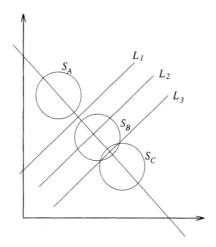

Figure 4.6. Three stimuli in the Ashby and Perrin model. The optimal decision boundaries for the three stimuli are L_1 and L_3 and L_2 is the optimal decision boundary between S_A and S_C if S_B is not present.

The dissimilarity between two stimuli is defined as

$$d(S_A, S_B) = -\log s(S_A, S_B) \tag{4.18}$$

This definition is not completely satisfactory, as Ashby and Perrin recognize. In their words: "For example, celery, apples, and automobiles are never confused, and yet we judge celery and apples to be more similar than celery and automobiles" [Ashby and Perrin, 1988].

Things become intriguing when *three* stimuli are considered. Consider the three stimuli of Fig. 4.6 with the relative optimal decision boundaries L_1 and L_3 (stimuli are represented by one of their iso-probability curves). Ashby and Perrin define the similarity of S_A to S_C as:

$$s(S_A, S_C) = \int_{\rho_C} f_A(x)\,dx \tag{4.19}$$

What is ρ_C? This depends on the presence of S_B. If S_B is present, then ρ_C is the region below L_3. If S_B is not present, then ρ_C is the region below L_2. The region ρ_C used in the first case is obviously included in the region ρ_C used in the second. This means that *the similarity of S_A to S_C is decreased by the presence of S_B*. A similarity measure that has this property is called *context-sensitive*. Tversky (1977) presents some data supporting the idea that human similarity assessment is indeed context-sensitive.

Geometric models are context-free, as the distance between S_A and S_C depends only on the coordinates of their representations in the perceptual space, which are not affected by the presence of S_B. Krumhansl's model is context sensitive: Although the distance $\phi(S_A, S_C)$ of Eq. (4.12) is not affected by the presence of S_B, this new stimulus changes the densities of stimuli $h(S_A)$ and $h(S_C)$ around S_A and S_C and therefore changes the similarity value.

4.2.2 Alternatives to the Distance Axioms

The distance axioms provide an unnecessarily rigid system of properties for similarity measures. In particular, it seems futile to impose on the perceptual distance d properties—like the triangle inequality—that may fail to translate into similar properties of the judged similarity δ and are, therefore, beyond experimental validation. Because psychological experiments are the only way of validating distance measures, every property inaccessible to experimentation should be abandoned as unnecessary or, at least, be regarded as a conceptual—and disposable—construct. Only properties that can be subject to experimental validation should be postulated (a la Newton's *hypotheses non fingo*). For the moment I will not consider whether a given property is true but merely whether it makes epistemological sense to postulate it (or its absence) for the distance measure at the basis of psychological models. While the answers to validity questions are empirical, the answer to the epistemological question depends only on the nature of the model. For the Thurstone-Shepard models, I will use the following definition:

DEFINITION 4.1. *Let \mathcal{M} be the class of monotonically increasing functions. A logic predicate P over d is an* ordinal property *if, for all $g \in \mathcal{M}$, $Pd \Rightarrow Pg(d)$.*

Since monotonically increasing functions do not affect the ordinal relations, it is possible to give an alternative formulation of the ordinal properties that is more important for applications.

Let S be the stimulus space, and X_n a set of n stimuli drawn from S. Also, let $r \in S$ be a reference stimulus. Given a distance function $d : S \times S \to \mathbb{R}^+$, the *order permutation* induced by d on X_n given r is $\pi_n(d, r, X_n) = \{\pi_1, \ldots, \pi_n\}$ such that

$$d(r, x_{\pi_i}) \leq d(r, x_{\pi_{i+1}}) \tag{4.20}$$

Given a set D of distance functions, the *set of order permutations* generated by the distances is

$$\Pi_n(D, r, X_n) = \{\pi_n(d, r, X_n) : d \in D\} \tag{4.21}$$

Finally, let P be a predicate on distance functions. Let Pd be the set of distances for which the predicate is true, and $\bar{P}d$ the set of distances for which the predicate is not true.

DEFINITION 4.2. *A predicate P is ordinal if there is a set X_n and a reference r such that*

$$\Pi_n(Pd, r, X_n) - \Pi_n(\bar{P}d, r, X_n) \neq \emptyset \tag{4.22}$$

In other words, there is a set of stimuli X_n and a reference r such that at least one permutation of X_n cannot be generated by any distance that does not have the property P but can be generated by some distance that has the property P.

This definition provides a basis to determine whether the property P holds based on ordinal measurements only.

Tversky and Gati (1982) identified three ordinal properties, and used them to replace the metric axioms in what they call a *monotone proximity structure*. Suppose for the sake of simplicity that the psychological space has two dimensions x and y, and let $d((x_1, y_1), (x_2, y_2))$ be the perceived distance between the stimuli (x_1, y_1) and (x_2, y_2). A monotone proximity structure is characterized by the three properties of *dominance, consistency,* and *transitivity*, defined as follows:

Dominance: $d((x_1, y_1), (x_2, y_2)) > max\{d((x_1, y_1), (x_1, y_2)), d((x_1, y_1), (x_2, y_1))\}$.
The distance between two points exceeds the distance between the projection of the points on the coordinate axes.

Consistency: for all x_1, x_2, x_3, x_4 and y_1, y_2, y_3, y_4

$$d((x_1, y_1), (x_2, y_1)) > d((x_3, y_1), (x_4, y_1)) \tag{4.23}$$

if and only if

$$d((x_1, y_2), (x_2, y_2)) > d((x_3, y_2), (x_4, y_2)) \tag{4.24}$$

and

$$d((x_1, y_1), (x_1, y_2)) > d((x_1, y_3), (x_1, y_4)) \tag{4.25}$$

if and only if

$$d((x_2, y_1), (x_2, y_2)) > d((x_2, y_3), (x_2, y_4)) \tag{4.26}$$

That is, the ordinal relation between dissimilarities along one dimension is independent of the value of the stimulus along the other coordinates.
To introduce the third property, I will need the following definition:

DEFINITION 4.3. *If* $d((x_1, y), (x_3, y)) > max\{d((x_1, y), (x_2, y)), d((x_2, y), (x_3, y))\}$ *then x_2 is said to be* between x_1 *and* x_3, *written* $x_1|x_2|x_3$.

Note that, in view of consistency, "betweenness" is well defined in that it is independent of the coordinate y that appears in the definition.
The third property of a monotone proximity structure is the following:

Transitivity: If $x_1|x_2|x_3$ and $x_2|x_3|x_4$, then it is $x_1|x_2|x_4$ and $x_1|x_3|x_4$.
This framework is more general than the geometric distance; while all distance measures (defined in a vector space) satisfy dominance, consistency and transitivity, not all the proximity structures satisfy the distance axioms.
Dominance is a weak form of the triangle inequality that applies along the coordinate axes. Consistency is related to the independence property that I will consider in the next section, and can be better understood by referring the stimuli to a curvilinear coordinate system, as in Fig. 4.7. Fix the value of one of the coordinates (let us say that the value of the second coordinate is fixed to the value p), and measure the distances $d((a, p), (b, p))$ and $d((c, p), (d, p))$. Suppose that the first is greater than the second. As it is the coordinate system curvilinear, the distance values will, in general, depend on the value of the coordinate that has

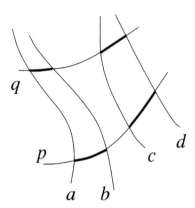

Figure 4.7. Stimuli in a curvilinear coordinate system.

been selected. That is, if the value of the second coordinate is set to q, then one obtains the distances $d((a,q),(b,q))$ and $d((c,q),(d,q))$ that will be, in general, different from $d((a,p),(b,p))$ and $d((c,p),(d,p))$. If consistency holds, though, the ordering relation between these two pairs will be maintained. That is, if it is $d((a,p),(b,p)) > d((c,p),(d,p))$, it will also be $d((a,q),(b,q)) > d((c,q),(d,q))$ and vice versa.

Transitivity ensures that the "in between" relation behaves as in the metric model, at least when moving along one of the coordinate axes. Note that in the Euclidean model—which is isotropic—every property holds (or does not hold) for a series of collinear points irrespective of the direction of the line that joins them. In a proximity structure, the directions of the feature axes have a special status. For instance, nothing is assumed about whether transitivity holds for points not collinear along one of the feature axes.

All distance measures predict that dominance consistency and transitivity hold. To help discriminate among the different models, Tversky and Gati proposed a fourth ordinal axiom that they call the *corner inequality*. If $x_1|x_2|x_3$ and $y_1|y_2|y_3$, the corner inequality holds if

$$d((x_1,y_1),(x_3,y_1)) > d((x_1,y_1),(x_2,y_2))$$
$$\text{and} \quad d((x_3,y_1),(x_3,y_3)) > d((x_2,y_2),(x_3,y_3)) \tag{4.27}$$

or

$$d((x_1,y_1),(x_3,y_1)) > d((x_2,y_2),(x_3,y_3))$$
$$\text{and} \quad d((x_3,y_1),(x_3,y_3)) > d((x_1,y_1),(x_2,y_2)) \tag{4.28}$$

From Fig. 4.8 it is easy to see that if the corner equality holds then the "corner" path from (x_1,y_1) to (x_3,y_3) is longer than the diagonal path. As in the case of dominance, the corner inequality assigns a special status to the axes of the perceptual space (or, in any case, to certain well specified directions, even if these do not coincide with the axes).

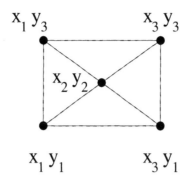

Figure 4.8. The corner inequality.

Assuming segmental additivity, Minkowski metrics imply the corner inequality, so violations of the corner inequality falsify models based on Minkowski metrics. Tversky and Gati present evidence that, under certain conditions, experiments violated the corner inequality, thus seemingly invalidating most geometric models of similarity.

The existence of "preferred directions" in this alternative metric structure makes it applicable only to feature spaces defined as vector spaces. In this sense, the distance axioms are more general that those of a proximity structure because they do not require any hypothesis about the feature space other than the existence of a distance function. Krumhansl's distance model appears like a reasonable solution in this situation, since it combines the high predictive power of the alternative axioms (except for not allowing violation of the triangle inequality) with the low methodological investment of not having to hypothesize a vector space structure.

4.2.3 The Feature Contrast Model

In a famous 1977 paper Tversky proposed his *feature contrast model*. Instead of considering stimuli as points in a metric space, Tversky characterizes them as sets of features. In Tversky's words, a feature *denotes the value of a binary variable (e.g., voiced vs voiceless consonant)*. An alternative interpretation that I will use quite often in the following is to consider binary features as the truth values of predicates about the stimulus. Thus a stimulus a has the feature "voiceless" if the predicate *x is a voiceless consonant* is true for $x = a$. The set of all true predicates for a given stimulus (in a certain domain) is its feature set.

Let a, b be two stimuli, and A, B the respective feature sets. Also, let $s(a, b)$ be a measure of the similarity between the stimuli a and b. Tversky's theory is based on the following assumptions:

Matching: $s(a, b) = F(A \cap B, A - B, B - A)$
That is, the similarity between a and b is a function of three feature sets: the features that a and b have in common ($A \cap B$), the features that belong to a but not to

b ($A - B$), and the features that belong to b but not to a ($B - A$). If the features are interpreted as predicates, the last two sets would correspond to the predicates that are true for a but false for b and to the predicates that are true for b but false for a, respectively.

Monotonicity: $s(a, b) > s(a, c)$ whenever $A \cap C \subseteq A \cap B$, $A - B \subseteq A - C$, $B - A \subseteq C - A$.

Monotonicity implies that similarity increases with the addition of common features ($A \cap B$ is extended) or with the deletion of distinctive features ($A - B$ or $B - A$ are reduced). As a simple example, take a few letters of the alphabet, and let the features be represented by the presence or absence of straight lines. In this case, E would be more similar to F that to I, because E and F have more features in common than E and I. On the other hand, I would be more similar to F than to E, as I and F have fewer distinctive features than I and E.

A function that satisfies matching and monotonicity is called a *matching function*.

Let X, Y, Z denote collections of features, and let the expression $F(X, Y, Z)$ be defined whenever there are A, B such that $X = A \cap B$, $Y = A - B$, $Z = B - A$. Define the relation \approx as follows: $V \approx W$ if there exist X, Y, Z such that one or more of the following holds:

$$F(V, Y, Z) = F(W, Y, Z)$$
$$F(X, V, Z) = F(X, W, Z)$$
$$F(X, Y, V) = F(X, Y, W) \qquad (4.29)$$

The pairs of stimuli (a, b) and (c, d) are said to agree on one (two, three) components whenever one (respectively, two, three) of the following hold:

$$(A \cap B) \approx (C \cap D)$$
$$(A - B) \approx (C - D)$$
$$(B - A) \approx (D - C) \qquad (4.30)$$

Based on these definitions, Tversky postulates a third property of the similarity measure:

Independence: Suppose the pairs (a, b) and (c, d), as well as the pairs (a', b') and (c', d') agree on the same two components, while the pairs (a, b) and (a', b') as well as (c, d) and (c', d') agree on the remaining (third) component. Then:

$$s(a, b) \geq s(a', b') \iff s(c, d) \geq s(c', d') \qquad (4.31)$$

Independence is quite a complicated definition, but it can be made clearer with an example. Consider the stimuli of Fig. 4.9. One can describe them by means of the following features:[4] *round profile, sharp profile, smiling mouth, frowning mouth,*

[4] The features are used here only for the sake of the example. I am in no way implying that these features, or anything like these is actually used to determine the similarity between these stimuli.

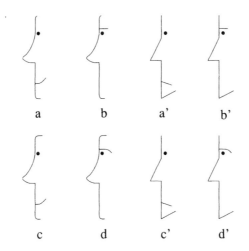

Figure 4.9. An example of independence.

straight eyebrow, and *curved eyebrow*. Then:

- $A \cap B = C \cap D$ = round profile = X

- $A' \cap B' = C' \cap D'$ = sharp profile = X'

- $A - B = C - D$ = smiling mouth = Y

- $A' - B' = C' - D'$ = frowning mouth = Y'

- $B - A = D - C$ = straight eyebrow = Z

- $B' - A' = D' - C'$ = curved eyebrow = Z'

It is now possible to apply independence: (a, b) and (c, d) agree on the first two components (in both pairs, both stimuli have round profile and in both pairs the first stimulus has a smiling mouth while the second does not); (a', b') and (c', d') also agree on the first two components (in both pairs, both stimuli have sharp profile and in both pairs the first stimulus has frowning mouth while the second does not). Finally, (a, b) and (a', b') agree on the third component (in both cases, the second member of the pair has straight eyebrows while the first does not), and (c, d) and (c', d') also agree on the third component (in both cases, the second member of the pair has curved eyebrows, while the first does not).

The independence property then entails that $s(a, b) > s(a', b')$ if and only if $s(c, d) > s(c', d')$. In other words if (a, b) are "closer" than (a', b'), then (c, d) are "closer" than (c', d'). This hypothesis, with some caveat about the selection of features, can be checked experimentally.

This property can be interpreted as follows. Suppose that one is comparing two pairs stimuli (a, b) and (c, d) and that one of the three arguments of the function F is the same for both pairs (say, for the sake of the example, that the third argument of F is the same: $B - A = D - C = Z$). In this case the ordering

between $s(a, b)$ and $s(c, d)$ will be determined by the other two arguments of F. The independence property states that this ordering does not depend on the particular value of Z: If we substitute Z' in place of Z in the computation of $s(a, b)$ and $s(c, d)$ the value of the two similarities will in general change, but their ordinal relation will remain the same.

The main result of Tversky's paper is the following *representation theorem* [Tversky, 1977]:

THEOREM 4.1. *Let s be a similarity function for which matching, monotonicity, and independence hold. Then there are a similarity function S and a nonnegative function f such that, for all a, b, c, d:*

- $S(a, b) \geq S(c, d) \iff s(a, b) \geq s(c, d)$

- $S(a, b) = f(A \cap B) - \alpha f(A - B) - \beta f(B - A)$

This result implies that any similarity ordering that satisfies matching, monotonicity, and independence can be obtained using a linear combination (contrast, in Tversky's parlance) of a function of the common features $(A \cap B)$ and of the distinctive features $(A - B$ and $B - A)$. This representation is called the *contrast model.*

Tversky's model can account for violation of all the geometric distance axioms. In particular, $S(a, b)$ is asymmetric if $\alpha \neq \beta$. If $S(a, b)$ is the answer to the question "how is a similar to b?" then, when making the comparison, subjects naturally focus more on the features of a (the subject) than on those of b (the referent), and they weigh the features of the subject more than those of the referent. This corresponds to the use of Tversky's measure with $\alpha > \beta$—in this case the model predicts

$$S(a, b) > S(b, a) \text{ whenever } f(A) < f(B) \qquad (4.32)$$

This implies that the direction of the asymmetry is determined by the relative "salience" of the stimuli: If b is more salient than a, then a is more similar to b than vice versa. In other words, the variant is more similar to the prototype than the prototype to the variant, in agreement with the experiments on goodness of form presented earlier in the chapter (p. 112).

This approach to asymmetry has been criticized by Ashby and Perrin in (1988). The value $f(A)$ is in general increasing with the number of features in A. In Tversky's interpretation, this means that the more features a stimulus has (the more predicates it satisfies), the more salient it is. Ashby and Perrin objected that "saliency" is a rather elusive concept and is, at best, weakly related to the number of properties that the stimulus predicates. This argument also brings up another issue, the problem of feature choice. Tversky assumes, more or less implicitly, that all the features are independent, a very troublesome assumption in real world situations.

4.3 Fuzzy Set-Theoretic Similarity

Tversky's experiments have shown that the feature contrast model has a number of desirable properties. Most noticeably, it explains violation of symmetry and of the corner equality.

Although this model is very appealing, it has a serious flaw for a theory based on preattentive similarity—the features used in Tversky's model are binary. I have noted that a natural interpretation for binary features is that of predicates about the stimulus. For instance, the presence of the feature "round corners" comes from the truth of the predicate "the corners of the figure are round" for that particular stimulus. This kind of predicates is not likely to be computed by simple mechanisms in the early vision areas of the brain, nor are they likely to be computed before recognition and categorization processes. The most likely operation that is done in the early vision areas is the local *measurement* of quantities. Preattentive similarity is more likely to be based on this kind of features. Apart from the neurological implausibility of logic predicates like those required by Tversky's model, there is the problem (which is relevant for applications) of how measurements, like lengths, angles, and so on, which are the usual features of preattentive similarity (and in image analysis), can be represented in the theory. Because of its binary features, Tversky is forced to adopt a rather unnatural convention for the representation of numerical quantities. For instance, positive quantities—such as a length—are discretized into a sequence l_i and represented as a collection of feature sets such that if $l_1 < l_2 \cdots < l_n$, then $A_1 \subset A_2 \cdots \subset A_n$. Quantities that can be either positive or negative are represented by even more complex constructions.

This kind of representation appears quite unnatural, but it has more or less gone unnoticed in the psychological literature. The reason for this is that it is acknowledged that, for human judgment, several similarity assessment processes are operating at the same time, and one could always argue that feature contrast similarity is operating mainly on binary features.

These considerations lead one to adapt the theory, eliminating the restriction of the use of binary features, and allowing it to work on any kind of measurement that might be done on an image. I will do this in a few steps, and this section presents the first. I will eliminate the use of binary features by developing a *fuzzy logic* version of Tversky theory. At first, this might not look like a dramatic improvement, just replacing predicates with fuzzy predicates, and true-false values with graded truth values. This model, however, will accomplish one important goal: It will provide a theory of similarity that has all the desirable characteristics of Tversky's model and, at the same time, is based on real-valued features measured on the stimulus.

The next subsection introduces the use of fuzzy predicates in the feature-contrast model. The use of fuzzy logic will allow the extension of Tversky's results to situations in which modeling by enumeration of features is impossible or problematic. Then I will deal with the problem of feature independence, showing

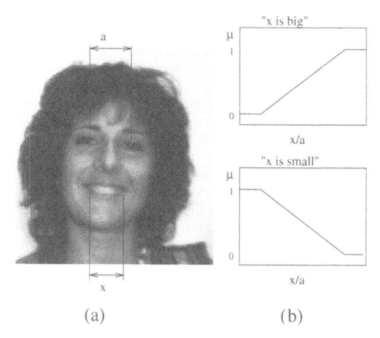

Figure 4.10. Determination of the truth value of the predicates "the mouth is wide" and "the mouth is narrow." The width of the mouth x is measured and normalized with respect to the distance between the eyes a. Then, two membership functions are used to determine the truth value of the two predicates.

that the use of fuzzy (nonadditive) measures provides a natural framework to deal with this problem.

4.3.1 Fuzzy Features Contrast Model

Consider a database of mug-shot images of faces, and its typical task, assessing the similarity between two faces. A face is characterized by a number of features of different types but, for the following discussion, I will only consider *geometric features*, as these lead naturally to predicate features. It seems pretty intuitive that face similarity is influenced by things like the size of the mouth, the shape of the chin, and so on. Also, intuitively, two faces with big mouths will be, all other things being equal, more similar than a face with a big mouth and one with a small mouth.

A predicate like *the mouth of this person is wide* can be modeled as a fuzzy predicate whose truth is based on the measurement of the width of the mouth. For instance, one can measure the width of the mouth x in Fig. 4.10a[5] and use two *truth functions* (see in what follows) like those in Fig. 4.10b to determine the truth value of the predicates "the mouth is wide" and "the mouth is narrow."

[5] In actual operations, the measurements are normalized by dividing them by the distance a between the eyes. This way the measure is invariant with respect to the size of the image.

In general, given an image I and a number of measurements s^i on the image, these measurements can be used to assess the truth of p *fuzzy predicates*. Some care must be taken to define the truth value of a fuzzy predicate. I use the following definition:

DEFINITION 4.4. *Let Ω be a set and $s : \Omega \to \mathbb{R}^m$ a measurement function on Ω. Let $P\omega$ be a predicate about $\omega \in \Omega$. The truth of the predicate $P\omega$ is a function*

$$T(P\omega) = \mu_P(s(\omega)) \tag{4.33}$$

with $\mu_p : \mathbb{R}^m \to [0,1]$.

In the preceding example, for instance, the truth of the predicate "the mouth of this person is wide" depends on measurements of the face (viz. the measurement of the width of the mouth).

From the measurements s^i it is possible to derive the truth values of a number p of fuzzy predicates, and collect them into a vector:

$$\mu(s) = \{\mu^1(s), \ldots, \mu^p(s)\} \tag{4.34}$$

I call $\mu(s)$ the (fuzzy) set of *true predicates* on the measurement set s. The set is fuzzy since a predicate P_j belongs to $\mu(s)$ to the extent $\mu^j(s)$. This value can be zero (the predicate is absolutely false), 1 (the predicate is absolutely true and fully belongs to $\mu(s)$), or something in between (the predicate belongs to $\mu(s)$ only to a certain extent). This fuzzy set can be used as a basis to apply Tversky's theory.

In order to apply the feature contrast model to the fuzzy sets $\mu(s)$ and $\mu(r)$ of the predicates true for the measurements s and r, it is necessary to choose a suitable salience function f, and compute the fuzzy sets $\mu(s) \cap \mu(r)$, $\mu(s) - \mu(r)$, and $\mu(r) - \mu(s)$.

The choice of the saliency is an important problem, and the concept of saliency itself is not very well defined. The rôle of the saliency function f will be clearer in later models. For the moment, I will stay on Tversky's path, and consider the saliency of a stimulus as a function of the number of its features. In particular, assume that the saliency of the fuzzy set $\mu = \{\mu^1, \ldots, \mu^p\}$ is given by the cardinality of the fuzzy set:

$$f(\mu) = \sum_{i=1}^{p} \mu^i \tag{4.35}$$

The extension of the Tversky distance requires the definition of the operations of intersection and difference of fuzzy sets. Traditionally, the intersection of fuzzy sets is defined as follows. Let μ_A and μ_B be the membership functions of two sets. Then the membership function of the intersection of A and B is defined as

$$\mu_{A \cap B}(x) = \min(\mu_A(x), \mu_B(x)) \tag{4.36}$$

Further, the difference of two fuzzy sets is defined by the function

$$\mu_{A-B}(x) = \max\{\mu_A(x), 1 - \mu_B(x)\} \qquad (4.37)$$

This definition, however, leads to some undesired effects. For instance, with these definitions the self-similarity of the stimulus a is given by

$$S(A, A) = \theta \sum_i \mu^i(s_a) - (\alpha + \beta) \sum_i \max\{\mu^i(s_a), 1 - \mu^i(s_a)\} \qquad (4.38)$$

For one thing, this means that the self-similarity of a depends on the values of α and β. This couples the determination of the self-similarity to the coefficients used to weight the importance of the distinctive features, while it would be desirable to have the two things as decoupled as possible. Then, the second summation is always greater or equal than the first. This implies that if one decides to assign a relatively large weight to the distinctive features, the self-similarity of certain stimuli could become negative.

All these things can be avoided if we require that the relation $\forall A (A - A) = \emptyset$ continue to hold in the fuzzy domain. I will cast this problem in a fairly general schema, since the same technique will become useful in the following chapters. Fagin (1966) introduced the concept of *norm*, *co-norm* (or, as they are sometimes called, t-norms and s-norms), and their relation. These functions will be considered in some detail in chapter 8 but, for the current purposes, the following few notes will suffice.

A function $\wedge : [0, 1]^2 \rightarrow [0, 1]$ is a norm if it satisfies the following conditions:

Commutativity: $\wedge(x, y) = \wedge(y, x)$

Associativity: $\wedge(\wedge(x, y), z) = \wedge(x, \wedge(y, z))$

Monotonicity: If $x \leq y$ and $w \leq z$, then $\wedge(x, w) \leq \wedge(y, z)$

Boundary: $\wedge(0, x) = 0$, and $\wedge(1, x) = x$.

The *dual* co-norm of \wedge is defined as

$$\vee(x, y) = 1 - \wedge(1 - x, 1 - y) \qquad (4.39)$$

(and satisfies the dual conditions of the norm \wedge). In addition, if the negation is defined by the operator $\neg(x) = 1 - x$, a form of the de Morgan theorems can be proven to hold (see Chapter 8).

The membership function of the intersection of two sets can be defined using a norm \wedge as

$$\mu_{A \cap B}(x) = \wedge(\mu_A(x), \mu_B(x)) \qquad (4.40)$$

The negation can be defined as

$$\mu_{\neg A}(x) = \neg(x) = 1 - \mu_A(x) \qquad (4.41)$$

and the union can be defined through the dual co-norm of \wedge. For instance, if $\wedge(x,y) = \min(x,y)$ the dual co-norm is $\vee(x,y) = \max(x,y)$, which is the traditional fuzzy logic definition of the "or" operator.

A possible definition of the difference between two sets that guarantees $A - A = \emptyset$ is obtained by using the operator $\ominus : [0,1]^2 \to [0,1]$ defined as

$$\ominus(x,y) = \max(x - y, 0) \tag{4.42}$$

The question is: What form should the operators \wedge and \vee take to be compatible with this definition of difference? Assume that the negation operator is $\neg(x) = 1 - x$ (i.e., $\mu_{\neg B} = 1 - \mu_B(x)$). Because $A - B = A \cap \neg B$, then it is $a \wedge \neg b = \max(a - b, 0)$ and, by the substitution $b \to 1 - b$:

$$\wedge(a,b) = \max(a + b - 1, 0) \tag{4.43}$$

which induces

$$\begin{aligned}\vee(a,b) &= 1 - \wedge(1 - a, 1 - b) \\ &= 1 - \max(1 - a - b, 0) \\ &= \min(1, a + b)\end{aligned} \tag{4.44}$$

Therefore

$$\begin{aligned}\wedge(a,b) &= \max(a + b - 1, 0) \\ \vee(a,b) &= \min(1, a + b) \\ \neg a &= 1 - a\end{aligned} \tag{4.45}$$

THEOREM 4.2. *The function $f(x,y) = \max(x + y - 1, 0)$ is a norm.*

PROOF. The verification of commutativity and monotonicity is immediate. For boundary, if $x = 0$ then, since $y \le 1$, $y - 1 \le 0$, therefore $\max(0 + y - 1, 0) = 0$. If $x = 1$, then, since $y \ge 0$, then $\max(1 + y - 1, 0) = y$.

Consider now associativity. It is

$$A = f(x, f(y,z)) = \max(x + \max(y + z - 1, 0) - 1, 0) \tag{4.46}$$

and

$$B = f(f(x,y), z) = \max(\max(x + y - 1, 0) + z - 1, 0) \tag{4.47}$$

Associativity holds if, for all x, y, z, $A = B$. There are four cases to consider:

$x + y - 1 \le 0$, $y + z - 1 \le 0$. In this case, $\max(y + z - 1, 0) = 0$, so $A = 0$, and $\max(x + y - 1, 0)$, so $B = 0$. Therefore $A = B$.

$x + y - 1 > 0$, $y + z - 1 \le 0$. In this case, $A = 0$, as before. Also, $\max(y + z - 1, 0) = y + z - 1$ and $B = \max(x + y + z - 2, 0)$. Since $y + z - 1 \le 0$, we have $x + y + z - 2 \le 0$, so $B = 0$, which implies $A = B$.

$x + y - 1 \le 0$, $y + z - 1 > 0$. This case is the symmetric of the previous one, and it also yields $A = B = 0$.

$x + y - 1 > 0$, $y + z - 1 > 0$. In this case all the first arguments of the maximum functions are positive, and $A = B = \max(x + y + z - 2, 0)$.

Therefore the function f is associative. □

Finally, by the way it is derived, it is obvious that the function \vee is the dual co-norm of \wedge.

With these definitions, one can write the Tversky's similarity function between two fuzzy sets $\mu(s)$ and $\mu(r)$ corresponding to measurements made on two images as:

$$
\begin{aligned}
S(s, r) = &\sum_{i=1}^{p} \max\{\mu^i(s) + \mu^i(r) - 1, 0\} \\
&- \alpha \sum_{i=1}^{p} \max\{\mu^i(s) - \mu^i(r), 0\} \\
&- \beta \sum_{i=1}^{p} \max\{\mu^i(r) - \mu^i(s), 0\}
\end{aligned}
\tag{4.48}
$$

I call the model defined by Eq. (4.48) the fuzzy features contrast (FFC) model.

It is easy to see that the fuzzy feature contrast model can be asymmetric (if $\alpha \neq \beta$). It is also easy to find an example of violation of the corner inequality. Consider Fig. 4.8 with $x_1 = y_1 = 0$, $x_2 = y_2 = 1/4$, and $x_3 = y_3 = 1$. Let the membership function in the FFC model be

$$
\mu(x) = \begin{cases} 0 & \text{if } x < 0 \\ x & \text{if } 0 \leq x \leq 1 \\ 1 & \text{if } x > 1 \end{cases}
\tag{4.49}
$$

Then it is:

$$
\begin{aligned}
d(x_1 y_1, x_3 y_1) &= d((0, 0), (1, 0)) = \beta \\
d(x_1 y_1, x_2 y_2) &= d\left((0, 0), \left(\frac{1}{4}, \frac{1}{4}\right)\right) = \frac{\beta}{2} \\
d(x_3 y_1, x_3 y_3) &= d((1, 0), (1, 1)) = \beta - 1 \\
d(x_2 y_2, x_3 y_3) &= d\left(\left(\frac{1}{4}, \frac{1}{4}\right), (1, 1)\right) = \frac{3\beta - 1}{2}
\end{aligned}
$$

Condition 4.27 is violated if $\beta > \beta/2$ and $\beta - 1 < (3\beta - 1)/2$, while condition 4.28 is violated if $\beta > (3\beta - 1)/2$ and $\beta - 1 < \beta/2$. Thus, the corner inequality is violated for $\beta < 1$.

A property similar to the representation theorem can be proven for the fuzzy measure. Let $y \in \mathbb{R}^n$, and

$$
y \xleftarrow{i} x = (y_1, \dots, y_{i-1}, x, y_{i+1}, \dots, y_n)
\tag{4.50}
$$

Then the following theorem holds:

THEOREM 4.3. *Let $F : \mathbb{R}^3 \leftarrow \mathbb{R}$ be an analytic function such that the following properties hold:*

1. *$F(x, y, z)$ is monotonically nondecreasing in x and monotonically nonincreasing in y and z. The partial derivatives of F are nonzero almost everywhere.*

2. *For all $i = 1, 2, 3$, if $\forall j \neq i, s_j = s'_j, t_j = t'_j, s_i = t_i, s'_i = t'_i$, then $F(s) \leq F(t) \Leftrightarrow F(s') \leq F(t')$.*

3. *For all s, the sets $\{t | F(s) \geq F(t)\}$ and $\{t | F(t) \geq F(s)\}$ are closed in the product topology of \mathbb{R}^3.*

4. *$F(y \overset{i}{\leftarrow} x_1) - F(y \overset{i}{\leftarrow} x_2) = F(y \overset{i}{\leftarrow} z_1) - F(y \overset{i}{\leftarrow} z_2)$ if and only if for all j there is a u_j such that $F(u_j \overset{j}{\leftarrow} x_1) - F(u_j \overset{j}{\leftarrow} x_2) = F(u_j \overset{j}{\leftarrow} z_1) - F(u_j \overset{j}{\leftarrow} z_2)$.*

Then there are functions G and $f : \mathbb{R} \rightarrow \mathbb{R}$ such that

$$G(x, y, z) = \alpha f(x) + \beta f(y) + \gamma f(z) \tag{4.51}$$

and $F(x, y, z) \geq F(x', y', z') \Leftrightarrow G(x, y, z) \geq G(x', y', z')$.

The following lemma will be needed in order to prove the theorem:

LEMMA 4.1. *Let f_1, f_2 be two analytic functions whose derivatives are nonzero almost everywhere. Then, for almost all x and almost all y it is possible to find x', y' such that*

$$f(x) - f(x') = f(y) - f(y') \tag{4.52}$$

Moreover, if this is true for x' then for every x'' such that $\|x - x''\| \leq \|x - x'\|$ it is possible to find y'' such that

$$f(x) - f(x'') = f(y) - f(y'') \tag{4.53}$$

The proof of this lemma is very simple and will be omitted.

PROOF OF THEOREM 4.3. By the theorem reported in Debreu (1960), the first three conditions guarantee that F can be written as

$$F(x_1, x_2, x_3) = V(f_1(x_1) + f_2(x_2) + f_3(x_3)) \tag{4.54}$$

where V is a monotonically increasing function. Because of this, the same ordinal properties of F can be obtained by the function

$$\tilde{F}(x_1, x_2, x_3) = f_1(x_1) + f_2(x_2) + f_3(x_3) \tag{4.55}$$

Since, by the first assumption, the function F is monotonic when only one of the variables is changed, each one of the f_i is either monotonically increasing or monotonically decreasing. Given the monotonicity characteristics of F, it is possible to write

$$\tilde{F}(x_1, x_2, x_3) = f_1(x_1) - f_2(x_2) - f_3(x_3) \tag{4.56}$$

with all the functions monotonically increasing. This, together with the fact that the derivatives of the f_i are nonzero almost everywhere, implies that the derivatives of the f_i have the same sign almost everywhere.

Property 4 implies that if

$$f_i(q_a) - f_i(q_b) = f_i(p_a) - f_i(p_b) \tag{4.57}$$

then for all j

$$f_j(q_a) - f_j(q_b) = f_j(p_a) - f_j(p_b) \tag{4.58}$$

Take x, x', y, y' with $x' > x$ and $y' > y$ such that

$$f_i(x') - f_i(x) = f_i(y') - f_i(y) \tag{4.59}$$

(the existence of these points is guaranteed by Lemma 4.1). By hypothesis it is

$$f_j(x') - f_j(x) = f_j(y') - f_j(y) \tag{4.60}$$

that is,

$$\frac{f_i(x') - f_i(x)}{f_j(x') - f_j(x)} = \frac{f_i(y') - f_i(y)}{f_j(y') - f_j(y)} \tag{4.61}$$

Consider a sequence $\{x_n\}$ such that $x_1 = x'$, $x_n > x_{n-1}$, $\lim_{n \to \infty} x_n = x$. By the second part of Lemma 4.1, it is possible to find a sequence y_n converging to y such that Eq. (4.61) holds for x_n, y_n, that is:

$$\frac{f_i(x_n) - f_i(x)}{f_j(x_n) - f_j(x)} = \frac{f_i(y_n) - f_i(y)}{f_j(y_n) - f_j(y)} \tag{4.62}$$

Since the functions f_i are analytic, the limits of these ratios converge to the limits of the derivatives:

$$\frac{f_i'(x)}{f_j'(x)} = \frac{f_i'(y)}{f_j'(y)} \tag{4.63}$$

This relation is true almost everywhere and, by the continuity of the functions f_i, it can be extended to the entire domain of definition, so:

$$\frac{f_i'(x)}{f_j'(x)} = \alpha > 0 \tag{4.64}$$

or:

$$f_i(x) = \alpha f_j(x) + \beta \tag{4.65}$$

The terms β are constants, and irrelevant for the ordinal properties of the function F; therefore, it is possible to write

$$\tilde{F}(x_1, x_2, x_3) = \gamma f(x_1) - \alpha f(x_2) - \beta f(x_3) \tag{4.66}$$

where the constants are positive and the signs are chosen in accord with the monotonicity properties of F. □

This distance, as well as all distances of fuzzy derivation depend on the definition of a suitable *membership* function [Dubois and Prade, 1980a]. In many cases it will be useful to have a smooth membership. The nature of the membership function depends on the nature of the features under consideration. There are two main classes of features that I will use, *linear* and *angular*. Linear features take value in a totally ordered space and are aperiodic. Typical membership functions for linear features are monotonically increasing (of the type "x is big") or monotonically decreasing (of the type "x is small"). A typical membership function for linear features is the *logistic* or *sigmoid*[6] function:

$$\mu_{\alpha,\beta}(x) = \frac{1}{1 + \exp(-\alpha(x - \beta))} \qquad (4.67)$$

where α and β are parameters that define the shape of the function and that are usually determined a priori.

Features like angles are naturally periodic. If a predicate is true for a value x of the feature, it will be equally true for $x + 2\pi$. The exact nature of the periodicity depends on the predicate. A predicate like "x is horizontal" will result in a membership function with period π, while a predicate like "x is facing east" will result in a membership function with period 2π. A typical membership function for angular features will look like the following:

$$\eta_{\omega,\alpha,\beta}(x) = |\cos(\omega\pi(x - \beta))|^{\alpha} \qquad (4.68)$$

where ω, α, and β are shape factors.

I should like to conclude this section with an observation. Consider a one-dimensional feature space, and plot the similarity between a variable stimulus s and a fixed reference stimulus r. The result is the series of curves in Fig. 4.11. This family of curves exhibits the exponential behavior observed by Shepard in his 1987 paper, which was introduced in section 4.2.1. In the same paper, Shepard observed discrepancies from his universal function g for certain types of stimuli. In particular, the exponential function seemed to fit the data in experiments in which *generalization is tested immediately after a single learning trial with a new stimulus* [Shepard, 1987]. If the experimental circumstances changed—for instance in protracted discrimination training with highly similar stimuli or with delayed test stimuli—the generalization data deviate from the simple exponential function to an inflected Gaussian function (Fig. 4.5). The curves of Fig. 4.11 present both these behaviors. Consider the portion of the curves with $s > r$—if the reference has a high saliency (e.g., $r = 1$), then the behavior is exponential, while if the reference has low saliency (e.g., $r = -1$), then the behavior is Gaussian.

This is quite an intriguing result, because it seems to suggest that, according to this theory, the effect of the experimental circumstances in which the Gaussian behavior was observed is to decrease the saliency of the reference. This

[6] So called because of the shape of its graph, which reminds us loosely of the letter "S."

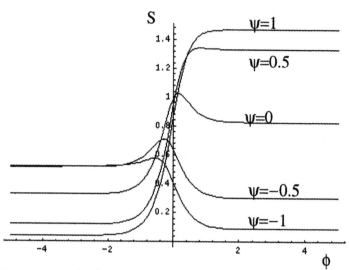

Figure 4.11. The fuzzy similarity in the one-dimensional case.

interpretation should be verified experimentally, a task that goes well beyond the scope of this book. It is however interesting to note that, at least in the case of protracted discrimination training with highly similar stimuli the loss of saliency could be due to effects already observed by Tversky (1977) and connected to the *diagnosticity* of a stimulus in a given situation. The pursuit of this idea would lead me too far from the topic, so I will just leave it here as an observation and an invitation to future speculation and experimentation.

4.3.2 Feature Dependence

The extension of Tversky's measure introduced in the previous section suffers from a drawback—it considers all the features as independent. For instance, in the characterization of a face, the truth of the statement "the mouth is wide" depends only on the width of the mouth, and on no other face measurement. This independence property is easily proved to be false for human perception. Consider, for instance, the famous visual illusion of Fig. 4.12, in which the horizontal line in (a) appears longer than the horizontal line in (b) although the two have the same length. This dependence is not modeled by the fuzzy measure in the previous section. Assume that the the truth of the predicate "line A is longer than line B" is given by a fuzzy inference rule like

If line A is long and line B is short, then line A is longer than line B.

I will use the following fuzzy implication rule: If we have two predicates "X is A," with a truth value $\mu_A(X)$, and a predicate "Y is B," with a truth value $\mu_B(Y)$, then the truth value of the implication "if X is A then Y is B" is given by

$$\mu_{A \Rightarrow B}(X, Y) = \mu_{A \vee \neg B}(X, Y) = \max\{\mu_A(X), 1 - \mu_B(Y)\} \qquad (4.69)$$

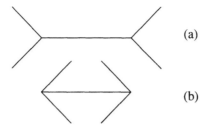

Figure 4.12. A proof that the truth of a fuzzy predicate can depend on measures of quantities different from the subject of the predicate; in this case, the truth of the predicate "the line is long" must be different in the two cases, since the predicate "line A is longer than line B" has a truth value different from zero. Yet the length of the two lines is the same. Therefore, the truth of the predicate depends on other measures.

Let μ' be the truth value of the predicate "line A is longer than line B," and μ_A, μ_B be the truth values of the predicates "line A is long," and "line B is long," respectively. Then

$$\mu_{\Rightarrow} = \max\{\min\{\mu_A, 1 - \mu_B\}, 1 - \mu'\} \tag{4.70}$$

Since the predicate "line A is longer than line B" is perceived as true, it is $\mu' > 1/2$. Moreover, the implication is valid and, therefore, $\mu_{\Rightarrow} > 1/2$. This implies

$$\min\{\mu_A, 1 - \mu_B\} > \frac{1}{2} \tag{4.71}$$

This relation must be true for all the values of μ_A. In particular, the effect is strong when the line A is not judged neither "long" nor "short," that is, when $\mu_A = 1/2$. In this case, for the inequality to be true, it must be $\mu_B < 1/2$.

The fuzzy feature contrast model must be refined to take this fact into account. This can be done two ways. One possible solution is to state that the truth of the ith predicate depends not only on the measurement x_i, but also on all the measurements on which the predicates that interact with i are based. For instance, if the truth of the jth predicate influences the truth of the ith, the truth value of the latter can be written as $\mu(x_i, x_j)$. One immediate possibility is to have μ depend, via a *correlation coefficient*, on the product of the two measurements:

$$\mu(x_i, x_j) = \mu\left(x_i + \alpha\left(x_i - \frac{1}{2}\right)\left(x_j - \frac{1}{2}\right)\right). \tag{4.72}$$

One problem of this approach is that now the function μ cannot be used to judge the length of the first line when it is presented alone (because, in that case, one would not know what value to assign to x_j!). This requires postulating quite a complicated mechanism: For every possible combination of predicates that interact with each other one must postulate a different truth function devoted exclusively to the determination of the truth of one predicate when the given combination of the other predicates is present. This is certainly possible but, as Occam's razor goes, it looks quite blunt.

Another possibility is to assume that the truth of each predicate is not affected by the truth of other predicates, but the way the predicates interact is. In this case, one does not measure the correlation between the different measures, such as in Eq. (4.72), but the correlation between the truth of predicates—if two predicates tend to be true together, they reinforce each other. This model applies to the following situation—imagine you know the length of the segments of Fig. 4.12 (possibly their lengths relative to the whole figure); then you can express a judgment as to whether the predicate "the horizontal segment is long" is true. This judgment does not depend on the other features on the image, and, if x_i is the length of the horizontal segment, it is modeled by the value $\mu_i(x_i)$.

However, when the same image is perceived, the length of the horizontal segment is perceived differently depending on the presence or absence of other features (like the existence of outwardly pointing diagonal segments). Although the truth of the predicate "the horizontal line is long" is still the same, the *measure* of the set of true features is changed because of the interaction between different predicates.

The latter model can be defined mathematically by replacing the function f in the definition of the fuzzy feature contrast similarity with a fuzzy integral defined over a suitable fuzzy measure. In particular, one can use a *Choquet Integral* [Murofushi and Sugeno, 1989; Ralescu and Adams, 1980; Wang and Klir, 1992], and a fuzzy measure that models the interaction between the different predicates [Miyajima and Ralescu, 1993; Makayama *et al.*, 1993]. The fuzzy measure and the relative Choquet integral are defined as follows:

DEFINITION 4.5. *Let $X = \{x_1, \ldots x_n\}$ be a finite universe. A fuzzy measure m is a set function $m : \mathcal{P}(X) \to [0,1]$ verifying the following axioms:*

- $m(\emptyset) = 0$

- $m(X) = 1$

- $A \subseteq B \Rightarrow m(A) \leq m(B)$

where $\mathcal{P}(X)$ indicates the power set of X, that is, the set of all subsets of X.

DEFINITION 4.6. *Let m be a fuzzy measure on X. The discrete Choquet integral of a function $f : X \to \mathbb{R}^+$ with respect to m is defined as:*

$$\int (f(x_1), \ldots, f(x_n)) m = \sum_{i=1}^{n} \left(f(x_{(i)}) - f(x_{(i-1)})\right) m(A_{(i)}) \tag{4.73}$$

where the notation $._{(i)}$ means that the indices have been permutated so that

$$0 \leq f(x_{(1)}) \leq f(x_{(2)}) \cdots \leq f(x_{(n)}) \leq 1 \tag{4.74}$$

$f(x_{(0)})$ is defined to be 0, and

$$A_{(i)} = \{x_{(i)}, \ldots, x_{(n)}\} \tag{4.75}$$

Suppose now that X is the universe of fuzzy predicates about a certain image, that is, $x_i = \mu_i(\phi)$, where ϕ is the vector of measurements, and μ_i the truth function for the ith predicate. Also, let f be the identity function $f(x) = x$. Assume, to simplify the notation, that the predicates are already ordered so that

$$0 \le \mu_1(\phi) \le \mu_2(\phi) \cdots \le \mu_n(\phi) \le 1 \qquad (4.76)$$

and define the dummy predicate μ_0 that is always false, that is, $x_0 = \mu_0(\phi) = 0$.

LEMMA 4.2. *The fuzzy cardinality of the set of true predicates is equal to n times the Choquet integral of the identity function when m is additive and equidistributed (i.e., sets of the same cardinality have equal measure)*

PROOF. Since $m(X) = 1$ and m is equidistributed, it is $m(\{x_i\}) = 1/n$. Moreover, because of additivity,

$$m(A_i) = \sum_{j=i}^{n} m(\{x_i\}) = \frac{n - i + 1}{n} \qquad (4.77)$$

therefore, the Choquet integral can be written as:

$$\int (x_1, \ldots, x_n) = \sum_{i=1}^{n} (x_i - x_{i-1}) \frac{n - i + 1}{n} = \frac{1}{n} \sum_{i=0}^{n} x_i - x_0 \qquad (4.78)$$

which, since $x_0 = 0$ by definition, is the desired result. □

So, when the measure is additive and equidistributed, the Choquet integral reduces to the cardinality of the fuzzy set, which is the saliency function used in Eq. (4.48). To see how it is possible to use the nonadditivity of the measure to model dependence between predicates, suppose that all the predicates are independent except for μ_{n-1} and μ_n, for which it is true that the truth of μ_n increases the possibility that μ_{n-1} also be true. Referring to Fig. 4.12, the two predicates might be:

P_1: "The diagonal lines point strongly outward."
P_2: "The horizontal line is long."

What is the effect of this dependency on the fuzzy measure? Since the perception of the outwardly pointing diagonal lines increases the perception of the length of the line, the set of two predicates $\{P_1, P_2\}$ has a higher significance, or degree of truth, than the truth of the two sets $\{P_1\}, \{P_2\}$ taken separately. That is, the measure of the set of true predicates is increased due to this dependence. If the truth values of the two predicates, consequent to the measurements, are x_{n-1} and x_n, it is

$$m(\{x_{n-1}, x_n\}) = m(\{x_{n-1}\}) + m(\{x_n\}) + \gamma_{n-1,n} m(\{x_{n-1}\}) m(\{x_n\}) \qquad (4.79)$$

where $\gamma_{n-1,n} \ge 0$ is a coefficient that models the dependence between the two predicates. In terms of the Choquet integral, the dependence between the two predicates gives more "weight" to the truth of x_{n-1} if x_n is also true.

To continue our example, consider an equidistributed measure:

$$m(\{x_i\}) = \frac{1}{n} \tag{4.80}$$

with the dependency between x_{n-1} and x_n yielding:

$$m(\{x_{n-1}, x_n\}) = \frac{2 + (y_{n-1,n})/n}{n} = \frac{2 + \tilde{y}}{n} \tag{4.81}$$

Further, suppose that all the other measures are additive, that is

$$m(\{x_{i_1}, \dots, x_{i_p}\}) = \sum_{j=1}^{p} m(\{x_{i_j}\}) = \frac{p}{n} \tag{4.82}$$

if either x_{n-1} or x_n do not belong to $\{x_{i_1}, \dots, x_{i_p}\}$, and

$$m(\{x_{i_1}, \dots, x_{i_p}\}) = \sum_{j=1}^{p} m(\{x_{i_j}\}) + y_{n-1,n} m(\{x_{n-1}\}) m(\{x_n\})$$
$$= \frac{p}{n} + \tilde{y} \tag{4.83}$$

if they do.

When the Choquet integral is computed, the predicates are ordered by their truth value. Suppose that the value $x_{n-1} = \mu(\phi)$ is the hth in the ordering, and that $x_n = \mu(\phi)$ is the kth, that is,

$$x_{(h)} = x_{n-1}$$
$$x_{(k)} = x_n \tag{4.84}$$

with, say, $k > h$. In this case, in the Choquet integral, there will be $n - k$ subsets that contain both x_{n-1} and x_n, and

$$\int (\mu_1, \dots \mu_n) = \frac{1}{n} \sum_{i=1}^{n} \mu_i + \frac{n-k}{n} \tilde{y} x_n \tag{4.85}$$

Thus, the measure of the set of predicates is increased due to the dependence of x_{n-1} and x_n. Note that none of the single truth values is changed (in the example: the judged length of the lines seen alone is still the same). The changed value of the set measure is only a property of the interaction between truth values as described by the fuzzy measure.

In the following, I will assume a fuzzy measure of the form:

$$m(\{x_{i_1}, \dots, x_{i_p}\}) = \sum_{j=1}^{p} m(\{x_{i_j}\}) + y_{i_1, \dots, i_p} \prod_{j=1}^{p} m(\{x_{i_j}\}) \tag{4.86}$$

The 2^n constants y_{i_1, \dots, i_p}, $i_1 < i_2 \cdots < i_p$ uniquely characterise the measure, and must be determined experimentally.

The y parameter must let the measure satisfy the three requirements of Definition 4.5. In particular, the measure of a set must be greater or equal to the

measure of all its subsets. Let us consider, without loss of generality, the two sets $A = \{x_1, \ldots x_p\}$ and $B = \{x_1, \ldots, x_k\}$, with $k > p$. Then one has

$$m(A) = \sum_{i=1}^{p} m(\{x_i\}) + y_A \prod_{i=1}^{p} m(\{x_i\})$$

$$m(B) = \sum_{i=1}^{k} m(\{x_i\}) + y_B \prod_{i=1}^{k} m(\{x_i\}) \tag{4.87}$$

By definition of fuzzy measure, it must be $m(B) \geq m(A)$ and, therefore,

$$m(B) - m(A) = \sum_{i=p+1}^{k} m(\{x_i\})$$

$$+ y_B \prod_{i=1}^{k} m(\{x_i\})$$

$$- y_A \prod_{i=1}^{p} m(\{x_i\})$$

$$\geq 0 \tag{4.88}$$

From this relation it is possible to derive the relation between y_A and y_B:

$$y_A \leq \frac{\sum_{i=p+1}^{k} m(\{x_i\})}{\prod_{i=1}^{p} m(\{x_i\})} + y_B \prod_{i=p+1}^{k} m(\{x_i\}) \tag{4.89}$$

In the case of an equidistributed measure ($m(\{x_i\}) = 1/n$), we have:

$$y_A \leq n^p(k - p) + \frac{y_B}{n^{k-p}} \tag{4.90}$$

Therefore, given a fuzzy measure m that takes into account the dependence among features, the Tversky similarity is defined as:

$$S(\phi, \psi) = \int \max\{\mu_i(\phi) + \mu_i(4) - 1, 0\}$$

$$- \alpha \int \max\{\mu_i(\phi) - \mu_i(\psi), 0\}$$

$$- \beta \int \max\{\mu_i(\phi) - \mu_i(\psi), 0\} \tag{4.91}$$

Both these measures reduce to the usual Tversky similarity if the features are binary and the measure is additive and equidistributed.

4.4 Consideration of Geometric Distances

Researchers have documented a number of different similarity mechanisms at play in similarity judgment. In a very real sense, similarity judgments are not a phenomenon, but a collection of rather different phenomena, only superficially

related. Torgerson (1965) distinguished two broad families of similarity assessments. In the first family, he includes similarity as a basic perceptual activity that operates between multidimensional perceptual vectors. In the second family, he included similarity as an indirect cognitive relation between stimuli represented by complex sheaves of attributes, only part of which are perceptual. The similarity perceptions of the first family are typically simpler than those of the second in which the whole range of phenomena encountered in the previous sections (contextuality, asymmetry, violation of the triangle inequality...) is manifest.

These phenomena appear in the case of cognitive similarity because the subjects are more free to move the focus from certain features to others, as demanded by the different similarity tasks. Sjöberg (1972), for instance, explains the asymmetry of human similarity perception with the assumption that similarity judgment involves an active search for ways in which objects are similar. For the violation of the triangle inequality, a famous example was given by William James (1890): A fire is similar to the moon on account of luminosity, and the moon is similar to a football on account of shape, but the fire and a football are not similar at all. This example, in the light of the observations in Chapter 2, also reveals another characteristic of cognitive similarity: its cultural derivation. The luminosity of the fire and the moon is recognized as a legitimate common feature in the light of a cultural convention while, for instance, the fact that the fire and the football are at the same distance from the observer is, by virtue of the same convention, not considered relevant ground for similarity.

Borrowing an example from Eco (1976, p. 194), saccharine is similar to sugar. But chemical analysis demonstrates that no objective resemblance exists between the two: sugar is a disaccharide with basic formula $C_{12}H_{22}O_{11}$, saccharine is a derivative of 0-sulfumide benzoic acid. Nor can the similarity be taken to be visual or haptic, for in this sense sugar should be considered more similar to salt than to saccharine. Saccharine is similar to sugar in that it gives us the perceptual stimulation that we classify as sweet. Although saccharine produces a different taste experience, both experiences go under the general semantic category of sweetness. But this similarity is only pertinent to a culture that recognizes sweetness as a sememe and opposes it to bitterness on one hand and to "saltiness" on the other. The features that have been isolated in order to assess the similarity between saccharine and sugar are not proper of the two compounds, but to their relation with the subject's cultural categories. For a culture with a more discriminating culinary semantic system (or for a refined cook), sweetness as such does not exist, but it resolves into a network of different types of sweetness, so that sugar and saccharine would be in opposition rather than in similarity relation.

The goal of an image database is to let the users superimpose their cultural semantics on the image data. As I argued in Chapter 2, the database itself does not possess the features for a meaningful semantic classification nor can it, as a matter of principle, possess them. The question at this point is whether incorporating in a database similarity measures which embody effects typical of cultural assessment of similarity is a fruitful operation or not. The answer

is a qualified yes. It is true that the features on which search engines are based are simple perceptual clues that belong to Torgerson's first family. In this sense, databases can be justified in using simple similarity measures. But, apart from the fact that, as mentioned on page 113, researchers have demonstrated that effects not explained by simple similarity measures appear in perceptual data (thereby making the use of more complex measures attractive for perceptual similarity), highly interactive databases have compelling reasons for making use of a rich similarity measures repertoire.

In an interactive database the interaction between the user and the system aims at inducing a categorization that, although based on perceptual features, is usually associated with Torgerson's cognitive judgment. In this work of super-position of cultural factors (from the user) into perceptual factors (derived from the database), it is quite likely that a similarity measure capable of displaying the characteristics of cognitive judgment will be more natural to the user, and instrumental in facilitating the "semantic endowment" process that constitutes the focus of the database.

It is therefore useful to define a general theory in which the various similarity criteria can appear as special cases. The metric nature of the features that are commonly derived from images suggests that such theory should be geometric. The remainder of this chapter will develop such a theory.

4.4.1 Metric and Similarity Structures

From the observations on the fuzzy form of the Tversky similarity model, one can derive two key observations: (1) the form of the distance function depends on the referent of the comparison; and (2) the space in which similarity is measured can be bounded, that is, two elements are not arbitrarily dissimilar but, as their features become more and more different, their dissimilarity "flattens out" to an upper limit. This section will cast these observations into a geometric theory, that is, one in which the similarity structure of the feature space is dependent upon an underlying metric structure of the feature space.

Metric structures. Let X be a set, and assume that there is a function $\rho : X \times X \to \mathbb{R}$ satisfying the distance axioms:

$$\rho(x, y) \in \mathbb{R} \qquad\qquad \text{for all } x, y \in X \qquad (4.92)$$

$$\rho(x, y) = 0 \qquad\qquad \text{if and only if } x = y \qquad (4.93)$$

$$\rho(y, z) \leq \rho(x, y) + \rho(x, z) \quad \text{for all } x, y, z \text{ in } X \qquad (4.94)$$

A function ρ with these properties is called a *metric* on X. Let $\mathfrak{D}(X)$ be the set of metrics on a set X. It is possible to prove [Copson, 1968] that the distance axioms imply that $\rho(x, y) \geq 0$ for all x, y (positivity) and that $\rho(x, y) = \rho(y, x)$ (symmetry). Also, using symmetry, the third relation (triangle inequality) can be

put into the more familiar form

$$\rho(x, y) \leq \rho(x, z) + \rho(z, y) \tag{4.95}$$

A *metric space* M is a pair $M = (X, \rho)$, where X is a set and ρ is a metric on X. Note that the function ρ is the integral part of the definition: Changing the distance function one obtains a different metric space, even if the set X is unchanged.

The metric space M is *bounded* if there is a positive number k such that $\rho(x, y) \leq k$ for all $x, y \in X$. In this case, the number

$$\delta(M) = \sup_{x, y \in X} \rho(x, y) \tag{4.96}$$

is called the *diameter* of the metric space. For an unbounded metric space, $\delta(M) = \infty$. The same definition can be applied to determine the diameter $\delta(A)$ of any subset A of a metric space.

Given the interest that bounded metric space has for image databases, I will spend a little time trying to characterize the properties of bounded distance functions. Most feature spaces are easily endowed with an unbounded distance function (e.g., a Euclidean distance if the space is a vector space). Thus, a good place to start for the study of bounded distance functions is the derivation of a bounded distance from an unbounded one. Consider a metric space $M = (X, \rho)$. One would like to derive from it another metric space $M' = (X, \rho')$ where $\rho'(x, y) = h(\rho(x, y))$ for some function $h : \mathbb{R} \to \mathbb{R}$. What properties should the function h have so that ρ' is a distance function? If h is at least C^2 (continuous until the second derivative), the answer is given by Theorem 4.4. Before proving the theorem, however, it is necessary to prove the following lemma. The form of this lemma is more general than is required in the proof of the theorem because it will also be used in the next section.

LEMMA 4.3. *Let h be an analytical (C^ω) function from \mathbb{R} to \mathbb{R}. Then*

$$h(a + b + w) + h(w) \geq h(a + w) + h(b + w) \tag{4.97}$$

for all $a, b > 0$, w iff $h''(x) \geq 0$ for all x.

PROOF. Suppose first that $h(a + b + w) + h(w) \geq h(a + w) + h(b + w)$ for all a, b, w. Expand h around w as follows:

$$h(a + b + w) = h(w) + h'(w)(a + b) + \frac{1}{2}h''(w)(a + b)^2 + o(a^2 + b^2) \tag{4.98}$$

$$h(a + w) = h(w) + h'(w)a + \frac{1}{2}h''(w)a^2 + o(a^2) \tag{4.99}$$

$$h(b + w) = h(w) + h'(w)b + \frac{1}{2}h''(w)b^2 + o(b^2) \tag{4.100}$$

The condition can be rewritten as

$$0 \geq -h''(w)ab + o(a^2 + b^2) \tag{4.101}$$

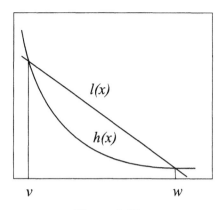

Figure 4.13.

This condition holds for all a, b. It is always possible to find a and b small enough so that the first term is greater in absolute value than $o(a^2 + b^2)$. For this value of a and b the condition equation (4.97) implies $h''(w) \geq 0$. Given the arbitrarines of w, the condition must be true for all w. This proves that $h''(w) \geq 0$ is a necessary condition.

To prove that the condition is also sufficient, consider the straight line $l(x)$ such that $l(w) = h(w)$ and $l(w + a + b) = h(w + a + b)$ (Fig. 4.13). For ease of notation, set $v = w + a + b$ so that the line is characterized by the conditions $l(w) = h(w)$ and $l(v) = h(v)$. Note that $w < w + a, w + b < v$. Consider now the function $f(x) = h(x) - l(x)$. It is easy to check that on the line $l(x)$ it is always true that $l(w + a + b) + l(w) = l(w + a) + l(w + b)$. Therefore, a sufficient condition for the satisfaction of Eq. (4.97) is $f(x) \leq 0$ for $w < x < v$. Also, it is obvious that $f''(x) = h''(x)$ for all x, as $l''(x) = 0$. Assume now that $f''(x) \geq 0$ and, by contradiction, assume that there is y with $w < y < v$ for which $f(y) > 0$. Note that because $f''(x) \geq 0$, $f'(x)$ is nondecreasing and therefore $f'(w) \leq 0$ and $f'(v) \geq 0$. Thus, there is $\varepsilon > 0$ such that, for $w < x < w + \varepsilon$ and for $v - \varepsilon < x < v$, $f(x) < 0$. If $f(x) > 0$ for some $x \in [w, v]$, then there is ξ such that $f(\xi) = 0$. This means that $f'(x) = 0$ at least twice—once for $\zeta_1 \in (w, \xi)$, and once for $\zeta_2 \in (x, v)$. Therefore, $f''(x)$ changes sign at least once, contradicting the hypothesis that $f'' \geq 0$. ☐

From this lemma one can immediately derive the following corollary, whose proof is immediate by replacing the function f with $-f$:

COROLLARY 4.1. *Let h be an analytical function from* \mathbb{R} *to* \mathbb{R}. *Then*

$$h(a + b + w) + h(w) \leq h(a + w) + h(b + w) \qquad (4.102)$$

for all $a, b > 0$, w *iff* $h''(x) \leq 0$ *for all* x.

Using the same techniques as in the proof of Lemma 4.3, it is possible to prove the following multidimensional version that will come in handy in the next section.

Similarity structures. A distance function d can be used to endow the space with a *similarity structure*, which transforms it into a similarity space. A *simple similarity function* on a space X is a function from X to \mathbb{R} with the following properties:

$$s(x,y) \in [0,1] \tag{4.107}$$
$$s(x,x) \geq s(x,y) \qquad \text{for all } y \tag{4.108}$$
$$s(x,y) = s(y,x) \tag{4.109}$$
$$s(x,y) \geq s(x,z) + s(z,y) - s(x,x) \quad \text{for all } x,y,x \in X \tag{4.110}$$

Let d be a distance measure on X, and let g be a function. The similarity function s is g-generated from d if $s(x,y) = g(d(x,y))$. The following theorem determines the characteristics that the function g must possess in order to generate a similarity function.

THEOREM 4.5. *Let $d \in \mathfrak{D}(X)$ be a distance function on the space X, and $g : \mathbb{R} \to \mathbb{R}$ a function such that:*

1. g is positive and monotonically nonincreasing,

2. $g(0) = 1$,

3. $g''(x) \geq 0$ for all x,

then the function $s(x,y) = g(d(x,y))$ is a similarity function.

PROOF. The first two points guarantee that the first two properties of the similarity function are satisfied. The third (symmetry) is a consequence of the symmetry of h, the fourth derives from $g''(x) \geq 0$ by Lemma 4.3. □

Spaces of distance functions. Given the metric space X, by Theorem 4.4 it is important to prove that X can be endowed with an infinite number of distance measures. Let $\mathfrak{D}(X)$ be the set of distance measures defined on X. The set $\mathfrak{D}(X)$ itself can be endowed with the structure of a metric space.

I will start with some general definitions: Given the space $L^2(Y)$ of measurable, real valued functions defined on a space Y, that is, the space of functions such that

$$\int_Y f^2(y)\,dy < \infty \tag{4.111}$$

one can define the scalar product of $f,g \in L^2(Y)$ as

$$\langle f,g \rangle = \int_Y f(y)g(y)\,dy \tag{4.112}$$

It is possible to prove that if f and g satisfy Eq. (4.111), then the integral equation (4.112) is well defined and has the standard properties of a scalar product. The

norm of a function is then defined as

$$\|f\|^2 = \int_Y f^2(y)\,dy \tag{4.113}$$

and the distance between two functions f and g is defined as

$$\eth(f,g) = \|f - g\| \tag{4.114}$$

It is possible to prove that the functional \eth does satisfy the axioms of a distance function, thus endowing the set $L^2(Y)$ with the structure of a metric space.

A distance function on X is a function $q : X \times X \to \mathbb{R}$. Defining $Y = X \times X$, one might try to give $\mathfrak{D}(X)$ the metric structure of $L^2(X)$. Alas, this is not possible because in the case of distance functions, the integral equation (4.111), which can be written

$$\int_Y q(y)\,dy = \int_X \int_X q(x,y)\,dx\,dy \tag{4.115}$$

diverges. In most cases, however, one is not interested in all the functions in $\mathfrak{D}(X)$, but in some subset of the space with opportune characteristics. In particular, the problems with the integral equation (4.115) come with the fact that the distance functions in $\mathfrak{D}(X)$ diverge as $x \to \infty$ and y stays finite, $y \to \infty$ and x stays finite, or both x and y go to infinity with different speeds. There is no limit in $\mathfrak{D}(X)$ to the speed with which distances grow. One, however, does not usually need distances that go to infinity arbitrarily fast. This motivates the following definition:

DEFINITION 4.7. *Given a function* $w \in L^2(X \times X)$, *with* $w(x,y) > 0$ *almost everywhere, the set* $\mathfrak{D}^w(X) \subseteq \mathfrak{D}(X)$ *is the set of functions* q *such that*

$$\int_X \int_X w(x,y)q^2(x,y)\,dx\,dy < \infty \tag{4.116}$$

The function w *is called the* kernel *of the set* $\mathfrak{D}^w(X)$.

It is easy to show that for every w, $\mathfrak{D}^w(X)$ has the structure of a vector space, that is, if $f,g, \in \mathfrak{D}^w(X)$, and $\alpha,\beta \in \mathbb{R}$, then $\alpha f + \beta g \in \mathfrak{D}^w(X)$. In this space, it is possible to define the inner product as

$$\langle f,g \rangle_w = \int_X \int_X w(x,y)f(x,y)g(x,y)\,dx\,dy \tag{4.117}$$

and the norm of a function as

$$\|f,g\|_w^2 = \int_X \int_X w(x,y)f^2(x,y)\,dx\,dy \tag{4.118}$$

The distance between two functions is again defined as

$$\eth_w(f,g) = \|f - g\|_w \tag{4.119}$$

(the subscript w can be omitted if no confusion ensues). Other distance functionals can be defined in $\mathfrak{D}^w(X)$. The most interesting in many applications are

the L_p distances:

$$\eth_{w,p}(f,g) = \left[\int\int_X \int_X w(x,y) |f(x,y) - g(x,y)|^p dxdy \right]^{1/p} \tag{4.120}$$

The limit for $p \to \infty$ of this family is the uniform distance

$$\eth_{w,\infty}(f,g) = \max_{x,y,\in X} w(x,y) |f(x,y) - g(x,y)| \tag{4.121}$$

The metric structure of the distance space is important because it allows the definition of concepts such as the continuity of operators on distance functions. The most common form of such operators is the *parametrized distance*, in which the distance function depends on a set of real-valued parameters. This is the case, for instance, of a query by example system that allows the user to "weigh" different similarity criteria by acting on some suitable interface elements such as "sliders." In general, let $\theta \in \mathbb{R}^n$ be a vector of parameters, and $q(x,y;\theta)$ a distance function that depends on θ. A functional $Q : \mathbb{R}^n \to \mathfrak{D}^w(X)$ can be defined that produces a distance function for every value of θ:

$$(Q(\theta))(x,y) = q(x,y;\theta) \tag{4.122}$$

The metric structure of $\mathfrak{D}^w(X)$ makes it possible to study properties such as the continuity of Q: Q is continuous in $\theta_0 \in \mathbb{R}^n$ if:

$$\forall \epsilon > 0 \ \exists \delta > 0 : \ \|\theta - \theta_0\| < \delta \Rightarrow \eth_w(Q(\theta), Q(\theta_0)) < \epsilon \tag{4.123}$$

which is the definition of the limit

$$\lim_{\|\theta - \theta_0\| \to 0} Q(\theta) = Q(\theta_0). \tag{4.124}$$

The presence of the function \eth_w in the definition of this limit makes the role of the metric structure of $\mathfrak{D}^w(X)$ manifest.

4.4.2 Variable Metric Structures

The structures introduced in the previous section endow the feature space with a metric structure in which the distance function satisfied the metric axioms of constancy of self-similarity, symmetry, and the triangle inequality. As was shown in section 4.2, however, these axioms do not hold in general for similarity perception. In this section I will introduce a more general metric structure that can account for the phenomena observed in similarity experiments.

Consider the space of distance functions $\mathfrak{D}^w(X)$ for some kernel function w, and fix a distance function \eth in this space. At the end of the previous section, I gave a definition of continuity for a functional $Q : \mathbb{R}^n \to \mathfrak{D}^w(X)$. A similar definition can be given for the more general case of a functional defined in a metric space.

DEFINITION 4.8. *Let Y be a metric space. A function* $f : Y \rightarrow \mathfrak{D}^w(X)$ *is continuous in* $y_0 \in Y$ *if*

$$\forall \epsilon > 0 \ \exists \delta > 0 : \ d_Y(y, y_0) < \delta \Rightarrow \eth_w(f(y), f(y_0)) < \epsilon \qquad (4.125)$$

where d_Y *is the distance function defined on* Y.

Note that if Y is a metric space, then every space of the form $Y \times \mathbb{R}^n$ is also a metric space. If $x = (x_1, \dots, x_n) \in \mathbb{R}^n$ and $y \in Y$, then, for instance,

$$d((y, x), (y', x')) = d_Y(y, y') + \sqrt{\sum_{k=1}^{n} (x_k - x_k')^2} \qquad (4.126)$$

is a distance function on $Y \times \mathbb{R}^n$. Because of this, the notion of continuity of Definition 4.8 applies to the following definition:

DEFINITION 4.9. *A* variable metric structure *on X is a continuous functional*

$$\mathfrak{m} : X \times \mathbb{R}^n \rightarrow \mathfrak{D}^w(X). \qquad (4.127)$$

The functional is called autonomous *if it depends only on X, while it is* external *if it depends only on* \mathbb{R}^n. *The space of variable metric structure on a space X is indicated with* $\mathfrak{V}(X)$.

An external metric structure functional is similarly a parametrized distance function of the type defined in the previous section. In the remainder of this section, I will be mostly interested in the dependence of the variable metric structure on X thus, for the moment, I will only consider autonomous structures. Given a point $a \in X$, the metric structure functional associates to it a distance function $\mathfrak{m}(a)$. The distance between two elements $x, y \in X$ in this distance function is $\mathfrak{m}(a)(x, y)$. The *diagonalization* of a metric structure functional is the function $\mathfrak{y} : X \times X \rightarrow X$ defined as

$$\mathfrak{y}(x, y) = \mathfrak{m}(x)(x, y) \qquad (4.128)$$

DEFINITION 4.10. *A* diagonal metric structure *on a metric space X is a function* $\mathfrak{y} : X \times X \rightarrow X$, *which can be expressed as the diagonalization of a metric structure functional on X. The space of diagonal metric structure on a space X is indicated with* $\mathfrak{K}(X)$.

In psychological terms, using a variable metric structure instead of a metric structure has an interesting interpretation, which leads to some interesting observations on the nature of the perceptual space.

The model underlying most similarity theories is the following: All stimuli are represented as points in a metric perceptual space, and a suitable function of the points $P1$ and $P2$ is used to determine their perceptual distance. This function is a property of the space and, as such, is independent of the points to be compared.

This hypothesis is not supported by any experiments. Most of the experiments in the literature belong to one of the following two categories:

- Given the stimulus $P1$ and the stimulus $P2$, determine how similar is $P2$ to $P1$.

- Given the stimuli $P1$, $P2$, and $P3$, determine which of $P1$, $P3$ is more similar to $P2$.

All one needs in order to interpret these experiments is to suppose that there is a function defined in the space around a *reference* stimulus, and depending on it, determine the similarity between the reference and a given stimulus.

Whenever similarity is judged, one *almost* always judges similarity with respect to a reference stimulus. Alternatively, one judges similarity with respect to a template or prototype. The experiments are therefore compatible with the hypothesis that *the perceptual space depends on the particular reference against which comparison is made.* In particular, deriving from the discussion in Attneave (1950), there is an a priori tendency to underestimate dissimilarity in the vicinity of the reference stimulus.

In other words: *The presence of a stimulus deforms the perceptual space in which similarity is measured.* When in an experiment subjects are asked, "how similar is A to B?" they tend to concentrate more on the features of B than on those of A. The features of B, on which the subjects are focusing, determine the shape of the perceptual space, and the distance function that is defined in it.

4.4.3 Distance Algebras

The manipulation of distance functions is an important component of a similarity engine and will be an important component of the query algebras introduced in Chapter 8. Operating on the distance functions defined on feature spaces is important in at least three distinct instances:

1. Within a single feature space, it may be necessary to change the distance function to reflect a change in the desired similarity criteria. A query such as "retrieve a region that is either red or green" can be satisfied by manipulating the distance function in a way that red and green will be considered very similar colors (low distance), while blue or any other color will be considered dissimilar (higher distance).

2. Within a single feature space, a query may ask for similarity with respect to a number of examples a_1, \ldots, a_q rather than similarity with respect to a given sample. In this case the (formal) distance between a point x and the query $d(x, \{a_1, \ldots, a_q\})$ will be a suitable combination of the distances $d(x, a_1), d(x, a_2), \ldots, d(x, a_q)$.

3. It is often necessary to combine distance functions from different feature spaces.

This section will consider the first of the preceding cases. Given the space $\mathfrak{D}(X)$ of the distance functions defined on a metric space X, this section will consider the definition and the properties of operators on $\mathfrak{D}(X)$.

I will start by defining two very general operators for the manipulation of distance functions.

The apply function operator. The application of a function $\phi : \mathbb{R} \to \mathbb{R}$ to a distance function is obtained by the operator $\Diamond : F \to \{\mathfrak{D}(X) \to \mathfrak{D}(X)\}$ where $\{\mathfrak{D}(X) \to \mathfrak{D}(X)\}$ is the set of functions from \mathfrak{D} to \mathfrak{D}, and F is a suitable subset of $\{\mathbb{R} \to \mathbb{R}\}$. In other words, for every function $\phi \in F$, $\Diamond(\phi)$ is a function that transforms a distance function in another distance function, and $\Diamond(\phi)(d)$ is a distance function. In the following, I will use the form $\Diamond_\phi(d)$ as an alternative to $\Diamond(\phi)(d)$. Given two points $x, y \in X$, the distance between them according to the modified distance function is

$$\Diamond_\phi(d)(x,y) = \phi(d(x,y)) \tag{4.129}$$

In order to characterize the operator \Diamond, it is necessary to characterize the space F of functions that can be applied to a distance function with the guarantee that the result is still a distance function. In other words: What characteristics of the function ϕ will guarantee that, given that d is a distance function, $\Diamond_\phi(d)$ will also be one?

If $\phi \in C^2$ (the space of functions with continuous second derivative), the answer is an immediate consequence of Theorem 4.4:

THEOREM 4.6. *Let $d \in \mathfrak{D}(X)$ be a distance function, and $\phi \in C^2$. Then $\Diamond_\phi(d)$ is a distance function iff*

$$\phi(0) = 0 \tag{4.130}$$
$$\phi(x) \geq 0 \quad \forall x \tag{4.131}$$
$$\phi' \geq 0 \quad \forall x \tag{4.132}$$
$$\phi''(x) \leq 0 \quad \forall x \tag{4.133}$$

If the function ϕ is not C^2, one can verify directly the inequality equation (4.102), or use the following property:

THEOREM 4.7. *Let $\phi : \mathbb{R} \to \mathbb{R}$, and let $\{\phi_n\}$ be a family of functions such that*

1. *For all n, ϕ_n satisfies the hypotheses of Theorem 4.6;*

2. $\lim_{n\to\infty} \phi_n = \phi$ *uniformly.*

Then $\Diamond_\phi(d)$ is a distance function.

PROOF. I will only prove the triangle inequality: positivity and symmetry are analogous. The proof is by contradiction. Assume that the triangle inequality does not

hold for $x, y \in X$. Then there is $\varepsilon > 0$ such that

$$\phi(d(x,y)) = \phi(d(x,z)) + \phi(d(z,y)) + \varepsilon \qquad (4.134)$$

Note that, by the first hypothesis of the theorem, all the functions $\Diamond_{\phi_n}(d)$ are distance functions. Choose n such that $|\phi_n - \phi| < \varepsilon/4$ for all x, y. Then

$$\phi_n(d(x,y)) \geq \phi(d(x,y)) - \frac{\varepsilon}{4}$$

$$\geq \phi(d(x,z)) + \phi(d(z,y)) + \varepsilon - \frac{\varepsilon}{4}$$

$$\geq \phi_n(d(x,z)) + \phi_n(d(z,y)) + \varepsilon - \frac{3}{4}\varepsilon$$

$$> \phi_n(d(x,z)) + \phi_n(d(z,y)) \qquad (4.135)$$

thereby contradicting the hypothesis that \Diamond_{ϕ_n} is a distance function. □

An important example of application of the previous theorem is the *truncation operator* τ_α, defined as $\tau = \Diamond_{u_\alpha}$ and

$$u_\alpha(x) = \begin{cases} x & \text{if } x < \alpha \\ \alpha & \text{otherwise} \end{cases} \qquad (4.136)$$

To see this, consider the function:

$$q(x) = \begin{cases} 0 & \text{if } x \leq 0 \\ x & \text{otherwise} \end{cases} \qquad (4.137)$$

It is clear that $u_\alpha(x) = x - q(x - \alpha)$. On the other hand, it is easy to see that the function $f_n(x) = x/(1 + \exp(-nx))$ converges uniformly to $q(x)$ as $n \to \infty$. Therefore, the function $\phi_n(x) = x - f_n(x - \alpha)$ converges uniformly to u_α as $n \to \infty$. Moreover, $f_n''(x) > 0$, thus, $\phi_n''(x) < 0$.

The composition operator. The composition operator puts together two distance functions to form a third one, under the action of a function $\phi : \mathbb{R}^2 \to \mathbb{R}$. Formally, it is defined as the operator $\Diamond : F \to \{\mathfrak{D}(X) \times \mathfrak{D}(X) \to \mathfrak{D}(X)$. Given two distance functions d_1, d_2, their composition under the action of the function ϕ is written $d_1 \Diamond(\phi)d_2$ or, in the notation that I will use more frequently, $d_1 \Diamond_\phi d_2$. The distance between two points $x, y \in X$ according to the new distance function is $(d_1 \Diamond_\phi d_2)(x,y)$.

As in the previous case, one is interested in determining the characteristics that the function ϕ must possess in order to have the operator generate distance functions. Compared to the previous case there is an additional constraint: It is desirable that the operator \Diamond_ϕ be commutative and associative, which implies

$$\phi(x,y) = \phi(y,x) \qquad (4.138)$$

$$\phi(x, \phi(y,z)) = \phi(\phi(x,y), z) \qquad (4.139)$$

The operator is said to be *conservative* if the function ϕ is such that $\phi(x,0) \leq x$ and $\phi(0,y) \leq y$, and is said to be *strictly conservative* if $\phi(x,0) = x$ and $\phi(0,y) = y$. The required properties are established by the following theorem:

THEOREM 4.8. *If $d_1, d_2 \in \mathfrak{D}(X)$, then $(d_1 \Diamond_\phi d_2) \in \mathfrak{D}(X)$ iff:*

1. $\phi(0,0) = 0$;

2. $\phi(x,y)$ is monotonically nondecreasing in both its arguments; and

3. the Hessian $H(\phi)$ is seminegative definite for all $x, y \in X$.

PROOF. The first condition is necessary and sufficient in order to have $(d_1 \Diamond_\phi d_2)$ $(x, x) = 0$. The second condition is necessary and sufficient in order to have $(d_1 \Diamond_\phi d_2)(x, y) \geq 0$.

For the triangle inequality, we must have $\phi(d_1(x, y), d_2(x, y)) \leq \phi(d_1(x, z), d_2(x, z)) + \phi(d_1(z, y), d_2(z, y))$. Because both d_1 and d_2 are distance functions, it is $d_1(x, y) \leq d_1(x, z) + d_1(z, y)$ and $d_2(x, y) \leq d_2(x, z) + d_2(z, y)$. Therefore, the condition translates to the following: $\phi(a, a') \leq \phi(b, b') + \phi(c, c')$ whenever $a \leq b + c$ and $a' \leq b' + c'$. Lemma 4.3 provides the necessary and sufficient condition for this to be true. $\qquad\square$

If the function ϕ is not C^2, the following theorem holds:

THEOREM 4.9. *Let $\phi : \mathbb{R} \times \mathbb{R} \to \mathbb{R}$, and let $\{\phi_n\}$ be a family of functions such that*

1. For all n, ϕ_n satisfies the hypotheses of Theorem 4.8;

2. $\lim_{n \to \infty} \phi_n = \phi$ uniformly.

Then $d_1 \Diamond_\phi d_2$ is a distance function.

PROOF. The proof is a parallel of the proof of Theorem 4.7. $\qquad\square$

A rather common case in applications is that in which the function ϕ depends on a parameter vector θ. In this case, the presence of the parameter vector can be indicated explicitly as \Diamond_ϕ^θ.

An important class of operators is given by the *quasilinear means*, which originate in simluation [Dujmovie, 1976] and fuzzy sets theory [Dyckhoff and Pedrycz, 1984]. The family of quasilinear means includes operators of the form

$$x \Diamond_\alpha y = \left(\frac{x^\alpha + y^\alpha}{2} \right)^{1/\alpha} \tag{4.140}$$

The usual means can be seen as special cases of the quasilinear mean as follows [Dubois and Prade, 1985]:

α	$x \Diamond_\alpha y$	
$-\infty$	$\min(x, y)$	
-1	$\frac{2xy}{x+y}$	(harmonic mean)
0	\sqrt{xy}	(geometric mean)
1	$\frac{x+y}{2}$	(arithmetic mean)
$+\infty$	$\max(x, y)$	

With a slight modification, one can define the *quasilinear mean operators* as follows. Given two distance functions on a metric space X, $d_1, d_2 \in \mathfrak{D}(X)$, a value $\alpha \geq 1$ (note the restriction with respect to the general operator), and a weight $0 \leq w \leq 1$, the distance function $d = d_1 \lozenge_\alpha^w d_2$ is defined as

$$(d_1 \lozenge_\alpha^w d_2)(x, y) = (w d_1(x, y)^\alpha + (1 - w) d_2(x, y)^\alpha)^{1/\alpha} \tag{4.141}$$

for $x, y \in X$. All these operators are conservative, but not strictly conservative. The justification for the use of this operator is given by the following theorem:

THEOREM 4.10. *Let $d_1(x, y), d_2(x, y) \in \mathfrak{D}(X)$, $\alpha \geq 1$ and $0 \leq w \leq 1$ be a weight. Then the function d defined as*

$$d(x, y) = (w d_1(x, y)^\alpha + (1 - w) d_2(x, y)^\alpha)^{1/\alpha} \tag{4.142}$$

is a distance.

PROOF. It is easy to see that the function $d(x, y)$ is positive and symmetric and that $d(x, x) = 0$. For the triangle inequality, let $q(x, y) = (w x^\alpha + (1 - w) y^\alpha)^{1/\alpha}$, so that $d(x, y) = q(d_1(x, y), d_2(x, y))$. It is then necessary to prove that

$$q(d_1(x, y), d_2(x, y)) \leq q(d_1(x, z), d_2(x, z)) + q(d_1(z, y), d_2(z, y)) \tag{4.143}$$

for all x, y, z. Note that

$$\frac{\partial q}{\partial x} = w(w x^\alpha + (1 - w) y^\alpha) x^{\alpha - 1} \geq 0 \tag{4.144}$$

and similarly for $\partial q / \partial y$. Therefore, q is monotonically nondecreasing in both x and y. Also, because both d_1 and d_2 are distance functions, it is

$$d_1(x, y) \leq d_1(x, z) + d_1(z, y) \tag{4.145}$$
$$d_2(x, y) \leq d_2(x, z) + d_2(z, y) \tag{4.146}$$

Thus, by monotonicity

$$q(d_1(x, y), d_2(x, y)) \leq q(d_1(x, z) + d_1(z, y), d_2(x, z) + d_2(z, y)) \tag{4.147}$$

Therefore, all that is left to do is to prove that, for all x_1, x_2, y_1, y_2, it is

$$q(x_1 + y_1, x_2 + y_2) \leq q(x_1, x_2) + q(y_1, y_2) \tag{4.148}$$

Consider two vectors

$$\tilde{x} = \begin{bmatrix} \tilde{x}_1 \\ \tilde{x}_2 \end{bmatrix} \qquad \tilde{y} = \begin{bmatrix} \tilde{y}_1 \\ \tilde{y}_2 \end{bmatrix} \tag{4.149}$$

and the function $f(x) = [x_1^\alpha + x_2^\alpha]^{1/\alpha}$. The Minkowski inequality states that $f(\tilde{x} + \tilde{y}) \leq f(\tilde{x}) + f(\tilde{y})$. Define

$$\begin{aligned} \tilde{x}_1 = w^{\frac{1}{\alpha}} x_1 \quad \tilde{y}_1 = (1 - w)^{\frac{1}{\alpha}} y_1 \\ \tilde{x}_2 = w^{\frac{1}{\alpha}} x_2 \quad \tilde{y}_2 = (1 - w)^{\frac{1}{\alpha}} y_2 \end{aligned} \tag{4.150}$$

Then $q(x_1, x_2) = f(\tilde{x})$, $q(y_1, y_2) = f(\tilde{y})$, and $q(x_1 + y_1, x_2 + y_2) = f(\tilde{x} + \tilde{y})$, so that inequality equation (4.148) is a consequence of the Minkowski inequality. \square

If $\alpha = 1$, $d_1 \diamond_1^w d_2$ is simply a weighted average of the two distance functions d_1 and d_2. On the other hand, suppose that d_1 and d_2 are two different weighted L_p distances:

$$d_1(x, y) = \left[\sum_i u_i |x_i - y_i|^p \right]^{1/p} \tag{4.151}$$

$$d_2(x, y) = \left[\sum_i v_i |x_i - y_i|^p \right]^{1/p}. \tag{4.152}$$

In this case, $d_1 \diamond_p^w d_2$ is

$$d(x, y) = \left[w \sum_i u_i |x_i - y_i|^p + (1 - w) \sum_i v_i |x_i - y_i|^p \right]^{1/p}$$

$$= \left[\sum_i (w u_i + (1 - w) v_i) |x_i - y_i|^p \right]^{1/p} \tag{4.153}$$

That is, if d_1 and d_2 are two L_p distance functions, $d_1 \diamond_p^w d_2$ is still an L_p distance function whose weights are the a convex combination (with weight w) of the weights of the two distances.

Note also that the operator \diamond_α^w is not commutative unless $w = 1/2$, and it easy to see that the operator \diamond_α^w is not associative. It will be shown in Chapter 8 that this fact is connected to the presence of the weight w.

An associative and commutative operator is the operator \diamond_+^α, defined as

$$(d_1 \diamond_+^\alpha d_2)(x, y) = (d_1(x, y)^\alpha + d_2(x, y)^\alpha)^{1/\alpha} \tag{4.154}$$

Note that this operator is strictly conservative.

The following corollary is an immediate consequence of Theorem 4.10:

COROLLARY 4.3. *Let $d_1(x, y), d_2(x, y) \in \mathfrak{D}(X)$, $\alpha \geq 1$ and $0 \leq w \leq 1$ be a weight. Then the function d defined as*

$$d(x, y) = (d_1(x, y)^\alpha + d_2(x, y)^\alpha)^{1/\alpha} \tag{4.155}$$

is a distance.

4.4.4 Similarity Algebras

Through the relation between distance functions and similarities, the space of similarity stuctures can be endowed with an algebra derived from that of the distance functions. The unary and the binary operator \diamond can be derived for similarity stuctures either directly using the properties (4.107)–(4.109), or they can be derived from the corresponding distance function operators using Theorem 4.5.

The apply function operator. From the properties equations (4.107)–(4.109) it is possible to derive the following characterization:

THEOREM 4.11. *Let* $s \in \mathfrak{S}(X)$ *be a similarity function, and* $\zeta \in C^2$. *Then* $\Diamond_\zeta(s)$ *is a similarity function iff*

$$\zeta(x) \geq 0 \quad \forall x \tag{4.156}$$

$$\zeta' \geq 0 \quad \forall x \tag{4.157}$$

$$\zeta''(x) \geq 0 \quad \forall x \tag{4.158}$$

PROOF. Much as in the case of distance, the theorem is an immediate consequence of Corollary 4.1. □

A property similar to Theorem 4.7 holds in the case of similarities as well.

THEOREM 4.12. *Let* s *be a similarity function,* $\zeta : \mathbb{R} \to \mathbb{R}$, *and* $\{\zeta_n\}$ *be a family of functions such that*

1. *For all* n, ζ_n *satisfies the hypotheses of Theorem 4.11;*

2. $\lim_{n \to \infty} \zeta_n = \zeta$ *uniformly.*

Then $\Diamond_\zeta(s)$ *is a similarity function.*

The apply function operator for similarity functions can also be derived based on the relation between similarities and distances established in Theorem 4.5. Let d be a distance function, and g a function that satisfies the hypotheses of Theorem 4.5. Then $s = g \circ d$, defined as $s(x, y) = g(d(x, y))$ is a similarity function. Consider now an operator \Diamond_ϕ, and use it to derive a new distance function $d' = \Diamond_\phi d$. Again, the function $s' = g \circ \Diamond_\phi d$ is a similarity function, and $s'(x, y) = g(\phi(d(x, y)))$. Can the function s' be seen as the result of the application of an operator \Diamond_ζ to the function s? In other words, is there a function ζ such that $s'(x, y) = \zeta(s(x, y))$?

The function ζ must be such that the diagram equation (4.159) commutes,

$$
\begin{array}{ccc}
\mathfrak{D} & \xrightarrow{\ g\ } & \mathfrak{S} \\
\downarrow{\scriptstyle \phi} & & \downarrow{\scriptstyle \zeta} \\
\mathfrak{D} & \xrightarrow{\ g\ } & \mathfrak{S}
\end{array}
\tag{4.159}
$$

which implies $\zeta = g \circ \phi \circ g^{-1}$, or $\zeta(x) = g(\phi(g^{-1}(x)))$. In order for ζ to generate a valid similarity operator, however, it is necessary to verify that it satisfies the hypotheses of Theorem 4.11. To verify this, consider that, *ex hypothesis*, the functions ϕ and g satisfy the conditions of Theorems 4.6 and 4.5, respectively. In particular,

$$\phi'(x) \geq 0 \quad \phi'' \leq 0 \tag{4.160}$$

$$g'(x) \leq 0 \quad g'' \geq 0 \tag{4.161}$$

The first derivative of ζ is given by Eq. (4.162), where the signs of all factors are indicated:

$$\zeta'(x) = \frac{\overset{\leq 0}{g''(\phi(g^1(x)))}\overset{\geq 0}{\phi'(g^{-1}(x))}}{\underset{\leq 0}{g'(x)}} \geq 0 \tag{4.162}$$

The second derivative is given by

$$\zeta''(x) = \frac{\overset{\geq 0}{g''(\phi(g^{-1}(x)))}\overset{\geq 0}{(\phi'(g^{-1}(x))^2)}}{\underset{\geq 0}{(g'(x))^2}} + \frac{\overset{\leq 0}{g'(\phi(g^{-1}(x)))}\overset{\leq 0}{\phi''(g^{-1}(x))}}{\underset{\geq 0}{(g'(x))^2}}$$

$$- \frac{\overset{\leq 0}{g'(\phi(g^{-1}(x)))}\overset{\geq 0}{\phi'(g^{-1}(x))}}{\underset{\geq 0}{(g'(x))^2}} \overset{\geq 0}{g''(x)} \tag{4.163}$$

From this, it is evident that the first two terms are positive, and the third is negative and, therefore, $\zeta'' \geq 0$. This leads to the following definition:

DEFINITION 4.11. *Given the operator \Diamond_ϕ on \mathfrak{D}, and a function g generating a similarity structure, the g-conjugate operator to \Diamond_ϕ on the space \mathfrak{S} of similarity structures is \Diamond_ϕ^g such that $\Diamond_\phi^g(s)(x,y) = g(\phi(g^{-1}(s(x,y))))$.*

The composition operator. Everything that was said for the function application operator can be said, *mutatis mutandis*, for the composition operator in a similarity space. In particular, the following theorem establishes the basic properties of a function that generates a composition of similarity measures.

THEOREM 4.13. *If $s_1, s_2 \in \mathfrak{S}(X)$, then $(s_1 \Diamond_\zeta s_2) \in \mathfrak{S}(X)$ iff*

 1. $\zeta(x,y)$ is monotonically nondecreasing in both its arguments; and

 2. the Hessian $H(\zeta)$ is semipositive definite for all $x, y \in X$.

As in the previous cases, it is possible to relax the assumption that ζ is C^2, provided a suitable uniform approximation can be found:

THEOREM 4.14. *Let $\zeta : \mathbb{R} \times \mathbb{R} \to \mathbb{R}$, and let $\{\zeta_n\}$ be a family of functions such that*

 1. For all n, ζ_n satisfies the hypotheses of Theorem 4.13;

 2. $\lim_{n \to \infty} \zeta_n = \zeta$ uniformly.

Then $s_1 \Diamond_\zeta s_2$ is a distance function.

Finally, given a combination operator and a function g that transforms a distance function in a similarity measure, it is possible to derive the g-conjugate operator in the similarity space. The operator can be written as $s_1 \Diamond_\zeta s_2$, where ζ

is the function $\zeta : \mathfrak{S} \times \mathfrak{S} \to \mathfrak{S}$ that makes the diagram equation (4.164) commute:

$$
\begin{array}{ccc}
\mathfrak{D} \times \mathfrak{D} & \xrightarrow{g \times g} & \mathfrak{S} \times \mathfrak{S} \\
\downarrow \phi & & \downarrow \zeta \\
\mathfrak{D} & \xrightarrow{\quad g \quad} & \mathfrak{S}
\end{array}
\tag{4.164}
$$

The function $g \times g$ is defined as the application of the function g to both members of a pair in $\mathfrak{D} \times \mathfrak{D}$, that is, $(g \times g)(d_1, d_2) = (g(d_1), g_2))$. Formally, if π_1 and π_2 are the projection operators defined on $\mathfrak{D} \times \mathfrak{D}$ (i.e., $\pi_1(d_1, d_2) = d_1$, and $\pi_2(d_1, d_2) = d_2$), then the function $g \times g$ is the function that makes the diagram equation (4.165) commute for $i = 1, 2$

$$
\begin{array}{ccc}
\mathfrak{D} \times \mathfrak{D} & \xrightarrow{g \times g} & \mathfrak{S} \times \mathfrak{S} \\
\downarrow \pi_i & & \downarrow \pi_i \\
\mathfrak{D} & \xrightarrow{\quad g \quad} & \mathfrak{S}
\end{array}
\tag{4.165}
$$

The conjugate operator is then defined as follows:

DEFINITION 4.12. *Given the operator \Diamond_ϕ on $\mathfrak{D} \times \mathfrak{D}$, and a function g generating a similarity structure, the g-conjugate operator to \Diamond_ϕ on the space $\mathfrak{S} \times \mathfrak{S}$ of similarity structures is \Diamond_ϕ^g such that $(s_1 \Diamond_\phi^g s_2)(x, y) = g(g^{-1}(s_1(x,y)) \Diamond_\phi g^{-1}(s_2(x,y)))$.*

The operator is said to be *conservative* if the function ϕ is such that $\phi(x, 0) \ge x$ and $\phi(0, y) \ge y$ and is said to be *strictly conservative* if $\phi(x, 0) = x$ and $\phi(0, y) = y$.

THEOREM 4.15. *If the distance composition operator \Diamond_ϕ is conservative, then its conjugate \Diamond_ϕ^g is also conservative, and if \Diamond_ϕ is strictly conservative, so is its conjugate.*

PROOF. Note that if g generates a similarity structure, then, by Theorem 4.5, g is nonincreasing. Because \Diamond_ϕ is conservative, it is $\phi(g^{-1}(s(x, y))) \le g^{-1}(s(x, y))$. Therefore,

$$
g(\phi(g^{-1}(s(x, y)))) \ge g(g^{-1}(s(x, y))) = s(x, y)
\tag{4.166}
$$

which proves that \Diamond_ϕ^g is conservative. Strict conservatism follows substituting all the inequalities with equalities in the previous equation. □

4.4.5 Algebras for Variable Metric Structures

An algebra of variable metric structures can be defined along the lines of the distance function algebra defined in the previous sections.

The create operator. The *create* operator builds a variable metric structure based on a distance function in $\mathfrak{D}(X)$ and a function defined on X. Given a function

$\phi : \mathbb{R} \times \mathbb{R} \to \mathbb{R}$, the create operator

$$\Box : F \to \{ L^2(X) \times \mathfrak{D}(X) \to \mathfrak{V}(X) \} \qquad (4.167)$$

is defined as

$$(\Box(\phi)(\psi, q))(z, x, y) = (\psi \Box_\phi q)(z, x, y) = \phi(\psi(z), \phi(x, y)) \qquad (4.168)$$

where the second, abbreviated notation will be the one I will use most often in the following. As before, the function ϕ may depend on a parameter vector θ, and this dependence can be made explicit writing the operator as \Box_ϕ^θ. Some restrictions must be placed on the set F of admissible functions that can be used to generate a variable metric structure:

DEFINITION 4.13. *A function $\phi : \mathbb{R} \times \mathbb{R} \to \mathbb{R}$ is* create-admissible *if:*

1. *$\phi(x, y) > 0$ for all x and for all $y > 0$;*

2. *$\phi(x, 0) = 0$ for all x;*

3. *$\frac{\partial^2 \phi}{\partial y^2}(x, y) \le 0$ for all x, y; and*

4. *$\frac{\partial \phi}{\partial y}(x, y) \ge 0$ for all x, y.*

The motivation for the first two properties is an obvious consequence of the required properties for a variable metric structure. For the second two, consider that if $\psi(x) = a = const.$ then the metric structure $(x \mapsto a)\Box_\phi q$ is a distance measure, and must satisfy the hypotheses of Theorem 4.4. For instance, the function $\psi(x, y) = x^2 y$ generates a multiplicative variable metric structure.

Abandoning the second condition gives a more general class of structures for which, however, many of the properties of metric spaces do not hold (in particular, the special case $\psi(x) = const.$ will no longer correspond to a standard metric space). In this case, choosing $\psi(x, y) = x^2 + y$, one obtains a class of metric structures similar to those of Krumhansl's model introduced in section 4.2.1.

Reshape operator. The create operator builds a variable metric structure starting from a distance function and a point function. The *reshape* operator is defined in the same way, but it takes a variable metric structure and modifies it by applying a point function. The reshape operator

$$\amalg : F \to \{ L^2(X) \times \mathfrak{V}(X) \to \mathfrak{V}(X) \} \qquad (4.169)$$

is defined as

$$(\amalg(\phi)(\psi, q))(z, x, y) = (\psi \amalg_\phi q)(z, x, y) = \phi(\psi(z), q(z, x, y)) \qquad (4.170)$$

where the function ϕ satisfies Definition 4.13. Note that the create operator is simply a special case of the reshape operator, with the limitation of having the second parameter restricted to being a distance function. In spite of this commonality,

it is often convenient to keep the two separated. Here, too, the operator will be written as \amalg^θ_ϕ if the function ϕ depends on a vector of parameters θ.

Apply function. The apply function operator has the same semantics as the homonym operator for distance functions. If $\phi \in F$ is a function, where F is the subset of $\{\mathbb{R} \to \mathbb{R}\}$ defined by the condition in Theorem 4.6, then the apply function operator

$$\triangle : F \to \{\mathfrak{V}(X) \to \mathfrak{V}(X)\} \tag{4.171}$$

is defined as

$$(\triangle(\phi)(q))(z,x,y) = (\triangle_\phi(q))(z,x,y) = \phi(q(z,x,y)) \tag{4.172}$$

As in the case of the previous operators, the restriction of the function ϕ to the set of functions that satisfy Theorem 4.6 derives from the requirement that, if q is a distance function, the result of the apply operator should also be a distance function.

Composition operator. In this case, too, the operator has the same semantics as its homonym for distance functions. The composition operator is defined as the operator

$$\triangle : F' \to \{\mathfrak{V}(X) \times \mathfrak{V}(X) \to \mathfrak{V}(X)\} \tag{4.173}$$

such that

$$(\triangle(\phi)(q,p))(z,x,y) = (q \triangle_\phi p)(z,x,y) = \phi(q(z,x,y),p(z,x,y)) \tag{4.174}$$

where $\phi \in F'$, and F' is the subset of $\{\mathbb{R} \times \mathbb{R} \to \mathbb{R}\}$ for which the hypotheses of Theorem 4.8 are satisfied. This restriction is, once again, necessary in order to deal consistently with the case in which q and p are distance functions.

In both cases, if the function ϕ depends on a vector of parameters θ, the notation \triangle^θ_ϕ will be used. Conservative and strictly conservative operators are defined as in the case of distance composition, applying the definition pointwise.

Diagonalize operator. This operator creates a diagonal metric structure from a variable metric structure. Given a function $\phi \in F$, where F is the subset of $\{\mathbb{R} \to \mathbb{R}\}$ of functions that satisfy the hypotheses of Theorem 4.6, the diagonalization operator

$$\nabla : F \to \{\mathfrak{V}(X) \to \mathfrak{K}(X)\} \tag{4.175}$$

is defined as

$$(\nabla(\phi)(q))(x,y) = (\nabla_\phi(q))(x,y) = \phi(q(x,x,y)) \tag{4.176}$$

with the notation ∇^θ_ϕ being used, as usual, for functions that depend on a vector of parameters.

4.4.6 Other Distance Compositions

The operators presented in the previous section form a rather general class, which creates powerful tools to manipulate distance functions and similarity structures. In some cases one needs some additional freedom of operation, for instance, to define functions that are not distances. A more general algebra of *scoring functions* will be introduced in section 8.2. This section will only point out a few additional operations that give rise to distance functions. Variable metric structures are generally used to model a situation in which a distance must be measured between elements of a feature space in the presence of a referent whose presence deforms the space. A common extension of this structure is needed when, instead of a referent, one has a set of referents.

Consider again a metric space (X, q) and let $A \subseteq X$ be a bounded subset of X. The distance from a point x to the set A is defined as

$$\hat{q}(x, A) = \min_{a \in A} q(x, a) \tag{4.177}$$

This function is a scoring function in the sense in which this term will be used in section 8.2, but not a distance function in the sense in which the term is used in this chapter, as does not allow one to compute a distance between arbitrary pairs of points $x, y \in X$. The function \hat{q}, however, can be used to endow the space X with a distance that depends on the set A using the following definition:

$$q_A(x, y) = \min\{q(x, y), \hat{q}(x, A) + \hat{q}(y, A)\} \tag{4.178}$$

Note that if one of the points is in A, say, $y \in A$, then $q_A(x, y) = \hat{q}(x, A)$. It is easy to prove that the function q_A is indeed a distance function.

Some examples of distance functions obtained using this definition are given in Fig. 4.14.

Another possibility to obtain a measure of dissimilarity from the set A is a weighted sum of distances from the members of the set [Porkaew *et al.*, 1999]:

$$\bar{d}(x, A) = \int_A w(u) d(x, u) \, du \tag{4.179}$$

which, in the common case in which the set A is finite, becomes

$$\bar{d}(x, A) = \sum_{u \in A} w(u) d(x, u) \tag{4.180}$$

This distance works well far away from the set A, but it may cause problems near A. In particular, for $x \in A$, it is $\bar{d}(x, A) \neq 0$. One can of course define

$$\bar{d}(x, A) = \begin{cases} \sum_{u \in A} w(u) d(x, u) & \text{if } x \notin A \\ 0 & \text{if } x \in A \end{cases} \tag{4.181}$$

but this definition makes the distance discontinuous in the points of A. On the other hand, one can take the function as a distance "induced" by A, without trying

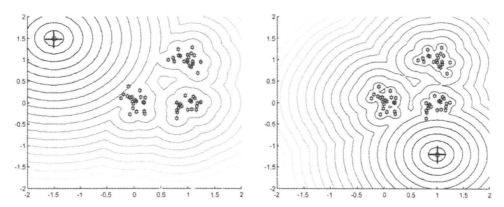

Figure 4.14. Examples of distance functions deriving from the presence of a set of references in a two-dimensional feature space. The star symbols indicate the elements, of the set, while the large cross symbol indicates the point with respect to which the distances are computed. The figures report the iso-distance curves of the distance function.

to interpret it as a distance "from" the set A, defining

$$\hat{d}(x, A) = \bar{d}(x, A) - \min_{y \in X} \bar{d}(y, A) \tag{4.182}$$

The definition can be extended to distances between pairs of points using the definition equation (4.178). The advantage of this definition is that the weights allow one to control the "importance" of the points of the set A. Figure 4.15 shows the iso-distance lines for this distance and the same reference points as in Fig. 4.14 for uniform values of the weights and for the case in which the part of the reference set with $x > 1$ has weights 50 times higher than the rest of the set. Notice that, in addition to the controllability afforded by the weights, this class of distance measures is less sensitive to the detailed placement of the point of the set, depending more on the general characteristics of the set.

In the common case in which the feature space is a vector space, it is also possible to use the reference set to modify the standard L^p distances. Assume $A = \{a^\lambda, \lambda = 1, \ldots, p\}$. The centroid of the set can be computed as

$$c_j = \frac{1}{N} \sum_{\lambda=1}^{p} a_j^\lambda \tag{4.183}$$

where a_j^λ is the jth coordinate of the element a^λ. The variance along the jth direction is

$$\sigma_j^2 = \frac{1}{N-1} \sum_{\lambda=1}^{p} \left(a_j^\lambda - c_j \right)^2 \tag{4.184}$$

The distance function can then be scaled according to the variance, giving more

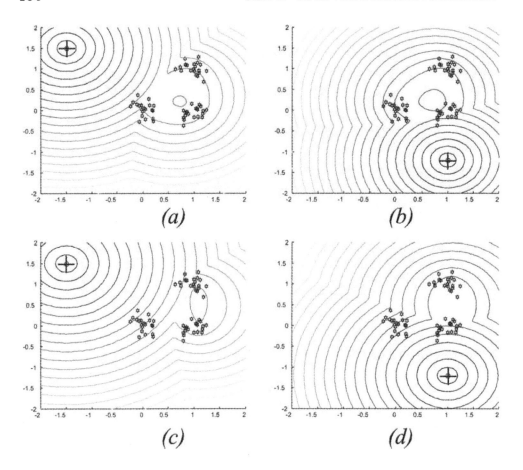

Figure 4.15. Examples of distance functions deriving from the presence of a set of references in a two-dimensional feature space, and using the weighted sum of distances from the elements of the set. The star symbols indicate the elements of the set, while the large cross symbol indicates the point with respect to which the distances are computed. The figures report the iso-distance curves of the distance function; (a) and (b) refer to the case in which all the elements in the set have the same weights. In the case of (c) and (d), the elements with an x coordinate greater than unity received a weight 50 times higher than the others.

relevance to the directions along which the set is more concentrated:

$$d(x, y) = \left[\sum_j \frac{1}{\sigma_j} |x_j - y_j|^p \right]^{1/p} \tag{4.185}$$

The weights $1/\sigma_j$ can be corrected with some factor under user control, so that the importance of certain directions can be imposed even if the reference set is widely spread along those directions.

5

Systems with Limited Ontologies

Pensé que nuestras percepciones eran iguales, pero que Argos las combinaba
de otra manera y constituía con ellas otros objectos; ...

Jorge Luis Borges, *El Imortal*

Somewhere I still have many issues of an old Italian technical magazine that some-
body gave to my father when he was a kid, in the early 1940s. One of the arti-
cles in the magazine talks about the recent dedication of the new *Centro per le
Applicazioni del Calcolo* (Center for the Applications of Computing) in Rome.
The dedication took place with great pomp in the presence of Mussolini himself.
The center was, as the article reports, at the forefront of research in numerical
analysis, was equipped with the latest in mechanical and graphical computing
equipment, and had 10 mathematicians, a number of technicians, and hundreds
of *computers.*

Do not start imagining such fantastic technological advancement in Fascist
Italy that the center could install not one but hundreds (!) of computers in an
age in which the number of electromechanical computing devices in the rest
of the world could be counted on the fingers of one hand: The term computer
was, of course, used to refer to the people who performed the menial task of
carrying out the thousands of operations required for the solution of compu-
tational problems. Twenty years later, in the early 1960s, when computer sci-
ence was establishing itself as a discipline on campuses throughout the US, the
term "computer" was already well established as referring to calculating machines
(which, prior to the 1950s, were simply known as "calculating machines"). With the

advent of the term "computer science," the "borrowing" of the term computer was completed.[1]

Whether for lack of attention to the humanistic culture, or for lack of time in a widely known fast-paced field, computer science never excelled in the creation of neologisms, often preferring the more prosaic creation of acronyms. Computer science can generate so many acronyms that, sometimes, reading a page of the discipline's literature makes one realize that there are, indeed, worse things than the dentist. So far, computer science has not approached the stylistic elegance of a word such as *semaphore* (French for "traffic light," from the greek $\sigma\varepsilon\mu\eta\iota o\nu$— sign—and $\varphi o\rho o\varsigma$—carrier) or "algorithm" (from the Twelfth Century translation by Robert of Chester of al-Khwārīzmī's *Algebra*, which begins with the words *Dicit Algoritmi*). The best we seem able to do is to borrow terms from other disciplines and adapt their meaning respecting more or less the original connotations.

Among the terms that computer science has borrowed, the term *ontology* (from the greek $o\nu\tau o\varsigma$, life, and $\lambda o\gamma o\varsigma$) has gained a certain prominence lately. In computer science (more specifically, in artificial intelligence), the term has a rather different meaning than in philosophy. In artificial intelligence, an ontology is a description of the concepts and the relationships that exist in the experience space of a certain agent. If the database is considered as an agent, its ontology is composed of the characteristics that are extracted from images and on which the database operates. These characteristics are extracted by suitable algorithms and stored as *features.*

Features define what characteristics of the images will be relevant to the database and, by this very action, delimit the set of taxonomies that the database can rely on in order to distinguish and classify images. The act of taxonomization itself causes what might be called the "loss of innocence" of a database system, because "Classifications are never innocent but streaked with arbitrariness and motivated by preconceptions and prejudices. Besides, they are constantly shifting, whether by design or in spite of our efforts to capture them" [Merrel, 1995]. In order to understand this, one does not need to arrive to the extremes of Borges' *Chinese Encyclopædia* that divides animals into the following bizarre set of categories:

(a) belonging to the emperor; (b) embalmed; (c) tame; (d) sucking pigs; (e) sirens; (f) fabolous; (g) stray dogs; (h) included in the present classification; (i) frenzied; (j) innumerable; (k) drawn with a very fine camelhair brush; (I) *et cetera*; (m) having just broken the water-pitcher; (n) that from a very long way look like flies [Borges, 1964].

[1] I am intentionally taking an anglocentric position. In other languages things went differently. Italians, for instance, took the more elegant decision to call the discipline *informatica*, thus removing it from the mechanical constraints of the device. In French the computer itself is known as *ordinateur*, a term that better reflects the prominent role of the computer in the redefinition of social hierarchies.

As a final etymological curiosity, the term *calculator* derives from the latin *calculus/i*, which means "pebble," and is a reference to the pebbles that the Romans used as an aid in counting and calculations.

Apart from the self-referentiality of item (h), this is a perfectly legitimate classification. Its strangeness derives from the unlikely association criteria of its classes and, ultimately, can be reduced to the fact that the similarity criterion on which it is based looks rather irrelevant and capricious when it comes to classifying animals. It is rather shocking to realize that, when one sets out to design features for a certain class of images, the taxonomy induced by those features may be as bizarre as that designed by Borges (as in the case of a color histogram that puts an apple, a Ferrari, and human blood in the same class because they are all red.) Between features and the appearance of taxonomies such as Borges', lies only the intuition of the designer and a deep understanding of the characteristics if the various feature models and their relation with more semantically orthodox classification schemes are known. At first sight, the fact that a whale and a rat should belong to the same category appears as arbitrary as any of the decisions in Borges' classification, but it starts making sense once we become acquainted with animal reproduction and—most importantly—with its role in determining the characteristics of animal societies. In other words, not all that looks strange is actually so. Some classifications may be based on cultural categories not immediately apparent given the elements to be classified.

The term feature is used here to indicate any quantity that can give information about the content of an image without allowing the full reconstruction of the image itself. When full reconstruction is possible (at least within a certain margin of error), I will use the term *representation*. The next chapter will consider the use of representations as features, while in this chapter I will consider quantities that provide information about the contents of an image without allowing reconstruction.

These features allow access only to some characteristics of the images, which are selected a priori by the designer. For this reason I call them "limited ontology," acknowledging the fact that concepts and relations not explicitly considered by the designer during the choice of the feature space cannot be represented and therefore cannot be the object of search. The rationale of this choice is rather clear by considering a toy example, a database in which the only feature extracted from an image is its dominant color. The only conceptualization possible in this case will contain only one concept, that is, color. Queries based on different conceptualizations in the user's semantic space cannot be mapped into the system's ontology. For example, it is impossible to translate a query based on the user's concept "shape" in this feature space.

There are a fairly limited number of relevant conceptualizations that can be attached to features that can be reliably extracted from images, and once the significant concepts have been individuated, there is little more that one can do in terms of ontological commitment in image databases. The limited conceptualization that could be supported by computer vision in image databases was soon individuated and categorized in what today are "classic" concepts, that is, *color* (global and local), *structure*, *texture*, *shape* (usually destined to rather rough

and imprecise representations), and their spatial relations. These features are the basis of the content conceptualization of a number of today's database systems. Notable exceptions are systems using features derived from image transforms, that we will consider in the next chapter. Another significant ontological extension of these features is represented by the inclusion of symbolic or semisymbolic (partially interpreted free text) semantics derived from text associated with the image. I will consider these systems in Chapter 7.

A limited ontology is not necessarily a problem. In low interactivity systems, the conceptualization in use is made explicit in the interface (e.g., in the form of knobs to regulate the importance of the various features for a query) and, provided that the system ontology is sufficiently rich, it is not perceived as a limitation by the user. Quite the contrary, an overly rich ontology can confuse the user with many interdependent choices and ultimately be counterproductive. Things are different in the case of exploratory systems, because in these systems one makes provisions for indirect reference to the underlying conceptualization through association of similar images. The lack of a direct reference to the concepts of the database and its substitution with indirect creation of concepts through manipulation makes the definition of a general ontology at least not overwhelming. The free association of images also tends to proceed along the lines of a higher-level semantic that the system cannot directly represent. This results in the request for similarity criteria whose support is not limited to the specific ontologies that a designer might have considered. Unlike the case of the knob manipulation, in which the ontological limitations of the system are made explicit, in exploratory databases the limitation would be hidden, and would result in unexpected breakdown when certain similarity criteria cannot be implemented for lack of feature support.

This point will be considered more thoroughly in the next chapter. It seems clear, however, that the semantic significance of designed features makes them the ideal vehicle for databases in which the similarity criterion is manipulated directly (as in most query-by-example systems), while the general ontology afforded by transform-type features makes them ideal for implicit manipulation of the similarity criterion. In this chapter, I will consider feature systems that give rise to limited ontologies and their use.

5.1 Features

The considerations and definitions given so far are extremely general, because nothing has been said about the specific nature of the features extracted from the images. Computer vision, which deals mainly in identification problems (i.e., matching), makes extensive use of many different types of features, such as strings of symbols, graphs, or vectors of numbers. Image databases have the additional requirement that the features should afford measuring the similarity between images. As shown in the previous chapter, a convenient way of determining

similarity is by a monotonically nonincreasing function of a distance measure defined in the feature space. This hypothesis (that similarity is derived from a metric) will be made throughout the book, and its natural consequence is that features should be defined in metric spaces.

A large class of features can be represented as a vector of continuous measurements on the images $S = \{x_1, \ldots, x_n\}$. In many cases, it makes sense to consider this set as a vector in an n-dimensional metric space V. In this case, I will use the notation $x = (x_1, \ldots, x_n)$, and will consider x_i as the projection of the vector on the ith axis of an n-dimensional coordinate system.

These features can naturally be represented in a vector space, therefore it is possible to define the componentwise difference between two vectors $(x - y)$ on which a definition of distance can be based. Other features are not so easily embedded into vector spaces. For example, features represented as graphs that encode structural properties of an image cannot in general be represented as vectors, and the definition of the distance must proceed on a case-by-case basis.

Another differentiaton that will be important in this chapter is between *point features* and *region features*. Point features are extracted at each point of the image and form a *field* defined wherever the image is.[2] Using a slightly different language, one can define an *image* as a function $f : S \subset \mathbb{R}^2 \to \mathcal{M}$, where S is the *domain* of the image (which, for real images is actually a subset of \mathbb{Z}^2), and \mathcal{M} is a space of *measurements*. In a gray-scale image, at each point in the image field the sensor measures the intensity of the light, which is a scalar quantity. Therefore, for gray-scale images, $\mathcal{M} = [a, b] \subset \mathbb{R}$. In color images, at each point the sensor measures three quantities that describe a color in a given color system. Therefore, for color images, $\mathcal{M} = C \subset \mathbb{R}^3$. Here, C is a suitable *color space*, which is metric space embedded in \mathbb{R}^3 (see the next section).

There is no need to stop here. If at every point in the image one extracts a descriptor of the local texture and encode it as a vector in, say, \mathbb{R}^n, then the set of such measurements can be considered as a *texture image* $f : S \subset \mathbb{R}^2 \to \mathbb{R}^n$. Similarly, every kind of point features will yield an image from the image domain to a suitable feature space. The distinction between an image and a field, in this case, appears rather arbitrary, and is dictated only by the incidental fact that for certain measurements (gray level and color, for instance) there are suitable rendering devices to produce images that can be seen and recognized. However, for others (such as the measurements in \mathbb{R}^n of the feature extractor) this is not the case. The distinction is obviously immaterial. All the forementioned examples from the gray level image to the texture descriptors are examples of measurements taken on a two-dimensional field with a well-defined topology. The term *feature image* or, when there is no danger of confusion, simply *image*, will be used to refer to all these. With this unification, it is possible to identify point features as those that

[2] Strictly speaking, point features would form a field only if the image were defined on a continuum rather than being represented as a discrete set of pixels.

define an image, and a point feature extractor as that which transforms an image into another image, possibly defined over a different measurement set. This includes rather esoteric measurement sets, such as temperature, intensity of foliage, albedo, and other measurements that one can find in images used in remote sensing, in which the term "image" has the generalized meaning that will be used in this chapter.

Region features are, by exclusion, those which do not define an image. If the image is segmented, divided into a number of regions, and the different regions are represented using some suitable method, the result is not an image. True, it is possible in general to construct some representation of these regions in the form of an image for display purposes, but this image is simply a representation, and not the actual features. If the segmentation algorithm extracted m regions, then the feature is a set $\{R_1, \ldots, R_m\}$, where each R is the representation of a region, an object whose complexity can vary from a simple vector in \mathbb{R}^n to a graph encoding some complex information about the region. If the representation includes, in addition to the description of the various regions, a representation of their structural relations, then the feature itself is a graph.

The first part of this chapter will introduce several common types of point features, the most commonly used of which are color and texture. These point features are often the building blocks on which region features are built. The second part of the chapter will consider several ways of building region features from the point features introduced in the first part. The simplest way to build a region feature from a field of point features is to give a statistical description of the values of the point features across the whole image. This is commonly accomplished by the use of histograms. The problem with histograms is that they often provide too synthetic a description of the features values in the image, given their high variability. A solution to this problem is the detection of regions in which the features are relatively constant. Once this is done, histograms (or even, more simply, the average value of the feature in a region) give a more accurate description. In this case, because the regions are no longer guaranteed to be rectangular, it is also necessary to provide a description of the shape of the region. This will lead naturally to the difficult problem of *segmentation* of an image, and to the related problem of *shape description*. In addition to providing a better way to describe the variability of features across the images, segmentation is also important because uniform regions are often important building blocks for the construction of objects. The problem of object constuction from regions, however, will not be considered in this chapter.

5.2 Color

Modern image processing and understanding systems work on color images, and all image databases use color as one of the possible search criteria [Jacobs *et al.*, 1995; Flickner *et al.*, 1995; Chang and Smith, 1995; Smith and Chang, 1995]. The

reasons for this popularity are easy to understand, for example, color is easy to deal with, fast to process, and is a powerful discriminant. A picture is in color if, processed in some suitable way, and displayed by some suitable device (such as monitor or a printer), it gives an observer a sensory impression chromatically similar to that of a real scene. More precisely, consider an experiment in which an observer is shown two patches of some material with different reflecting characteristics and is asked to find the boundary between the two. An image is a true color image if the experiment can be repeated with the image, rather than with the real colored patches, obtaining comparable results. An image is "gray scale" if patches with the same brightness that were distinguished in the experiment with real patches are not distinguished in the image.

From this definition it follows that the property of being a true color image rather than a gray-scale image is more a matter of degree than a distinct property. This is true, and the degree by which an image can be considered as having colors is known as *saturation*.

Mathematically, a color image is a function $f : S \subset \mathbb{R}^2 \to C \subset \mathbb{R}^3$, where S is bounded. A gray-level image is a function $f : S \subset \mathbb{R}^2 \to \mathcal{L} \subset \mathbb{R}$. The color set C appears at first sight unbounded as, in principle, one can have images of arbitrarily high brightness. There are, however, two considerations that suggest considering C as bounded, one of theoretical nature, and the other more practical. Theoretically, it is physically possible to generate light of any intensity that one might desire. Color, however, does not measure the physical light but the impression that light makes on an observer. As the light increases, the iris of the observer closes, and the perception of light remains the same. If the brightness becomes too intense, one must close one's eyes or risk blindness. Thus, although the space of physical light is unbounded, there are good reasons to model the space of sensory impressions of light as bounded. The practical consideration is connected to the theoretical one. The colors encountered in digitized images can assume a rather limited range of values. It is only thanks to the adaptability of the human visual system (responsible for the theoretical boundedness of the space C) that one can make some sense out of the severely limited pictures that appear on a computer screen or on the pages of a magazine.

Thanks to boundedness, in general, the color space C can often be taken to coincide with the unit cube of \mathbb{R}^3 or, for some system, with a cylinder or a cone in \mathbb{R}^3. The three coordinates of a generic color space C will be labeled c_1, c_2, and c_3. Specific coordinate names will be assigned to the axes of the color space when color systems will be introduced. It is important to understand that this definition of color images has nothing to do with human (or, for that matter, animal) color perception. Animal color perception is a solution to a specific ecological problem, and it evolved based on the fact that the sun emits electromagnetic radiation over a certain range of wavelengths, and different parts of the world that surrounds us reflect light with different spectral properties. The spectral distribution of the light that hits the sensors of an animal carries important information about the nature of certain components of the environment, and it makes sense to spend

some effort and neural machinery trying to analyze it [Bruce and Green, 1985]. This makes it a lot easier to spot a flower to land on, an apple to eat, or a fellow parrot with which to mate.

A complete spectral analysis of the incoming light would be too expensive and needlessly accurate. Frugal evolution used several clever ways to solve the problem approximately and efficiently. (No animal needs to do a full spectral analysis of the incoming light. It would be an unnecessary overkill, and the additional neural machinery and additional energy consumption—and the consequent need for more food—would result in an ecological disadvantage.) Most animal "light analyzers" are based on the presence of several kinds of receptors (two or three [Yeo, 1979; Rose and Woosley, 1949]) in the retina with different spectral sensitivity curves, or mechanisms such as opponent color cells [Bruce and Green, 1985].

This evolutionary solution is not a database system's concern. From the point of view of image analysis, terms such as wavelength or spectral distribution mean nothing. The only difference between gray level and color images is the co-domain of the image function. There, of course, connections between color images and natural color perception are made. The co-domain of color images is in \mathbb{R}^3 because humans have three different types of receptors. In addition, color images can be used as an input to a machine that stimulates our eyes in a way that we consider similar to that done by nature. These connections are clearly present, but it would be misleading to think that they have anything to do with the working of image analysis systems. All the data about animal behavior, ecology and neurophysiology of vision constitute *meta-information*, that is, they can be used to reason about the system, and to draw analogies useful for design. In a database system, however, "color" means strictly "three-dimensional co-domain."

5.2.1 Color Representation

Color vision is used by primates and other animals to do a crude spectral analysis of the incoming light. We see a colored world because we have three different types of cones in the retina, thus one might think that all colors can be obtained by combining the light emitted by three separate sources that stimulate the three types of receptors appropriately [Goldstein, 1989]. This is indeed the case, as can be proven by the following *tristimulus* experiment. An observer looks into a box at a screen that is divided into two parts separated by a curtain, as in Fig. 5.1. The right half of the screen is illuminated by a test light T with a spectral distribution controlled by the experimenter. The left half of the screen is illuminated by three sources of different spectral content, called *primaries*. There are three knobs that make it possible to independently control the intensities of the three primaries. The task of the subject is to turn the knobs so that the two halves of the screen appear of the same color. It turns out that with one or two primaries the task is in general impossible, while with three primaries (subject to some conditions that will be discussed shortly) the match can be obtained for all possible spectral

Figure 5.1. The tristimulus experiment.

distributions of the test light T: *By manipulating the intensities of three primaries P_1, P_2, and P_3, it is possible to match any possible color.*

If $C(\lambda)$ is the spectral distribution of the test light T, $P_1(\lambda)$, $P_2(\lambda)$, and $P_3(\lambda)$ are the spectral distributions of the three primaries, and $A_1(C)$, $A_2(C)$, and $A_3(C)$ are the three intensity values that give the same color, we write:

$$\left[\sum_{i=1}^{3} A_i(C)P_i(\lambda) \right] \approx [C(\lambda)] \tag{5.1}$$

I have used the symbol \approx as a reminder of the fact that the correspondence between the two sides of the equation is only perceptual. Physically, in general, the spectral distributions of the two will be different (three primaries cannot certainly create all possible spectral distributions just by linear combination.)

In most cases, it is preferable to normalize the values A_i with respect to the value they must have to match a reference white w, so as to obtain the quantities

$$T_i(C) = \frac{A_i(C)}{A_i(w)} \tag{5.2}$$

where the T_i are known as the *tristimulus values*. For some test distributions $C(\lambda)$, some of the tristimulus values T_i must be negative. During the experiments, a negative weight to one of the three primaries can be simulated by physically moving one (or two, if necessary) of the primaries on the test-light side, so that it too will illuminate the right-hand side of the screen. At least one of the tristimulus values is always positive.

In order to guarantee matching, the three primaries must be independent: The spectral distribution of any of the three must not be given by a linear

combination of the spectral distributions of the other two. If the primaries are independent, and negative values of the tristimulus values $T_i(C)$ are allowed, then every test light can be matched using the three primaries and the tristimulus values.

The $T_i(C)$ are a function of the color of the test light. As there are many possible colors, it is not easy to manage this functional dependency, and it is desirable to reduce it to something simpler. This is possible by defining the *tristimulus functions* $T_i(\lambda)$. The value of the tristimulus function $T_i(\lambda)$ corresponds to the tristimulus value $T_i(C)$ for a color given by a pure monochromatic light of wavelength λ. In other words, the value $T(\lambda)$ corresponds to the tristimulus value for a color $C(\lambda') = \delta(\lambda' - \lambda)$. The functions $T_i(\lambda)$ are defined by the relation:

$$\left[\sum_{i=1}^{3} T_i(w) T_i(\lambda) P_i(\lambda') \right] \approx [\delta(\lambda' - \lambda)] \tag{5.3}$$

With these functions, the tristimulus values for a color $C(\lambda)$ are given by:

$$A_i(C) = T_i(w) T_i(C) = \int T_i(w) T_i(\lambda) C(\lambda) d\lambda \tag{5.4}$$

It is possible to have a more precise representation of the curves $T_i(\lambda)$ by taking a closer look at how colors are perceived. The human retina contains three types of cones with different spectral absorption curves. (The spectral absorption curve plots the probability of absorbing a quantum of light as a function of the wavelength λ.) The spectral absorption curves of the three types of cones in the human retina are plotted in Fig. 5.2. Some animals have only two types of cones, and even in the human eye the three components given by the three types of cones are hardly the end of the story: There are color opponent cells [Goldstein, 1989], and there is a standing hypothesis that a proper model of human color perception should be four-dimensional rather than three-dimensional

Figure 5.2. Spectral absorption curves for the three types of cones in the human retina.

[Lammens, 1994; Boynton, 1979]. These problems are of little relevance in image analysis, because the three-dimensional color space is a given of most image formats.

The response of the ith type of cones to a frequency distribution $C(\lambda)$ is:

$$R_i = \int S_i(\lambda)C(\lambda)d\lambda \tag{5.5}$$

Two frequency distributions are perceived as the same color if they provoke the same neural response in all three types of cones. Suppose a subject is shown a certain color $C(\lambda)$ and asked to adjust three tristimulus values so that the combination of the three primaries P_1, P_2, and P_3 matches the test color. The neural response for that subject to the combination of primaries is:

$$\tilde{R}_i = \int \left[\sum_k A_k(C)P_k(\lambda) \right] S_i(\lambda)d\lambda \tag{5.6}$$

which, in view of Eq. (5.4), can be expressed in terms of the tristimulus functions as:

$$\tilde{R}_i = \sum_k \int\int A_k(\lambda)P_k(\lambda')S_i(\lambda')C(\lambda)d\lambda d\lambda' \tag{5.7}$$

(where, for simplicity, $A_k(\lambda) = T_i(\lambda)T_i(w)$ is used instead of the normalized tristimulus values). If the two colors are perceived as equal, then they must elicit the same neural response, that is:

$$\tilde{R}_i = \sum_k \int\int A_k(\lambda)P_k(\lambda')S_i(\lambda')C(\lambda)d\lambda d\lambda' = \int S_i(\lambda)C(\lambda)d\lambda = R_i \tag{5.8}$$

This can be written as:

$$\int \left[\left[\sum_k \int S_i(\lambda')A_k(\lambda)P_k(\lambda')d\lambda' \right] - S_i(\lambda) \right] C(\lambda)d\lambda = 0 \tag{5.9}$$

Equation (5.9) must hold for every possible distribution $C(\lambda)$, as it is known experimentally that every color can be matched in the tristimulus experiment. This means that

$$\left[\sum_k \int S_i(\lambda')A_k(\lambda)P_k(\lambda')d\lambda' \right] - S_i(\lambda) = 0 \tag{5.10}$$

or

$$\sum_k \int S_i(\lambda')A_k(\lambda)P_k(\lambda') = S_i(\lambda) \tag{5.11}$$

This equation can be rewritten as

$$\sum_k A_k(\lambda) \int S_i(\lambda')P_k(\lambda')d\lambda' = S_i(\lambda) \tag{5.12}$$

The term under the integral sign depends only on the primaries and the neural responses, and it is a constant independent of the wavelength. Define

$$M_{ik} = \int S_i(\lambda')P_k(\lambda')d\lambda' \tag{5.13}$$

from which it is possible to derive the tristimulus functions:

$$\begin{bmatrix} A_1(\lambda) \\ A_2(\lambda) \\ A_3(\lambda) \end{bmatrix} = M^{-1} \begin{bmatrix} S_1(\lambda) \\ S_2(\lambda) \\ S_3(\lambda) \end{bmatrix} \tag{5.14}$$

or, in short:

$$A(\lambda) = M^{-1}S(\lambda) \tag{5.15}$$

The normalized tristimulus functions are obtained as:

$$T_i(\lambda) = \frac{A_i(\lambda)}{A_i(w)} \tag{5.16}$$

The values of the T_i depend on the primaries chosen. The original primary sources recommended by the Commission Internationale de L'Eclairage (CIE) are three monochromatic sources ($P_i(\lambda) = \delta(\lambda - \lambda_i)$) with $\lambda_1 = 700$ nm (red), $\lambda_2 = 546.1$ nm (green) and $\lambda_3 = 435.8$ nm (blue). A color expressed in terms of the tristimulus values relative to these CIE monochromatic primaries, is said to be expressed in the RGB *color system*.

A *color system* is a systematic way of identifying colors using a vector of numerical values. Most color systems use three values that, for some of them, can be interpreted as the tristimulus values with respect to some system (real or virtual) of primaries. Colors that cannot be matched unless one of the primaries is moved over to the side of the test light (as I mentioned describing the tristimulus experiment) have the corresponding coordinate in the color system negative. For some other system this interpretation is not possible, but colors are still identified using three numerical values.

The *chromaticities* of a color are defined as

$$t_i(C) = \frac{T_i(C)}{T_1(C) + T_2(C) + T_3(C)} \tag{5.17}$$

Clearly, $t_1(C) + t_2(C) + t_3(C) = 1$, so that only two of them are independent. The three chromatic components $t_i(C)$ define a point on a constant brightness plane in the color space. Two of these coordinates, say, t_1 and t_2, represent the chrominance components of a color (e.g., hue and saturation). The color space can be represented as a coordinate system (t_1, t_2, Y) in which Y is the brightness coordinate and the planes $Y = const.$ are chrominance planes. Figure 5.3 shows the chromaticity diagram for the CIE spectral primary system. The points along the line are the pure colors, and the region inside that line contains all the visible colors. The straight line between the blue (360 nm) and the red (780 nm) contains

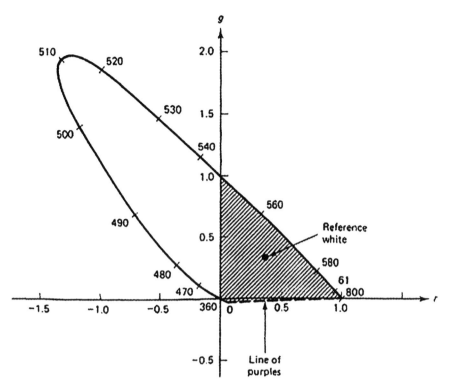

Figure 5.3. Chromaticity diagram for the CIE spectral primary system. G. Wyszecki and W. S. Stiles, *Color Science; Concepts and Methods, Quantitative Data and Formulas,* 1967 and reprinted by permission of John Wiley & Sons, Inc.

the purple colors, and is called the *line of purples*. The triangle joining the points of coordinates $(0,0)$, $(1,0)$, and $(0,1)$ contains the colors for which all the three tristimulus values are positive, and is called the *color gamut*. The colors inside the gamut are physically reproducible by a system using the three primaries, for example, a monitor. The reference white has coordinates $(1/3, 1/3)$.

As was mentioned in the preceding, there is an infinity of color systems. If r, g, b are the tristimulus values of the RGB system, and f_1, f_2, f_3 are three monotonically continuous functions, then the relations

$$h_i = f_i(r, g, b) \qquad (5.18)$$

define another color system. Most of these possible color systems are of no practical interest. By and large, color systems of interest in image databases are defined and used that satisfy one of the following criteria:

Physically interesting. A color system can be used because it fits quite well with some kind of physical device of interest, and makes it easy to reproduce color on such device. For instance, the RGB system owes much of its popularity among

computer scientists to the fact that it maps nicely to the control inputs of a color monitor.

Perceptually motivated. A color system can provide a useful way of describing the way people perceive color. The perfect situation is that in which the Euclidean distance (or some other distance known a priori) between the description of two colors matches the perceived difference between the two colors.

Invariant. A color system is invariant if changes in the color caused by a fixed group of transforms leaves the representation unchanged. In a sense, an invariant color system is a bad one, because it does not provide a complete description of every possible color, but groups together certain colors in the same class. This, however, is precisely what many image database applications need, that is, a color system that can abstract from certain unimportant differences that, from the point of view of the user in certain application, are irrelevant [Gevers and Smeulders, 1996].

The RGB system is physically interesting, but there are a number of problems with it. One of them concerns the color gamut (the set of colors for which all the coordinates are positive.) When trying to reproduce colors by physical means, the color gamut is the only area that can be reproduced. It can be seen in Fig. 5.3 that the color gamut for the RGB system is quite small, thus not many colors can be reproduced. This is hard to realize by looking at the beautiful pictures on a computer display, but that is the way it is! The fact that the images displayed on a monitor appear real is another gracious concession to our very forgiving visual system.

It is interesting that no physically realizable primaries have been found that can reproduce all the colors: For some colors some of the tristimulus values become negative. The CIE developed the X, Y, Z system of "virtual" primaries such that all the tristimulus values are positive. The primaries X, Y, Z are not physically realizable. In this system, Y represents the brightness of the color, and X, Z represent the chrominance. The chromaticity diagram for the X, Y, Z system is depicted in Fig. 5.4. As expected, the diagram is contained in the first quadrant of the coordinate system. The coordinates of the reference white are $X = Y = Z = 1$; XYZ is the official CIE color system. The CIE tristimulus functions are defined in XYZ [Wyszecki and Stiles, 1967], and all the other color systems are defined in terms of XYZ. In Table 5.1, however, RGB will be considered as the fundamental color system, and XYZ will be defined in terms of it. This is consistent with the fact that in all computer applications images are given as RGB triplets and therefore for an image database, RGB is the truly fundamental system. Other physically motivated systems reported in Table 5.1 and Table 5.2 are the YIQ system, which is part of the NTSC standard, and the NTSC R_N, G_N, B_N system.

Perceptually motivated color systems attempt to define a color space in which a simple metric will suffice to model human color perception. A very useful tool to measure the adherence to the perceptual distance is given by the *MacAdams ellipses*. If we fix a color, we change its coordinates slightly until an observer notices that the color has changed, mark the point of the new color, and repeat

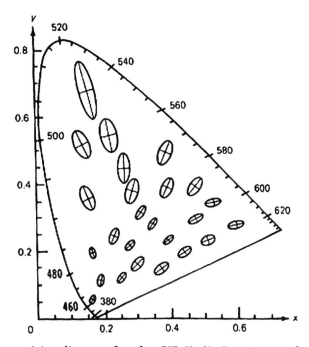

Figure 5.4. Chromaticity diagram for the CIE X, Y, Z system with the MacAdams ellipses having just noticeably different colors. G. Wyszecki and W. S. Stiles, *Color Science; Concepts and Methods, Quantitative Data and Formulas*, 1967 and reprinted by permission of John Wiley & Sons, Inc.

the operation for various displacements of the coordinates. The result is an ellipse known as the *MacAdams ellipse*. Colors inside the MacAdams ellipse are indistinguishable from the color in the middle, while colors on the MacAdams ellipse are *just noticeably different* (JND) from the color at the center of the ellipse. Figure 5.4 shows the MacAdams ellipses at several points of the X, Y, Z diagram. The ellipses have different orientation and size because the X, Y, Z space is *distorted* with respect to the perceptual space [Wyszecki and Stiles, 1967]. If the MacAdams ellipses were all circumferences of the same size, the color space would be *perpetually uniform*, and the perceptual color difference could be calculated as the Euclidean distance between the corresponding points.

In the *uniform chromaticity scale* (UCS) u, v, Y system, these ellipses, which in the X, Y, Z system have eccentricities up to 20:1, are transformed into much more circular entities (eccentricity $\approx 2:1$). The U^*, V^*, W^* system is a modification of UCS. The W^* component is the cube root of the luminance and represents the brightness of a uniform color patch. For colors with very little saturation the Euclidean distance between the coordinates of two points is a good approximation of the perceptual distance between their colors. The S, θ, W^* system is a polar representation of U^*, V^*, Z^* in which S represents the saturation and θ the hue. Finally, the L^*, a^*, b^* color system, similarly to the U^*, V^*, W^* system, gives a relatively uniform color space in which color differences can be computed.

Table 5.1. Some common color systems.

CIE spectral primary system: RGB	Monochromatic primary sources: red (700 nm), green (546.1 nm), blue (435.8 nm). Reference white has flat spectrum and $R = B = G = 1$
CIE X, Y, Z system \quad Y = luminance	$\begin{bmatrix} X \\ Y \\ Z \end{bmatrix} = \begin{bmatrix} 0.490 & 0.310 & 0.200 \\ 0{:}177 & 0.813 & 0.011 \\ 0.000 & 0.010 & 0.990 \end{bmatrix} \begin{bmatrix} R \\ G \\ B \end{bmatrix}$
CIE uniform chromaticity scale (UCS) system $u;v;Y$ Y = luminance u, v = chroma U, V, W: tristimulus values corresponding to u, v	$u = \dfrac{4X}{X + 15Y + 3Z}$ $v = \dfrac{6Y}{X + 15Y + 3Z}$ $U = \dfrac{2X}{3}; \quad V = Y; \quad W = \dfrac{-X + 3Y + Z}{2}$
W^*, V^*, W^* system (modified UCS system) Y = luminance ($[0.01,1]$) u_0, v_0 = chromaticity of reference white W^* = contrast of brightness	$U^* = 13U^*(u - u_0)$ $V^* = 13U^*(v - v_0)$ $W^* = 25(100Y)^{1/3} - 17 \quad 1 \le 100Y \le 100$

Some of the most common color systems are reported in Table 5.1 and Table 5.2.

The tristimulus experiment (and the color systems that are based on it) makes a number of assumptions, which correspond to just as many limitations in its applicability. The most relevant are (see also Lammens (1994)):

1. The experiment determines single-point color perception only. Color systems derived from the tristimulus experiment do not consider *context* phenomena, such as induced colors, Mach bands, and other effects that depend on the interaction between different colors in the visual field. Although these effects are important from a psychophysical point of view, current techniques for the processing of color images are not nearly sophisticated enough to grant consideration of these phenomena. The interested reader should consult some of the many books on human vision, for example, Boynton (1979).

2. Color systems assume that the visual system is adapted, and do not consider problems of color constancy under varying lighting conditions.

Table 5.2. Other common color systems.

S, ϑ, W^* system (polar form of U^*, V^*, W^*) S = saturation ϑ = hue W^* = brightness	$S = \sqrt{\tilde{U}^{*2} + \tilde{V}^{*2}} = 13W^*\sqrt{(\tilde{u} - u_0)^2 + (\tilde{v} - v_0)^2}$ $\vartheta = \tan^{-1}\dfrac{V^*}{U^*} = \tan^{-1}\dfrac{v - v_0}{u - u_0}$
NTSC receiver primary system R_N, G_N, B_N	$\begin{bmatrix} R_N \\ G_N \\ B_N \end{bmatrix} = \begin{bmatrix} 1.910 & -0.533 & -0.288 \\ -0.985 & 2.000 & -0.028 \\ 0.058 & -0.118 & 0.896 \end{bmatrix} \begin{bmatrix} X \\ Y \\ Z \end{bmatrix}$
NTSC transmission system Y, I, Q Y = luminance I, Q = chrominance	$\begin{bmatrix} Y \\ I \\ Q \end{bmatrix} = \begin{bmatrix} 0.299 & 0.587 & 0.114 \\ 0.596 & -0.274 & -0.322 \\ 0.211 & -0.523 & 0.312 \end{bmatrix} \begin{bmatrix} R_N \\ G_N \\ B_N \end{bmatrix}$
L^*, a^*, b^* system L^*: brightness a^*: red-green content b^*: yellow-blue content	$L^* = 25\left(\dfrac{100Y}{Y_0}\right)^{1/3} - 16$ $a^* = 500\left[\left(\dfrac{X}{X_0}\right)^{1/3} - \left(\dfrac{Y}{Y_0}\right)^{1/3}\right]$ $b^* = 200\left[\left(\dfrac{Y}{Y_0}\right)^{1/3} - \left(\dfrac{Z}{Z_0}\right)^{1/3}\right]$

5.2.2 The Perception of Colors

Color is not a physical property of the incoming light, but a perceptual property of the color perceiver. In addition to being a useful ecologic characteristic that allows one to distinguish a ripe apple from a green one, it influences our perception of a scene in many subtle ways.

Art has a long tradition of using color to stimulate emotions in the observer. Placing the right color at the right place is in part a matter of intuition (or talent, or whatever one decides to call it) and in part a matter of intellectual and rational knowledge. It is impossible to ascertain the relative importance of these two components. Their relative share, and the part of this share that the artist is willing to admit, change with time and culture. I do not think that Bach would have objected to the observation that many of his contrapuntal deductions were the result of indefatigable work. To improvise the *Ricercar a 3* from the *Musikalische Opfer* in front of Frederick the great, as many critics think he did, however, requires a genius beyond comprehension. On the other hand, many Romantics

liked to overestimate the role of inspiration, in harmony with their philosophy
that encouraged disregard for rationality.

The Nineteenth Century saw the first attempts to develop a complete the-
ory of color perception.[3] In 1810 Runge published his color theory based on a
spherical coordinate system. In the same year, Goethe published his major work
on color [von Goethe, 1970]. Cevreul published "De la Loi du Contraste Simultané
des Colors at de l'Assortiment des Objects Coloris" in 1839, a work that would
become the scientific foundation of impressionism [Cevreul, 1987]. Most of these
color theories did not survive a thorough scrutiny because of their lack of physi-
ological foundation, their primitive model of the brain, and their lack of scientific
rigor. However, they are important because they provide a model of psychological
perception of color, which is adequate for many purposes.

In this century, there have been attempts to systematize knowledge of color
from the point of view of the artist.[4] In this section, I will try to introduce the
salient characteristics of Itten's color model. Itten's theory is presented in two
books: the 1961 *The Art of Color* [Itten, 1961], and the 1970 *The Elements of
Color*, which is an abridgment of the first. The work of Itten was brought to my
attention for the first time by Del Bimbo and his group at the Università di Firenze,
who used it for their "color semantic" search in databases of paintings [Corridoni
et al., 1996].

Any attempt to explain, at least in part, the effects of the use of colors on the
observer is certainly interesting per se. However, it is hard to predict how useful
it will be in any specific circumstance. Systems such as that of Del Bimbo and his
group are used by people who are artists, critics or, in any case, have a more than
casual interest in art. For these people, we can safely assume a certain knowledge
of color, at least intuitively. For other, less artistic-oriented applications, only time
will tell.

Itten is not interested in individual colors as much as he is in *contrasts* of
colors. In particular, he is interested in what people perceive as *harmony* of colors.
Itten bases his considerations on the use of a color circle, first developed by Runge
and known as the *Runge-Itten circle*. Itten then developed this circle into a three-
dimensional *color sphere*.

To build the circle, one starts by painting the three primary colors, red, green,
and yellow[5] in the shape of a triangle (see color plate 1) with the yellow at the
top, the red at the lower right, and the blue at the lower left. The colors must be
carefully chosen so that the brightness of the different patches is the same. I will

[3] The term is used here to emphasize that these theories were intended to model the psychological
act of perceiving color, rather than the physical act of creating them.

[4] I use the word artist liberally. In this section I have in mind mainly the painter using such traditional
media as canvas, wood, and colors.

[5] Itten is a painter, and he is mainly concerned with subtractive synthesis of colors. In his context,
his choice of primaries makes sense. I will talk more extensively about the differences between Itten's
approach and ours in the following.

let Itten explain the rest (1970, p. 29):

> About this triangle we circumscribe a circle, in which we inscribe a regular hexagon. In the isosceles triangles between adjacent sides of the hexagon, we place three mixed colors, each composed of two primaries. [...]
>
> Now, at a convenient radius outside the first circle, let us draw another circle, and divide the ring between them into twelve equal sectors. In this ring, we repeat the primaries and secondaries at their appropriate locations, leaving a blank sector between every two colors. In these blank sectors, we paint the tertiary colors, each of which result from mixing a primary with a secondary. [...]
>
> Thus we have constructed a regular 12-hue color circle in which each hue has its own unmistakable place [...]. The sequence of the colors is that of the rainbow or natural spectrum.

The result is the Runge-Itten color circle. A more complete representation of color is given by the *Itten color sphere*, which, in addition to hue, takes into account contrast and saturation. A general idea of the organization of the sphere is in Fig. 5.5. The north pole $(0, 0, 1)$ of the sphere is white, and the south pole $(0, 0, -1)$ is black. The z axis contains the shades of gray. This is the line of color with zero saturation. As one moves from the z axis towards the surface of the sphere, saturation increases and the surface contains the completely saturated colors. As the z coordinate decreases, the brightness decreases from 1 (when $z = 1$) to 0 (when $z = -1$). Moving along one of the horizontal circles centered at the z axis, the hue changes. In fact, every one of these circles is a Runge-Itten circle with colors of a given saturation and brightness. Color plate 2 shows some views of the Itten sphere.

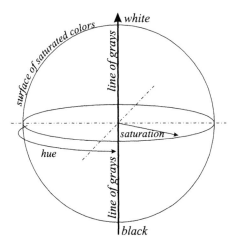

Figure 5.5. A schematic representation of the Itten color sphere.

Itten defines and studies seven types of contrast:

1. contrast of hue;

2. light-dark contrast;

3. cold-warm contrast;

4. complementary contrast;

5. simultaneous contrast;

6. contrast of saturation; and

7. contrast of extension.

The last contrast is actually a contrast in the areas of the color regions, this it does not properly belong in a color theory.

The most interesting part of Itten's book, for image analysis applications, is that in which he tries to describe color harmony in terms of the position of colors on the color circle or the color sphere. He calls *harmonious chord* a group of two or more colors that stand in harmonic relation. The two simplest combinations of harmonic colors that Itten analyzes are the dyadic and the triadic:

Dyads: In the color circle, two diametrically opposite colors are complementary, and form a harmonious dyad. In the color sphere, two colors placed symmetrically with respect to the central axis of the sphere form an harmonious dyad.

Triads: Three colors in the color circle that form an equilateral triangle form an harmonious triad. Also, if one of the colors in a harmonious dyad is replaced by its two neighbors, the result is an isosceles triangle, and the colors are a harmonious triad.

5.3 Texture

Saint Augustine said about the concept of time: "If you don't ask me what it is, I know it. If you do ask me, I don't know it." Something not too different could be said about the concept of texture in computer vision. Some definitions make reference to haptic rather than visual qualities. The definition in *Webster's Dictionary* seems as good as any: "**1: Texture** *n* [L *textura*, fr. *textus*, pp. of *texere* to weave—more at TECHNICAL] **1a**: something composed of closely interwoven elements; *specif.* a woven cloth."

In computer vision, the term acquires a rather more technical meaning. A texture is composed of the frequent repetition of similar elements called *texemes*. Texemes are repeated with a mix of regularity and randomness and, in order for a patch of image to be considered textured, there must be a large number of rather small texemes. Being textured is therefore a function of the scale at which the image is observed. An image that appears as a combination of two or three objects

at a given scale can result in a texture combination of many texemes when observed at a different scale. In very general terms, it is reasonable to say that *a texture is a combination of a relatively large number of objects in which the individuality of each object is not regarded as important, and in which the structural properties of the set of objects is predominant.*

In the previous definition, I have purposely eliminated the requirements that objects must be similar. Certain textures are composed of groups of rather different elements. A picture of a patch of gravel, for instance, is usually considered as a good example of texture in spite of the fact that stones can differ in size, color, and shape. The similarity at play in the image of a texture is an *ensemble similarity*, not the kind one measures between pairs of images.

The computer vision literature reports two large families of methods for the characterization of textures: *statistical* and *syntactic*. Statistical methods disregard the characterization of the texemes as objects and study the statistical properties of the field of the gray levels of an image. Syntactic texture description make an analogy between the elements of a texture and the terminal symbols of a formal language [Tomita *et al.*, 1982]. A formal grammar is used to describe the shape of the texemes and their relationships. Just as in the case of grammars for the description of languages, texture grammars contain recursive generative rules, and formal methods can be used to derive parsers for the recognition of texture starting from these generative rules. Due to the variability of real-world textures, nondeterministic or stochastic rules are sometimes used as part of a texture grammar [Fu, 1974].

The use of texture grammar places emphasis on the individual elements and on the regularity of their relations rather than on ensemble properties. This is somewhat in contrast with the spirit of the definition of texture given in the preceding and, I would argue, the source of most of the problems that syntactic methods encounter in the definition and recognition of natural and irregular textures. In the context of image databases, statistical methods have the additional advantage of generating features that often can be arranged in vectors, giving access to a plethora of techniques for defining and manipulating texture similarity. Because of this, statistical methods are predominant in the texture portion of image databases, and the remainder of this section will be completely devoted to them.

5.3.1 The Problem of Scale

This chapter considers texture as point features for two reasons. First much as it is possible to define a color descriptor at every point of an image, it is possible to define a texture descriptor. Second, if the image were an ideal analytical function in the continuum, it would be possible to compute texture descriptions based on local variations only. In practice, however, texture descriptors are based on a *neighborhood* around the point in which they are nominally defined. The size of this neighborhood is an important factor in the characterization of the texture.

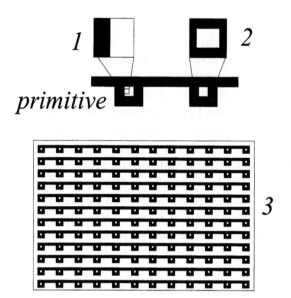

Figure 5.6. Differences in the analysis of this texture arise at different scales.

In the texture of Fig. 5.6, for instance, considering the primitive at the scale of square 1 results in a texture with strong vertical orientation, considering it at a larger scale (square 2) results in a isotropic texture, and considering it at a still larger scale (square 3) results in a texture with a dominant horizontal component.

A measure of scale significance is used in *Blobworld* [Carson *et al.*, 1999], based on some previous work by Leung and Malik (1996), and making use of a measure called *polarity*. Qualitatively, the polarity is a measure of the extent to which all the gradients in a given neighborhood point in the same direction. The polarity is computed as follows. Let $[\cdot]_+$ and $[\cdot]_-$ be the positive and negative truncation operators, that is:

$$[x]_+ = \begin{cases} x & \text{if } x > 0 \\ 0 & \text{otherwise} \end{cases} \tag{5.19}$$

and $[x]_- = [-x]_+$. Also, let $G_\sigma(x, y)$ be a Gaussian kernel of variance σ. By computing the convolution of the Gaussian kernel with the image $(G_\sigma(x, y) * I)^6$ the value σ determines the scale at which the image is considered. Let $\phi(x, y)$ be the dominant direction of the image at the pixel considered and at the scale σ. One way to compute the dominant direction $\phi(x, y)$ is to approximate the gradient $\nabla I(x, y)$ using finite differences (e.g., $\nabla I(x, y) \approx [I(x + 1, y) - I(x, y), I(x, y + 1) - I(x, y)]^T$, or using some more sophisticated approximation [Press *et al.*, 1986])

[6] The symbol $*$ will be used here, as customary, to indicate the convolution operator. If I and J are two images, or an image and a two-dimensional kernel, then $I * J$ is a two-dimensional array defined as

$$(I * J)(i, j) = \sum_{k,h} I(h, k) J(i - h, j - k).$$

and compute the 2×2 matrix

$$M_\sigma(x,y) = G_\sigma(x,y) * \nabla I (\nabla I)^T \tag{5.20}$$

The direction of the eigenvector corresponding to the dominant eigenvalue is the direction $\phi(x,y)$. Once $\phi(x,y)$ is computed, let $\hat{n}(x,y)$ be a unit vector perpendicular to the direction $\phi(x,y)$.[7] Then, define the quantities

$$E_+(x,y) = G_\sigma(x,y) * [\nabla I(x,y) \cdot \hat{n}(x,y)]_+ \tag{5.21}$$

and

$$E_-(x,y) = G_\sigma(x,y) * [\nabla I(x,y) \cdot \hat{n}(x,y)]_- \tag{5.22}$$

Qualitatively, the values E_+ and E_- measure how many vectors in the neighborhood are on the "positive side" or the "negative side" of the dominant direction, respectively. Finally, the polarity at the scale σ and the point (x,y) is given by

$$p_\sigma = \frac{|E_+(x,y) - E_-(x,y)|}{E_+(x,y) + E_-(x,y)} \tag{5.23}$$

The polarity p_σ is a number between zero and unity, and varies as the scale σ changed. Its behavior in typical images can be summarized as follows:

Edge: If an edge is present at the point (x,y), then $p_\sigma(x,y)$ will remain close to unity at all scales σ.

Texture: In textured regions, p_σ decays with σ. As the window that is being considered increases, pixels with different gradient orientations are included in the window, therefore the dominance in any diven direction decreases.

Uniform: In a uniform region, p_σ is arbitrary and randomly variable with σ as the gradients have very small magnitudes and the angles are random and very unstable.

In Carson *et al.* (1999), the scale at which the texture features should be extracted is chosen by observing the derivatives of the polarity with respect to scale. The general idea is that if the texture is approximately periodic, the polarity will tend to stabilize when the scale will encompass more or less one period. A number of different scales σ_k are considered. Each scale produces a "polarity image" $p_{\sigma_k}(x,y)$. Each polarity image is then convolved with a Gaussian with standard deviation $2\sigma_k$, thus obtaining a smoothed polarity image $\tilde{p}_{\sigma_k}(x,y)$. For each pixel (x,y) the first scale for which the difference $|\tilde{p}_{\sigma_k} - \tilde{p}_{\sigma_{k-1}}|$ is less than 2% is selected.

Scale detection can be done prior to scale extraction. The remainder of this section introduces a variety of methods for texture description; in all cases, it will be assumed that the scale of the image or the size of the pixel's neighborhood has been selected using an appropriate scale selection method or are given a priori.

[7] There are two such unit vectors. The choice of one over the other does not change the result.

5.3.2 Statistical Texture Features

A well-known class of methods describes a texture through a statistical analysis of the discrete field of gray-level values. For the time being, the textured image will be a gray-level discrete function $f : S \subset \mathbb{Z}^2 \to \mathbb{R}$.

Autocorrelation. The spatial organization of a texture can be described using the autocorrelation of the function f at various interpixel distances [Sonka *et al.*, 1999]:

$$C_{ff}(p, q) = \frac{MN}{(M - p)(N - q)} \frac{\sum_{i=1}^{M-p} \sum_{j=1}^{N-q} f(i, j) f(i + p, j + q)}{\sum_{i=1}^{M} \sum_{j=1}^{N} f^2(i, j)} \tag{5.24}$$

If the textures possesses some direction of symmetry with respect to one or more vantage points, then the autocorrelation function can be computed as a function of a distance parameter. The distance function used in this case should be such that the iso-distance curves from the vantage point will coincide with the directions of symmetry. For instance, for a texture with horizontal and vertical symmetries, one can use the L_∞ distance function, while for completely rotation-invariant textures, one can use the Euclidean distance. In any case, let $d((x_1, y_1), (x_2, y_2))$ be a distance function between pairs of pixels based on the symmetry properties of the texture. Also, let $A(r) = \{(p, q) : r - \varepsilon \leq d((0, 0), (p, q)) \leq r + \varepsilon\}$, where ε is a tolerance parameter whose value will be discussed in the following. The distance-based autocorrelation function is in this case

$$C_{ff}(r) = \frac{1}{|A_{ij}(r)|} \frac{MN}{(M - p)(N - q)} \frac{\sum_{i=1}^{M-p} \sum_{j=1}^{N-q} \sum_{p,q \in A_{ij}(r)} f(i, j) f(i + p, j + q)}{\sum_{i=1}^{M} \sum_{j=1}^{N} f^2(i, j)}$$

$$\tag{5.25}$$

The parameter ε is used to avoid losing pixels because of rounding errors. Due to the discrete nature of the pixels, only a limited number of distance values are actually possible. For an image of size $n \times n$ and the L_∞ distance, for instance, the distance between two pixels can only assume the values $\{0, 1, \ldots, n\}$. Because of this, for most values of r, it would be $C_{ff}(r) = 0$. The value ϵ should be large enough so that, for any value of r, the set $A(r)$ will contain some pixels.

Having $\varepsilon > 0$ also introduces some *crosstalk* between different values of $C_{ff}(r)$. That is, if r and r' are close enough, the values $C_{ff}(r)$ and $C_{ff}(r')$ will no longer be independent because many pixels will appear in both $A(r)$ and $A(r')$. This is usually not a problem as the function $C_{ff}(r)$ is never itself used as a feature, but it is sampled either to form a feature vector or as a pre-processing stage for further processing. All that is necessary is that, if the function $C_{ff}(r)$ is sampled in the points r_i, $i = 1, \ldots, m$, then the value ε should be small enough to guarantee that there will be no crosstalk between $C_{ff}(r_1)$ and $C_{ff}(r_{i+1})$. In the case of the L_∞ distance, a value $\varepsilon = 1/2$ guarantees that no pixel distance will be lost and that there will be no crosstalk for a sampling $r_i = i$.

The autocorrelation function is rarely used as a feature itself because it is often large and not very manageable. In many cases, a more compact characterization is desirable. Given the statistical nature of the autocorrelation function, it is natural to characterize it in terms of its moments. Let $1 \le p, q \le M$ be the interval in which the autocorrelation function is computed. The average of $C_{ff}(p, q)$ is

$$\bar{C}_f f = \frac{1}{M^2} \sum_{p=1}^{M} \sum_{q=1}^{M} C_{ff}(p, q) \qquad (5.26)$$

The moment of order (k, l) of the function C_{ff} is given by

$$M(k, l) = \sum_{p=1}^{M} \sum_{q=1}^{M} (p - \mu_1)^k (q - \mu_2)^l C_{ff}(p, q) \qquad (5.27)$$

where

$$\mu_1 = \sum_{p=1}^{M} \sum_{q=1}^{M} p C_{ff}(p, q) \quad \text{and} \quad \mu_2 = \sum_{p=1}^{M} \sum_{q=1}^{M} q C_{ff}(p, q) \qquad (5.28)$$

are the coordinates of the center of mass of the function C_{ff}. The most significant coefficients for texture description are the *profile spreads* $M(1, 0)$ and $M(0, 1)$, the *cross correlation* $M(1, 1)$, and the *second degree spread* $M(2, 2)$.

Co-occurrence. Co-occurrence matrices measure the repeated occurrence of some gray-level patterns over the texture. In general, the configuration varies rapidly with distance in fine textures and slowly with coarse textures. Such patterns can be measured by a matrix of relative frequencies $P_{\phi,q}(a, b)$, counting how often two pixels of gray levels a and b appear separated by a distance q in the direction ϕ. Formally,

$$P_{\phi,q}(a, b) = \frac{1}{M^2} \left| \left\{ (i, j), (h, k) : d((i, j), (h, k)) = q, \right. \right.$$

$$\left. \left. \tan \phi = \frac{i - j}{h - k}, f(i, j) = a, f(h, k) = b \right\} \right| \qquad (5.29)$$

where M is the linear size of the texture patch. The two equalities $d((i, j), (h, k)) = q$ and $\tan \phi = i - j/h - k$ should be replaced with two approximate equalities using two parameters ε_q and ε_ϕ as in the previous case, subject to the same constraints.

As in the previous case, symmetries in the texture translate into relaxed constraints for the co-occurrence matrix. In the case of a complete radial symmetry, for instance, the co-occurrence matrices are functions only of the distance q:

$$P_q(a, b) = \frac{1}{M^2} |\{(i, j), (h, k) : d((i, j), (h, k)) = q, f(i, j) = a, f(h, k) = b\}| \quad (5.30)$$

Similar to the autocorrelation function, co-occurrence matrices are rarely used as features per se. Rather, they are used as a starting point for deriving other more synthetic features, the most common of which are [Sonka *et al.*, 1999]:

Energy $\sum_{a,b} P_{\phi,d}^2(a,b)$

Entropy $\sum_{a,b} P_{\phi,d}(a,b) \log P_{\phi,d}(a,b)$

Maximum probability $\max_{a,b} P_{\phi,d}(a,b)$

Contrast $\sum_{a,b} |a-b|^\kappa P_{\phi,d}^\lambda(a,b)$ (typically, $\kappa = 2$, and $\lambda = 1$).

Inverse difference moment $\sum_{a,b;a\neq b} \frac{P_{\phi,d}^\lambda(a,b)}{|a-b|^\kappa}$

5.3.3 Gabor Decomposition

Decomposition of texture images using the Gabor function has proven a very successful method for characterizing textures for image database applications [Manjunath and Ma, 1996]. A possible explanation for this success is connected to the metric properties of transforms such as Gabor's, which will be considered in more detail in the next chapter. This section will only present the main ideas and properties.

A two-dimensional Gabor *mother wavelet* is a harmonic oscillator composed of a sinusoidal plane wave of a given frequency, oriented in direction of the x axis, which modulates a Gaussian envelope function. A Gabor function is fully determined by its frequency (ω), and bandwidth (σ_x, σ_y). The two-dimensional complex Gabor mother wavelet is defined as:

$$G(x,y) = \frac{1}{2\pi\sigma_x\sigma_y} \exp\left[-\frac{1}{2}\left(\frac{x^2}{\sigma_x^2} + \frac{y^2}{\sigma_y^2}\right)\right] \exp(2\pi i \omega x) \qquad (5.31)$$

In general, only the real part of the function is considered:

$$G(x,y) = \frac{1}{2\pi\sigma_x\sigma_y} \exp\left[-\frac{1}{2}\left(\frac{x^2}{\sigma_x^2} + \frac{y^2}{\sigma_y^2}\right)\right] \cos(2\pi \omega x) \qquad (5.32)$$

A bank of Gabor filters is obtained by dilating and rotating the mother wavelet:

$$G_{mn}(x,y) = a^{-m} G(x',y') \qquad (5.33)$$
$$x' = a^{-m}(x\cos\theta_n + y\sin\theta_n)$$
$$y' = a^{-m}(-x\sin\theta_n + y\cos\theta_n)$$

where $a > 1$, n and m are integers, $\theta = n\pi/K$, and K is the total number of orientations. The placement of the Gabor filters in the (ω_x, ω_y) plane, and the shape of two of these filters is shown in Fig. 5.7. An image $I(x,y)$ is analyzed by convolution with the bank of filters, obtaining a series of filter response functions $w_{mn}(x,y)$ as

$$w_{mn}(x,y) = \sum_{a,b} G_{mn}(x-a, y-a) I(a,b) \qquad (5.34)$$

As in the previous cases, the matrices $w_{mn}(x,y)$ are not used directly to represent the images. Rather, for every $w_{mn}(x,y)$, the mean and standard deviation

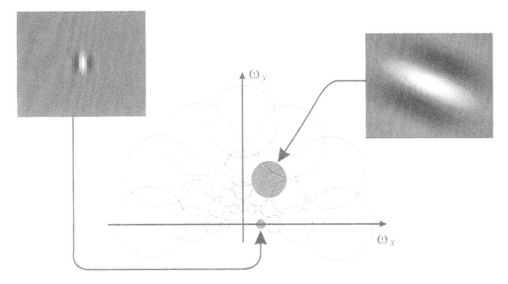

Figure 5.7. Gabor filter spectra, and responses of two Gabor filters.

are computed, and the values are collected to form a feature vector. In Manjunath and Ma (1996), the filter bank consisted of five scales and six directions, that is, of 30 different filters. From the reponse of every filter, two quantities (average and standard deviation) are extracted, resulting in a 60-dimensional feature vector.

The use of Gabor filters provides excellent performance in many cases, but it has a few drawbacks. The selection of the right combination of filters is somewhat image dependent, and in certain applications can be nontrivial. Gabor filters are nonorthogonal, and this makes the creation of fast algorithms for image filtering using a bank of filters problematic. In many cases, the filters are convolved one by one with the original image, resulting in a rather computationally intensive feature-extraction phase.

5.3.4 Quadrature Mirror Filters

Quadrature mirror filters are used to divide a sequence of length n into two sequences of length $n/2$ in such a way that the first sequence represents a lower resolution of the original one (i.e., the first sequence is a lowpass version of the original sequence), and the second sequence contains the "missing detail" that has to be added to the first sequence in order to reconstruct the original. Quadrature mirror filters are introduced in the next chapter. The one-dimensional filter can be applied to an image by transforming first the rows and then the columns. Traditionally, when transforming a one-dimensional sequence of length n, the two transformed sequences are organized as a single sequence of length n placing the lowpass portion (or length $n/2$) first and the high-pass portion (also of length $n/2$) next. When the same arrangement is applied to the transform of an image of

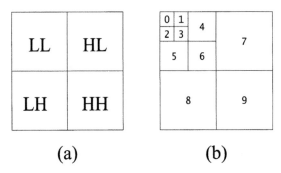

$$(a) \hspace{4cm} (b)$$

Figure 5.8. Standard placement of the subbands in a quadrature mirror filter application (a), and result after three applications of the filter (b).

size $n \times n$, we obtain the arrangement of Fig. 5.8a. The result of three applications of the quadrature mirror filter is the system of 9 bands in Fig. 5.8b. Let c_{ij}^k be the matrix of coefficients in the kth band, and $n(k)$ be the size of the band. If the original image has size $2^m \times 2^m$, the transform can be applied m times, creating $3m + 1$ bands. For the kth band, it is

$$n(k) = \begin{cases} 1 & \text{if } k = 0 \\ 2^{\lfloor \frac{k-1}{3} \rfloor + 1} & \text{otherwise} \end{cases} \tag{5.35}$$

Features are then extracted from the individual subbands. A typical example of a feature that can be extracted from a multiresolution decomposition is the *energy* of the bands [Laine and Fan, 1993]. For the kth band, the energy is given by

$$E_k = \sum_{i,j=1}^{n(k)} c_{ij}^2 \tag{5.36}$$

The energy is usually computed only for the bandpass portion of the decomposition, that is, in Fig. 5.8b, the energy is not computed for band number 0. As these bands have zero mean, the features E_k also correspond to the variance of the coefficients inside the band. An alternative is given by the mean deviation

$$D_k = \sum_{i,j=1}^{n(k)} |c_{ij}|. \tag{5.37}$$

Because the average of the coefficients inside a band is zero, using the features E_k, which correspond to the variance of the coefficients, is equivalent to describing the probability distribution of the coefficients with a Gaussian distribution. It is possible to have a more precise characterization of the texture by a more precise statistical model. Mallat (1989) observed that for a variety of natural textures, the probability density of the coefficients can be modeled by a function of the family

$$p(u) = K e^{-(|u|/\alpha)^\beta} \tag{5.38}$$

The coefficients K (which is a normalization factor), α, and β completely characterize the probability distribution, and can be used as texture features. Given

the coefficients c_{ij}, the probabilities $p(u)$ can be estimated by computing their histogram (histograms will be described in detail in the next section). Let N_u be the number of coefficients c_{ij} with value equal to u, that is, $N_u = |\{c_{ij} : c_{ij} = u\}|$.[8] Then the value $p(u)$ is given by $p(u) = N_u/(n(k)^2)$. A method for computing K, α, and β, was proposed in Van De Wouwer *et al.* (1999). Compute the coefficients

$$m_1 = \int |u| p(u)\, du, \quad m_2 = \int |u|^2 p(u)\, du \tag{5.39}$$

From these coefficients one obtains:

$$\beta = F^{-1}\left(\frac{m_1^2}{m_2}\right)$$

$$\alpha = m_1 \frac{\Gamma(1/\beta)}{\Gamma(2/\beta)}$$

$$K = \frac{\beta}{2\alpha\Gamma(1/\beta)} \tag{5.40}$$

where

$$F(x) = \frac{\Gamma^2(2/x)}{\Gamma(3/x)\Gamma(1/x)} \tag{5.41}$$

and

$$\Gamma(x) = \int_0^\infty e^{-t} t^{x-1}\, dt \tag{5.42}$$

is the Euler function.

5.4 Histograms

Content-based image retrieval makes extensive use of histograms for image representation. Their most usual embodiment is the color histogram but, given their importance and their generality, I will introduce them as a general feature representation tool, and analyze their properties and shortcomings for image database applications.

Consider an image I, and assume that for every pixel certain measurements are performed obtaining a *measurement vector x*. For each image, this results in a function $f_I : R \subset \mathbb{R}^2 \to M \subset \mathbb{R}^m$, where m is the number of measurements. In the case of color, for instance, one measures the color of every pixel. In this case it is $m = 3$, and the function f_I assigns to each image point the coordinates of its color expressed in a conventionally established color system. Other examples

[8] This simple computation of the probability density function is possible because, in all practical cases, the coefficients c_{ij} are approximated to take value in a finite set. If the coefficients are real numbers, a more complicated approximation procedure should be employed.

include the response of certain directional filters for the detection of edges or the response of feature extractors for the characterization of textures.

In this section I will often assume that the set of values M is a compact and bounded subset of \mathbb{R}^m. In practice, both R and M will be finite sets, with R being the set of pixels in the image, and M being the (finite) set of possible values of the features. As a general rule, I will introduce the definitions and properties of histograms for the continua R and M, as this makes it possible to access the well-established machinery for the study of continuous functions, and will make the properties of the histograms more readily apparent. At the same time, the properties and definitions will be extended to the *discrete histogram*.

The basic content-based image retrieval problem of characterizing the difference between two images I and J (relative to the given measurements) can be formalized as the measurement of the distance between the two measurement functions f_I and f_J. Pragmatically, there are two requirements for such a measurement:

- The distance between f_I and f_J should not depend on the specific form of the functions but on what visually one would define as the "general characteristics" of the functions. Given the imprecision of the term "visual general characteristics," the determination of the suitable distance is a matter to be settled empirically.

- If the distance is to be used in a database, it must also be applied to suitably compact representations of the functions f. The complete representation of the discrete function f for an image of size $r \times c$ requires $r \times c \times m$ values, making it impractical for most applications.

5.4.1 Global Histograms

One possible representation for the function f is the probability density function of its values. If x is a random variable uniformly distributed in R, then $f(x)$ is also a random variable whose probability distribution depends on the function f. The value $p_f(u)\,ds$ is the probability that the value $f(x)$ belongs to a cube whose lower corner is in u and whose side is ds. Let $C_m(x, d)$ be the cube in \mathbb{R}^m with lower corner x and side d, that is:

$$C_m(x, d) = \{y \in \mathbb{R}^m : x_i \le y_i \le x_i + d_i, \ i = 1, \ldots m\} \tag{5.43}$$

then

$$p_f(u)\,ds = P\{f(x) \in C_m(u, ds)\} \tag{5.44}$$

This probability distribution function is the *continuous histogram* of the function f.

Many applications do not deal with the continuous histogram of f, but with a suitable approximation of it. Consider a set of m-dimensional indices

$\mathfrak{K} = \{(k_1, k_2, \ldots, k_m) : 0 \leq k_i \leq k\}$ and a finite partition of M indexed by \mathfrak{K}, $\mathfrak{B} = \{B_\kappa : \kappa \in \mathfrak{K}\}$; B_κ is called the κth *bin* of the partition. The function

$$b_\kappa(x) = \begin{cases} 1 & \text{if } x \in B_\kappa \\ 0 & \text{otherwise} \end{cases} \tag{5.45}$$

is the *indicator function* of the bin B_κ.

Let x be a random variable uniformly distributed in R, and let sample $S = \{x_1, \ldots, x_N\}$ be drawn from x, with $|S| = N$. The *discrete m-dimensional histogram* of f is the vector

$$\mathcal{H} = (h_{\kappa_1}, \ldots, h_{\kappa_q}) \tag{5.46}$$

where

$$h_\kappa = \frac{1}{N} \sum_{x \in R} b_\kappa(x). \tag{5.47}$$

An important property of the discrete histogram is the following:

THEOREM 5.1. *For every histogram computed according to Eq. (5.47) it is $\sum_\kappa h_\kappa = 1$*

PROOF. Consider the sets

$$N_\kappa = \{x_i \in S : f(x) \in B_\kappa\} \tag{5.48}$$

By hypothesis, \mathfrak{B} is a partition of M, and $N_\kappa = f^{-1}(B_\kappa)$, which implies that the N_κ are a partition of S, that is:

$$\kappa \neq \kappa' \Rightarrow N_\kappa \cap N_{\kappa'} = \emptyset \tag{5.49}$$

$$\bigcup_{\kappa \in \mathfrak{K}} N_\kappa = S. \tag{5.50}$$

It is easy to see that this must be the case: If the first equation were not true, there would be an x such that $f(x)$ belongs to two different B_κ, while if the second were not true, there would be an x such that $f(x)$ does not belong to any B_κ. If either of these were the case, \mathfrak{B} would not be a partition of M.

Note that $\sum_{x \in R} b_\kappa(x) = |N_\kappa|$. Therefore, $h_\kappa = |N_\kappa|/N$. The theorem follows from the face that as the N_κ are a partition of S, then $\sum_\kappa |N_k| = |S| = |N|$. \square

Basic histogram distances. In image databases, histograms are computed in order to characterize images and to be able to determine differences among images. This requires the definition of distances between histograms.

Note that although histograms have been used for a long time in computer vision for problems such as segmentation or contrast enhancement [Jain, 1989], traditional applications require the *manipulation* of histograms, and are not concerned with the problem of defining distances between pairs of histograms. A number of histogram distances have been proposed in the image database literature. The most common are the following:

Intersection $d_\cap(p_f, p_g) = 1 - \int_M \min(p_f(u), p_g(u))\,du$;

L_1 **Distance** $d_1(p_f, p_g) = \int_M |p_f(u) - p_g(u)|\,du$;

L_2 **Distance** $d_2(p_f, p_g) = [\int_M |p_f(u) - p_g(u)|^2\,du]^{1/2}$; and

L_∞ **Distance** $d_\infty(p_f, p_g) = \max_M |p_f(u) - p_g(u)|$.

The intersection distance is reported in this list because it is widely used in the literature. However, if the histograms are normalized, the intersection distance reduces to the L_1 distance, as proved by the following theorem. (The theorem is more general than what is needed here because it applies also to the case of histograms whose integral is not equal to one, and it is basically a restatement of a similar property proved for discrete histograms in Swain and Ballard (1991).)

THEOREM 5.2. *If $\int p_f = \int p_g$, then $d_\cap(p_f, p_g) = d_1(p_f, p_g)$*

PROOF. Because both p_f and p_g are nonnegative for every point u, it is

$$p_f(u) = \begin{cases} \min(p_f(u), p_g(u)) + |p_f(u) - p_g(u)| & \text{if } p_f(u) > p_g(u) \\ \min(p_f(u), p_g(u)) & \text{otherwise} \end{cases} \tag{5.51}$$

and

$$p_g(u) = \begin{cases} \min(p_f(u), p_g(u)) & \text{if } p_f(u) > p_g(u) \\ \min(p_g(u), p_f(u)) + |p_f(u) - p_g(u)| & \text{if } p_f(u) \le p_g(u) \end{cases} \tag{5.52}$$

Thus, for every u it is

$$p_f(u) + p_g(u) = 2\min(p_f(u), p_g(u)) + |p_f(u) - p_g(u)| \tag{5.53}$$

Let $\int p_f(u)\,du = \int p_g(u)\,du = \Lambda$. Then, by Eq. (5.54),

$$\Lambda = \frac{1}{2}\int p_f(u) + p_g(u)\,du = \int \min(p_f(u) + p_g(u))\,du + \frac{1}{2}\int |p_f(u) - p_g(u)|\,du \tag{5.54}$$

The intersection distance is defined as

$$d_\cap(p_f, p_g) = \frac{\Lambda - \int \min(p_f(u) + p_g(u))\,du}{\Lambda} \tag{5.55}$$

Replacing the Λ in the numerator with the right-hand side of Eq. (5.55), yields

$$d_\cap(p_f, p_g) = \frac{1}{2\Lambda}\int |p_f(u) - p_g(u)|\,du \tag{5.56}$$

\square

Note that if the two histograms do not have the same integral, the intersection is not a distance because, in general, $d(p_f, p_g) \ne d(p_g, p_f)$. As was observed in Chapter 4, this is, in general, a desirable property of a model of human similarity perception, and the enforcement of a property (the equality of the integrals) that

restores symmetry may seem counterproductive. The reasons for ignoring asymmetry in this case are two. First, the unitary value of the integrals derives naturally from the probabilistic interpretations of the histograms. Second, the asymmetry of human similarity perception is related to the different *saliency* of the stimuli (making the variant more similar to the original than the original to the variant) while, in the case of histograms, the integral of a histogram depends on the size of the image, which has no relation to the saliency of its content. The asymmetry of the distance function in nonnormalized histograms would be an accident with no relation to human asymmetry.

As I will continue to consider normalized histograms, the intersection measure is equivalent to the L_1 metric, and I will ignore it for the most part in the following.

Discrete histograms. The measures presented so far can naturally be extended to discrete histograms \mathcal{H} and \mathcal{L} by the following definitions:

Intersection $d_\cap(\mathcal{H}, \mathcal{L}) = 1 - \sum_\kappa \min(h_\kappa, l_\kappa)$;

L_1 **distance** $d_1(\mathcal{H}, \mathcal{L}) = \sum_\kappa |h_\kappa, l_\kappa|$;

L_2 **distance** $d_2(\mathcal{H}, \mathcal{L}) = [\sum_\kappa |h_\kappa, l_\kappa|^2]^{1/2}$;

L_∞ **distance** $d_\infty(\mathcal{H}, \mathcal{L}) = \max_\kappa(h_\kappa, l_\kappa)$.

These distances are defined considering the histograms as an approximation of the continuous histogram in the function approximation sense. Correspondingly, the discrete distances can be seen as approximations of the metric of the space of continuous histograms. An alternative is to consider discrete histograms as a *sample* from the underlying probability distribution. I will pursue this view later in this section.

Problems with the distances. The distances introduced in the previous section for discrete histograms present several problems. In particular, the L_1 distance tends to produce false negatives: Images that are visually similar can have a large L_1 distance (and therefore a low similarity). As an example, consider the histogram of the gray levels of an image, with 8 bins (that is, with $m = 1$, and $N = 8$). The images that I consider have 256 gray levels, which are assigned to the eight bins according to the schema in Table 5.3. Consider now the three images of Fig. 5.9. The first image is a checkerboard in which the squares have gray values 30, 93, 158. The second image is a similar checkerboard with gray levels 35, 98, 163. If the quality of the print is very good and you have good eyes, you can probably see a difference between the two, but I would not count on it: The two images look essentially the same.

The third image in Fig. 5.9 is also a checkerboard, with squares of gray levels 0, 62, 75. I do not expect anybody to have problems distinguishing this one from the previous two. The eight-bins histograms corresponding to these three images are in Fig. 5.10. The distance between the histogram of (a) and that of (b) and the

Table 5.3. Assignment of gray levels to bins in the case of a 256 gray-level image and 8-bins histogram.

Bin	Gray levels
0	0–31
1	32–63
2	64–95
3	96–127
4	128–159
5	160–191
6	192–213
7	214–255

distance between the histogram of (a) and that of (c) are reported in Table 5.4. According to all these distance measures, image (a) is more similar to (c) than to (b).

The problem with these measures is that they do not consider the fact that the space M is often metric, and that some bins are more "similar" than others. The histograms of Fig. 5.10a and Fig. 5.10b have the same shape, shifted by one bin. Because the gray levels in bin i are (or can be) very similar to those in bin $i + 1$, the two histograms of Fig. 5.10a and Fig. 5.10b could correspond (as indeed they

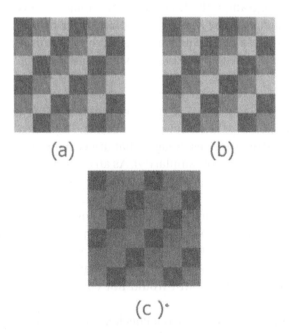

(a) (b)

(c)·

Figure 5.9. Three checkerboard images. The first two are different, but they appear the same. The third one is clearly distinguishable from the previous two. The gray-level histograms, however, tell a different story.

Table 5.4. The distances $d(a, b)$ and $d(a, c)$ for the three types of distance considered.

Dist. type	$d(a, b)$	$d(a, c)$
L_1	2	$\frac{2}{3}$
L_2	$\frac{\sqrt{2}}{\sqrt{3}}$	$\frac{\sqrt{2}}{3}$
L_∞	$\frac{1}{3}$	$\frac{1}{3}$

are in this case) to slightly different versions of the same image, one of which is slightly lighter than the other.

The problem can be generalized to more complicated histograms. In many cases, the space M is metric, and one should take into account the fact that some bins are similar and some are not. According to the distances introduced so far, if two histograms have similar values in *corresponding* bins, their distance will be low; if they have widely different values in corresponding bins, their distance will be high. There are two basic techniques to avoid brittleness problems. The first is to make the bins "fuzzy" so that a pixel will not fall into a single bin but will be "spread" among neighboring bins. The second technique is to define a distance measure that takes into account the similarity between bins, so that if two images have similar values of the histogram in *similar* bins, their distance will not be too high.

Fuzzy bins. The problems highlighted in the previous section are due to discontinuities in the histogram computation: Small changes in the image function can cause large changes in the histogram. In other words, if $L^2(R, M)$ is the space of square integrable measurement functions, and $H_d(M, \mathbb{R})$ is the space of m-dimensional histograms endowed with the distance d, the histogram computation function $\Xi : L^2(R, M) \to H_d(M, \mathbb{R})$ is discontinuous.

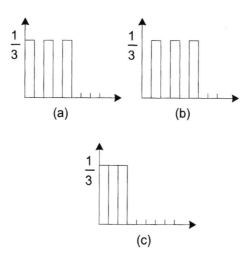

Figure 5.10. The histograms corresponding to the checkerboard images of Fig. 5.9.

To understand why, it is necessary to consider how the function is computed. The measurement space M is partitioned in a number of bins B_κ, $\kappa \in K$. Let $b_\kappa(x)$ be the indicator function of the κth bin: $b_\kappa(x) = 1$ if $x \in B_\kappa$, 0 otherwise. Incidentally, note that $supp(b_\kappa) = B_\kappa$[9] and $\forall x \sum_\kappa b_\kappa(x) = 1$. The histogram computation function returns a vector H whose κth element is

$$h_\kappa = \int_R b_\kappa(f(x))\,dx \qquad (5.57)$$

Consider now a function such there is a region V with area A in which the value of $f(x)$ is a frontier point for the bucket B_κ, that is, it is possible to find an increment ε with $\|\varepsilon\|$ as small as we want so that for all $x \in V$, $f(x) \in B_\kappa$ and $f(x) + \varepsilon \notin B_\kappa$. Define a region V' such that $V \subset V'$, and a continuous function

$$f'(x) = \begin{cases} f(x) & \text{if } x \notin V' \\ f(x) + \varepsilon & \text{if } x \in V \end{cases} \qquad (5.58)$$

It is clear that the region $Q = V' - V$ can be made as small as desired and because $\|\varepsilon\|$ can be arbitrarily small for every $\delta > 0$ it is possible to find V' and ε such that $\|f - f'\| < \delta$ (assume, for the sake of argument, that the L_2 norm is being used). All points in V belong to the bucket B_κ for f, and do not belong to the bucket B_κ for f'. The behavior of the points in $V' - V$ is not known (going from f to f' they can go into the bucket B_κ, out of it, remain inside or remain outside), but if A' is the area of $V' - V$, it is

$$\int_R b_\kappa(f(x))\,dx - A - A' \le \int_R b_\kappa(f'(x))\,dx \le \int_R b_\kappa(f(x))\,dx - A + A' \qquad (5.59)$$

That is, the difference between the two histograms is at least $|A - A'|$, which can be made arbitrarily large by an appropriate choice of the function f (and hence of the region V). This shows that, if the bucket indicator functions are discontinuous, arbitrarily small changes in certain functions (or, in the specific example of image analysis, of certain images) can cause large changes in their histogram, thus creating false distance determination, as was the case for the images of Fig. 5.9.

On the other hand, one can easily prove the following theorem:

THEOREM 5.3. *If the bucketing functions b_κ are continuous and square integrable over R, then the function Ξ is continuous in the following sense. Let $f, g \in L^2(R, M)$. Then*

$$\lim_{\varepsilon \to 0} \Xi(f + \varepsilon g) = \Xi(f) \qquad (5.60)$$

[9] The support of a function, $supp(f)$ is the closure of the set of points for which the function f is nonzero. That is, indicating with \bar{A} the closure of the set A, it is

$$supp(f) = \{x : f(\bar{x}) \ne 0\}$$

PROOF. The bucketing function computes the κth bin as

$$h_\kappa = \int_R b_\kappa(f(x))\,dx \tag{5.61}$$

If b_κ is continuous in its argument then $b_\kappa(f + \varepsilon g)$ is continuous in ε for all x. Because the functions b_κ are square integrable over R, the integral is also continuous.

Finally, because all the bin values of the histogram are continuous in the parameter ε, the histogram is (for, say, the L_2 norm) continuous in ε. □

A general way to create a continuous bucketing function is given by special families of functions called *partitions of unity* [Okubo, 1987]. In its general form, a partition of unity is defined as follows. Let X be a smooth manifold. A *covering* of X is a collection $\mathcal{V} \in 2^X$ such that $\bigcup_{v \in \mathcal{V}} V = X$. If every V is an open set, \mathcal{V} is called an *open covering*. The covering is *finite* if \mathcal{V} contains a finite number of sets, and it is *locally finite* if for every point $x \in X$ there exists an open set W_x containing x such that

$$\{V \in \mathcal{V} : V \cap W_x \neq \emptyset\} \tag{5.62}$$

is a finite set. If X is compact, it has a finite covering. Obviously, a finite covering is also locally finite. A covering \mathcal{U} is a refinement of the covering \mathcal{V} if for every $V \in \mathcal{V}$ there is $U \in \mathcal{U}$ such that $U \subset V$. A manifold X is *paracompact* if every open covering has a locally finite refinement.

A smooth partition of unity of X is a pair $(\mathcal{V}, \mathcal{F})$ where \mathcal{V} is a locally finite covering, and $\mathcal{F} = \{\phi_v\}_{v \in \mathcal{V}}$ is a collection of smooth real-valued functions so that

$$f_v \geq 0 \tag{5.63}$$
$$supp(f_v) \subseteq V$$
$$\sum_{v \in \mathcal{V}} f_v(x) = 1 \quad \forall x$$

The possibilty of defining a continuous partition of the measurement space is given by the following theorem [Okubo, 1987].

THEOREM 5.4. *Let X be a paracompact manifold. Then, given an open covering \mathcal{U} of X there exists a smooth (C^ω) partition of unity $(\mathcal{V}, \mathcal{F})$ such that \mathcal{V} is a refinement of \mathcal{U}.*

In most histogram applications, smoothness is too strict a condition, and a *continuous* partition of unity will be sufficient. The explicit determination of a partition of unity is rather easy in the case in which the support of the family of functions ϕ is a regular grid. In the case of a two-dimensional domain, consider a grid similar to that of Fig. 5.11. First, let R consist in the whole \mathbb{R}^2, and let f be a continuous function such that $f(0) = 1, f(1) = 0$, and $f(x) = 1 - f(-x)$. Functions satisfying these conditions are, for instance, $f(x) = 1 - x$ and $f(x) = \cos^2(\pi/2)x$.

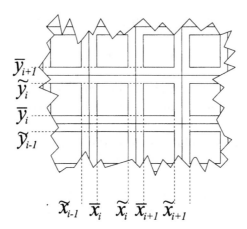

Figure 5.11. A regular grid for the determination of a partition of unity.

Consider the anchor point vectors

$$\begin{aligned}
\tilde{x} &= [\ldots, \tilde{x}_{i-1}, \tilde{x}_i, \tilde{x}_{i+1}, \ldots] \\
\bar{x} &= [\ldots, \bar{x}_{i-1}, \bar{x}_i, \bar{x}_{i+1}, \ldots] \\
\tilde{y} &= [\ldots, \tilde{y}_{i-1}, \tilde{y}_i, \tilde{y}_{i+1}, \ldots] \\
\bar{y} &= [\ldots, \bar{y}_{i-1}, \bar{y}_i, \bar{y}_{i+1}, \ldots]
\end{aligned} \tag{5.64}$$

and define the family of functions

$$F_i(x, \tilde{x}, \bar{x}) = \begin{cases}
f\left(\frac{\bar{x}_i - x}{\bar{x}_i - \tilde{x}_i}\right) & \text{if } \tilde{x}_{i-1} \le x \le \bar{x}_i \\
1 & \text{if } \bar{x}_i \le x \le \tilde{x}_i \\
f\left(\frac{x - \tilde{x}_i}{\bar{x}_{i+1} - \tilde{x}_i}\right) & \text{if } \tilde{x}_i \le x \le \bar{x}_{i+1} \\
0 & \text{otherwise}
\end{cases} \tag{5.65}$$

Finally, define

$$\phi_{ij} = F(x, \tilde{x}, \bar{x}) F(y, \tilde{y}, \bar{y}) \tag{5.66}$$

It is easy to see that the family ϕ_{ij} forms a partition of unity for the whole \mathbb{R}^2.

If, as it is often the case, one is interested in the definition of a partition of unity in a finite rectangle, the same functions can be used with some variations in correspondence of the borders of the rectangle. The function corresponding to the first grid division will be of the form

$$F_0(x, \tilde{x}, \bar{x}) = \begin{cases}
1 & \text{if } x \le \tilde{x}_0 \\
f\left(\frac{x - \tilde{x}_0}{\bar{x}_1 - \tilde{x}_0}\right) & \text{if } \tilde{x}_0 \le x \le \bar{x}_1 \\
0 & \text{otherwise}
\end{cases} \tag{5.67}$$

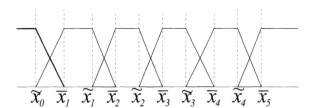

Figure 5.12. Example of partition of unity for the definition of fuzzy regions.

and the last will be of the form

$$
F_N(x, \tilde{x}, \bar{x}) = \begin{cases} f\left(\frac{\bar{x}_N - x}{\bar{x}_N - \tilde{x}_N}\right) & \text{if } \tilde{x}_{N-1} \leq x \leq \bar{x}_N \\ 1 & \text{if } \bar{x}_N \leq x \\ 0 & \text{otherwise} \end{cases} \tag{5.68}
$$

(Fig. 5.12).

Weighted Euclidean distance. Instead of acting on the bin shape (or in addition to it), it is possible to alleviate the discontinuity problem of Fig. 5.9 by explicitly considering the similarity between the points in the measurement space that the bins represent. This can be done by defining a similarity function $a: M \times M \rightarrow [0, 1]$ in the measurement space M.

Assume, for the sake of simplicity, that the space M coincides with \mathbb{R}, that is, that all histograms are one-dimensional (the results in the following can easily be extended to multidimensional histograms). The value $a(u, v)$ is equal to the similarity between u and v. Assume that $a(u, v) = g(d(u, v))$, where $d \in \mathfrak{D}(\mathbb{R})$ is a distance function and g satisfies the hypotheses of Theorem 4.5.

Let $L^2(X, \mathbb{R})$ be the space of square integrable functions from a space X to \mathbb{R}. Obviously, all histograms belong to $L^2(\mathbb{R}, \mathbb{R})$, and, for all the similarity functions a that I will consider, I will assume $a \in L^2(\mathbb{R}^2, \mathbb{R})$. The similarity function a induces a linear transform in the space $L^2(\mathbb{R}, \mathbb{R})$ defined as

$$
(Af)(y) = \int_{-\infty}^{\infty} a(y, x) f(x) \, dx \tag{5.69}
$$

It is easy to see that the integrability properties of a and f make the transform well defined.

The *characteristic elements* of a linear transform A are defined as those functions ϕ such that $A\phi = \mu\phi$, where $\mu \in \mathbb{R}$ is the *characteristic value* associated to the characteristic element ϕ. For the characteristic value μ it is possible to write

$$
\mu = \frac{\langle A\phi, \phi \rangle}{\langle \phi, \phi \rangle} \tag{5.70}
$$

This equation implies that if a linear transformation is *positive* ($\langle Af, f \rangle \geq 0$ for all f), then its characteristic values are all positive. Also, a linear transformation is *symmetric* if for all f, g, $\langle Af, g \rangle = \langle f, Ag \rangle$. For these transforms it can be proven that $A^* = A$, which is why they are also called *self-adjoint*.

Given a symmetric positive-linear transform, one can define a norm in $L^2(\mathbb{R}, \mathbb{R})$ as

$$\|f\|_A = \sqrt{\langle Af, f \rangle} = \left[\int \int a(x, y) f(x) f(y) \, dx \, dy \right]^{1/2}. \qquad (5.71)$$

This norm induces a distance function in the space $L^2(\mathbb{R}, \mathbb{R})$ (which, as noted before, contains all one-dimensional histograms) defined as

$$d_A(f, g) = \|f - g\|_A \qquad (5.72)$$

The function a is not completely arbitrary: There are certain conditions that it must satisfy to guarantee that d_A is a distance function. In particular, one must guarantee that the linear transform (5.69) is positive. From the definition equation (5.71) it is clear that if the function a is symmetric in its arguments ($a(x, y) = a(y, x)$), then the transformation A is symmetric.

LEMMA 5.1. *If A can be written as A = QQ, where Q is a symmetric transform, then A is positive.*

PROOF. From the equality

$$\langle Qf, g \rangle = \langle f, Q^* g \rangle = \langle f, Q g \rangle \qquad (5.73)$$

which is valid for symmetric transforms, it follows that

$$\langle Af, f \rangle = \langle QQf, f \rangle = \langle Qf, Qf \rangle \geq 0 \qquad (5.74)$$

\square

Before proving that the quantity $\langle Af, f \rangle$ is indeed a norm, I will state without proof the following version of the Cauchy-Schwartz inequality:

LEMMA 5.2. *Let A be a positive symmetric linear transform on a real Hilbert space \mathcal{H}, and let $\|f\| = \langle Af, f \rangle$. Then for all functions f, g, $|\langle Af, g \rangle| \leq \|f\|_A \|g\|_A$.*

Note that, by symmetry, it is also true that $|\langle Ag, f \rangle| \leq \|f\|_A \|g\|_A$.

The following theorem gives a necessary condition for the operator A to define a distance function:

THEOREM 5.5. *If A is a positive linear operator on a Hilbert space \mathcal{H}, $\|f\|_A = \sqrt{\langle Af, f \rangle}$ is a norm, and $d(f, g) = \|f - g\|_A$ is a distance function.*

PROOF. Lemma 5.1 guarantees that $\|f\|_A \geq 0$. Also, by the linearity of the scalar product, if $\alpha \in \mathbb{R}$,

$$\|\alpha f\|_A = \sqrt{\langle A(\alpha f), \alpha f \rangle} = |\alpha| \sqrt{\langle Af, f \rangle} = |\alpha| \|f\|_A. \qquad (5.75)$$

In order to complete the proof, it is only necessary to show that the triangle inequality holds, that is, that $\|f + g\|_A \leq \|f\|_A + \|g\|_A$. It is

$$\|f + g\|_A^2 = \langle Af + Ag, f + g \rangle$$
$$= \langle Af, f \rangle + \langle Af, g \rangle + \langle Ag, f \rangle + \langle Ag, g \rangle$$
$$= \langle Af, f \rangle + 2\langle Af, g \rangle + \langle Ag, g \rangle$$
$$\leq \|f\|_A^2 + 2\|f\|_A\|g\|_A + \|g\|_A^2 \tag{5.76}$$

where the last inequality is a consequence of the Cauchy-Schwartz inequality. Therefore,

$$\|f + g\|_A^2 \leq (\|f\|_A + \|g\|_A)^2 \tag{5.77}$$

\square

Symmetry and positivity of the operator A are therefore sufficient for it to define a histogram norm and, therefore, a histogram distance.

This class of distances can easily be extended to discrete histograms, which is the most interesting case for image database applications. In the case of one-dimensional histograms, described by vectors $h = [h_1, \ldots, h_n]$, the distance is based on the scalar product $\langle h, g \rangle_A = \langle Ah, g \rangle$, where A is a symmetric positive-definite matrix, that is,

$$\langle h, g \rangle_A = \sum_{i,j=1}^{n} a_{ij} h_i g_j \tag{5.78}$$

Exactly as in the continuum, if $A = Q^2$ and Q is a symmetric matrix, then $\|h\|_A = \langle h, h \rangle_A$ is a norm. Analogously to the continuum, A is a similarity matrix if

$$a_{ij} \geq 0 \quad \forall i, j$$
$$a_{ii} = 1 \quad \forall i \tag{5.79}$$
$$a_{ij} \geq a_{ik} + a_{kj} - 1 \quad \forall i, j, k$$

If $A = Q^2$, then $a_{ij} = \sum_k q_{ik} q_{kj}$, and the conditions on a are enforced if the following conditions are satisfied by q:

$$\sum_r q_{ir}^2 = 1 \quad \forall i$$
$$\sum_r q_{ir} q_{jr} \geq 0 \quad \forall i, j \tag{5.80}$$
$$\sum_r [q_{ir} q_{jr} - q_{ir} q_{hr} - q_{jr} q_{kr}] + 1 \geq 0$$

As for continuous histograms, I will consider the special case for which $a_{ij} = a_{|i-j|}$.[10]

[10] In order to simplify the notation in the following. I will assume that the indices of all the vectors start from 0 rather than from 1, as it is customarily done. This will allow me to write $a_{ij} = a_{|i-j|}$ rather than $a_{ij} = a_{|i-j|+1}$.

The similarity function is now a similarity vector $a = [a_0, \ldots, a_{n-1}]$ and from $a_{ij} = \sum_k q_{ik} q_{kj}$ it follows that

$$a_{|i-j|} = \sum_{k=0}^{n-1} q_{|i-k|} q_{|k-j|} \tag{5.81}$$

Setting $j - i = u$, one obtains

$$a_u = \sum_{k=0}^{n-1} q_{|i-k|} q_{|i-k-u|} = \sum_{k=0}^{n-1} q_u q_{k-u} \bmod n \tag{5.82}$$

From now on, for the sake of simplicity, I will consider all the indices modulo n, so that it is possible to write

$$a_u = \sum_{k=0}^{n-1} q_u q_{k-u} \tag{5.83}$$

The condition for similarity results in the following requirements for q:

$$a_i \geq 0 \Rightarrow \sum_{k=0}^{n-1} q_k q_{k+u} \geq 0$$

$$a_0 = 1 \Rightarrow \sum_k q_k^2 = 1 \tag{5.84}$$

$$a_{u+v} \geq a_u + a_v - 1 \Rightarrow \sum_k q_k[q_{k+u+v} + q_k - (q_{k+u} + q_{k+v})] \geq 0$$

A sufficient condition for the last inequality is

$$q_k + q_{k+u+v} \geq q_{k+u} + q_{k+v} \quad \forall k, u, v \tag{5.85}$$

As in the case of continuous histograms, the distance can be generalized to multidimensional histogram spaces. The generalization per se is quite immediate, thus the most interesting aspect of it is the generalization of the condition $a_{ij} = a_{|i-j|}$.

Let m be the dimension of the histogram space M, and $\iota = \{i_1, \ldots, i_m\} \in \mathcal{I}$ an index on a lattice in M. A histogram is a vector $[h_\iota]$, with $\iota \in \mathcal{I}$. A linear transform in the histogram space is defined as

$$(Ah)_\iota = \sum_{\eta \in \mathcal{I}} a_{\eta \iota} h_\eta \tag{5.86}$$

and the A-scalar product as

$$\langle h, g \rangle_A = \sum_{\iota, \eta} a_{\eta \iota} h_\eta g_\iota \tag{5.87}$$

All the usual definitions apply to these multi-index matrices. In particular, the A-scalar product induces a metric if A is positive. The requirement $a_{ij} = a_{|i-j|}$ can be extended by endowing the set of indices \mathcal{I} with a distance function $\delta : \mathcal{I} \times \mathcal{I} \to \mathbb{N}$, so that the requirement on the matrix A becomes $a_{\eta \iota} = a_{\delta(\eta, \iota)}$.

The only critical requirement that is necessary to enforce in order for a to be a similarity measure is, exactly as in the previous cases, the triangle inequality (unitarity, positivity, and symmetry are enforced in the same way as in the case of a single index). In this case, given three elements $\eta, \mu, \lambda \in \mathcal{I}$, the requirement is

$$a_{\eta\mu} \geq a_{\eta\lambda} + a_{\lambda\mu} - 1 \tag{5.88}$$

which, in the current predicament, means

$$a_{\delta(\eta,\mu)} \geq a_{\delta(\eta,\lambda)} + a_{\delta(\lambda,\mu)} - 1 \tag{5.89}$$

Given a specific distance measure δ, this condition can be translated in a series of inequalities much like in the one-dimensional case. A more general solution is based on the triangle inequality applied to the distance δ. As $\delta(\eta, \mu) \leq \delta(\eta, \lambda) + \delta(\lambda, \mu)$, it is possible to formulate the following general definition:

DEFINITION 5.1. *The vector a_k is a similarity vector if*

$$a_k \geq a_i + a_j - 1 \tag{5.90}$$

whenever $k \leq i + j$.

As in the case of a one-dimensional histogram, the matrix A is positive if it can be written as $A = Q^2$, where Q is a symmetric multi-index matrix. That is,

$$a_{\iota\eta} = \sum_{\lambda \in \mathcal{I}} q_{\iota\lambda} q_{\lambda\eta} \tag{5.91}$$

If $A = Q^2$, then a sufficient condition on Q for A to be a similarity measure is $q_h + q_{h+k} \geq q_{h+i} + q_{h+j}$ whenever $k \leq i + j$.

Sample distribution distances. All the methods examined so far for the determination of histogram distances considered the histograms as the discretization of a continuous function. However, it is possible to assume a different point of view, and to consider a histogram as a sample from a probability distribution. This point of view leads naturally to the following definition of similarity: *The similarity between two histograms is equal to the probability that the two histograms are samples from the same probability distribution.*

In other words, one has to answer the following question: Given two samples h and g of n elements each, what is the probability that the two were obtained by sampling the same distribution?

It is not easy to answer this question exactly, but one can settle for the next best thing: Compute some function that goes to zero when that probability goes to unity.

The idea will be made clearer by starting with a slightly different problem: Given a known distribution $F_0(x)$ and an unknown distribution F from which n samples are drawn, under what circumstances can it be concluded that the two distributions coincide? Let $F_0(x)$ be a one-dimensional distribution function, and $x_1 \leq x_2 \leq \cdots \leq x_n$ be an ordered sample of n independent observations from an

unknown distribution function $F(x)$. The problem is one of statistical hypothesis testing, with hypothesis $F(x) = F_0(x)$. The function $F(x)$ is, of course, unknown, but it is possible to test the sample distribution $F_n(x)$, defined as $F_n(x) = i/n$, where $x_i \leq x < x_{i+1}$. The issue is then the determination of statistics $S_n = S(F_n, F_0)$ such that, when $F = F_0$,

$$P \left\{ \lim_{n \to \infty} S_n = 0 \right\} = 1 \qquad (5.92)$$

(i.e., S_n converges with probability 1).

Before continuing, I should say a few words about the relation between the discrete histograms and the sampled distribution $F_n(x)$. Consider again a one-dimensional continuous histogram $h(x)$, $x \in \mathbb{R}$. The corresponding distribution function is $H(x) = \int_{-\infty}^{x} h(u)\,du$. A statistical sample $H(x)$ is a set of n distinct points distributed according to $H(x)$. That is, every time a new point x_i is selected, the probability that $x \leq x_i \leq x + dx$ is $h(x)\,dx$. With probability 1, all the samples will be different. When the histogram is computed, however, the elements x_i of the statistical sampling are collected into b bins. Let the kth bin have limits $[\bar{x}_k, \bar{x}_{k+1})$. If there are n_k samples x_i such that $\bar{x}_k \leq x_i < \bar{x}_{k+1}$, then the kth entry of the histogram has value $h_k = n_k$.

The creation of an histogram is therefore different from a pure statistical sampling because the samples belonging to a bin are grouped together and become indistinguishable. A consequence of this difference is that the number n which appears in S_n (the size of the statistical sample) should not be confused with the number of bins in the histograms. The value n refers to the total number of points in the histogram, that is, in the case of an image histogram, n is the number of pixels of the image from which the histogram is derived. This means that, even for small-sized images, the number of samples is very large (of the order of thousands of samples). As will be evident shortly, this fact can lead to underestimating the similarity of the histograms. Thus, shortly, I will change this definition. For the moment, however, I will assume that n is the number of pixels in an image. In order for the following techniques to work it will turn out that it is necessary to normalize the images so that they all contain the same number of pixels. This is not a great restriction because most histogram comparison techniques require the same thing.

A consequence of the histogram computation technique is that the exact location of the samples is unknown. All that is known is that h_k of them are located somewhere in the interval $[\bar{x}_k, \bar{x}_{k+1})$. It is possible to make a number of hypotheses on the exact location of these samples. The simplest (although by no means the most correct) hypothesis is that all the h_k samples contained in the kth bin are located at the center of the bin, that is, in $(\bar{x}_k + \bar{x}_{k+1})/2$ (as a matter of fact, it does not matter where in the bin they are placed; the relevant hypothesis is that they are all coincident).

With these observations on the size of the sample and the location of the point in mind, I can now turn to the introduction of a statistics with the convergence

property equation (5.92), that is, the *Kolmogorov-Smirnov statistics*, which is defined as

$$D_n = \sup_{-\infty \leq x \leq \infty} |F_n(x) - F_0(x)| \tag{5.93}$$

This statistics is not yet the solution for the histogram comparison problem as it is applicable only for comparison with a known distribution F_0. In histogram comparison one has *two* samples F_n and G_n from two unknown distribution functions F and G, and the hypothesis to check is $F = G$, the common distribution being otherwise unspecified.

In order to measure the probability associated with this hypothesis it is necessary to use an extended version of the Kolmogorov-Smirnov statistics,[11] and define:

$$D_{nn}^+ = \sup_{-\infty \leq x \leq \infty} (F_n(x) - G_n(x)) \tag{5.94}$$

$$D_{nn}^- = \sup_{-\infty \leq x \leq \infty} (G_n(x) - F_n(x)) \tag{5.95}$$

$$D_{nn} = \max(D_{nn}^+, D_{nn}^-) \tag{5.96}$$

Let y_1, \ldots, y_b be the center points of the b bins. Then $(F_n(x) - G_n(x))$ increases by $h_i - g_i$ at $x = y_i$, and it is constant for $y_i \leq x < y_{i+1}$. Thus it is possible to write

$$D_{nn}^+ = \max_i \left(\sum_{k=1}^{i} (h_k - g_k) \right) \tag{5.97}$$

$$D_{nn}^- = \max_i \left(\sum_{k=1}^{i} (g_k - h_k) \right) \tag{5.98}$$

$$D_{nn} = \max_i \left| \sum_{k=1}^{i} (g_k - h_k) \right| \tag{5.99}$$

Durbin (1973) showed that D_{nn}^+ (and, consequently, D_{nn}^- and D_{nn}) is distribution free, that is, its probability distribution does not depend on that of F_n and G_n. Strictly speaking, this is not true for histograms because of the assumption that all the samples are concentrated at the midpoint of every bin. However, for histograms with a reasonably large number of bins, D_{nn} is insensitive enough to the distributions of F_n and G_n that it can still be considered distribution free.

[11] The original formulation considered two sampled distributions F_n and G_m with a different number of samples. I will only consider the special case $n = m$, which is the case when histograms are normalized.

Gnedenko and Korolyuk (1961) computed the distribution of D_{nn}^+ as

$$P\{D_{nn}^+ > d\} = \frac{\binom{2n}{n-c}}{\binom{2n}{n}} \tag{5.100}$$

where $c = -\lfloor -nd \rfloor$. Also, the distribution of D_{nn} is given by

$$P\{D_{nn} > d\} = K_n(d) = \left[\binom{2n}{n-c} + \sum_{i=1}^{\lfloor n/c \rfloor} (-1)^{i+1} \binom{2n}{n-ic} \right] \binom{2n}{n}^{-1} \tag{5.101}$$

The behavior of the function K_n is shown in Fig. 5.13. With this function available, a similarity measure between histograms can be defined as follows. Given two histograms h and g such that $\sum_i h_i = \sum_i g_i = n$, define

$$\tilde{s}_p(h, g) = K_n \left(\max_i \left| \frac{\sum_{j=1}^i h_j - g_j}{n} \right| \right). \tag{5.102}$$

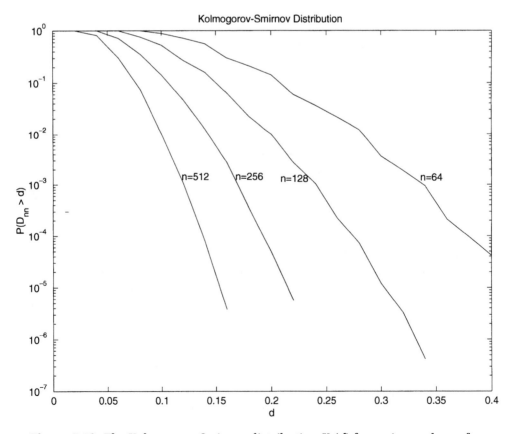

Figure 5.13. The Kolmogorov-Smirnov distribution $K_n(d)$ for various values of n.

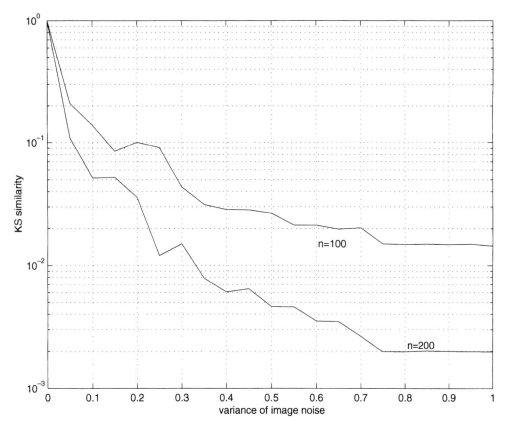

Figure 5.14. The behavior of the Kolmogorov-Smirnov similarity measure as a function of the noise introduced in an image.

This function defines a similarity measure between h and g, but it is often difficult to handle because of its very rapid rate of descent. If n is of the order of magnitude of the number of pixels in a small image (1000–10,000), the similarity between two images decreases very rapidly as a simple experiment can reveal. Take an image and compute its histogram $h(0)$. Then corrupt the image with a Gaussian noise with variance σ^2, compute the histogram of the noisy image $h(\sigma)$, and then compute the similarity between the two. Repeating the experiment for a number of images, one can plot the similarity $\tilde{s}_p(h(0), h(\sigma))$ as a function of σ. The result is reported in Fig. 5.14. It is clear from the figure that, even with the very low value of $n = 200$, the curve decreases very rapidly. With the more realistic value $n = 5000$, the behavior of the curve is almost pathological, and hence the computation becomes extremely unstable. It is necessary to use in K_n a number n lower than the number of pixels in the image. This reduction, of course, has no theoretical meaning and should be considered a simple heuristic device to obtain a more manageable decrease in the similarity. However, one can derive some indications on a suitable value for n by studying the behavior of the image sampling process.

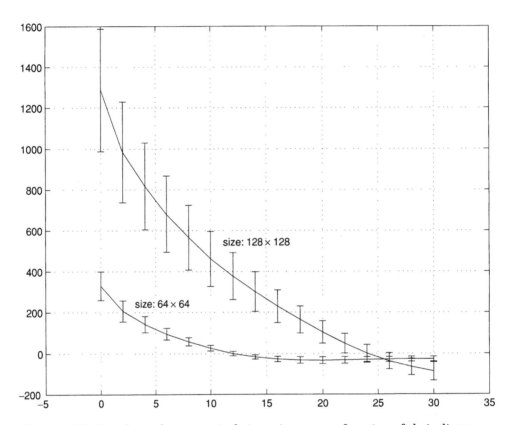

Figure 5.15. Correlation between pixels in an image as a function of their distance.

The sampling process on which the Kolmogorov-Smirnov measure is based assumes that the samples are independent. The pixels of an image, on the other hand, are not, at least for short interpixel distances. The correlation between pixels as a function of the distance can be evaluated by looking at a representative samples of images. The result of such a measurement are reported in Fig. 5.15 for several image sizes. The distance at which the correlation is zero is roughly linear in the number of pixels on one side of the image (as expected) and is approximately equal to 25 for an image of size 128×128. This corresponds to a sampling with approximately $(128 \times 128)/(25 \times 25) \approx 26$ independent samples, corresponding to the use of the function K_{26} for the evaluation of the histogram similarity.

Statistical moments. A well-known way to characterize a distribution is through its statistical moments. The first moment of a distribution with probability density f is its average:

$$m_0(f) = \mu_f = \int_{-\infty}^{\infty} f(x)\,dx \qquad (5.103)$$

The pth moment is defined as

$$m_p(f) = \left[\int_{-\infty}^{\infty} (f(x) - \mu)^p dx \right]^{1/p} \qquad (5.104)$$

Two moments (apart from the average) are well known enough to deserve a special name: The second statistical moment is the *standard deviation* σ, and the third is the *skew s*.

Given a sample from the distribution F (with density f), with the characteristics discussed earlier (i.e., with the samples concentrated at the middle point of each bin), and given that the kth bin has h_k samples and its middle point has feature value x_k, the sampled average is

$$m_{0;n}(h) = \mu_n = \frac{1}{n} \sum_{i=1}^{b} x_i h_i \tag{5.105}$$

where, as usual, b is the number of bins in the histogram, and n is the size of the statistical sample, that is, the number of pixels in the image. The pth moment is given by

$$m_{p;n}(h) = \frac{1}{n} \left[\sum_{i=1}^{b} (x_i h_i - \mu_n)^p \right]^{1/p} \tag{5.106}$$

The complete series of moments for $p = 1, \ldots, \infty$ uniquely identifies the distribution. For most practical purposes, a rather limited number of moments will provide sufficient characterization and discriminating power.

Stricker and Orengo (1995) noticed that in most practical situations the first three statistical moments are sufficient to characterize a color histogram (this may not be true for other feature histograms, however). These moments can be collected into a vector, and standard vector distances can be used to measure the dissimilarity of features. Stricker and Orengo use a weighted L_1 distance that in the general case can be written as

$$d(h, g) = \sum_{p=1}^{\infty} w_i |m_{p;n}(h) - m_{p;n}(g)| \tag{5.107}$$

This distance measure is in some sense more "coarse" than the other histogram measures, because it operates on a reduced representation of the histogram which, itself, is already a reduced representation of the image. This coarseness is not necessarily a problem, in fact, quite the opposite. The moment representation proved (at least in the case of color histograms) to be quite robust to the bin boundary problem encountered in Section 5.4.1, and still provide enough discriminating power to capture important variations in color. This, combined with the fact that the method requires only the storage of nine real values for color histograms (three moments for each of the three color channels) made it a fairly successful method in recent applications. Note that, given an image with n pixels, if x_i is the value of the feature to be histogrammed at point i, the average can be written as

$$m_{0;n}(h) = \mu_n(h) = \frac{1}{n} \sum_{i=1}^{n} x_i \tag{5.108}$$

and the pth statistical moment as

$$m_{p;n}(h) = \frac{1}{n}\left[\sum_{i=1}^{n}(x_i - \mu_n)^p\right]^{1/p} \tag{5.109}$$

these expressions do not contain the bin number b: The moments of the probability distribution of the features of an image can be computed without going through the discrete histogram.

It is possible at this point to make a comparison of some of the distance measures introduced so far. A simple way to study the behavior of a histogram measure it to see how the similarity that it induces changed as images experience some simple and controllable transform. The simplest such modification is the insertion of additive noise. In order to verify the distance measures, I took a sample of 10 images and, for each one of them, I generated 15 modifications by adding to each pixel uniformly distributed noise in the range $[0, \sigma]$ for different values of σ. A sample of eight noisy versions of one of the images is shown in Fig. 5.16. Given an original image, the distance between the histogram of the image and that of a noisy version of the same image was computed using the L_1, L_2 and L_∞ distances on the complete histogram, normalizing them to $[0, 1]$, and computing

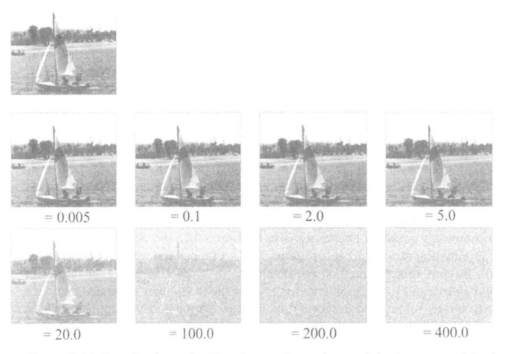

Figure 5.16. Samples from the 15 noisy versions of one of the images used in the histogram distance-evaluation experiment.

Figure 5.17. Comparison between several types of histogram distances and the perceived similarity between noisy images.

the similarity $s(x, y) = 1 - d(x, y)$. The same transform was applied to the L_2 distance between the Stricker and Orengo characterization of histograms. Finally, the Smirnov-Kolmogorov probabilistic similarity between the original and the noisy version was computed.

In order to have a performance reference, people were asked to judge how similar the images were to the noisy versions, giving a number on a scale from zero to one (with one meaning that the images were identical, and zero being the similarity between the original and a white paper). The results of these comparisons are in Fig. 5.17. Note that the perceptual similarity has a plateau when images become very dissimilar. A similar behavior is observed in the Smirnov-Kolmogorov similarity and in the Stricker and Orengo distance. This behavior appears to be another example of the "flattening" of perceptual similarity and distance as the stimuli become more and more different than was already observed in Chapter 4. This simple experiment, unfortunately, does not allow one to determine the importance of the phenomenon in the applications.

5.4.2 Discriminating Power of Histograms

A histogram is a global characterization of the distribution of values in a given feature space. This characteristic makes histograms quite robust to small localized changes in an image, but also represents their main limitation. Due to their global character, a number of transformations of the image will result in the same (or almost the same) feature vector.

This is a normal consequence of the invariance characteristics of the global histogram. Whenever a feature vector is invariant with respect to some transformation group, it loses the capacity to distinguish between images related through a transformation of that group. A feature vector invariant with respect to all possible transformations an image can undergo would have the same value for all images, and would therefore be unable to distinguish any image from any other. Feature histograms are invariant to image translation and rotation (strictly speaking, the invariance is guaranteed if the image is cyclic, as if drawn on the surface of a torus), and because of this their discriminating power is relatively low.

A possible measure of the discriminating power of histograms is their *indexing capacity*, that is, the number of substantially different histograms that can be stored in the histogram space.

Given a threshold t, two histograms H_1 and H_2 are said to be t-different if $d(H_1, H_2) \geq t$. With the notion of t-difference it is possible to define *substantial difference* as t_0-difference for some suitable threshold t_0. The question is: How will the threshold t_0 be chosen?

Stricker (1994) analyzed the distribution of histogram distances in the histogram space. The result was that such distribution is rather independent on the images from which the histograms are derived, although it depends on the metric used for the space. The results relative to the L_1 and L_2 metrics are reportd in Fig 5.18. The L_1 distance has a bimodal distribution with one of the modes at the maximal distance. The L_2 has one mode with a peak at about 25% of the maximal distance. The L_2 norm tends to produce smaller distances than the L_1 norm. In the L_1 norm, the distance between two histogram is maximal if they have no nonempty bins in common. In the L_2 distance, on the other hand, the distance is maximal only if each histogram has only one nonzero bin, and the positions of the

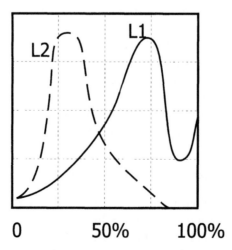

Figure 5.18. The distribution of distance between histograms in the histogram space equipped with the L_1 and L_2 metrics.

nonzero bins in the two histograms do not coincide. Furthermore in general, the L_2 distance between two histograms is large only if they have few nonzero bins and their intersection is small. Photographs tend to have many nonzero bins, so that the L_2 distance between their histograms tends to be rather small, causing the peak relatively near the origin in Fig. 5.18.

Reasonable positions for the threshold t_0 are in the rapidly growing area before the first peak: If the threshold t_0 is larger than the location of the first peak, all histograms will be considered similar, and the search will result in many mismatches. On the other hand, a threshold too close to zero will result in too strict a criterion.

Let images be normalized to contain n pixels, and consider the space \mathcal{H} of color histograms with q bins. For a given threshold t_0, how many t_0-different histograms does the space contain? This number is important because it is the number of histograms that can meaningfully be distinguished: If this number is less than the number of images in the database, then there will be images that the histograms will not separate. This number is called the *capacity* of the histogram space; it depends on the space itself, the distance function used, and the threshold t, and is indicated with $C(\mathcal{H}, d, t)$.

The following result, due to Stricker (1994), applies to the case of L_1 and L_2 distances, and reveals an intriguing connection with coding theory:

THEOREM 5.6. *Let $A(p, 2l, w)$ denote the maximal number of codewords in a binary code of length p, constant weight w, and Hamming distance $2l$. Then the capacity of the histogram space \mathcal{H} with n bins and images with N pixels satisfies the following inequality:*

$$C(\mathcal{H}, d, t) \geq \max_{\substack{w, l \\ \alpha \leq l \leq w \leq q \\ l \leq q/2}} A(n, 2l, w) \qquad (5.110)$$

where $\alpha = wt/2N$ if the metric is the L_1 distance, and $\alpha = (wt/N)^2$ if the distance is L_2.

The value of the function $A(n, 2l, w)$ is in general not known, but its boundary value has been studied in the coding literature. Stricker (1994) applies these results to obtain the following theorem:

THEOREM 5.7. *Let q be the smallest prime power such that $q \geq n$. Let $l(w) = \lceil wt/2N \rceil$ and $\beta = n$ in the L_1 case, $l(w) = \lceil 1/2(wt/N)^2 \rceil$ and $\beta = \min(n, \lfloor 2(N/t)^2 \rfloor)$ in the L_2 case. Then the capacity of the histogram space satisfies the following inequality:*

$$C(\mathcal{H}, d, t) \geq \max_{w \leq \beta} \frac{1}{q^{l(w)-1}} \binom{n}{w} \qquad (5.111)$$

The bound is tighter for higher values of the threshold t. The lower bound on the capacity of the histogram space is shown in Fig. 5.19 for the L_1 and L_2 metrics and for histograms with 64 and 256 bins. Note that for small values of t

Figure 5.19. Lower bounds of the histogram space capacity for the L_1 and L_2 for images with 64 K pixels and histograms with 64 and 256 bins. The threshold t is given as a percentage of the maximum distance, which, if N is the number of pixels in the image, is $2N$ for the L_1 metric and N for the L_2.

the capacity of the space is so large that the fact that the bound is not tight is not a problem.

5.4.3 Spatial Histograms

The lack of spatial characterization is a major limitation of the global histogram. Images with wildly different spatial layouts can have very similar color distributions and therefore very similar color histograms. The spatial distribution of features, which is one of the most powerful perceptual clues for the characterization of an image, is wholly lost in a histogram. For example, the position of the edges is completely disregarded in an edge direction histogram, so that the picture of a rectangle would look exactly the same as the picture of a cross.

An obvious solution to this lack of localization is to include location into the measurement function from which the histogram is derived. So far, I have considered a measurement function $f : R \to M$, where M is the measurement space. One can include a spatial component in the histogram by considering a measurement function $g : R \to R \times M$ such that $\pi_1(g) = id_R{}^{12}$ and $\pi_2(g) = f$. A (continuous) localized histogram is the probability density function of the measurement function g.

The value of the function g at a point x is $g(x) = (x, f(x))$. The distribution of this function is pathological because each value x yields a precise value $f(x)$ and not a distribution. Therefore, given the first element of the pair (x), the value of

[12] The functions π_1 and π_2 are the *projection* functions of the Cartesian product. If $X \times Y$ is the Cartesian product of two spaces and $(x, y) \in X \times Y$, then $\pi_1(x, y) = x$ and $\pi_2(x, y) = y$. Similarly, for a function $f : Z \to X \times Y$, $\pi_1(f)$ is the function $Z \to X$ defined as $(\pi_1(f))(z) = \pi_1(f(z))$, and similarly for π_2.

the second is deterministic, that is, $p_f(y \mid x) = \delta(y - f(x))$. This is a rather inconvenient distribution to deal with but, fortunately, one does not have to do so, as this undesirable characteristic will disappear by considering discrete histograms.

In keeping with the spirit of the previous sections, I will immediately consider the most general case of fuzzy bins. Let $(\mathcal{V}, \mathcal{F})$ be a partition of unity defined on $R \times M$, and for $v \in \mathcal{V}$, let $\phi_v(x, y)$, $x \in R$, $y \in M$ be the vth function of the family. Then the discrete localized histogram is defined as the array H indexed by \mathcal{V}, whose vth element is

$$h_v = \sum_{x \in R} \phi_v(g(x)) = \sum_{x \in R} \phi_v(x, f(x)) \tag{5.112}$$

An interesting case is that in which the functions ϕ_v are separable, that is, $\phi_v(x, y) = \psi_v(x)\zeta_v(y)$, so that

$$h_v = \sum_{x \in R} \psi_v(x)\zeta_v(f(x)) \tag{5.113}$$

In many cases, the indices v have the same Cartesian product structure as the space $R \times M$, that is, one can write $v = (u, w)$ and $\phi_v(x) = \psi_u(x)\zeta_w(f(x))$, so that the localized histogram can be written as:

$$h_v = h_{(u,w)} = \sum_{x \in R} \psi_u(x)\zeta_w(f(x)) \tag{5.114}$$

To better understand the consequences of this structure, consider the case in which ψ_u and ζ_w are the indicator functions of families of sets constituting a partition of R and M. In other words, let there exist families of sets $\{X_u\}$ and $\{M_w\}$ so that $u \neq u' \Rightarrow X_u \cap X_{u'} = \emptyset$, $\bigcup_u X_u = R$, $w \neq w' \Rightarrow M_w \cap M_{w'} = \emptyset$, $\bigcup_w M_w = M$. Then it is possible to write

$$h_v = \sum_{x \in R} \psi_u(x)\zeta_w(f(x)) = \sum_u \sum_{x \in X_u} \zeta_w(f(x)) \tag{5.115}$$

The quantity

$$h_w^u = \sum_{x \in X_u} \zeta_w(f(x)) \tag{5.116}$$

for a fixed u is a vector containing the histogram of the measurements on the image restricted to $x \in X_u$. In other words, it is the global histogram of the region X_u of the image. The idea can be extended in a straightforward way to generic partitions of unity (subject to separability) defining

$$h_w^u = \sum_{x \in R} \psi_u(x)\zeta_w(f(x)) \tag{5.117}$$

The top index of this histogram captures the localization component: The vector h^u is a global histogram of the (fuzzy) region u. The global histogram of the image can be reconstructed thanks to the properties of the partition of unity as $h_w = \sum_u h_w^u$.

So far, the nature of the region u was left unspecified. In the simplest case, the regions u can be a fixed partition of the image (giving an elementary localization of the images based on a fixed geographic partition). In more sophisticated instances, the regions are determined by some content-dependent method, for example, by segmentation (which will be discussed later in this chapter). From the point of view of the definition of a single histogram, it makes little difference whether the regions on which it is based are obtained by a simple a priori division of the space R or by some content-dependent method: All that matters is that a suitable partition of unity can be defined. However, when the space of all histograms is considered, there is an important difference. In the case of the a priori division the functions ψ_u will be the same for all histograms (because the form of the ψ_u depends only on the id_R component of the function g, that is, it is content-independent, and is given by the a priori division, which is the same for all histograms); in the case of a content-dependent division, the form of ψ_u depends on f (the image content) so that the histogram is properly written as[13]

$$h_w^u = \sum_{x \in R} \psi_u(f)(x)\zeta_w(f(x)) \tag{5.118}$$

In this case the difference between the histograms h^u (the histogram for the region u of the image) relative to the function f_1 and the histogram k^u relative to the function f_2 has two components:

- The difference between the probability distributions of the measurements inside the regions: $\sum_{x \in R} \psi_u(f_1)(x)\zeta_w(f_1(x))$ and $\sum_{x \in R} \psi_u(f_2)(x)\zeta_w(f_2(x))$.

- The difference in shape and location of the two regions $\phi(f_1)$ and $\psi(f_2)$.

The measurement of these two differences will be presented in Section 5.5 as part of the presentation of segmentation algorithms, while this section will only consider histograms based on an a priori partition of the region R, which has a considerable importance in applications. After that, I will consider a technique that is a simple modification of the general localized histogram model, and which has received quite a lot of attention from image database researchers, that of *correlograms*.

Fixed regions local histograms. The division of the image into fixed regions is a natural consequence of the properties of the separable partition of unity $\phi_v(x,y) = \psi_v(x)\zeta_v(y)$. The function $\zeta_v(y)$, $y \in M$ divides the measurement space in bins (which can be fuzzy as in Section 5.4.1), while the function $\psi_V(x)$ divides the image domain R into regions whose shape is the same for all images. The

[13] Note the difference in notation between $\psi(f)(x)$ and $\zeta_w(f(x))$. In the case of ψ, the form of the function is determined by the *whole* function f and the resulting function is then computed at the point x. This corresponds to the fact that in a segmentation algorithm the region to which the point x belongs does not depend only on the features at x, but on the whole image content. In the case of ζ the shape of the function is determined a priori and its value depends on the value $f(x)$.

histogram h^u in Eq. (5.118) describes the contents of region u. As the regions in the images are all the same, the extension of histogram distances to localized histograms is rather easy. Let $d_H(h, g)$ be one of the histogram distances defined in Section 5.4.1, and let $h = [h^1, \ldots, h^r]$ and $g = [g^1, \ldots, g^r]$. Then a distance between the localized histograms h and g is given by

$$\delta_1(h, g) = \sum_u w^u d_H(h^u, g^u) \qquad (5.119)$$

with $w^u \geq 0$ and $\sum_u w^u = 1$. It is easy to prove that if d is a distance function, so is δ_1. Other possible definitions are

$$\delta_p(h, g) = \left[\sum_u (w^u d_H(h^u, g^u))^p \right]^{1/p} \qquad (5.120)$$

and

$$\delta_\infty(h, g) = \max_u w^u d_H(h^u, g^u) \qquad (5.121)$$

These measures of distance may incur in the same brittleness problems in which the binwise distance between histograms incur. Fuzzy regions will attenuate the problem but if fuzzy regions cannot be used or are not sufficient, it is possible to use a technique similar to that used in Section 5.4.1. Let $R^u, i = 1, \ldots, r$ be the regions in which the image is divided, and let h^u be the histogram relative to region R_u.

Let $d_R(u, v)$ be a measure of the distance between regions R_u and R_v. Several such distances are possible. An obvious choice is the distance between the centroids of the two regions in the image plane, that is, if

$$c^u = \frac{1}{|R^u|} \left[\begin{array}{c} \sum_{(i,j) \in R^u} i \\ \sum_{(i,j) \in R^u} j \end{array} \right] \qquad (5.122)$$

then $d_R(u, v) = d(c^u, c^v)$, where d is the Euclidean distance between points in the image plane. Another possibility is to define the *adjacency graph*, in which nodes represent regions and two nodes are connected with an edge if the corresponding regions are adjacent. In this case, the distance $d_R(u, v)$ can be defined as the minimum number of edges that one must traverse in order to go from region R^u to region R^v.

In any case, once the distance d_R is defined, it can be transformed into a similarity using an appropriate function g, and the region similarity matrix S can be defined as $S_{uv} = g(d_R(u, v))$. Consider now an image characterized by r histograms $h^u, u = 1, \ldots, r$, one for each region. Assume that a suitable distance between histograms d_H is defined. The distance between the localized histograms h and g, defined as in the preceding, is given by

$$\delta(h, g) = \sum_{u,v} S_{u,v} d_H(h^u, h^v) \qquad (5.123)$$

Note that if $S_{uv} = \text{diag}(w^1, \ldots, w^r)$ this distance reduces to Eq. (5.119).

Correlograms. Correlograms are a simple extension of histograms, and are designed to take advantage of the simple observation that image features are spatially correlated: Features corresponding to nearby pixels are more likely to have similar values than features corresponding to far-away pixels. A correlogram [Huang *et al.*, 1997] is a measure of the probability that two pixels, placed at a distance d from one another, will have features value f_1 and f_2, respectively. Note that, at first sight, this is not a localized histogram in the sense of the previous section because it does not depend on the location of the pixels but on the distance between pixels. It is possible, however, to reduce it to a localized histogram using a simple trick. Let $f : R \to M$ be the measurement function, and consider the Cartesian product of f by itself:

$$f^2 = f \times f : R \times R \to M \times M \tag{5.124}$$

defined as $f^2(x_1, x_2) = (f(x_1), f(x_2))$. Using this feature function, the histogram function h becomes

$$h : R \times R \to (R \times R) \times (M \times M) \tag{5.125}$$

Equation (5.114) still applies with $x = (x_1, x_2)$ and $f(x) = (f(x_1), f(x_2))$. For the sake of simplicity, I will consider only the case of the nonfuzzy discrete histogram. Let $d : R \times R \to \mathbb{R}^+$ be a suitable distance function between pixels, and a set of distance values $\{\rho_0 = 0 \le \rho_1 \le \ldots \le \rho_r\}$. Define the function ψ_u in Eq. (5.114) as

$$\psi_u(x) = \psi_u(x_1, x_2) = \begin{cases} 1 & \text{if } \rho_{u-1} \le d(x_1, x_2) < \rho_u \\ 0 & \text{otherwise} \end{cases} \tag{5.126}$$

Also, divide the feature space M into K bins indexed by the set of m-dimensional indices $\mathfrak{K} = \{(k_1, \ldots, k_m)\}$, with $|\mathfrak{K}| = K$, and let B_κ, $\kappa \in \mathfrak{K}$ be the κth bin. Divide the index w into a pair $w = (a, b)$, and define the function ζ_w as

$$\zeta_w(f^2(x)) = \zeta_{(a,b)}(f_1(x), f_2(x)) = \begin{cases} 1 & \text{if } f_1(x) \in B_a \text{ and } f_2(x) \in B_b \\ 0 & \text{otherwise} \end{cases} \tag{5.127}$$

With these definitions, the *correlogram* of the measurement function f is given by the $2m + 1$-dimensional array

$$h_v = h_{u,a,b} = \sum_{x \in R \times R} \psi_u(x) \zeta_{(a,b)}(f^2(x)) \tag{5.128}$$

In probabilistic terms, given the partition of the distances into bins $D_u = \{x : \rho_{u-1} \le x < \rho_u\}$, and of the feature space into bins B_κ, the correlogram can be defined as

$$h_{u,a,b} = P\{(x_1, x_2) : d(x_1, x_2) \in D_u \wedge f(x_1) \in B_a \wedge f(x_2) \in B_b\} \tag{5.129}$$

5.5 Segmentation

Segmentation is one of the most complicated and widely studied problems in computer vision. In very ambitious terms, segmentation is the study of methods for isolating objects on an image. Considering it in these general terms, the segmentation problem is ill-posed because an image alone is in general not sufficient for uniquely identifying semantically meaningful objects. Segmentation methods for video can be remarkably successful by using motion as a basis for segmentation in that objects tend to move uniformly or, at least, in predictable ways. Segmentation algorithms for static images cannot, unfortunately, rely on such a precious clue.

In less ambitious terms, segmentation algorithms try to divide an image in a series of "uniform" regions. Such regions are the basic constituents of objects. If good object models are available, regions can be merged into semantically more meaningful objects, if not, they can be used as primitives for region-based retrieval. Although more feasible than object segmentation, dividing up an image in homogeneous regions is still a very difficult problem. A lot of problems derive from the ambiguity hiding inside the term "uniform." A "uniformity criterion" is used to determine whether or not, for the purposes of segmentation, a given region should be considered uniform. If the uniformity criterion that we use is too strict, a region that perceptually would appear uniform will be divided in several regions, while if the criterion is too relaxed, regions that perceptually would appear separated will be considered as a single region.

To make things more complicated, perceptual uniformity does not depend only on the absolute difference between the perceptual features, but also on their spatial distribution. Consider, for instance, the two images in Fig. 5.20. Perceptually, the image on the left-hand side appears composed of two regions (a gray square inside a white one), while that on the right-hand side appears composed of three regions (two rectangles of different color inside a white square). However, the initial and final gray levels of the image on the left-hand side are exactly the same as the gray levels of the two regions in the image on the right-hand side.

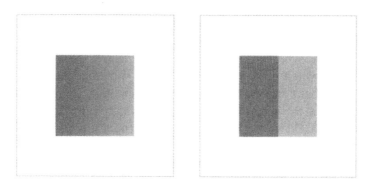

Figure 5.20. If the two regions on the right-hand side are separated, then the image on the left-hand side will also be separated in two regions.

Therefore, if an algorithm uses gray level as a feature, and considers the difference in gray levels as an indicator of uniformity, every algorithm that will divide the two regions on the right-hand side will also divide the region on the left-hand side in at least two parts.

Although this simple example used gray level as a segmentation criterion, other features can be used as well. The most common segmentation features are gray level, color, and texture. In this section I will describe segmentation algorithms as independently as possible of the specific features on which segmentation is based. I will simply assume that, given an image, it is possible to compute a suitable point feature $f(i, j)$ for each pixel (i, j). The point feature f will be represented as a vector in \mathbb{R}^q.

Given its importance and difficulty, segmentation received an extraordinary amount of attention from computer vision researchers. Every major conference on computer vision and image processing in the last 30 years had at least a few papers on segmentation, and every journal in computer vision or related fields published a number of segmentation papers every year. It will be impossible here to do justice to all the approaches proposed. It will be impossible even to produce a significant bibliography of segmentation papers. This section will contain the barest description of the "classic" segmentation algorithms (those on which a number of improved and generalized versions are based), and of segmentation methods designed mainly with image database problems in mind. Further information and references on segmentation methods can be found in most computer vision textbooks (see, for instance, Jain (1989), Jain *et al.* (1995), and Sonka *et al.* (1991).

5.5.1 Clustering Methods

Clustering methods attempt to separate the regions in the feature space, assigning pixels to different regions based on the value of the point features only, without considering the spatial arrangement of the pixels [Jain and Dubes, 1988]. If the feature space is one-dimensional (e.g., if the feature used is the gray level of a pixel), these methods are also known as *thresholding methods* because in this case, clustering reduces to the selection of an appropriate threshold (or several thresholds) to separate the histogram of the image into a number of separate classes.

In the case in which the feature vector is one-dimensional ($q = 1$), clustering segmentation is therefore reduced to the determination of one or more thresholds. Assuming, for the sake of simplicity, that we are only interested in the distinction between background and objects, the problem is reduced to the determination of a threshold T such that pixel (i, j) is considered part of the background if $f(i, j) < T$, and part of the objects otherwise. Intuitively, if the feature has a bimodal histogram, a good threshold value is at the minimum between the two maxima [Sonka *et al.*, 1999]. If the histogram is multimodal, the threshold can be placed between any two maxima (different thresholds will, obviously, give different results), or multithreshold (one threshold between every pair of maxima)

can be employed. Deciding whether a histogram is bimodal or multimodal, on the other hand, may not be easy [Rosenfeld and De La Torre, 1983]. The following algorithm selects the optimal threshold in the case of a bimodal histogram, and it has been shown to work quite well even if the histogram is not bimodal [Riddler and Calvard, 1978]:

ALGORITHM 5.1. *Let \mathcal{B} be the set of background pixels, and \mathcal{O} the set of object pixels. Initialize \mathcal{B} to contain the four corner pixels of the image only, and \mathcal{O} to contain all other pixels in the image.*

$$
\begin{aligned}
&1 \ \ set \ t \leftarrow 1, \ T^{(t)} \leftarrow \infty \\
&2 \ \ do \\
&3 \qquad \mu_{\mathcal{B}}^{t} \leftarrow \tfrac{1}{|\mathcal{B}|} \textstyle\sum_{(i,j)\in\mathcal{B}} f(i,j) \\
&4 \qquad \mu_{\mathcal{O}}^{t} \leftarrow \tfrac{1}{|\mathcal{O}|} \textstyle\sum_{(i,j)\in\mathcal{O}} f(i,j) \\
&5 \qquad T^{(t+1)} \leftarrow \tfrac{\mu_{\mathcal{B}}^{t}+\mu_{\mathcal{O}}^{t}}{2} \\
&6 \qquad \mathcal{O} \leftarrow \{(i,j) : f(i,j) > T^{(t+1)}\} \\
&7 \qquad \mathcal{B} \leftarrow \{(i,j) : f(i,j) \le T^{(t+1)}\} \\
&8 \ \ until \ T^{(t+1)} = T^{(t)}
\end{aligned}
$$

An example of application of the algorithm is shown in Fig. 5.21. Note that in this case the threshold after the second iteration (Fig. 5.21b) actually gives better

original

iteration #2 (threshold = 227)

iteration #5 (threshold = 155)

Figure 5.21. Example of segmentation with iterative threshold selection. Original image (a), segmentation after two iterations (b), and after five iterations (c).

results than the threshold at convergence (Fig. 5.21c). A slight modification to the algorithm that sometimes gives better results uses the variance of the object and background regions in addition to the averages:

ALGORITHM 5.2. *Let \mathcal{B} be the set of background pixels, and \mathcal{O} the set of object pixels. Initialize \mathcal{B} to contain the four corner pixels of the image only, and \mathcal{O} to contain all other pixels in the image.*

1 *set* $t \leftarrow 1$. $T^{(t)} \leftarrow \infty$

2 *do*

3 $\qquad \mu_{\mathcal{B}}^{t} \leftarrow \frac{1}{|\mathcal{B}|} \sum_{(i,j) \in \mathcal{B}} f(i,j)$

4 $\qquad \mu_{\mathcal{O}}^{t} \leftarrow \frac{1}{|\mathcal{O}|} \sum_{(i,j) \in \mathcal{O}} f(i,j)$

5 $\qquad \sigma_{\mathcal{B}}^{t} \leftarrow \left[\frac{1}{|\mathcal{B}|(|\mathcal{B}|-1)} \left(|\mathcal{B}| \sum_{(i,j) \in \mathcal{B}} f(i,j)^2 - \left[\sum_{(i,j) \in \mathcal{B}} f(i,j) \right]^2 \right) \right]^{1/2}$

6 $\qquad \sigma_{\mathcal{O}}^{t} \leftarrow \left[\frac{1}{|\mathcal{O}|(|\mathcal{O}|-1)} \left(|\mathcal{O}| \sum_{(i,j) \in \mathcal{O}} f(i,j)^2 - \left[\sum_{(i,j) \in \mathcal{B}} f(i,j) \right]^2 \right) \right]^{1/2}$

7 $\qquad T^{(t+1)} \leftarrow \frac{\sigma_{\mathcal{B}}^{t} \sigma_{\mathcal{O}}^{t}}{\sigma_{\mathcal{B}}^{t} + \sigma_{\mathcal{O}}^{t}} \left(\frac{\mu_{\mathcal{B}}^{t}}{\sigma_{\mathcal{B}}^{t}} + \frac{\mu_{\mathcal{O}}^{t}}{\sigma_{\mathcal{O}}^{t}} \right)$

8 $\qquad \mathcal{O} \leftarrow \{(i,j) : f(i,j) > T^{(t+1)}\}$

9 $\qquad \mathcal{B} \leftarrow \{(i,j) : f(i,j) \leq T^{(t+1)}\}$

10 *until* $T^{(t+1)} = T^{(t)}$

Figure 5.22 shows the application of the modified thresholding selection to the same image of Fig. 5.21. Note that in this case the algorithm converges after three iterations. In spite of the reasonably good performance on this simple image, thresholding runs into problems for the majority of images. An example is shown in Fig. 5.23. It is possible, in this case, to improve the result by adaptively selecting

iteration #2 (threshold = 227) iteration #3 (threshold = 254)

Figure 5.22. Example of segmentation with the modified iterative threshold selection. Segmentation after two iterations (a), and after three iterations (b).

Figure 5.23. Example of segmentation in which global thresholding does not give acceptable results.

local thresholdings, different for different parts of the image, and depending on the local contrast [Jain *et al.*, 1995].

k-Means clustering. For higher-dimensional feature spaces, segmentation requires clustering and cannot be reduced to a simple thresholding. Clustering is a research topic in itself [Jain and Dubes, 1988], and will be considered only superficially in this chapter. Given a set of points in \mathbb{R}^n,[14] a clustering algorithm divides them into classes R_i, $i = 1, \ldots, k$. Many clustering algorithms assume that the R_i are a partition of the data set D, that is, $R_i \cap R_j = \emptyset$ for $i \neq j$, and that $\bigcup R_i = D$, although some algorithms relax either one or both of these assumptions. The general principle governing clustering is that the classes should be *compact* and *well separated*. If the classes are described by Gaussian distribution, this means that the algorithm will try to minimize the within-class variance while maximizing the between-classes variances and, at the same time, keeping the number of classes low (if this constraint is not added, an optimal solution according to many criteria is to define a class for each element in the data set). A simple clustering algorithm to do this is the k-means. The main limitation of k-means is that the number of classes must be known in advance. This problem can partially be overcome by repeating the clustering analysis for various values of k and choosing the solution that better fits a given criterion.

ALGORITHM 5.3. *The number of desired clusters k is given. The clusters are represented as sets C_i, $i = 1, \ldots, k$, holding the elements that belong to a given cluster, and by their centroids μ_i.*

[14] There are clustering algorithms that do not assume that the feature space has a vector space structure, but only that it has a metric space structure, that is, that there is a distance defined between every pair of points. These algorithms will not be considered here. See Jain and Dubes (1988) for examples.

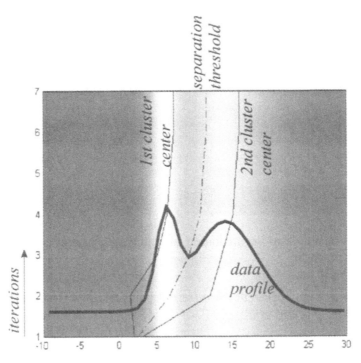

Figure 5.24. k-Means used for threshold selection in a one-dimensional clustering problem.

1. *Initialize $C_i = \emptyset$, $i = 1, \ldots, k$.*
2. *Initialize μ_i to random points in the feature space.*
3. *while $\neg Conv(C_i, \mu_i)$ do*
4. *For every point x*
5. *$j \leftarrow \text{minarg}_{i=1,\ldots,k} d(x, \mu_i)$*
6. *$C_i \leftarrow C_j \cup x$*
7. *For $i = 1, \ldots, k$*
8. *$\mu_i = \frac{1}{|C_i|} \sum_{x \in C_i} x_i$*
9. *end*

For one-dimensional domains, k-means provides a form of iterative threshold selection. Figure 5.24 shows the results of a one-dimensional clustering. The bimodal curve superimposed on the figure is the data profile, replicated in the gray pattern underlying the figure. The three curves that go from the bottom to the top of the figure represent the two cluster centroids and their middle point (the optimal threshold) as evaluated by k-means during seven iterations of the algorithm. The number of iterations is on the vertical axis, and increases from bottom to top.

Expectation maximization. A more sophisticated way of separating the points in the feature space is by modeling their distribution as a *mixture of Gaussians*.

Assume that the feature space has an underlying probability distribution

$$p(x \mid \Theta) = \sum_{i=1}^{k} \alpha_i G(x \mid \theta_i) \tag{5.130}$$

where $\Theta = [\alpha_1, \ldots, \alpha_k, \theta_1, \ldots, \theta_k]$ is the vector of the parameters of the model $\theta_i = [\mu_i, \Sigma_i]$, and the functions G are Gaussians

$$G(x \mid \theta_i) = \frac{1}{(2\pi)^{n/2} |\Sigma_i|^{1/2}} e^{-1/2(x-\mu_i)^T \Sigma^{-1}(x-\mu_i)} \tag{5.131}$$

Given the data set $D = [x^1, \ldots, x^N]$ of feature points, the probability that point x^u is generated by the distribution equation (5.130)

$$p(x^u \mid \Theta) = \sum_{i=1}^{k} \alpha_i G_{[\mu_i, \Sigma_i]}(x^u) \tag{5.132}$$

and the probability that the whole dataset is generated by the distribution equation (5.130) is

$$\prod_{u=1}^{N} \sum_{i=1}^{k} \alpha_i G(x^u \mid \theta_i) \tag{5.133}$$

The same quantity is also called the *likelihood* that the vector Θ describes the distribution of the points in D, $H(\Theta \mid x)$. The optimal parameter vector Θ is obtained by maximizing the value H. In most cases one does not work directly with H, but with its logarithm, the *log-likelihood*

$$\mathcal{L}(\Theta \mid x) = \sum_{u=1}^{k} \log p(x^u \mid \Theta) \tag{5.134}$$

The optimal parameter vector Θ is determined via the expectation maximization EM algorithm [Dempster *et al.*, 1977]. The idea of the algorithm is the following. Assume that the number k of Gaussians in the model is known (the determination of k will be considered at the end of the section). The problem would be easy if one knew for every point x^u which of the k Gaussian distributions generated it. Let w_r^u be a set of variables such that $w_1^u = 1$ if point x^u was generated by the rth Gaussian, and zero otherwise. In this case, one could compute the parameters μ_r and Σ_r for the rth Gaussian using the formulas for the single Gaussian, that is:

$$\mu_i = \frac{1}{\sum_u w_r^u} \sum_{x^u} w_r^u x^u \tag{5.135}$$

and

$$\Sigma_i = \frac{1}{\sum_u w_r^u - 1} \sum_{x^u} w_r^u (x^u - \mu_r)(x^u - \mu_r)^T \tag{5.136}$$

The weight α_r would be given by $\alpha_r = \sum_u w_r^u / |D|$. The variables w_r^u are, unfortunately, not known, but they can be added to the estimation problem. At first sight, this might not seem such a great idea: We have moved from the problem of

estimating Θ to the problem of estimating Θ *and* the variables w_r^u. It must be considered, however, that if the w_r^u are known, the vector Θ can be easily computed using Eqs. (5.135) and (5.136), so that the problem is now essentially to estimate the w_r^u. But, by the same token, if Θ were known, one could simply estimate w_r^u as

$$w_r^u = \frac{1}{\sum_{i=1}^{k} \alpha_i G(x^u \mid \theta_i)} \alpha_r G(x^u \mid \theta_r) \tag{5.137}$$

This is the ideal situation for an iterative algorithm: Given w_r^u it is possible to compute Θ, and given Θ it is possible to compute w_r^u. The question, as in all the iterative algorithms, is to find a good initialization. This problem will be considered shortly. But, for now, assume that a first estimate of the vector Θ is available. The EM algorithm is as follows:

ALGORITHM 5.4. *Assume that the number k of Gaussians in the model is known. Also, let Θ be an initial estimate for the parameter vector. Initialize stop = false.*

1. *while \negstop*
2. *for each point x^u*
3. $S_{x^u} \leftarrow \sum_{i=1}^{k} \alpha_i G(x^u \mid \theta_i)$
4. *for $r = 1, \ldots k$*
5. $w_r^u \leftarrow \frac{1}{S_{x^u}} \alpha_r G(x^u \mid \theta_r)$
6. *for $r = 1, \ldots k$*
7. $\alpha_r \leftarrow \frac{1}{|D|} \sum_{x^u} w_r^u$
8. $\mu_r \leftarrow \frac{1}{\sum_{x^u} w_r^u} \sum_{x^u} w_r^u x^u$
9. $\Sigma_r \leftarrow \frac{1}{\sum_u w_r^u - 1} \sum_{x^u} w_r^u (x^u - \mu_r)(x^u - \mu_r)^T$
10. $\mathcal{L}(\Theta) = \sum_{x^u} \log \sum_{r=1}^{k} \alpha_r G(x^u \mid \theta_r)$
11. *if $\left| \frac{\mathcal{L}(\Theta) - \mathcal{L}^{old}}{\mathcal{L}^{old}} \right| < \varepsilon$*
12. *stop = true*
13. *else*
14. $\mathcal{L}^{old} \leftarrow \mathcal{L}(\Theta)$

Initializing the algorithm is in general not easy, and the final results do depend on a good initialization. In the case of image segmentation, Carson *et al.* (1999) divided the image in a number of regions equal to the number of Gaussians, shaped like those in Fig. 5.25. The average and variance of the feature vectors in each of the regions are computed and used to initialize the k Gaussians. In order to guarantee robustness, the whole algorithm is repeated, restarting it each time with small random perturbation of the means, and the result with the maximum overall log-likelihood is used.

In order to select the proper mixture model, various values of k must be tried. It is obvious, however, that larger values of k will in general give better likelihood, even if it means overfitting the data. It is necessary somehow take into account

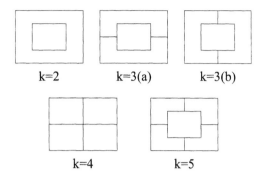

$$k=2 \qquad k=3(a) \qquad k=3(b)$$

$$k=4 \qquad k=5$$

Figure 5.25. Regions for the initialization of the EM algorithm.

the fact that using fewer Gaussians is preferable. Using the log-likelihood as a measure of fit, it is possible to apply the principle of *minimum description length* [Carson *et al.*, 1999; Rissanen, 1978; Rissanen, 1989; Schwartz, 1978]. The optimal value of k is that which maximizes

$$\mathcal{L}(\Theta) - \frac{m_k}{2} \log |D| \tag{5.138}$$

where m_k is the number of parameters needed for a model with k components. In the case of Gaussians it is

$$m_k = (k-1) + kn + k\frac{n(n+1)}{2} \tag{5.139}$$

5.5.2 Region Merging and Region Splitting

The algorithms presented in the previous section consider only the values of the features, and try to isolate features of different values. They do not take advantage of the topological relations between the pixels of an image. Because segmentation seeks to extract *connected* regions from an image, topological relations are extremely important for a good segmentation. Before analyzing region-based segmentation algorithms, however, it is important to say a few words about topology in discrete images.

Curves, regions, and edges. Most images are composed of a square grid of pixels, and topological relations rely on the relations between neighboring pixels. Therefore, in order to determine topological relations, it is necessary to clarify what is meant by *neighboring* pixels. In computer vision, two types of neighborhoods are used, the 4-neighborhood and the 8-neighborhood, and are represented in Fig 5.26. In the 4-neighborhood, only the four pixels that have a boundary in common with a given pixel are considered its neighbors, while in the 8-neighborhood, the eight pixels that have either a boundary or a point in common with a given pixel are considered its neighbors.

With the concept of neighborhood, it is possible to define a connected region: A region R is *connected* if given any two pixels $x, y \in R$, it is possible to find a

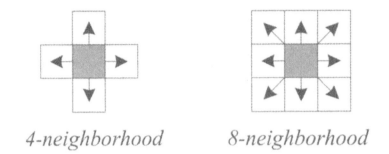

4-neighborhood *8-neighborhood*

Figure 5.26. The 4-neighborhood and the 8-neighborhood of a pixel.

sequence of pixels z_1, \ldots, z_n such that $z_1 = x$, $z_n = y$, $z_i \in R$ for all i, and z_i is a neighbor of z_{i+1}. It is also possible to define a curve as a region in which every point has at most two neighbors (for the 4-neighborhood) or four neighbors (for the 8-neighborhood) that belong to the region, and a closed curve as a curve in which for every point x there is a path that goes from x back to x passing through all the pixels of the curve. Depending on the neighborhood chosen for a particular application one obtains different topologies. For instance, the curve of Fig. 5.27 is closed if one uses the 8-neighborhood topology, while it is not even connected if one uses the 4-neighborhood topology.

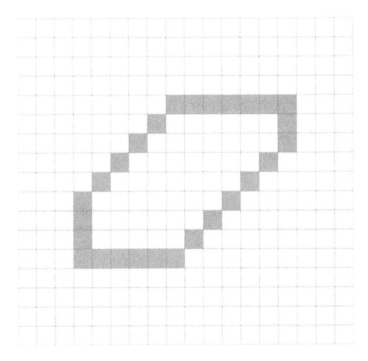

Figure 5.27. A curve that is closed according to the 8-neighborhood but not according to the 4-neighborhood.

Not all the properties that hold for the geometry of the continuum translate smoothly into discrete geometry. In the continuum, for instance, a closed curve divides the plane in two disconnected regions, while an open curve leaves the plane connected. Consider, however, the curve of Fig. 5.27. If the 4-neighborhood is adopted, then the curve is not closed, and the background is not connected. On the other hand, if the 8-neighborhood is adopted, the curve is closed but the background is connected! This particular paradox is avoided in many applications by considering the 4-neighborhood for the foreground and the 8-neighborhood for the background. If such a convention is adopted, then the curve of Fig. 5.27 is open and the background is connected.

In an image in which pixels can assume many levels of gray, a useful concept is that of *crack edge*. Each pixel has up to four crack edges attached, one for each one of its four neighbors. A crack edge is present whenever there is a difference in the brightness level of two pixels, and its strength is given by the absolute value of the difference between the pixels. For instance, given pixel (i, j) with gray value $g(i, j)$, the strength of the crack edge between the pixel and its "eastern" neighborhood is given by $|g(i, j) - g(i, j + 1)|$. The direction of a crack edge is conventionally assumed to be that of increasing brightness.

Region merging. Segmentation algorithms try to determine a partition of the image in regions that are, in some generic sense, *homogeneous*. Assume that a predicate H is available to evaluate the homogeneity of a region. Then a segmentation algorithm attempts to divide the image in a set of regions R_1, \ldots, R_S such that

$$\forall i \quad H(R_i) \tag{5.140}$$

and

$$\forall i, j \quad R_i \parallel R_j \Rightarrow \neg H(R_i \cup R_j) \tag{5.141}$$

where $R_i \parallel R_j$ means that R_i and R_j are adjacent.

Region merging starts by considering each pixel as a separate region and merging adjacent regions as long as the compound region satisfies the homogeneity condition equation (5.140). When it is impossible to merge two regions without violating the homogeneity predicate, the segmentation algorithm stops. One problem of region merging is that the final result depends on the strategy followed to merg the regions. In fact, given three regions R_1, R_2, and R_3, the decision to merge R_1 and R_2 may cause the composite $R_1 \cup R_2$ not to be merged with R_3 because the overall characteristics of $R_1 \cup R_2$ do not allow the merging, while, had R_2 been compared with R_3, the compound $R_2 \cup R_3$ would have been formed, and R_1 would not have been merged.

The following is a simple example of a region-merging algorithm.

ALGORITHM 5.5. *Let $I(i, j)$ be the gray-level image to be segmented. Given a pixel p of the image, $\mathcal{N}(p)$ is its neighborhood (either 4- or 8-neighborhood). In output, the*

*matrix R(i, j) contains the region number for all pixels in the image. A data struc-
ture keeps track if, in a given iteration, the merging of two regions has already been
attempted. The structure supports the predicate attempted(r_1, r_2), which returns
true if the merging of regions r_1 and r_2 has already been attempted, try(r_1, r_2),
which sets the value attempted to true for the regions r_1 and r_2, and clear, which
resets all attempted values to false.*

1. *Initialize the set of region to all the connected
 components of equal gray level*
2. *Set changed ← true*
3. *while changed do*
4. *changed ← false*
5. *for all pixels p*
6. *for all $p' \in \mathcal{N}(p)$*
7. *if $R(p) \neq R(p') \wedge \neg attempted(R(p), R(p'))$*
8. *if Uniform($R(p), R(p')$)*
9. *for all pixels $q : R(q) = R(p')$*
10. *$R(q) \leftarrow R(p)$*
11. *changed = true*
12. *else*
13. *try($R(p), R(p's)$)*
14. *end*

The predicate *Uniform* determines whether the region deriving from the con-
junction of the two regions $R(p)$ and $R(p')$ is uniform enough to allow the union
of the two. Typically, the predicate *Uniform* is obtained by determining some
continuous measure of the nonuniformity of a region and comparing it with a
predefined threshold.

Region splitting. Region splitting proceeds the other way around with respect
to region merging. It starts by considering the whole image as a single region, and
then evaluating the uniform predicate. In general, the predicate will not be true.
The image is then split in four, and the procedure is repeated for all four parts.
The algorithm for region splitting is quite simple if implemented in a language
that allows recursion, and can be summarized as follows:

ALGORITHM 5.6. *Let $I(i, j)$ be the gray-level image to be segmented. The algorithm
returns an array s, of the same size as I, in which every pixel is labeled with the
region to which it belongs. The function rn() returns a new region number for
every call. Given an array a, a_r and a_c are the number of rows and columns of a,
respectively. The notation $a[1 \cdots n, 1 \cdots m]$ is used to indicate subarrays of the
array a. The predicate Uniform is used as before to determine whether a region is
uniform.*

1. *function s = split(I)*
2. *s is a new array of the same size as I*
3. *if Uniform(I)*
4. $v = rn()$
5. $s[i, j] = v, i = 1, \ldots, s_r, j = 1, \ldots, s_c$
6. *else*
7. $s[I \cdots \lfloor \frac{s_r}{2} \rfloor, 1 \cdots \lfloor \frac{s_c}{2} \rfloor]] = split(I[1 \cdots \lfloor \frac{s_r}{2} \rfloor, 1 \cdots \lfloor \frac{s_c}{2} \rfloor])$
8. $s[\lfloor \frac{s_r}{2} \rfloor + 1 \cdots s_r, 1 \cdots \lfloor \frac{s_c}{2} \rfloor]] = split(I[\lfloor \frac{s_r}{2} \rfloor + 1 \cdots s_r 1 \cdots \lfloor \frac{s_c}{2} \rfloor])$
9. $s[1 \cdots \lfloor \frac{s_r}{2} \rfloor, \lfloor \frac{s_c}{2} \rfloor + 1 \cdots s_c] = split(I[\cdots \lfloor \frac{s_r}{2} \rfloor, \lfloor \frac{s_c}{2} \rfloor + 1 \cdots s_c])$
10. $s[\lfloor \frac{s_r}{2} \rfloor + 1 \cdots s_r, \lfloor \frac{s_c}{2} \rfloor + 1 \cdots s_c]$
 $= split(I[\lfloor \frac{s_r}{2} \rfloor + 1 \cdots s_r, \lfloor \frac{s_c}{2} \rfloor + 1 \cdots s_c])$
11. *end*

Typically, a problem of region splitting is the large number of region it creates. The example of Fig. 5.28, contains a single object over a uniform background but because of the region-splitting algorithm, the final segmentation contains 20 regions. Because of this, Algorithm 5.6 is never used alone, but in conjunction with region merging. A simple solution is to use region splitting as a starting point for region merging. More complex schemes perform the split and merge at the same time [Jain *et al.*, 1995; Sonka *et al.*, 1999].

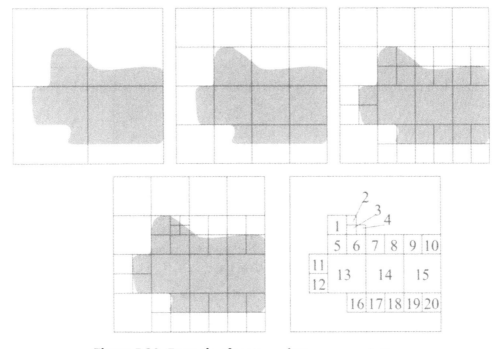

Figure 5.28. Example of region-splitting segmentation.

5.5.3 Edge Flow

A final example of a segmentation algorithm, developed in the context of image
database, is Ma and Manjunath's *edge flow* [Ma and Manjunath, 1997]. The idea of
edge flow is to start from points inside the regions, and let the region grow along
the direction of the "flow" (that is, of the gradient) of the features that are used for
segmentation. The growth is interrupted when two neighboring pixels are found
that have flows in opposite directions. In this case, the segment between the two
pixels is considered a boundary.

More specifically, the flow vector F at the image location s along a direction θ
is a function

$$F(s, \theta) = F[E(s, \theta), P(s, \theta), P(s, \theta + \pi)] \qquad (5.142)$$

where $E(s, \theta)$ represents the *edge energy* at point s along the direction θ, which is
a measure of the local rate of change in the feature field at location s in direction
θ; $P(s, \theta)$ is the probability of finding an edge if the feature field flows by a small
(ideally: infinitesimal) amount in direction θ. To make things more concrete, start
by considering a Gaussian function centered at s (assume, without loss of gener-
ality, that s is the origin of coordinate system), and with standard deviation σ,
$G_\sigma(x, y)$. The first derivative of the Gaussian G along the x axis is given by

$$G_\sigma'(x, y) = -\frac{x}{\sigma^2} G_\sigma(x, y) \qquad (5.143)$$

Also, given a small number d, define the difference of offset Gaussians along the
x axis as

$$\Delta G_\sigma(x, y) = G_\sigma(x, y) - G_\sigma(x + d, y) \qquad (5.144)$$

These two functions can generate two families of functions obtained by rotation:

$$G_{\sigma, \theta}'(x, y) = G_\sigma'(x', y') \qquad (5.145)$$

and

$$\Delta G_{\sigma, \theta}(x, y) = \Delta G_\sigma(x', y') \qquad (5.146)$$

where $x' = x \cos \theta + y \sin \theta$, and $y' = -x \sin \theta + x \cos \theta$.

Consider now an image $I(x, y)$ taken at a certain scale σ by convolving it with
a Gaussian: $I_\sigma(x, y) = G_\sigma(x, y) * I(x, y)$. The edge-flow energy is defined as the
magnitude of the gradient of the smoothed image I_σ along the orientation θ. That
is, if \hat{n} is the unit vector in direction θ, we have:

$$E(s, \theta) = |\nabla I_\sigma \cdot \hat{n}| = |\nabla (G_\sigma(x, y) * I(x, y)) \cdot \hat{n}| \qquad (5.147)$$

which, by the linearity of the derivation and convolution operators, is equivalent
to

$$E(s, \theta) = |I(x, y) * G_{\sigma, \theta}'| \qquad (5.148)$$

where $s = (x, y)$. In order to compute P it is necessary to estimate the probability of finding the nearest flow boundary in direction θ. This probability can be obtained by checking the difference between the predicted value of the image at a small distance in direction θ and its actual value. If the feature field does not contain boundaries in direction θ, then such prediction will be fairly accurate, while if it does, there will be a significant error. The prediction error can be computed as

$$\varepsilon(s, \theta) = |I_\sigma(x + d \cos \theta, y + d \sin \theta) - I_\sigma(x, y)| = |I(x, y) * \Delta G_{\sigma,\theta}(x, y)| \quad (5.149)$$

where d is the distance at which the prediction s made. Ma and Manjunath (1997) reportedly use $d = 4\sigma$. Given this error, the value $P(s, \theta)$ is computed as

$$P(s, \theta) = \frac{\varepsilon(s, \theta)}{\varepsilon(s, \theta) + \varepsilon(s, \theta + \pi)} \quad (5.150)$$

An image can be described by several sets of features at the same time. Given a set A of features, $E_a(s, \theta)$ and $P_a(s, \theta)$ are the flow functions computed for feature a. The overall flow functions can be computed by convex combination:

$$E(s, \theta) = \sum_{a \in A} E_a(s, \theta) w(a) \quad (5.151)$$

$$P(s, \theta) = \sum_{a \in A} P_a(s, \theta) w(a) \quad (5.152)$$

$$\sum_{a \in A} w(a) = 1 \quad (5.153)$$

The flow function, which has been formally defined as $F(s, \theta)$, has at the point s a magnitude and a direction, which are determined as follows. First, identify the direction $\Theta(s)$ that maximizes the probability of change over a half-plane, that is:

$$\Theta(s) = \arg \max_\theta \left\{ \sum_{\theta \leq \theta' \leq \theta + \pi} P(s, \theta') \right\} \quad (5.154)$$

The final edge flow is defined as the vector sum of the flows E with their directions in the range identified by $\Theta(s)$:

$$F(s) = \sum_{\Theta(s) \leq \theta \leq \Theta(s) + \pi} E(s, \theta) e^{i\theta} \quad (5.155)$$

$F(s)$ is a complex number, whose magnitude represents the edge energy and whose angle represents the flow direction. After the edge flow F is computed for every point of an image, it can be propagated along its direction, identifying the positions where the flow changes direction. These positions correspond to boundaries in the image.

Figure 5.29. Results of edge flow on an image on which global thresholding fails.

ALGORITHM 5.7. (*from Ma and Manjunath (1997)*).

1. *Set $n = 0$. Compute $F(s)$ for each pixel, and set $F_0(s) = F(s)$.*
2. *while changed*
3. *Set $F_{n+1}(s) = 0$ for all s.*
4. *for each $s = (x, y)$*
5. *let $s' = (x', y')$ be a neighbor of s such that*
 $$\angle F_n(s) \leftarrow \tan^{-1} \frac{y' - y}{x' - x}$$
6. *if $F_n(s') \cdot F_n(s) > 0$*
7. $F_{n+1}(s') \leftarrow F_{n+1}(s') + F_n(s)$
8. *else*
9. $F_{n+1}(s) \leftarrow F_{n+1}(s) + F_n(s)$
10. $n \leftarrow n + 1$
11. *end*

When the propagation reaches a stable state, the locations that have nonzero edge flow coming from two opposite directions identify the region boundaries. After the boundaries have been detected, disjoint pieces are connected to form closed contours, and a region-merging algorithm is used to reduce the number of regions.

Figure 5.29 shows the contours and the regions found by the edge-flow segmentation algorithm on the same image of Fig. 5.23.

5.6 Shape Description and Similarity

Segmentation introduces a new concept in the description of an image, specifically, that of *region*, that is, a connected area of the image plane with an approximately constant feature description. The introduction of this new element has several important repercussions for the representation of images and the

determination of their similarity. With segmentation, an image $I_i \in D$ is represented as a set of regions $I_i = \{R_1, \ldots, R_{r_i}\}$ whose number changes depending on the image. Each region, in turn, can be represented as a triple $R_i = (F_i, S_i, p_i)$, where F_i is a representation of the features inside the region (which, *ex hypothesis*, have a more or less constant value), S_i is a representation of the shape of the region, and p_i represents the position of the region inside the image. The task of determining the difference between two regions, taken in isolation from their image context, is therefore composed of the following two tasks:

1. determining the difference between the features of the regions by defining a suitable distance measure in the space of the feature representations; and

2. determining the difference between the shapes of the two regions by defining a distance in the space of shape representations.

When the regions are introduced in the context of an image, one should also consider two additional elements:

3. determining the difference in spatial relations between pairs of similar images; and

4. taking into account the fact that the two images can have a different number of regions, which generates the potentially explosive combinatorial problem of associating multiple regions in an image with a single region in another.

The next sections will consider the four preceding points, starting with the description of the contents of a region.

5.6.1 The Contents of a Region

As in the previous section, the image is described by a field f of point features with values in \mathbb{R}^q. As a consequence of the segmentation process, all the point features inside a region will have a relatively constant value, so that a simple and often sufficient characterization of the features in the region R_i is the average of the feature:

$$\bar{f}^i = \frac{1}{|R_i|} \sum_{(x,y) \in R_i} f(x, y) \tag{5.156}$$

In some cases this characterization might not be sufficiently precise. In these circumstances, the features inside a region can be described by their histogram, using one of the methods of Section 5.4, for example, the histogram $\mathcal{H}(f|_{R_i})$[15] defined as in Eq. (5.46). The advantage in this case is that it is possible to use all the properties of the histograms and the distance functions defined in Section 5.4.

[15] If f is a function, and R a subset of the domain of f, the function $f|_R$ is the restriction of f to the set R.

The histogram can usually be approximated using the statistical moments equation (5.104) or simply using the mean \bar{f}^i and the autocorrelation matrix Σ, with

$$\Sigma^i_{hk} = \frac{1}{|R_i| - 1} \sum_{(x,y) \in R_i} (f_h(x,y) - \bar{f}^i_h)(f_k(x,y) - \bar{f}^i_k) \qquad (5.157)$$

where \bar{f}^i_k is the kth component of the average feature in region R_i. A more simplified representation uses the standard deviations of the individual components:

$$\sigma^i_k = \sqrt{\frac{1}{|R_i| - 1} \sum_{(x,y) \in R_i} (f_k(x,y) - \bar{f}^i_k)^2} \qquad (5.158)$$

5.6.2 Region Shape

A representation of the shape of region R_i can be computed using a *mask*, that is, a binary image M^i with $M^i(x,y) = 1$ if $(x,y) \in R_i$, and $M^i(x,y) = 0$ otherwise. Equivalently, this mask can be seen as the *indicator function* of the set R_i, $r_i(x,y)$. Regions can be described either by describing their boundary or by describing the set R_i.

In the specific case of image databases, region representation is always used in order to determine differences between regions (as opposed, for instance, for region matching or for model fitting). This generates special requirements on the representation. In particular, the representation should be continuous with the shape change in the selected metric[16], otherwise the distance computation will be very unstable.

Edge distribution representations. The shape of a region can be represented by a histogram of the directions of the edges along its border. As with all histogram representations, one loses some of the the spatial arrangement component of the border of the region, and measures only the probability that a certain part of the border will have certain characteristics. The *chord distribution* representation [Smith and Jain, 1982] is defined as follows. Let $b(x,y)$ be equal to unity if the pixel (x,y) is on the border, and zero otherwise. The chord distribution is the histogram

$$h(\Delta x, \Delta y) = \int b(x,y)b(x + \Delta x, y + \Delta y) dx\, dy \qquad (5.159)$$

[16] More properly, the region description should be Lipschitz in the chosen metric with respect to the hypothetical perceptual metric. That is, let R_1 and R_2 be two regions, let $d_p(R_1, R_2)$ be the perceptual distance between the two regions (as estabilished, for instance, through an experiment), f be the representation into some suitable metric feature spce F, and d the distance function in F. Then the Lipschitz requirement is that there be a constant $C > 0$ such that, for all regions R_i, R_j:

$$d(F(R_1), F(R_2)) \le Cd_p(R_1, R_2)$$

In practice, one also wants C to be close to unity so that changes in the region shape that result in small perceptual differences will also result in small differences in the representation and vice versa.

A rotation-invariant representation can be obtained by integrating over all angles:

$$h_r(r) = \int_{-\pi/2}^{\pi/2} h(r\cos\theta, r\sin\theta)r\,d\theta \qquad (5.160)$$

The function $h_r(r)$ varies linearly with scale. A representation invariant with scale (but linearly varying with rotation) can be obtained by integrating over r:

$$h_\theta(\theta) = \int_0^{r_{max}} h(r\cos\theta, r\sin\theta)\,dr \qquad (5.161)$$

A combination of both representations has been shown to give a robust shape descriptor [Cootes *et al.*, 1992], and histogram distances can be used to compute the dissimilarity between representations.

A different type of histogram representation can be obtained using a series of kernels with maximum response in certain directions. Let $K_\phi(x, y)$ be a kernel that responds maximally to an edge in direction ϕ. An oriented edge image can be obtained as

$$M_\phi(x, y) = K_\phi(x, y) * M(x, y) \qquad (5.162)$$

Using a number of filter kernels K_ϕ it is possible to compute the response of the image along several directions. Each $M_\phi(x, y)$ is itself an image, and can be represented by its intensities histogram $h_\phi(v)$. Putting the images together results in a direction/intensity histogram $h(\phi, v) = h_\phi(v)$, which can be used as a shape representation.

Figure 5.30 shows four shape masks and the respective direction/energy histograms in the polar plane. In order to make the presentation more readable, the logarithm of the histogram, rather than the histogram itself, is being drawn. Also, in the case of a region mask, a large majority of the pixels are not part of an edge and therefore the response of the lernel K_ϕ is zero for all directions ϕ. These pixels are not considered in the histogram.

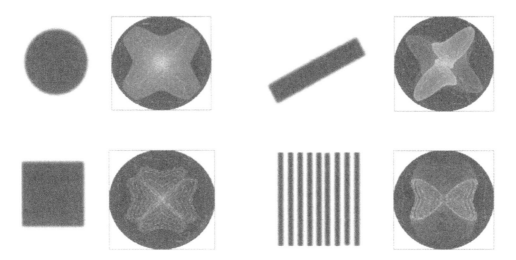

Figure 5.30. Four different shapes and their respective edge-direction histograms.

Note that the histogram of the circle is not isotropic as one would expect. The anisotropy is an effect of the preferential directions determined by the pixels and that influence the response of the kernel. In this case, the kernel was a rotated gradient of Gaussian, and the effect can be observed to vary with the variance of the Gaussian. A better representation would be obtained by including the scale into the histogram, obtaining a three-dimensional histogram $h(\phi, \upsilon, \sigma)$.

Shape without segmentation. The same technique can be used to obtain a crude representation of shape without segmentation. The idea is to apply one of the localized histogram techniques of Section 5.4.2 to the whole image, as it is. The result is too rough to be called shape representation, but it can be assimilated to what is sometimes called *structure* [Flickner *et al.*, 1995; Gupta, 1995], because the histogram reveals the prevalent direction of the edges in the different parts of the image. The simplest way is to divide the image in a regular grid (possibly using fuzzy regions), and compute one histogram for each square of the grid. The distance between two images is, in this case, one of the distances equations (5.119), (5.120), or (5.121). As an example, Fig. 5.31 shows the edge-direction histograms deriving from the division of the image of Fig. 5.23 into nine regions.

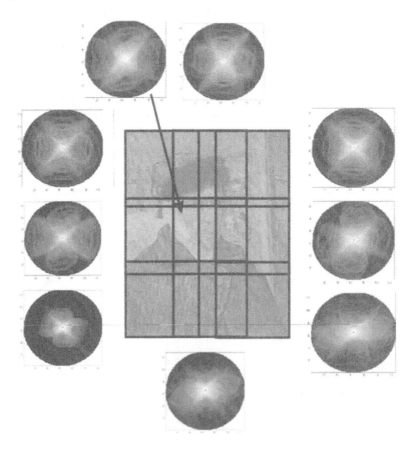

Figure 5.31. Segmentation-free structure representation.

Fourier descriptors. The boundary of a region can be imagined as a curve $z(t)$ in the complex plane by interpreting x as the real axis and y as the imaginary axis. The function can be considered as periodic of period L, with L being the length of the boundary. This allows it to be represented by its Fourier transform:

$$z(s) = \sum_n F_n e^{i\frac{2\pi}{L}ns} \tag{5.163}$$

The coefficients F_n are the *Fourier descriptors* of the curve, and are given by

$$F_n = \frac{1}{L} \int_0^L z(s) e^{-i\frac{2\pi}{L}ns} ds \tag{5.164}$$

If the boundary is given as coordinate pairs (x_m, y_m), with $(x_1, y_1) = (x_L, y_L)$, then the Fourier coefficients can be computed as [Shridhar and Badreldin, 1984]

$$a_n = \frac{1}{L-1} \sum_{m-1}^{L-1} x_m e^{-i\frac{2\pi}{L-1}mn} \tag{5.165}$$

$$b_n = \frac{1}{L-1} \sum_{m-1}^{L-1} y_m e^{-i\frac{2\pi}{L-1}mn} \tag{5.166}$$

These coefficients are rotation- and translation-variant, but invariant descriptors can be obtained as

$$r_n = (|a_n|^2 + |b_n|^2)^{1/2} \tag{5.167}$$

The coefficients r_n represent a loss of information, in the sense that it is impossible to reconstruct the shape based on them.

One great advantage of Fourier descriptors is that they give an *incremental* representation of the shape, with the low-order coefficients describing a rough outline of the shape, and the higher-order coefficients filling in the details. In general, a few Fourier descriptors (typically, less than 20) are sufficient for a very precise representation of the shape. Figure 5.32 shows the reconstruction of a square of length 516 pixels using a number of coefficients varying from 10 to 40.

From the point of view of image databases, this allows an easy customization of the distance measure. Given two regions R_u, and R_v, let a^u and a^v be the vectors of the respective Fourier descriptions, and $\delta(x, y)$ be a distance function defined between pairs of real numbers. A *shape* distance between the two regions can then be defined as

$$d(R_u, R_v) = \left[\sum_{i=1}^k w_i \delta(a_i^u, a_i^v)^p \right]^{1/p} \tag{5.168}$$

for some $p > 1$, and $\sum_{i=1}^k w_i = 1$. Through the adaptation of the weights w_i it is easy to control the nature of the shape similarity implemented by d. If only the low-order weights are significant, the distance d will be low for shapes whose global characteristics are the same, regardless of the detailed shapes, while if the high-order weights are also significant, the finer details of the shape will also

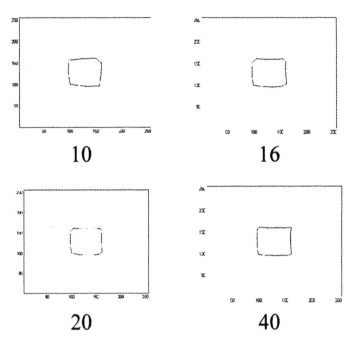

Figure 5.32. Shape reconstruction using the Fourier coefficients.

be considered. Fourier transforms are a simple example of multiscale shape representation; More sophisticated models were considered, for instance, in Del Bimbo and Pala (1999).

Moments. Unlike the previous methods, statistical moments are applied to the indicator function of the region, without boundary extraction. Moment representations interpret a normalized gray-level image function $f(x, y)$ as the probability density of a two-dimensional random variable. In this section, the function being described will often be the indicator function of a region R_i, $r_i(x, y)$, but this is not necessary in general. Consider, for instance, a point feature $f : D \to \mathbb{R}^q$. Moments can be used to describe the behavior of the kth component of the feature in the region R_i by applying the theory of this section to the function

$$f_k|_{R_i} = f_k \circ r_i. \tag{5.169}$$

Whatever the function f to be described, assume that it has been normalized so that $\int_D f = 1$. In this case, it can be considered as a probability density and described using statistical moments [Papoulis, 1991]. The moment of order (p, q) of the probability density is:

$$m_{[p,q]} = \int_{-\infty}^{\infty} \int_{-\infty}^{\infty} x^p y^q f(x, y) \, dx \, dy \tag{5.170}$$

which in the discrete translates into the sum

$$m_{[p,q]} = \sum_{i=-\infty}^{\infty} \sum_{j=-\infty}^{\infty} i^p j^q f(i,j) \tag{5.171}$$

These moments vary with rotation, scaling, and translation. Translation invariance can be obtained by using the central moments

$$\mu_{[p,q]} = \int_{-\infty}^{\infty} \int_{-\infty}^{\infty} (x - x_c)^p (y - y_c)^q f(x,y) \, dx \, dy \tag{5.172}$$

or the discrete version

$$\mu_{[p,q]} = \sum_{i=-\infty}^{\infty} \sum_{j=-\infty}^{\infty} (i - x_c)^p (j - y_c)^q f(i,j) \tag{5.173}$$

where x_c and y_c are the coordinates of the region's center of gravity:

$$x_c = \frac{m_{[1,0]}}{m_{[0,0]}} \quad y_c = \frac{m_{[0,1]}}{m_{[0,0]}} \tag{5.174}$$

Assume, without loss of generality, that the function $f(x,y)$ has been translated in a coordinate system in which $x_c = y_c = 0$. The coefficient $\mu_{[p,q]}$ is obtained by computing the inner product between the function $f(x,y)$ and the monomial $x^p y^q$. This operation is very similar to a transform such as the Fourier or Wavelet transforms, with the exception that the family of functions $x^p y^q$ does not form an orthonormal basis. It is possible to apply the *Gram-Schmidt orthogonalization procedure* [Apostol, 1997] to derive an orthonormal basis from the family $x^p y^q$. A more interesting family can be obtained by passing from the rectangular to the polar coordinate system. Assume that the shapes are translated so that their centroid is at the origin, and normalized to fit into the unit disk. It is then possible to expand any shape in the plane into the set of basis functions:

$$v_{pq}(r, \theta) = r^p e^{iq\theta} \tag{5.175}$$

where v_{pq} is defined in the unit disk $C^2 = \{(r, \theta) : r \leq 1\}$. These functions are also not orthogonal, but it is possible to apply the Gram-Schmidt orthogonalization procedure to them. The result is the *Zernike basis* $\mathcal{Z}_{[p,q]}$, given by

$$\mathcal{Z}_{[p,q]}(r, \theta) = R_{[p,q]}(r) \exp(iq\theta) \tag{5.176}$$

where $p \geq 0$, $q \in \mathbb{Z}$ is such that $|q| \leq p$ and $p - |q|$ is even, and $R_{[p,q]}(r)$ is the radial polynomial

$$R_{[p,q]}(r) = \sum_{s=0}^{\frac{p-|q|}{2}} (-1)^s \frac{(p-s)! r^{p-2s}}{s! \left(\frac{(p+|q|)}{2} - s \right)! \left(\frac{(p-|q|)}{2} - s \right)!} \tag{5.177}$$

Note that $R_{[p,-q]} = R_{[p,q]}$. Therefore, the difference between $\mathcal{Z}_{[p,-q]}$ and $\mathcal{Z}_{[p,q]}$ is only of phase. The *Zernike moment* of order p with repetition q for a function f

defined in the unit disk is

$$A_{[p,q]} = \frac{p+1}{\pi} \int_0^{2\pi} \int_0^1 f(r,\theta) Z^*_{[p,q]}(r,\theta) r \, dr \, d\theta \qquad (5.178)$$

(where x^* denotes the complex conjugate of x). The Zernike moments are translation- and scale-invariant, because the function has been modified to fit the unit circle. Taking the module of the moments we can also achieve rotation invariances.[17]

Moment representations have the same incremental representation properties of the Fourier coefficients. In particular, the second-order statistical moments $\mu_{[1,0]}$, $\mu_{[1,1]}$, and $\mu_{[0,1]}$ will give a representation of the shape as the best fitting ellipsoid. A similar representation of shape was used in Carson *et al.* (1999).

The shape distance between two regions can still be defined as

$$d(R_u, R_v) = \left[\sum_{p,q} w_{pq} \delta \left(\mu^u_{[p,q]}, \mu^v_{[p,q]} \right)^p \right]^{1/p} \qquad (5.179)$$

and the weights w_{pq} used in a similar way to control the coarseness of the similarity measure. Note that often moments with the same value of $p + q$ provide different information at the different scale. It is therefore convenient to use weights depending only on $p + q$: $w_{pq} = w_{p+q}$.

5.6.3 Spatial Relations

The third element in the determination of the similarity between images divided into regions is the determination of the spatial relations between pairs or groups of regions. Two images with similar regions can have very different interpretations if the regions have different spatial organizations. The most striking examples of this phenomenon are pictures intentionally designed to deceive, such as the paintings of the Renaissance Florentine painter *Arcimboldo*, in which pieces of fruit were spatially organized to give the impression of a face, or the famous caricature of Sigmund Freud, in which the body of a naked woman is placed in such a position that the body parts form the face of the father of psychoanalysis.

The exact characterization of the spatial relations between two regions is an exceedingly difficult task, as one can easily understand by looking at the examples of Fig. 5.33. A hypothetical exact representation of spatial relation should capture all possible relations between the pairs in Fig. 5.33 and allow the definition of a distance function to determine the perceptual difference between every pair of pairs. Fortunately, cases such as those represented in Fig. 5.33 do not occur often in practice and, even if they did, the roughness of the shape representations that

[17] Some care should be taken when deciding what kind of invariance one desires from a representation. While invariance is often useful to discard irrelevant information, it also represent a loss of information. As a simple example, rotation invariance will make the numerals "6" and "9" undistinguishable.

Figure 5.33. Examples of spatial relations between pairs of regions.

have been introduced in the previous section make it futile to try and represent spatial relation with such a precision.

The representation of spatial relations is often approximated for another reason, namely, the combinatorial explosion due to the association problem. Given a query image with N regions, and a database image with M regions, there are $M!/((M - N)!N!)$ ways of associating the N regions with M of the N regions in the image (assuming $M > N$) and, in principle, all these combinations must be attempted. Two ways of mitigating this combinatorial explosion are the use of approximate representations that reduce the possibilities of associations, or the use of other region-similarity measures (for example, the similarity in content and in shape introduced in the previons sections) to reduce the number of likely associations.

Relation between centroids. The simplest way to approximate a region is to consider it as a point, which is usually chosen to be the center of mass (centroid) of the region. Such a solution is especially acceptable in domains in which the regions are relatively small compared to the distance between them (e.g., facial features, such as eyes and mouth in frontal images of faces). The relation between the centers of two regions A and B can be represented simply by their distance $\delta(A, B)$ and by the angle between the line joining them and a fixed reference direction $\theta(A, B)$ (Fig. 5.34) Note that $\delta(A, B) = \delta(B, A)$ and that $\theta(A, B) = \theta(B, A) + \pi \mod 2\pi$. The relation between the two regions can be encoded as a single complex number $c(A, B) = \delta(A, B) \exp(i\theta(A, B))$, in which case the equality $c(A, B) = c(B, A)^*$ holds. The *spatial relation distance* between two pairs of regions (A, B), and (A', B')

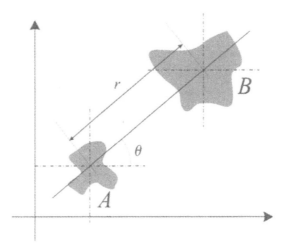

Figure 5.34. Distance and angle between centroids as features for spatial relations.

can be measured simply as

$$d_s((A, B), (A', B')) = |c(A, B) - c(A', B')| \qquad (5.180)$$

(In the case of spatial relations, of course, the distance is not measured between regions, but between pairs of regions.)

Relative position relations. In some cases a characterization such as the previous one can be insufficiently expressive. A user is more likely to express spatial relations in terms of linguistic concepts such as *above, below, to the left of*, and *to the right of* rather than by precise directions. Fuzzy logic offers a standard way of passing from linguistic variables to numeric descriptions. Consider the center A of a region, and divide the space around it into four quadrants as in Fig. 5.35a. If the centroid of another object falls within the region labeled *below*, then the object is below that under consideration, and so on. The classification in regions is too rigid and brittle, and it is convenient to make it fuzzy. When this is done, the relation between two regions A and B will be characterized by four numbers μ_l, μ_b, μ_r, μ_a, representing the degree of truth of the propositions *region B is to the left of region A, region B is below region A, region B is to the right of region A*, and *region B is above region A*. The membership functions μ are a function of the angle θ between the line joining the two regions and the horizontal (Fig. 5.35b). The four functions μ_l, μ_b, μ_r, μ_a should be such that, for every angle θ,

$$0 \leq \mu_i(\theta) \leq 1 \quad i = \{l, b, r, a\} \qquad (5.181)$$
$$\mu_l(\theta) + \mu_b(\theta) + \mu_r(\theta) + \mu_a(\theta) = 1 \qquad (5.182)$$

A simple solution is to make the membership functions μ shifted versions of a single function f with domain $[-\pi/2, \pi/2]$, as in Fig. 5.35c. In this case, for instance, the function μ_r would be nonzero only for $-\pi/2 < \theta < \pi/2$ and, in each of the four quadrants of Fig. 5.35d there are only two nonzero functions.

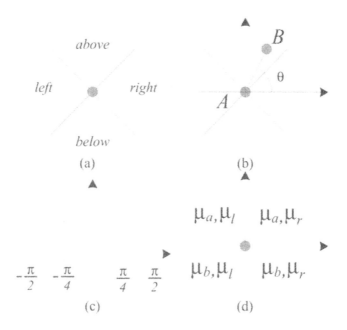

Figure 5.35. Use of fuzzy logic for the determination of linguistic spatial relations.

The preceding conditions on the functions μ translate in the following conditions on f:

$$f(x) \geq 0$$
$$f(0) = 1$$
$$f(x) = f(-x)$$
$$1 - f(x) = f\left(\frac{\pi}{2} - x\right) \tag{5.183}$$

Examples of functions with the required characteristics are the piecewise-linear function

$$f(\theta) = \begin{cases} 1 - \left|\frac{2\theta}{\pi}\right| & \text{if } |\theta| < \frac{\pi}{2} \\ 0 & \text{otherwise} \end{cases} \tag{5.184}$$

or the truncated cosine

$$f(\theta) = \begin{cases} \frac{1+\cos(2\theta)}{2} & \text{if } |\theta| < \frac{\pi}{2} \\ 0 & \text{otherwise} \end{cases} \tag{5.185}$$

In terms of the function f, the four membership functions are defined as

$$\mu_r(\theta) = f(\theta) \tag{5.186}$$
$$\mu_a(\theta) = f\left(\theta - \frac{\pi}{2}\right) \tag{5.187}$$
$$\mu_l(\theta) = f(\theta - \pi) \tag{5.188}$$
$$\mu_b(\theta) = f\left(\theta + \frac{\pi}{2}\right) \tag{5.189}$$

As usual, in image database applications one is interested in defining a measure of similarity or, equivalently, a distance between two pairs of objects that stand in a given spatial relation. Suppose, for instance, that image I_1 is composed of objects A and B in a directional relation characterized by the values $\mu_r, \mu_a, \mu_l, \mu_b$, and image I_2 is composed of objects A' and B' in a directional relation characterized by the values $\mu_r', \mu_a', \mu_l', \mu_b'$. A simple similarity measure can be given by the truth value of the fuzzy predicate "the relation between A and B is the same as the relation between A' and B'," which can be translated as follows:

A is above B and A' is above B'

or

A is left of B and A' is left of B'

or

A is below B and A' is below B'

or

A is right of B and A' is right of B'

This predicate can be made into a similarity measure using any pair of norm-conorm functions to express the "and" and the "or" operators. Using the usual min and max operators one gets the similarity measure

$$S_p((A, B), (A', B')) = \max\{\min\{\mu_a, \mu_a'\}, \min\{\mu_l, \mu_l'\}, \min\{\mu_r, \mu_r'\}, \min\{\mu_b, \mu_b'\}\}$$
$$(5.190)$$

A distance function can be derived from this similarity function as

$$d_p((A, B), (A', B')) = g(S_p((A, B), (A', B')))$$
$$(5.191)$$

where g is a function that satisfies the hypotheses of Theorem 4.5.

The same results can be applied to the case of a constraint determined by a linguistic variable. For instance, instead of retrieving images with a pair of objects in the same spatial relation as those of a given image, a user may query an image with a pair of objects one *above* the other. This is equivalent to making a query with an image in which two objects A and B are in the relation $(\mu_r, \mu_a, \mu_l, \mu_b) = (0, 1, 0, 0)$.[18] In this case the similarity between an image with two objects (A', B') and the query "object A above object B" is

$$S_p(Q, (A', B')) = \min\{\mu_a, \mu_a'\} = \mu_a'$$
$$(5.192)$$

[18] An image with two objects, one of which is *above*, is obviously the same as an image with two objects, one of which is *below* the other. The question that one should consider in this case is whether or not the two objects are independently identified. If the two objects are independently identified (e.g., asking for a *red* object above a *green* object), then the relation $(\mu_r, \mu_a, \mu_l, \mu_b) = (0, 1, 0, 0)$ is not equivalent to the relation $(\mu_r, \mu_a, \mu_l, \mu_b) = (0, 0, 0, 1)$. If the objects are not independently identified, then both relations can be a solution to the query. The difference between the two cases will be discussed in Section 5.7.

Near and far relations. Another important class of spatial relations is represented by *distance* relations. Let I be an image containing two regions A and B, and I' an image containing two regions A' and B'. Assume that in both images the regions are disjoint (the relations resulting from intersecting regions will be considered in the next section). The distance equation (5.180) takes into account both the direction and the length of the segment joining two centroids and therefore already measures the difference in the distance relation between two areas. Just as in the case of relative positioning, however, one would like to establish a connection between the measurement of the interarea distance and the linguistic expressions used to describe such relation. In the case of distance, these terms are two, that is, *near* and *far*. The truth functions of the predicates "A is far from B" and "A is near to B" are the same that were used in Chapter 4 to model the predicates "X is big" and "X is small" (see Section 4.3.1) where, in this case, X is the distance between the centroids of A and B. The truth functions for *far* and *near* could be, for instance,

$$\mu_F(d(A,B)) = \frac{1}{1 + \exp(-\omega(d(A,B) - \beta))} \tag{5.193}$$

$$\mu_N(d(A,B)) = 1 - \mu_F(d(A,B)) \tag{5.194}$$

where the ω determines the "crispness" of the function (for $\omega \to \infty$ two regions are either near, with $\mu_N = 1$ and $\mu_F = 0$ or far, with $\mu_N = 0$ and $\mu_F = 1$), and β determines the cut-off value at which regions are neither near nor far. As in the case of relative positions, the similarity between the relation between regions A and B and that between regions A' and B' is given by the truth value of the following predicate:

> A is near B and A' is near B'
>
> or
>
> A is far from B and A' is far from B'

that is, using the min and max as logic operators:

$$S_d((A,B),(A',B')) = \max\{\min\{\mu_N(d(A,B)), \mu_N(d(A',B'))\},$$
$$\min\{\mu_F(d(A,B)), \mu_F(d(A',B'))\}\} \tag{5.195}$$

A distance function for the distance relation can be derived as

$$d_d((A,B),(A',B')) = g(S_d((A,B),(A',B'))) \tag{5.196}$$

where g is a function that satisfies the hypotheses of Theorem 4.5. Linguistic queries are dealt with as in the case of relative position.

Topological relations between objects. When the objects present in the image are represented as regions, the metric relation between the centroids must be supplemented with the topological relation between the two regions. A relation is *topological* if it is invariant to continuous transformations of the image plane.

If you imagine the image plane made of rubber that can be pulled and deformed, and draw on it two intersecting regions, the regions will continue to intersect no matter how the rubber is stretched or compressed, as long as you do not tear it. Therefore, intersecting each other is a topological relation between two images.

Directional relations such as those considered in the previous section are not invariant to rotations although they are to translation and scaling. If *distance* relations such as *near* and *far* are added, the resulting set of relations is invariant to translation only. Finally, if the *absolute* positions are used, the resulting relations are not invariant to any transformation of the plane. The hierarchy of relations and the relative invariances can be visualized as follows:

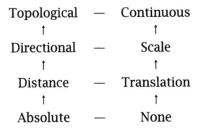

where the arrows indicate a passage from the particular to the more general.

If the analysis is limited to point regions, as in the previous section, the only significant topological relations are *coincident* and *distinct*. Considering the objects as regions in the plane, however, allows one to consider richer sets of topological relations.

In the simpler case, regions can simply be classified as *disjoint* or *not-disjoint* (or *overlapping*) [Roussopoulos *et al.*, 1995]. A finer topology can be obtained by considering each region as a set of points P characterized by an interior \underline{P} and a border ∂P. The relations between two regions R_1 and R_2 can be expressed in terms of the relations between their interiors and their borders [Egenhofer, 1991]. Consider the five relations between two sets $|$, \bowtie, $=$, \subset, and \supset, illustrated in Fig. 5.36. Defining each region with its interior and border, the relation between two regions is given by one of the 25 pairs of combinations of relations between

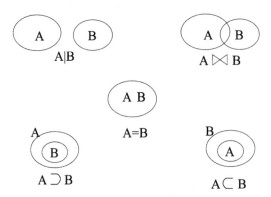

Figure 5.36. The five possible relations between two sets.

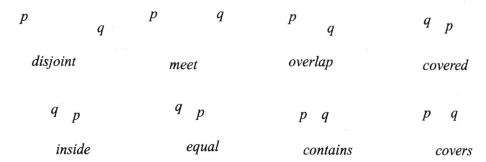

Figure 5.37. The eight possible topological relations between two regions characterized by interior and boundary.

their interiors and their border. For instance, the *disjoint* relation between two regions R_1 and R_2 is characterized by the pair of relations $\underline{R_1} \mid \underline{R_2}$, and $\partial R_1 \mid \partial R_2$ (see Fig. 5.37a). Not all the 25 relations between two regions are possible. In particular, the following constraints apply:

LEMMA 5.3. *Given two regions R_1 and R_2, the relations between their interiors and boundaries satisfy the following constraints:*

 1. If $\underline{R_1} = \underline{R_2}$, then $\partial R_1 = \partial R_2$.

 2. It is never the case that $\partial R_1 \subset \partial R_2$, or $\partial R_1 \supset \partial R_2$.

 3. If $\underline{R_1} \bowtie \underline{R_2}$, then $\partial R_1 \bowtie \partial R_2$.

PROOF (SKETCH). The first equation is an immediate consequence of the definition of border. The second is a consequence of the fact that the borders of the regions are closed nonself-intersecting curves (a proper subset of such a curve is always an open curve), and the third is a consequence of the fact that if two connected open sets overlap, then their boundaries intersect. □

 Once these constraints are taken into account, one is left with eight possible relations between two regions, defined in Table 5.5 and illustrated in Fig. 5.37.

Table 5.5. Formation of topological relations between regions

	$\underline{R_1}, \underline{R_2}$	$\partial R_1, \partial R_2$
disjoint	\|	\|
meet	\|	^
overlap	^	^
covered	⊂	^
inside	⊂	\|
equal	=	=
covers	⊃	^
contains	⊃	\|

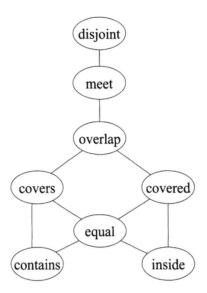

Figure 5.38. Adjacency graph for the five topological relations between two regions.

In image databases, one is interested in determining the *distance* between relations. That is, given two regions (A, B), which are in topological relation t_1, and two regions (A', B'), which are in topological relation t_2, one is interested in determining the contribution of such spatial organization to the overall distance between the images of which the regions are part. In other words, one is interested in determining a distance between t_1 and t_2.

The distance between two topological relations can be determined with the help of an adjacency graph. Two relations are adjacent if one can be transformed directly into the other (that is, without going through any other relation) by a continuous deformation of the regions. For instance, the relation *disjoint* can be transformed into *meet* by moving one of the regions closer to the other, but it cannot be directly transformed into the relation *overlap* because in doing so, it is necessary to go through the relation *meet*. The adjacency graph for the five relations of Fig. 5.37 is shown in Fig. 5.38. The graph distance d_g between two relations is simply the number of edges that it is necessary to cross to go from one relation to the other. For instance, the graph distance between the relations *disjoint* and *inside* (t_1 and t_5) is $d_g(t_1, t_5) = 4$. The distance (*tout court*) between two relations is a monotonically increasing function of their graph distance:

$$d_t(t_1, t_2) = f(d_g(t_1, t_2)) \qquad (5.197)$$

The reason for introducing the function f is that the graph distance tends to be brittle in the presence of errors. It is possible to go from relation t_1 to relation t_2 moving the segments by a single pixel, and, for the sake of robustness, the two should be considered very similar. On the other hand, relations such as t_1 and t_4 should be considered significantly different. A function f with $f'' > 0$ will help underplay the distance between neighboring relations.

Directional relations between rectangles. In many cases regions are represented by an approximate shape, especially for indexing (Chapter 9). In this case, the spatial relations between the representation are only an approximation of the spatial relations between the regions. A common representation is through minimal bounding rectangles (MBRs) [Papadias *et al.*, 1995] with sides parallel to the axes. The projection of a MBR on one of the axes is a segment, and the spatial relation between two MBRs is given by the Cartesian product of the spatial relation between their projections. Two segments can be represented as two pairs (p_1, p_2) and (q_1, q_2), with $p_1 < p_2$ and $q_1 < q_2$ so that the relations between the two segments can be represented as a subset of the Cartesian product of the relations between two points. Finally, there are three possible spatial relations between two points p and q: $p < q$, $p = q$, and $p > q$.

The relation between the two segments (p_1, p_2) and (q_1, q_2) is completely characterized by the four relations $p_1 R q_1$, $p_1 R q_2$, $p_2 R q_1$, and $p_2 R q_2$ between their endpoints, where $R \in \{<, =, >\}$, which would yield a total of $3^4 = 81$ possible relations. The constraints $p_1 < p_2$ and $q_1 < q_2$ limit the number of relations in which two segments of positive length can actually exist. For instance, it is not possible for two segments to be characterized by a set of relations containing $p_1 > q_1$ and $p_2 < q_1$. In order to determine these constraints, order the set of point relations $\{<, =, >\}$ according to the possible positions that a point p can have when posed in relation R with a fixed point q. In other words, order the point relations as

$$< \prec = \prec > \tag{5.198}$$

Assume also that the relation is reflexive: $R \prec R$. Note that if two points p_1 and p_2 are in two relations R_1 and R_2 with a fixed point q (i.e., $p_1 R_1 q$ and $p_2 R_2 q$) and $R_1 \prec R_2$, then $p_1 \leq p_2$. The following proposition then follows immediately:

LEMMA 5.4. *Let (p_1, p_2) and (q_1, q_2) be two pair of points with $p_1 < p_2$ and $q_1 < q_2$, and let there be four relations between them $p_1 R_{11} q_1$, $p_1 R_{12} q_2$, $p_2 R_{21} q_1$, and $p_2 R_{22} q_2$. Then*

$$
\begin{aligned}
R_{11} &\prec R_{12} \\
R_{11} &\prec R_{22} \\
R_{12} &\prec R_{22} \\
R_{12} &\prec R_{21}
\end{aligned}
\tag{5.199}
$$

When these constraints are taken into account, the number of possible relations between two segments is reduced to 13 [Allen, 1983]. These 13 relations are represented in Fig. 5.39.

The relation between two rectangles is completely determined by the spatial relations between their projections on the two axes. These two projections are independent, therefore the relations between two rectangles are given by the full Cartesian product of the relations between segments, which gives a total of 169 possible spatial relations, shown in Fig. 5.40.

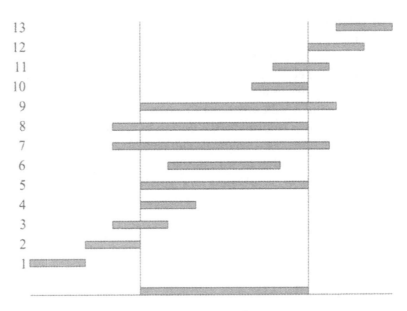

Figure 5.39. The 13 possible relations between two segments.

As in the case of topological relations, in order to evaluate the contribution of spatial relations to the distance between pairs of images, one is interested in determining a distance between two relations r_1 and r_2.

The spatial relation between two rectangles is determined as a pair of one-dimensional spatial relations, namely, those between the projections of the rectangles on the coordinate axes. Therefore, it is possible to express the two relations r_1 and r_2 as pairs $r_1 = (r_1^x, r_1^y)$ and $r_2 = (r_2^x, r_2^y)$ of one-dimensional relations. Similarly, the distance $d(r_1, r_2)$ can be expressed in terms of the distances between the one-dimensional relations that compose r_1 and r_2. The problem is then to determine the distance between two one-dimensional relations o_1 and o_2 taken among the 13 of Fig. 5.39. This can be done (much as in the case of the topological relations) with the help of adjacency graph of Fig. 5.41. The distance between two relations is once again a monotonically increasing function of their graph distance:

$$d_{1d}(o_1, o_2) = f(d_g(o_1, o_2)) \tag{5.200}$$

The distance between the two-dimensional spatial relation of two regions can be computed using any of the combination methods used in Chapter 4:

$$d_{2d}(r_1, r_2) = f(d_{1d}(r_1^x, r_2^x) \oplus d_{1d}(r_1^y, r_2^y)) \tag{5.201}$$

for instance:

$$d_{2d}(r_1, r_2) = [d_{1d}(r_1^x, r_2^x)^p + d_{1d}(r_1^y, r_2^y)^p]^{1/p} \tag{5.202}$$

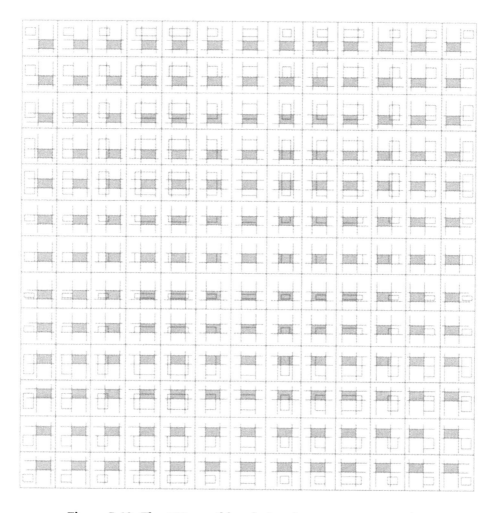

Figure 5.40. The 169 possible relations between two rectangles.

A more robust determination of the distance between two spatial relations can be obtained by modeling the points as probability distributions. Consider again the problem of determining the relation between two points a and b (which, in the error-free case, can be one of the three relations $a < b$, $a = b$, and $a > b$).

In many practical cases, one has a nominal value for the position of the point, subject to measurement uncertainty. (Think, for example, of the determination of the position of the edge points in an image.) A possible way to model this uncertainty is to consider the points as drawn from a Gaussian distribution: $p_a(x) = (1/\sqrt{\pi}\sigma)\exp(-(x-a)^2/\sigma^2)$ and $p_b(x) = (1/\sqrt{\pi}\sigma)\exp(-(x-b)^2/\sigma^2)$, where a and b are the nominal (measured) values of the position of the points, and σ is a measure of the expected measurement error. Given the distribution of the points a and b, one can consider the probabilities of the three-order relations

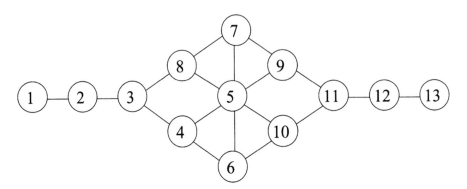

Figure 5.41. Adjacency graph for the 13 relations between two parallel segments.

between a and b, obtaining

$$P\{a = b\} = 0 \tag{5.203}$$

$$P\{a > b\} = \int_{-\infty}^{\infty} p_b(v) \int_{v}^{\infty} p_a(u)\,du\,dv$$

$$P\{a < b\} = \int_{-\infty}^{\infty} p_b(v) \int_{-\infty}^{v} p_a(u)\,du\,dv$$

Note that the events $\{a = b\}$ form a zero-measure set, therefore the probability that $a = b$ is zero. This simplifies the relations between two segments, reducing them from the 13 in Fig. 5.39 to the six of Fig. 5.42. The probabilities of these relations are given by the product of the probabilities that the endpoints of the segments are in the relations implied by the segment relation. Given a segment $a = (a_1, a_2)$, the probability distributions of the endpoints are not independent because they are connected by the constraint $a_2 > a_1$. If the segments are considerably longer than the uncertainty in the positioning of the endpoints, however, the independence assumption will not lead to serious errors. Given two segments

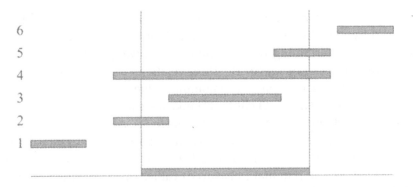

Figure 5.42. The six possible relations between two segments in the probabilistic model.

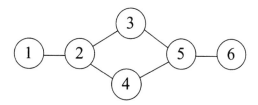

Figure 5.43. Adjacency graph for the six relations between two parallel segments in the probabilistic case.

$a = (a_1, a_2)$ and $b = (b_1, b_2)$, then, the probabilities of the six spatial relations are given by

$$p_1(a, b) = P\{a_1 < b_1\}P\{a_2 < b_1\} \tag{5.204}$$
$$p_2(a, b) = P\{a_1 < b_1\}P\{a_2 > b_1\}P\{a_2 < b_2\}$$
$$p_3(a, b) = P\{a_1 > b_1\}P\{a_1 < b_2\}P\{a_2 > b_1\}P\{a_2 < b_2\}$$
$$p_4(a, b) = P\{a_1 > b_1\}P\{a_1 < b_2\}P\{a_2 > b_2\}$$
$$p_5(a, b) = P\{a_1 > b_2\}P\{a_2 > b_2\}$$
$$p_6(a, b) = P\{a_1 < b_1\}P\{a_2 > b_2\}$$

The adjacency graph for the six relations of Fig. 5.42 is given in Fig. 5.43. Given the graph distance $d_g(o_i, o_j)$ between two relations, and given two pairs of segments (a, b) and (a', b'), the *expected distance* between the spatial configurations of the two is

$$d_{1d}^P((a, b), (a', b')) = \sum_{i,j=1}^{6} d_g(o_i, o_j)p_i(a, b)p_j(a', b') \tag{5.205}$$

This distance measure is computationally very expensive because for all possible combinations of the segments, all the six spatial relations contribute to it, each one with a probability computed as an expensive integral. A considerably simpler distance can be obtained by assuming that the error in the location of each point is uniformly distributed. More precisely, if the nominal location of a point is a, assume that the distribution of the point location is

$$p_a(x) = \begin{cases} 0 & \text{if } |x - a| > \frac{\delta}{2} \\ \frac{1}{\delta} & \text{otherwise} \end{cases} \tag{5.206}$$

This gives the following probabilities for the spatial relations between two points

with nominal positions a and b:

$$P\{a = b\} = 0 \tag{5.207}$$

$$P\{a > b\} = \begin{cases} 1 & \text{if } b < a - \delta \\ \frac{\delta + a - x}{2\delta} & \text{if } a - \delta \le b \le a + \delta \\ 0 & \text{if } b > a + \delta \end{cases}$$

$$P\{a < b\} = \begin{cases} 0 & \text{if } b < a - \delta \\ \frac{x - a - \delta}{2\delta} & \text{if } a - \delta \le b \le a + \delta \\ 1 & \text{if } b > a + \delta \end{cases}$$

The probabilities of the relations between segments $a = (a_1, a_2)$ and $b = (b_1, b_2)$ are still given by Eq. (5.204), and the distance between two configurations of segments (a, b) and (a', b') is still given by Eq. (5.205). The difference in this case is that most of the terms will be zero and the others can be computed using a simple linear function rather than the integral of an exponential function.

Finally, the relations between two rectangles is computed as a composition of the one-dimensional distances as in the case of exact point location equation (5.201).

5.7 Similarity of Region Images

The final issue of this chapter is how to put together all the descriptions and distances introduced in the previous sections to determine the distance between two images. An image I_i is divided into a set of regions or objects, and the distance between two images is expressed in terms of these objects. Let $I_i = \{o_i^1, \ldots, o_i^{N_i}\}$ be the set of objects that form the image I_i. Note that the number of objects depends on the image. Each object is a pair $o_i^k = (\phi_i^k, \omega_i^k)$, where ϕ_i^k is a suitable description of the interior of the image (e.g., the conjunction of a color histogram and an average texture descriptor), and ω_i^k is a suitable descriptor of the shape of the image. Let Φ and Ω be the metric spaces in which these descriptors are defined, and let $d_\Phi(\phi_i^k, \phi_j^h)$ and $d_\Omega(\omega_i^k, \omega_j^h)$ be the distance functions between pairs of objects (which can belong to different images, because the spaces Φ and Ω are assumed to be independent of the image being considered).

An image is represented by a fully connected graph, called the *attributed relational graph* (ARG) [Petrakis and Faloutsos, 1997]. The graph of image I_i contains N_i nodes (as many as the objects in the image). Each node is labeled with the descriptor of an object (ϕ_i^k, ω_i^k), and edges are labeled with a descriptor of the relation between the objects connected by the edge. The label of the edge between objects o_i^k and o_i^h takes the form

$$r_i^{hk} = [\theta_i^{hk}, \lambda_i^{hk}, \sigma_i^{hk}] \tag{5.208}$$

where:

- θ_i^{hk} is the angle between the x-axis (or some other universal reference axis) and the line between the centroids of o_i^k and o_i^h. Note that $\theta_i^{hk} = \theta_i^{kh} + \pi$.

- λ_i^{hk} is the distance between the centroids of o_i^h and o_i^k. Note that $\lambda_i^{hk} = \lambda_i^{kh}$.

- σ_i^{hk} is a representation of the topological (or topo-directional, in the case of bounding rectangles) relation between the regions describing o_i^h and o_i^k. Typically, the representation will be of the type

$$\sigma_i^{hk} = [\sigma_i^{hk,1}, \ldots, \sigma_i^{hk,p}] \qquad (5.209)$$

where $\sigma_i^{hk,u}$ can be one of the relation probabilities in the previous section, or one of the membership functions $\mu_a, \mu_l, \mu_b, \mu_r$, or any other representation of topological relations.

Given the image I_i containing objects $\{o_i^1, \ldots, o_i^{N_i}\}$, the ARG describing it is $G_i = \{\mathcal{N}_i, \mathcal{E}_i\}$, where $\mathcal{N}_i = \{o_i^k = (\phi_i^k, \omega_i^k)\}$ is the set of nodes, and

$$\mathcal{E}_i : \mathcal{N}_i \times \mathcal{N}_i \rightarrow E : (o_i^k, o_i^h) \mapsto r_i^{kh} = [\theta_i^{hk}, \lambda_i^{hk}, \sigma_i^{hk}] \qquad (5.210)$$

is the function assigning edge labels to each pair of nodes.

Determining the similarity of two such graphs can be formalized as a constraint satisfaction problem. Consider two ARGs G_1 and G_2 with the same number of nodes. Let $\mathcal{N}_1 = \{o_1^1, \ldots, o_1^n\}$ and $\mathcal{N}_2 = \{o_2^1, \ldots, o_2^n\}$ be the two sets of nodes. An *association* between G_1 and G_2 is a permutation $\{\alpha(1), \ldots, \alpha(n)\}$ of $1, \ldots, n$, which associates the node o_1^i with the node $o_2^{\alpha(i)}$. When the association α is defined, the two graphs are said to be *matched*.

Given two matched graphs, it is possible to compute the distances between the representations of corresponding nodes and the representations of corresponding edges. The distances can be put together using one of the operators \oplus defined in Chapter 4, obtaining the distance between G_1 and G_2 given the association α:

$$d(G_1, G_2 \mid \alpha) = f \left(\bigoplus_{i=1}^{n} d_\phi(\phi_1^i, \phi_2^{\alpha(i)}) \oplus \bigoplus_{i=1}^{n} d_\omega(\omega_1^i, \omega_2^{\alpha(i)}) \oplus \bigoplus_{i,j=1}^{n} d_\theta(\theta_1^{ij}, \theta_2^{\alpha(i)\alpha(j)}) \right.$$

$$\left. \oplus \bigoplus_{i,j=1}^{n} d_\lambda(\lambda_1^{ij}, \lambda_2^{\alpha(i)\alpha(j)}) \quad \oplus \bigoplus_{i,j=1}^{n} d_\sigma(\sigma_1^{ij}, \sigma_2^{\alpha(i)\alpha(j)}) \right) \qquad (5.211)$$

Consider now a query Q given as an ARG $Q = \{\mathcal{N}_q, \mathcal{E}_q\}$. The basic database search operation is the determination of the distance between this query and an image $I_i = \{\mathcal{N}_i, \mathcal{E}_i\}$. In this case, the number of objects in the query and in the image will be different. Consider the most common case, that is, the case in which the image contains more objects than the query. In this case, the set of query objects is given by $\mathcal{N}_q = \{o_q^1, \ldots, o_q^m\}$ and the set of image objects is given by $\mathcal{N}_i = \{o_i^1, \ldots, o_i^{n_i}\}$, with $n_i > m$. The process of matching the objects of the query with those of the image is the same as before, with the difference that in this case the association function α is not a permutation but an injective function $\{1, \ldots, m\} \rightarrow \{1, \ldots, n_i\}$. Given the association α between objects in the query and objects in the image, the distance between the matched query and image can be computed as in Eq. (5.211). The distance between the query Q and image I_i is then

given by

$$d(Q, I_i) = \min_{\alpha} d(Q, I_i|\alpha) \tag{5.212}$$

The case in which there are more objects in the query than there are in the image—that is, the case in which $m > n_i$—can be reduced to the previous one by computing $d(I_i, Q)$. The treatment of this case, however, has semantic implications that go beyond the simple mathematical formulation. To match a query with an image in this situation, in fact, entails ignoring part of the query. Asking for a picture of a car in front of a house, and receiving the picture of a house without car can or cannot be acceptable depending on the application. In many cases, it will be necessary either to discard images that contain fewer objects than the query or, in any case, weight negatively the situation, possibly by multiplying the distance for a given factor.

A more serious concern has to do with the computational efficiency of the distance computation. The optimization process equation (5.212), in fact, is at least as hard as the subgraph isomorphism problem,[19] which is known to be *NP*-complete [Meseguer, 1989; Grigni *et al.*, 1995]. Standard combinatorial analysis reveals that the number of possible functions α is $n_i!/(n_i - m)!$. In the common situation in which $n_i \gg m$, this number is $O(n_i^m)$, meaning that the complexity of the problem is exponential in the size of the query.

This problem is seriously hampering the possibility of complex object-based queries, especially in the cases (which will be considered in Chapter 10) in which the query is built automatically from relevant feedback information. In these cases, the value of m can grow rapidly, and efficient solutions are needed. Because an efficient exact solution is impossible.[20], there are two possibilities of attacking the problem:

- Devise heuristics that are always guaranteed to find an approximate solution in polynomial time. In some cases, these algorithms might overestimate or underestimate the distance between the query and an image, causing failed retrieval of acceptable images or retrieval of unacceptable images.

- Devise heuristics that always retrieve the best images and that, although with a worst-case exponential time (there is no way around that!), perform, in most cases of practical importance, in polynomial time.

[19] This is easy to see considering that Eq. (5.212) is a generalization of subgraph isomorphism. If all the distances involved in the computation are of the form

$$d(x, y) = \begin{cases} 0 & \text{if } x = y \\ 1 & \text{otherwise} \end{cases}$$

the problem is equivalent to a subgraph isomorphism.

[20] Short, of course, of a proof that $P = NP$. This equation (or its converse) is the crux and delight of complexity theory and has not yet formally been disproved. However, most mathematicians suspect, and all engineers know, that P and NP are two different classes, and that there is no hope of solving an *NP*-complete problem in a time less than exponential.

6

Systems with General Ontologies

... pensé que acaso no había objectos para él, sino un continuo y vertiginoso continuo juego de impresiones brevísimas...

Jorge Luis Borges, *El Imortal*

Hercule Poirot had convened all the suspects in the dining room at Long Meadows, and was well on his way to explaining the facts that led him to uncover the murderer of Mrs. McGinty (Agatha Christie's *Mrs. McGinty's Dead*).

In Mrs. Upward house there was a book found and on the flyleaf of that book is written *Evelyn Hope*. Hope was the name Eva Kane took when she left England. If her real name was Evelyn then in all probability she gave the name of Evelyn to her child when it was born. *But Evelyn is a man's name as well as a woman's.* Why had we assumed that Eva Kane's child was a girl? [Christie, 1992]

Thanks to his ability to see beyond the obvious interpretation and categorization (all of which pointed to a woman as the murderess), Poirot was able to deduce that the murder had been committed by Mr. Robin Upward, née Evelyn Kane. Feats like this require the capacity to see and go beyond the confines of accepted categorizations. In a database, the accepted categorization is in many cases given by the selection of a feature that the designer created before the database was created: All the features presented in the previous chapter presuppose some decision about what categories are important and what can be ignored. This presupposition is perfectly obvious in many cases, especially when an image is immersed in a context that can be determined independently of the contents

263

of the images. When this happens, the context will suggest what categorization can be useful for the database. This is certainly the case for databases working in the *closed world modality* of section 2.3 and, to some extent, in the *linguistic modality*. When a database is working in the *user modality*, however, it is asked to participate in the creation of its own context, and in this situation a greater ontological freedom can be required. In some cases, as in Borges' *Chinese Encyclopædia*, this ontological freedom generates nonsense[1]; in other cases, as in Mrs. McGinty's murder, it can reveal a truth that a more conventional interpretation was hiding.

The feature systems with general ontologies that are considered in this chapter reduce the "ontological commitment" of the feature systems considered in the previous chapter. Each of the feature systems of the last chapter derived from an a priori decision as to what constitutes important components in an image. Using features to describe the shape of a homogeneous region implies that such shape has relevance in the process of signification. Such relevance goes beyond the purely syntactic description:—only the components for which features are selected have (or, better, are endowed with) semantic value. In other words, such features are based on a prior semantic assessment of the relevance of certain components of the image. Only once these components have been identified can one face the technical problem of how to extract an appropriate description from the image data.

The features introduced in this chapter do not rely on any prior semantic assessment, but attempt a *syntactic* description of the image as a datum. Most of the methods here are based on *transforms*: mappings from the image space to some different space that preserve all information in the image, in the sense that they allow a reconstruction (subject to errors and approximation, as will be shown in the following) of the image they describe. Transforms are not completely free of ontological investments, but these investments are perceptual rather than semantic. Many transforms of practical utility decompose images along axes that are known to play an important role in the early analysis of image, like spatial frequency, scale, and direction.

This ontological commitment is of a very different nature than that made with the choice of a limited ontology feature. In a sense, where the previous commitment was semantic, the present one is syntactic. In the case of limited ontology features, one's commitment includes the decision of what information will be semantically relevant and which can be discarded. In the case discussed in this chapter, all information is retained, and the only commitment regards the modalities and the perceptual parameters along which information is analyzed.

[1] But sometimes, as in the case of Borges' *Chinese Encyclopædia*, this nonsense has the important function of making one think about the process of categorization!

6.1 Bases, Frames, and Transforms

This section will present a brief introduction to image transforms, function bases, and function frames.

A set $V = \{v_1, \ldots, v_n, \ldots\}$ is a (complex) vector space if it is possible to define an internal *sum* operator $(+)$ and an exterior product (\cdot) so that

1. for all $u, v \in V$, $u + u \in V$

2. for all $v \in V, c \in \mathbb{C}$, $cv \in V$

3. $u + v = v + u$, $v + (u + w) = (u + v) + w$

4. $\exists 0 \in V : \forall v \in V, v + 0 = v$

5. $c \cdot (u + v) = c \cdot u + c \cdot v$, $(c + d) \cdot v = c \cdot v + d \cdot v$, $1 \cdot v = v$

The dot will often be omitted in the typographical expression of the exterior product, which will be written simply as cu. In this chapter, the set V will often be a set of functions from a space X to \mathbb{C}. In this case the sum and the external product are define pointwise as

$$(f + g)(x) = f(x) + g(x)$$
$$(cf)(x) = cf(x) \tag{6.1}$$

It is immediate to verify that these operations give the set of functions the structure of a vector space.

A *basis* of V is a set of elements $\{\phi_i \in X\}$ such that

1. Every $f \in X$ can be expressed as $f = \sum_n c_n \phi_n$, $c_n \in \mathbb{C}$ and

2. $\sum_n a_n \phi_n = 0$ if and only if $a_n = 0$ for all n (linear independence).

LEMMA 6.1. *The coefficients c_n in the expansion of f are unique.*

PROOF. Suppose that it is not true, that is, there is a function f that can be expressed as

$$f = \sum_n c_n \phi_n = \sum_n c'_n \phi_n \tag{6.2}$$

where for some j it is true that $c_j \neq c'_j$. Then one can write

$$f - f = 0 = \sum_n (c_n - c'_n) \phi_n \tag{6.3}$$

but as at least one of the coefficients $(c_n - c'_n)$ is different from zero, the equation contradicts the linear independence of the basis elements. □

The *inner product* of two elements $u, v \in V$ is a functional $\langle u, v \rangle \in \mathbb{C}$ such that:

Positivity: for all $v \in V$, $\langle v, v \rangle$ is real and positive

Hermiticity: for all $u, v \in V$, $\langle u, v \rangle^* = \langle v, u \rangle$

Linearity: for all $u, v, w \in V$ and $c \in \mathbb{C}$, $\langle u, cv + w \rangle = c\langle u, v \rangle + \langle u, w \rangle$

The inner product is linear in the second factor only. From linearity and hermiticity it follows that the inner product is antilinear in its first argument:

$$\langle cu + w, v \rangle = c^*\langle u, v \rangle + \langle w, v \rangle \tag{6.4}$$

The *norm* of an element $v \in V$ is defined as

$$\|v\| = \langle v, v \rangle^{1/2} \tag{6.5}$$

it is possible to prove that this function satisfies all the required properties of a norm.

A *real* vector space is a vector space for which the exterior product is defined on \mathbb{R} rather than \mathbb{C}. In this case, the inner product also takes values on \mathbb{R}, hermiticity becomes symmetry:

$$\langle u, v \rangle = \langle v, u \rangle \tag{6.6}$$

and linearity is in both arguments. The typical example of vector space is the space of n-tuples of real numbers $v = [v_1, \ldots, v_n]$, with $\langle u, v \rangle = \sum_i u_i v_i$.

In order to extend the concept of inner product to function spaces, let $L^2(X)$ be the set of functions from $X \to \mathbb{C}$ such that

$$\int_X |f|^2 dx < \infty \tag{6.7}$$

With this condition, it is natural to define

$$\langle f, g \rangle = \int_X f^*(x) g(x) \, dx \tag{6.8}$$

and, consequently,

$$\|f\|^2 = \int_X |f(x)|^2 dx \tag{6.9}$$

One of the problems with this definition is that these integrals do not exist for many (in fact, for most) functions $X \to \mathbb{C}$. The problem is not just that the integrals diverge for certain functions. Even if one takes X to be a bounded interval, say $X = [0, 1] \subset \mathbb{R}$, the Riemann integral of many functions does not exist because the Riemann sums involved in its definition do not converge. For instance, the function

$$q(x) = \begin{cases} 1 & \text{if } x \text{ is rational} \\ 0 & \text{if } x \text{ is irrational} \end{cases} \tag{6.10}$$

has no Riemann integral in $[0, 1]$ although it is defined and bounded anywhere in $[0, 1]$. The definition can be made sufficiently general using Lebesgue integration.

This distinction will not be important in the following, therefore I will assume that the space of functions is restricted enough so that Eq. (6.8) is always defined in terms of the standard Riemann integral. With these provisions, it is possible to prove that Eq. (6.8) is indeed an inner product on $L^2(X)$, that is, it is positive, Hermitian, and linear. Also, the norm in Eq. (6.9) satisfies:

$$\|f + g\| \leq \|f\| = \|g\| \qquad |\langle f, g \rangle| \leq \|f\| \|g\| \qquad (6.11)$$

Let $\{f_1, f_2, \ldots\}$ be a sequence of elements of a vector space. If

$$\lim_{m,n \to \infty} \|f_m - f_n\| = 0 \qquad (6.12)$$

the sequence is called a *Cauchy sequence*. A vector space is *complete* if every Cauchy sequence converges in the space, that is, if Eq. (6.12) implies that there is an element $f \in V$ such that

$$\lim_{n \to \infty} \|f - f_n\| = 0 \qquad (6.13)$$

A complete vector space with a positive, Hermitian, linear inner product is called a *Hilbert space*, and in its generic form is indicated by \mathcal{H}.

The space of square integrable functions on a given space X is a Hilbert space, but many of its subspaces are not. Consider, for instance, the space \mathcal{H}_C of *continuous* functions on \mathbb{R}. Although this subspace of \mathcal{H} is a vector space, it is not complete. To see this, consider the family of functions

$$f_n(x) = \frac{1}{1 + \exp(-nx)} \qquad (6.14)$$

For each n, $f_n \in \mathcal{H}_C$ (all these functions are continuous). The sequence is Cauchy because, in \mathcal{H}, it has a limit, which is the function

$$f_\infty(x) = \begin{cases} 1 & \text{if } x > 0 \\ 0 & \text{if } x < 0 \\ \frac{1}{2} & \text{if } x = 0 \end{cases} \qquad (6.15)$$

However, the sequence does not converge in \mathcal{H}_C, because the function f_∞ is discontinuous.

If \mathcal{H} and \mathcal{K} are two Hilbert spaces, and $A : \mathcal{H} \to \mathcal{K}$ is a functional, A is linear if

$$A(cf + g) = cA(f) + A(g) \qquad (6.16)$$

A is *bounded* is there is a constant C such that, for all $f \in \mathcal{H}$, $\|Af\|_\mathcal{K} \leq C\|f\|_\mathcal{H}$ (the two norms are computed in two different Hilbert spaces, as pointed out by the subscripts).

Every element $h \in \mathcal{H}$ defines a linear functional $h^* : \mathcal{H} \to \mathbb{C}$ defined by

$$h^* g = \langle h, g \rangle \qquad (6.17)$$

Note that $|h^* g| = |\langle h, g \rangle| \leq \|h\| \|g\|$, therefore h^* is bounded. This observation shows that every element in \mathcal{H} defines a linear functional. The converse is also true:

THEOREM 6.1. *(Riesz Representation Theorem) let \mathcal{H} be any Hilbert space. Then every bounded linear functional $H : \mathcal{H} \to \mathbb{C}$ can be represented in the form $H = h^*$ for a unique $h \in \mathcal{H}$, that is,*

$$Hg = h^*g = \langle h, g \rangle \tag{6.18}$$

for every $g \in \mathcal{H}$.

Let $\{\phi_i\}$ be a basis of \mathcal{H}. The basis is *orthonormal* if

$$\langle \phi_i, \phi_j \rangle = \delta_{ij} \tag{6.19}$$

As the ϕ_i are a basis, it is possible to express every element $f \in \mathcal{H}$ as

$$f = \sum_i c_i \phi_i \tag{6.20}$$

Orthogonality gives an easy way to determine the coefficients c_i. In fact, taking the inner product between f and the basis elements, one obtains:

$$\langle f, \phi_n \rangle = \sum_i c_i \langle \phi_i, \phi_n \rangle = c_n \tag{6.21}$$

The coefficients c_i are the *ϕ-transform* of the element f. If f can be expressed as in Eq. (6.20), then Eq. (6.21) gives its ϕ-transform. The converse is not necessarily true: given a sequence of coefficients c_n, Eq. (6.20) does not necessarily define an element in \mathcal{H}, because the summation might diverge. The orthogonality relation of the basis ϕ_i implies that

$$\|f\|^2 = \sum_i |c_i|^2 < \infty \tag{6.22}$$

that is, if the coefficients c_n are the transform of the function f, it is $\sum_i |c_i|^2 < \infty$. The converse is also true: a series of coefficients c_n is the transform of f iff $\sum_i |c_i|^2 < \infty$.

In the case in which $\mathcal{H} = L^2(X)$, and the inner product equation (6.8) is used, the coefficients of the transform of a function f take the familiar form

$$c_i = \int_X f(x)\phi_i(x)\,dx \tag{6.23}$$

This formulation is quite general, but not enough—it does not include some of the most common transforms used in image processing, such as the Fourier transform or the DCT. This is the case because trigonometric functions such as sine and cosine are periodic, and therefore the integral of Eq. (6.8) does not converge.

6.1.1 Periodic Functions and the Fourier Transform

Let $L_T^2(\mathbb{R})$ be the set of all measurable functions that are periodic of period T, that is $f(t + T) = f(t)$ for almost all t, and that satisfy[2]

$$\int_{t_0}^{t_0+T} |f(t)|^2 dt < \infty \tag{6.24}$$

If f and g are periodic (from now on, I will say simply "periodic" instead of "periodic of period T"), it is immediate to see that $f + g$ and cf are also periodic. It is also possible to show that a Cauchy sequence of periodic functions converges to a periodic function. Therefore, $L_T^2(\mathbb{R})$ is a Hilbert space with inner product

$$\langle f, g \rangle = \int_{-T/2}^{T/2} f(t)g(t)dt \tag{6.25}$$

(The integrals such as in Eq. (6.24) are independent of t_0; for the sake of simplicity I have assumed $t_0 = T/2$.) The behavior of a periodic function is completely determined by its behavior in $[-T/2, T/2]$. In fact, $L_T^2(\mathbb{R})$ is isomorphic to $L^2([-T/2, T/2])$. The functions

$$e_n(t) = \frac{1}{\sqrt{T}} e^{2\pi i \omega_n t} \tag{6.26}$$

where $\omega_n = n/T$ is an orthogonal basis of $L_T^2(\mathbb{R})$ and $\|e_n\|^2 = 1$. As in the previous section, any periodic function f with $\|f\|^2 < \infty$ can be expressed as

$$f(t) = \frac{1}{\sqrt{T}} \sum_n F_n e^{2\pi i \omega_n t} \tag{6.27}$$

with

$$F_n = \frac{1}{\sqrt{T}} \int_{-T/2}^{T/2} f(t) e^{2\pi i \omega_n t} dt \tag{6.28}$$

Conversely, if $\{F_n\}$ is a sequence such that $\sum_n |c_n|^2 < \infty$, then they are the transform of a function f. The series $\{F_n\}$ is called the *Fourier transform* of f.

Fourier transforms are naturally extended to functions of multiple variables. In the case of two variables (which is of particular interest for images), if $L_{T_1,T_2}^2(\mathbb{R}^2)$ is the space of periodic functions of period T_1 in the first variable and T_2 in the second, then the inner product is defined as

$$\langle f, g \rangle = \int_{-T_1/2}^{T_1/2} \int_{-T_2/2}^{T_2/2} f(u, v)g(u, v)dudv \tag{6.29}$$

and the basis of the space is given by the double sequence of functions

$$e_{nm}(u, v) = \frac{1}{\sqrt{T_1 T_2}} e^{2\pi i \omega_n u} e^{2\pi i v_m v} \tag{6.30}$$

[2] An equality is said to be valid for almost all t, or almost everywhere, if the set of values of t for which the equality is not valid has zero measure.

with $\omega_n = n/T_1$ and $\nu_m = m/T_2$. The Fourier coefficients of a function f are given by

$$F_{nm} = \frac{1}{\sqrt{T_1 T_2}} \int_{-T_1/2}^{T_1/2} du \; e^{2\pi i \omega_n u} \int_{-T_2/2}^{T_2/2} dv \; e^{2\pi i \nu_m v} f(u, v) \tag{6.31}$$

In image processing the case of greatest interest is that in which the function f is discrete, that is, $f(u, v)$ is a doubly periodic sequence f_{nm} of period N in both dimensions. In this case, the Fourier transform of the image is given by

$$F_{mn} = \frac{1}{N} \sum_{h=0}^{N-1} \sum_{k=0}^{N-1} e^{-2i(2\pi/N)hm} e^{-2i(2\pi/N)kn} f_{hk} \tag{6.32}$$

The function f_{hk} can be reconstructed using the inverse transform:

$$f_{hk} = \frac{1}{N} \sum_{m=0}^{N-1} \sum_{n=0}^{N-1} e^{2i(2\pi/N)hm} e^{2i(2\pi/N)kn} F_{mn} \tag{6.33}$$

If \mathcal{F} is the (linear) Fourier transform operator, the relation between direct and inverse transform can be written $\mathcal{F}^{-1} = \mathcal{F}^*$, that is, the Fourier operator is unitary—for every pair of sequences f and g it is

$$\langle f, g \rangle = \langle \mathcal{F}f, \mathcal{F}, g \rangle \tag{6.34}$$

From this property it follows that the Fourier transform preserves the distance based on the inner product of the sequence space, that is, in most cases, it preserves the Euclidean distance.

6.1.2 Frames

Like bases, frames are families of functions that generate all the elements of a Hilbert space \mathcal{H}. Unlike bases, however, frames are in general *overcomplete*, that is, the linear independence condition no longer holds. As a consequence, the representation of a function in terms of frames is redundant and, in general, not unique. In spite of this, frame decompositions have many advantages in terms of robustness and significance of the transform.

DEFINITION 6.1. *Let \mathcal{H} be a Hilbert space. A family of elements $\varphi_n \in \mathcal{H}$ is called a frame if these exist $A > 0$ and $B < \infty$ such that, for all $f \in \mathcal{H}$,*

$$A \|f\|^2 \le \sum_n |\langle f, \varphi_n \rangle|^2 \le B \|f\|^2 \tag{6.35}$$

A and B are called the frame bounds. A frame is tight if $A = B$, it is exact if it ceases to be a frame when one of its elements is removed.

Before continuing, it is useful to analyze briefly the rationale behind this definition. Consider the elements φ_n and, for every element $x \in \mathcal{H}$, consider the internal products $c_n = \langle \varphi_n, x \rangle$. It is quite natural to ask three questions:

- Under what conditions do the coefficients c_n completely characterize an element x? This can be expressed more precisely as follows: when is the following proposition true:

$$(\forall n \quad \langle \varphi_n, x \rangle = \langle \varphi_n, y \rangle) \Rightarrow x = y \tag{6.36}$$

Or equivalently:

$$(\forall n \quad \langle \varphi_n, x \rangle = 0) \Rightarrow x = 0 \tag{6.37}$$

- Is it possible to reconstruct the element x as a superposition of the elements φ_n, that is, is there an algorithm for finding the coefficients r_n in the expression:

$$x = \sum_n r_n \varphi_n \tag{6.38}$$

Note that if the φ_n are an orthonormal basis of \mathcal{H} the r_n's are simply the internal products $\langle \varphi_n, x \rangle$, that is, $r_n = c_n$, but this is not true for all frames.

- Is it possible to characterize *every* element $x \in \mathcal{H}$ in this way?

If one wants a reasonably stable reconstruction of the function f, the following property is necessary: two sequences c_n^1 and c_n^2 are "close" if and only if the functions f_1 and f_2 from which they were derived are "close." In other words, the map from functions to sequences of transform coefficients must be continuous. In order to define continuity, it is necessary to define a suitable topology in the space of functions and in the space of sequences of coefficients. It is actually possible to do more, and define a distance between functions and a distance between sequences. In the space $L^2(X)$ of functions, the distance induced by the inner product is

$$d^2(f_1, f_2) = \langle f_1 - f_2, f_1 - f_2 \rangle \tag{6.39}$$

while in the space of sequences a similar distance is:

$$d^2(c^1, c^2) = \sum_n (c_n^1 - c_n^2)^2 \tag{6.40}$$

This definition implicitly assumes that sequences c^1 and c^2 are in $l^2(\mathbb{Z})$, that is, for every function $f \in \mathcal{H}$,

$$\sum_n |\langle f, \varphi_n \rangle|^2 < \infty \tag{6.41}$$

In practice this is verified for most families φ_n of practical interest. As the distances depend on the differences between functions and on the difference between sequences, saying that if two functions f_1 and f_2 are "close" the corresponding sequences c^1 and c^2 are also "close" is tantamount to saying that if a function f is "small" (i.e., $\|f\|$ is small), then the corresponding transform is also

small. This can be expressed as

$$\sum_n \langle f, \varphi_n \rangle \le B \|f\|^2 \tag{6.42}$$

Conversely, if $\sum_n |\langle f, \varphi_n \rangle|^2$ is small, then $\|f\|^2$ should also be small. In particular, there must be an $\alpha < \infty$ such that $\sum_n |\langle f, \varphi_n \rangle|^2 < 1$ implies $\|f\|^2 \le \alpha$. Take an arbitrary f, and define $\tilde{f} = [\sum_n |\langle f, \varphi_n \rangle|^2]^{-1/2} f$. Clearly, $\sum_n |\langle \tilde{f}, \varphi_n \rangle|^2 \le 1$, so that it must be $\|\tilde{f}\| \le \alpha$, which means

$$\left[\sum_n |\langle f, \varphi_n \rangle|^2 \right]^{-1} \|f\|^2 \le \alpha \tag{6.43}$$

or, defining $A = \alpha^{-1}$,

$$A\|f\|^2 \le \sum_n |\langle f, \varphi_n \rangle|^2 \tag{6.44}$$

The definition of a frame, which is nothing but the conjunction of Eqs. (6.42) and (6.44), is therefore a natural consequence of the stability requirements of a function representation.

If the frame is tight ($A = B$), then for all $f \in \mathcal{H}$,

$$\sum_n |\langle f, \varphi_n \rangle|^2 = A \|f\|^2 \tag{6.45}$$

From the polarization identity

$$\langle f, g \rangle = \frac{1}{4}[\|f + g\|^2 - \|f - g\|^2 + i\|f + ig\|^2 - i\|f - ig\|^2] \tag{6.46}$$

it is possible to derive the equality [Daubechies, 1992]:

$$A\langle f, g \rangle = \sum_j \langle f, \varphi_j \rangle \langle \varphi_j, g \rangle \tag{6.47}$$

from which it is possible to derive a reconstruction formula for f:

$$f = A^{-1} \sum_j \langle f, \varphi_j \rangle \varphi_j \tag{6.48}$$

This reconstruction formula looks a lot like that for an orthogonal basis, but remember that frames are *not* bases. For one thing, a frame is redundant. One can remove some functions φ_j and still be able to reconstruct the function f. This also implies that the reconstruction formula 6.48 is not unique—there are other sets of coefficients $a_i \ne \langle f, \varphi_j \rangle$ such that

$$f = \sum_j a_j \varphi_j \tag{6.49}$$

However, it is possible to prove that if a frame is tight, and for all j $\|\varphi_j\| = 1$, then it is an orthonormal basis. For a proof, see Daubechies (1992, p. 57).

From the same page of the same book, I appropriated the following definition:

DEFINITION 6.2. *If $\{\varphi_j\}$ is a frame in a Hilbert space \mathcal{H}, then the frame operator F is the linear operator from \mathcal{H} to $l^2(J)$ defined as:*[3]

$$(Ff)_j = \langle f, \varphi_j \rangle \tag{6.50}$$

From the definition of frame, it is easy to see that $\|Ff\|^2 \le B\|f\|^2$. The *adjoint operator* F^* of F is the operator

$$F^* : l^2(J) \to \mathcal{H} \tag{6.51}$$

defined by the equality

$$\langle F^*c, f \rangle = \langle c, Ff \rangle \tag{6.52}$$

Note that the internal product on the left-hand side of the equality is the internal product defined in \mathcal{H}, while that on the right-hand side is the internal product defined in $l^2(J)$.

From the equality

$$\langle c, Ff \rangle = \sum_{j \in J} c_j \overline{\langle f, \varphi_j \rangle} = \sum_{j \in J} c_j \langle \varphi_j, f \rangle \tag{6.53}$$

it follows that

$$F^*c = \sum_{j \in J} c_j \varphi_j \tag{6.54}$$

It is possible to show that $\|F^*\| = \|F\|$ and that the frame condition implies that

$$\|F^*c\| \le B^{1/2}\|c\| \tag{6.55}$$

Also

$$\sum_{j \in J} |\langle f, \varphi_j \rangle|^2 = \|Ff\| = \langle F^*Ff, f \rangle \tag{6.56}$$

so that the frame condition can be rewritten as:

$$A \cdot I \le F^*F \le B \cdot I \tag{6.57}$$

This also implies that F^*F is invertible (see Daubechies, 1992) and

$$B^{-1} \cdot I \le (F^*F)^{-1} \le A^{-1} \cdot I \tag{6.58}$$

Consider now the operator $S : \mathcal{H} \to \mathcal{H}$ defined as $S = F^*F$. From the definition of F and F^* it is easy to see that

$$\forall f \in \mathcal{H} \quad Sf = \sum_j \langle f, \varphi_j \rangle \varphi_j \tag{6.59}$$

Because of the forementioned properties, S is invertible. In addition, the following lemma holds:

[3] Let $J \subseteq \mathbb{N}$, then $l^2(J) = \{c = \{c_j\}_{j \in J} : \sum_{j \in J} |c_j|^2 < \infty\}$.

LEMMA 6.2. *For every function $f \in \mathcal{H}$, it is*

$$B^{-1}\|f\| \le \sum_{j=\in J} |\langle f, S^{-1}\varphi_j\rangle| \le A^{-1}\|f\| \tag{6.60}$$

PROOF. By definition, $S = F^*F$, therefore

$$S^* = (F^*F)^* = F^*F^{**} = F^*F = S \tag{6.61}$$

also, $(S^{-1})^* = S^{-1}$. From this it follows that

$$\langle f, S^{-1}\varphi_j\rangle = \langle S^{-1}f, \varphi_j\rangle \tag{6.62}$$

Then

$$\sum_{j\in J} |\langle f, S^{-1}\varphi_j\rangle|^2 = \sum_{j\in J} |\langle S^{-1}f, \varphi_j\rangle| = \|FS^{-1}f)\|^2 = \langle S^{-1}f, F^*FS^{-1}f\rangle = \langle S^{-1}f, f\rangle \tag{6.63}$$

The lemma is then an immediate consequence of the relation

$$B^{-1} \cdot I \le S^{-1} \le A^{-1} \cdot I \tag{6.64}$$

□

This lemma implies that the sequence

$$\varphi_j^* = S^{-1}\varphi_j \tag{6.65}$$

is also a frame, which is called the *dual frame* of $\{\varphi_j\}$. From Eq. (6.59) it follows that

$$f = S^{-1}\left(\sum_{j\in J}\langle f, \varphi_j\rangle\varphi_j\right) = \sum_{j\in J}\langle f, \varphi_j\rangle S^{-1}\varphi_j = \sum_{j\in J}\langle f, \varphi_j\rangle\varphi_j^* \tag{6.66}$$

This relation provides a nice algorithm for the reconstruction of f from the transform coefficients $\langle f, \varphi_j\rangle$:

1. given a frame $\{\varphi_j\}$, one can compute the dual frame

$$\varphi_j^* = S^{-1}\varphi_j \tag{6.67}$$

2. given a function f, compute the *frame decomposition*

$$c_j = \langle f, \varphi_j\rangle \tag{6.68}$$

3. reconstruct f from its decomposition as

$$f = \sum_{j\in J} c_j\varphi_j^* \tag{6.69}$$

All this, except for the presence of the dual frame $\{\varphi_j^*\}$, looks very much like what one does with bases. Constructing the dual frame, however, is not trivial, as it requires the inversion of S, which is an operator on a space with infinite dimensionality.

If the frame is "almost exact," that is, if $A \approx B$, it is possible to derive an approximate algorithm. Suppose that

$$r = \frac{B}{A} - 1 \ll 1 \tag{6.70}$$

In this case, the inequality equation (6.57) implies that S is close to $(A + B)/2 \cdot I$, and therefore S^{-1} is close to $2/(A + B) \cdot I$, and

$$\varphi_j^* \approx \frac{2}{A + B} \varphi_j \tag{6.71}$$

More precisely, it is possible to write

$$f = \frac{2}{A + B} \sum_{j \in J} \langle f, \varphi_j \rangle \varphi_j + Rf \tag{6.72}$$

where

$$R = I - \frac{2}{A + B} S \tag{6.73}$$

that is,

$$-\frac{B - A}{B + A} \cdot I \le R \le \frac{B - A}{B + A} \cdot I \tag{6.74}$$

This implies that

$$\|R\| \le \frac{B - A}{B + A} = \frac{r}{2 + r} \tag{6.75}$$

If r is small, the first part of Eq. (6.72) gives an acceptable reconstruction of f. If r is not small, the simple base-like reconstruction formula does not work, and it is necessary to evaluate φ_j^* more precisely. There is an algorithm with exponential convergence that permits the approximate reconstruction of φ_j^*. Since in image databases transforms are used for feature extraction, and reconstruction is a somewhat secondary issue, I will not present the details of the derivation of the algorithm, but only the final result. Given the transform generated by the frame $c_j = \langle f, \varphi_j \rangle$, it is possible to reconstruct f as follows:

$$f = \lim_{N \to \infty} f_N \tag{6.76}$$

with

$$f_N = f_{N-1} + \frac{2}{A + B} \sum_{j \in J} [c_j - \langle f_{N-1}, \varphi_j \rangle] \varphi_j \tag{6.77}$$

the details of this algorithm are found in Daubechies (1992, p. 62).

6.2 Group Representations and Image Transforms

The representation of groups into $L^2(X)$ (the set of square integrable functions defined from the space X into itself) can be used to generate image transforms

in a natural way. One important characteristic of these transforms, especially for image databases, is that if the group used to generate the transform has a metric structure, this structure can be used to endow the space of transformed images with a metric. Thus, group generated transforms provide a natural way to measure the distances between transformed images.

Consider the measured space $L^2(X, m)$, where m is a measure on X, and a Lie group \mathfrak{G}. Assume that \mathfrak{G}, as a manifold, is a metric space. (This is not strictly necessary for the development of the theory of transforms, but I will need the hypothesis later on in order to define a distance in the set of transformed images.)

Further, assume that \mathfrak{G} acts freely on X on the left. This means that there is a function

$$l : \mathfrak{G} \times X \to X \tag{6.78}$$

such that

$$\forall \mathfrak{g}_1, \mathfrak{g}_2 \in \mathfrak{G}, x \in X \quad l(\mathfrak{g}_1 \cdot \mathfrak{g}_2, x) = l(\mathfrak{g}_1, l(\mathfrak{g}_2, x)) \tag{6.79}$$

Using the notation $l_\mathfrak{g} = l(\mathfrak{g}, \cdot)$, this means that

$$l_{\mathfrak{g}_1 \cdot \mathfrak{g}_2} = l_{\mathfrak{g}_1} \circ l_{\mathfrak{g}_2} \tag{6.80}$$

or, in other words, that group multiplication commutes with function composition; this implies that $l_e(x) = x$. As another notational simplification, it is customary to use the group multiplication symbol for the action of \mathfrak{g} on X, that is:

$$l_\mathfrak{g}(x) = \mathfrak{g} \cdot x \tag{6.81}$$

The action of \mathfrak{G} is free if the only element of \mathfrak{G} that leaves X unchanged is the unity:

$$\mathfrak{g} \cdot x = x \Rightarrow \mathfrak{g} = e \tag{6.82}$$

I will also assume that the space X is homogeneous with respect to \mathfrak{G}, that is, \mathfrak{G} can transform any element of X into any other element:

$$\forall x, x' \in X \; \exists \mathfrak{g} \in \mathfrak{G} : x' = \mathfrak{g} \cdot x \tag{6.83}$$

This conditions is basically a "freedom of action" condition of the group \mathfrak{G}: it implies that no part of the space X is barred from the action of \mathfrak{G}.

Finally, let the measure m be *quasi-invariant* with respect to the action of \mathfrak{G}, that is, let $dm(\mathfrak{g} \cdot x)$ be continuous with respect to $dm(x)$ for all x and \mathfrak{g}. This final condition guarantees that \mathfrak{G} does not alter the metric structure of X too drastically: If a region of X has finite area, it will still have finite area after the action of $\mathfrak{g} \in \mathfrak{G}$; likewise, regions of null area will not suddenly become nonzero just because of the action of \mathfrak{G}.

A representation of \mathfrak{G} in $L^2(X, m)$ is a function

$$\pi : \mathfrak{G} \to L^2(X, m) \tag{6.84}$$

that associates to every element \mathfrak{g} a function

$$\pi(\mathfrak{g}) : X \to X \tag{6.85}$$

such that the composition of functions π commute with the group composition:

$$\pi(\mathfrak{g}_1 \cdot \mathfrak{g}_2) = \pi(\mathfrak{g}_1) \circ \pi(\mathfrak{g}_2) \tag{6.86}$$

The "canonical" representation of the group \mathfrak{G} into $L^2(X, m)$, is defined by the following theorem.

THEOREM 6.2. *Let \mathfrak{G} be a group acting freely on X, X be homogeneous with respect to the action of \mathfrak{G}, and let m be a measure on X quasi-invariant with respect to the action of \mathfrak{G}. Then the representation $\pi : \mathfrak{G} \to L^2(X, m)$ defined as*

$$\pi(\mathfrak{g})(f) : x \mapsto \sqrt{\frac{dm(\mathfrak{g}^{-1} \cdot x)}{dm(x)}} f(\mathfrak{g}^{-1} \cdot x) \tag{6.87}$$

is a unitary representation of \mathfrak{G}

PROOF. I will start by proving that π is a homomorphism of \mathfrak{G} into $L^2(X, m)$. Consider two elements \mathfrak{g}_1 and \mathfrak{g}_2 of \mathfrak{G}, and the composition $\pi(\mathfrak{g}_1) \circ \pi(\mathfrak{g}_2)$. It is possible to write it as:

$$\pi(\mathfrak{g}_1)(\pi(\mathfrak{g}_2)f) = \pi(\mathfrak{g}_1)(q) \tag{6.88}$$

with

$$q(x) = (\pi(\mathfrak{g}_2)(f))(x) = \sqrt{\frac{dm(\mathfrak{g}_2^{-1} \cdot x)}{dm(x)}} f(\mathfrak{g}_2^{-1} \cdot x) \tag{6.89}$$

Applying again the definition, one obtains

$$
\begin{aligned}
(\pi(\mathfrak{g}_1)(q))(x) &= \sqrt{\frac{dm(\mathfrak{g}_1^{-1} \cdot x)}{dm(x)}} q(\mathfrak{g}_1^{-1} \cdot x) \\
&= \sqrt{\frac{dm(\mathfrak{g}_1^{-1} \cdot x)}{dm(x)}} \sqrt{\frac{dm(\mathfrak{g}_1^{-1} \cdot \mathfrak{g}_2^{-1} x)}{dm(\mathfrak{g}_1^{-1} \cdot x)}} f(\mathfrak{g}_1^{-1} \cdot \mathfrak{g}_2^{-1} \cdot x) \\
&= \sqrt{\frac{dm((\mathfrak{g}_2 \cdot \mathfrak{g}_1)^{-1} x)}{d(x)}} f((\mathfrak{g}_2 \cdot \mathfrak{g}_1)^{-1} x) \\
&= (\pi(\mathfrak{g}_2 \cdot \mathfrak{g}_1)(f))(x) \tag{6.90}
\end{aligned}
$$

This proves that $\pi(\mathfrak{g}_2) \circ \pi(\mathfrak{g}_1) = \pi(\mathfrak{g}_2 \cdot \mathfrak{g}_1)$ and, therefore, that π is a homomorphism.

In order to prove that the representation is unitary, consider first that the function π is obviously linear: It is easy to check from the definition that $\pi(\mathfrak{g})(\phi + \phi) = \pi(\mathfrak{g})(\psi) + \pi(\mathfrak{g})(\phi)$, where the sum of two functions is intended to be pointwise.

A linear transformation T in a vector space V is unitary if, for all $u, v \in V$

$$\langle Tu, Tv \rangle = \langle u, v \rangle \tag{6.91}$$

In this case, the space V is $L^2(X, m)$, and the elements u and v are functions defined on X. Using the usual definition of inner product, it follows that:

$$
\begin{aligned}
\langle \pi(g)(\psi), \pi(g)(\phi) \rangle &= \int_X \sqrt{\frac{dm(g^{-1} \cdot x)}{dm(x)}} \psi(g^{-1} \cdot x) \sqrt{\frac{dm(g^{-1} \cdot x)}{dm(x)}} \phi(g^{-1} \cdot x)\, dm(x) \\
&= \int_X \frac{dm(g^{-1} \cdot x)}{dm(x)} \psi(g^{-1} \cdot x) \phi(g^{-1} \cdot x)\, dm(x) \\
&= \int_X \psi(g^{-1} \cdot x) \phi(g^{-1} \cdot x)\, dm(g^{-1} \cdot x) \tag{$*$} \\
&= \langle \psi, \phi \rangle \tag{6.92}
\end{aligned}
$$

The equality $(*)$ in the previous derivation is a consequence of the homogeneity assumption: since X is homogeneous with respect to the action of \mathfrak{G} then, for every g, gx spans the whole X. $\qquad\square$

If the representation of \mathfrak{G} is applied to a specific function $\psi \in L^2(X, m)$, one obtains the *transformation kernel*, that is, the family of functions

$$\psi_g = \pi(g)(\psi) \tag{6.93}$$

This kernel generates a form of continuous wavelet transform. For this reason, I will borrow a few names, and call ψ a *mother wavelet*. Every element $g \in \mathfrak{G}$ generates a *wavelet function* from the mother wavelet, given by:

$$\psi_g(x) = \sqrt{\frac{dm(g^{-1} \cdot x)}{dm(x)}} \psi(g^{-1} \cdot x) \tag{6.94}$$

EXAMPLE. As an example, let \mathfrak{G} be the one-dimensional affine group $\mathfrak{A} \approx \mathbb{R}^2$, with elements $g = (a, b)$, $a, b \in \mathbb{R}$ and composition law given by:

$$(a, b) \cdot (a', b') = (aa', b' + a'b) \tag{6.95}$$

It is easy to show that the identity element is $(1, 0)$ and that the inverse of (a, b) is $(a^{-1}, -a^{-1}b)$. This group acts freely on $L^2(\mathbb{R})$ with the action

$$(a, b) \cdot x \mapsto ax + b \tag{6.96}$$

and

$$(a, b)^{-1} \cdot x = a^{-1}(x - b) \tag{6.97}$$

The natural measure on \mathbb{R} is quasi-invariant with respect to the group \mathfrak{A}, since

$$dm(gx) = dm(ax + b) = a\, dm(x) \tag{6.98}$$

The unitary representation of this group is therefore given by

$$(\pi(a,b)(\psi))(x) = \frac{1}{\sqrt{a}}\psi\left(\frac{x-b}{a}\right) \tag{6.99}$$

The *wavelet transform* of a function is defined as follows:

DEFINITION 6.3. *Let* $f : X \to N$ *be a function from a measurable space X to the measurable space N, that is,* $f \in L^2(X,N)$, *and* \mathfrak{G} *a group that acts freely on X and satisfies the hypotheses of Theorem 6.2.*
The wavelet transform of f is the mapping

$$T : L^2(X,N) \to L^2(\mathfrak{G},N) \tag{6.100}$$

defined as:

$$T_f(g) = \langle f, \psi_g \rangle = \langle f, \pi(g)(\psi) \rangle \tag{6.101}$$

The wavelet transform has interesting and important *covariance* properties with respect to the transformed function and the action of the group that generates the transform.

A transform is covariant with respect to a given action if, when the original function is changed in a certain way, the transformed function is changed in the same way. For example, consider a hypothetical transform generated by the group of translations. This transform is *covariant* with respect to translations if the transform of a translated version of the original function is the translated version of the original transform. In a general case, the same property should hold for all the actions of the group \mathfrak{G} on the space X.

This property does indeed hold, and is a simple consequence of the fact that the representation is unitary:

THEOREM 6.3. *For the wavelet transform T induced by the unitary canonical representation of the mother wavelet* ψ, *and for every* $\mathfrak{h}, \mathfrak{g} \in \mathfrak{G}$, *it is:*

$$T_{\pi(\mathfrak{h})\cdot f}(\mathfrak{g}) = T_f(\mathfrak{h}^{-1}\cdot\mathfrak{g}) \tag{6.102}$$

PROOF. The transform of $\pi(\mathfrak{h}\cdot f)$ is:

$$\begin{aligned}
T_{\pi(\mathfrak{h})\cdot f}(\mathfrak{g}) &= \langle \pi(\mathfrak{h})\cdot f, \pi(\mathfrak{g})\cdot\psi \rangle \\
&= \langle \pi(\mathfrak{h})\cdot f, \pi(\mathfrak{h}\mathfrak{h}^{-1}\mathfrak{g})\cdot\psi \rangle \\
&= \langle \pi(\mathfrak{h})\cdot f, \pi(\mathfrak{h})\cdot\pi(\mathfrak{h}^{-1}\mathfrak{g})\cdot\psi \rangle
\end{aligned} \tag{6.103}$$

Since the representation is unitary, the last expression can be rewritten as

$$\langle f, \pi(\mathfrak{h}^{-1}\mathfrak{g})\cdot\psi \rangle \tag{6.104}$$

which is, by definition, $T_f(\mathfrak{h}^{-1}\cdot\mathfrak{g})$. □

6.2.1 Boundedness Modulo a Subgroup

The definition of the wavelet transform so far has been independent of any partic-
ular property of the group \mathfrak{G}. The group \mathfrak{G}, however, determines important prop-
erties of the wavelet transform; in particular, the group \mathfrak{G} determines whether the
wavelet transform T_f has a bounded inverse.

The question of invertibility is extremely important in image encoding and
compression because, in that case, an image is transformed with the idea of being
eventually transformed back and displayed. In the context of image analysis, the
necessity for invertibility is less clear, and is bounded to raise a few eyebrows. In
image analysis one uses transforms as features for content representation and,
not having any need to reconstruct the original image (the image is, of course,
compressed and stored separately for displaying the results of the search), it is not
clear why invertibility should be an issue—after all, most of the features presented
in Chapter 5 were not invertible (that is: they did not allow a full reconstruction
of the image). Therefore, why should one make such a fuss about invertibility in
the case of transform features?

Invertibility is important because it guarantees that no information is lost in
the feature extraction process. This is not a problem for the kind of features that
I have called "limited ontology" because, in that case, the ontological choice made
by the designer determines what kind of information should be preserved and
what kind should be discarded. In other words, limited ontology features *must*
discard certain aspects of an image and, therefore, it is perfectly natural for them
not to be invertible. In the case of transform features, on the other hand, invertibil-
ity is part of their rejection of ontological commitments; given that the designer
does not specify what is semantically relevant and what is not, a feature should
preserve as much information as possible, ideally to the point of allowing a recon-
struction of the image (this is impossible in many practical applications because
the necessities of efficient coding demand that some information be discarded;
the principle, however, stands).

Many invertibility issues in transforms are connected to the properties of the
transform operator, defined as

$$\mathcal{A}: L^2(X) \to L^2(X): f \mapsto \mathcal{A} \cdot f \tag{6.105}$$

where

$$(\mathcal{A} \cdot f)(x) = \int_{\mathfrak{G}} T_f(g)\psi_g(x)d\mu(g) \tag{6.106}$$

and $d\mu$ is a left-invariant measure on \mathfrak{G}.

More specifically, the question of whether the operator \mathcal{A} is bounded and
whether it is a multiple of the identity are connected with invertibility.

Intuitively, boundedness guarantees that all the information present in the
original image is stored in the transform with a finite amount of energy. If
some information is stored with zero energy (which effectively means that the

information is lost), then one needs an unbounded (infinite energy) operator to reconstruct the image. Therefore, the existence of a bounded inverse guarantees that all the information present in the image is preserved. Being a multiple of the identity, on the other hand, guarantees that the adjoint operator Ad A inverts the transform (up to a constant multiplying factor).

I will start with the second problem, for which there are several results derived from the theory of square-integrable representations [Torrésani, 1994; Grossman *et. al.*, 1985; Duflo and Moore, 1976]. In particular, it is possible to give the conditions under which the the operator Ad A inverts the transform.

DEFINITION 6.4. *The representation π of \mathfrak{G} is* square-integrable *if π is irreducible and there exists a function $\psi \in L^2(X)$ such that the set of diagonal matrix elements $\phi_\psi(\mathfrak{g}) = \langle \psi, \pi(\mathfrak{g}) \cdot \psi \rangle$ belongs to $L^2(\mathfrak{G})$. Any function ψ with this property is said to be* admissible.

THEOREM 6.4. *Let π a square integrable unitary representation of the locally compact group \mathfrak{G} in $L^2(X)$, and let ψ be an admissible function. Then the map*

$$T : L^2(X) \to L^2(\mathfrak{G}) : f \mapsto \frac{1}{\sqrt{c_\psi}} T_f \qquad (6.107)$$

is an isometry, and it can be inverted by its adjoint.

The boundedness of the inverse presents a more serious problem because many groups of considerable interest in application do not have a bounded inverse [Ali *et.al.*, 1991; Kalisa and Torrésani, 1993]. In a sense, unboundedness of the operator A arises when the group \mathfrak{G} is "too big" to describe the function f. There are extra factors in the representation that provide no information on f but along which the transform must integrate anyway.

In this case, it is interesting to consider representations of the group \mathfrak{G} *modulo a subgroup \mathfrak{H}*, which allow one to drop the dimensions that provide no information and integrate only along the directions that do provide information about the function.

In other words, it would be useful to restrict the integral that appears in the definition of A to the homogeneous space $\mathfrak{G}/\mathfrak{H}$, for some appropriate subgroup \mathfrak{H}. Since the representation π is not defined in $\mathfrak{G}/\mathfrak{H}$ (it is defined in \mathfrak{G}), it will be necessary first to embed $\mathfrak{G}/\mathfrak{H}$ into \mathfrak{G}. This can be done naturally, as \mathfrak{G} is transformed canonically into a fiber bundle of structure

$$\Pi : \mathfrak{G} \to \mathfrak{G}/\mathfrak{H} \qquad (6.108)$$

Let $\sigma : \mathfrak{G}/\mathfrak{H} \to \mathfrak{G}$ be a section of this fiber bundle and define the representation

$$\pi_\sigma = \pi \circ \sigma \qquad (6.109)$$

and let μ be a measure on $\mathfrak{G}/\mathfrak{H}$.

DEFINITION 6.5. *The section σ is said to be* admissible *if there exists a bounded positive invertible operator A with bounded inverse, and a function $\phi \in L^2(\mathbb{R}^n)$*

such that for all $f \in L^2(\mathbb{R}^n)$

$$\int_{\mathfrak{H}} |\langle \pi_\sigma \cdot \phi, f \rangle|^2 d\mu(\mathfrak{x}) = \langle f, \mathcal{A} \cdot f \rangle \tag{6.110}$$

σ *is strictly admissible if it is admissible and the operator* \mathcal{A} *is a multiple of the unity, that is, if the previous equation can be rewritten as:*

$$\int_{\mathfrak{H}} |\langle \pi_\sigma \cdot \phi, f \rangle|^2 d\mu(\mathfrak{x}) = K \|f\|^2 \tag{6.111}$$

In the case of a strictly admissible section, it is possible to introduce the *generalized wavelet* as

$$\psi_{\mathfrak{g}} = \pi \circ \sigma(\mathfrak{g}) \circ \psi = \pi_\sigma(\mathfrak{g}) \circ \psi \tag{6.112}$$

while in the case of an admissible section, the generalized wavelet can be defined as

$$\psi_{\mathfrak{g}} = \mathcal{A} \circ \pi_\sigma \circ \psi \tag{6.113}$$

with $\mathfrak{g} \in \mathfrak{G}/\mathfrak{H}$. The transform operator is

$$\mathcal{A}_\sigma : L^2(\mathcal{X}) \to L^2(X) : f \mapsto \mathcal{A}_\sigma \cdot f \tag{6.114}$$

where

$$(\mathcal{A}_\sigma \cdot f)(x) = \int_{\mathfrak{G}/\mathfrak{H}} \langle f, \psi_{\mathfrak{g}}(x)) \rangle \psi_{\mathfrak{g}}(x) d\mu(\mathfrak{g}) \tag{6.115}$$

Depending on the properties of \mathcal{A}, it can be possible to use the isometry

$$T : L^2(X) \to L^2(\mathfrak{G}/\mathfrak{H}) : f \mapsto \langle f, (\pi \circ \sigma)(\mathfrak{g}) \circ \psi \rangle \tag{6.116}$$

as the generalized wavelet transform of the function f.

In the case of a group \mathfrak{G}, the wavelet transform had the covariance property

$$T_{\pi(\mathfrak{h}) \cdot f}(\mathfrak{g}) = T_f(\mathfrak{h}^{-1}\mathfrak{g}) \tag{6.117}$$

In the case of the quotient space, in general, $\sigma(\mathfrak{G}/\mathfrak{H})$ is not a group, and Eq. 6.117 does not hold. However, if the section σ is strictly admissible, the following *twisted covariance* property holds [Kalisa and Torrésani, 1993]:

$$T_{\pi_\sigma(\mathfrak{x}) \cdot \pi_\sigma(\mathfrak{y})^{-1} \cdot f}(\mathfrak{x}) = T_f(\mathfrak{y}) \tag{6.118}$$

for $\mathfrak{x}, \mathfrak{y} \in \mathfrak{G}/\mathfrak{H}$.

Phase space. One natural candidate for the subgroup \mathfrak{H} is the (geometric) *phase-space* associated with the group \mathfrak{G}, obtained as follows. Take a unitary representation π of \mathfrak{G}. Differentiating π at the identity element of \mathfrak{G}, one obtains a representation $d\pi$ of the Lie algebra $D\mathfrak{G}$ of \mathfrak{G}. The group \mathfrak{G} acts on the Lie algebra through the adjoint representation

$$\text{Ad} : \mathfrak{G} \to \text{Aut}\, D\mathfrak{G} : \mathfrak{g} \mapsto \text{Ad}(\mathfrak{g}) \tag{6.119}$$

where Ad (\mathfrak{g}) is an automorphism of $D\mathfrak{G}$ defined as

$$\text{Ad}\,(\mathfrak{g}) : D\mathfrak{G} \to D\mathfrak{G} : \mathfrak{x} \mapsto \mathfrak{g}\mathfrak{x}\mathfrak{g}^{-1} \tag{6.120}$$

The adjoint representation can be obtained as the differential at the identity of the adjoint representation of the group \mathfrak{G} into itself:

$$A(\mathfrak{g}) : \mathfrak{h} \mapsto \mathfrak{g}\mathfrak{h}\mathfrak{g}^{-1} \quad \mathfrak{g}, \mathfrak{h} \in G \tag{6.121}$$

Analogously, one can consider the pull-back of the same representation:

$$A(g)^*(e) : D\mathfrak{G}^* \to D\mathfrak{G}^* \tag{6.122}$$

which is indicated as $Ad^*(\mathfrak{g})$. The mapping $\mathfrak{g} \mapsto Ad^*(\mathfrak{g})$ defines a representation of \mathfrak{G} in $D\mathfrak{G}^*$ known as the *co-adjoint representation* [Kirillov, 1976]. The co-adjoint representation is easy to compute if the group \mathfrak{G} is realized in matrix form and can be considered as a subgroup of $GL(n, C)$, the group of all invertible $n \times n$ matrices. All the groups that will be considered in the following have this property. If this is true, then the Lie algebra $D\mathfrak{G}$ is a subalgebra of $\text{Mat}_n(C)$, the group of all $n \times n$ matrices. Let $D\mathfrak{G}^\perp$ be the orthogonal complement to $D\mathfrak{G}$ under the bilinear form

$$\langle X, Y \rangle = Re\ tr\ XY \tag{6.123}$$

let V be any subspace of $\text{Mat}_n(C)$ complementary to $D\mathfrak{G}^\perp$, and P the projection on V parallel to $D\mathfrak{G}^\perp$. Then one can identify $D\mathfrak{G}^*$ with V. In this case, the coadjoint representation assumes the form

$$\pi^*(\mathfrak{g})x = P(\mathfrak{g}x\mathfrak{g}^{-1}), \quad x \in V\ \mathfrak{g} \in \mathfrak{G} \tag{6.124}$$

As an example, consider the group \mathfrak{G} of matrices in $GL(n, C)$ consisting of all real upper triangular matrices with entries of "1" on the main diagonal; \mathfrak{G} is a subgroup of $GL(n, C)$ under matrix multiplication. Then V is the spaces of real lower triangular matrices with zero entries on the main diagonal, and P is the operator that sets to zero all the entries on or above the main diagonal.

The group \mathfrak{O}_u of orbits of the Lie group \mathfrak{G} in the coadjoint representation with the factor topology of the natural topology in $D\mathfrak{G}^*$ is called the *phase space* (in the geometric sense) of \mathfrak{G}, and is a natural candidate to study the square integrability of the representations.

6.2.2 Affine Wavelets

Wavelet transforms surged to tremendous popularity during the past decade, to the point of almost supplanting the Fourier transform, at least in terms of the interest shown by researchers if not in sheer number of applications. The signal processing rationale for wavelets is quite independent of considerations about the group generation of transforms, and arises from the search of a compromise on the *localization* of signals in the time- (or space-) frequency axis.

Consider a function of a single variable and its Fourier transform:

$$f(t) = \frac{1}{\sqrt{T}} \sum_n F_n e^{2\pi i \omega_n t} \tag{6.125}$$

The basis functions $w_n(t) = e^{2\pi i \omega_n t}$ are harmonic and perfectly localized in frequency, that is, the spectrum of w_n is composed of a single pulse at a frequency ω_n. On the other hand, the functions are not localized in space, that is, there is no finite interval T such that $t \notin T \Rightarrow w_n(t) = 0$. Because of this, the value of each of the coefficents F_n depends on the whole function f. From the relation

$$F_n = \frac{1}{\sqrt{T}} \int_{-T/2}^{T/2} f(t) e^{2\pi i \omega_n t} dt \tag{6.126}$$

and the fact that $e^{2\pi i \omega_n t}$ has infinite support, it follows that a local change in the function f will change all the coefficients of its Fourier transform.

The opposite situation is represented by the following "δ-transform." The properties of the Dirac δ distribution allow one to write a "transform" of the function f as

$$F(u) = \int f(t) \delta(t - u) dt \tag{6.127}$$

(note that, of course, $F(u) = f(u)$), and the reconstruction formula

$$f(t) = \int F(u) \delta(u - t) du \tag{6.128}$$

This transform (which, I admit, is a bit silly), is the dual of the Fourier transform. The functions of the basis (the δ functions) are perfectly located in space (they are zero everywhere except in a point), but have a flat spectrum; from the theory of Fourier transforms one can derive that a delta function has components at all frequencies.

In many image processing problems one looks for a transform with somewhat mixed properties—the transform at a certain point should depend only on values of the function in a neighborhood of that point, and of the frequency content in a given range. A form of Heisenberg's uncertainty principle first noticed by Gabor implies that there can be no function perfectly localized in space and frequency, that is, every function with a finite support in space will have an infinite support in frequency, and vice versa. Gabor also proved that the optimal space-frequency localization is obtained using Gaussian-modulated sinusoids, now known as the Gabor function, and an example of which was given in (Eq. 5.31, p. 164).

Wavelets are functions that are localized both in space and in frequency, that is, a coefficient of a wavelet transform encodes the behavior of a function around a certain location and around a certain *scale*. In this section, I will briefly introduce the continuous wavelet transform that, although seldom used in practice, is a very simple example of group-generated transforms[4].

[4] There are interesting connections between continuous multiresolution analysis and the analysis of images in *scale-space* that I will not consider here [Van den Boomgaard and Smeulders, 1995]. See also Florack *et. al.,* (1995).

The most common forms of wavelets used in image processing are generated by the affine group "$ax + b$." The generic element of the group is $\mathfrak{a} = (a, b)$, the composition law is (see also Eq. (6.95)):

$$(a, b) \cdot (a'b') = (aa', b' + a'b) \tag{6.129}$$

and the inverse is given by

$$(a, b)^{-1} = \left(a^{-1}, -\frac{b}{a} \right) \tag{6.130}$$

The group acts on a mother wavelet ψ as

$$\psi_{a,b}(x) = \frac{1}{\sqrt{a}} \psi \left(\frac{x - b}{a} \right) \tag{6.131}$$

The continuous (one-dimensional) wavelet transform of a function f is the function

$$T_f(a, b) = \langle f, \psi_{a,b} \rangle \tag{6.132}$$

If the mother wavelet satisfies the following admissibility condition:

$$c_\psi = \int |\hat{\psi}(\xi)|^2 \frac{d\xi}{\xi} < \infty \tag{6.133}$$

where

$$\hat{\psi}(\xi) = \int \psi(x) e^{-i\xi x} dx \tag{6.134}$$

then any Hardy function $f \in H^2(\mathbb{R})$, where

$$H^2(\mathbb{R}) = \{ f \in L^2(\mathbb{R}) : \forall \xi < 0 \ \hat{f}(\xi) = 0 \} \tag{6.135}$$

can be reconstructed from the transform as

$$f(x) = \frac{1}{c_\psi} \int_{\mathbb{R}^+ \times \mathbb{R}} T_f(a, b) \psi_{a,b}(x) \frac{da}{a} \frac{db}{b} \tag{6.136}$$

the transform can be extended to all the functions $f \in L^2(\mathbb{R})$ by assuming that $|\hat{\psi}(\xi)|$ is an even function.

If we consider that the single dimensional transform is more than an academic exercise, many image processing applications use a one-dimensional transform applied in sequence to the two dimensions of the image. That is, given an image $f(x, y)$, the transform is first applied in the x direction for a fixed y obtaining

$$T_f'(a, b; y) = \int f(x, y) \psi_{a,b}(x) dx \tag{6.137}$$

The result is a function of y, to which the transform is applied, and considering a and b as parameters:

$$T_f(a, b, a', b') = \int T_f'(a, b; y) \psi_{a',b'}(y) dy \tag{6.138}$$

The discretization of this process leads to interesting connections with quadrature mirror filters, which will be considered in more detail in Section 6.2.5.

According to the covariance properties proved in this chapter, the function $T_f(a, b)$ is expected to be covariant with respect to translation and scaling. In other words, the transform of a translated and scaled version of f should be a translated and scaled version of T_f.

In order to see that this is indeed the case, consider an element (u, v). Its action on f is given by:

$$(\pi(u, v) \cdot f)(x) = \frac{1}{\sqrt{u}} f\left(\frac{x - v}{u}\right) \tag{6.139}$$

which is a scaled and translated version of f. The wavelet transform of this version of f is

$$
\begin{aligned}
T_{\pi(u,v) \cdot f}(a, b) &= \langle (\pi(u, v) \cdot f), (\pi(a, b) \cdot \psi) \rangle \\
&= \frac{1}{\sqrt{a}} \frac{1}{\sqrt{u}} \int_X f\left(\frac{x - v}{u}\right) \psi\left(\frac{x - b}{a}\right) dx
\end{aligned}
\tag{6.140}
$$

with the change of variable $y = (x - v)/u$, one obtains $dy = (1/u)dx$ and $x = uy + v$, so:

$$
\begin{aligned}
T_{\pi(u,v) \cdot f}(a, b) &= \frac{1}{\sqrt{ua}} \int_X f(y) \psi\left(\frac{uy - (b - v)}{a}\right) dy \\
&= T_f\left(\frac{a}{u}, \frac{b - v}{u}\right)
\end{aligned}
\tag{6.141}
$$

which is the desired result—the transform of $\pi(u, v) \cdot f$ is a scaled and translated version of T_f.

Note that the translated and scaled version of the transform in the previous example has a very simple relation with the scaled version of f. In particular, if (u, v) acts on f, the transform is translated and scaled by $(u, v)^{-1}$:

$$T_{\pi(u,v) \cdot f}(a, b) = T_f((u, v)^{-1} \cdot (a, b)) \tag{6.142}$$

The generalization of wavelet analysis to higher dimensions (particularly interesting for images in the two-dimensional case) is more complicated, because the Hardy space $H^2(\mathbb{R})$ is strictly a one-dimensional object, since it requires the possibility of ordering its domain. One possible way to deal with the general n-dimensional case is to add a rotation component $r \in SO(n)$. In the case of a bi-dimensional transform, $SO(2)$ is a one-dimensional group with group parameter θ and composition law

$$\theta_1 \cdot \theta_2 = \theta_1 + \theta_2 \pmod{2\pi} \tag{6.143}$$

The group can be realized as a subgroup of $GL(2, \mathbb{R})$, identifying θ with the matrix

$$r(\theta) = \begin{bmatrix} \cos\theta & \sin\theta \\ -\sin\theta & \cos\theta \end{bmatrix} \tag{6.144}$$

with the matrix multiplication as the group composition law. The complete group \mathfrak{A}_R is topologically equivalent to $\mathbb{R} \times \mathbb{R}^2 \times SO(2)$, and is composed of a scale factor

$a \in \mathbb{R}$, a translation $b \in \mathbb{R}^2$, and a rotation $\theta \in [0, 2\pi)$. The generic element of the group is of the form

$$\mathfrak{g} = (a, b, \theta) \tag{6.145}$$

its composition law is

$$(a, b, \theta) \cdot (a', b', \theta') = (aa', b' + a' r(\theta')b, \theta + \theta') \pmod{2\pi} \tag{6.146}$$

and the inverse of the element \mathfrak{g} is

$$(a, b, \theta)^{-1} = (a^{-1}, -a^{-1}r(\theta)b, 2\pi - \theta) \tag{6.147}$$

The group acts on $L^2(\mathbb{R}^2)$ as

$$\psi_{\mathfrak{g}}(x) = (\pi(\mathfrak{g})(\psi))(x) = \frac{1}{\sqrt{a}}\psi\left(r^{-1}(\theta)\frac{x-b}{a}\right) \tag{6.148}$$

A measure on this group is given by

$$d\mu(a, b, \theta) = \frac{da}{a}\frac{db}{a^2}d\theta \tag{6.149}$$

The admissibility condition for ψ in this case becomes

$$k_\psi = \int_{\mathbb{R}^2}|\hat{\psi}(\xi)|^2\frac{d\xi}{\|\xi\|^2} < \infty \tag{6.150}$$

The wavelet transform is now the function T_f defined as

$$T_f(a, b, \theta) = \langle f, \psi_{(a,b,\theta)}\rangle = \frac{1}{\sqrt{a}}\int_{\mathbb{R}^2}f(x)\psi\left(r^{-1}(\theta)\frac{x-b}{a}\right)dx \tag{6.151}$$

and the reconstruction relation for f is

$$f(x) = \int_{\mathbb{R}^+\times\mathbb{R}^2\times[0,2\pi)}T_f(a, b, \theta)\psi_{(a,b,\theta)}(x)\frac{da}{a}\frac{db}{a^2}d\theta \tag{6.152}$$

As it is, the group cannot be realized as a subgroup of $GL(n, \mathbb{R})$ for any n because of the nonlinearity of the relation between θ and $r(\theta)$. An equivalent group, however, can be written without explicitly using the parameter θ with generic element

$$\mathfrak{g} = (a, b, r) \tag{6.153}$$

where $r \in SO(2)$ is a rotation matric, and composition law

$$(a, b, r) \cdot (a', b', r') = (aa', b' + a'r'b, rr') \tag{6.154}$$

In this case, the group is isomorphic to the subgroup of $GL(3, \mathbb{R})$ of matrices of the form

$$\mathfrak{g} = \begin{bmatrix} 1 & b \\ 0 & [r] \end{bmatrix} \tag{6.155}$$

and matrix multiplication as the composition law.

Note that his group is, in a sense, "redundant," because the translation b alone covers the whole plane, without need of the rotation r. All one really needs in

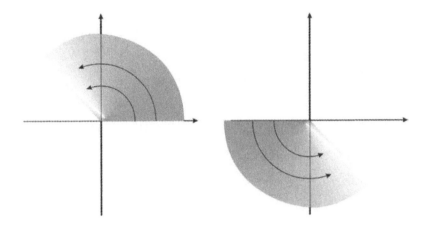

Figure 6.1. The points on the x axis and rotations up to π are sufficient to cover the plane.

order to place points in the plane is the possibility of placing a point on the x axis and rotating it by an angle up to π, as shown in Fig. 6.1. It is convenient, therefore, to represent the group modulo a subgroup that will contain, in a sense, all the "redundancy" of the original group. Consider, for starters, the finite group consisting of the two matrices

$$m_1 = \begin{bmatrix} 1 & 0 \\ 0 & 1 \end{bmatrix} \quad m_2 = \begin{bmatrix} -1 & 0 \\ 0 & -1 \end{bmatrix} \tag{6.156}$$

It is possible to show that $\{m_1, m_2\}$ with the matrix multiplication is a subgroup of $SO(1)$: the subgroup composed of rotations of angles multiples of π that is, of angles $\theta = z\pi, z \in \mathbb{Z}$.

Inside \mathfrak{A}_R, consider now the subgroup \mathfrak{M} of elements of the type

$$\left(1, \begin{bmatrix} 0 \\ b \end{bmatrix}, m\right) \tag{6.157}$$

with $m \in \{m_1, m_2\}$, which is a subgroup of \mathfrak{A}_R because the composition of two elements in \mathfrak{M} gives

$$\left(1, \begin{bmatrix} 0 \\ b \end{bmatrix}, m\right) \cdot \left(1, \begin{bmatrix} 0 \\ b' \end{bmatrix}, m'\right) = \left(1, \begin{bmatrix} 0 \\ b' \pm b \end{bmatrix}, mm'\right) \tag{6.158}$$

A section $\sigma : \mathfrak{A}_R/\mathfrak{M} \rightarrow \mathfrak{A}_R$ can then be defined as

$$\sigma(a, b, \theta) - \left(a, \begin{bmatrix} b \\ 0 \end{bmatrix}, \theta\right) \tag{6.159}$$

where $a, b \in \mathbb{R}$, $\theta \in [0, \pi)$. The wavelets generated in this section are

$$\psi_{(a,b,\theta)} = ((\pi \circ \sigma)(a, b, \theta)(\psi))(x) = \frac{1}{\sqrt{a}} \psi \left[r(\theta) \frac{1}{a} \left(x - \begin{bmatrix} b \\ 0 \end{bmatrix} \right) \right] \tag{6.160}$$

In this case, of course, the covariance of the transform becomes a twisted covariance.

6.2.3 Other Wavelet-Generating Groups

Other wavelet generating groups can be defined and are used for image analysis. In this section, I will present two variants of the *Weyl-Heisenberg group*. The wavelets generated by the action of this group add a new element to the scaling, translation, and rotation of the groups considered so far—modulation by a complex exponential. This kind of modulation had already been introduced in section 5.3.3, as a component of the Gabor transform and a form of Gabor analysis is indeed the product of the action of the Weyl-Heisenberg group.

The polarized Weyl-Heisenberg group. The first example I will consider is that of the n-dimensional polarized Weyl-Heisenberg group $\mathfrak{W}_p \equiv \mathbb{R}^{2n} \times S^1$. The elements of the group are of the form $\mathfrak{g} = (q, p, \phi)$, with $p, q \in \mathbb{R}^n$, $\phi \in [0, 2\pi)$, and the group operation is

$$(q, p, \phi) \cdot (q', p', \phi') = (q + q', p + p', \phi + \phi' + p \cdot q \pmod{2\pi}) \quad (6.161)$$

Note that the elements of this group cannot be realized as matrices, that is, as a subgroup of $GL(m, \mathbb{R})$ for some m because of the presence of the subgroup S^1 (i.e., of the (mod 2π) in the composition law), which cannot be implemented as a matrix multiplication. Such realization is possible for the *full* (unpolarized) *Weyl Heisenberg group* $\mathfrak{W}_F \equiv \mathbb{R}^{2n} \times \mathbb{R}$, with group operation

$$(q, p, \phi) \cdot (q', p', \phi') = (q + q', p + p', \phi + \phi' + p \cdot q) \quad (6.162)$$

In this case, the group is isomorphic to the subgroup of $GL(n + 2, \mathbb{R})$ composed of matrices of the type

$$\mathfrak{g} = \begin{bmatrix} 1 & p^T & \phi \\ 0 & 1 & q \\ 0 & 0 & 1 \end{bmatrix} \quad (6.163)$$

Note, however, that this group, although structurally the same as the polarized group, does not have square integrable representations, essentially because the compact subgroup S^1 has been replaced by the noncompact \mathbb{R}, leading to divergent integrals.

Turning back to the polarized group, all its irreducible unitary representations are equivalent to the following form, for some $m \in \mathbb{Z}$:

$$(\pi(q, p, \phi)(f))(x) = \exp[im(\phi - p \cdot (x - q))]f(x - q) \quad (6.164)$$

Usually one sets $m = 1$. This choice generates a form of Gabor analysis with a window of a fixed size:

$$G_f(b, \omega) = \int f(x) \exp[i\omega(x - b)]g(x - b)^* dx \quad (6.165)$$

and

$$f(x) = \frac{1}{2\pi\|g\|^2} \int G_f(b,\omega) \exp[i\omega(x-b)]g(x-b)^* \, db \, d\omega \qquad (6.166)$$

Affine Weyl-Heisenberg wavelets. The n-dimensional affine Weyl-Heisenberg group \mathfrak{W} is isomorphic to

$$\mathfrak{W} \equiv \mathbb{R}^{2n+1} \times \mathbb{R}_+^* \times SO(n) \qquad (6.167)$$

The generic element of the group is of the form

$$\mathfrak{g} = (q, p, a, r, \phi) \qquad (6.168)$$

with $q, p \in \mathbb{R}^n$, $a \in \mathbb{R}^+$, $\phi \in \mathbb{R}$, and $r \in SO(n)$. The group multiplication is

$$(q, p, a, r, \phi) \cdot (q', p', a', r', \phi') = (q + arq', p + a^{-1}rp', aa', r \cdot r', \phi + \phi' + p \cdot (ar \cdot q)) \qquad (6.169)$$

and the inverse of the element g is

$$(q, p, a, r, \phi)^{-1} = (-a^{-1}r^{-1} \cdot q, -ar^{-1} \cdot p, a^{-1}, r^{-1}, -\phi + pq) \qquad (6.170)$$

A left-invariant measure on \mathfrak{W} is given by

$$d\mu(q, p, a, r, \phi) = dq \, dp \, \frac{da}{a} \, dm(r) \, d\phi \qquad (6.171)$$

where $dm(r)$ is a measure on $SO(n)$ normalized so that $m(SO(n)) = 1$.

The group \mathfrak{W} can be realized as a subgroup of $GL(n, \mathbb{R})$ by identifying the element \mathfrak{g} with the matrix

$$\mathfrak{g} = \begin{bmatrix} 1 & [ar^{-1} \cdot p]^T & \phi \\ 0 & [ar] & [q] \\ 0 & 0 & 1 \end{bmatrix} \qquad (6.172)$$

with the usual matrix multiplication as the group law. The derivation, up to Eq. (6.2) included, of the unitary representation for this group is quite involved, and can be skipped without compromising the rest of the section.

The Lie algebra $D\mathfrak{W}$ of \mathfrak{W} can also be represented as a matrix algebra as follows. For $\lambda \in \mathbb{R}$, and $R \in DSO(n)$ (the Lie algebra of $SO(n)$), set $R^\lambda = R + \lambda I$, where I is the unit matrix, then

$$D\mathfrak{W} = \left\{ \begin{bmatrix} 0 & \xi^T & t \\ 0 & R^\lambda & x \\ 0 & 0 & 0 \end{bmatrix}, \xi, x \in \mathbb{R}^n, \lambda, t \in \mathbb{R}, R \in SO(n) \right\} \qquad (6.173)$$

A basis of $D\mathfrak{W}$ is given by I, the unit $(n+2) \times (n+2)$ matrix, and the following set of $(n+2) \times (n+2)$ matrices:

$$T = \begin{bmatrix} 0 & \cdots & 0 & 1 \\ 0 & \cdots & 0 & 0 \\ \vdots & & \vdots & \vdots \\ 0 & \vdots & 0 & 0 \end{bmatrix} \qquad (6.174)$$

$$P_i = \begin{bmatrix} \overbrace{0 \quad \cdots \quad 0}^{i} & 1 & \cdots & 0 \\ 0 \quad \cdots \quad 0 & 0 & \cdots & 0 \\ \vdots \qquad\qquad \vdots & \vdots & & \vdots \\ 0 \quad \cdots \quad 0 & 0 & \cdots & 0 \end{bmatrix} \qquad \{P_i\}_{\mu\nu} = \delta_{\mu,0}\delta_{\nu,i+1} \qquad (6.175)$$

$$Q_i = \left.\begin{bmatrix} 0 & 0 & \cdots 0 \\ \vdots & \vdots & \vdots \\ 0 & 0 & \cdots 0 \\ 0 & 0 & \cdots 1 \\ \vdots & \vdots & \vdots \\ 0 & 0 & \cdots 0 \end{bmatrix}\right\} i \qquad \{Q_i\}_{\mu\nu} = \delta_{\nu,n+2}\delta_{\mu,i+1} \qquad (6.176)$$

$$J_j^i = \begin{bmatrix} 0 & \cdots \cdots\cdots \cdots & 0 \\ \vdots & & \vdots \\ 0 & \cdots \quad 0 \;\; -1 \;\; \cdots & 0 \\ 0 & \cdots \quad 1 \quad 0 \;\; \cdots & 0 \\ \vdots & & \vdots \\ 0 & \cdots \cdots\cdots \cdots & 0 \end{bmatrix} \qquad \{J_j^i\}_{\mu\nu} = \delta_{\nu,j+1}\delta_{\mu,i+1} - \delta_{\nu,i+1}\delta_{\mu,j+1}.$$

$$(6.177)$$

Then every element $X \in D\mathfrak{W}$ can be written as

$$X = x^i Q_i + \xi^i P_i + \lambda I + R_i^j J_j^i + tT \qquad (6.178)$$

For the purposes of image databases, the most interesting case is that in which $n = 2$, because images are defined on \mathbb{R}^2. The case $n = 2$ is also more tractable than the general case because the group $SO(n)$ (which is a component of the Weyl-Heisenberg group) is an Abelian one-parameter group for $n = 2$.

The presence of the group $SO(n)$ in \mathfrak{W} makes it not solvable, which makes the study of unitary irreducible representations problematic. One can, however, study the coadjoint orbits [Kirillov, 1976] to look for indications on the structure of the group and its representations. It is possible to use the matrix representation

$$g = \begin{bmatrix} 1 & [ar^{-1} \cdot p]^T & \phi \\ 0 & [ar] & [q] \\ 0 & 0 & 1 \end{bmatrix} \in \mathfrak{W} \qquad (6.179)$$

The unitary representation of $D\mathfrak{W}$ into $L^2(\mathbb{R}^2)$ has the form

$$X = \begin{bmatrix} 0 & \xi^T & t \\ 0 & R^\lambda & x \\ 0 & 0 & 0 \end{bmatrix} = x^i Q_i + \xi^i P_i + \lambda I + R_i^j J_j^i + tT \in D\mathfrak{W} \qquad (6.180)$$

Then the adjoint representation of \mathfrak{W} into $D\mathfrak{W}$, $Ad(\mathfrak{g})(X) = \mathfrak{g}X\mathfrak{g}^{-1}$, is given by the matrix

$$\begin{bmatrix} 0 & x & y \\ 0 & z & t \\ 0 & 0 & 0 \end{bmatrix} \tag{6.181}$$

with

$$
\begin{aligned}
x &= [a^{-1}r \cdot \xi (R^\lambda)^T \cdot r^{-1} \cdot p]^T \\
y &= t + a(r^{-1} \cdot p) \cdot x - a^{-1}\xi \cdot (r^{-1} \cdot q) - p \cdot (r \cdot R^\lambda \cdot r^{-1} \cdot q) \\
z &= [r \cdot R^\lambda \cdot r^{-1}] \\
t &= ar \cdot x - rR^\lambda r^{-1} \cdot q
\end{aligned}
\tag{6.182}
$$

From this it and from the equality

$$rR^\lambda r^{-1} = \lambda K + (rRr^{-1})_i^j J_j^i \tag{6.183}$$

the adjoint action of \mathfrak{W} can be derived as:

$$
Ad(\mathfrak{g}) : \begin{bmatrix} x \\ \xi \\ \lambda \\ R_i^j \\ t \end{bmatrix} \mapsto \begin{bmatrix} \cdot x - \lambda q - R_i^j r J_j^i r^{-1} q \\ a^{-1}r\xi + \lambda p - R_i^j r J_j^i r^{-1} p \\ \lambda \\ (rRr^{-1})_i^j \\ t + a(r^{-1}p)x - a^{-1}\xi(r^{-1}q) - \lambda pq - R_i^j p(rJ_j^i r^{-1}q) \end{bmatrix}
\tag{6.184}
$$

and

$$
Ad(\mathfrak{g}^{-1}) : \begin{bmatrix} x \\ \xi \\ \lambda \\ R_i^j \\ t \end{bmatrix} \mapsto \begin{bmatrix} a^{-1}r^{-1} \cdot x + \lambda a^{-1}r^{-1}q + R_i^j a^{-1}r^{-1}J_j^i q \\ ar^{-1}\xi - \lambda ar^{-1}p + R_i^j ar^{-1}J_j^i p \\ \lambda \\ (r^{-1}Rr)_i^j \\ t - px - \xi q - \lambda pq - R_i^j p(J_j^i q) \end{bmatrix}
\tag{6.185}
$$

The coadjoint representation acts on the dual algebra $D\mathfrak{W}^*$ and in the matrix representation, and with respect to the dual basis $\{Q_i^*, P_i^*, J_j^{i*}, T^*, K^*\}$ is defined as

$$Ad^*(\mathfrak{g}) = (Ad(\mathfrak{g}^{-1}))^T \tag{6.186}$$

The coadjoint action is then given by

$$
Ad^*(\mathfrak{g}) : \begin{bmatrix} x^* \\ \xi^* \\ \lambda^* \\ (R_i^j)^* \\ t^* \end{bmatrix} \mapsto \begin{bmatrix} a^{-1}rx^* - pt^* \\ ar\xi^* + qt^* \\ \lambda^* + (a^{-1}rx^*)q - (ar\xi^*)p - pqt^* \\ (rR^*r^{-1})_i^j + (a^{-1}rx^*)(J_j^i q) + (ar\xi^*)(J_j^i p) - t^* p(J_j^i q) \\ t^* \end{bmatrix}
\tag{6.187}
$$

It is possible to distinguish three types of orbits [Kalisa and Torrésani, 1993]:

- Degenerate or semidegenerate orbits, which correspond to the choice

$$x^* = \xi^* = t^* = 0 \tag{6.188}$$

In this case λ^* is a constant, and the orbits are $SO(2)$ orbits.

- Affine orbits. These are characterized by $t^* = 0$.

- Stone-Von-Neumann orbits, characterized by $t^* \neq 0$. In this case, for any initial value x^*, ξ^*, one can find values of p, q, a such that $x^* = \xi^* = 0$. Without loss of generality, it is therefore possible to assume that the initial x^*, ξ^* are zero. In the two-dimensional case, the rotation group $SO(2)$ is a one-dimensional Abelian group. Assuming that θ is the group parameter of $SO(2)$, then the coadjoint orbits are characterized by $t^* \in \mathbb{R}$, $x^*, \xi^* \in \mathbb{R}^2$ and

$$\lambda^* = \lambda_0^* + \frac{x^* \cdot \xi^*}{t^*}$$
$$\theta^* = \theta_0^* - \frac{x^* \times \xi^*}{t^*} \tag{6.189}$$

The last case is the most interesting. In this case, the stability group of a point in the coadjoint orbit Y is:

$$\mathfrak{W}_Y = \{(0, 0, a, r, \phi), a \in \mathbb{R}_+^*, r \in SO(2), \phi \in \mathbb{R}\} \tag{6.190}$$

and the phase space is

$$\mathfrak{O} \approx \mathfrak{W}/\mathfrak{W}_Y \tag{6.191}$$

The corresponding Stone-Von-Neumann representation acts on $L^2(\mathbb{R}^2)$ as:

$$\pi(q, p, a, r, \phi)(f)(\xi) = a\, e^{i[\lambda^* \ln a + t^*(\phi + \xi p)]} f(ar^{-1}(\xi + q)) \tag{6.192}$$

As the parameters λ^* and t^* are not relevant in the context of space-frequency representations of images, it is possible to set $\lambda^* = 0$ and $t^* = 1$, so that the representation becomes:

$$\pi(q, p, a, r, \phi)(f)(\xi) = a\, e^{i[\phi + \xi p]} f(ar^{-1}(\xi + q)) \tag{6.193}$$

It is possible to verify by direct calculation that the representation π is not square integrable. In this case, as seen before, it is necessary to restrict π to coset spaces, in particular to the phase space. Given the choice of the coadjoint orbits, the phase space is the quotient of the group by the following subgroup:

$$\Gamma = \{(0, 0, a, r, \phi)\} \tag{6.194}$$

In the space $\Sigma = \mathfrak{W}/\Gamma$ the representation requires the definition of a section of the form (assuming $\phi = 0$)

$$\sigma(p, q) = (q, p, \beta(p), \rho(p)) \tag{6.195}$$

with $\beta : \Sigma \to \mathbb{R}_+^*$ and $\rho : \Sigma \to SO(2)$, which gives a representation of the form

$$(\pi(p,q)(f))(x) = \beta(x)^{-1} e^{ip \cdot (x-q)} f\left(\rho(p)^{-1} \frac{x-q}{\beta(p)}\right) \qquad (6.196)$$

Consider a function $\psi \in L^1(\mathbb{R}^2) \cap L^2(\mathbb{R}^2)$, and set

$$\psi_{(q,p)}(x) = \beta(x)^{-1} e^{ip \cdot (x-q)} \psi\left(\rho(p)^{-1} \cdot \frac{x-q}{\beta(p)}\right) \qquad (6.197)$$

Then, to any $f \in L^2(\mathbb{R}^2)$, associate the *affine Weyl-Heisenberg transform*:

$$T_f(q,p) = \langle f, \psi_{(q,p)} \rangle \qquad (6.198)$$

T_f is bounded and [Kalisa and Torrésani, 1993]:

$$T_f(q,p) = (2\pi)^{-2} \beta(p) \int d\xi \, \hat{f}(\xi) e^{i\xi \cdot q} \hat{\psi}[u_\xi(p)]^* \qquad (6.199)$$

where

$$u_\xi(p) = \beta(p)\rho(p)^{-1} \cdot (\xi - p) \qquad (6.200)$$

It can be shown that if β and ρ are such that

$$\beta(p)^{-1}\rho(p) = Kp + F \qquad (6.201)$$

for some fixed (1,2) tensor K and (1,1) tensor F, then the section is strictly admissible and the inverse transform is bounded for any ψ such that the function

$$Q(\xi) = \int_{u_\xi(\mathbb{R}^2)} du \frac{|\hat{\psi}(u)|^2}{|Det(K \cdot u - 1)|} \qquad (6.202)$$

is bounded from both above and below. One case in which this is true is when $u_\xi(\mathbb{R}^2) = \mathbb{R}^2$. In this case $Q(\xi)$ is a constant function and, provided that the function ψ decays fast enough when $|u| \to \infty$, it is a finite constant equal to

$$Q = \int_{\mathbb{R}^2} du \frac{|\hat{\psi}(u)|^2}{|Det(K \cdot u - 1)|} \qquad (6.203)$$

This is true in several cases from which it is possible to derive wavelet transforms of practical interest.

One such case is that in which $\beta = \rho = 1$, for which it is

$$\psi_{(q,p)}(x) = e^{ip \cdot (x-q)} \psi(z - q) \qquad (6.204)$$

which is the usual two-dimensional Gabor analysis. In general, if ρ is a constant, the section is strictly admissible. Unfortunately, when ρ is constant it is impossible to "rotate" the mother wavelet ψ in the image plane. This presents no problems in a situation such as traditional Gabor analysis, in which the function ψ is Gaussian and, therefore, rotation invariant. In this case the use of ρ is pointless, since $\psi(\rho(p) \cdot x) = \psi(x)$. If one wants to use a nonisotropic mother wavelet ψ, however, it will be necessary to rotate it as the phase modulation p changes direction. The determination of a strictly admissible section in the general case is

intractable, but it is possible to find some reasonable solution for the case $n = 2$ for which the rotation group has the simple structure of a one-parameter Abelian group. I will only consider the case in which the function ψ is rotated in synchrony with the phase p. Then, writing $p = \lambda v$ with $\lambda = \|p\|$, and $\|v\| = 1$,

$$\rho(p) = \begin{bmatrix} n^1 & n^2 \\ -n^2 & n^1 \end{bmatrix} \tag{6.205}$$

It is $u_\xi(\mathbb{R}^2) = \mathbb{R}^2$ if the equation

$$u_\xi(p) = \beta(p)\rho(p)^{-1} \cdot (\xi - p) = x \tag{6.206}$$

has a solution p for every x and for every ξ. Assuming that $\beta(p)\rho(p)^{-1}$ is non-singular (which, as will be shown shortly, is indeed the case), this equation can be rewritten as

$$(\xi - p) = \beta(p)^{-1}\rho(p) \cdot x \tag{6.207}$$

(since β is a scalar, it is $\rho(p)\beta(p)^{-1} = \beta(p)^{-1}\rho(p)$). The function β is as yet unspecified. However, in order to apply Eq. (6.202), Eq. (6.201) must hold. A function β that satisfies this relation is $\beta(p) = 1/\|p\|$. With this function, one obtains

$$\beta(p)^{-1}\rho(p) = \begin{bmatrix} p^1 & p^2 \\ -p^2 & p^1 \end{bmatrix} \tag{6.208}$$

so that Eq. (6.207) becomes:

$$\begin{bmatrix} p^1 & p^2 \\ -p^2 & p^1 \end{bmatrix} \begin{bmatrix} x^1 \\ x^2 \end{bmatrix} = \begin{bmatrix} p^1 x^1 + p^2 x^2 \\ -p^2 x^1 + p^1 x^2 \end{bmatrix} = \begin{bmatrix} \xi^1 - p^1 \\ \xi^2 - p^2 \end{bmatrix} \tag{6.209}$$

This equation must have a solution for all ξ and for all x. Rewriting this as an equation in the unknown p, one obtains

$$\begin{bmatrix} 1 + x^1 & x^2 \\ x^2 & 1 - x^1 \end{bmatrix} \begin{bmatrix} p^1 \\ p^2 \end{bmatrix} = \begin{bmatrix} \xi^1 \\ \xi^2 \end{bmatrix} \tag{6.210}$$

The determinant of this equation is $1 - ((x^1)^2 + (x^2)^2)$. This means that the equation does not have a solution on the circle $((x^1)^2 + (x^2)^2) = 1$. This does not impair the general solution, as the set

$$Q = \{(x, y) : ((x^1)^2 + (x^2)^2) = 1\} \tag{6.211}$$

has measure zero in \mathbb{R}^2. Therefore, $u_\xi(\mathbb{R}^2) = \mathbb{R}^2 - Q$ where $\mu(Q) = 0$. In other words, the section σ with

$$\beta(p) = \frac{1}{\|p\|} \tag{6.212}$$

and

$$\rho(p) = \frac{1}{\|p\|} \begin{bmatrix} p^1 & p^2 \\ -p^2 & p^1 \end{bmatrix} \tag{6.213}$$

is admissible, and it is possible to derive a valid wavelet transform from it. The wavelet function for this transform is derived by the mother wavelet as

$$\psi_{(q,p)}(x) = e^{ip\cdot(x-q)}\,\psi\left(\begin{bmatrix} p^1 & -p^2 \\ p^2 & p^1 \end{bmatrix}\cdot(x-q)\right) \tag{6.214}$$

These results can be summarized as follows. The representation of the whole affine Weyl-Heisenberg group with element

$$\mathfrak{g} = (q, p, a, r, \phi) \tag{6.215}$$

acts on $L^2(\mathbb{R}^2)$ as

$$(\pi(q, p, a, r, \phi)(f))(x) = a e^{i(\phi + \xi p)} f(ar^{-1}(x+q)) \tag{6.216}$$

This representation is not square integrable, which leads to a search for the definition of an appropriate coset space in order to reduce the number of dimensions along which the transform is integrated. As the constant phase shift ϕ is of scarce interest in applications, the transform can be limited to sections with $\phi = 0$. A section is then defined by taking the traslation q and the phase term p as independent parameters, and by making the scale a and the rotation r depend on p. That is, the section is composed of elements of the form

$$\sigma(p, q) = (q, p, \beta(p), \rho(p), 0) \tag{6.217}$$

An admissible section is obtained by setting

$$\beta(p) = \frac{1}{\|p\|}$$

$$\rho(p) = \frac{1}{\|p\|}\begin{bmatrix} p^1 & p^2 \\ -p^2 & p^1 \end{bmatrix} \tag{6.218}$$

that is, for every $p \in \mathbb{R}^2$, the scale is given by the norm of the phase vector, and the function f is rotated in the same direction as the phase vector, the wavelet associated to the parameters p and q is

$$\psi_{(q,p)}(x) = e^{ip\cdot(x-q)}\,\psi\left(\begin{bmatrix} p^1 & -p^2 \\ p^2 & p^1 \end{bmatrix}\cdot(x-q)\right) \tag{6.219}$$

If p is expressed as a vector of length p_o rotated by an angle θ, that is, if

$$p = r(\theta)\begin{bmatrix} p_0 \\ 0 \end{bmatrix} \tag{6.220}$$

the wavelet can be expressed as

$$\psi_{(q,p)}(x) = e^{ip_0 r(\theta)(x-q)}\,\psi(p_0 r(\theta)^{-1}(z-q)) \tag{6.221}$$

Note that, unlike the Gabor transform, the mother wavelet ψ is rotated in synchrony with the phase $\theta(p)$ and scaled as the frequency $\|p\|$.

6.2.4 Discrete Subgroups and Transforms

Continuous transforms are a useful theoretical tool, but they are seldom used in practice. Image analysis is usually obtained through a discrete transform, which results in a finite set of coefficients that can be stored and manipulated by a digital computer. Just like continuous transforms are generated by the action of a group on the image space, discrete transforms are generated by the action of a discrete subgroup of the same groups. Given a group \mathfrak{G} that generates a continuous wavelet transform, consider a discrete subgroup $\mathfrak{G}_D \subseteq \mathfrak{G}$. In particular, if \mathfrak{G} is a Lie group of dimension n, consider a set of indices $\mathfrak{I} \subset \mathbb{Z}^n$. The set

$$\mathfrak{G}_D = \{\mathfrak{g}_j \in \mathfrak{G} : j \in \mathfrak{I}\} \tag{6.222}$$

is a subgroup of \mathfrak{G} if

- $\mathfrak{e} \in \mathfrak{G}_D$

- $\mathfrak{g}_1, \mathfrak{g}_2 \in \mathfrak{G}_D \Rightarrow \mathfrak{g}_1 \cdot \mathfrak{g}_2 \in \mathfrak{G}_D$

- $\mathfrak{g} \in \mathfrak{G}_D \Rightarrow \mathfrak{g}^{-1} \in \mathfrak{G}_D$

Given a representation of \mathfrak{G}, $\pi : \mathfrak{G} \to L^2(X)$, the restriction of π to \mathfrak{G}_D is obviously a representation of \mathfrak{G}_D. In particular, the canonical unitary representation of \mathfrak{G}_D is

$$[\pi_D(\mathfrak{g}_j)f](x) = \sqrt{\frac{dm(\mathfrak{g}_j^{-1} \cdot x)}{dm(x)}} f(\mathfrak{g}_j^{-1} \cdot x) \tag{6.223}$$

and the \mathfrak{G}_D-frame transform of a function f with mother wavelet ψ is:

$$T_f : \mathfrak{G}_D \to C : f \mapsto \langle f, \pi_D(\mathfrak{g}_j)\psi \rangle \tag{6.224}$$

The indexing system \mathfrak{I} plays an important role in most applications—the discrete transform is usually stored in a suitable data structure indexed by this index system. Additionally, as will be shown in section 8.4, the structure of this index system plays an important role in the definition of feature algebras for querying image data.

In this chapter, I am interested simply in establishing a connection between the index structure of the discrete transform and the distance function that will be used for image similarity. To this end, I will begin by endowing the set of indices \mathfrak{I} with a group structure such that there is a homomorphism η of \mathfrak{I} into \mathfrak{G}_D:

$$\eta(i \cdot j) = \eta(i) \cdot \eta(j) \tag{6.225}$$

$$\eta(0) = \mathfrak{e} \tag{6.226}$$

where 0 is the unit element of the group \mathfrak{I}.

This homomorphism induces a distance function in the group \mathfrak{I} by

$$d_{\mathfrak{I}}(i,j) = d_{\mathfrak{G}}(\eta(i), \eta(j)) \tag{6.227}$$

The discrete wavelet transform can now be defined in terms of elements of the group \mathfrak{I} as

$$\Phi_f : \mathfrak{I} \to \mathcal{C} : j \mapsto \langle f, \pi_D(\mathfrak{g}_j)\psi \rangle \qquad (6.228)$$

Thanks to the distance $d_{\mathfrak{I}}$, this transform has a metric structure just like the continuous transform.

A discrete wavelet transform is therefore based on a set of functions

$$\psi_j = \pi(\mathfrak{g}_j)(\psi) \quad j \in \mathfrak{I} \qquad (6.229)$$

It is natural to inquire about the representativity and reconstruction possibilities of the family $\{\psi_j\}_{j \in \mathfrak{I}}$; in particular, one is interested in whether the family forms a basis or a frame of the space f images. For most functions ψ and groups, unfortunately, the family $\{\psi_j\}$ is not an orthogonal basis. In particular, most of the "interesting" mother wavelets ψ—for instance those which have certain space-frequency localization properties, do not generate bases. Considerably more families, however, are frames, and have the representation and reconstruction properties introduced in section 6.1.2.

It is not always easy to determine whether the family $\{\psi\}$ constitutes a frame, but some results have been obtained for particular groups. For the important case of the one-dimensional affine group, for instance, Daubechies proved the following necessary condition (1992):

THEOREM 6.5. *If the family $\psi_{j,k} = a_0^{-m/2} \psi(a_0^{-m} x - nb_0), j, k \in \mathbb{Z}$ constitutes a frame for $L^2(\mathbb{R})$ with frame bounds A, B, then*

$$\frac{b_0 \log a_0}{2\pi} A \le \int_0^\infty \xi^{-1}|\hat{\psi}(\xi)|^2 d\xi \le \frac{b_0 \log a_0}{2\pi} B \qquad (6.230)$$

and

$$\frac{b_0 \log a_0}{2\pi} A \le \int_0^\infty |\xi|^{-1}|\hat{\psi}(\xi)|^2 d\xi \le \frac{b_0 \log a_0}{2\pi} B \qquad (6.231)$$

Discrete affine wavelets. Consider again the one-dimensional affine group (a, b) with the canonical representation (Eq. 6.99),

$$[\pi(a, b)\psi](x) = \frac{1}{\sqrt{a}} \psi\left(\frac{x - b}{a}\right) \qquad (6.232)$$

Consider the discrete subset \mathfrak{A}_D of elements of the form (a_0^m, nb_0), for fixed a_0 and b_0. The index set has elements (m, n) with $m \in \mathbb{N}$ and $n \in \mathbb{Z}$. Note that, because of the requirement that $m \ge 0$, this set is not a group, but a semi-group, that is, the inverse of an element in \mathfrak{A}_D is not, in general, an element of \mathfrak{A}_D. For instance, the inverse of the element $(a_0^m, 0)$ is $(a_0^{-m}, 0)$ but if $m > 0$, $(a_0^{-m}, 0)$ is not an element of \mathfrak{A}_D.

The group composition law is

$$(a_0^{m_1}, n_1 b_0) \cdot (a_0^{m_2}, n_2 b_0) = (a_0^{m_1 + m_2}, (a_0^{m_1} n_2 + n_1) b_0) \qquad (6.233)$$

and the canonical representation of the subgroup is

$$[\pi(a_0^m, nb_0)\psi](x) = a_0^{-m/2}\psi\left(a_0^{-m}(x - nb_0)\right) \tag{6.234}$$

For $a_0, b_0 \in \mathbb{N}$, the set of indices is isomorphic to the discrete affine group if it is endowed with the group multiplication

$$(m_1, n_1) \cdot (m_2, n_2) = (m_1 + m_2, n_1 + a_0^{m_1} n_2) \tag{6.235}$$

In the study of wavelet transforms, it is common practice to choose $a_0 = 2$, $b_0 = 1$, making the index group isomorphic to \mathbb{Z}^2 and giving it the multiplication law

$$(m_1, n_1) \cdot (m_2, n_2) = (m_1 + m_2, n_1 + 2^{m_1} n_2) \tag{6.236}$$

and canonical representation,

$$[\pi(m, n)\psi](x) = 2^{-m/2}\psi\left(2^{-m}(x - n)\right) \tag{6.237}$$

In the discrete case (I will stay on the single dimensional case for the moment), both the kernel and the signal are given as sequences of numbers. Let $f[i]$ be the sequence and $\psi[i]$ the kernel, with $i \in \mathbb{Z}$. The coefficients of the transform are given by

$$c[m, n] = \sum_i 2^{-m/2}\psi[2^{-m}(i - n)]f[i] \tag{6.238}$$

Defining $j = 2^{-m}i$ gives one

$$c[m, n] = 2^{-m/2}\sum_j \psi[j - 2^{-m}n]f[2^m j] \tag{6.239}$$

With this version of the formula, one can compute the transform without defining one filtering kernel for each m—all that is necessary to do is to down-sample the function f as 2^{-m}.

The transformation of the one-dimensional affine group into a discrete group works quite nicely but, unfortunately, things will not be as smooth for the two-dimensional case. Before looking into this, I will introduce yet another bit of notation. Let \mathfrak{G} be a group and \mathfrak{H} be a subset of \mathfrak{G}. Then $\mathfrak{H}]$ is the smallest semi-group contained in \mathfrak{G} containing \mathfrak{H}, and $[\mathfrak{H}]$ is the smallest subgroup of \mathfrak{G} containing \mathfrak{H}.

For instance, let \mathfrak{G} be the additive group on \mathbb{R}, and $\mathfrak{H} = \{0, 1, 2\}$. Then $\mathfrak{H}] = \mathbb{N}$ and $[\mathfrak{H}] = \mathbb{Z}$.

Consider the rotation and translation group in the plane $\mathfrak{R} \equiv \mathbb{R} \times SO(2)$. An element of \mathfrak{R} is given as (a, r) with $a \in \mathbb{R}$ and $r \in SO(2)$. The plane rotation group $SO(2)$ is a one-parameter group with parameter θ, and such that $r(\theta_1) \cdot r(\theta_2) = r(\theta_1 + \theta_2 \bmod 2\pi)$. The composition law of \mathfrak{R} is:

$$(a, r) \cdot (a', r') = (a + r \cdot a', r \cdot r') \tag{6.240}$$

This composition law has a structure very similar to that of the the affine group, so at first sight it is not clear why the discretization of \mathfrak{R} should be more of a

problem than that of \mathfrak{A}. The problems arise from the fact that, in the case of the affine group, one can let one member of the group (the translation b) take values in \mathbb{Z}, and consider a set of scales (the scale parameters of the form 2^m with $m \geq 0$) that was at one time closed with respect to the group composition and a subset of \mathbb{Z}. Thanks to this choice, the operation

$$b + 2^m b' \tag{6.241}$$

always gave values in \mathbb{Z}.

In the case of translation and rotation, however, one must consider the presence of the rotation group $SO(2)$, which is composed of matrices of the form

$$r(\theta) = \begin{bmatrix} \cos\theta & \sin\theta \\ -\sin\theta & \cos\theta \end{bmatrix} \tag{6.242}$$

Apart from very special cases, it is not possible to find a subset of rotations so that $a + r \cdot a' \in \mathbb{Z}$. As a matter of fact, it is not even possible to restrict the operation to \mathbb{Q}, the set of rationals.

In other words: one can take translations and scales and discretize them in such a way that every composition will always have integer numbers as results but, as rotations are introduced in the group, they will make the results "slip away" from the set of integers. This is due ultimately to the fact that, except for very special cases, some of the values $\cos\theta$ or $\sin\theta$ will be irrational numbers.

Consider the following set $\mathfrak{H} \subset \mathfrak{R}$:

$$\mathfrak{H} = \left\{ (n, r(\theta_i)) : n \in \mathbb{Z}^2, \theta_i = \frac{2\pi i}{N} \right\} \tag{6.243}$$

The problem is to guarantee that $[\mathfrak{H}]$ will still be a discrete (that is, countable) subgroup of \mathfrak{G}. The composition of the r's does not present any particular problem:

$$r(\theta_i) \cdot r(\theta_j) = r(\theta_{i+j \bmod N}) \tag{6.244}$$

If $N = 2$, or $N = 4$, then all the entries in the matrices $r(\theta)$ are integers, so, if $n, n_1 \in \mathbb{Z}^2$, it is also true that $n + r(\theta_i) \cdot n_1 \in \mathbb{Z}^2$. In this case the discretization will proceed with no problem, because $[\mathfrak{H}] = \mathfrak{H}$.

If $N > 4$, there are troubles: the entries of θ_i are irrational numbers and, if $n, n_1 \in \mathbb{Z}^2$, $n + r(\theta_i) \cdot n_1$ is not even in \mathbb{Q}^2. However, the following property holds:

LEMMA 6.3.

$$[\mathfrak{H}] \subseteq \left\{ \left(\sum_{j=0}^{N} a_j r(\theta_j), r(\theta_k) \right) : a_j \in \mathbb{Z}^2, k = 1, \ldots, N \right\} = \mathfrak{Z} \tag{6.245}$$

PROOF. To prove this property, it is necessary to show that: (a) all the elements of \mathfrak{H} belong to \mathfrak{Z}; and (b) \mathfrak{Z} is a subgroup. In order to prove (b), it is necessary to prove that: (b.1) the unit element is in \mathfrak{Z}; (b.2) that \mathfrak{Z} is closed with respect to group composition; and (b.3) that \mathfrak{Z} contains the inverse of all its elements.

To prove (a), note that $r(\theta_0) = I$, the identity matrix, and, therefore, the elements of \mathfrak{H} are elements of \mathfrak{Z} with $a_j = 0$ for $j > 0$. This also proves (b.1) because the unit element is in \mathfrak{H}.

To prove (b.2), let $\mathfrak{Z}_1, \mathfrak{Z}_2 \in \mathfrak{Z}$, with

$$\mathfrak{Z}_1 = \left(\sum_{j=0}^{N} a_j r(\theta_j), r(\theta_k) \right) \tag{6.246}$$

and

$$\mathfrak{Z}_2 = \left(\sum_{j=0}^{N} b_j r(\theta_j), r(\theta_h) \right) \tag{6.247}$$

Then

$$\mathfrak{Z}_1 \cdot \mathfrak{Z}_2 = \left(\sum_{j=0}^{N} a_j r(\theta_j) + r(\theta_k) \sum_{j=0}^{N} b_j r(\theta_j), r(\theta_k) \cdot r(\theta_h) \right)$$

$$= \left(\sum_{j=0}^{N} [a_j r(\theta_j) + b_j r(\theta_{j+k \bmod N})], r(\theta_{k+h \bmod N}) \right)$$

$$= \left(\sum_{j=0}^{N} [a_j + b_{j-k \bmod N}] r(\theta_j), r(\theta_{k+h \bmod N}) \right) \tag{6.248}$$

that, as $a_j + b_{j-k \bmod N} \in \mathbb{Z}^2$, is also in \mathfrak{Z}. From the previous equation it is also possible to obtain the expression of the inverse of an element in \mathfrak{Z} and verify that it is indeed in \mathfrak{Z}, thereby proving (b.3). □

Group \mathfrak{Z} is indeed a discretization of the rotation and translation group, albeit a very complicated one. It can be indexed with a set of $2N + 1$ integers:

$$(n_0, \ldots, n_{N-1}, k) \tag{6.249}$$

with $n_i \in \mathbb{Z}^2$. The N pairs of integer numbers are the coefficients of the $r(\theta_i)$ in the summation and the last integer is the coefficient of the rotation. The composition law for the indices group is given by

$$(n_1, \ldots, n_{N-1}, k) \cdot (m_1, \ldots, m_{N-1}, h)$$

$$= (n_1 + m_{1-k \bmod N}, \ldots, n_{N-1} + m_{N-1-k \bmod N}, h + k \bmod N). \tag{6.250}$$

The previous considerations apply to the group of translations and rotations. In order to discretize the whole affine group, one must also consider scaling.

The elements of the group are now of the form (b, a, r) with $b \in \mathbb{R}^2$, $a \in \mathbb{R}^+$, and $r \in SO(2)$. The composition law is

$$(a, b, r) \cdot (a', b', r') = (aa', b' + a'r'b, r \cdot r') \tag{6.251}$$

Analogous to the previous case, consider the subset

$$\mathfrak{H} = \left\{ (a_0^m, n, r(\theta_i)) : n \in \mathbb{Z}^2, m \in \mathbb{N}, \theta_i = \frac{2\pi i}{N} \right\} \tag{6.252}$$

and try to determine \mathfrak{H}]. (Note that in this case, just as for the affine group, I will look for only a semi-group because negative scales are not defined.) A lemma very similar to the previous case holds:

LEMMA 6.4.

$$[\mathfrak{H}] \subseteq \left\{ \left(\sum_{j=0}^{N} a_j r(\theta_j), 2^m, r(\theta_k) \right) : a_j \in \mathbb{Z}^2, m > 0 \right\} = 3 \qquad (6.253)$$

The proof is very similar to that of the previous lemma, and I will not repeat it.

The composition law for the subgroup induces the following composition law in the group of indices:

$$(a_1, \ldots, a_{N-1}, m, k) \cdot (b_1, \ldots, b_{N-1}, q, h)$$
$$= (a_1 + 2^m b_{(1-k) \bmod N}, \ldots a_{N-1} + 2^m b_{(N-1-k) \bmod N}, m + q, (k + h) \bmod N) \quad (6.254)$$

Although this solution maintains a group structure into the discrete set, the resulting structure is very complicated, and does not preserve the simple composition of translation, scaling, and rotation of the continuous group.

It is convenient, in this case, to abandon the requirement that the discrete group be a subgroup of the continuous group, and derive the transform in terms of an adequate discrete set with a mapping to the continuous group. The discrete set will provide the index structure necessary for the discrete transform, while the continuous group will provide the metric structure necessary for distance computations.

Consider the semi-group $\mathfrak{R} = \mathbb{N} \times \mathbb{Z}^2 \times \mathbb{Z}_N$, where \mathbb{Z}_N is the cyclic group modulo N. The elements of the group are of the form

$$\mathfrak{n} = (n, m, \zeta) \qquad (6.255)$$

and the group operation is

$$(n, m, \zeta) \cdot (n', m', \zeta') = (n + n', m + m', \zeta + \zeta' \pmod{N}) \qquad (6.256)$$

Given $a_0, b_0 \in \mathbb{R}^+$, $\theta_0 = 2\pi/N$, define the mapping

$$y : \mathfrak{R} \to \mathfrak{A} : (n, m, \zeta) \mapsto (a_0^n, mb_0, \theta_0 \zeta) \qquad (6.257)$$

Note that, of course, y is not a homomorphism. The mapping y generates the discrete sequence of wavelets:

$$\psi_{(n,m,\zeta)}(x) = \psi_{y(n,m,\zeta)}(x) = a_0^{-n/2} \psi(a_0^{-n} \rho(\zeta)(x - mb_0)) \qquad (6.258)$$

where

$$\rho(\zeta) = \begin{bmatrix} \cos \frac{2\pi}{N} \zeta & -\sin \frac{2\pi}{N} \zeta \\ \sin \frac{2\pi}{N} \zeta & \cos \frac{2\pi}{N} \zeta \end{bmatrix} \qquad (6.259)$$

CHAPTER 6: SYSTEMS WITH GENERAL ONTOLOGIES

and the discrete transform of the function f is given by

$$T_f(n, m, \zeta) = \langle f, \psi_{n,m,\zeta} \rangle \tag{6.260}$$

Affine Weyl-Heisenberg wavelets. The same problems deriving from the attempt to discretize the "rotating" two-dimensional affine group will hinder any attempt to find a discrete subgroup of the affine Weyl-Heisenberg group. Discretizing the elements of \mathfrak{H} entails, in addition to the same discretization that was necessary for the two-dimensional "rotating" affine group, discretization of the phase term p. This term composes as $p + a^{-1}rp'$, and therefore, if one attempts to discretize this term one will encounter all the problems encountered in the discretization of the translation term of the affine group.

Fortunately, it is not necessary to discretize the Weyl-Heisenberg group. The phase space of \mathfrak{W} (p. 293) has the form

$$\sigma(p, q) = (p, q, \beta(p), \rho(p)) \tag{6.261}$$

In this space, the composition law must combine only p and q, which can be assumed to take integer values and compose by addition. The element in \mathfrak{W} associated with (p, q) is

$$\left(p, q, \frac{1}{\|p\|}, \frac{1}{\|p\|} \begin{bmatrix} p^1 & p^2 \\ -p^2 & p^1 \end{bmatrix} \right) \tag{6.262}$$

A discrete subset of (p, q) is easily derived by choosing elements of the form

$$\left(\begin{bmatrix} 2^{-m_1} \\ 2^{-m_2} \end{bmatrix}, \begin{bmatrix} q_1 \\ q_2 \end{bmatrix} \right) \tag{6.263}$$

with $n_i \in \mathbb{Z}$, and $m_i \in \mathbb{N}$. The reason for this choice should be apparent by writing out the wavelet derived from the representation of the phase-space:

$$\psi_{(m_1,m_2),(q_1,q_2)} = \exp\left(i[2^{-m_1}, 2^{-m_2}] \begin{bmatrix} x^1 & - q_1 \\ x^2 & - q_2 \end{bmatrix} \right) \psi \left(\begin{bmatrix} 2^{-m_1} & -2^{-m_2} \\ 2^{-m_2} & 2^{-m_1} \end{bmatrix} \begin{bmatrix} x^1 & - q_1 \\ x^2 & - q_2 \end{bmatrix} \right) \tag{6.264}$$

The element p controls the scale of the representation, and a compact discretization usually requires a scale exponential with the index. A scale linear with the index would be very redundant and, ultimately, waste too much space. Think about filtering an image of size 128×128. If the scale goes as 2^m, where m is the scale index, then $m = 0, \ldots, 6$. If the scale goes like m, then $m = 0, \ldots, 127$.

This representation also suggests the law for composing the elements of the phase space:

$$\left(\begin{bmatrix} 2^{m_1} \\ 2^{m_2} \end{bmatrix}, \begin{bmatrix} q_1 \\ q_2 \end{bmatrix} \right) \cdot \left(\begin{bmatrix} 2^{n_1} \\ 2^{n_2} \end{bmatrix}, \begin{bmatrix} u_1 \\ u_2 \end{bmatrix} \right) = \left(\begin{bmatrix} 2^{m_1+n_1} \\ 2^{m_2+n_2} \end{bmatrix}, \begin{bmatrix} q_1 + 2^{m_1} u_1 \\ q_2 + 2^{m_2} u_2 \end{bmatrix} \right) \tag{6.265}$$

This makes it possible to represent the "interesting" part of the Weyl-Heisenberg group using only four indices, where two of them control the displacement, one the scale, and one the rotation.

6.2.5 Quadrature Mirror Filters

Quadrature mirror filters (QMF) are a form of wavelet analysis of an image. Since
the application of QMFs to images and other two-dimensional sequences is usu-
ally decomposed into the application of the corresponding one-dimensional op-
erations to the rows and to the columns of the image in sequence, I will briefly
introduce the one-dimensional filter first.

The idea of QMFs is to divide the sequence of length n into two sequences of
length $n/2$. The first sequence contains the low-frequency portion of the original
(i.e., it is the result of the application of a lowpass filter to the original sequence).
The second contains the high-frequency portion of the same sequence. In more
intuitive terms, the first sequence of length $n/2$ contains a "coarse" version of the
original sequence, while the second sequence encodes the detail that is missing
in order to reconstruct the complete sequence.

Before introducing discrete quadrature mirror filters, it is opportune to start
with a slightly more general theory valid for arbitrary functions. Consider the
space $L^2(\mathbb{R})$ of square integrable functions on \mathbb{R}, and a sequence of successive
approximation subspaces

$$\cdots V_2 \subset V_1 \subset V_0 \subset V_{-1} \subset V_{-2} \cdots \tag{6.266}$$

such that

$$\overline{\bigcup_{j\in\mathbb{Z}} V_j} = L^2(\mathbb{R}), \quad \bigcap_{j\in\mathbb{Z}} V_j = \{0\} \tag{6.267}$$

In addition, let P_j be the orthogonal projection operator onto V_j. The first of
Eqs. (6.267) implies that for every function f, $\lim_{n\to-\infty} P_n f = f$. A sequence of
subspaces such as Eq. (6.266) is a *multiresolution decomposition* if

$$f \in V_j \Leftrightarrow f(2^j \cdot) \in V_0 \tag{6.268}$$

As an example, the following family of subspaces constitutes a multiresolution
decomposition

$$V_j = \{f \in L^2(\mathbb{R}) : \forall k \in \mathbb{Z} \ f|_{[2^j k, 2^j(k+1))} = \text{const}\} \tag{6.269}$$

I will use this sequence of subspaces for discrete sequences. Every sequence
defined on the set of integer indices is contained in V_0, therefore $V_0 = V_{-1} =
V_{-2} = \cdots$. In this case, it will be sufficient to stop the multiresolution analysis
at V_0, without it being necessary to go to more detailed spaces. The space V_0 is
assumed to be translation invariant, that is, $f \in V_0 \Leftrightarrow f(\cdot - n) \in V_0$ for all integers
n. This, in turn, implies that $f \in V_j \Leftrightarrow f(\cdot - 2^j n) \in V_j$.

Finally, assume that there is a function ϕ and a family

$$\phi_{j,n}(x) = 2^{-j/2}\phi(2^{-j}x - n) \tag{6.270}$$

such that $\{\phi_{0,n}, n \in \mathbb{Z}\}$ is an orthonormal basis of V_0. This also implies that
$\{\phi_{j,n}, n \in \mathbb{Z}\}$ is an orthonormal basis of V_j. The function ϕ is called a *scaling
function*.

In some cases, the scaling function is defined implicitly by recursion. Because $\phi = \phi_{0,0} \in V_0$, $V_0 \subset V_{-1}$, and the family $\{\phi_{-1,n}\}$ is a basis of V_{-1}, it is possible to write

$$\phi = \sum_n h_n \phi_{-1,n} \tag{6.271}$$

that is

$$\phi(x) = \sqrt{2} \sum_n h_n \phi(2x - n) \tag{6.272}$$

The number of nonzero coefficients depends on the nature of the function ϕ, and is called the *order* of the scaling function. Usually the functions are scaled so that the area they subsume is unitary, which generates the constraint $\sum_k h_k = 2$. Further, the family of functions $\phi_k(x) = \phi(x-k)$ will be required to be orthogonal, that is,

$$\int \phi(x)\phi(x - k)\,dx = \delta_{0,k} \tag{6.273}$$

For every $j \in \mathbb{Z}$, let W_j be the orthogonal complement to V_j in V_{j-1}, that is, let $V_{j-1} = V_j \oplus W_j$, with $W_j \perp W_{j'}$ for $j \neq j'$. Then, for every $j < j'$,

$$V_j = V_{j'} \oplus \bigoplus_{k=0}^{j'-j-1} W_{j'-k} \tag{6.274}$$

which implies

$$L^2(\mathbb{R}) = \bigoplus_{j\in\mathbb{Z}} W_j \tag{6.275}$$

which is a decomposition of $L^2(\mathbb{Z})$ into a series of mutually orthogonal subspaces. The W_j also inherit the scaling property of the V_j's (because, of course, $W_j \subset V_{j-1}$):

$$f \in W_j \Leftrightarrow f(2^j \cdot) \in W_0 \tag{6.276}$$

In W_j it is possible to define an orthonormal basis of *wavelet functions* $\{\psi_{j,k}k \in \mathbb{Z}\}$ such that there is a function ψ (the *mother wavelet*) for which it holds

$$\psi_{j,k}(x) = 2^{-j/2}\psi(2^{-j}x - k) \tag{6.277}$$

The properties of the orthogonal decomposition of the space V_{j-1} guarantee that, for all functions $f \in L^2(\mathbb{R})$,

$$P_{j-1}f = P_j f + \sum_{k\in\mathbb{Z}} \langle f, \psi_{j,k}\rangle \psi_{j,k} \tag{6.278}$$

Given the relation between the sequence V_j and the spaces W_j, it is not surprising that a family of wavelet functions ψ can be derived from the scaling functions ϕ. The following theorem (proved in [Daubechies, 1992]) shows this relation:

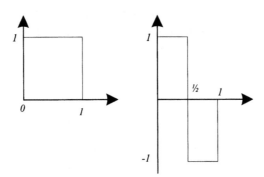

Figure 6.2. The Haar scaling function and wavelet.

THEOREM 6.6. *Let $(V_j)_{j \in \mathbb{Z}}$ be a multiresolution decomposition, and $\phi_{j,n}$ a doubly indexed family of function such that the family $(\phi_{j,n})_{n \in \mathbb{Z}}$ is a basis of V_j. Then a family of functions $\psi_{j,n}$ such that Eq. (6.278) holds is given by Eq. (6.277) with*

$$\psi(x) = \sum_n (-1)^{n-1} h^*_{-n-1} \phi_{-1,n} = \sqrt{2} \sum_n (-1)^{n-1} h^*_{-n-1} \phi(2x - n) \qquad (6.279)$$

The simplest example of a scaling/wavelet pair is given by the Haar functions, represented in Fig. 6.2. The scaling function (on the left) has order 2 with $h_0 = h_1 = 1$. Other examples of coefficients for low-order scaling functions are given in Table 6.1.

Consider now the space V_0 of functions $f : \mathbb{Z} \to \mathbb{R}$. Define the approximation space V_1 by the condition:

$$f(t) \in V_1 \Leftrightarrow f(2t) \in V_0 \qquad (6.280)$$

In addition, let W_1 denote the orthogonal complement to V_1 in V_0: $V_0 = V_1 \oplus W_1$. It is easy to see that V_1 is the space of functions such that $f(2i) = f(2i + 1)$. On the other hand, W_1 is the space of functions such that $f(2i) = -f(2i+1)$. In order to prove the latter property, let $f \in V_1$, and $g \in W_1$, and consider the product $\langle f, g \rangle$:

$$\langle f, g \rangle = \sum_k f(k) g(k)$$

$$= \sum_i (f(2i) g(2i) + f(2i + 1) g(2i + 1)) \qquad (6.281)$$

Table 6.1. Coefficients of three low-order wavelet functions

Wavelet	h_0	h_1	h_2	h_3	h_4	h_5
Daubechies-6	0.332671	0.806891	0.459877	−0.135011	−0.085441	0.035226
Daubechies-4	$\frac{1}{4}(1 + \sqrt{3})$	$\frac{1}{4}(3 + \sqrt{3})$	$\frac{1}{4}(3 - \sqrt{3})$	$\frac{1}{4}(1 - \sqrt{3})$		
Haar	1.0	1.0				

defining $a_i = f(2i) = f(2i + 1)$ and $b_i = g(2i) = -g(2i + 1)$, the previous summation becomes $\sum_i(a_ib_i - a_ib_i) = 0$. This proves that W_1 and V_1 are orthogonal subspaces. Consider now $h \in V_0$. It is necessary to prove that $h(i) = f(i) + g(i)$, with $f \in V_1$, and $g \in W_1$. To prove this, it is sufficient to define f, g as

$$f(2i) = f(2i + 1) = \frac{h(2i) + h(2i + 1)}{2} \tag{6.282}$$

$$g(2i) = -g(2i + 1) = \frac{h(2i) - h(2i + 1)}{2} \tag{6.283}$$

It is easy to see that these two functions satisfy the required conditions. To sum up, given a sequence f_0 of real numbers, it is possible to write:

$$f_0(i) = f_1(i) + g_1(i) \tag{6.284}$$

where $f_1(2i) = f_1(2i + 1)$ and $g_1(2i) = -g_1(2i + 1)$. The function f_1 is a "low resolution" representation of the function f_0, and the function g_1 provides the detail that is missing from f_1. It is possible to continue the decomposition starting, this time, from $f_1 \in V_1$ and decomposing it into $f_2 \in V_2$ and $g_2 \in W_2$, and so on, according to the following ladder scheme:

$$
\begin{array}{ccccc}
V_0 & \longrightarrow & V_1 & \longrightarrow & V_2 & \longrightarrow & \cdots \\
\downarrow & & \downarrow & & \downarrow & & \\
W_1 & & W_2 & & W_3 & &
\end{array}
\tag{6.285}
$$

Figure. 6.3 shows an example of a sequence decomposed into a a sequence of orthogonal subspaces.

Consider again the decomposition $f_0 = f_1 + g_1$. The original sequence has n samples but, because of the relation $f(2i) = f(2i + 1)$, only $n/2$ samples will be necessary in order to represent f_1. Similarly, $n/2$ samples will suffice for the representation of g_1.

In other words, the representation is efficient—any sequence of n samples (with n even) can be decomposed into low details and high details parts, and the total number of samples necessary to represent the two components is still n.

Figure 6.3.

Figure 6.4. The decomposition of a sequence of samples after the second decomposition step.

The decomposition can be continued according to Fig. (6.3): The sequence f_1 is now an element of V_1, and can be decomposed as $f_1 = f_2 + g_2$, $f_2 \in V_2$, $g_2 \in W_2$; f_1 is composed of $n/2$ samples, but both f_2 and g_2 can fit into $n/4$ each, giving a situation like that in Fig. 6.4. If L represents the lowpass filter derived from the scaling function, H the highpass filter derived from the wavelet function, and $\downarrow 2$ the operation of downsampling by a factor of 2, the operation can be represented as in Fig. 6.5. Note that, although the various bands are obtained using scaled versions of the wavelet functions, in this schema the same filter (designed using the coefficients of Table 6.1) is applied, without scaling. An effect equivalent to scaling is obtained in this case by downsampling, analogously to what was done in Eq. (6.239). The inverse scheme can be applied in order to reconstruct the original sequence.

For image applications, rather than looking for "true" two-dimensional wavelets, a common solution is to apply the one-dimensional transform to the rows and columns of the image. Applying the transform to the rows and downsampling yields the situation in Fig. 6.6a, where "L" indicates the portion of the image that has been lowpass filtered, and "H" the portion that has been high-pass filtered. Repeating the operation for the columns gives the situation in Fig. 6.6b. The portion "LL" has been filtered lowpass in both directions, and contains a low resolution version of the original image; the portion "HL" has been filtered high-pass on the rows and lowpass on the columns, and contains the details of the vertical edges of the image; the portion "LH," conversely, has been filtered lowpass on the rows and high-pass on the columns, and contains the details of the horizontal edges of the image; finally, the portion "HH" has been filtered high-pass in both directions, and contains the details of single points and skewed edges. An example of an image thus analyzed is shown in Fig. 6.7, where the contrast in the LH, HL and HH bands has been artificially increased to evidence the details.

Just as in the one-dimensional case, the application of the filter can be repeated recursively on the LL image, which will again be split into four components, as in Fig. 6.7. In order to identify them, bands are usually numbered according to the conventional scheme of Fig. 6.8.

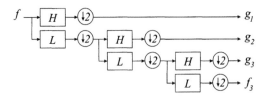

Figure 6.5. Filtering schema for the decomposition of a sequence.

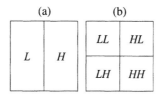

(a) (b)

LL	HL
LH	HH

L	H

Figure 6.6. The first two decompositions in the transform of an image.

The wavelet functions used in quadrature mirror filters appear superficially similar to the discretization of the continuous wavelets transform presented in section 6.2.4, but there is an important difference: the discrete affine transforms used in this case to generate the function $\psi_{j,k}$ are *not* a discrete subgroup of the continuous affine group.

In order to see this, consider that the discrete affine transforms, considered as elements of the affine group, act on a function ψ as

$$(\pi(j,k)(\psi))(x) = \psi(2^{-j}x - k) \tag{6.286}$$

with $j, k \in \mathbb{Z}$ (this representation is not unitary, but this is not important right now). The composition of (j, k) with (j', k') would then act as

$$(\pi(j,k)(\pi(j',k')(\psi)))(x) = \psi(2^{-(j+j')}x - (k + 2^{-j}k')) \tag{6.287}$$

but, in general, $(k + 2^{-j}k') \notin \mathbb{Z}$, so that there is no element (j'', k'') for which Eq. (6.287) is the representation.

Some image distances rely, as will be discussed in the next section, on a measure of distance between the elements of the group that generates the transform.

Figure 6.7. Example of image transform with quadrature mirror filters.

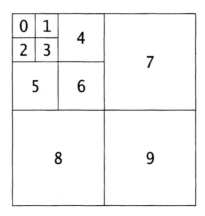

Figure 6.8. Conventional numbering of the bands in a transform.

It is still possible to consider the immersion from the discrete set \mathbb{Z}^2 of pairs (j, k) into the affine group \mathfrak{A}:

$$\eta : \mathbb{Z}^2 \to \mathfrak{A} : (j, k) \mapsto (2^{-j}, k) \qquad (6.288)$$

The immersion η induces a transform from the space of distances defined on \mathfrak{A} to the space of distances on \mathbb{Z}^2:

$$\eta^* : \mathfrak{D}(\mathfrak{A}) \to \mathfrak{D}(\mathbb{Z}^2) \qquad (6.289)$$

defined as

$$(\eta^*(d))((j, k), (j', k')) = d((2^{-j}, k), (2^{-j'}, k')) \qquad (6.290)$$

The fact that \mathbb{Z}^2 with the given composition law is not a subgroup of \mathfrak{A}, however, will result in the loss of certain invariant properties of the distances defined on \mathfrak{A}.

The transform of an image is stored in a matrix with a structure like that of Fig. 6.8. The question, then, is: Given two elements (i, j) and (i', j') of the matrix, what is the group distance between them? This entails solving the following problem: Given an element $[i, j]$ of the matrix with the transform of f, what are the group indices that generated it?

In order to answer this question, I will start with a one-dimensional problem. Consider a sequence of $N = 2^n$ samples, which has been split k times, giving a division like that in Fig. 6.9. The question in this case is posed as follows: Given the element in position i, which I will indicate as $[i]$, what are the parameters (j, k)

Figure 6.9. Band numbering for a single dimensional transform.

that generated it, that is, what are the j and k such that $[i]$ was generated as

$$[i] = 2^{-j/2} \int f(x)\psi(2^{-j}x - k)\,dx \tag{6.291}$$

In order to determine this, it is necessary to analyze the structure of the bands. If the sequence has length 2^n, and is split k time, then the elements with $0 \leq i \leq 2^{n-k} - 1$ are in band 0, the elements with $2^{n-k} \leq i \leq 2^{n-(k-1)} - 1$ are in band 1, and so on. In other words, band h contains elements with $2^{n-(k-h-1)} \leq i \leq 2^{n-(k-h)}$. It is possible then to define the *band number function* as

$$b_{n,k}(i) = \begin{cases} 0 & \text{if } i < 2^{n-k} \\ h & \text{if } 2^{n-(k-h+1)} \leq i \leq 2^{n-(k-h)} \end{cases} \tag{6.292}$$

Moreover, the following function determines at which element in the sequence band q begins,

$$e_{n,k}(q) = \begin{cases} 0 & \text{if } q = 0 \\ 2^{n-(k-q+1)} & \text{if } q > 0 \end{cases} \tag{6.293}$$

Band number 0 is not generated by any wavelet function, as it is the result of the convolution of the sequence with scaling function ϕ. I will ignore it for the moment. For an index i belonging to a band other than zero, the element $[i]$ was obtained by convolving the sequence with the function

$$\psi_{b_{n,k}(i),\, i - e_{n,k}(i)} = 2^{-b_{n,k}(i)/2}\psi(2^{-b_{n,k}(i)}x - (i - e_{n,k}(i))) \tag{6.294}$$

Therefore, given two elements in the sequence with indices i and i', the distance between them in the affine group is

$$d_{\mathbb{S}}(i, i') = d_{\mathfrak{A}}((2^{-b_{n,k}(i)}, i - e_{n,k}(i)), (2^{-b_{n,k}(i')}, i - e_{n,k}(i'))) \tag{6.295}$$

The method can easily be extended to two-dimensional images transformed by applications of the one-dimensional transform to the columns and the rows. If \oplus is one of the distance composition operators introduced in Chapter 4, then the group distance between the elements (i, j) and (i', j') of a transform like that in Fig. 6.7 is

$$\begin{aligned} d_{\mathbb{S}^2}((i,j),(i',j')) = {} & d_{\mathfrak{A}}((2^{-b_{n,k}(i)}, i - e_{n,k}(i)), (2^{-b_{n,k}(i')}, i - e_{n,k}(i'))) \\ & \oplus d_{\mathfrak{A}}((2^{-b_{n,k}(j)}, i - e_{n,k}(j)), (2^{-b_{n,k}(j')}, i - e_{n,k}(j'))) \end{aligned} \tag{6.296}$$

6.3 Measuring the Distance

The transforms introduced thus far represnt a color image as a function $f : \mathfrak{G} \to \mathcal{C}$, where \mathfrak{G} is some suitable Lie group (or a phase space of such a group), and \mathcal{C} is a color space. The problem now is how to define a suitable measure of the distance between two such functions, that is, between two transformed images.

The color space \mathcal{C} has a metric structure because, given two colors in any color system, it is always possible to transform them in some perceptually uniform

color system (e.g., La^*b^*) and compute the distance between these representations.

Similarly, the group \mathfrak{G} has a metric structure derived from some distance function, that is, one of the distances introduced in the previous section. In practice, the transformed image is stored in memory, and the corresponding function is not of the type $f : \mathfrak{G} \to \mathcal{C}$, but it is a function

$$f : \mathfrak{I} \to \mathcal{C} \tag{6.297}$$

defined over a discrete set of indices \mathfrak{I} which may or may not have a group or semi-group structure. In these cases, the group in which the index set is mapped will induce a distance measure between indices. If $\eta : \mathfrak{I} \to \mathfrak{G}$ is the immersion of the index system into the group \mathfrak{G}, then η induces a distance transform

$$\eta^* : \mathfrak{D}(\mathfrak{G}) \to \mathfrak{D}(\mathfrak{I}) \tag{6.298}$$

defined as

$$(\eta^*(d))(i,j) = d(\eta(i), \eta(j)) \tag{6.299}$$

with $i, j \in \mathfrak{I}$, and d is a distance function on \mathfrak{G}.

With these relations in place, the issue is now the definition of a distance in the space $L^2(\mathfrak{G}, \mathcal{C})$—the vector space of square integrable functions from \mathfrak{G} to \mathcal{C}—or $L^2(\mathfrak{I}, \mathcal{C})$—the vector space of square summable functions from the index set \mathfrak{I} to the color space \mathcal{C}, which contains the set of color images.

In this section, I will consider two different approaches to the problem. The first will give rise to a class of metrics that I call *point metrics*. Point metrics are easy to compute and very flexible. They are very good to measure "global" distances between images. By "global," I mean distances that treat the image as a whole sensorial impression, and not as a collection of separate elements. The main problem with point metrics is that they are not invariant to any transformation so that the distance between an image and a translated version of it generally will be quite large. This is a consequence of the fact that, much like the bin-wise distances between histograms, point metrics do not account for distance and similarity between indices—two images with similar values in adjacent indices will still be considered different. There are ways to deal with this problem, at least partially. The effects of translation or rotation are more serious at high frequencies (where most of the detail is located), but low frequencies are pretty much translation and (although not so much) rotation invariant. If we restrict our measurements to low resolutions (which we can easily do with point distances), we will be relatively insensitive to rotation and translation.

This is not a completely satisfactory solution, however, and in the following section we will consider a more general (and, alas, more expensive) class of measures that allow us to incorporate invariance with respect to the group transformations that generated the representation or, equivalently, allow us to provide translation invariance in the group space \mathfrak{G}.

6.3.1 Point Distances

The minimal notion of distance between two transforms does not require any of the assumptions that I just made about the metric structure of the index system \mathfrak{J} or the group \mathfrak{G}[5]: it merely requires the existence of a metric structure in the color space \mathcal{C}.

In the continuous case, a family of L_p point distances between image representations is defined as

$$d(f, h) = \left[\int_{\mathfrak{G}} w(\mathfrak{g}) d_{\mathcal{C}}(f(\mathfrak{g}), h(\mathfrak{g}))^p d\mathfrak{g} \right]^{1/p} \tag{6.300}$$

where $d_{\mathcal{C}}$ is the distance function defined in the color space \mathcal{C}. In the discrete case, consider a composition operator \Diamond and an apply function operator \Diamond_{ξ}. A general form of pointwise distance is defined as

$$\Diamond_{i \in \mathfrak{J}} [(\Diamond_{\xi(i)} d_{\mathcal{C}})(f(i), g(i))] \tag{6.301}$$

For instance, with

$$(\Diamond_{\xi(i)} d_{\mathcal{C}}) = w_i d_{\mathcal{C}}(\cdot, \cdot)^p \tag{6.302}$$

and $\Diamond = +$, one obtains the Minkowski metric (apart from the $1/p$ power):

$$d(f, g) = \sum_{i \in \mathfrak{J}} w_i d_{\mathcal{C}}(\cdot, \cdot)^p \tag{6.303}$$

The function $\xi(i)$ can be used to "modulate" the distance in order to adapt it to the various requirements of a query. Typically, the function $\xi(i)$ will depend on a number of parameters θ that will be changed under the action, direct or indirect, of the user interface. In the case of Eq. (6.303), for example, $\xi(i)(x) = w_i x$, and the values of the function themselves are the parameters. This is the most general case imaginable, but it leads to a large number of parameters, often unmanageable. In many cases, one would like to have a function that depends on a smaller parameter vector, which controls some intuitively understandable global quantities, for example, the behavior of the distance at various scales.

As a simple example, consider the two-dimensional "rotated" affine group of section 6.2.2. A function that centers the distance function at a certain scale and a certain location can be defined as:

$$\xi(n, m, \zeta; \theta)(x) = \exp\left[-\frac{(a_0^n - a_0^{n_0})^2}{\sigma_0^2} \right] \exp\left[-\frac{(mb_0 - m_0 b_0)^2}{\sigma_1^2} \right] \cdot x \tag{6.304}$$

where $\theta = [n_0, m_0, \sigma_0, \sigma_1]$ allows one to decide where the function should be centered and how narrow the band around the center in which the distance is

[5] In the continuum, the definition requires an integral so that in reality the group \mathfrak{G} as a manifold is still required to be orientable and to allow the definition of the fundamental form.

measured should be. A distance defined using this function is particularly sensitive to differences in coefficients around the scale $a_0^{n_0}$ and position $m_0 b_0$.

6.3.2 General Distances

An image is a function $f : \mathfrak{G} \to C$, and its *graph* is a subset of $\mathfrak{G} \times C$. In the following I will use the notation $\pi_1 : \mathfrak{G} \times C \to \mathfrak{G}$ and $\pi_2 : \mathfrak{G} \times C \to C$ to indicate the natural projections on the first and second components of $\mathfrak{G} \times C$. The subsets generated as graphs of functions from \mathfrak{G} to C are not completely general, that is, not every subset of $\mathfrak{G} \times C$ is the graph of some function. It is easy to prove, however, that graphs of functions are completely characterized by the following two properties:

THEOREM 6.7. *Let S be a subset of $\mathfrak{G} \times C$. There is a function $f : \mathfrak{G} \to C$ such that $S = \text{graph}(f)$ iff $\pi_1(S) = \mathfrak{G}$ and if for all $s_1, s_2 \in S$ it is $\pi_1(s_1) = \pi_1(s_2) \Rightarrow s_1 = s_2$.*

PROOF. If there is a function such that $S = \text{graph}(f)$, the result is obvious. Suppose now that a set with the desired characteristics exists, and define $f : \mathfrak{G} \to C$ as

$$f(x) = \pi_2(\pi_1^{-1}(x)) \tag{6.305}$$

The properties of the set S guarantee that the back-projection π_1^{-1} is a well-defined function on all \mathfrak{G} and, therefore, that f is also well defined. □

Let F be the set of graphs defined in $\mathfrak{G} \times C$, that is, the set of all subsets of $\mathfrak{G} \times C$ that satisfy the hypotheses of Theorem 6.7. Image representations are elements of F and therefore it is possible to measure the distance between image representation by endowing F with a metric. In order to do this, I will start by defining a distance in $\mathfrak{G} \times C$. A point $q \in \mathfrak{G} \times C$ can be represented as a pair $q = (\mathfrak{g}, c)$, with $\mathfrak{g} \in \mathfrak{G}$ and $c \in C$, and the canonical projections giving $\pi_1((\mathfrak{g}, c)) = \mathfrak{g}$, $\pi_2((\mathfrak{g}, c)) = c$. Assume that distance functions $d_{\mathfrak{G}} \in \mathfrak{D}(\mathfrak{G})$ and $d_C \in \mathfrak{D}(D)$ have been defined.

Given a strictly conservative combination operator \Diamond_ϕ, the distance function $\tilde{d} \in \mathfrak{D}(\mathfrak{G} \times C)$ is defined as

$$\tilde{d} = (d_{\mathfrak{G}} \circ (\pi_1 \times \pi_1)) \Diamond_\phi (d_C \circ (\pi_2 \times \pi_2)) \tag{6.306}$$

that is:

$$\tilde{d}(q, q') = \phi(d_{\mathfrak{G}}(\pi_1(q), \pi_1(q')), d_C(\pi_2(q), \pi_2(q'))) \tag{6.307}$$

The hypothesis that \Diamond_ϕ is strictly conservative is more constraining than would be necessary, but it guarantees that \tilde{d} is well behaved, the presence of the projections notwithstanding. Were the hypothesis not made, one could use a function such as $\phi(x, y) = y$, which is conservative but not strictly conservative. In this case it would be

$$\tilde{d}(q, q') = d_C(\pi_2(q), \pi_2(q')) \tag{6.308}$$

which is not a distance, as it is $\tilde{d}(q, q') = 0$ every time that it is $\pi_2(q) = \pi_2(q')$, even if it is $q \neq q'$.

Note that if one defines

$$d_n(x, y) = \begin{cases} 0 & \text{if } x = y \\ n & \text{otherwise} \end{cases} \tag{6.309}$$

and

$$\tilde{d}_n = (d_n \circ (\pi_1 \times \pi_1)) \Diamond_\phi (d_C \circ (\pi_2 \times \pi_2)) \tag{6.310}$$

the distance

$$\tilde{d}_\infty = \lim_{n \to \infty} \tilde{d}_n \tag{6.311}$$

is equivalent to the point distances of the previous section.

The Hamming distance between a point $q \in \mathfrak{G} \times C$ and a set $A \subseteq \mathfrak{G} \times C$ is defined as

$$d(q, A) = \inf\{\tilde{d}(q, a) : a \in A\} \tag{6.312}$$

When applied to graphs, the distance has the following property:

LEMMA 6.5. *Let $A \subseteq \mathfrak{G} \times C$ be the graph of a function $f : \mathfrak{G} \to C$, then*

1. *For every $q \in \mathfrak{G} \times C$ there is $\tilde{q} \in A$ such that $\pi_1(q) = \pi_1(\tilde{q})$.*

2. *$d(q, A) \leq d_C(q, \tilde{q})$.*

PROOF. The first property is an immediate consequence of the fact that, because A is a graph, $\pi_1(A) = \mathfrak{G}$, proven in Theorem 6.7.

For the second property, as $\pi_1(q) = \pi_1(\tilde{q})$, then $d_\mathfrak{G}(\pi_1(q), \pi_1(\tilde{q})) = 0$, and

$$\tilde{d}(q), q) = \phi(0, d_C(q, \tilde{q})) = d_C(q, \tilde{q}) \tag{6.313}$$

since ϕ is, *ex hypothesis*, strictly conservative. Consequently,

$$d(q, A) = \inf\{\tilde{d}(q, a) : a \in A\} \leq d_C(q, \tilde{q}) \tag{6.314}$$

\square

The distance between two graphs A and B is defined as

$$d(A, B) = \sup\{d(\mathfrak{b}, A) : \mathfrak{b} \in B\} \tag{6.315}$$

Note that in all practical applications the sets are finite—because a function is represented as a finite set of coefficients—and the operations of sup and inf can be replaced by max and min. The function $d(A, B)$ thus defined is not symmetric and is therefore not a distance, but a variable metric structure. Asymmetry can easily be seen from the example of Fig. 6.10, in which:

$$d(A, B) = \max\{d(\mathfrak{b}, A) : \mathfrak{b} \in B\} = y \tag{6.316}$$

$$d(B, A) = \max\{d(\mathfrak{a}, B) : \mathfrak{a} \in A\} = x \tag{6.317}$$

$$\square = set \ B$$

$$\bigcirc = set \ A$$

Figure 6.10. Example to show the asymmetry of the distance between sets

and, therefore, $d(A, B) > d(B, A)$. A true distance measure can be obtained by defining

$$d'(A, B) = \max\{d(A, B), d(B, A)\} \qquad (6.318)$$

In some occasions, though, it may be useful to use the asymmetric definition as a more fitting model of perceptual similarity. In a case like that of Fig. 6.10, for example, the point at a distance y from the others is often an outlier—the majority of (prototypical) examples resemble each other and only a few variations have outliers far away from all the elements of the other sets. In this case, the inequality $d(A, B) > d(B, A)$ reflects the observation (from Chapter 4) that the variant is more similar to the prototype than the prototype is to the variant.

This is also evident in the case in which the number of coefficients varies from image to image, and the distance is being measured between two sets of coefficients A and B, one of which is a subset of the other, say, $A \subset B$. In this case, A can be identified as the prototype, to which B adds some details forming a variant. It is easy to see that in this case $d(B, A) = 0$ and $d(A, B) > 0$.

This observation also applies to the case in which the query represents a prototype of what is to be retrieved, and is composed only of a few coefficients. In this case, the asymmetric distance definition places the query Q and its answer in the prototype/variant relationship as the sets A and B in Fig. 6.10.

6.3.3 Natural Distances

One of the reasons for introducing group-based transforms is the possibility to introduce a distance function between elements of a group. The next section will show how to use this distance in order to define a distance between transformed images but, for the time being, the task at hand is the definition of a distance between the elements of a group.

There are, in general, an infinite number of distance functions that can be defined in a group. This is, of course, an advantage, since one of the cornerstones of a geometric theory of similarity is the possibility of tailoring the distance function to the specific needs of a query. The specific distances that arise from the query can be the most diverse. They can, for instance, emphasize a region of the group over others, or certain parameters over others. It is interesting, however, to start by defining a "ground zero," a *natural distance* (or a family of natural

distances) for any particular group used to generate the transforms. I will leave the concept of "natural" unspecified for the moment. Informally, a natural distance is one that does not place a particular emphasis on any area of the group.

The concept, in addition to a considerable intrinsic interest, is useful in cases in which distances are adapted by some optimization procedure. Some of the interfaces that will be discussed in Chapter 10 provide user feedback in the form of "sample distances" between selected pairs of images. That is, the user selects some images $\{I_1, \ldots, I_u\}$ as representatives of his interests, and determines some desired distances δ_{ij} between images I_i and I_j. The distance function depends on a parameter vector θ and, given the example distances δ_{ij}, part of the query process consists of solving an optimization problem of the type

$$\min_{\theta} E(|d(I_i, I_j; \theta) - \delta_{ij}|) \tag{6.319}$$

where E is a suitable cost function.

The parameter vector θ is often of very high dimensionality. On the other hand, the distances δ_{ij} are obtained through user interaction and, very often, only a few of them are available. This makes Eq. (6.319) underconstrained.

In these cases, it is often advisable to introduce a regularization term. If a natural distance n is available, regularization can be given in terms of the difference between the adopted distance and the natural distance. The optimization problem then becomes

$$\min_{\theta} \left[E(|d(I_i, I_j; \theta) - \delta_{ij}|) + \alpha \|d(\cdot, \cdot; \theta) - n(\cdot, \cdot)\| \right] \tag{6.320}$$

where $\alpha > 0$ determines the balance between fit and regularity [Tihonov, 1963]. If the natural distance belongs to the family under consideration, that is, if there is θ_0 such that $d(\cdot, \cdot; \theta_0) = n(\cdot, \cdot)$, and the dependence of d on θ is sufficiently regular, then the optimization problem can be replaced with the simpler

$$\min_{\theta} \left[E(|d(I_i, I_j; \theta) - \delta_{ij}|) + \alpha \|\theta - \theta_0\| \right] \tag{6.321}$$

Natural distance for the affine group. I will start the derivation of the natural distance for the one-dimensional affine group with some observations. Consider a point (a, b), and apply a "scale only" transformation $(a', 0)$. The resulting point is:

$$(a', 0) \cdot (a, b) = (a'a, b) \tag{6.322}$$

Physically, the point (a, b) and the point $(a_0 a, b)$ correspond to the same location in the sequence, since there is no actual displacement between the two. It is therefore reasonable (or, indeed, "natural") to assume that the distance between the two points depends only on the difference of scale, that is, on a'.

This fact motivates the following definition:

DEFINITION 6.6. *Let \mathfrak{G} be the affine group, and \mathfrak{H} the subgroup defined as $\mathfrak{H} = \{(a, 0)\}$. A distance function $d : \mathfrak{G} \times \mathfrak{G} \rightarrow \mathbb{R}^+$ is* quasi-natural *if for all \mathfrak{g} and \mathfrak{g}' such*

that $\mathfrak{g} = \mathfrak{h}\mathfrak{g}'$ *with* $\mathfrak{h} \in \mathfrak{H}$, *it is*

$$d(\mathfrak{g}, \mathfrak{g}') = f(\mathfrak{h}) \tag{6.323}$$

In other words, if element \mathfrak{g} *is obtained by scaling the element* \mathfrak{g}' *with the scale factor* \mathfrak{h}, *the distance between the two depends only on the scale factor.*

It is easy to see that the following property holds:

THEOREM 6.8. *Every distance of the form*

$$d((a_1, b_1), (a_2, b_2)) = f\left(\frac{a_1}{a_2}, b_1, b_2\right) \tag{6.324}$$

such that $f(a, b, b) = 0$ *is quasi-natural.*

In addition to this, one would like to have some invariance in the physical space of the translation. That is, the distance between two elements corresponding to positions i and j of the sequence should depend only on the absolute value of the difference $i - j$. Consider two pure translations, $(1, b)$ and $(1, b')$. The property is satisfied if the function f of the previous theorem is of the type

$$d((1, b), (1, b')) = f(1, |b - b'|) \tag{6.325}$$

Take now the two elements and scale them by a scale factor $(a, 0)$. The two elements now become (a, b) and (a, b'), which are still translation invariant using the previous definition. This motivates the following definition:

DEFINITION 6.7. *A distance function* $d : \mathfrak{A} \times \mathfrak{A} \to \mathbb{R}^+$ *is* natural *if it is of the form*

$$d((a, b), (a', b')) = f\left(\frac{a}{a'}, |b - b'|\right) \tag{6.326}$$

The natural distance can also be written in the form

$$d((a, b), (a', b')) = f(\log a - \log a', |b - b'|) \tag{6.327}$$

The two-dimensional "rotated" affine group is similar to the one-dimensional, but it highlights a general procedure for building natural distances. The group is composed of elements $\mathfrak{a} = (a, b, r)$[6], and has a composition law

$$(a, b, r) \cdot (a', b', r') = (aa', b' + a'r, b, r \cdot r') \tag{6.328}$$

It was already noted that the group is redundant, and that it is convenient to define a section

$$\sigma(a, b, \theta) = \left(a, \begin{bmatrix} b \\ 0 \end{bmatrix}, \theta\right) \tag{6.329}$$

The parameters b and θ span the image plane, while the parameter a controls the scale at which the analysis takes place. I call the space spanned by b and θ the

[6] I am using the version of the group in Eq. (6.153), without the explicit parameter θ.

physical space. Consider two elements with the same coordinates in the physical space at different scales. The first element is at scale a, and its image in the group \mathfrak{A}_R is given by Eq. (6.329). Applying the scale transformation $(a', 0, 0)$, one gets the element

$$\left(aa', \begin{bmatrix} b \\ 0 \end{bmatrix}, \theta \right) = \mathfrak{a} \qquad (6.330)$$

Given that these two elements represent the same element in the physical space, the distance between the two should only be a function of the difference in scale. This is the case if the distance function between two elements of the section $\mathfrak{A}_R / \mathfrak{M}$ is of the form

$$d((a, b, \theta), (a', b', \theta)) = f\left(\frac{a}{a'}, b, b', \theta, \theta' \right) \qquad (6.331)$$

where f is such that $f(x, y, y, z, z) = 0$ for all x, y, z. A function with these characteristics is called *quasi-natural*. The definition of quasi-natural distance applies to a more general class of groups:

DEFINITION 6.8. *Let \mathfrak{G} be a group generating a transform, and let it be expressible as $\mathfrak{G} = \mathfrak{H} \times \mathfrak{S}$, where \mathfrak{S} is a subgroup that spans the space in which the image is defined* (physical space). *A distance $d \in \mathfrak{D}(\mathfrak{D})$ is quasi-natural if*

$$d((\mathfrak{h}', e) \cdot (\mathfrak{h}, \mathfrak{s}), (\mathfrak{h}, \mathfrak{s})) = f(\mathfrak{h}') \qquad (6.332)$$

Consider now the elements of the form $(1, b, \theta)$. These elements span the physical space, so it is natural to ask that the distance between them be a function of their difference in the physical space. Let $\eta : \mathbb{R} \times [0, \pi) \to \mathbb{R}^2$ the function that maps the element $(1, b, \theta)$ in its location in the physical space (in this case $\eta(b, \theta) = r(\theta)[b, 0]^T$); the distance between two points $(1, b, \theta)$ and $(1, b', \theta)$ should be a function of $\eta(b, \theta) - \eta(b', \theta)$. This difference should be independent of the scale at which the comparison is made, at least if both elements are taken at the same scale. In the general case, the following definition applies:

DEFINITION 6.9. *Let \mathfrak{G} be expressible as $\mathfrak{G} = \mathfrak{H} \times \mathfrak{S}$ as before, and let $\eta : \mathfrak{S} \to \mathbb{R}^2$ be the mapping from the physical space to the image plane. A distance $d \in \mathfrak{D}(\mathfrak{D})$ is natural if it is quasi-natural and*

$$d((\mathfrak{h}', e) \cdot (1, \mathfrak{s}), (\mathfrak{h}', e) \cdot (\mathfrak{h}, \mathfrak{s}')) = f(\eta(\mathfrak{s}) - \eta(\mathfrak{s}')) \qquad (6.333)$$

where f is an even function.

Applying this definition to the case of the two-dimensional rotated affine group, it is easy to show that all the distances of the form

$$d((a, b, \theta), (a', b', \theta)) = f\left(\frac{a}{a'}, r(\theta)b - r(\theta')b' \right) \qquad (6.334)$$

where f is even in the second argument are natural.

Natural distance for the Weyl-Heisenberg group. The starting point for the definition of the natural distance in the affine group \mathfrak{A}_R was the observation that there is a subgroup that covers the image plane, called the *physical space*. In the case of the phase space of the affine Weyl-Heisenberg group, the subgroup with elements of the form

$$\left(0, \begin{bmatrix} q_1 \\ q_2 \end{bmatrix}\right) \tag{6.335}$$

is the physical space. The definition of seminatural distance is almost exactly like that for the affine group:

DEFINITION 6.10. *Let Σ be the phase space of the affine Weyl-Heisenberg group, and \mathfrak{H} the subgroup defined as*

$$\mathfrak{H} = \left\{ \mathfrak{h} \in \sigma : \mathfrak{h} = \left(\begin{bmatrix} p_1 \\ p_2 \end{bmatrix}, 0 \right) \right\} \tag{6.336}$$

A distance function $d : \Sigma \times \Sigma \to \mathbb{R}^+$ is seminatural *if*

$$\forall \mathfrak{g}_1, \mathfrak{g}_2 \in \Sigma \, \exists \mathfrak{h} \in \mathfrak{H} : \mathfrak{g}_1 = \mathfrak{h} \cdot \mathfrak{g}_2 \Rightarrow d(\mathfrak{g}_1, \mathfrak{g}_2) = f(\mathfrak{h}) \tag{6.337}$$

Taking an element

$$\mathfrak{g} = \left(\begin{bmatrix} p_1 \\ p_2 \end{bmatrix}, \begin{bmatrix} q_1 \\ q_2 \end{bmatrix} \right) \tag{6.338}$$

and applying a transformation in \mathfrak{H}:

$$\mathfrak{h} = \left(\begin{bmatrix} r_1 \\ r_2 \end{bmatrix}, 0 \right) \tag{6.339}$$

one obtains the element

$$\mathfrak{h} \cdot \mathfrak{g} = \left(\begin{bmatrix} r_1 p_1 \\ r_2 p_2 \end{bmatrix} \begin{bmatrix} r_1 q_1 \\ r_2 q_2 \end{bmatrix} \right) \tag{6.340}$$

It is then possible to prove that the natural distance functions are given by

$$d\left(\left(\begin{bmatrix} p_1 \\ p_2 \end{bmatrix}, \begin{bmatrix} q_1 \\ q_2 \end{bmatrix} \right), \left(\begin{bmatrix} r_1 \\ r_2 \end{bmatrix}, \begin{bmatrix} w_1 \\ w_2 \end{bmatrix} \right) \right) = f\left(\begin{bmatrix} \log p_1 - \log r_1 \\ \log p_2 - \log r_2 \end{bmatrix}, \begin{bmatrix} \dfrac{q_1}{p_1} - \dfrac{w_1}{r_1} \\ \dfrac{q_2}{p_2} - \dfrac{w_2}{r_2} \end{bmatrix} \right) \tag{6.341}$$

6.3.4 Invariance Properties

One of the motivations for the introduction of a distance function more general than the point distances is invariance. There are situations in which similarity should be invariant with respect to a well-defined group of transformations. Point measures can do this only to a limited extent—it is possible to define a measure that is invariant to some subgroup of C. For instance, for color images it is possible

to define a luminance-invariant measure or a saturation-invariant measure. On the other hand, it is impossible to create a translation-invariant point measure because point measures are, in a sense, unaware of the group \mathfrak{G} that determines the geometry of the image transform. Every point is considered as an independent entity. If the fiber at point x of a given image is the same as the fiber at point $x + y$ of another image, the pointwide distance cannot detect it.

The situation is different for the general distance. Now the group \mathfrak{G} has a role as important as that of the group C.

Let \mathfrak{H} be a subgroup of \mathfrak{G}, and, for $\mathfrak{g}, \mathfrak{g}' \in \mathfrak{G}$, define $\mathfrak{g} \overset{\mathfrak{H}}{\sim} \mathfrak{g}'$ if there is $\mathfrak{h} \in \mathfrak{H}$ such that $\mathfrak{g} = \mathfrak{h}\mathfrak{g}'$.

LEMMA 6.6. *The relation $\overset{\mathfrak{H}}{\sim}$ is an equivalence, that is, it is reflexive, symmetric, and transitive.*

PROOF. As \mathfrak{H} is a subgroup, then for $\mathfrak{h}, \mathfrak{h}' \in \mathfrak{H}$ it is $\mathfrak{h}\mathfrak{h}' \in \mathfrak{H}$, and for every $\mathfrak{h} \in \mathfrak{H}$, it is $\mathfrak{h}^{-1} \in \mathfrak{H}$. From these two properties and the fact that $\mathfrak{h}\mathfrak{h}^{-1} = \mathfrak{e}$, it also results that the neutral element \mathfrak{e} is in \mathfrak{H}.

Reflexivity is a consequence of the latter property: because, for all \mathfrak{g} it is $\mathfrak{g} = \mathfrak{e}\mathfrak{g}$ and $\mathfrak{e} \in \mathfrak{H}$, it is $\mathfrak{g} \overset{\mathfrak{H}}{\sim} \mathfrak{g}$.

If $\mathfrak{g} \overset{\mathfrak{H}}{\sim} \mathfrak{g}'$, then $\mathfrak{g} = \mathfrak{h}\mathfrak{g}'$ for $\mathfrak{h} \in \mathfrak{H}$. Therefore, $\mathfrak{g}' = \mathfrak{h}^1\mathfrak{g}$, and $\mathfrak{h}^{-1} \in \mathfrak{H}$, which implies $\mathfrak{g}' \overset{\mathfrak{H}}{\sim} \mathfrak{g}$.

Finally, if $\mathfrak{g} = \mathfrak{h}\mathfrak{g}'$ and $\mathfrak{g}' = \mathfrak{h}'\mathfrak{g}''$, then $\mathfrak{g} = \mathfrak{h}\mathfrak{h}'\mathfrak{g}''$, with $\mathfrak{h}\mathfrak{h}' \in \mathfrak{H}$. Therefore, $\mathfrak{g} \overset{\mathfrak{H}}{\sim} \mathfrak{g}'$ and $\mathfrak{g}' \overset{\mathfrak{H}}{\sim} \mathfrak{g}''$ implies $\mathfrak{g} \overset{\mathfrak{H}}{\sim} \mathfrak{g}''$. $\qquad\square$

Given an element $\mathfrak{g} \in \mathfrak{G}$, indicate with $[\mathfrak{g}]$ the set

$$[\mathfrak{g}] = \{\mathfrak{g}' \in \mathfrak{G} | \exists \mathfrak{h} \in \mathfrak{H} : \mathfrak{g}' = \mathfrak{h}\mathfrak{g}\} \tag{6.342}$$

From the definition and the group properties of \mathfrak{H} it follows that, if $\mathfrak{g} = \mathfrak{h}\mathfrak{g}'$ for some $\mathfrak{h} \in \mathfrak{H}$, then $[\mathfrak{g}] = [\mathfrak{g}']$. The *coset* space $\mathfrak{G}/\mathfrak{H}$ is the set of elements $[\mathfrak{g}]$. The coset space can be given a coset structure defining $[\mathfrak{g}][\mathfrak{g}'] = \{\mathfrak{h}\mathfrak{g}\mathfrak{g}', \mathfrak{h} \in \mathfrak{H}\}$. Note that $[\mathfrak{e}] = \mathfrak{H}$.

The group $\mathfrak{G}/\mathfrak{H}$ can be endowed with a distance function $d^{\mathfrak{H}} \in \mathfrak{D}(\mathfrak{G}/\mathfrak{H})$:

$$d^{\mathfrak{H}} : \mathfrak{G}/\mathfrak{H} \times \mathfrak{G}/\mathfrak{H} \to \mathbb{R}^+ \tag{6.343}$$

This distance induces a function q in the group \mathfrak{G} defined as

$$q(\mathfrak{g}, \mathfrak{g}') = d^{\mathfrak{H}}([\mathfrak{g}], [\mathfrak{g}']) \tag{6.344}$$

Note that, in \mathfrak{G}, this is not a distance function, because it is $q(\mathfrak{g}, \mathfrak{g}') = 0$ whenever $[\mathfrak{g}] = [\mathfrak{g}']$, which happens for some $\mathfrak{g} \neq \mathfrak{g}'$.

In order to characterize the functions q induced in \mathfrak{G} by the distance $d^{\mathfrak{H}}$, I will open a parenthesis. This part is necessary only to prove Theorem 6.10, and can be skipped in the first reading.

The following theorem is a standard result in set theory, reported, for instance, in McCarty (1988).

THEOREM 6.9. *A function $f : A \to B$ defines an equivalence relation R on its domain A by xRy iff $f(x) = f(y)$. Further, f induces a function h from the quotient set A/R into B, $h : A/R \to B$ by $h([x]) = f(x)$*

From this theorem, the following property can be deduced:

LEMMA 6.7. *A function $f : \mathfrak{G} \to \mathbb{R}$ can be written as a function $l : \mathfrak{G}/\mathfrak{H} \to \mathbb{R}$ that is, $f(\mathfrak{g}) = l([\mathfrak{g}])$ iff for all $\mathfrak{g} \in \mathfrak{G}$ and for all $\mathfrak{h} \in \mathfrak{H}$ it is $f(\mathfrak{g}) = f(\mathfrak{h}\mathfrak{g})$.*

PROOF. The "only if" part is trivial: if $f(\mathfrak{g}) = l([\mathfrak{g}])$, then $f(\mathfrak{g}) = l([\mathfrak{g}]) = l([\mathfrak{h}\mathfrak{g}]) = f(\mathfrak{h}\mathfrak{g})$.

For the "if" part, if it is $f(\mathfrak{g}) = f(\mathfrak{h}\mathfrak{g})$ for all $\mathfrak{g} \in \mathfrak{G}$ and $\mathfrak{h} \in \mathfrak{H}$, then the relation R of Theorem 6.9 is composed of all sets such that $\mathfrak{g}R\mathfrak{g}' \to \mathfrak{g}' = \mathfrak{h}\mathfrak{g}$, that is, $R = \mathfrak{G}/\mathfrak{H}$. □

Applying the previous lemma twice, one gets the following property:

THEOREM 6.10. *A function $f : \mathfrak{G} \times \mathfrak{G} \to \mathbb{R}$ can be written as a function $l : \mathfrak{G}/\mathfrak{H} \times \mathfrak{G}/\mathfrak{H} \to \mathbb{R}$ that is, $f(\mathfrak{g}, \mathfrak{g}') = l([\mathfrak{g}], [\mathfrak{g}]')$ iff for all $\mathfrak{g}, \mathfrak{g}' \in \mathfrak{G}$ and for all $\mathfrak{h} \in \mathfrak{H}$ it is $f(\mathfrak{g}, \mathfrak{g}') = f(\mathfrak{h}\mathfrak{g}, \mathfrak{g}')$.*

The invariance properties of the group distance induce an analogous invariance in the space of image transforms:

THEOREM 6.11. *Let \mathfrak{G} be a group of transformations, \mathfrak{H} a subgroup, and assume that the metric in \mathfrak{G} is defined as*

$$d : \mathfrak{G}/\mathfrak{H} \times \mathfrak{G}/\mathfrak{H} \to \mathbb{R}^+ \tag{6.345}$$

If $f_1, f_2 : \mathfrak{G} \to \mathbb{R}$ are two functions such that

$$\exists \mathfrak{h} \in \mathfrak{H} : \quad \forall \mathfrak{g} \in \mathfrak{G} \quad f_1(\mathfrak{g}) = f_2(\mathfrak{h}\mathfrak{g}) \tag{6.346}$$

then $d(f_1, f_2) = 0$.

PROOF. I will start by proving that, for every point $\mathfrak{p} \in \text{graph}(f_1)$, there is a point $\mathfrak{p}' \in \text{graph}(f_1)$ such that $\tilde{d}(\mathfrak{p}, \mathfrak{p}') = 0$, where \tilde{d} is the distance defined in Eq. (6.306). Let $\mathfrak{p} = (\mathfrak{g}, f_1(\mathfrak{g})) \in \text{graph}(f_1)$, and consider the point $\mathfrak{p}' = (\mathfrak{h}\mathfrak{g}, f_2(\mathfrak{h}\mathfrak{g})) \in \text{graph}(f_2)$. By hypothesis, $f_1(\mathfrak{g}) = f_2(\mathfrak{h}\mathfrak{g})$, therefore

$$d_{\mathcal{C}}(\pi_2(\mathfrak{p}), \pi_2(\mathfrak{p}')) = 0 \tag{6.347}$$

Further, because of invariance,

$$d_{\mathfrak{G}}(\pi_1(\mathfrak{p}), \pi_1(\mathfrak{p}')) = d^{\mathfrak{H}}([\mathfrak{g}], [\mathfrak{h}\mathfrak{g}]) = 0 \tag{6.348}$$

from which it follows that $\tilde{d}(\mathfrak{p}, \mathfrak{p}') = \phi(0, 0) = 0$. Given any point $\mathfrak{p} \in \text{graph}(f_1)$, therefore, it is

$$d(\mathfrak{p}, \text{graph}(f_2)) = \min\{\tilde{d}(\mathfrak{p}, \mathfrak{p}') : \mathfrak{p}' \in \text{graph}(f_2)\} = 0 \tag{6.349}$$

and, consequently, $d(\text{graph}(f_1), \text{graph}(f_2)) = 0$. □

The difficulty in defining a distance $d^{\mathfrak{H}} \in \mathfrak{D}(\mathfrak{G}/\mathfrak{H})$ varies depending on the group \mathfrak{H}. One case in which such a definition is particularly easy is that in which \mathfrak{H} is the subspace spanned by a subset of the parameters of \mathfrak{G}. In this case, the group has the structure $\mathfrak{G} = \mathfrak{R} \times \mathfrak{H}$, and the elements can be written as $\mathfrak{g} = (\mathfrak{q}, \mathfrak{h})$, with $\mathfrak{h} \in \mathfrak{H}$. Let a distance be defined as

$$d((\mathfrak{q}, \mathfrak{h}), (\mathfrak{q}', \mathfrak{h}')) = f(\mathfrak{q}, \mathfrak{q}') \tag{6.350}$$

If $\mathfrak{g}'' = \hat{\mathfrak{h}}\mathfrak{g}'$, then $\mathfrak{g}'' = (\mathfrak{q}, \hat{\mathfrak{h}}\mathfrak{h})$, and

$$\begin{aligned}
d(\mathfrak{g}'', \mathfrak{g}') &= d((\mathfrak{q}, \hat{\mathfrak{h}}\mathfrak{h}), (\mathfrak{q}', \mathfrak{h}')) \\
&= f(\mathfrak{q}, \mathfrak{q}') \\
&= d((\mathfrak{q}, \mathfrak{h}), (\mathfrak{q}', \mathfrak{h}')) \\
&= d(\mathfrak{g}, \mathfrak{g}') \tag{6.351}
\end{aligned}$$

which, by virtue of Theorem 6.10, proves that the distance is invariant to the action of \mathfrak{H}.

Another possibility to achieve invariance is to define

$$\tilde{d}(\mathfrak{g}, \mathfrak{g}') = \min_{\mathfrak{h} \in \mathfrak{H}} d(\mathfrak{g}, \mathfrak{h}\mathfrak{g}) \tag{6.352}$$

This distance too satisfies the hypotheses of Theorem 6.10. In fact, let $\tilde{d}(\mathfrak{g}, \mathfrak{g}') = \delta$, and assume that the minimum is achieved for $\mathfrak{h} = \mathfrak{h}_0$, that is, $\tilde{d}(\mathfrak{g}, \mathfrak{g}') = d(\mathfrak{g}, \mathfrak{h}_0\mathfrak{g}') = \delta$. Consider now $\tilde{d}(\mathfrak{g}, \mathfrak{h}_1\mathfrak{g}')$, for some $\mathfrak{h}_1 \in \mathfrak{H}$. Because $\mathfrak{h}_2 = \mathfrak{h}_0\mathfrak{h}_1^{-1} \in \mathfrak{H}$, it is

$$\tilde{d}(\mathfrak{g}, \mathfrak{h}_1\mathfrak{g}') \leq d(\mathfrak{g}, \mathfrak{h}_2\mathfrak{h}_1\mathfrak{g}') = d(\mathfrak{g}, \mathfrak{h}_0\mathfrak{g}') = \delta \tag{6.353}$$

therefore, $\tilde{d}(\mathfrak{g}, \mathfrak{h}_1\mathfrak{g}') \leq \delta$. However, a symmetric argument shows that, if it were $\tilde{d}(\mathfrak{g}, \mathfrak{h}_1\mathfrak{g}') < \delta$, there would be $\tilde{\mathfrak{h}}$ such that $d(\mathfrak{g}, \tilde{\mathfrak{h}}\mathfrak{g}') < \delta$, and therefore it would be $\tilde{d}(\mathfrak{g}, \mathfrak{g}') < \delta$, which contradicts the hypothesis that the value of such a distance was δ. Therefore, it must be $\tilde{d}(\mathfrak{g}, \mathfrak{h}_1\mathfrak{g}') = \delta$ and, by Theorem 6.10, the distance is \mathfrak{H}-invariant.

Before ending this section on invariance, a warning is appropriate. Invariance is a very useful thing, but it can come back to haunt the careless user. Every invariance imposed on the distance function corresponds to a loss of information. For instance, rotation invariance is a very useful thing, but it entails the inability to distinguish a "6" from a "9." Excessive invariance frequently creates more problems than it solves. It is often a better idea to rely on quasi-invariance or, formally, infinitesimal invariance. Infinitesimal invariance can be easily defined and studied in the Lie algebra associated with the transformation group, but I will not consider it here. What it boils down to, in practice, is that you do not want the distance function to be exactly zero in \mathfrak{H}. All you need is that the distance in \mathfrak{H} should grow much more slowly than the distance in \mathfrak{G}. This way, the distance between two slightly transformed elements \mathfrak{g} and $\mathfrak{h} \cdot \mathfrak{g}$, with $\mathfrak{h} \approx \epsilon$ is almost zero, while if the transformation \mathfrak{h} is large, we are still able to recognize the two elements. The distance between 9 and 9 should be small, but that between 9 and 6 should not!

6.4 Approximate Representations

The transforms considered in the previous sections are cumbersome indeed. Consider an image of size 128×128 (a rather typical size for an image from which to extract features), and a transform consisting in a Laplacian pyramid with 7 scales. This will result in more than 20,000 coefficients, each of which is the result of a filter operation on a color and composed of three numbers. A conservative estimate (two bytes per number) leads to 131,070 bytes per image. With images this size, the index of a database with 1,000,000 images would take a whopping 131 Gbytes.

Clearly, it is necessary to find more efficient ways to represent images.

A transformed image is represented by a finite set of points in $\mathfrak{G} \times \mathcal{C}$, and there are many ways in which they can be represented economically. One of the best known is *vector quantization.*

6.4.1 Vector Quantization

Vector quantization is a well-known technique for the compact representation of sets of n-dimensional points. I will give here a very brief introduction to the technique followed by a description of its application to the problem at hand. Vector quantization is an important and well-developed technique. Most of its applications are in data compression. In this section, I will describe very simple and widely used vector quantization techniques.

Vector quantization represents a (large) number N of vectors $\{v_1, \ldots v_N\}$ by a (relatively small) number M of vectors $\{c_1, \ldots, c_M\}$. The set

$$C = \{c_1, \ldots, c_M\} \tag{6.354}$$

is called the *codebook.*[7]

If a sender wants to transmit one of the vectors (say v_k) to the receivers, it will look at the codebook and find the vector c_h closest to v_k. Then, instead of sending the index k of the vector, it will send the index h of the *code vector* c_h. Because transmitting the index k requires $\lceil \log_2 N \rceil$ bits, while sending the index h requires $\lceil \log_2 M \rceil$ bits, if $N \gg M$ there can be considerable savings in the number of bits.

After the transmitter does the work, the receiver has a simple task—it has a copy of the codebook, and will just look up the hth element, which it will interpret as the result of the transmission. There will be, of course, be an error $v_k - c_h$.

Figure 6.11 shows schematically a two-dimensional vector quantizer. The small dots are the input data, and the larger dots are the codebook vectors. In this example, the vector v_i is quantized as vector c_k. In other words, if vector v_i is

[7] This definition is not unique. In some application, it is convenient to assume an infinite number of vectors v_i drawn according to a fixed but unknown distribution. For current purposes, the definition I am giving is more appropriate.

Figure 6.11. Schematic description of a vector quantizer.

presented in input, the code vector c_k is produced in output. Formally, the quantization function Q can be defined as

$$Q(v) = c_k \text{ iff } d(v, c_k) < d(v, c_i) \; \forall i \neq k \qquad (6.355)$$

where d is a suitable metric in the vector space. The presence of d in the definition of the quantization function is what makes vector quantization particularly interesting in this case, because the coefficients of the image transforms are, indeed, elements of a metric space.

The polygon V_h shown in gray in Fig. 6.11 is the set of points quantized to c_h:

$$V_h = \{v : Q(v) = c_h\} \qquad (6.356)$$

This set is called the *Voronoi polygon* of c_h.

The whole problem of vector quantization is, understandably enough, to derive a "good" codebook C. Better yet, one would like to obtain an optimal codebook C—a codebook that, among all the codebooks of equal size, minimizes predefined error measures. There are a number of *codebook design* algorithms. Most of them are at a level of sophistication not needed here. I will present a simple and very well-known algorithm: the *Linde-Buzo-Gray* (LBG) algorithm [Sayood, 1996].

The LBG codebook design is very similar to another well-known algorithm: the k-means algorithm, used for data clustering [Jain and Dubes, 1988]. Given a large number of vectors (the *training set*), and an initial hypothesized codebook, assign each vector in the training set to the closest code vector. After this assignment is done, move the codebook vectors, placing each of them at the centroid of the set of vectors that use it as a code. Repeat until the error stabilizes.

Like other similar algorithms, LBG tries to minimize a suitable error measure. If the vector v_i (with components v_{ij}) is approximated by the code vector

c_k (with components c_{kj}), the error measure between the two is defined as a function $f(v_i, c_k) \in \mathbb{R}$. The function f must be greater than or equal to zero, with $f(x, x) = 0$ for all x and $f(x, y) > 0$ if $x \neq y$. Common error functions are the L^2 (least squares) error

$$f(v_i, c_k) = \left[\sum_j (v_{ij} - c_{kj})^2 \right]^{1/2} \tag{6.357}$$

the L^1 error

$$f(v_i, c_k) = \sum_j |v_{ij} - c_{kj}| \tag{6.358}$$

and the L^∞ (uniform approximation) error

$$f(v_i, c_k) = \max_j |v_{ij} - c_{kj}| \tag{6.359}$$

If the space to which the vectors belong is not Euclidean, a slightly more general formulation is necessary. For every distance d defined in the space of the vectors, one can define $f(v_i, c_k) = d(v_i, c_k)$. The three error functions given in the preceding are obviously obtained for vector spaces with the L^2, L^1, and L^∞ distances, respectively.

The complete LBG algorithm is the following:

1. Start with an initial codebook $\{c_k, k = 1, \ldots, M\}$ and a training set $\{v_i, i = 1, \ldots, N\}$. Set $k = 0$, $D^{(0)} = 0$. Select a positive threshold ϵ.

2. Assign each vector v_i to the closest code vector $c_k = Q(v_i)$. Set

$$V_k = \{v_i : Q(v_i) = c_k\} \tag{6.360}$$

 Assume, for the moment, that no quantization region V_k is empty. (I will deal with the problem of empty quantization regions in a moment.)

3. Compute the average distortion

$$D^{(k)} = \frac{1}{N} \sum_{i=1}^{N} f(v_i, Q(v_i)) \tag{6.361}$$

 where f is a distortion measure (e.g., one of the measures introduced above).

4. If

$$\frac{D^{(k)} - D^{(k-1)}}{D^{(k)}} < \epsilon \tag{6.362}$$

 stop; otherwise continue.

5. Set $k \leftarrow k + 1$. Compute the new codebook. The new location of the code vector c_k is given by

$$c_k = \frac{1}{|V_k|} \sum_{v_i \in V_k} v_i \tag{6.363}$$

This algorithm can be applied to the points in the space $\mathfrak{I} \times \mathcal{C}$, obtaining an approximation of the image with an arbitrary number of coefficients.

6.4.2 Quality of Representation

Representing a transform by vector quantization entails an approximation and, therefore, in a rather general sense, a loss of quality in the representation. The concept of "quality of representation" is used here in a rather informal sense. Defining it formally requires considering all possible image associations that a user might want to make. In a database, these associations are obtained by changing the characteristics of the distance function that acts on a fixed representation.

The quality of representation could be defined in the abstract as the number of semantically meaningful associations that can be based on the representation, assuming the arbitrariness of the selection of the distance. This definition, in addition to being fraught with severe theoretical problems, is scarcely operative. For the purposes of this section, I will simply consider the capacity of reconstructing the image as a measure of the quality of representation. This definition too is far from perfect but it is quite reasonable and, if nothing else, leads to a simple experimental evaluation.

The experiment I consider uses a set of 2000 images. Each image is normalized to a size 256×256, and the complete frame decomposition is computed, with frames generated using the "Mexican hat" function

$$\psi(x) = (1 - \|x\|^2) \exp(-\|x\|^2) \tag{6.364}$$

The frame is generated using a discrete subgroup of the affine group "$ax + b$" characterized by $a = 2^m$, $b = n$ ($m, n \in \mathbb{N}$). This generates the family of functions

$$\psi_{m,(n_1,n_2)} = \psi(2^{-m}(x - [n_1, n_2])) \tag{6.365}$$

This family of functions composes a frame with $A = 3.223$ and $B = 3.596$. Note that $B/A = 1.11$, so the simple base-like reconstruction formula will lead to a certain reconstruction error.

In order to evaluate the reconstruction error, the 2000 images are transformed and reconstructed. The differences between the original and the reconstructed images are then measured as the average squared pixel/pixel difference.

As reconstruction is not perfect, there will be an error, which I call the *inherent error* e_∞ due to imperfect reconstruction of the frame. When vector quantization is used in order to to reduce the number of coefficients to n, there will also be a *total error* e_n, due both to the imperfect frame reconstruction and to the error due to the vector quantization approximation.

The results of Fig. 6.12 show three curves. The first is the total error, plotted against the size of the codebook for vector quantization. The horizontal line is the inherent error, which obviously is independent of the codebook size. The third curve represents the *relative error*, defined as

$$\rho(n) = \frac{e_n - e_\infty}{e_\infty} \tag{6.366}$$

Figure 6.12. Inherent error, total error, and relative error for a sample of 2000 images.

Note that the total error is about the same order of magnitude as the absolute error.

This graph does not provide a good indication of how well the representation would work in an image database. To do this, it is necessary to use a database-related measure, such as the weighted displacement, which was defined in section 3.3.1.

Figure 6.14 shows the results a test that uses 20 images taken at random from the database. The distance between images is defined simply as the sum of the

Figure 6.13. Image reconstruction. Original (a), reconstruction from full frame transform (b), and reconstruction with 20 (c) and 100 (d) coefficients.

Figure 6.14. Weighted displacement for the reconstructed images.

pixel-by-pixel squared errors. This measure is a bit unfair: From the example of
Fig. 6.13 it is clear that some of the "high level" structures are maintained even
in reconstructions from a very limited number of coefficients, while the color of
single pixels can be wrong. Note, however, that even with a relatively small number
of coefficients, the weighted displacement is less than 3, indicating that either a
few important images are displaced not too far from their intended location, or
that a number of nonrelevant images are displaced.

6.4.3 Approximate Distance Computation

According to the methodology developed in this chapter, starting from the con-
tinuous function $f : \mathfrak{G} \to C$, one can use a discrete subgroup of \mathfrak{G} to generate a
frame decomposition of the image, and then use vector quantization to reduce the
function to a relatively low number of parameters. The usefulness of the approx-
imate representation, however, rests on the possibility of extending the distance
measure defined so far to work on the new representation. This will require, of
course, accepting some approximation in the distance computation.

I will start with a discrete image that has not been quantized yet. The discrete
transform of an image can be described as a generalized matrix indexed by the
elements of the indexing group or system \mathfrak{I}, and with elements in C (or in some
suitable discretization of the color space). The group \mathfrak{I} can be endowed with a
distance function $d_{\mathfrak{I}}$ derived from the group \mathfrak{G}, which generates the continuous
transform. Consider now two elements of the matrix, χ_i and χ_j, with $i, j \in \mathfrak{I}$, and
$\chi_i, \chi_j \in C$. The distance between these two elements is given by Eq. (6.306):

$$\tilde{d}(\chi_i, \chi_j) = \phi(d_{\mathfrak{I}}(i, j), d_C(\chi_i, \chi_j)) \tag{6.367}$$

Note that a symbol like χ_i is used here in two slightly different meanings. On the
left-hand side of the equation, χ_i is an element of the matrix, placed in a position

given by the index i, while on the right-hand side of the equation, the symbol χ_i is used to indicate the value assumed by that element. This slightly ambiguous use of the matrix elements is very common, and should not be a problem. It will also save me some complications in an already quite complicated notation.

The distance between an element of a matrix A and the matrix B is

$$\tilde{d}(\alpha_i, B) = \inf\{d(\alpha_i, \beta_j), j \in \mathfrak{J}\} \tag{6.368}$$

and the distance between two matrices A and B is

$$d(A, B) = \frac{1}{\|A\|} \sum_{i \in \mathfrak{J}} d(\alpha_i, B) \tag{6.369}$$

So far so good—nothing really new happened. I have simply redefined the distance equation (6.306) using the indices in \mathfrak{J} instead of the elements \mathfrak{g} of the group \mathfrak{G}.

I now introduce vector quantization. After quantization, an image is represented by a series of Voronoi polygons in the space $\mathfrak{J} \times C$, and each Voronoi polygon is represented by a "placeholder," that is, by its code vector. This makes things quite complicated because Voronoi polygons are not represented explicitly. In other words, there is no explicit memory structure that contains the boundary of a given polygon. These boundaries are given by the position of the centroid and the position of *all the other centroids of the other Voronoi polygons resulting from the quantization.* It will be necessary to introduce approximations in order to make the problem tractable.

I will start with an idealized case and then work my way to a more realistic one. An image is represented by a set of Voronoi polygons that cover all \mathfrak{G}; each polygon has associated a color in C (i.e., the color of its representative point). Consider two images A and B, duly encoded and assume, for the moment, that *the Voronoi polygons of A and B coincide.* In other words, A and B have the same "map" on \mathfrak{G}, and differ only for the colors of the polygons (see Fig. 6.15). Looking at the images "from above" (abstractly, projecting them on \mathfrak{G}) one would see only one set of Voronoi polygons.

These polygons (and their centroids, which are the only thing we physically have) are there to represent the whole transform. In a sense, the problem at hand is to compute the distance between the complete discrete transforms using these representative polygons. Here, when I talk about *finding the distance between two coefficients of the transform,* I mean the coefficients of the original (noncompressed) transform. In a sense, these are now "virtual" coefficients, which are present only through the representatives obtained by the vector quantization algorithm.

Consider now one of these "virtual" coefficients a_j of an image A, and the determination of the distance between this and image B. Consider first a generic "virtual" coefficient b_i of B. The distance between the two satisfies the relation:

$$\tilde{d}(a_j, b_i) = \phi(d_{\mathfrak{J}}(i, j), d_C(a_j, b_i)) \tag{6.370}$$

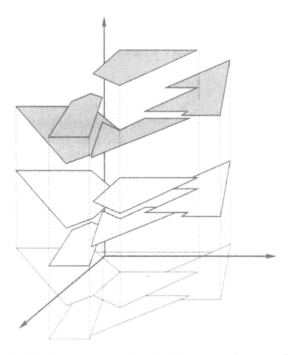

Figure 6.15. Idealized assumption for the Voronoi polygons of two images.

In addition there is a coefficient b_j of B such that $\pi_1(b_j) = \pi_1(a_j) = j$ (this is a consequence of the assumption that the Voronoi polygons coincide). The distance between the two is computed along the color space, and is

$$\Delta_j = d_C(a_j, b_j) \tag{6.371}$$

The distance between a_j and B is, at most, Δ_j.

Now let $b_\mathfrak{h}$ be the coefficient of B at a minimal distance from a_j, that is, the coefficient such that

$$\tilde{d}(a_j, b_\mathfrak{h}) = \min\{d(a_j, b_i) \,:\, i \in \mathfrak{I}\} \tag{6.372}$$

Note that it is necessary to find $b_\mathfrak{h}$ in order to compute the distance between a_j and B. The problem is, where can $b_\mathfrak{h}$ be? The obvious place to look for $b_\mathfrak{h}$ is around b_j, which has the same projection as a_j on the index system, so the question becomes, where can the index \mathfrak{h} be in relation to the index j? From the definition of distance and the fact that ϕ is strictly conservative, it is easy to see that it must be

$$d_\mathfrak{I}(j, \mathfrak{h}) < \Delta_j \tag{6.373}$$

This relation provides a range in which to look for the distance between the coefficient a_j and the image B. It is not necessary to explore all \mathfrak{I} (in other words, it is not necessary to explore the whole matrix in which B is represented), but only to analyze a sphere of radius Δ_j around the index j.

Consider two overlapping Voronoi polygons S_A and S_B belonging to images A and B, respectively. Take a point $a_j \in S_A$. According to the forementioned considerations, there is a point $b_j \in S_B$ such that $\pi_1(a_j) = \pi_1(b_j) = j$, and

$$\tilde{d}(a_j, b_j) = d_C(a_j, b_j) = \Delta \qquad (6.374)$$

Because the two Voronoi polygons have constant color, the value Δ does not depend on the particular point a_j, but is a constant depending only on the colors of the representatives of S_A and S_B. I call this the *color distance* between S_A and S_B. In addition to the color distance, I will need the following definitions:

DEFINITION 6.11. *Let $V = \{S_1, \ldots, S_V\}$ be the set of Voronoi polygons of an image, $S_k \in V$ and $a \in S_k$. The point a is at distance d from the border of S_k if*

$$d = \inf\{d_J(a, b) : b \notin S_k\} \qquad (6.375)$$

I will use the notation $\delta(a) = d$.

DEFINITION 6.12. *Let S_A and S_B be two overlapping Voronoi polygons with color distance Δ. A point $a \in S_A$ is internal if $\delta(a) > \Delta$, and is a boundary point otherwise. The interior of S_A, $\underline{S_A}$, is the set of internal points of S_A, and the border of S_A, \overline{S}_A, is the set of boundary points.*

LEMMA 6.8. *Let S_A and S_B be two overlapped Voronoi polygons with color distance Δ. If a is an internal point of S_A, then*

$$d(a, S_B) = \Delta \qquad (6.376)$$

The proof follows immediately from the definition and from the fact that ϕ is strictly conservative. The distance between S_A and S_B is

$$d(S_A, S_B) = \frac{1}{\|S_A\|} \sum_{a \in S_A} d(a, S_B) = \frac{1}{\|S_A\|} \left[\sum_{a \in \underline{S_A}} d(a, S_B) + \sum_{a \in \overline{S}_A} d(a, S_B) \right] \qquad (6.377)$$

Let $\varepsilon(S_A, S_B)$ be the average distance between the points in the border of S_A and S_B:

$$\varepsilon(S_A, S_B) = \frac{1}{\|\overline{S}_A\|} \sum_{a \in \overline{S}_A} d(a, S_B) < \Delta \qquad (6.378)$$

Then, because of the previous lemma,

$$d(S_A, S_B) = \Delta + \frac{\|\overline{S}_A\|}{\|S_A\|} \varepsilon(S_A, S_B) \qquad (6.379)$$

Because of the bounds on ε, it is

$$\Delta \leq d(S_A, S_B) \leq \left(1 + \frac{\|\overline{S}_A\|}{\|S_A\|}\right) \Delta \qquad (6.380)$$

If $\|\overline{S}_A\| \ll \|S_A\|$, then

$$d(S_A, S_B) \approx \Delta \qquad (6.381)$$

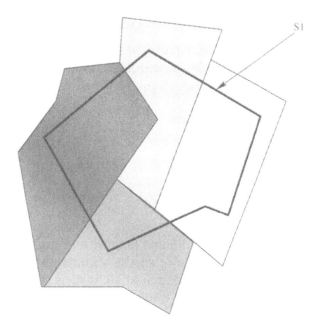

Figure 6.16. More realistic Voronoi polygons of two images.

The assumption that the Voronoi polygons are overlapped is grossly inadequate. If the Voronoi polygons are projected on the group \mathfrak{G}, the situation appears more like that of Fig 6.16. The polygon S_1 belonging to the image A overlaps the polygons R_1, R_2, \ldots, R_n belonging to B. How much does every polygon R_i overlap S_1? One can make a simple assumption: The degree by which two Voronoi polygons overlap depends only on the distance between their centroids. If S is a region, let \hat{S} be its centroid. Then the overlap between the polygon S of image I_1 and the polygon A of image I_2 depends only on $d_{\mathfrak{G}}(\pi_1(\hat{S}), \pi_1(\hat{A}))$. Let S be again a polygon of I_1, and order all the polygons of I_2 in order of increasing $d_{\mathfrak{G}}(\pi_1(\hat{S}), \pi_1(\hat{A}))$. That is,

$$d_{\mathfrak{G}}(\pi_1(\hat{S}), \pi_1(\hat{A}_i)) \le d_{\mathfrak{G}}(\pi_1(\hat{S}), \pi_1(\hat{A}_{i+1})) \tag{6.382}$$

Let ρ_i be the fraction of the area of S that is overlapped by the first i polygons A_1, \ldots, A_i. Also, let $d_i = d_{\mathfrak{G}}(\pi_1(\hat{S}), \pi_1(\hat{A}_i))$. Assume that if there is a polygon with the centroid in the same position as the centroid of S, then this polygon overlaps all S. That is, if $d_1 = 0$, then $\rho_1 = 1$ (and, of course, $\rho_i = 1$ for all i). If this does not happen, the first polygon will take a fraction $f(d_1)$ of the area of S_1. The ith polygon will similarly take on a fraction $f(d_i)$ of the area not already occupied by the previous $i - 1$ polygons. This means that

$$\rho_i = \rho_{i-1} + f(d_i)(1 - \rho_{i-1}) \tag{6.383}$$

with $\rho_0 = 0$. The first thing one needs to make sure of is that the fraction of the area covered by n Voronoi polygons never exceeds 1:

LEMMA 6.9. *If ρ_i is given by Eq. (6.383) and $f(d_i) \leq 1$ then $\rho_i \leq 1$ for all i.*

PROOF. The proof is by induction. First, $\rho_1 = f(d_1)$ (the fraction of the area occupied by the Voronoi polygon whose centroid is closer to that of S_1), which, by hypothesis, is < 1. Assume now that all $\rho_i \leq 1$ for all $i \leq k$. Then $(1 - \rho_k) \geq 0$, and, as $f(d_{k+1}) \leq 1$, it is

$$f(d_{k+1})(1 - \rho_k) \leq (1 - \rho_k) \qquad (6.384)$$

therefore,

$$\rho_{k+1} = \rho_k + f(d_{k+1})(1 - \rho_k) \leq \rho_k + (1 - \rho_k) = 1 \qquad (6.385)$$

\square

In general, it is desirable that a limited number of Voronoi polygons A_i will cover S_1 completely. Thus, let us say that the Voronoi polygons A_i such that $d_{\circledcirc}(\pi_1(\hat{S}), \pi_1(\hat{A}_i)) > \Delta_0$ will not overlap S_1 at all. If A_k is the last polygon such that $d_{\circledcirc}(\pi_1(\hat{S}), \pi_1(\hat{A}_k)) \leq \Delta_0$, then the whole of S_1 should be covered by the first k polygons A, that is, it should be $\rho_i = 1$ for $i \geq k$. How to obtain this is explained by the following lemma:

LEMMA 6.10. *$f(d_k) = 1$ then $\rho_i = 1$ for all $i \geq k$.*

PROOF. The result derives immediately from the recursion that, if $f(d_k) = 1$, then $\rho_k = 1$. Then, by induction:

$$\rho_{k+1} = \rho_k + f(d_{k+1})(1 - \rho_k) = \rho_k = 1 \qquad (6.386)$$

If all the $\rho_i = 1$ with $k \leq i \leq h$, then

$$\rho_{h+1} = \rho_h + f(d_{h+1})(1 - \rho_h) = \rho_h = 1 \qquad (6.387)$$

\square

A simple way to obtain this is to have $f(d)$ increasing with d and reaching a plateau with value 1 when $d > \Delta_0$. This means that Voronoi polygons A_i that are farther away from S_1 will take up a progressively increasing portion of the remaining area. Let us assume, for instance, that $f(d_1) = 0.3$ and $f(d_2) = 0.4$. The first Voronoi polygon A_1 will take up 30% of the area of S_1, while the second polygon, A_2 will take up 40% of the remaining area. One would like, however, that *in absolute terms*, the area that A_1 takes up be bigger than the area that A_2 takes up. The fraction of the area that A_1 takes up is 0.3, while the fraction of the area that the second polygon takes up is $(1 - 0.3) \times 0.4 = 0.7$.

The total fraction of the area that the ith polygon takes up is

$$\alpha_i = \rho_i - \rho_{i-1} = f(d_1)\left(1 - \sum_{j=1}^{i-1} \alpha_j\right) \qquad (6.388)$$

which can also be expressed entirely in terms of the f_i's as

$$\alpha_n = f(d_n) \left[1 - \sum_{k=1}^{n-1} f(d_k) \prod_{j=1}^{k-1} (1 - f(d_j)) \right] \tag{6.389}$$

A trivial way to ensure that the α_i are decreasing is to have $f(d_i) > 1/2$: if every polygon takes more than half the remaining area of S_1, you can be sure that the next polygon will take less! Since it must also be $f(0) = 1$, I use a function that decreases from 1 to a certain value $\eta > 1/2$ as d goes from 0 to $\lambda \Delta_0$ ($\lambda < 1$), and then increases to 1 as d goes from $\lambda \Delta_0$ to Δ_0. I use the function

$$f(d) = \begin{cases} 1 - (1 - \eta)\frac{d}{\lambda \Delta_0} & \text{if } d \le \lambda \Delta_0 \\ h + (1 - \eta)\frac{d - \lambda \Delta_0}{(1 - \lambda)\Delta_0} & \text{if } \lambda \Delta_0 < d \le \Delta_0 \\ 1 & \text{if } d > \Delta_0 \end{cases} \tag{6.390}$$

with $\eta = 1/2$, $\Delta_0 = 1/2$, and $\lambda = 0.1$. It turns out that this estimate is too conservative—in most cases a value $\eta = 0.4$ or $\eta = 0.3$ would do. However, as the exact value seems to have little influence on the final result, there is little point in finding a stricter bound.

If one nevertheless needs a stricter bound, the thing is complicated. Using the expression for α_n, and writing $f(d_i) = f_i$ for simplicity, the condition translates to:

$$f_n \left[1 - \sum_{k=1}^{n-1} f_k \prod_{j=1}^{k-1} (1 - f_j) \right] \le f_{n-1} \left[1 - \sum_{k=1}^{n-2} f_k \prod_{j=1}^{k-1} (1 - f_j) \right] \tag{6.391}$$

which, after some manipulation, becomes:

$$\frac{1}{f_n} \ge \frac{1}{f_{n-1}} \left[1 - \frac{f_{n-1} \prod_{j=1}^{n-2}(1 - f_j)}{1 - \sum_{k=0}^{n-2} f_k \prod_{j=1}^{k-1}(1 - f_j)} \right] = \frac{1}{f_{n-1}} \left[1 - \frac{Y_{n-1}}{1 - \sum_{k=0}^{n-2} Y_k} \right] \tag{6.392}$$

where

$$Y_k = f_k \prod_{j=1}^{k-1}(1 - f_j) \tag{6.393}$$

The condition is satisfied if

$$0 \le \left[1 - \frac{Y_{n-1}}{1 - \sum_{k=1}^{n-2} Y_k} \right] \le 1 \tag{6.394}$$

Because $0 \le f_i \le 1$, it is $Y_k \ge 0$. The condition then requires

$$1 - \sum_{k=1}^{n-2} Y_k \ge Y_{n-1} \tag{6.395}$$

or

$$\sum_{k=1}^{n} Y_k \le 1 \tag{6.396}$$

for all n. Writing this as

$$f_n \prod_{j=1}^{n-1} (1 - f_j) + \sum_{k=1}^{n-1} Y_k \leq 1 \tag{6.397}$$

one obtains the condition

$$f_n \leq \frac{1 - \sum_{k-1}^{n-1} Y_k}{\prod_{j=1}^{n-1} (1 - f_j)} \tag{6.398}$$

It is very difficult to determine which functions satisfy this bound for all possible choices of d_i. One can, however, opt for a practical compromise: Define a "sensible" function f that should not cause problems most of the time, and use Eq. (6.397) to check the newly computed values and, if necessary, correct them.

At this point, if Δ_i is the color distance between S_1 and the Voronoi polygon A_i, the distance of S_1 from image A is simply

$$d(S_1, A) = \sum_{i:d_i < \Delta_0} \alpha_i \Delta_i \tag{6.399}$$

If the image S is composed of the polygons $\{S_1, \ldots, S_m\}$, the distance between the two images is

$$d(S, A) = \frac{1}{m} \sum_{j=1}^{m} d(S_i, A) \tag{6.400}$$

With this equation we can obtain an approximate estimate of the "true" distance between the two images. The complete algorithm for the computation of the distance is as follows:

Distance algorithm.

 1. Images A and B are represented by the list of centroids of Voronoi polygons

$$\{A_1, \ldots, A_m\}$$

and

$$\{B_1, \ldots, B_m\}$$

and by the associated lists of colors

$$\{\mathcal{A}_1, \ldots, \mathcal{A}_m\}$$

and

$$\{\mathcal{A}_1, \ldots, \mathcal{B}_m\}$$

We are also given the distance function $d_\mathcal{C}$ in the color space and the distance function $d_\mathfrak{G}$ in the transformation group. Set $d = 0$.

2. For all polygons A_i:

 (a) Sort the centroids $\{B_1, \ldots, B_m\}$ in order of increasing distance d_\oplus from A_i. Let $\{B_{p_1}, \ldots, B_{p_m}\}$ be the resulting permutation. Set $d_k = d_\oplus(A_i, B_{p_k})$.

 (b) Set

 $$d \leftarrow d + \sum_{k:d_k < \Delta_0} d_C(A_i, B_{p_k}) \qquad (6.401)$$

3. Set $d \leftarrow d/m$

The computationally more intensive part of this algorithm is to sort all the centroids B in order of increasing distance from every centroid in A. If the representation has N Voronoi polygons, this requires N sortings, for a total of $N^2 \log N$ operations. This is a powerful reason to keep the number of regions low!

The problem actually might not be that bad, because the positions of the polygons in the space are fixed once and for all. Distance computation requires essentially finding the k closest neighbors, and there are a number of efficient algorithms for this problem either exact or approximate, that will be presented in Chapter 9.

7

Writing About Images

... consideré la posibilidad de un linguaje que ignorara los sustantivos, un linguaje de verbos impersonales o de indeclinable epítetos.

Jorge Luis Borges, *El Imortal*

In 1996 a serious earthquake hit the region of *Umbria*, in central Italy. The earthquake produced dozens of victims and damage to the inestimable artistic patrimony of the region. The most significant work damaged by the seism was the magnificent *ciclo* of frescoes in the *basilica superiore* in the town of Assisi, the birthplace of Saint Francis. The frescoes were painted by Giotto, probably the greatest pictorial genius that the middle ages ever produced, and who narrated the life of Saint Francis and the early years of the monastic order he founded.

Cicli of frescoes like this were not uncommon in the iconography of the Catholic church, and were used mainly for the edification and instruction of the largely illiterate peasantry. Frescoes told the story of Jesus and the apostles, and illustrated church doctrines. To this day, this form of art is used in the yearly ritual of the *via crucis*, in which a series of 14 "stations" of the cross containing iconographic material is traversed during the telling of the story.

The Catholic attempt to educate and inform through image was unequaled until this century in the western world. Reformed religions, in the sixteenth century, were talking to a more literate bourgeoisie, and did not need to rely so much on icons. This characteristic is behind the unforgettable metaphor by Umberto Eco, (2000) according to which the Macintosh—with its sumptuous icons and its promise that everybody can reach his/her goal—is catholic, while DOS is protestant: "it allows free interpretation of scripture, demands difficult personal decision ... and takes for granted that not all can reach salvation."

Still, images cannot tell everything. Much like icons are a more limited language than linguistic abstractions, images can only relate to the concrete and the immediate. Image interpretation requires a context that is better provided by text. It may be possible to identify a bunch of people on the side of the road. It may not even be logically impossible to detect a waiting expression on some of the faces. But to know that those people are waiting for the liberation of Nelson Mandela after 26 years in jail requires information beyond that contained in the picture. At least the location and date of the picture, and a general knowledge of contemporary history are additionally required.

On a number of occasions it makes sense to extract features from the text accompanying a picture. Using text requires that a human operator enter a description of an image. Due to this requirement, search by description has traditionally been considered a very expensive operation and not a viable option for databases with large quantities of images. This observation is, in general terms, true. Not only does the description of an image require human intervention, it often requires the intervention of rather specialized personnel. In the previous example of the crowd waiting for the liberation of Nelson Mandela, it would be useful to have a description outlining the significance of the event. It is not just the liberation of a prisoner (after all, prisoners are released every day without crowd), but a significant shift in the political balance of a country, and a symbolic event for civil rights throughout the world. The event per se is much less significant than the chain of changes in which it was framed, all of which might be relevant for a search including that particular image. Entering this kind of information requires a certain social and historical sensibility that not everybody possesses. The requirement for well-educated personnel makes the practice of assigning fragments of text to image all the more expensive.

In addition to this, many significant images do not have, as I mentioned in Chapter 2, a meaning per se, but receive one through three different modalities of signification, one of which relies explicitly on the association between images and a textual discourse. This opens the possibility that a single image can have multiple interpretations. The choice between different interpretations depends on the context of a query and on the personal characteristics of the author of the query but, in any case, the relation between different interpretations is something new and typical of image databases, something which is not modeled by the traditional methods of information retrieval. Information retrieval deals mainly with texts, and a piece of text is already the product of a set of circumstances and of a particular point of view. Image retrieval deals with images, which are, to a considerable extent, neutral with respect to the different interpretations, and can support many of them, possibly each very different. The relation between the different interpretations of the image is not a simple superposition because, in many cases, it is impossible to endorse all of them. One can see a picture of German reunification as a historical landmark in the unification of eastern and western Europe, or one can see it as an example of the haste and superficiality

with which western Europe dealt with eastern Europe shortly after the fall of communist governments. In general, one person will not hold both points of view. The different interpretations cannot be seen as contradictory because both, in a sense, are true. True, at least, in the sense that there are people for which each one of them is true. The relation in question is something new and unique deriving from the association of images and text.

This chapter will take a gradual approach to the problem. At first I will make the simplifying assumption that there is *one* text which, for all practical purposes, explains or comments on the contents of a given image. This takes the problem into the well-studied realm of information retrieval. The first two sections of this chapter will be an overview of information retrieval techniques, limited to the aspects of the discipline that are most relevant to work in image databases. Then, the various problems deriving from the association of text to images will be considered. The chapter will close on a more exquisitely technical note by considering a common scenario in which images can be automatically (or, more properly, semiautomatically) associated to text: harvesting images from pages on the World Wide Web.

7.1 Automatic Text Analysis

If it is possible to presume the existence of a network of texts that describes exactly what an image is about, the image retrieval problem translates to the following: How is it possible to access a piece of text based on its contents?

The general philosophy in attacking this problem is the same as in Chapter 5—the text is represented by formally defined *identifiers* that characterize it, and upon which suitable similarity measurement and search algorithms operate.

It is useful to distinguish between *objective* and *nonobjective* identifiers. Objective identifiers contain information that includes the author of a document, its publication date, its length, and other things usually not subject to dispute. Nonobjective identifiers contain information about the contents of the document, and are less stable and more open to dispute. In general, if one asks a number of people to describe the contents of a document, one expects them all to come up with the same objective identifiers (if they do not, we think that there might be something wrong with them—either they do not know that particular piece of information, or they are confused), but one does not expect them to come up with the same nonobjective identifiers. Needless to say, nonobjective identifiers are the harder to extract automatically and the more interesting.

In most information retrieval systems, the contents of a document are represented by a nonobjective identifier called an *index*, usually consisting of a set of *index terms*. In addition to the index terms, the index can contain information about the relevance of the terms for the description of the document content (*terms weights*), or the influence of a term on other terms of the index (*term relationships*).

Terms are words extracted from a vocabulary that can be either *controlled* or *uncontrolled*. When a controlled vocabulary is used, the set of words that can be used to compose indices is determined a priori, and does not change for the whole database. The presence of a fixed set of terms also allows in many cases the definition of precise guidelines for assigning terms to documents, resulting in very consistent indices, and a uniform indexing quality. Controlled vocabularies are rather common for manual indexing (as made in libraries, for instance), but are rather difficult to apply to automatic indexing methods. The reason for this is that most automatic methods use a subset of the document as index and, unless the vocabulary of the documents is restricted to begin with, it is difficult to ensure that the vocabulary of the index will be.

Many common indexing methods are *single term*. That is, an index is a set of terms considered individually, without taking into account the possible relations between terms. Each term is supposed to convey some information about the contents of the document, and this information is conveyed no matter what other terms are present. On the contrary, in *terms in context* methods some indicator of the relationship between terms is available. In this case, the presence of a given term can reinforce or attenuate the significance of another term to which it is related.

Indices and terms are usually evaluated by their *exhaustivity* and *specificity*. The exhaustivity of an index measures the degree to which all the aspects of the subject matter in a text are recognized and represented in the index. Specificity measures the breadth or narrowness of the coverage of a single term. Broad terms cover vast areas of the semantic space, and can retrieve a large number of documents, but in general cannot isolate very well the relevant documents from the nonrelevant. Narrow terms retrieve relatively few items, which are highly relevant to the query in question, but can leave out material that the user would also consider relevant. In terms of the precision and recall measures introduced in Chapter 3 (Eqs. 3.1 and 3.2), using very broad terms results in high recall and low precision, while using very narrow terms results in high precision and low recall.

Table 7.1 contains definitions that will be used throughout the chapter.

7.1.1 Single Term Indexing

In a sense, it can be said that automatic information retrieval begins with the hypothesis that the frequency of a word in a text provides a measure of the word significance. The measurement should not only consider such frequency, but also the rank order of a word among all the words that constitute the text [Luhn, 1958]. A well-known empirical principle, Zipf's law [Zipf, 1949], states that the product of the frequency of use of words times their rank order is approximately constant. This allows one to define two cut-offs for the determination of significant words in a fragment of text (Fig. 7.1). The portion of the graph on the left of the upper cut-off (the name refers to the fact that the portion on the left contains high frequency

Table 7.1. Definitions of symbols used in this chapter

Symbol	Meaning
N	The number of documents in the database
M	The size of the dictionary used for indexing
D_d	The dth document in the database
T_t	The tth term in the dictionary of terms used in indexing
R	The number of documents relevant for a given query
df_t	The term frequency for T_t: the number of documents in which T_t appears as a term
$tf_{d,t}$	The term frequency of term T_t in document D_d, that is the number of times term T_t appears in document D_d
tn_t	Total number of occurrences of the term t in the collection
l_d	Length of document D_d
\bar{l}	Average document length in the collection

words, although the sheerly visual point of view, the term "lower cut-off" would fit better) contains very common words, like "the," "and," and so on, which give no indication of the topic of the text simply because they will be found in any text, irrespective of their topics. They are, in other terms, too broad. The portion

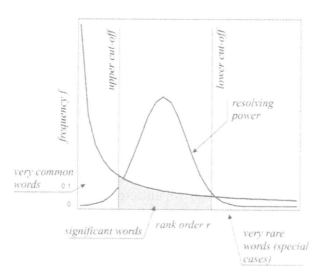

Figure 7.1. A plot of the hyperbolic relation between word frequency and word ranking, and of the resolving power of significant words.

of the graph at the right of the lower cut-off, on the other hand, contains words that are so specific that each one of them will probably single out just one text. They are too narrow. The resolving power of a word (i.e., its ability to discriminate content) reaches a peak at a position roughly midway between the two cut-offs. The observation, unfortunately, gives no indication as to how the cut-off values should be set. The general principles on which Fig. 7.1 is based, however, give rise to a number of solutions of practical applicability, in particular for the assignment of *weights* to term, as will be discussed in the following. The same observations are also at the origin of the following algorithm for the derivation of an index.

In most cases, three dictionaries are given: a dictionary C_1 of very common words in a given language, a dictionary S_1 of common suffixes, and a dictionary X_1 of exceptions to the suffixes. In the case of English, the first dictionary would contain words like *and, of, from*, and so on. The second would contain fragments like *-ed, -ness, -ing, -ity*, and so on, and the third would contain exceptions like *pity* which, in spite of ending with *-ity* is not a derivative word like, for example, *polarity*.

ALGORITHM 7.1. C_1 *is the dictionary of common words,* S_1 *the dictionary of suffixes, and* X_1 *a dictionary of exceptions to the suffixes.*

$I \leftarrow \text{index}(W)$
1. $I \leftarrow \varnothing$.
2. while $W \neq \varnothing$
3. Take a word $w \in W$; $W \leftarrow W - \{w\}$.
4. if $w \notin C_1$
5. if there is a suffix v of w such that $v \in S_1$ then
6. if $w \in X_1$
7. $I \leftarrow I \cup \{w\}$
8. else (if $w \notin X_1$)
9. $w' \leftarrow w - v$
10. $I \leftarrow I \cup \{w'\}$
11. else
12. $I \leftarrow I \cup \{w\}$

The operation in steps 5–10 is known as a *stemming* and, although it has been given a rather superficial treatment here, it is a very delicate part whose feasibility depends a lot on the language in which the text is written.

Loosely speaking, languages can be divided into two categories, *inflected languages* and *noninflected languages*. An inflected language, like Spanish or Italian, uses suffixes to "modulate" the words, express their relation with the other words, and fit together the various parts of the speech. Noninflected languages use word position and word modifiers to achieve the same result. English is not a very inflected language, although there is some residual inflection in the conjugation of the past tense or of the third person of the present tense of verbs. Latin, on the other hand, is a very inflected language, which uses suffixes to completely

specify the function of a word in a sentence. In English, for instance, the sentences *Hannibal eats the girl* and *The girl eats Hannibal* have very different meanings (at least from the point of view of Hannibal and the girl, and who is eating whom!) In Latin, however, the sentences *Hannibal puellam devorat, Puellam Hannibal devorat, Hannibal devorat puellam,* and so on, have all the same meaning (which amounts to the fact that Hannibal is the eater, and the girl is the eatee), because the suffix "-am" in the word *puellam* indicates that the word is the object of the sentence.

Similarly, English uses the word "will" to indicate that a verb is to be intended in the future tense, while Spanish uses suffixes like *-è*. The Spanish for *I speak* is *yo hablo,* and the Spanish for *I will speak* is *yo hablarè*. Spanish also uses suffixes to distinguish among the various subjects as well, so that the subject *yo* in the previous sentences is redundant, while pronouns are always necessary in English. Japanese is even less inflected than English, and uses words like *ka* to indicate a question, *wa* to indicate the matter that the sentence is considering, and so on.

Stemming is easier the less inflected the language is, because suffixes are seldom applied regularly, and can result in deep modifications of the root of the sentence. On the other hand, parsing a sentence is easier for more inflected languages, because the lexical analysis of a word gives indications on the function of that word in the sentence.

It is inevitable that stemming will produce errors. Fortunately, experiments have shown that the error rate tends to be of the order of 5% [Lovins, 1971]. A contribution to the robustness of stemming comes from the fact that irregularities are often produced by the prolonged use of a word, and are more pronounced the more common a word is (in English, verbs like *to be, can, to go* are irregular, while verbs like *calculate* or *photograph,* as well as lexical extravaganzas like *download* are regular). That is, specialized words, which encode most of the information about a piece of text, tend to be more regular and therefore easier to stem.

The previous algorithm has the limit of being excessively empirical, especially in its dependence on the dictionary C_1, and of not attempting to discard words that, although infrequent, bear no relevance to the topic of a text. A different approach to the determination of the relevant terms is based on assumptions about the statistical distribution of words in text [Salton, 1988; Van Rijsbergen, 1979]. The model distinguishes two types of words. *Function* words deal with the threading of the discourse or with themes of rather broad interest (introduction to a topic, switching from a topic to another, conclusions,...) rather than with a particular subject; *specialty* words carry the content of a particular piece of text [Harter]. The statistical model is based on the observation that function words are closely modeled by a Poisson distribution over all documents of a collection[1], while specialty words are usually not Poisson distributed. Given a corpus of texts and a function word *w*, then the probability that a given text will have *n*

[1] The argument can also be applied to multiple chunks of a same document.

occurrences of the word w is

$$f(n) = \frac{e^{-x}x^n}{n!} \tag{7.1}$$

where x is a parameter that varies from word to word and, for a given word, is proportional to the length of the text. Under the assumption that specialty words are the true vehicle of the content of a document, then every word that follows a Poisson distribution should be discarded from the index.

The rationale behind the use of these statistical distributions for indexing is that a document will be considered relevant to a query based on the relative extent to which the topic of the query is treated in the document and this, in turn, is measured by the number of occurrences in the document of words connected to the topic. Under this assumption, a document will be assigned the word w as a keyword only if the probability that the document will be judged relevant for a request containing the word w exceeds a certain threshold. To calculate this probability, it is necessary to determine the distribution of the specialty word w.

The probability distribution of w cannot be Poisson (for otherwise w would be a function word). Imagine that the specialty word w divides the corpus in several classes of documents, which are about the topic represented by w in different degrees (or, if you prefer, several classes distinguished by their different "aboutness" with respect to the topic w). Within each one of these sets, the word w does not carry any additional information and, therefore, its distribution should be Poisson (in other words, within each one of these classes, w is no longer a specialty word). The overall distribution of w can then be modeled as a mixture of Poisson distributions. Assume, for the sake of simplicity, that w divides the corpus into two sets—the set A of documents that are "very much about" the topic w, and the set \bar{A} of document that are "not much about" the topic w. Let p_A be the probability that a randomly chosen document will belong to the set A, then

$$f(n) = p_A \frac{e^{-x_1}x_1^n}{n!} + (1 - p_A)\frac{e^{-x_2}x_2^n}{n!} \tag{7.2}$$

where x_1 and x_2 are the mean occurrences of the word w for documents in A and \bar{A}, respectively. The probability of relevance of a document that contains k times the word w is

$$\rho(k) = \frac{p_A e^{-x_1}x_1^k}{p_A e^{-x_1}x_1^k + (1 - p_A)e^{-x_2}x_2^k} \tag{7.3}$$

The keyword w is added to the index of a document that contains it k times if $\rho(k) > \tau$, where τ is a predefined threshold. The value of the threshold is, as usual, a compromise. If τ is low, even documents that contain the word w a limited number of times will be assigned it as an index, resulting in high recall, but low precision. On the contrary, a large value of τ will result in the assignment of the word w as an index only to those documents that contain it many times. In this case, documents that could be relevant to the topic w might not be retrieved, resulting in high precision but low recall.

The basic assumption on which the method is based is also debatable, that is, that the massive presence of a word in a document means that the document is about a certain topic. This is generally true for specialty words but, if the document collection is broad, ambiguities introduce errors that can be solved only using relations between words, and this is particularly true for corpuses involving technical disciplines, that borrow massively from other fields: a document containing the word *windows* many times could be about computers or carpentry. To a more limited extent, this is also true for more traditional disciplines, for example, a document containing the word "culture" could be about agriculture, biology, or the pursuit of scholarly knowledge; a document containing the word "binding" could be about books or legal contracts, and so on.

7.1.2 Term Weighting

Automatically generated indices tend to contain a rather large number of terms, not all of which are equally relevant for the characterization of the contents of a document. *Weighting* is the operation by which numeric values are assigned to terms in order to capture their importance for the characterization of a document. As in the case of index assignment, the basic idea is to use the frequency of words in documents as a measure of their relevance.

The simplest solution is to assign to a word a weight proportional to its frequency in a document. That is, if the term T_t appears $tf_{d,t}$ times in document D_d, its weight will be $w_{d,t} = c_d tf_{d,t}$, for some suitable normalization constant c, for instance $c_d = (\sum_t tf_{d,t})^{-1}$. Weighting proportional to term frequency produces in general good recall, since if, for example, a document is about hermeneutics, the word "hermeneutics" will appear quite often. Proportional weighting, however, can lead to low precision. High precision requires the ability to discard nonrelevant documents. Terms assignment based on frequency counting leads to acceptable precision only if the distribution of the terms is very skewed—not many documents possess a given term. If T_t appears in df_t documents in a collection of N documents, then a good indication of the value of T_t as a discriminatory term is a decreasing function of df_t—terms that appear in only a few documents discriminate better than terms that appear in many documents. This measure is called the *inverted document frequency*, indicated as idf_t. There are several "flavors" of this measure, deriving from slight adjustments of the basic idea that work better in certain contexts. The most common are:

$$idf_t = \log_2 \frac{N}{tn_t} + 1 \qquad (7.4)$$

$$idf_t = \log_2 \frac{\max_t(n_t)}{tn_t} + 1 \qquad (7.5)$$

$$idf_t = \log_2 \frac{N}{df_t} \qquad (7.6)$$

$$idf_t = \log_2 \frac{N - tn_t}{tn_t} \qquad (7.7)$$

From the preceding observation, terms with a high value for indexing a particular document (and which therefore should be assigned a high weight) are determined to have the following two characteristics:

1. they appear in relatively few documents in the collection (low document frequency df_t); and

2. they appear many times in the document in question (high term frequency $tf_{d,t}$).

A typical function that assign weights to the terms using these criteria will give the term T_t a weight

$$w_{d,t} = tf_{d,t}\, idt_t \tag{7.8}$$

for document D_d, where idt_t is defined using one of the Eqs. (7.4)–(7.7).

Probabilistic weighting. The previous weighting models are based on rather empirical observations, without the guidance of an underlying model. In this section, I will present a model of term significance based on probability theory. Assume, as a start, that documents are described by binary attributes, that is, by the presence or absence of index terms[2]. A document is described by a vector $x = \{x_1, \ldots, x_M\}$ with $x_t \in \{0, 1\}$ where $x_t = 1$ if term T_t appears in the document, and $x_i = 0$ otherwise.

Distinguishing between relevant and nonrelevant documents entails the definition of two quantities, a *measure of relevance*—to order documents in order of relevance—and a *relevance criterion* that will provide a stopping criterion, that is, if the relevance of a document for a given query is less that a certain threshold, the document will be considered irrelevant. In order to compute these two quantities it is necessary to compute the probability that a document d is relevant *given a query Q*, that is, $P_Q(relevance \mid document)$. The relevance that appears in the previous expression is essentially semantics—it measures whether the *meaning* of the document will be relevant for the query Q given by the user. This type of relevance is not directly accessible, but I will assume that it can be determined based on measurements of the terms frequencies in a given document and, possibly, its relations with other documents. Note also that the probability P_Q is relative to a specific query Q. In the following, I will assume that the query Q is fixed beforehand and consequently I will omit the index Q. The dependency of the whole treatment on the specific query should always be kept in mind, however. I will return to this point towards the end of this section.

Assume that there are two mutually exclusive events:

$$\omega_1 : x \text{ is relevant}$$

$$\omega_2 : x \text{ is irrelevant}$$

[2] In reality, the *number of occurrences* of a term in a document is also to be taken into account. This will be done at the end of the section.

The problem can be formulated as a decision problem, estimating $\mathbb{P}(\omega_i|x)$, $i = 1, 2$. The quantities $\mathbb{P}(\omega_i|x)$ cannot be estimated directly but, via the Bayes theorem, one gets

$$\mathbb{P}(\omega_i|x) = \frac{\mathbb{P}(x|\omega_i)\mathbb{P}(\omega_i)}{\mathbb{P}(x)} \tag{7.9}$$

where $\mathbb{P}(\omega_1)$ is the prior probability of relevance, $\mathbb{P}(\omega_2)$ is the prior probability of irrelevance, and $\mathbb{P}(x) = \sum_i \mathbb{P}(x|\omega_i)\mathbb{P}(\omega_i)$ is the probability of observing x independently of its relevance. Given a decision rule to decide whether x is relevant based on $\mathbb{P}(\omega_i|x)$, the probability of error given a document descriptor x is

$$\mathbb{P}(e|x) = \begin{cases} \mathbb{P}(\omega_1|x) & \text{if } \omega_2 \text{ is decided} \\ \mathbb{P}(\omega_2|x) & \text{if } \omega_1 \text{ is decided} \end{cases} \tag{7.10}$$

The average error is given by $\mathbb{P}(e) = \sum_x \mathbb{P}(e|x)\mathbb{P}(x)$. This error is minimized if, for every x, Eq. (7.10) is minimized. This is done if, for every x, the decision ω_i that maximizes $\mathbb{P}(\omega_i|x)$ is made, leading to the following decision rule:

$$\text{if } \mathbb{P}(\omega_1|x) > \mathbb{P}(\omega_2|x) \text{ then } \omega_1 \text{ else } \omega_2 \tag{7.11}$$

There is still a problem to solve, that of estimating $\mathbb{P}(x|\omega_i)$. Mathematically, the most tractable solutions are obtained by making the (rather stringent) assumption that the components x_i of x are stochastically independent. In this case, it is possible to write

$$\mathbb{P}(x|\omega_i) = \prod_{t=1}^{M} \mathbb{P}(x_t|\omega_i) \tag{7.12}$$

Defining the variables $p_t = \mathbb{P}(x_t = 1|\omega_1)$ and $q_t = \mathbb{P}(x_t = 1|\omega_2)$, and noting that

$$\mathbb{P}(x_t = 0|\omega_1) = 1 - p_t, \quad \mathbb{P}(x_t = 0|\omega_2) = 1 - q_t \tag{7.13}$$

the conditional probabilities for x can be written as

$$\mathbb{P}(x|\omega_1) = \prod_{t=1}^{M} p_t^{x_t}(1 - p_t)^{1-x_t} \tag{7.14}$$

$$\mathbb{P}(x|\omega_2) = \prod_{t=1}^{M} q_t^{x_t}(1 - q_t)^{1-x_t} \tag{7.15}$$

Using Bayes theorem and the fact that all the quantities are positive, we can write the condition for the choice of ω_1 in the decision rule and Eq. (7.12) can be expressed as

$$\frac{\mathbb{P}(x|\omega_1)\mathbb{P}(\omega_1)}{\mathbb{P}(x|\omega_2)\mathbb{P}(\omega_2)} > 1 \tag{7.16}$$

that is, taking the logarithm and using the relations for the conditional

probabilities of x,

$$
\begin{aligned}
g(x) &= \log \prod_{t=1}^{M} \frac{p_t^{x_t}(1 - p_t)^{1-x_t}}{q_t^{x_t}(1 - q_t)^{1-x_t}} \frac{\mathbb{P}(\omega_1)}{\mathbb{P}(\omega_2)} \\
&= \sum_{t=1}^{M} \left[x_t \log \frac{p_t}{q_t} + \log \frac{1 - p_t}{1 - q_t} - x_t \log \frac{1 - p_t}{1 - q_t} \right] + \log \frac{\mathbb{P}(\omega_1)}{\mathbb{P}(\omega_2)} \\
&= \sum_{t=1}^{M} \left[\log \frac{p_t(1 - q_t)}{q_t(1 - p_t)} x_t + \log \frac{1 - p_t}{1 - q_t} \right] + \log \frac{\mathbb{P}(\omega_1)}{\mathbb{P}(\omega_2)} \\
&> 0
\end{aligned}
\tag{7.17}
$$

This is a linear discriminant function of the type

$$
g(x) = \sum_{t=1}^{M} \chi_t x_t + \zeta
\tag{7.18}
$$

with

$$
\chi_t = \log \frac{p_t(1 - q_t)}{q_t(1 - p_t)}
\tag{7.19}
$$

and

$$
\zeta = \sum_{t=1}^{M} \log \frac{1 - p_t}{1 - q_t} + \log \frac{\mathbb{P}(\omega_1)}{\mathbb{P}(\omega_2)}
\tag{7.20}
$$

Equation (7.18) has an interesting interpretation. The terms χ_t can be seen as weights that determine the relevance of term T_t for the characterization of the document *given the query* Q. The function g for a document can be computed simply by adding the weight of the terms that are present in the document to the constant ζ. The constant ζ itself can be seen as a cut-off criterion. The documents for which $\sum_t \chi_t x_t < -\zeta$ can be considered irrelevant and not returned.

The weights χ_t have been derived under the hypothesis that the feature vector was binary, that is, that terms either were or were not present in the document. As noted in the previous section, however, the number of occurrences of a term in a document is related to its diagnostic value. Using the same considerations that led to Eq. (7.8), the term T_t has for document D_d a weight

$$
c_{d,t} = t f_{d,t} \chi_t
\tag{7.21}
$$

In order to determine the value of these weights, one needs to determine the coefficients q_t and p_t that appear in Eq. (7.19). This determination is not easy because, as claimed repeatedly in the beginning of the section, all the considerations made so far are relative to a particular query. For instance, the number R of relevant documents is to be intended as the number of relevant documents for one specific query. If no a priori information is available, the coefficients q_t and p_t must be given some approximate values. In general, the number of relevant documents for a query is much less than the number of documents in the database, that is, $R \ll N$. In this case, q_t can be approximated by the probability of

occurrence of the term in the whole collection: $q_t \approx df_t/N$. The occurrence probabilities of terms in the few relevant documents can be assumed constant, for example, $p_t = 0.5$, which gives

$$\chi_t = \log \frac{N - df_t}{df_t} \tag{7.22}$$

The probabilistic analysis, therefore, results in the establishment of a weighting scheme which assigns to term T_t for document D_d a weight

$$c_{d,t} = tf_{d,t} \log \frac{N - df_t}{df_t} \tag{7.23}$$

7.1.3 The Vector Space Model

An alternative way to look at the weights attached to the terms of a document is to consider collections of weights as vectors in a suitable vector space. Consider a system in which indexing is obtained through the use of M terms T_1, \ldots, T_M. In the vector space model, these terms identify the axes of an M-dimensional coördinate system in the indexing space. A document D_d is represented by a vector $(c_{d,1}, \ldots, c_{d,M})$ where the element $c_{d,t}$ represents the occurrence of term T_t in the document. The weight $c_{d,t}$ can simply assume the values $\{0, 1\}$, representing the presence or absence of the term, or can assume numeric values reflecting the importance of the term for the characterization of the document using one of the weight assignment techniques of the previous sections.

A query Q is usually expressed as a set of terms that the user believes to be relevant for the topic he is looking for, and (possibly) a measure of the relative importance of these terms. In other words, a query is represented as a vector of weights (q_1, \ldots, q_M) assigned to terms. This is the same representation as that of a document. In other words, in the vector space model, a query is just another document made of terms and weights associated to these terms or, more precisely, a query is a vector in the same space as the documents, so that the same representation used for documents can be used for queries as well, and the distance between the query and a document will be computed using the same techniques used to determine the distance between documents.

Formally, the document D_d can be written as

$$D_d = \sum_{t=1}^{M} c_{d,t} T_t \tag{7.24}$$

The similarity between two vectors can be measured by the cosine of the angle between them, given by

$$\cos \theta(A, B) = \frac{\langle A, B \rangle}{\|A\| \|B\|} \tag{7.25}$$

Under the conventional assumption that singleton terms have unit length

$(\|T_j\| = 1)$, the similarity between a document and the query is given by

$$S(Q, D_d) = \frac{\sum_{t=1}^{M} c_{d,t} q_t}{\sqrt{\sum_{t=1}^{M} c_{d,t}^2 \sum_{t=1}^{M} q_t^2}} \tag{7.26}$$

This measure depends on the hypothesis that the terms are uncorrelated, that is, $\langle T_i, T_j \rangle = \delta_{ij}$.

This assumption allows a simple calculation of the similarity between a query and a document (or, equivalently, between two documents). Note that, at first sight, the task of representing documents and of measuring their distance may appear quite daunting, since they belong to a space of extremely high dimension (M is the size of the dictionary that, for large collections containing documents on many different topics, can easily consist of thousands of terms). In general, however, documents are represented by a relatively small set of terms. Let C_d be the set of terms that characterize document D_d and, for each $T_t \in C_d$ let there be an associated weight $c_{d,t}$. Similarly, let R be the set of terms in the query, and q_t the associated weights. Assuming without loss of generality that the weights of each document (and of the query) are normalized ($\sum_t c_{d,t} = 1$ and $\sum_t q_t = 1$), the distance between the query Q and document D_d is simply

$$S(Q, D_d) = \sum_{t: T_t \in R \cap C_d} c_{d,t} q_t \tag{7.27}$$

This equation implies that, in order to compute the similarity between Q and D_d, one needs to consider only the terms that the two have in common, multiply the corresponding weights in C_d and R, and add the results.

The assumption that the terms are independent, however, is obviously false. Not only is it false, but the analysis of the dependences between indexing terms can help in understanding the true dimension of the semantic space in which the meaning of a document can be indexed.

7.2 Latent Semantics

All the methods presented in the previous sections were based on the same underlying similarity principle, that is, two documents are similar (or, equivalently, a query and a document are similar) to the extent to which they contain the same terms (limiting the measurement to specialty terms). However, users look for documents based on their conceptual content, and word frequencies are at best a partial and unreliable indicator of the conceptual contents of a document. Given this situation, it is convenient to treat the problem of determining the conceptual content of a document as a statistical problem, in which the observed terms play the role of noisy statistical observations.

The method of latent semantics [Deerwester *et al.*, 1990] uses singular value decomposition (SVD) to derive a (relatively) low dimensional semantic space from the high dimensional terms space of the vector model.

In very broad terms, two issues lie at the root of all problems of term-based indexing approaches, *synonymy* and *polysemy*. *Synonymy* is the phenomenon by which two different words refer to the same concept. Strictly speaking, in the model of meaning considered in Chapter 2 there are no synonyms. Words that at first sight describe the same object differ almost always for extension or interpretation, the difference being sometimes speaker-related. At the level of definition allowed by the standard techniques of information retrieval, however, synonymy is a rather common occurrence. In a sense, information retrieval has a very coarse view of semantic, one in which only the major distinctions are preserved, and in which most of the subtle variations of meaning are lost. In this context, the variability in the use of terms is rather common. In Furnas *et al.*, (1983), for instance, it is noted that people choose the same main word to refer to the same well-known concept only 20% of the time. Similar inconsistencies have been identified in the assignment of index terms [Fidel, 1985; Bates, 1986].

Polysemy refers to the fact that, in many cases, words have more than one meaning. Terms like "volume" or "mint" have different referential significance depending on the context in which they are used. Rhetorical figures tend to exacerbate the problem—having a "train of thought" has nothing to do with railroad transportation, and the expression "rhetorical figure" itself has little to do with illustration (except, of course, in a metaphorical sense).

In the light of the observations of Chapter 2, the failure of single term models is easily understandable, as they fail to recognize the essential nature of language as a system, in which the meaning of a term is only determined by association and contrast with other terms.

Groups of terms or, even better, the association and missed associations between terms are a much better indicator of the "real" meaning of a document than single terms. The term "bridge" per se has a whole range of possible meanings. It is only through the association with terms like "dentist" that its meaning is defined. A single term is not a *sememe*; rather, the analysis of the associations between terms can lead us to a space in which sememes (which, unlike the axes of the term space in the vector model, can reasonably be considered orthogonal) are represented.

As an example, consider a hypothetical situation with three different documents and the significant terms in Table 7.2. If a query like *a jingle used in a commercial* is given, documents 1 and 3 will be retrieved, although document 3

Table 7.2. Example of a database giving counterintuitive results to a query such as *Jingles used in commercials* due to the polysemy of the words *jingle* and *commercial*

Document	*commercial*	*jingle*	*advertising*	*music*	*horse*
1	×	×	×	×	
2			×	×	
3	×	×			×

Table 7.3. A toy database of articles in database and image retrieval

Document	Title
d1	An efficient **clustering** algorithm for large **databases**
d2	**Query** unnesting in **object**-oriented **databases**
d3	**Similarity query processing** using disk arrays
d4	**Dimensionality** reduction for **similarity** searching in dynamic **databases**
d5	A **storage** and access **structure** for efficient **query processing** in spatial **database** systems
d6	An **index structure** for high dimensional data
v1	**Image query** and **indexing** for digital x-rays
v2	Adaptive **storage** and **retrieval** of large compressed **images**.
v3	**Video** and **image clustering** using relative entropy
v4	**Object**-based **video indexing** for virtual studio production
v5	**Similarity measures** for **image** and **video databases**
v6	**Video retrieval** content analysis by ImageMiner

is obviously about commercially used one-horse sleighs. The problem is that the term "jingle" is used both to refer to a short and catchy piece of music and to a type of sleigh, and the term "commercial" is an adjective referring to businesses and a slang term for advertising on radio or television[3].

The cooccurrence of terms is clearly important in order to answer a query like this one. If the words "jingle" and "music" occur together often in a collection, then the presence of the word "music" (e.g., in the second document) should bear some relevance to a query containing the word "jingle." One needs to define a suitable *latent semantic* space in which documents containing words that occur together are close to each other.

Note that there is a duality in the definition of the semantic space—documents are similar to each other if they contain many terms that are similar to each other; on the other hand, terms are similar to each other if they tend to occur in documents that are similar to each other. This duality suggests the use of the so-called *two-mode factor analysis* [Harshman and Lundy, 1984; Kruskal, 1978]. Both terms and documents are represented as points in the same space, and similarity between points is computed using the internal product. The analysis begins with an $N \times M$ matrix of document-term occurrences. Consider a hypothetical database of articles of interest in image retrieval composed of 12 documents and represented in Table 7.3. Six of the titles (d1 \cdots d6) are extracted from database publications,

[3] Sometimes ambiguity is strictly limited in time and space. The advertising semantics of both the words "jingle" and "commercial" is rather recent, and the use of "commercial" as a noun to denote a television advertisment is limited, among English-speaking countries, to the United States.

Table 7.4. The term-document occurrence matrix for the toy example

	1	2	3	4	5	6	7	8	9	10	11	12	13
d1	1	1	0	0	0	0	0	0	0	0	0	0	0
d2	0	1	1	1	0	0	0	0	0	0	0	0	0
d3	0	0	1	0	1	0	0	0	1	0	0	0	0
d4	0	1	0	0	1	1	0	0	0	0	0	0	0
d5	0	1	1	0	0	0	1	1	1	0	0	0	0
d6	0	0	0	0	0	1	0	1	0	0	1	0	0
v1	0	0	1	0	0	0	0	0	0	1	1	0	0
v2	0	0	0	0	0	0	1	0	0	1	0	1	0
v3	1	0	0	0	0	0	0	0	0	1	0	0	1
v4	0	0	0	1	0	0	0	0	0	0	1	0	1
v5	0	1	0	0	1	0	0	0	0	1	0	0	1
v6	0	0	0	0	0	0	0	0	0	0	0	1	1

while the other six (v1 \cdots v6) were extracted from publications on image content analysis closer to the computer vision community. The significant words that appear in at least two documents are in boldface, and are used for indexing (words that derive from the same stem, like *dimensionality* and *dimensional* will be considered equivalent). The document-term occurrence matrix is shown in Table 7.4. Note that, since in this toy example no terms appears more than once in any title, the matrix contains only zeros and ones. In general, the element c_{ij} of the matrix contains the number of occurrences of term T_j in document D_i. The rectangular matrix gives the necessary dual representation. Terms are vectors in a space whose basis is composed of documents, and are expressed as a linear combination of the documents in which they appear. Documents, on the other hand, are vectors in a space whose basis is composed of terms, and are represented as a linear combination of the terms that appear in them. Documents are expressed as in Eq. 7.24:

$$D_d = \sum_{t=1}^{M} c_{d,t} T_t \qquad (7.28)$$

and terms are expressed dually as

$$T_t = \sum_{d=1}^{N} c_{d,t} D_d \qquad (7.29)$$

That is, if D is the vector of all documents in the database and T the vector of all terms in the dictionary, $D = AT$ and $T = A'D$. The matrix A expresses the structure of the term-document relationship. Breaking it down in *singular vectors* using *singular value decomposition* (SVD, [Press *et al.*, 1986]) the original relationship is decomposed into linearly independent components. Singular values are the

rectangular matrices correspondent of spectral decomposition for square matrix, and determine a set of uncorrelated directions in the space spanned by the matrix. Formally, the decomposition is written as

$$C = U \cdot S \cdot V'$$ (7.30)

where C is the $N \times M$ terms-document matrix. If $m \leq \min(N, M)$ is the rank of C, then U is a $N \times m$ orthogonal matrix ($U'U = I_m$), S is a $m \times m$ diagonal matrix containing the *singular values* of the matrix C, and V is a $M \times m$ orthogonal matrix ($V' \times V = I_M$)[4].

Both U and V have orthonormal columns. The decomposition defines a m-dimensional *latent semantics* space in which the documents and terms can be represented. The columns of V define m orthonormal vectors in the term-document space, expressed in the term base T_t. Projection on these vectors transforms a vector expressed in the term basis into a vector expressed in the basis z_μ, $\mu = 1, \ldots, m$ of the latent semantic space. For a document $D = \sum_t a_t T_t$, the representation in the latent semantic space is $D = \sum_\mu \delta_\mu z_\mu$, where

$$\delta_\mu = \langle D, z_\mu \rangle = \sum_j a_j \langle T_j, z_\mu \rangle = \sum_j a_j v_{j\mu} = V'_{\cdot,\mu} a$$ (7.31)

and $V_{\cdot,\mu}$ is the μth column of V. The representation of the document D in the latent space is therefore given by the vector $\Delta = V'a$. If $\{z_\mu\}$ is the canonical basis of the latent semantic space, then the term T_t is expressed in this basis as

$$T_t = \sum_{\mu=1}^{m} v_{t\mu} z_\mu$$ (7.32)

and the document D_d as

$$D_d = \sum_{\mu=1}^{m} u_{d\mu} z_\mu$$ (7.33)

The tth term is a canonical vector in this basis and, therefore, its representation is $T_t = e_t$[5]. Its representation in the latent semantics basis is therefore given by $V'e_j$, that is, by the jth row of V.

Similarly, the matrix U defines m orthonormal vectors and its rows are the positions in the latent semantics space of the documents in the database.

As in spectral decomposition, the magnitude of the singular values is connected to the relative importance of the associated dimension in the latent semantics space. Traditionally, the result of the SVD has the diagonal of S ordered

[4] The relation between SVD and spectral decomposition is more than a mere analogy—U is the matrix of eigenvector of the symmetric square matrix CC' and V is the matrix of eigenvectors of the symmetric square matrix $C'C$. In both cases, S^2 is the matrix of eigenvalues.

[5] As customary in linear algebra, e_j denotes the element $e_j = [0, \ldots, \overset{j}{\overbrace{0, 1, 0}}, \ldots, 0]$

in decreasing magnitude of the singular values, so that s_{11} is the most significant singular value and s_{kk} is the least significant. This property can be used to obtain an approximate representation of the matrix C using a latent semantic space with a reduced dimensionality. If $A_{r|s}$ is the matrix composed of the first r rows and the first s columns of the matrix then one can build a reduced dimensionality latent semantic space by considering the matrix $S_{k|k}$, with $k \le m$. In this case, one obtains an approximation of the matrix C, \hat{C}, defined as

$$\hat{C} = U_{N|k}S_{k|k}V'_{M|k} = \hat{U}\hat{S}\hat{V}' \qquad (7.34)$$

The axes Σ_μ of the latent semantic space form a conceptual characterization of a document. Much like in Saussurre's analysis in Chapter 2, terms do not have a meaning per se (i.e., terms are not uniquely associated to concepts), but networks of relations between terms do. In this case, the network of association between terms is represented by the linear combination of terms occurrences. The elements z_μ are the independent and uncorrelated conceptual units that the document contains. Uncorrelated in this case means that knowing that one of these units is present in a document gives no information on the presence of other conceptual units in the same document. The approximate representation keeps only the most relevant conceptual units, where relevance is defined based on distinguishability, that is, a conceptual unit is relevant if its distribution in the documents has a high variance. This means that the unit is neither too common not too rare.

For the toy example of Table 7.3, singular value decomposition yields a matrix S given by

$$S = \text{diag}(3.318, 2.484, 2.076, 1.979, 1.751, 1.629, 1.498,$$
$$1.333, 0.951, 0.734, 0.58, 0.278) \qquad (7.35)$$

Taking the first two components only and projecting the documents in the resulting latent semantic space, one obtains the situation of Fig 7.2. The two classes of documents (database and vision) are clearly separated in the semantic space, in spite of the fact that in many cases documents belonging to different classes have terms in common. Terms can also be represented in the reduced semantic space, the jth row of $V_{M|2}$ being the position of term T_j. The result is shown in Fig 7.3. Notice that the terms "image" and "video" are quite separated from the rest, being the most highly indicative of one of the two conceptual classes of the document set. Similarly, the words "query" and "database" are indicative of the other class. The placement of terms in the latent semantic space is context dependent. In general, the words "query" and "retrieval" are very connected. In the common parlance of content-based image retrieval and databases, however, the former discipline makes heavy use of the word "retrieval" and very little use of the word "query," while database research uses mostly the word "query." This context bias explains why the semantics of the words "query" and "retrieval" are considered very different.

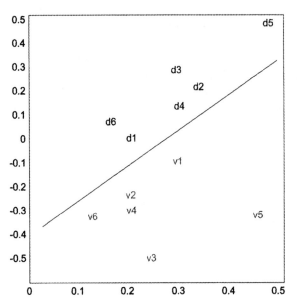

Figure 7.2. Documents of the toy database in the two-dimensional latent semantic space.

Figure 7.4 shows terms and documents in the semantic space with a link connecting documents with the terms they contain.

The latent semantics space can be used for comparisons between documents, and terms, and between queries and documents. There are four types of comparison that are of interest for retrieval: *document to document* (how similar are D_i

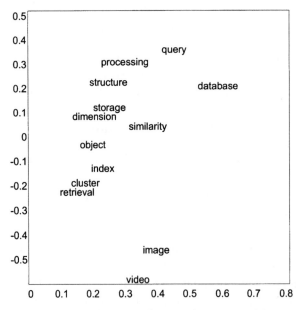

Figure 7.3. Terms of the toy database in the two-dimensional latent semantic space.

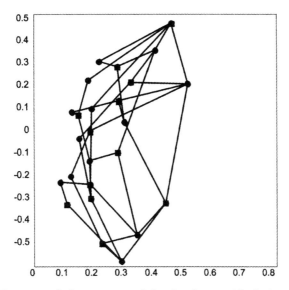

Figure 7.4. Terms and documents of the database with their associations.

and D_j), *term to term* (how similar is the semantics of terms T_i and T_j), *document to term* (how associated are document D_d and term T_t), and *query to document* (how relevant is document D_d for query Q). All these comparisons, of course, will be made using the approximate matrix \hat{C}.

Document to document. Comparing two documents entails computing the internal product of two rows of the matrix \hat{C}. Therefore, the similarity between documents D_i and D_j is given by the element (i, j) of the symmetric matrix $\hat{C}\hat{C}'$. Using the SVD decomposition, the fact that $\hat{S}' = \hat{S}$, and the orthogonality of V one obtains

$$\hat{C}'\hat{C} = \hat{U}\hat{S}\hat{V}'\ \hat{V}\hat{S}\hat{U}' = \hat{U}\hat{S}^2\hat{U}' \tag{7.36}$$

This means that the similarity between D_i and D_j can be obtained by taking the dot product of rows i and j of the matrix \hat{U}, where the dot product is defined as

$$\langle x, y \rangle_S = \sum_i x_i y_i s_i^2 \tag{7.37}$$

This corresponds to a space in which the metric is not Euclidean, but characterized by a metric tensor $g_{ij} = s_i^2 \delta_{ij}$.

Term to term. Dually to the document-to-document case, comparing two terms entails computing the internal product of two columns of the matrix \hat{C}. The similarity between term T_i and document T_j is given by

$$\hat{C}'\hat{C} = \hat{V}\hat{S}\hat{U}'\ \hat{U}\hat{S}\hat{V}' = \hat{V}\hat{S}^2\hat{V}' \tag{7.38}$$

As before, the similarity is obtained by the dot product of two rows of \hat{V} in a space characterized by the metric tensor $g_{ij} = s_i^2 \delta_{ij}$.

Document to term. The relevance of term T_t for document D_d is given simply by the value of the element \hat{C}_{dt}. The matrix \hat{C} is given by $\hat{U}\hat{S}\hat{V}'$, which means that the relevance of T_t for D_d is obtained by the dot product between the dth row of \hat{U} and the tth row of \hat{V}, the dot product being defined as

$$\langle x, y \rangle_{\sqrt{s}} = \sum_i x_i y_i s_i \tag{7.39}$$

This time, the dot product is taken in a space with metric tensor $g_{ij} = s_i \delta_{ij}$. Note that it is not possible to find a single metric space in which the three types of comparisons can be made.

Query to document. Given a query q, it is possible to build its terms vector C^q, where C_j^q represents the number of times T_j appears in the query. This query represents a "pseudo-document" that will be compared with the other documents in the database. In order to do so, one needs to start with the terms vector C_q and derive a representation U_q of the query in the latent semantic space that can be used just as one of the rows of U to compute the dot product between the query and the documents.

7.3 Relevance Feedback

The characterization of the content of a document by its index is always imperfect and, consequently, the results of a query are also imperfect. Trying to improve the indexing technique can go only so far. Instead of trying to obtain a perfect first-shot solution, an alternative is to start an iterative process, in which the user will, step by step, improve the results of the query. A rather general class of techniques for doing so goes under the name of *relevance feedback*.

Operatively, in relevance feedback the user looks at the documents returned by the system as an answer, and, among them, picks some examples of what is particularly *relevant* and (depending on whether the particular form of relevance feedback allows this) some examples of documents that are *irrelevant* (that is, documents that were not supposed to be returned as part of the answer).

Relevance feedback methods use, often in combination, two types of techniques: *term reweighting* and *query expansion*. Represent a query as a set of pairs:

$$Q = \{(w_k, T_k), k = 1, \ldots n_Q\} \tag{7.40}$$

then, term reweighting changes the query, based on user input, by changing the values of w_k, without adding any new pair, while query expansion adds (or, sometimes, removes) some new pairs (w, T) without changing the weights of

the existing pairs. The difference between the two classes, although tradition-ally made, becomes more blurred if the query is expressed in the vector space model. In this case, it is

$$Q = \sum_{t=1}^{M} w_t T_t \tag{7.41}$$

where $w_t = 0$ for all the terms not included in the query. The difference between query reweighting and query expansion in this case is that query reweighting is only allowed to operate on nonzero weights, changing their values, while query expansion is only allowed to operate on zerovalued weights. Some algorithms, of course, do both things.

7.3.1 Rocchio Algorithm

One of the earliest and most successful algorithms for relevance feedback is the Rocchio algorithm, whose original description was published in 1965, and reprinted in 1971 [Rocchio, 1971]. The algorithm has a simple interpretation in the vector space model. As mentioned before, a query Q can be represented as a document that is, as a vector in the space,

$$Q = \sum_{t=1}^{M} w_t T_t \tag{7.42}$$

where w_t is the relevance of term T_t for the query.

When the answer to the query is presented, the user will select some relevant documents and a set of irrelevant documents, both represented as sets of vectors in the space.

The effect of relevance feedback—illustrated in Fig. 7.5 for the case in which only relevant documents were selected—is to move the query point (that is, the query document) closer to the center of the documents considered relevant. The new query will reveal some new documents (indicated with a black cross in Fig. 7.5)

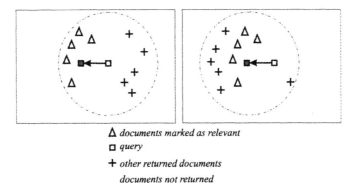

Δ documents marked as relevant
\square query
$+$ other returned documents
documents not returned

Figure 7.5. Schematic illustration of the effect of relevance feedback.

that, hopefully, will be more relevant to the topic that the user has in mind than those that have been dropped from the query (the gray crosses in Fig. 7.5).

Let $\{r_1,\ldots,r_p\} \subset \{1,\ldots,N\}$ be the indices of the documents that the user marked as relevant, and let $R = \{R_{r_k}, k = 1,\ldots,p\}$ be the corresponding set of relevant documents. Similarly, let $\{s_1,\ldots,s_q\} \subset \{1,\ldots,N\}$ be the indices of the documents that the user marked as irrelevant, and $S = \{S_{s_k}, k = 1,\ldots,q\}$ the corresponding set of irrelevant documents.

Formally, Rocchio's algorithm performs a second query replacing the query Q with the modified query Q_1, defined as

$$Q_1 = Q + \frac{\beta}{p}\sum_{k=1}^{p} R_{r_k} - \frac{\gamma}{q}\sum_{k=1}^{q} S_{s_k} \tag{7.43}$$

where $\beta, \gamma > 0$ are two weighting constants that determine the "strength" of the action of the feedback. The best results, according to Salton and Buckley (1990), are obtained with $\gamma = 0.25$ and $\beta = 0.75$. Writing

$$R_{r_k} = \sum_{t=1}^{M} c_{r_k,t} T_t \quad S_{s_k} = \sum_{t=1}^{M} c_{s_k,t} T_t \tag{7.44}$$

the new query can be written as the vector

$$Q_1 = \sum_{t=1}^{M}\left[w_t + \frac{\beta}{p}\sum_{k=1}^{p} c_{r_k,t} - \frac{\gamma}{q}\sum_{k=1}^{q} c_{s_k,t}\right] T_t \tag{7.45}$$

This result in a reweighting scheme, in which the weight of the term T_t in the query—which originally was w_t—is assigned a value

$$w_t \leftarrow w_t + \frac{\beta}{p}\sum_{k=1}^{p} c_{r_k,t} - \frac{\gamma}{q}\sum_{k=1}^{q} c_{s_k,t} \tag{7.46}$$

in the new query[6].

Several variations of Rocchio's strategy were analyzed by Ide (1971); the first was the same as Rocchio's formula, without normalization:

$$Q_1 = Q + \sum_{k=1}^{p} R_{r_k} - \sum_{k=1}^{q} S_{s_k} \tag{7.47}$$

the second allowed only positive feedback:

$$Q_1 = Q + \sum_{k=1}^{p} R_{r_k} \tag{7.48}$$

[6] As mentioned before, this reweighting actually includes a query expansion, because weights that were originally zero in the query Q, thereby effectively eliminating the term T_t from the query, can now become nonzero, including the term in the query.

the third (called Ide dec hi) allows negative feedback only from the highest ranking irrelevant document:

$$Q_1 = Q + \sum_{k=1}^{p} R_{r_k} - S_{s_1} \qquad (7.49)$$

Several modifications to this general scheme have been proposed. As an example, Allan 1996 considers the set of relevant and documents, and the 500 most frequent terms. Each of these terms is assigned a weight

$$w_t \leftarrow w_t + 2w_t^{\text{rel}} - \frac{1}{2}w_t^{\text{not-rel}} \qquad (7.50)$$

where the weight w_t^{rel} is obtained as

$$idf_t = \frac{\log \frac{N+0.5}{df_t}}{\log(N+1)}$$

$$tb_{d,t} = \frac{tf_{d,t}}{tf_{d,t} + \frac{1}{2} + \frac{2}{3}\frac{l_d}{l}}$$

$$b_{d,t} = 0.4 + 0.6 \cdot tb_{d,t} \cdot idf_t$$

$$w_t^{\text{rel}} = \frac{1}{p}\sum_{i=1}^{p} b_{r_i,t}, \qquad (7.51)$$

and the weight w_t^{nonrel} is computed similarly using the terms on the irrelevant set. When the weight w_t has been computed for all the terms, the 100 terms with the highest ranking are added to the query.

Note that this method is in a sense intermediate between allowing irrelevant documents and not allowing them—irrelevant documents are allowed but their goal is, in a sense, to discard terms rather than add a negative weight to them, because in the end only terms with a strong positive feedback will be added to the query.

7.4 Evaluation

The evaluation of an information retrieval system is a complex affair indeed, and it is of great interest for image retrieval, as many evaluation issues are the same in the two fields. In Chapter 3, I hinted at the fact that evaluation is essentially and inextricably a social issue that hinges on what values one consider "positive" and how the system is placed in reference to these values. These problems are present in information retrieval as well.

The purely technical aspect of evaluation, assuming that short-term user satisfaction is an adequate social measure of effectiveness, is also quite involved, starting from the problem of *what* exactly to measure in an information retrieval system. Van Rijsbergen 1979, citing Cleverdon *et al.* (1966) identifies six main measurable quantities:

1. The *coverage* of a collection, that is, the extent to which the system includes matter relevant to a certain class of users;

2. the *time lag*, that is, the interval between the time a request is made and the time an answer is given (this interval is extremely important in interactive systems);

3. the *presentation* of the output (how many elements are presented, how easy is first is to determine which is relevant and which is not, and so on);

4. the user's *effort* necessary to obtain an answer from the system;

5. the *recall* of the system, that is, the proportion of the relevant that the system presents in the answer; and

6. the *precision* of the system, that is, the fraction of the retrieved material that is actually relevant.

The first quantity (coverage) is measured using typical methods of library science. The second quantity is a typical *physical evaluation* quantity—it is characteristic of most computer systems and is measured using standard computer science techniques. The following two quantities (presentation and effort) have a great importance in many computer (and, in general, social and conversational) systems, and will be covered in Chapter 10. Typically, the evaluation methodology of information retrieval is centered around precision and recall, which jointly determine what is commonly (sometimes rather informally) called the *effectiveness* of the retrieval system.

The study of the evaluation techniques for information retrieval systems is particularly interesting in the present context because many of these techniques can be extended to the evaluation of content-based image retrieval systems but, in doing this, one should always keep in mind that texts and images are the subjects of very different processes of signification and that certain assumptions that are made for texts may fail to extend to images. The difference is clear in this quotation from van Rijsbergen (1979):

> Relevance is a subjective notion. Different users may differ about the relevance or non-relevance of particular documents to a given question. However, *the difference is not large enough to invalidate experiments which have been made with document collections for which test questions with corresponding relevance assessments are available.* (emphasis mine)

This assumption has never been demonstrated for an image outside of very narrow domains in which one of the possible interpretations is favored by the practices and conventions of the domain. Furthermore, if the model presented in Chapter 2 is valid, no such assumption can be made, not even provisionally. The whole concept of relevant set becomes then very problematic, and the evaluation

Table 7.5. The "contingency table" for precision and recall[a]

	Relevant	Nonrelevant	
Retrieved	$A \cap B$	$\bar{A} \cap B$	B
Nonretrieved	$A \cap \bar{B}$	$\bar{A} \cap \bar{B}$	\bar{B}
	A	A	

[a] Given a query, A is the set of relevant documents in the database, B the set of retrieved documents.

techniques must be adapted along the lines discussed in Chapter 3. This chapter, however, is concerned with the transfer of signification from textual material to the images embedded in it, and the following sections apply to the evaluation of the document retrieval phase that will precede such transfer.

7.4.1 Precision and Recall

Precision and recall are often introduced in terms of the "contingency" Table 7.5.

In terms of this table, three quantities are defined. The *precision* is the fraction of retrieved documents that is actually relevant:

$$P = \frac{|A \cap B|}{|B|} \tag{7.52}$$

the *recall* is the fraction of relevant documents that are retrieved:

$$R = \frac{|A \cap B|}{|A|} \tag{7.53}$$

the *fallout* is the fraction of nonrelevant documents that are retrieved:

$$F = \frac{|\bar{A} \cap B|}{|\bar{A}|} \tag{7.54}$$

The three measures are not independent. If one indicates with G the fraction of relevant documents in the whole collection, that is, $G = |A|/N$ (where N, as before, is the number of documents in the collection), then the following relation holds:

$$P = \frac{RG}{RG + F(1 - G)} \tag{7.55}$$

In many cases, the output of the system depends on a parameter λ. The system can simply return the first λ documents in order of measured relevance, or return all the documents for which the coordination level (the number of terms that the query has in common with a document) is beyond a certain value λ. In all these cases, letting the parameter λ assume different values, one obtains pairs (P_λ, R_λ) of precision and recall for each value of the parameter (or, depending on the evaluation methodology, precision and fall-out). The values (P_λ, R_λ) can be plotted in a *precision-recall* curve, such as the one shown in Fig. 7.6.

Figure 7.6. Precision-recall curves for two queries. The numbers indicate the value of the control parameter.

In many cases, curves are obtained by averaging over several queries. Note that some care is needed because the known points (P_λ, R_λ) for the different queries generally do not coincide and, therefore, some suitable interpolation scheme must be applied before averaging the curves.

7.4.2 Other Models

Precision and recall are, for some occasion, inconvenient parameters to manage, mostly because taken individually they give no real indication of the effectiveness of a system and, therefore, must always be considered as a pair, for example, as a curve such as the one in Fig. 7.6. This is rather inconvenient if one must, for example, compare two systems.

Alternative methods have been devised to derive a single measure of performance. In the remainder of this section I will very briefly present three such methods.

Expected search length. Cooper's expected search length method [Cooper, 1968] is based on a specific usage hypothesis: an information retrieval system is installed in order to save a group of people the labor of perusing a collection to look for relevant information and discard irrelevant information along the way. This saved labor is, according to Cooper, the true measure of effectiveness of an information retrieval system. The measure employed is the number of documents that the user has to look at in order to retrieve n relevant documents, as opposed

Rank	1	1	1	2	2	2	2	2	3	3	3	3	3	4	4	4	4	4	4	4
Relevant	N	N	Y	Y	N	Y	Y	Y	N	Y	Y	N	N	N	N	N	N	N	Y	N

Figure 7.7. Example of partial ordering of an output with indication of relevance.

to the number of documents that one has to look at if the collection is browsed at random.

The method assumes that the output is a partially ordered list, in the sense that at any ranking position there can be more than one document, as in Fig. 7.7. Assume that a user is interested in retrieving six documents. Then the search will stop at ordering level 3: two documents will be retrieved with ranking 1, three with ranking 2, and, as soon as the first relevant document at level 3 is retrieved, the search is over. However, the elements at level 3 are not ordered and therefore are accessed in a random order. One may be lucky and receive the relevant document at the first try, or unlucky, and retrieve the three irrelevant documents at level 3 before any of the relevant ones.

The measure of search length must therefore be averaged over the possible search length. With the quantities defined in Table 7.6, the expected search length is

$$L(q) = j + \frac{i \cdot s}{r + 1} \tag{7.56}$$

A measure of effectiveness is obtained averaging the measure over a set of queries

$$\bar{L} = \frac{1}{|Q|} \sum_{q \in Q} L(q) \tag{7.57}$$

Table 7.6. Definitions of symbols used for the derivation of expected search length

Symbol	Meaning
j	The total number of irrelevant documents in all levels preceding the final one
r	The number of relevant documents at the final level
i	The number of irrelevant documents at the final level
s	The number of relevant documents required at the final level in order to satisfy the query
R	The total number of documents relevant to the query
I	The total number of documents irrelevant to the query
S	The total number of documents desired

A more significant measure of effectiveness is given by the reduction in search length over a random search. The latter quantity is given by

$$A(q) = \frac{S \cdot I}{R + 1} \tag{7.58}$$

and the *expected search reduction factor* is

$$\frac{A(q) - L(q)}{A(q)} \tag{7.59}$$

or, better yet, its average over a group of queries.

Rocchio's measures. In 1966 Rocchio (1971) presented the derivation of two indices of effectiveness based on recall and precision. The first one is the *normalized recall*, which measures the effectiveness of a ranking in relation to the best possible and the worst possible ranking. Figure 7.8 shows the recall as a function of the number of documents retrieved for a database of 25 documents in the case in which there are 5 documents relevant to the query. The figure shows the best possible case (the relevant documents are in the first 5 position), the worst possible (the relevant documents are in the last 5 position), and an intermediate case that is to be evaluated.

A possible measure of the quality of the retrieval is given by the area between the "best" curve and the "actual" curve. If n is the number of relevant documents, and r_i is the rank at which the ith relevant document is found, then Rocchio computed this area as:

$$A_b - A_a = \frac{1}{n} \sum_{i=1}^{n} (r_i - i) \tag{7.60}$$

The area between the best and worst curve is given by $N - n$. This can be used to normalize the previous expression, obtaining:

$$R_{\text{norm}} = 1 - \frac{1}{n(N - n)} \sum_{i=1}^{n} (r_i - i) \tag{7.61}$$

A similar procedure can be used for precision, yielding a normalized precision

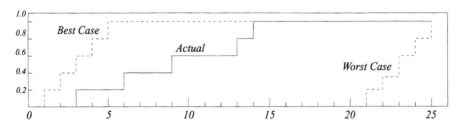

Figure 7.8. Best, worst and intermediate case for recall in a database of 25 documents with 5 relevant documents.

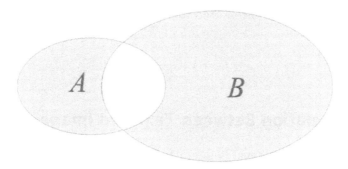

Figure 7.9. Definition of symmetric difference.

measure

$$P_{\text{norm}} = 1 - \frac{\sum_{i=1}^{n}(\log r_i - \log i)}{\log \binom{N}{n}} \tag{7.62}$$

Note that, unlike simple precision and recall, each one of these measures alone constitutes a satisfactory index of effectiveness. The two measures are consistent in the sense that if one of them is 0 (respectively, 1), then the other is also 0 (respectively, 1). The two measures, however, differ in the intermediate case. In particular, normalized precision assigns a greater weight to the initial document ranks, while normalized recall assigns a uniform weight to all documents.

Normalized symmetric difference. This measure was derived by van Rijsbergen using measure-theoretic arguments. It is presented here using a simple intuitive argument, but the reader is urged to consult van Rijsbergen's formulation (1979). In an ideal information retrieval system, one would get all the relevant documents and nothing else, giving 100% precision and recall. This is rarely the case and, in practice, the situation looks like that of Fig. 7.9, where A is the set of relevant documents, B the set of retrieved documents, and $A \cap B$ the set of relevant documents that are actually retrieved. A sensible measure of the effectiveness of the system is the size of the shaded area, which is the *symmetric difference* between A and B, defined as $A \cup B - A \cap B$. Normalizing this measure, one obtains a measure of effectiveness

$$E = \frac{|A \cup B - A \cap B|}{|A| + |B|} \tag{7.63}$$

which, in terms of precision and recall, becomes

$$E = 1 - \frac{1}{\frac{1}{2}\left[\frac{1}{P} + \frac{1}{R}\right]} \tag{7.64}$$

A parameter $\alpha \in (0, 1)$ is often used to balance between precision and retrieval, obtaining

$$E_\alpha = 1 - \frac{1}{\frac{\alpha}{P} + \frac{(1-\alpha)}{R}} \tag{7.65}$$

7.5 The Relation Between Text and Images

Content-based image retrieval is interested in text retrieval because of the relation between text and images as highlighted in Chapter 2. As was pointed out in Chapter 2 one can define two types of such relations, resulting in two different modalities of signification for images. The first, which is part of what was called *closed world modality*, is embodied in the assignment of labels or keywords to images; the second, which was called *linguistic modality*, includes the images in an autonomous linguistic discourse.

 The first case—assigning labels to images—is a library taxonomy problem, and goes beyond the scope of this book. One may in this case assume that an expert is available who, given a collection of images and a domain, will assign to the images keywords with high discriminatory power and low ambiguity in that domain, and, possibly, will provide weights for them.

 The most interesting case for the current context is that in which images are part of an autonomous discourse, which could be self-sustained without any reference to them, and from which they receive meaning. Given the interest in the automatic analysis of such a signification, it is quite natural to start from a well-known case in which such a mixture of textual discourse and images is already in a form that, syntactically at least, can be analyzed automatically—the World Wide Web.

7.5.1 Some Truisms on Web Structures

The World Wide Web is a set of documents, called *pages*, containing primarily text and images (video is still relatively rare, as are ad hoc graphic animations) and grouped into collections called *sites*. Each site contains a special document, called the *home page* for that site, which is automatically referenced if the name of the site is used without specifically requesting any of the documents in it. Documents can reference one another through *links*. A link can reference a whole site (in which case it will implicitly reference the home page of that site), a document, or a specific part of a document.

 Relevant parts of a document are identified by *tags*, in a way specified syntactically by hypertext mark-up language (commonly refered to as HTML). In particular, images are placed in a document using the `` tag. Some tags relevant for the determination of the meaning of images are shown in Table 7.7. The presence of links gives the World Wide Web the structure of a directed graph in which pages are nodes and links are edges; the collection of pages into sites creates a second,

Table 7.7. Some web page "tags" of interest for image signification

Tag	Meaning
<TITLE>	The title of a document
<META>	Nondisplayed information about the document
<A>	Link information (link, or target for a link)
	Image embedded in the document

coarser, graph structure in which sites are nodes, and there is an edge between two sites if any page in the first site references a page in the second site. There are two consequences of this organization—the first, purely technical, is that this organization makes it possible to "jump" from page to page following the link references and, therefore, provides the basis for an algorithm that, starting from any chosen page, will explore the web (or, at least, the connected component containing that page). These algorithms, commonly known as *web crawlers*, or *web spiders*, are briefly introduced in Appendix A. More important, the structure of the graph has some important implications for the signification process.

Internet text is not like normal written text for a number of reasons, and at a variety of levels. At the lexical level, Amitay (1998) noted that the distribution of words in web pages is different from that of normally written English[7]. The sentence structure of web pages is more fragmented than that of other written documents and, often, pages contain many syntactic units without a proper sentence form. There are, Amitay reports, web pages that contain no verb or delimiter, although there are more than 60 words in them. In general, delimiters are less frequently used in web pages: the word "the" makes up about 7% of regular written English, but only 3% of "web English." While, on one hand, a lot can be said on the impoverishment of the tongue of Shakespeare that lurks behind this lexical finding, on the other hand, this finding is very useful for automatic analysis of the text because the naive structure tends to make word count more significant.

At the level of single pages, the structure and conventions of web text are also different from those of written English. Web pages tend to be rather short, shorter than a typical newspaper article or book chapter. Unlike a book chapter—which is typographically a rather undifferentiated piece of text—the typical web page contains several identifiable markers, including a title, some keywords (inside a <META> tag, and not displayed), and links (which, in addition to being semantically charged, are often typographically differentiated). Outstanding or differentiated portions of the text are generally the preferred location for discriminating terms or context specification and, as they are more frequent in web pages than in English text, one can expect discriminating and context-establishment terms to be equally more frequent.

[7] Amitay's analysis was limited to the English language; unfortunately, I have no information regarding pages written in other languages.

The most interesting level of differentiation of web language, however, is revealed by looking at the organization of groups of pages, in particular at their link structure. This is hardly surprising, as a single document is seldom self-contained, as it presupposes a context in which interpretation can take place, while a link to a document is often placed in a page that, not presupposing a similar context, often provides it explicitly. One does not expect that the Academic Press page should contain the words "Scholarly Book Publisher," as the activity that goes on at Academic press is part of the context that is presupposed when the page is viewed. On the other hand, a generic web page that, for one reason or another, needs to link to the Academic Press web page is more likely to recreate part of this context by writing something like ... *the American publisher Academic Press has published* ... , where underlined text represents a link to the Academic Press page. In other words, one can observe a *displacement* phenomenon: the best place to look for the content of a page is not the page itself, but the text around the links to that page.

The portion of the text around the link in which useful information about the linked page can be found is called the *anchor text* for that link [Chakrabarti *et al*, 1998]. In the same paper, Chakrabati and colleagues also try to determine the extent of the anchor text. They found that the 50 characters preceding the link (where the link is everything included between the <A HREF> tag and the tag) and the 50 characters following it constituted a satisfactory portion to be used as anchor text, unless that span contained other links, in which case the window should only go as far as the nearest link. Similar results were reported by Davison (2000). Davison also found quantitative substantiation for the claim that the anchor text of links is a better description of a page content than the description given by the authors of the pages.

Considering single links between pair of pages still gives a partial view of the structure of the web. Rather, the complete pattern of links between sites is a better description of the underlying social organization of the web. In [Chakrabarti *et al.*, (1999)] the point of view is taken that one of the most prominent aspects of such social organization is the *conferral of authority* to certain pages. Authority, in a distributed environment, is conferred by having a large number of links related to a certain topic point to the same page. To this end, [Chakrabarti *et al.*, (1999)] defines two types of pages that are relevant for authority conferral: *authorities* and *hubs*. An authority, as mentioned before, is a page to which many pages relative to a topic link. Hubs, on the other hand, are pages that contain many links relative to the same topic. An interesting sociological observation about the web is that, by and large, authorities do not link to each other, which is why hubs are necessary as "authority conferral" pages. There is, therefore, a duality between authorities and hubs—given a topic, an authority is a page that is linked by many hubs, while a hub is a page that links to many authorities.

Consider a subgraph (P, L) of the World Wide Web consisting of pages relevant to a certain topic (this assumption is convenient, but unrealistic; it will be relaxed shortly), where P is the set of pages, and L the set of links between them. Given

a page $p \in P$, define the *outgoing pages set* $O(p)$ as $O(p) = \{p' \in P : (p, p') \in L\}$; that is, $O(p)$ is the set of pages that can be reached from p following a link. Similarly, the *incoming pages set* of p, $I(p)$ is defined as $I(p) = \{p' \in P : (p', p) \in L\}$. Associate to each page p two quantities a_p and h_p, the *authoritativeness* and what, for want of a better term, might be termed the *comprehensiveness* of a page. The authoritativeness of a page is given by the number of good hubs that point to it and, therefore, it can be written as

$$a_p = \sum_{q \in I(p)} h_q \qquad (7.66)$$

Similarly, the comprehensiveness of a page is given by the number of good authorities to which it points, that is:

$$h_p = \sum_{q \in O(p)} a_q \qquad (7.67)$$

These two equations can be iterated, normalizing the values between two iterations to avoid divergence, to obtain the following algorithm:

ALGORITHM 7.2. *The algorithm receives the graph (P, L) of interesting pages and links. Each page $p \in P$ has two attributes p.a and p.h containing its authoritativeness and comprehensiveness. The algorithm returns the same graph with all the parameters p.a and p.h marked.*

$p \leftarrow$ Authorities(P, L)
1. for each $p \in P$
2. $p.a \leftarrow \sum_{q \in I(p)} q.h$
3. for each $p \in P$
4. $p.h \leftarrow \sum_{q \in O(p)} q.a$
5. for each $p \in P$
6. $p.a \leftarrow p.a/(\max_{q \in P} q.a)$
7. $p.h \leftarrow p.a/(\max_{q \in P} q.h)$
8. return (P, L)

The algorithm can be written in a more compact way that also sheds more light in its logic. Let A be the connectivity matrix of the graph (P, L), that is, $a_{ij} = 1$ if $(p_i, p_j) \in L$, $a_{ij} = 0$ otherwise. Further, put the values a_p and h_p in vectors $a = (a_1, \ldots, a_{|P|})$ and $h = (h_1, \ldots, h_{|P|})$. Then the update of the authoritativeness vector can be written as $a \leftarrow A^T h$ and $h \leftarrow Ap$, that is:

$$a \leftarrow A^T h \leftarrow A^T A a = (A^T A)a \qquad (7.68)$$

and

$$h \leftarrow Aa \leftarrow AA^T h = (AA^T)h \qquad (7.69)$$

These iterations, once normalized, can be shown to converge to the principal eigenvector of $(A^T A)$, or (AA^T), respectively, and this will happen for every non-degenerate choice of the initial vector a (respectively, h). This is important because

it implies that the authoritativeness and comprehensiveness of certain pages is an intrinsic property of the link structure, and not of the particular initialization that one chooses.

The previous algorithm assumed that the graph (P, L) contained only pages more or less relevant to a given topic. This is usually not the case: papers like that by [Chakrabarti *et al.*, (1999)] apply the algorithm to a graph obtained using rather loose criteria (and rightly so). Typically, a search on the topic of interest is made using one of the traditional web search engines, resulting in a *root set* of a few hundred pages. The set is augmented by including all pages that are linked by pages of the root set and pages that link to pages in the base set. This enlargement operation can be repeated if desired. This typically results in a set of a few thousand pages that contains authorities, hubs, other pages about the same topic, and pages that have very little to do with the topic. The pages can be distinguished using the anchor text around the links (note that, apart from the creation of the initial graph, the previous algorithm did not consider the text inside the page at all). To each link $l \in L$, let t_l be the associated anchor text, and $w_l = w_{p,q}$ a measure of the relevance of the anchor text for the link l from page p to page q. Then the iteration can be written as

$$a_p = \sum_{q \in I(p)} w_{q,p} h_q \qquad (7.70)$$

and

$$h_p = \sum_{q \in O(p)} w_{p,q} a_q \qquad (7.71)$$

or, in terms of the weight matrix W, $a \leftarrow (W^T W) a$, and $h \leftarrow (W W^T) h$.

7.5.2 That is Good, but Where are the Images?

So far, I have considered documents containing text, but the main point of this section is to find a relation between images and some suitable text that describes them. An image can be considered as a web document that instead of being linked through a <A HREF> tag is linked through an tag. The same general principles that apply to links between documents apply to links between a page and an image—the anchor text around the tag provides information about the content of an image. Unlike the case of text pages, however, in which one could assume that all, or most pages contained relevant information, images can have a number of functions in web pages, most of them unrelated to the contents of the page. A possible and partial taxonomy of such functions is presented in Table 7.8. The percentage of content images (images related to the content of the page) is relatively small. Paek and Smith (1998) analyzed a few web sites, and found that content images constituted between 10% and 30% of the total number of images. Sites whose content is primarily textual, and contain few images, also tend to have a lower percentage of content images; the site with the highest percentage of

Table 7.8. Taxonomy of image functions on a web page

Images	Nonfunctional (content)		
	Functional	Navigation	Buttons
			Arrows
			Image maps
		Decor	Masthead
			Background
			Lines
			Bullets
		Commercial	Logos
			Advertising

content images that Paek and Smith found was that of the television station and the American news organization CNN, while the site with the lowest percentage of content images was that of the California government.

The general domain habits and conventions of the web provide enough context for a reasonably reliable identification of content images. The simplest and more reliable clue is the number of incoming links. Harmandas *et al.* (1997) noticed that 90% of content images had only one incoming links, and the remaining 10% had two (Fig. 7.10). On the other hand, the distribution of incoming links for functional images is shown in Fig. 7.10. From these graphs it appears that every image with more than two incoming links can *ipso facto* be considered a functional image, while every image with only one incoming link can be considered a content image. Note that, although the problem of determining the number of incoming links is in general unsolvable (a page contains only outgoing links), in the case of images the overwhelming majority of links comes from pages in the same domain, thus

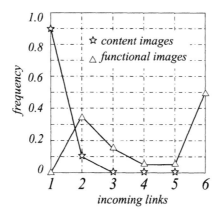

Figure 7.10. Distribution of the number of incoming links for content images and functional images (adapted from Harmandas *et al.* 1999)

Table 7.9. Features used by Paek and Smith for classifying images as functional or content

Feature No.	Type	Description
0	Context	Image format (gif, jpg)
1	Context	HTML image type
2	Context	Image no./total no. of images
3	Visual	Number of colors
4	Visual	Percentage of black
5	Visual	Percentage of gray
6	Visual	Percentage of white
7	Visual	Number of grays
8	Visual	Number of hues
9	Visual	Number of saturation levels
10	Visual	Perc. of colors at quarter sat.
11	Visual	Perc. of colors at half sat.
12	Visual	Perc. of colors at full sat.
13	Visual	Image width
14	Visual	Image height
15	Text	Advertisement label presence
16	Text	Body label presence
17	Text	Decorative label presence
18	Text	Information label presence
19	Text	Logo label presence
20	Text	Navigation label presence

making the problem easily solvable, at least for any domain with fixed structure, without dynamic generation of pages.

Several visual, geometric and syntactic clues can be used to solve the remaining ambiguities. Paek and Smith used the 20 features of Table 7.9 in order to classify an image as content or functional. The "label presences" of features 15-20 are set to true if certain keywords are spotted in the vicinity of the image. Paek and Smith use a set of preclassified images as an input to a decision tree learning procedure, which creates a decision tree that classifies images based on these 20 features. Harmandas, on the other hand, prefers to consider all images, weighting them inversely to the number of pages linking to them. This way, most of the functional images were pushed down the list of results without significantly affecting the position of the others.

This model of detection of the function of images is based on several levels of behavioral, technical and social assumptions about the designers of web pages. Functional images tend to be smaller in size than content images; they tend to be cartoonish, which means that they contain fewer, more saturated colors (and,

technically, they are often stored as "gif" files); and they tend to be reused over and over again to give the site a consistent look, so that they have many incoming links, and so on.

Once content images are identified, the same techniques used for characterizing the content of a page can be used to describe them, with the exception that, because they are *nontextual* pages, it is not possible to rely on their content to describe them[8]; instead the description has to rely on the content of the pages that link to the image.

The following model is inspired by that of Harmandas *et al.* (1997). The terms attached to an image come from four different sources in the page that links to the image (or in the union of such pages, if more than one page links to the same content image). Each source has an associated "thematic weight" indicating the reliability of that source for the characterization of the content of the image. The sources are:

- the ALT text of the image link, with weight v_a;

- the anchor text of the link to the image, with weight v_t;

- the title of the page containing the link, with weight v_n; and

- the keywords of the page with the link, with weight v_k.

The weight of a term is then multiplied by the thematic weight corresponding to the section in which the term is found. Assuming that, in the index of image I_k, the term T_t appears $t_{t,k}^a$ times in the ALT tag, $t_{t,k}^k$ times among the keywords, $t_{t,k}^n$ times in the title, and $t_{t,k}^t$ times in the anchor text, the associated weight is

$$\alpha_{t,k} = \alpha(T_t, I_k) = (t_{t,k}^a v_a + t_{t,k}^k v_k + t_{t,k}^n v_n + t_{t,k}^t v_t) \log \frac{N - df_t}{df_t} \qquad (7.72)$$

The elements $\alpha_{t,k}$ provide a characterization of the image I_k as a document, that is, the image I_k is represented in the term space as

$$I_k = \sum_{t=1}^{M} \alpha_{t,k} T_t \qquad (7.73)$$

7.6 Image-Text Integration

The results in the previous section allowed one to consider an image taken from the web as a document, characterized by coefficients in a basis of terms T_t. This representation allows one to answer queries based on a textual description of images and, in general, allows one to do all the operations defined in information

[8] In this case I am only considering textual techniques; it is obviously possible to try to describe the content of an image using image analysis techniques. I will return to this possibility shortly.

retrieval, including latent semantics indexing and relevance feedback. At this point an image can be characterized in two ways: either visually, using the features defined in the last two chapters, or linguistically, using the image to document association defined in this chapter. Both these characterizations induce a metric in the space of images, and it is natural to ask how it is possible to integrate these two different metrics to obtain a truly lexico-visual indexing. In this section, I will briefly introduce two methods, which I call the *visual dictionary* and the *mutual influence*.

7.6.1 Visual Dictionary

A visual dictionary is a collection of images and the distances between them that provides a visual example of a certain set of terms. Given a set of terms, it is possible to query the images using their document representation, retrieving a set of images that represent a possible answer to the query. In the document space, these images will be characterized by an interimage distance that, in addition to relevance for the query, provides a more general context in which they are placed. If it were possible to adapt the visual distance measure so that the visual distance between these images was the same as their lexical distance, then one would hopefully have a visual referent in which other images could be inserted based only on their visual characteristics.

More precisely, assume that the database of images D is endowed with a visual distance measure d_v depending on a vector of parameters θ, and let $d_v(I_k, I_h; \theta)$ be the distance between images I_k and I_h, given the parameter vector θ. A similarity measure is derived from this distance as $s_v(I_k, I_h; \theta) = g(d_v(I_k, I_h; \theta))$. In addition, assume that the images also have a lexical representation as

$$I_k = \sum_{t=1}^{M} \alpha_{t,k} T_t \tag{7.74}$$

The lexical similarity between two images is given by

$$s_l(I_k, I_h) = \langle I_k, I_h \rangle == \sum_{t=1}^{M} \alpha_{t,k} \alpha_{t,h} \tag{7.75}$$

As the process starts with a linguistic query, the query is also represented as a set of weighted terms:

$$Q = \sum_{t=1}^{M} q_t T_t \tag{7.76}$$

The visual dictionary of the query is composed of K images with the highest similarity to the query:

$$V(Q) = \{I_k, k = 1, \ldots, K : \forall I \in D - V, \forall k, s_l(Q, I_k) \geq s_l(Q, I)\} \tag{7.77}$$

These images also have a similarity determined by the terms associated to them, and this similarity reveals the relation among them and between them and the

query. In order to reproduce as much as possible this relation in the visual field, the visual similarity distance is changed so as to reproduce as well as possible the lexical similarity between images. If E is a suitable cost functional, then a vector θ is derived solving the optimization problem:

$$\min_{\theta} E \left(\sum_{I_k, I_h \in V(Q)} |s_v(I_k, I_h; \theta) - s_l(I_k, I_h)| \right) \qquad (7.78)$$

Finally, each image in the database is assigned a score

$$\sigma(I_k) = \max_{I \in V(Q)} s_v(I_k, I; \theta) \qquad (7.79)$$

and the first N images in score order are returned as an answer to the query. The score σ is in this case assigned to the images as the maximum of the similarity between the image and the images in the set $V(Q)$. Clearly, other operators can be used, like weighted sums, or other functions, as discussed in section 4.4.6.

Note that the textual query that produces $V(Q)$ was made here on the whole database. This is not necessary in general; the only assumption of the method is that the visual dictionary $V(Q)$ be part of the database. Textual annotation can be present only for a subset of the database, in which case the visual dictionary can be used to extend the query to a set of images that could not be associated with text.

7.6.2 Mutual Influence

The previous section essentially described the way in which the linguistic similarity between images can be used to deform the feature space by modifying the visual similarity measure between images. The action between the two spaces, visual and linguistic, is, however, dual—if some indication is available that certain images should be considered similar for a given query, this fact will influence the similarity between the terms associated to those images.

The techniques developed in this section will become useful, especially with the *direct manipulation* interfaces described in Chapter 10, but their derivation can be cast in a more general setting. Consider again the images expressed as in the previous section, with the similarity between images given by Eq. (7.75). The similarity between terms, $\langle T_t, T_u \rangle$, is given by

$$s_l(T_t, T_u) = \langle T_t, T_u \rangle == \sum_{k=1}^{N} \alpha_{t,k} \alpha_{u,k} \qquad (7.80)$$

Note that if $A = \{\alpha_{t,k}\}$ is the matrix of the terms weights, then the similarity between I_k and I_h is the element (k, h) of the $N \times N$ matrix AA', while the similarity between terms T_t and T_u is the (t, u) element of the $M \times M$ matrix $A'A$.

Assume now that, somehow, an $N \times N$ matrix ψ is given such that the element ψ_{ij} is some desired or measured distance between images I_i and I_j. How does this fact change the relation between terms? In particular, how does it affect the similarity between terms?

The most obvious solution would be to change the weight matrix A in such a way that $AA' = \Psi$ and, from the new matrix—call it \tilde{A}—compute the new term similarity $\tilde{A}'\tilde{A}$. This results in a rather intractable quadratic problem, so I will opt for a more gentle, iterative solution. An alternative one might try, instead of solving the quadratic problem, would be that of moving the matrix a step in the right direction, that is, find a matrix \tilde{A} such that

$$\tilde{A}\tilde{A}' = (1 - \gamma)AA' + \gamma\Psi \tag{7.81}$$

for some small constant γ. As γ is small, one can expect that the matrix \tilde{A} will not be too different from A. In particular, one can write $\tilde{A} = A + E$, where $E = \{\epsilon_{ij}\}$ is composed of small elements. The previous equation can be expanded as

$$\tilde{A}\tilde{A}' - AA' = \gamma(\Psi - AA') \tag{7.82}$$

and

$$\begin{aligned}
\tilde{A}\tilde{A}' &= (A + E)(A + E)' \\
&= AA' + AE' + E'A + EE' \\
&\approx AA' + AE' + E'A
\end{aligned} \tag{7.83}$$

where the last approximation derives from the assumption that E is composed of small elements whose squares are negligible. The equation therefore becomes

$$AE' + EA' = \gamma(\Psi - AA') \tag{7.84}$$

Note that the right-hand side is typically symmetric, as is Ψ, and therefore the left-hand side is also symmetric, from which it follows that $EA' = AE'$, and the equation becomes

$$AE' = \gamma(\Psi - AA') \tag{7.85}$$

This is a system of $N \times M$ linear equations in the unknown matrix E. It can be written in the traditional form $\mathcal{A}\mathcal{E} = \mathcal{B}$ defining

$$\mathcal{A} = \begin{bmatrix}
\alpha_{11} & \alpha_{12} & \cdots & \alpha_{1M} & 0 & 0 & \cdots & & & & & \cdots & 0 \\
0 & 0 & \cdots & 0 & \alpha_{11} & \alpha_{12} & \cdots & \alpha_{1M} & 0 & 0 & & \cdots & 0 \\
0 & 0 & \cdots & 0 & 0 & 0 & \cdots & 0 & \cdots & \alpha_{11} & \alpha_{12} & \cdots & \alpha_{1M} \\
\alpha_{21} & \alpha_{22} & \cdots & \alpha_{2M} & 0 & 0 & \cdots & & & & & \cdots & 0 \\
0 & 0 & \cdots & 0 & \alpha_{21} & \alpha_{22} & \cdots & \alpha_{2M} & 0 & 0 & & \cdots & 0 \\
0 & 0 & \cdots & 0 & 0 & 0 & \cdots & 0 & \cdots & \alpha_{21} & \alpha_{22} & \cdots & \alpha_{2M} \\
\vdots & \vdots & & & & \vdots & & & & & & & \vdots \\
\alpha_{N1} & \alpha_{N2} & \cdots & \alpha_{NM} & 0 & 0 & \cdots & & & & & \cdots & 0 \\
0 & 0 & \cdots & 0 & \alpha_{N1} & \alpha_{N2} & \cdots & \alpha_{NM} & 0 & 0 & & \cdots & 0 \\
0 & 0 & \cdots & 0 & 0 & 0 & \cdots & 0 & \cdots & \alpha_{N1} & \alpha_{N2} & \cdots & \alpha_{NM}
\end{bmatrix} \tag{7.86}$$

$$\mathcal{E} = [\epsilon_{11}, \epsilon_{12}, \ldots, \epsilon_{1M}, \epsilon_{21}, \ldots, \epsilon_{2M}, \ldots, \epsilon_{N1}, \ldots, \epsilon_{NM}]' \tag{7.87}$$

and similarly for $y(\Psi - AA')$. The solution of this system will give a matrix E that represents the first "step" of the weight matrix A in the direction of the similarities Ψ. One can then define

$$A \leftarrow A + E \tag{7.88}$$

and repeat the whole process. At the end, the result will be a matrix A that will allow the calculation of the new term-to-term similarities as influenced by the similarity between the images associated to those terms. These similarities will be used in the combined images/term interfaces of Chapter 10.

This system of equations appears at first sight daunting—it is, after all, a system of $N \times M$ equations, where both N and M are of the order of thousands! In general, however, because the similarity matrix Ψ comes from the user interface, there will be only a handful of nonzero entries, corresponding to a small group of images that the user has selected. Instead of solving the whole system, it will then be sufficient to consider a reduced matrix A consisting of the images whose similarity has been redefined in the matrix Ψ and the terms associated to those images or, if this still results in a very large system, only the most influential terms for those images (i.e., the terms with the highest weights). Finally, if the linear system is still large, it is opportune to use an iterative method to solve it. The iteration for the solution of the linear system can then be mixed with the iteration of (7.88), computing a fixed number of iterations for the solution of the linear system, then one iteration (7.88), and so on.

and similarly for $\mathbf{g}(\tau) = \Delta\mathbf{A}^t$. The solution of this system will give a matrix \mathbf{J} that represents the first "step" of the weight matrix. Up to a direction of the simulation Ψ one can then define

III

e cerca e truova e quello officio adempie

8

Algebra and the Modern Query

et in illo die me non rogabitis quicquam amen amen dico vobis si quid petieritis
Patrem in nomine meo dabit vobis usque modo non petistis quicquam in nomine
meo petite et accipietis ut gaudium vestrum sit plenum

evangelium secundum Ioannem (16, 22-24)

The poster outside the movie theater tells everyone who might be interested that
the movie theater is showing "Young Frankenstein." From where I sit in one of
the last rows of the theater (the last remaining vestige of my teenage days, in
which I used to sit in the same general area with my girlfriend, utterly unin-
terested in whatever situation the screen was giving life to), I enjoy the dialog.
Young Baron Frederick von Frankenstein (Gene Wilder) has just been attacked
by the newly awakened monster (Peter Boyle) who was scared by a cigarette lit
at that particular moment by Igor (Marty Feldman) for no apparent reason other
than to scare him. Taken by surprise, he starts gesturing towards his assistant
Inga (Teri Garr) and the forementioned Igor in an attempt trying to convey his
needs:
Frederick: What is it? What's the matter? Quick, give him the-. Quick, give him
the-.
Igor: What? Give him the what? Three syllables. First syllable. Sounds like-
Inga: Head. Sounds like head. Bed? Uh, said?
Igor & Inga: Said.
Igor: Said.

Inga: Said. Second syllable. Little word. This? That? The?
Igor: A? Said a?
Inga: Said a?
Igor: Dirty word. He said a dirty word.
Igor & Inga: Sounds like-
Inga: To give? Give?
Igor: Sedagive. Give him a sedagive.
Inga: Oh, tive. Tive. Sedative.
Igor: On the nosey.

There are occasions—possibly a trifle more plausible than this one—in which the capacity to express quickly and completely what one wants is indeed very useful, and expressing queries to a database is certainly one of them. The structure of a database is in general rather complicated, technically involved, and—for the sake of efficiency—semantically rather awkward. To deal with the data the way they are stored can be considered, if not the equivalent, at least a close parent of trying to write a word processing application using the programming tool that the first microcomputers made available to the programmer—a set of eight switches and eight lights to enter bytes one by one.

Query languages are the database equivalent of programming languages, in that they allow one to use a higher level view to manipulate and query the data in the database. Query languages are usually a syntactic specification that rests on a query algebra, which defines the operations that are possible on the data, their interactions, and their effects. The algebra, on the other hand, is defined based on an abstract data model. If this were a popularity contest among database languages, the hands-down winner would be the combination of the relational data model, the corresponding relational algebra, and, on top of that, the SQL query language.

To the best of my knowledge there is so far no similar data model or algebra dedicated to image databases. There is not, to this day, a clear convention on what *data types* should be involved in the storage and manipulation of images and similarity measures, nor of what algebras should be defined to work on them. All these things will be necessary for the creation of image (or, more in general, feature data) databases with capabilities comparable to those of existing text databases. This chapter will try to move some steps in this direction. I will start by developing a simple model of image algebra, modeled on relational algebra. This data model depends crucially on *scoring functions* that will order the set of images with respect to a given query. As shown in the previous chapters, the manipulation of these functions is an integral part of the query process. Section 8.2 defines scoring functions as a data type, and an algebra for manipulating them. Finally, section 8.3 will define a more complete data model in which images and features can be defined as data types and manipulated.

8.1 A First Model of Image Data

Querying and manipulating queries in databases with complex descriptions of image data is an area of study with an independent justification, requiring special techniques, and generating its own problems. If the problems connected to the specification, optimization, and processing of image queries are to be considered with a certain generality, it is necessary to abstract from the particular image representation being used in a specific system, and look for techniques that can be applied to all (or, at least, to a significant number of) image representations.

This section will define a data model for image database independent, to a large extent, on the particular features that are used to represent images, and will introduce certain basic operations that permit the execution of queries on these features. The way the model is presented is somewhat inspired by the relational data model [Ullman, 1982], but it will differ in some important aspects.

8.1.1 A Quick Review of Relational Algebra

In the relational model data are represented as *tables*, also called *relations*. This naming convention derives from the fact that a table with k columns (also called *attributes*) can be seen as a k-ary relation between all the elements of a row (also called *record* or a *tuple*). The number k is also called the *arity* of the relation. For instance, the table

Employee				
ID	Name	Fiscal_Code	Salary	Years_on_Job
01024	Berkowitz	368419219	90000	5
04659	O'Connor	536213888	80000	3
01788	Fitzpatrick	341889312	95000	6

is a relation between employee IDs, names, fiscal codes, and so on. A table in a relational database is considered as a *set* of tuples, which implies that the physical ordering of its records is immaterial. Several tables can be related through a common field. For instance, in the employee database of this example, there may be a second table specifying the days of vacation that every employee took during the current year. The relation between an employee and his days of vacation is maintained through the field "ID," which is common to both tables:

Vacation	
ID	Vacation
01024	15
04659	21
01788	18

Looking at the two tables, one can see that O'Connor (ID 04659) took 21 days of vacation this year, while Berkowitz (ID 01024) took only 15. Conventionally, the field f of a table t is indicated by $t.f$.

The set of column names of a relational table and the relative data types is called its *schema*. If table T has attributes A_1, \ldots, A_k, of types t_1, \ldots, t_k, respectively, the schema of the table is written $T(A_1 : t_1, \ldots, A_k : t_k)$ or, using an abbreviated notation, simply $T(A_1, \ldots, A_k)$. The database of the examples in the preceding is then constituted by the following tables:

Employee(ID:int, Name:string,Fiscal_Code:int,Salary:int,Years_on_Job:int)

Vacation(ID:int,Vacation:int)

or, using the abbreviated notation,

Employee(ID,Name,Fiscal_Code,Salary,Years_on_Job)

Vacation(ID,Vacation)

Relational algebra defines operators that manipulate and query relational tables. In a relational database, the output of a query is always a table, containing certain selected attributes of all the records that satisfy the query. The operations defined in relational algebra are the following:

Union. The union of two tables T and Q ($T \cup Q$) is a table containing all the records that are in T, in Q, or in both of them (these records are counted only once, in accordance with the definition of a set). The union is defined only if tables T and Q have the same fields, that is, if they have the same schema.

Difference. The difference of two tables ($T - Q$) is the set of tuples that are in T but not in Q. Again, the operation applies only if T and Q have the same schema.

Cartesian product. Let T be a table with k columns and Q a table with h columns. The Cartesian product $T \times Q$ is a table with $k + h$ columns, and is the set of the tuples whose first k elements are the tuples of T, and whose last h components are the tuples of Q. If T has t rows and Q has q rows, the Cartesian product $T \times Q$ has tq rows.

Projection. Projection builds a new relational table from an existing one by taking a number of columns and rearranging them in the specified order. Given a table with n columns, the operator π_{i_1, \ldots, i_k} builds a table with k columns (i.e., a relation with arity k). The first column of the new relation is column i_1 of the original table, the second column is column i_2 of the original table, and so on. For instance, given the relation

T_{11}	T_{12}	T_{13}	T_{14}	T_{15}
T_{21}	T_{22}	T_{23}	T_{24}	T_{25}
T_{31}	T_{32}	T_{33}	T_{34}	T_{35}
T_{41}	T_{42}	T_{43}	T_{44}	T_{45}

then the operation $\pi_{5,2,1}(T)$ yields the relation

T_{15}	T_{12}	T_{11}
T_{25}	T_{22}	T_{21}
T_{35}	T_{32}	T_{31}
T_{45}	T_{42}	T_{41}

In this example the columns of the table were identified by their index. If the columns have names, as in the previous example, the projection operator can use them. For instance, a projection operator for the employee table could be $\pi_{Name,Salary,ID}$.

Selection. Given a formula F involving constant, index numbers into tables, arithmetic operators ($\leq, -, \geq, <, >, \neq$), and logic operators ($\wedge, \vee, \neg$), the operator $\sigma_F(T)$ extracts from the table F all the rows that satisfy the formula F and builds a new table with them. For instance, the operation $\sigma_{Salary>85000}(Employee)$ results in the table

ID	Name	Fiscal_Code	Salary	Years_on_Job
01024	Berkowitz	368419219	90000	5
01788	Fitzpatrick	341889312	95000	6

In addition to these actual operations, I will use the notation $T[i]$ to refer to the ith row of the table T.

Most relational algebras define utility operations in terms of the formal operations defined in the preceding. The most common of such operations defined in relational algebra is *join*. If T and Q are two tables of arity t and q, respectively, and θ is an arithmetic comparison operator, the θ-join of T and Q on columns i and j is written $T \bowtie_{i\theta j} Q$. The operator can be defined in terms of the operators introduced so far as follows:

$$T \bowtie_{i\theta j} Q = \sigma_{i\theta(t+j)}(T \times Q) \tag{8.1}$$

That is, out of the Cartesian product $T \times Q$, the θ-join selects those rows such that the ith component of R stands in the relation θ with the jth component of Q.

The *natural join*, written $T \bowtie Q$, is applicable when the relations have named columns. To compute $T \bowtie Q$, the procedure is as follows:

1. compute $T \times Q$;

2. for each name A which names both a column of T and a column of Q, select from $T \times Q$ those tuples such that $T.A = Q.A$; and

3. in the product $T \times Q$, each column name that denotes both a column of T and a column of Q will be repeated twice; in each case, retain only one of such column.

Formally, let A_1, \ldots, A_k be the names of columns that are common to T and Q, B_1, \ldots, B_m the name of the columns that are only in T, and C_1, \ldots, C_n the columns that are only in Q. Then

$$T \bowtie Q = \pi_{(T.A_1,\ldots,T.A_k,T.B_1,\ldots,T.B_m,Q.C_1,\ldots,Q.C_n)} \sigma_{(\wedge_{i=1}^{k} T.A_i = Q.A_i)} (T \times Q) \qquad (8.2)$$

As an example, the join "Employee \bowtie Vacation" gives as a result the table

ID	Name	Fiscal_Code	Salary	Years_on_Job	Vacation
01024	Berkowitz	368419219	90000	5	15
04659	O'Connor	536213888	80000	3	21
01788	Fitzpatrick	341889312	95000	6	18

The join is a very important operation in databases. The Cartesian product of two tables is very seldom computed since, most of the time, it gives rise to very large tables, most entries of which are meaningless. For instance, the Cartesian product of the Employee and Vacation tables would give rise to entries containing the data about an employee and the vacation time of another employee. Join is often implemented as a primitive operation in relational databases as a mean to put together the contents of two tables.

8.1.2 An Algebra for Image Databases

The basic unit of representation of an image in a database is a relational table with one image per row, in which a column represents the *handle* of the image, and the other columns represent different descriptions of the image in terms of *features*. I call these tables *ordered relations* (the rationale for this name should be clear in a short while). A simple example is the following:

Image Description			
h	Color	Wavelet	Regions
1	\mathcal{H}_1	t_1	G_1
2	\mathcal{H}_2	t_2	G_2
\vdots		\vdots	
n	\mathcal{H}_n	t_n	G_n

This relation (called "image description") contains n images. Image i is described by the color histogram \mathcal{H}_i, the vector t_i of coefficients of a wavelet transform, and the region graph G_1. Each column (except the handle) contains elements belonging to a feature space. Each one of these feature spaces represents a data type, that is, an algebra of operation that can be made on data belonging to that type. These are called *feature data types*, and are the main focus of this section.

A database like the previous one can be created by joining tables with only two columns: the handle and a feature type. The previous table, for instance, can be obtained by joining the following three tables on the handle field:

Image Color		Image Wavelet		Image Regions	
h	Color	h	Wavelet	h	Regions
1	\mathcal{H}_1	1	t_1	1	G_1
2	\mathcal{H}_2	2	t_2	2	G_2
\vdots		\vdots		\vdots	
n	\mathcal{H}_n	n	t_n	n	G_n

I call this representation the *standard form* of an image database. In this section, I will assume that all databases are in standard form, that is, all relations will be in the form $T(h, x)$, where h is a handle of some specified type (usually an integer or a string of characters), and x is the feature description of the image, belonging to some *feature type X*.

Feature types. Each feature x belongs to a feature data type X. The definition of a complete algebra of features is a complex issue that will be considered only partially in section 8.4. At this time, it will be assumed that for every feature type X there exists an associated distance type $\mathfrak{D}(X)$, with $\mathfrak{D}(X) \subset \{X \times X \to \mathbb{R}^+\}$ defined in Chapter 4. The notation $x : X$ will be used to indicate that x is a variable or a constant of type X. For each feature type the following operations are defined:

construction. a constructor $C_X(I)$ builds a feature value given an image I;

distance. for each pair of elements $x : X, y : X$, and $d : \mathfrak{D}(X)$, the value $d(x, y)$ is defined and is called the d-distance between x and y;

scoring distance. for each element $x : X$ and $d : \mathfrak{D}(X)$, the value $d(0_d, x)$ is defined, where 0_X is a conventional point in the feature space whose definition can depend on the distance d. This value is called the *scoring distance* of the feature x. The *score* of the feature can be obtained as $g(d(0_d, x))$, where g is a function that satisfies the hypotheses of Theorem 4.5.

Ordered relations. The main difference between the relations in a database and those containing images in an image database is that the former are sets of tuples, while the latter are *ordered* sets of tuples. Every feature relational table T has an implicit column ς containing the *score* of each row in the table, which is a real number between 0 and 1, that is, for every table T, $T[i].\varsigma \in \mathcal{I}$ for all i, where $\mathcal{I} = [0, 1]$ and $T[i]$ is the ith row of the table. Higher score values correspond to images more relevant for the current query. Operations on tables can be divided into three broad classes:

1. operations that change the value of the score field, leaving the structure and the other values of the table intact;

2. operations that select part of a table, leaving the schema of the table intact; and

3. operations that change the schema of a table.

This section is concerned only with operators in the first two categories. The next section will introduce operators in the third category, in particular, the *join* operator, which presents aspects of all three categories given in the preceding. All the operators in this section are *stateless*: the result of an operator does not depend on the previous application of the same or other operators.

Scoring operator. The scoring operator Σ changes the value of the scoring field of an image relational table. The scoring operator uses a *scoring function*. Given a table $T(id, x)$, $x \in X$, a scoring function is a function $s : X \to \mathcal{I}$, and $\beth(X)$ is the space of the scoring functions on the feature space X. Given the scoring function $s \in \beth(X)$, the operator $\Sigma_T(s)$ assign the value $s(x)$ to the score field of each row of T, that is, for each row of T: $(\Sigma_T(s)[i]).\varsigma = s(x)$.

Selection operators. There are three selection operators that extract part of a table T:

$\sigma_k^{\#}(T)$ selects the k elements in the table with the highest score (k-nearest neighbors operator). Note that, if k is greater than the number of rows in T, $\sigma_k^{\#}(T) = T$.

$\sigma_\rho^>(T)$ selects all the elements in the table with a score greater than ρ. Similarly, the operator $\sigma_\rho^\geq(T)$ retrieves all the images with a score $\geq \rho$. Note that $\sigma_0^\geq(T) = T$.

$\sigma_P^h(T)$ selects all the images whose handle satisfies the predicate P. In most cases the handle number has no specific meaning so the predicate P is often of the form $h = h_0$ or $h \in H$, where H is a set of handles.

Unions. Given two tables T_1 and T_2, two union operators, $\overline{\cup}$ and $\underline{\cup}$ are defined. The max-union $T_1 \overline{\cup} T_2$ is a table composed of records belonging to either one of the tables. If two records are identical in all explicit attributes (that is, in all attributes except possibly for the implicit score attribute ς), only one of them is retained, and the score of this record is the maximum of the scores of the two copies. The min-union $T_1 \underline{\cup} T_2$ is defined similarly, except that, in case of duplicate records, the minimum of the two scores is retained.

Intersections. Given two tables T_1 and T_2, two intersections are defined, $\overline{\cap}$ and $\underline{\cap}$. In both cases, the resulting table contains all the records that appear with the

same explicit attributes in both tables. In the intersection $T_1 \overline{\cap} T_2$, the score of each record is given by the maximum of the scores the record has in the two tables, while in the intersection $T_1 \underline{\cap} T_2$, the score is given by the minimum of the scores that the record has in the two tables.

Difference. The difference of two tables $T_1 - T_2$ contains all the records of T_1 that do not appear in T_2. As in the previous case, a record of T_1 is assumed to appear in T_2 if the values of its explicit attributes are the same, independently of whether the value of the score attribute is the same.

Special selection functions. Given a table T, first(T) returns the record with the highest score, and last(T) returns the record with the lowest score. Given a table T and a record R, the operator next(T, R) returns the record that immediately follows R in scoring order. In all these cases, what is really returned is, of course, a table. The table will usually contain one record (the record with the highest or lowest score, or the record that follows the given one), but can contain more than one record in case of ties. Similarly, the record R in next(T, R) is really a table with only one record. If the parameter R in next(T, R) is a table containing more than one record, the function returns the record (or the records) following the last in the table R, that is,

$$\text{next}(T, R) = \text{next}(T, \text{last}(R)) \tag{8.3}$$

Score operations. Some of the the previous operations computed the equality of records independently of the value of their scores because scores are not explicit attributes. If scores need to be considered as part of the equality, it is necessary to create a real-valued attribute of the record and assign the score value to it, using the pseudo-attribute ς to access the value. The schema $\text{IMG}(id:\text{int}, x:feature, s:real)$ keeps the score in the field s. If T is a table with schema IMG, scores are assigned to the field s using the assignment $T.s = T.\varsigma$. The function $score(s, T)$ assigns the score to the field s of all the records of the table T.

In many cases the scoring function is based on either a distance function or a similarity function (the first case can be reduced to the second, as seen in Chapter 4). If $S(x, y)$ is a measure of similarity between x and y, then a common query is to assign scores based on the similarity between the images and a given query image h_0 in the database. The feature vector of image h_0 can be accessed with the operator $\sigma_{h=h_0}(T).x$, and the similarity between a feature vector x and the query image can be written as

$$s(x) = S(x, \sigma_{h=h_0}(T).x) \tag{8.4}$$

Note that $s \in \beth(X)$, that is, s is a scoring function for the feature type X. A query by example requesting the 100 images closer to image h_0 can be expressed as

$$\sigma_{100}^{\#} \left(\Sigma_T (z \mapsto S(z, \sigma_{h=h_0}(T).x)) \right) \tag{8.5}$$

In many cases, it is useful to define a *natural scoring operator* for a table T with feature X. This operator has no particular theoretical significance, but it is important in practice because, as will be seen in the next chapter, indexing schemes are often built around a certain similarity measure and making queries based on the natural operator is more efficient than asking queries relative to arbitrary operators. Let T be a table in which the feature is of type X, and let n_X be the natural similarity measure for the feature type X. Then n_X is also the natural scoring operator for the table T. Given the frequent use of this similarity, it is convenient to define a simplified notation for the assignment of scores based on it. The notation $\Sigma_T^{h_0}$ will be used to indicate that the scoring function is measuring similarly with the image h_0 based on the natural similarity function. That is:

$$\Sigma_T^{h_0}(T) = \Sigma_T(z \mapsto n_T(z, \sigma_{h=h_0}(T).x)) \qquad (8.6)$$

Much like the score attribute ς, the natural distance function will be considered as a virtual attribute of a table. Given the table T, $T.v$ is its natural distance function. Note that, unlike all the other attributes, v is an attribute of the table, and not of its rows. That is, the expression $T[i].v$ is for now meaningless (it will receive a meaning later on, in section 8.3.1).

In general, one would like to have a user specify a distance function that the system will use. Such a distance can come from a combination of natural scoring functions or be defined as an external function. The first case will be considered later in this chapter. If the distance function is external, and depends on an array of values w, the query takes the form:

$$\sigma_{100}^{\#} (\Sigma_T(s : z \mapsto \exp(- \vDash d(w; z, \sigma_{h=h_0}(T).x)))) \qquad (8.7)$$

where \vDash is the external evaluation operator.

8.2 An Algebra of Scoring Functions

Many queries more complex that the simple examples already mentioned will require composing the scores of two separate tables. Consider, for instance, a database with *two* tables: $T(h, x)$, with $x : X$, and $Q(h, y)$, with $y : Y$. Here, X and Y are feature types. The two tables have, as usual, scoring fields $T.\varsigma$ and $Q.\varsigma$. Assume, just to make things more concrete, that the type X measures color similarity, and that the type Y measures texture similarity. The two tables can be sorted by similarity with a given image h_0, obtaining the tables

$$T' = \Sigma_T(s : z \mapsto \exp(-n_X(z, \sigma_{h=h_0}(T).x))) \qquad (8.8)$$

and

$$Q' = \Sigma_Q(s : z \mapsto \exp(-n_Y(z, \sigma_{h=h_0}(Q).y))) \qquad (8.9)$$

Suppose, however, that one wants similarity with respect to color and texture. Further, for the sake of simplicity, assume that one is not interested in carrying over the features, so that the results will be a table with a single column: $R(h)$. How will the scores be assigned to this table? It is necessary to define a suitable set of functions q such that $R.\varsigma = q(T'.\varsigma, Q'.\varsigma)$.

Before proceeding to do this, an observation is necessary. The function q given in the preceding is a function $q : \mathcal{I}^2 \rightarrow \mathcal{I}$. Let X and Y be two feature types, and $\beth(X)$ and $\beth(Y)$ the associated spaces of scoring functions. Then the function q induces a function q, $\mathsf{q} : \beth(X) \times \beth(Y) \rightarrow \beth(X \times Y)$, defined as follows: if $s \in \beth(X)$ and $r \in \beth(Y)$, then the function $\mathsf{q}(s, r)$ is defined as

$$(\mathsf{q}(s, r))(T.x, T.y) = q(s(T.x), r(T.y)) \tag{8.10}$$

This observation will be important in the following, as it will allow the definition of scoring functions for tables with multiple feature types.

Most of the combination functions presented in the following were first proposed in the fuzzy logic literature. One can consider the score of a row in a table as the degree of membership of that row in the solution set. Thus, if a row has a score of 1, it will fully belong to the solution set, a row with a score of 0 will not belong to the solution set, and a row with a score between 0 and 1 will belong to the solution set only to a certain degree. Rows in relational databases have scores that take only the values 0 and 1.

The fuzzy analogy is useful because it provides some intuitive grounding in the search for combination functions, although one should always keep in mind that the final model must be justified on purely geometric grounds. In the example of tables T and Q in the preceding, for instance, the two were supposed to be composed so as to give similarity with respect to both color *and* texture. In a relational database, such an operation would be obtained through set intersection ($R = T \cap Q$), the set-theoretic operation corresponding to the logic conjunction (the "and" operator \wedge). Other combinations require set union (\cup) and set complementation $(\neg T)$[1], corresponding to the logic disjunction (the "or" operator \vee), and to logic complementation (the "not" operator \neg). A good starting point in the study of combination operators is to study sets of operators that resemble the logic conjunction ("and"), disjunction ("or"), and complementation ("not"). In particular, these would be operators that reduce to the usual logic operators if the scores take values in $\{0, 1\}$. I will start with complementation, following rather closely the work of Dubois and Prade (1985) and Fagin (1996).

[1] In most relational algebras, the complementation operator \neg is considered *unsafe*, because, given a set P, the set of tuples are not in P is, in general, infinite, unless some special care is taken to limit the domain of discourse. This corresponds to transform the negation operator in a suitable difference of set (one of which can be the whole domain under consideration). In this section, I will be somewhat sloppy, and apply the complementation operator rather freely. In practice, of course, the domain of discourse is always limited to a subset S of the entire database D so a set like $\neg T$ should always be intended as $S - T$. In some cases, complementation is restricted to appear only in predicates involving conjunctions, that is, in predicates of the form $a \wedge \neg b$. In this case, the complement is said to be "guarded."

8.2.1 Complementation

Let ς be the score of a particular image—represented by its handle h and a feature vector x—when a condition q is given. What should the score of the same image be when the condition $\neg q$ is given? Such a score is called the *complement* of ς, and I will indicate it for the moment with $\neg \varsigma$. Complementation can be defined pointwise as a mapping $c : \mathcal{I} \to \mathcal{I}$ such that $\neg \varsigma = c(\varsigma)$. The following axioms have been suggested as natural conditions for the function c [Bellman and Giertz, 1973]:

1. $c(1) = 0$, $c(0) = 1$ (that is, for ordinary sets, c coincides with the ordinary complementation);

2. c is strictly decreasing and continuous; and

3. c is involutive, that is, $\forall \varsigma \in \mathcal{I}, c(c(\varsigma)) = \varsigma$.

If these axioms are satisfied and c is continuous, then there is a unique value $\varsigma_c \in \mathcal{I}$ such that $c(\varsigma_c) = \varsigma_c$. Let ϕ be a strictly increasing mapping $\mathcal{I} \to [0, +\infty]$ such that $\phi(0) = 0$ and $\phi(1)$ is finite. Define the *pseudoinverse* of ϕ as

$$\phi^*(y) = \begin{cases} \phi^{-1}(y) & \text{if } y \in [0, \phi(1)] \\ 1 & \text{otherwise} \end{cases} \tag{8.11}$$

then the function

$$c(x) = \phi^*(\phi(1) - \phi(x)) \tag{8.12}$$

satisfies the complementation axioms. The function ϕ is called the *generator* of c. Conversely, any complement c can be defined as in Eq. (8.12), and the function ϕ is unique up to a multiplicative constant, so that it is always possible to assume $\phi(1) = 1$ and make the function unique. It is also easy to verify that $\varsigma_c = \phi^{-1}(\phi(1)/2)$.

If $\phi(x) = x$, then $c(x) = 1 - x$, which is the complement function commonly used in fuzzy logic. Another complementation operator that satisfies the axioms 1-3 is Sugeno's λ-complement [Sugeno, 1977]:

$$c_\lambda(x) = \frac{1 - x}{1 + \lambda x} \tag{8.13}$$

where $\lambda > -1$.

8.2.2 Conjunction and Disjunction

Let $\varsigma(P)$ be the score of an image when the query is P and $\varsigma(Q)$ the score when the query is Q. The score for queries $P \wedge Q$ and $P \vee Q$ can then be defined using two functions $\star, \dagger : \mathcal{I} \times \mathcal{I} \to \mathcal{I}$ such that

$$\varsigma(P \wedge Q) = \varsigma(P) \star \varsigma(Q) \tag{8.14}$$

$$\varsigma(P \vee Q) = \varsigma(P) \dagger \varsigma(Q) \tag{8.15}$$

In general, it is desirable to carry over to the domain of scores as many properties as possible from Boolean algebra so that, for instance, if the scores are only 0 and 1 (the relational case), the logic operators \wedge and \vee translate into set intersection and union, respectively. There are, however, limits to what one can carry over to the domain of graded responses, as stated by the following theorem, from Dubois and Prade (1980b).

THEOREM 8.1. *If the excluded middle law $x \vee \neg x = 1$ (respectively, the noncontradiction principle $x \wedge \neg x = 0$) is valid for values $0 < x < 1$, and the complement belongs to the family of equations (8.12), then the operator \vee (respectively, \wedge) is no longer idempotent, that is $x \vee x \neq x$ (respectively, $x \wedge x \neq x$).*

In addition, the idempotency of the "or" and "and" operators derives from their mutual distributivity so that the hypotheses of the theorem also prohibit mutual distributivity. Consequently, one is forced to choose between the excluded middle and the noncontradiction law on one side, and idempotency and distributivity on the other. This choice will also constrain the design of the database system. In general terms, the excluded middle and noncontradiction will result in a more intuitive query langage, while idempotency and distributivity will offer more possibilities for the algebraic manipulation of queries and, consequently, more possibilities for query optimization.

Triangular norms. An important class of functions that for the aggregation of scores is given by the so-called *triangular norms* [Dubois and Prade, 1985; Fagin, 1996]. A triangular norm (which was introduced briefly in section 4.3.1) is a function $t : \mathcal{I}^2 \to \mathcal{I}$ that satisfies the following conditions:

\wedge-**conservation:** $t(0,0) = 0$, $t(x,1) = t(1,x) = x$;

monotonicity: $t(x,y) \le t(x',y')$ if $x \le x'$ and $y \le y'$;

commutativity: $t(x,y) = t(y,x)$;

associativity: $t(t(x,y),z) = t(x,t(y,z))$.

Given these axioms, it is quite natural to choose the operation \star to be a triangular norm, that is, for queries P and Q,

$$\varsigma(P \wedge Q) = \varsigma(P) \star \varsigma(Q) = t(\varsigma(P), \varsigma(Q)) \tag{8.16}$$

A *triangular co-norm* is a function $s : \mathcal{I}^2 \to \mathcal{I}$ that satisfies the following axioms:

\vee-**conservation:** $s(1,1) = 1$, $s(x,0) = s(0,x) = x$;

monotonicity: $s(x,y) \le s(x',y')$ if $x \le x'$ and $y \le y'$;

commutativity: $s(x,y) = s(y,x)$;

associativity: $s(s(x,y),z) = s(x,s(y,z))$.

Triangular co-norms are a natural candidate for the disjunction operator †:

$$\varsigma(P \vee Q) = \varsigma(P) \dagger \varsigma(Q) = s(\varsigma(P), \varsigma(Q)) \tag{8.17}$$

Triangular norms and triangular co-norms are dual, and their duality is expressed through the complement functions c. In fact, if t is a triangular norm and c a complement, then the function

$$s(x, y) = c(t(c(x), c(y))) \tag{8.18}$$

is a triangular co-norm, which is called the *c-dual* of the triangular norm t. Writing the functions t, s, and c as operators, one finds the familiar De Morgan's laws:

$$x \dagger y = \neg(\neg x \star \neg y) \tag{8.19}$$

and

$$x \star y = \neg(\neg x \dagger \neg y) \tag{8.20}$$

When $c(x) = 1 - x$, the operators \star and \dagger are called simply dual. Table 8.1 gives some examples of triangular norms and the dual co-norms.

Triangular norms and triangular co-norms provide a very flexible and powerful framework for assigning scores to images on the basis of complex queries. Consider, for instance, a database with 6 images h_1, \ldots, h_6, with two similarity criteria (let us call them conventionally the criterion C—from color—and the criterion T—from texture). The similarity between image h_1 (the query image) and the other images is given in Table 8.2 (image h_1 is, of course, maximally similar to itself according to both criteria).

Table 8.1.

Norm	Co-Norm
Minimum	Maximum
$\min(x, y)$	$\max(x, y)$
Drastic product	Drastic sum
$\begin{cases} \min(x, y) & \text{if } \max(x, y) = 1 \\ 0 & \text{otherwise} \end{cases}$	$\begin{cases} \max(x, y) & \text{if } \min(x, y) = 0 \\ 1 & \text{otherwise} \end{cases}$
Bounded difference	Bounded sum
$\max(0, x + y - 1)$	$\min(1, x + y)$
Einstein product	Einstein sum
$\dfrac{x + y}{2 - (x + y - xy)}$	$\dfrac{x + y}{1 + xy}$
Algebraic product	Algebraic sum
xy	$x + y - xy$
Hamacher product	Hamacher sum
$\dfrac{xy}{x + y - xy}$	$\dfrac{x + y - 2xy}{1 - xy}$

Table 8.2.

	C	T
h_1	1	1
h_2	0.9	0.1
h_3	0.1	0.9
h_4	0.2	0.2
h_5	0.5	0.5
h_6	0.8	0.8

Tables 8.3 and 8.4 show the scores obtained by these images for the queries $C \wedge T$, $C \vee T$, $C \vee \neg T$, and $(C \wedge \neg T) \vee (\neg C \wedge T)$, respectively, (the latter is an exclusive or query, in which one requests images similar to the example in either criterion but not in both).

Given the parallelism between triangular norms and co-norms applied to scores and scoring functions, and Boolean operations applied to query conditions, I will drop the use of the symbols \star, \dagger, and c and use the same symbols \wedge, \vee, and \neg for both the Boolean operation and the associated scoring operator. Then, given queries P and Q, one can write

$$\varsigma(P \wedge Q) = \varsigma(P) \wedge \varsigma(Q)$$
$$\varsigma(P \vee Q) = \varsigma(P) \vee \varsigma(Q)$$
$$\varsigma(P \wedge \neg Q) = \varsigma(P) \wedge \neg \varsigma(Q)$$

and so on, where the right-hand side expressions correspond to applications of the norm and co-norm functions.

The min and max operators ($x \wedge y = \min(x, y)$, $x \vee y = \max(x, y)$) are idempotent and mutually distributive operators: they are the only possible choices for idempotent intersection and union among triangular norms and co-norms [Bellman and Giertz, 1973]. The practical disadvantage of using min and max is that the result is always equal to one of the two terms. Thus, if $\varsigma_1 = \varsigma_2 = 0.2$ and $\varsigma_3 = 1$, then both $\varsigma_1 \wedge \varsigma_2 = 0.2$, and $\varsigma_1 \wedge \varsigma_3 = 0.2$, irrespective of the fact that in the first case both conditions are almost false while in the second at least one of them

Table 8.3.

	$C \wedge T$						$C \vee T$					
h_1	1	1	1	1	1	1	1	1	1	1	1	1
h_2	.2	0	.1	.17	.18	.19	.9	1	1	.93	.92	.9
h_3	.2	0	.1	.17	.18	.19	.9	1	1	.93	.92	.9
h_4	.2	0	0	.02	.04	.1	.2	1	.4	.38	.36	.33
h_5	.5	0	0	.2	.25	.33	.5	1	1	.8	.75	.67
h_6	.8	0	.6	.61	.64	.67	.8	1	1	.97	.96	.89

Table 8.4.

	$C \wedge \neg T$						$\tilde{C} \wedge \neg T\ddot{O} \vee \tilde{N} \dashv C \wedge T\ddot{O}$					
h_1	0	0	0	0	0	0	0	0	0	0	0	0
h_2	.8	0	.7	.7	.72	.73	.8	0	.7	.71	.73	.74
h_3	.1	0	0	.01	.02	.07	.8	0	.7	.71	.73	.74
h_4	.2	0	0	.14	.16	.19	.2	0	0	.27	.29	.32
h_5	.5	0	0	.2	.25	.33	.5	0	0	.38	.43	.5
h_6	.2	0	0	.13	.16	.19	.2	0	0	.27	.29	.32

is fully true. Intuitively, one would assign a higher score to the second situation because, in that case, at least part of the query is completely fulfilled. A conjunction operator such as, say, the Einstein product would differentiate between these two situations by giving $\varsigma_1 \wedge \varsigma_2 = 0.02$, and $\varsigma_1 \wedge \varsigma_3 = 0.2$.

Strict norms. The requirements for a norm can be strengthened by requiring them to be strictly monotonic in both arguments, and adding the following *Archimedean property*:

$$\forall x \in (0,1) \quad x \wedge x < x \tag{8.21}$$

$$\forall x \in (0,1) \quad x \vee x > x \tag{8.22}$$

The resulting class of functions is called *strict norms* (and co-norms). The general form of strict norms and co-norms has been characterized by Schweizer and Siklar (1961). If ϕ is a complementation generator with $\phi(1) = 1$, then

$$x \wedge y = \phi^{-1}(\phi(x)\phi(y)) \tag{8.23}$$

is a strict conjunction. If h is an increasing bijection $h : \mathcal{I} \to [0, \infty]$, with $h(0) = 0$, and $h(1) = +\infty$, then

$$x \vee y = h^{-1}(h(x) + h(y)) \tag{8.24}$$

is a strict disjunction. Strict conjunctions can also be written in terms of additive generators taking $f = -\log \phi$. In this case, f is a decreasing bijection $\mathcal{I} \to [0, \infty]$ with $f(0) = +\infty$ and $f(1) = 0$. The conjunction can be written in the form

$$x \wedge y = f^{-1}(f(x) + f(y)) \tag{8.25}$$

Given the operators \wedge and \vee, the functions f and h are determined up to a multiplicative constant. Choosing $f(x) = -\log x$ and $h(x) = -\log(1 - x)$, one obtains the algebraic product and sum of Table 8.1. The following properties hold for strict operations [Dubois and Prade, 1985]:

1. They are never mutually distributive or idempotent, nor do they satisfy the excluded-middle and noncontradiction laws, for any choice of complementation.

2. Given a pair of functions f and h, generating conjunction and disjunction, there need not exist an involutive complementation which satisfies De Morgan's laws. If De Morgan's laws hold with a complementation c, then it is easy to check that it must be $f = ah \circ c$, $a > 0$, which gives $c = h^{-1} \circ (1/a)f$. This function is not necessarily involutive.

3. Given a conjunction generated by f, there is a unique disjunction such that De Morgan's laws hold, and this disjunction is generated by $h = f \circ c$.

4. For any sequence $\{x_n\}_{n \in \mathbb{N}}$ such that $0 < x_n < 1$,

$$F_n = x_1 \wedge \cdots \wedge x_n > 0 \quad \lim_{n \to +\infty} F_n = 0$$

$$G_n = x_1 \vee \cdots \vee x_n < 1 \quad \lim_{n \to +\infty} G_n = 1 \tag{8.26}$$

Parametrized families of strict norms have appeared in the literature. Schweizer and Sklar, (1961) proposed the family

$$x \wedge y = T_p(x, y) = (x^{-p} + y^{-p} - 1)^{-1/p} \tag{8.27}$$

for $p \geq 0$. Note that T_0 is the product and T_∞ is the minimum operator. The disjunction operator is determined by the complementation c that one chooses and the relation $h = f \circ c$.

Hamacher (1978) found the only strict family that can be expressed as rational functions:

$$x \wedge y = H_y(x, y) = \frac{xy}{y + (1 - y)(x + y - xy)} \tag{8.28}$$

For $y = 0$ one obtains the Hamacher product of Table 8.1, and for $y = 1$ the regular product.

Nilpotent operators. Another family of operators can be obtained by maintaining the structure of Eqs. (8.23)–(8.24) but assuming that $h(1)$ and $f(0)$ are finite. In this case, it will also be necessary to use the pseudo-inverses f^* and h^* in lieu of the inverses f^{-1} and h^{-1}. The bounded difference and the bounded sum of Table 8.1 are nilpotent triangular norms, which are given by $f(x) = 1 - x$, and $h(x) = x$. Nilpotent norms satisfy the following properties (compare to Eq. 8.26):

$$\exists n < +\infty \quad x_1 \wedge \cdots \wedge x_n = 0$$

$$\exists n < +\infty \quad x_1 \vee \cdots \vee x_n = 1 \tag{8.29}$$

Nilpotent operators are neither idempotent nor mutually distributive. However, if c is a complementation generated by a function ϕ, then ϕ can be used as a generator for the disjunction:

$$x \vee y = \phi^*(\phi(x) + \phi(y)) \tag{8.30}$$

Then the c-dual conjunction has generator $f(x) = \phi(1) - \phi(x)$, and it satisfies the De Morgan's laws, the excluded middle and noncontradiction.

8.2.3 Other Operators

Triangular norms have the advantage of a semantic interpretation that models, more or less, that of the common logic connectives. If such a concordance is not required, many more operators can be explored. Indeed, this possibility is a characteristic of multivalued logic while, in Boolean logic, one can prove the following property:

LEMMA 8.1. *Let \diamond be a symmetric Boolean operator such that $1 \diamond 1 = 1$ and $0 \diamond 0 = 0$. Then \diamond is either \wedge or \vee.*

PROOF. The proof is immediate by considering the possible forms that the truth table of the operator can take, and considering symmetry. If $1 \diamond 0 = 0$, then $\diamond = \wedge$, while if $1 \diamond 0 = 1$, then $\diamond = \vee$. □

This is no longer true for combinations of continuous scores. Note that all pairs of operators deriving from triangular norms and co-norms satisfy

$$x \wedge y \leq \min(x, y) \tag{8.31}$$

and

$$x \vee y \geq \max(x, y) \tag{8.32}$$

There is, therefore, space for defining new operators that take values between minimum and maximum. Such operators are the *means*.

Means. A mean of two scores is an operation \triangle satisfying the following axioms:

1. $\min(x, y) \leq x \triangle y \leq \max(x, y)$;

2. $x \triangle y = y \triangle x$; and

3. \triangle is increasing in both arguments and continuous.

The first point implies that every mean is idempotent ($x \triangle x = x$). On the other side, the following proposition from Dubois and Prade (1984) shows that means are seldom associative (where associativity is defined by the equality $x \triangle (y \triangle z) = (x \triangle y) \triangle z$):

THEOREM 8.2. *There is no associative strictly increasing mean, and the only associative means are the medians defined by*

$$med_\alpha(x, y) = \begin{cases} y & \text{if } x \leq y \leq \alpha \\ \alpha & \text{if } x \leq \alpha \leq y \\ x & \text{if } \alpha \leq x \leq y \end{cases} \tag{8.33}$$

Weaker forms of associativity have been proposed:

bisymmetry. (originally in Dubois, 1983; cited in Dubois and Prade, 1985)

$$(x \triangle y) \triangle (z \triangle t) = (x \triangle z) \triangle (y \triangle t) \tag{8.34}$$

autodistributivity. (Aczel, 1966)

$$x \triangle (y \triangle z) = (x \triangle x) \triangle (x \triangle z) \tag{8.35}$$

These two properties are closely related:

THEOREM 8.3. *Idempotency and bisymmetry imply autodistributivity. Conversely, an autodistributive operation which is also strictly increasing in both places is also idempotent.*

PROOF. [from Dubois and Prade, 1985] assume that \triangle is idempotent and symmetric. Then

$$
\begin{aligned}
x \triangle (y \triangle z) &= (x \triangle x) \triangle (y \triangle z) \quad \text{(by idempotency)} \\
&= (x \triangle y) \triangle (x \triangle z) \quad \text{(by bisymmetry)}
\end{aligned}
\tag{8.36}
$$

Conversely, if \triangle is autodistributive, then

$$x \triangle (y \triangle z) = (x \triangle x) \triangle (y \triangle z) \tag{8.37}$$

Using strict monotonicity, the mapping $g(x) = x \triangle x$ can be proved to be injective, therefore $x = (x \triangle x)$. □

The general functional representation of autodistributive and bisymmetric strictly monotonic means (which, by the previous theorem, are equivalent) was discovered by Aczel (1966) and it is of the form:

$$x \triangle y = f^{-1} \left(\frac{f(x) + f(y)}{2} \right) \tag{8.38}$$

where $f : \mathcal{I} \to \mathbb{R}$ is continuous and strictly monotonic. If $f = x^\alpha$, one obtains the class of operators:

$$x \triangle_\alpha y = \left(\frac{x^\alpha + y^\alpha}{2} \right)^{1/\alpha} \tag{8.39}$$

which were already used in Chapter 4 as an operator for the combination of distances (Eq. (4.140)). In addition, the following property holds for means:

THEOREM 8.4. *The dual of a mean with respect to a complementation operator c is a mean.*

PROOF. Define the dual of a mean \triangle as the operator $x \oplus y = c(c(x) \triangle c(y))$. The operator \oplus is obviously commutative (since \triangle is). It is also easy to see that \oplus is continuous (for the continuity of \triangle and c), and increasing in both places. For this last property, if x increases, then $c(x)$ decreases, therefore $c(x) \triangle c(y)$ also decreases by the monotonicity of \triangle and, as c is decreasing, $c(c(x) \triangle c(y))$

will increase. The same holds for monotonicity in y. To prove that the first axiom of the means is true for \oplus, consider that, by the properties of the mean, it is

$$\min(c(x), c(y)) \le c(x) \triangle c(y) \le \max(c(x), c(y)) \qquad (8.40)$$

Consider $\min(c(x), c(y))$, and assume that $c(x) < c(y)$, in which case $\min(c(x), c(y)) = c(x)$. As c is decreasing, this means that $x > y$. We can then write $\min(c(x), c(y)) = c(\max(x, y))$. Similarly, one can see that the same is true if $c(x) > c(y)$. With a symmetric argument, it is also possible to see that $\max(c(x), c(y)) = c(\min(x, y))$. Therefore, Eq. (8.40) can be written as

$$c(\max(x, y)) \le c(x) \triangle c(y) \le c(\min(x, y) \qquad (8.41)$$

Taking the complement of the three terms, and considering that c is decreasing and involutive ($c(c(x)) = x$), one gets

$$\min(x, y)) \le c(c(x) \triangle c(y)) = x \oplus y \le \max(x, y) \qquad (8.42)$$

which proves the theorem. $\qquad\qquad\qquad\qquad\qquad\qquad\qquad\qquad\qquad\square$

8.2.4 Associative Operators

In query processing, associativity and distributivity of operators are very desirable qualities. Each associativity or distributivity property corresponds to an opportunity for query manipulation and, by extension, an opportunity for optimization. It is very difficult to conciliate associativity and distributivity with some extension of logical conjunction and disjunction. The only operators that seem to satisfy most "Boolean intuition" and are at the same time associative and distributive are maximum and minimum.

The parallel with logic is quite useful in a query algebra because it provides a useful grounding to the expression of a query ("I want an image that is blue at the top *and* red at the bottom") and, as such, has the potential of creating a viable link between the linguistic domain of the queries and the similarity domain of the image relations. Such a parallel, however, is not strictly necessary. It is possible to define operations on scores in a completely abstract way. The final gauge, of course, will be given by a combination of two criteria: How well the operators lend to efficient implementation (in particular, how well will they lend to query optimization), and how well they model the user's linguistic queries.

Assume that a complementation operator c is given. An *associative, c-symmetric sum* \diamond is an operator on the $[0, 1]$ such that

1. $0 \diamond 0 = 0$, $1 \diamond 1 = 1$

2. $x \diamond y = y \diamond x$ (commutativity)

3. $x \diamond (y \diamond z) = (x \diamond y) \diamond z$ (associativity)

4. for every $\varepsilon > 0$, \diamond is increasing and continuous in both places for $x, y \in [\varepsilon, 1 - \varepsilon]$

5. $c(x \diamond y) = c(x) \diamond c(y)$

Aczel (1966) derived a class of associative symmetric sums using the additive representations of monotonic associative operations on the real line. In particular, he proposed operators of the form

$$x \diamond y = f^{-1}(f(x) + f(y)) \tag{8.43}$$

It is easy to see that the operator is associative. In fact:

$$\begin{aligned} x \diamond (y \diamond z) &= f^{-1}(f(x) + f(f^{-1}(f(y) + f(z)))) \\ &= f^{-1}(f(x) + f(y) + f(z)) \\ &= f^{-1}(f(f^{-1}(f(x) + f(y))) + f(z)) \\ &= (x \diamond y) \diamond z \end{aligned} \tag{8.44}$$

The following properties hold for functions that generate c-symmetric associative sums:

LEMMA 8.2. *If \diamond is a c-symmetric associative sum then $x \diamond c(x) = s_c$.*

PROOF. Considering the quantity $c(x \diamond c(x))$ we have

$$\begin{aligned} c(x \diamond c(x)) &= c(x) \diamond c(c(x)) \quad &\text{By axiom 5} \\ &= c(x) \diamond x \quad &\text{By the involutive property} \\ &= x \diamond c(x) \quad &\text{By commutativity} \end{aligned} \tag{8.45}$$

From $c(x \diamond c(x)) = x \diamond c(x)$ it follows that $x \diamond c(x) = s_c$. \square

THEOREM 8.5. *Let f be a function that generates a c-symmetric associative sum as in Eq. (8.43), and let s_c be the value such that $c(s_c) = s_c$. Then $f(0)$ and $f(1)$ are unbounded and $f(x) = 0$ iff $x = s_c$.*

PROOF. Substituting $x = s_c$ in the previous lemma, one obtains $s_c \diamond s_c = s_c$. Using this equality in Eq. (8.43) gives $f(s_c) = 2f(s_c)$. Similarly, the two equalities of axiom 1 yield $f(0) = 2f(0)$ and $f(1) = 2f(1)$. The only values that can make these equalities true while maintaining the monotonicity of f are $f(0) = -\infty$, $f(s_c) = 0$, $f(1) = +\infty$. If f is monotonic, then $f(x) = 0 \Rightarrow x = s_c$. \square

Moreover, c-symmetric associative sums of the form of Eq. (8.43) have the following properties:

THEOREM 8.6. *If \diamond is a c-symmetric associative sum, then, for all $x \in (0, 1)$,*

$$x \diamond s_c = x \quad 0 \diamond x = 0 \quad 1 \diamond x = 1 \tag{8.46}$$

PROOF. Whereas $f(s_c) = 0$, one has

$$x \diamond s_c = f^{-1}(f(x) + f(s_c)) = f^{-1}(f(x)) = x \tag{8.47}$$

Let $y \in (0, 1)$, then

$$\lim_{y \to 0^+} \frac{f(y) + f(x)}{f(y)} = 1 \tag{8.48}$$

therefore,

$$\lim_{y \to 0^+} f^{-1}(f(y) + f(x)) = \lim_{y \to 0^+} f^{-1}(f(y)) = 0 \tag{8.49}$$

That is, the proof that $1 \diamond x = x$ is symmetric. \square

Equation (8.43) can be used to characterize the complementation c given the function f. Putting $y = c(x)$ yields

$$f^{-1}(f(x) + f(c(x))) = x \diamond c(x) = s_c \tag{8.50}$$

so that $f(x) + f(c(x)) = f(s_c) = 0$ and so that $c(x)$ is given by $c(x) = f^{-1}(-f(x))$.

The associativity of the sum is restricted to the open interval $(0, 1)$. For $x = 0$ or $x = 1$ the sum is not continuous. In fact, $c(x) \diamond x = s_c \in (0, 1)$. Thus, if $x \to 0$ (and, therefore, $c(x) \to 1$), it is

$$\lim_{x \to 0} c(x) \diamond x = s_c \in (0, 1) \tag{8.51}$$

but $0 \diamond x = 0$ and $1 \diamond x = 1$.

If $c(x) = 1 - x$, then a c-symmetric associative sum can be obtained using f such that $f(1 - x) + f(x) = 0$. If $F : \mathcal{I} \to \mathbb{R}$ is continuous and strictly monotonic, then such a function is given by

$$f(x) = F(x) - F(1 - x) \tag{8.52}$$

As an example, choosing $\Phi(x) = \log x$ gives $f(x) = \log((1 - x)/x)$, and produces the combination function used in Kayser (1979).

Given a symmetric associative sum, it is possible to define a dual associative product as

$$x \otimes y = f^{-1}(f(x)f(y)) \tag{8.53}$$

The following properties hold for the associative product:

THEOREM 8.7. *The associative product is distributive with respect to the associated distributive sum, that is, for all x, y, z:*

$$x \otimes (y \diamond z) = (x \otimes y) \diamond (x \otimes z) \tag{8.54}$$

Moreover, it is $x \otimes s_c = s_c$.

PROOF. The property follows directly from the definition:

$$\begin{aligned}
x \otimes (y \diamond z) &= f^{-1}(f(x) \cdot f(f^{-1}(f(y) + f(z)))) \\
&= f^{-1}(f(x) \cdot (f(y) + f(z))) \\
&= f^{-1}((f(x)f(y)) + (f(x)f(z)))) \\
&= f^{-1}(f^{-1}(f(f(x)f(y)) + f^{-1}(f((f(x)f(z)))))) \\
&= (x \otimes y) \diamond (x \otimes z) \quad (8.55)
\end{aligned}$$

For the second property, because it is $f(s_c) = 0$, it is $x \otimes s_c = f^{-1}(f(x)f(s_c)) = f^{-1}(0) = s_c$. \square

8.2.5 Weighted Combinations of Scores

The operators introduced in the previous sections offer ways to combine search criteria and, therefore, to create queries that include several of them. Each operator combines such criteria in a fixed and predefined way. In many applications, the user might need the possibility of expressing the *relevance* of each criterion. Part of a criterion that identifies nature images could include blue in the upper portion of the images and green in the lower portion (grass). The presence of the blue, however, can be considered more important than that of the green, as some of the images might contain trees and other brownish bushes. In these cases, the user wants some control over the relative weight of the different query terms. Let s_b be the score of an image with respect to the "blue upper portion" query, and s_g be its score with respect to the "green lower portion."

In the approximation that I am using for databases, these two scores do not depend on the different weights that are given to the two criteria[2]. The weights will enter into play when the two scores are combined. Somehow, the score with the highest weight must influence the final result more than the score with the lower weight. If the combination operator is the arithmetic average, and the relative weights for the two criteria are θ_b and θ_g (with $\theta_b > \theta_g$), the weighted combination is obtained as the well-known weighted average

$$\frac{\theta_b s_b + \theta_g s_g}{\theta_b + \theta_g} \quad (8.56)$$

This section will generalize weighting to be applied to any of the composition operators defined in the previous section, using a weighting method first described by Fagin and Wimmers (1997), where most of the properties were proved. Fagin and Wimmers start from three desirable properties in a weighting formula. First, when all the weights are equal, the result should be the original composition

[2] From a cognitive point of view, this assumption is troublesome at the very least. As noticed in section 4.2.1 the perception of similarity with respect to any given criterion will change depending on the other criteria that are being used for the overall evaluation. Given the current state of database technology, however, the approximation that I am making here appears as the only viable solution.

operator. In the preceding example, in which the composition operator was the arithmetic mean, when $\theta_b = \theta_g$ one expects to obtain the arithmetic mean again. Second, if a particular criterion has zero weight, then it should be possible to drop that criterion without affecting the score. Third, the value of the result should be a continuous function of the value of the weights.

Quite surprisingly, given these criteria and an additional assumption (a type of local linearity), the formula for the weighted combination is unique.

To set the problem in a rather general setting, assume that there are m possible criteria, and let $Q = (\varsigma_1, \ldots, \varsigma_m)$ be the scores of a given image for the m criteria. If $J \subset \{1, \ldots, m\}$ is a subset of the indices of the scores, then $Q \uparrow J$ will indicate the restriction of $(\varsigma_1, \ldots, \varsigma_m)$ to the indices in J.

Assume that a combination operator \diamond is given and, for the moment, assume that \diamond is associative. The combination of two scores is then a function of the scores: $\varsigma_i \diamond \varsigma_j = f(\varsigma_i, \varsigma_j)$. Similarly, the combination of q scores can be considered as a function of their values:

$$\varsigma_1 \diamond \varsigma_2 \cdots \diamond \varsigma_q = f(\varsigma_1, \ldots, \varsigma_q) \qquad (8.57)$$

If the operator \diamond is not associative, the functional form of Eq. (8.57) still holds. The only difference is that, in the case of Eq. (8.57), the value of f does not change when its arguments are shuffled while, in the case of a nonassociative operator, it will. It is, however, possible to define a conventional order of application of the operator \diamond, given by the order in which the arguments appear in f, and write

$$(((\varsigma_1 \diamond \varsigma_2) \diamond \varsigma_3) \cdots \diamond \varsigma_q) = f(\varsigma_1, \ldots, \varsigma_q) \qquad (8.58)$$

Further, the functional notation extends naturally to the case of a single argument as $f(\varsigma) = \varsigma$.

A *weighting* over $\{1, \ldots, m\}$ is a function Θ whose domain is a nonempty subset of $\{1, \ldots, m\}$, and whose range is $[0, 1]$ such that $\sum_i \Theta(i) = 1$. The value $\Theta(i)$ is the ith weight, and will be written as θ_i. As in the case of the scores, Θ can be defined on a subset of the indices $J \subset \{1, \ldots, m\}$.

A *weighted combination operator* is a function whose domain is the set of all pairs $(\Theta, Q \uparrow J)$, where Θ is a weighting defined over the set of indices J. Thus, if $J = \{i, j\}$, then $Q \uparrow J = (\varsigma_i, \varsigma_j)$, and $\Theta = (\theta_i, \theta_j)$. The value of the weighted operator applied to the scores Q with weights Θ will be written as $f_\Theta(Q)$. The *support* of Θ is defined as the subset J of indices such that $j \in J \Rightarrow \theta_j > 0$.

With these definitions, it is possible to define the desirable properties of the weighted operator more formally.

1. The application of the weighted operator with evenly balanced weights is equivalent to the application of the unweighted combination operator, that is:

$$f_{(1/m, \ldots, 1/m)}(\varsigma_1, \ldots, \varsigma_m) = f(\varsigma_1, \ldots, \varsigma_m) \qquad (8.59)$$

This property is express by saying that the weighted operator is *based on the unweighted operator*.

2. If a particular argument has zero weight, then it can be dropped from the weighted operator without consequences. Formally, let J be the support of Θ, then

$$f_\Theta(Q) = f_{\Theta \upharpoonright J}(Q \uparrow J) \qquad (8.60)$$

or

$$f_{(\theta_1,\dots,\theta_{m-1},0)}(\varsigma_1,\dots,\varsigma_m) = f_{(\theta_1,\dots,\theta_{m-1})}(\varsigma_1,\dots,\varsigma_{m-1}) \qquad (8.61)$$

This property is expressed by saying that the weighted operator is *compatible*.

3. The weighted operator is continuous in the weights, that is,

$$f_{(\theta_1,\dots,\theta_m)}(\varsigma_1,\dots,\varsigma_m) \qquad (8.62)$$

is continuous in $(\theta_1,\dots,\theta_m)$.

These three properties are not sufficient to determine the weighted operator uniquely; an additional property is needed. The most natural property would be *linearity*, that is, the requirement that, for each $\alpha \in [0,1]$,

$$f_{\alpha\Theta+(1-\alpha)\Theta'}(Q) = \alpha f_\Theta(Q) + (1-\alpha)f_{\Theta'}(Q) \qquad (8.63)$$

This requirement turns out to be too restrictive because it would force one to choose the arithmetic mean as the combination operator, as stated by the following theorem, whose proof is in Fagin and Wimmers (1997):

THEOREM 8.8. **(Fagin and Wimmers)** *The following statements are equivalent:*

1. *the weighted combination is linear*

2. $f(\varsigma_1,\dots,\varsigma_m) = 1/m \sum_i f(\varsigma_i)$

3. $f_{(\theta_1,\dots,\theta_m)}(\varsigma_1,\dots,\varsigma_m) = \sum_i \theta_i f(\varsigma_i)$

Linearity is too restrictive a property, as it would make it impossible to use any composition operator other than the mean. It is, however, possible to enforce a weaker form of linearity, called *local linearity*.

Two weightings, Θ and Θ' are called *comonotonic* if they agree on the order of importance of the arguments. That is, there are no values i and j such that $\theta_i < \theta_j$ and $\theta_i' > \theta_j'$. Another way of expressing the same concept is the following. Say that a permutation $\{\pi_1,\dots,\pi_m\}$ of $\{1,\dots m\}$ *orders* Θ if, for all i, $\theta_{\pi_i} \geq \theta_{\pi_{i+1}}$. Then two weightings Θ and Θ' are comonotonic if every permutation that orders Θ also orders Θ'.

DEFINITION 8.1. *A weighted operator f_Θ is locally linear if, for $\alpha \in [0,1]$, it is*

$$f_{\alpha\Theta+(1-\alpha)\Theta'}(Q) = \alpha f_\Theta(Q) + (1-\alpha)f_{\Theta'}(Q) \qquad (8.64)$$

whenever Θ and Θ' are comonotonic.

It can be proved [Fagin ad Wimmers, 1997] that local linearity implies continuity with respect to the weights Θ. Continuity with respect to the scores Q depends, of course, on the continuity of the unweighted operator f.

The main result of Fagin and Wimmers (1997) is the following theorem:

THEOREM 8.9. *For every combination operator f there exists a unique weighted operator that is based on f, compatible, and locally linear. If Θ is the weighting, and $\{\pi_1, \ldots, \pi_m\}$ is a permutation that orders Θ, then the weighted operator is given by*

$$f_\Theta(Q) = (\theta_{\pi_1} - \theta_{\pi_2})f(\varsigma_{\pi_1}) + 2(\theta_{\pi_2} - \theta_{\pi_3})f(\varsigma_{\pi_1}, \varsigma_{\pi_2})$$
$$+ \cdots + m\theta_{\pi_m}f(\varsigma_{\pi_1}, \varsigma_{\pi_2}, \ldots, \varsigma_{\pi_m}) \tag{8.65}$$

If the combination is obtained through an additive operator \diamond, then it is possible to use the notation

$$f(\varsigma_1, \ldots, \varsigma_k) = \varsigma_1 \diamond \cdots \diamond \varsigma_k = \overset{k}{\underset{i=1}{\diamondsuit}} \varsigma_i \tag{8.66}$$

and, if by convention, $\theta_{m+1} = 0$ is chosen, it is possible to define the weighted combination as

$$f_\Theta(Q) = \sum_{i=1}^{m} i(\theta_{\pi_i} - \theta_{\pi_{i+1}}) \underset{j \in \{\pi_1, \ldots, \pi_i\}}{\diamondsuit} \varsigma_j \tag{8.67}$$

In the case in which \diamond is a binary operator, the weighted version of \diamond is written $a \underset{w}{\diamond} b$, with $w = (w_1, w_2)$ and is defined as

$$a \underset{w}{\diamond} b = \begin{cases} (w_1 - w_2)a + 2w_2(a \diamond b) & \text{if } w_1 \geq w_2 \\ (w_2 - w_1)b + 2w_1(a \diamond b) & \text{if } w_2 > w_1 \end{cases} \tag{8.68}$$

while in the general case the operator is written

$$\underset{\{w_1, \ldots w_n\}}{\diamondsuit} \varsigma_i \tag{8.69}$$

Note that, in spite of the superficial appearances, the weighting operator is well defined even in the presence of pairs of coefficients with the same value. For instance, if $m = 3$, and $\theta_1 > \theta_2 = \theta_3$, there are two equivalent orderings of the coefficients. The ordering $\theta_1, \theta_2, \theta_3$ leads to the combination

$$(\theta_1 - \theta_2)\varsigma_1 + 2(\theta_2 - \theta_3)(\varsigma_1 \diamond \varsigma_2) + 3\theta_3)(\varsigma_1 \diamond \varsigma_2 \diamond \varsigma_3) \tag{8.70}$$

while the ordering $\theta_1, \theta_3, \theta_2$ leads to

$$(\theta_1 - \theta_3)\varsigma_1 + 2(\theta_3 - \theta_2)(\varsigma_1 \diamond \varsigma_3) + 3\theta_2)(\varsigma_1 \diamond \varsigma_3 \diamond \varsigma_2) \tag{8.71}$$

The first terms are equal, because $\theta_2 = \theta_3$. The third terms are also equal because $\theta_2 = \theta_3$ and because the operator \diamond is commutative. The second term is different in the two cases ($\varsigma_1 \diamond \varsigma_2 \neq \varsigma_1 \diamond \varsigma_3$), but in both cases is multiplied by a zero weight.

The following corollary provides some additional characterization of the weighted operator.

COROLLARY 8.1. *Let α_i be the coefficient of $\varsigma_{\pi_1} \diamond \cdots \diamond \varsigma_{\pi_i}$ in the weighted operator, so that*

$$f_{\Theta}(Q) = \sum_{i=1}^{m} i\alpha_i \diamond_{j \in \{\pi_1, \ldots, \pi_i\}} \varsigma_j \tag{8.72}$$

Then $\alpha_i > 0$ for each i, and $\sum_i \alpha_1 = 1$.

PROOF. The coefficient α_i is given by $\alpha_i = i(\theta_{\pi_i} - \theta_{\pi_{i+1}})$ for $i = 1, \ldots, m-1$, and $\alpha_{\pi_m} = m$. Given the properties of the ordering, it is obvious that $\alpha_i \geq 0$. Moreover, it is

$$\begin{aligned}
\sum_i \alpha_i &= \sum_{i=1}^{m-1} i(\theta_{\pi_i} - \theta_{\pi_{i+1}}) + m\theta_{\pi_m} \\
&= \sum_{i=1}^{m} i\theta_{\pi_i} - \sum_{i=1}^{m-1} i\theta_{\pi_{i+1}} \\
&= \sum_{i=1}^{m} i\theta_{\pi_i} - \sum_{i=2}^{m} (i-1)\theta_{\pi_i} \\
&= \theta_{\pi_1} + \sum_{i=2}^{m} \theta_{\pi_i} \\
&= 1
\end{aligned} \tag{8.73}$$

□

Several important properties of scoring operators fail to translate to the weighted case. For instance, in general, weighted operators are not associative, even when their weighted counterparts are. Let \diamond be a binary operator, and $w = (w_1, w_2)$, $v = (v_1, v_2)$ be two weight vectors with $w_1 > w_2$ and $v_1 > v_2$. Then

$$\begin{aligned}
a \underset{w}{\diamond} (b \underset{v}{\diamond} c) &= (w_1 - w_2)a \\
&\quad + 2w_2(a \diamond ((v_1 - v_2)b + 2v_2(b \diamond c)))
\end{aligned} \tag{8.74}$$

and

$$\begin{aligned}
(a \underset{w}{\diamond} b) \underset{v}{\diamond} c &= (v_1 - v_2)((w_1 - w_2)a + 2w_2(a \diamond b)) \\
&\quad + 2w_2(((w_1 - w_2)a + 2w_2(a \diamond b)) \diamond c)
\end{aligned} \tag{8.75}$$

which are in general not equal. For instance, if $\diamond = \min$, $a > b > c$, and $a > (v_1 - v_2)b + 2v_2 c$, then

$$(w_1 - w_2)a + 2w_2(a \diamond b) = (w_1 + w_2)a \tag{8.76}$$

and

$$a \diamond ((v_1 - v_2)b + 2v_2(b \diamond c)) = a \tag{8.77}$$

so that

$$a \underset{w}{\diamond} (b \underset{v}{\diamond} c) = (w_1 + w_2)a \tag{8.78}$$

and

$$(a \underset{w}{\diamond} (b \underset{v}{\diamond} c) = (v_1 - v_2)(w_1 + w_2)a + 2v_2 c \tag{8.79}$$

Similarly, weighted operators are not distributive, even when their unweighted counterparts are.

8.2.6 A functional View of the Scoring Operators

All the combination operators considered so far have been operating on the results of the scoring functions, but it is immediate to use them to define operators on the scoring functions themselves. A scoring function on a feature type X is a member of $\beth(X) \subseteq \{f : X \to [0,1]\}$. Given an operator $\diamond : [0,1] \times [0,1] \to [0,1]$, and two scoring functions $\mathfrak{g}, \mathfrak{h} \in \beth(X)$, an operator \diamond_\beth on $\beth(X)$ is defined by

$$x(\mathfrak{g} \diamond_\beth \mathfrak{h})y = (x\mathfrak{g}y) \diamond (x\mathfrak{h}y) \tag{8.80}$$

That is, \diamond_\beth is the operator $\beth(X) \times \beth(X) \to \beth(X)$ such that the following diagram commutes:

$$
\begin{array}{ccc}
\beth(X) \times \beth(X) & \xrightarrow{\;\diamond_\beth\;} & \beth(X) \\
{\scriptstyle \text{eval} \times \text{eval}} \downarrow & & \downarrow {\scriptstyle \text{eval}} \\
[0,1] \times [0,1] & \xrightarrow{\;\diamond\;} & [0,1]
\end{array}
\tag{8.81}
$$

As it is usually clear from the context whether one is talking about the operator \diamond defined on values or about the operator \diamond_\beth defined on scoring functions, I will lighten up the notation somewhat and use the symbol \diamond to refer to both operators.

Similarly, it is possible to use the scoring operators to define scoring functions that operate on multiple feature types. Let X and Y be two feature types and then a scoring function \mathfrak{f} with *signature* (X, Y) is a function $\mathfrak{f} : X \times Y \to [0,1]$. Such functions are generally composed starting from functions in $\beth(X)$ and $\beth(Y)$, using a combination operator. If a combination operator on scores \diamond is given, then the operator $\diamond : \beth(X) \times \beth(Y) \to \beth(X, Y)$ is the operator such that the following

diagram commutes

$$
\begin{array}{ccc}
\beth(X) \times \beth(Y) & \xrightarrow{\diamond_\beth} & \beth(X, Y) \\
{\scriptstyle \mathrm{eval} \times \mathrm{eval}} \downarrow & & \downarrow {\scriptstyle \mathrm{eval}} \\
[0,1] \times [0,1] & \xrightarrow{\diamond} & [0,1]
\end{array}
\tag{8.82}
$$

and, if $\mathfrak{g} \in \beth(X)$ and $\mathfrak{h} \in \beth(Y)$ then

$$(\mathfrak{g} \diamond \mathfrak{h})(x, y) = \mathfrak{g}(x) \diamond \mathfrak{h}(y) \tag{8.83}$$

8.3 A More Complete Data Model

The combination functions provide the necessary machinery for the creation of a more complete data model. Consider an image database composed of two tables with, say, color and wavelets features.

c	
h	Color
1	\mathcal{H}_1
2	\mathcal{H}_2
⋮	⋮
n	\mathcal{H}_n

w	
h	Wavelet
1	t_1
2	t_2
⋮	⋮
n	t_n

One would like to *join* these tables so as to obtain a single table with both features:

u		
h	Color	Wavelet
1	\mathcal{H}_1	t_1
2	\mathcal{H}_2	t_2
⋮		
n	\mathcal{H}_n	t_n

The question that arises immediately is: what will be the value of the score field of this new table? The operators introduced in the previous section give the tools to build such a score so that, for instance, given the operator \diamond, one can have $u[i].\varsigma = c[i].\varsigma \diamond w[i].\varsigma$.

This is not yet sufficient: In addition to the individual scores it is also necessary to endow the new table with a natural scoring function. This will be done using the same operator \diamond or, more appropriately, the scoring function operator induced by \diamond. The new table will therefore have $u.v = c.v \diamond w.v$.

In order to formalize these notions, it is necessary to introduce another concept, that of *feature signature* (or, more simply, signature), of a table.

DEFINITION 8.2. *Let $T(A_1, \ldots, A_k)$ be the schema of the table T, and let $B = \{B_1, \ldots, B_q\} \subseteq \{A_1, \ldots, A_k\}$ the subset of the schema comprising all feature attributes. Then B is called the* feature signature *of the table T.*

Without loss of generality, I will assume that the columns are ordered so that the first q components of the schema are the feature signature, and the remaining $k - q$ are standard data types. The schema will be written as $T(A_1, \ldots, A_q | A_{q+1}, \ldots, A_n)$. $T(A_1, \ldots, A_q | \cdot)$ and $T(A | \cdot)$ will indicate the feature signature of the table. When it is necessary to take the union of two schemas, I will assume that the result will again be ordered in this way.

DEFINITION 8.3. *Let $T(A|A')$ and $U(B|B')$ be two feature relational tables, and let $A \cap B = \emptyset$. The \diamond-join of the two is the table*

$$V = T \overset{\bowtie}{\diamond} U \tag{8.84}$$

defined as follows:

1. *The table has schema $V(A \cup B | A' \cup B')$, and its columns are given by*

$$V = \sigma_{t.h=u.h}(t \times u) \tag{8.85}$$

2. *If row i of V is obtained from row a of T and row b of U, then*

$$V[i].\varsigma = T[a].\varsigma \diamond U[b].\varsigma \tag{8.86}$$

3. *The natural similarity measure of the table is*

$$V.\nu = T.\nu \diamond U.\nu \tag{8.87}$$

If the join operator is weighted and an explicit specification of the weights is necessary, I will put them on top of the operator, $V = T \overset{w}{\underset{\diamond}{\bowtie}} U$.

The join operator provides a powerful mechanism for creating composite queries. For instance, the query "return the 100 images closest to image k with respect to color and texture," (where texture features are in the table $t(\text{id}, \text{texture})$ and the operator "and" is the minimum) is embodied in the following expression:

$$\sigma_{100}^{\#}(\Sigma_T^k(c) \underset{\min}{\bowtie} \Sigma_U^k(t)) \tag{8.88}$$

The query: "return the 100 images most similar to k in color and to l in texture, where the first condition is twice as important as the second," is expressible as

$$\sigma_{100}^{\#}\left(\Sigma_T^k(c) \overset{(2/3,1/3)}{\underset{\min}{\bowtie}} \Sigma_U^l(t)\right) \tag{8.89}$$

8.3.1 Scoring Function and Operators

A scoring function for a data type X $s \in \daleth(X)$ is a function that takes an element $x \in X$ and assigns it a score $\varsigma \in [0,1]$, that is, $\daleth(X) \subseteq \{s : X \to [0,1]\}$ In the forementioned examples, the scoring function was obtained by measuring the similarity between a generic feature and that of a "query" image. These two

modes of computing a score (either as the result of a scoring function or as a similarity measure) are an inconvenience when it comes to computing complex scoring functions by combining simpler ones, because one would be faced with the problem of combining very different kinds of functions, some of which take an argument, some of which take two. The problem can be avoided using the concept of *currying*.

First, it is convenient to assign a type to functions, and make them into first order variables that can be computed and assigned. A function f that takes values of type X into values of type Y (that is, $f : X \rightarrow Y$) is a value of type $(X \rightarrow Y)$.

Consider now a function of two arguments $z = f(x, y)$. The function can be considered as a value of type $(X \times Y \rightarrow Z)$ (which takes an X-value and a Y-value into a Z-value). On the other hand, for a fixed x, the function maps Y-values into Z-values. Therefore, *for fixed* x, the function is of type $(Y \rightarrow Z)$. Therefore, the operation f can be seen as associating to every value $x \in X$ a function in $(Y \rightarrow Z)$. The "value" of f for $x = x_0$ is the function $f(x_0, \cdot)$. In order to make the difference in interpretation more evident, I will write the function as $f(x)(y)$, and its value for $x = x_0$ as $f(x_0)(\cdot)$. The functor f now has a single argument (x) and its value is a function. That is, f is a value of type $(X \rightarrow (Y \rightarrow Z))$. The function f is said in this case to be a *curried* function.

Although the proper way to write a curried function is $f(x)(y)$, I will use the simpler notation $f(x, y)$ when there is no possibility of confusion.

A similarity function for a type X can therefore be seen as a curried function of type $(X \rightarrow (X \rightarrow [0, 1]))$. Given a query image h_0, the function $f(h_0)(\cdot)$ is a scoring function of type $\beth(X)$, which can enter into operations with other scoring functions, regardless of their origin.

The \diamond-join introduced in the previous section implicitly created a new scoring function given the "natural" scoring functions of the two tables that were joined. While the natural scoring function (or the natural similarity measure from which it has been obtained by currying) can be a useful construct for efficient indexing, it is obvious that complex queries require a more flexible management of similarity functions and scoring functions, including the possibility to use externally defined functions. I will use the following definition:

- $\mathcal{X} = \{X_1, \ldots, X_t\}$ is the set of feature types used in the database.

- $\beth(S) = \{\beth(X_1), \ldots, \beth(X_t)\}$ is the set of the associated scoring functions, with $\beth(X_i) : (X \rightarrow [0, 1])$.

- $\Omega = \{\omega_1, \ldots, \omega_p\}$ is a set of operators. Each ω_i has an associated *arity* a_i, which is an integer greater than zero. An operator ω_i is a function of type $([0, 1]^{a_i} \rightarrow [0, 1])$. Given a set of a_i feature types $\{X_{k_1}, \ldots, X_{k_{a_i}}\}$ the operator ω_i induces a functional operator (which will also be indicated with ω_i) of arity a_i and signature $(X_{k_1}, \ldots, X_{k_{a_i}})$, which is a function

$$\omega_i : \beth(X_{k_1}) \times \cdots \times \beth(X_{k_{a_i}}) \rightarrow \beth(X_{k_1}, \ldots, X_{k_{a_i}}) \tag{8.90}$$

A scoring function is defined by the following rules:

1. If X is a feature type and n_X is its natural similarity measure, then $n_X(x)(\cdot)$, $x \in X$ is a scoring function of type $\beth(X)$.

2. If f is an external function that takes a value $x \in X$ and returns a value in $[0,1]$, then $\vDash f$ is a scoring function, where $\vDash \cdot$ is the external evaluation operator.

3. If ω_i is an operator with arity a_i and f_1, \ldots, f_{a_i} are scoring functions of types $\beth(X_1), \ldots, \beth(X_{a_i})$, then

$$f_1, \ldots, f_{a_i} \omega_i \tag{8.91}$$

is a scoring function of type $\beth(X_1, \ldots, X_{a_i})$. As a special notation, if $a_i = 1$, the operation will be written $\omega_i f$, and if $a_i = 2$ it will be written as $f_1 \omega_i f_2$.

4. If the operator ω_i in the previous point is weighted, then the result is a scoring function for all legal values of the weights.

5. Nothing else is a scoring function.

Given a feature type X, stored in a table T, let $n_X \in \mathfrak{S}(X)$ be its natural similarity function (which can be derived from the natural distance function of X using the techniques developed in Chapter 4). This function is the attribute $T.\nu$ of the table containing X. The natural scoring function with respect to the ith row of the table is then $n_X(T[i].x) = T.\nu(T[i].x) \in \beth(X)$. This natural scoring function is an attribute of the record, and can be thought of as an additional virtual attribute of the table, just like the score $T[i].\varsigma$. The attribute ν of the record will contain such a function.

Note that the same name ν is used here in two slightly different senses. The attribute $T.\nu$ of the table is a similarity function, while the attribute of a specific record, $T[i].\nu$, is a scoring function, that is, $T.\nu \in \mathfrak{S}(X)$, and $T[i].\nu \in \beth(X)$.

The operator Σ_T^k is defined as:

$$\Sigma_T^k = n_X(T[k].x) \tag{8.92}$$

If $s, q \in \mathfrak{S}(X)$ are two similarity functions, and \diamond is an operator on them, then \diamond induces an operator on the scoring functions derived from s and q (which I will indicate with the same symbol) such that, if $f = s(x)$ and $g = r(x)$ are two scoring functions, it is

$$(f \diamond g)(y) = (s \diamond r)(x, y) \tag{8.93}$$

As seen in the previous section, when two tables T and U are joined, the resulting table $V = T \bowtie_\diamond U$ has the natural similarity measure $V.\nu = T.\nu \diamond U.\nu$. The previous equation now allows the definition of the natural scoring functions for the records

of the table V: if the ith row of V derives from the rows a of T and b of U, then

$$V[i].v = T[a].v \diamond U[b].v \qquad (8.94)$$

8.4 Image Structure and Feature Algebra

The data model presented so far is quite useful for image descriptions of the type that I have called *with general ontology*, that is, characterized by a global description of the image, and in which the only structure is that of the feature space itself. Limited ontology features generally describe an image by committing to the importance of some structure derived from the image data. In many cases this structure is represented by regions that are identified during a segmentation process. The data model introduced so far does not provide any representation of such a structure. Other data models, like the Nes and Kersten's Acoi algebra [Nes and Kersten, 1998], take this structure explicitly into account, by defining regions as primitive data types.

According to the model proposed in Chapter 5, these structural features also rely on similarity and scoring functions. It is, therefore, possible to incorporate them into the general data model provided that one can define appropriate data types and algebras for them.

This section will introduce a possible typing system for image features, and their related algebras. There is no clear consensus as yet of what constitutes a good typing system and feature algebra for image databases. This section is, in any case, a partial answer at best.

An image is a spatial organization of data, and a description of an image in terms of region features should take into account the need to describe both the content of a region of the image and its spatial location.

The following data typing system is based on that of the ML programming language [Ullman, 1994], of which it is a subset.

8.4.1 General Data Types

The feature model has four basic types: *int; real; boolean,* and *unit.* Unit is a special type whose only member is the empty value (). The fact that variable x belongs to type μ will be written as $x:\mu$. Data types can be combined to create more complex types using several *data type constructors.*

Given data types μ and τ, the data type $\mu \times \tau$ is the type of all the pairs (x, y) such that $x:\mu$ and $y:\tau$. As in the previous sections, $\sigma \to \tau$ is the datatypes of all the functions from σ to τ. Given the function f such that $f(x) = y$, with $x:\mu$ and $y:\tau$, the type of f can be deduced from its definition. This will be written with the following notation:

$$\frac{x:\mu \quad y:\tau}{f:\mu \to \tau} \qquad (8.95)$$

If μ is a data type, then $[\mu]$ is the datatype of the lists of elements of μ. The type $[\mu]$ is defined recursively as follows:

$$\frac{}{[\,]:[\mu]} \qquad \frac{x:\mu \quad X:[\mu]}{x \wr X:[\mu]} \tag{8.96}$$

The first expression declares that the empty list is of type $[\mu]$, while the second declares that, if X is a list of elements of type μ and x is an element of type μ, then inserting the element x as the first element of the list X still gives as a result a list of type $[\mu]$.

The operator \wr is a function that takes an element of type μ and a list of type $[\mu]$ and returns a list of type $[\mu]$. For instance, if X is of type [int], then \wr : int \times [int] \rightarrow [int]. The problem is how to define the type of operator \wr in a completely abstract way. The operator is *polymorphic*, in the sense that it can take arguments of any type, as long as certain relations are respected (in this case, the second argument must be a list of elements of the same type as the first argument).

The type of operator \wr can be expressed using *type variables*. Much like variables are placeholders that can take any value inside a type, type variable are placeholders that can take any type. When a variable in an expression is instantiated, all the instances of that variable are bound to the same type. I will use the first letters of the Greek alphabet, α, β, and γ to indicate type variables. The type of the operator \wr is therefore $\wr : \alpha \times [\alpha] \rightarrow [\alpha]$.

If μ is a datatype, then $\{\mu\}$ is the types of sets of elements $x:\mu$. The definition of the type is

$$\frac{}{\emptyset:\{\mu\}} \qquad \frac{x:\mu}{\{x\}:\{\mu\}} \qquad \frac{X:\{\mu\} \quad Y:\{\mu\}}{X \cup Y:\{\mu\}} \tag{8.97}$$

from which it follows that the type of union operator \cup is $\cup : \{\alpha\} \times \{\alpha\} \rightarrow \{\alpha\}$ and that of the singleton operator is $\{\cdot\} : \alpha \rightarrow \{\alpha\}$.

Arrays are generally considered as list, and the array access functions are defined recursively in terms of list access functions. Given the importance that arrays have in image processing and representation, it is convenient in an image database to define them as primary types. This can be done by seeing arrays as functions from sets of integers to the desired data type. I will use the symbol $[\![\mu]\!]^n$ to denote n-dimensional arrays of type μ. Note that $[\![\mu]\!]^0$ is isomorphic to μ. Two-dimensional arrays are particularly important in image features, since images themselves are two-dimensional arrays. In order to simplify somewhat the notation in some of the following equations, I will assume that when the dimension of an array is not indicated, the array is two-dimensional, that is, $[\![\mu]\!] = [\![\mu]\!]^2$.

A zero-dimensional array a is simply a function $a:\mathit{unit} \rightarrow \mu$, while an n-dimensional array is a function from integers to arrays of dimension $n-1$, that is:

$$\frac{a:\mathit{unit} \rightarrow \mu}{a:[\![\mu]\!]^0} \qquad \frac{a:\text{int} \rightarrow [\![\mu]\!]^{n-1}}{a:[\![\mu]\!]^n} \tag{8.98}$$

A two-dimensional array is therefore a curried function $a:\text{int} \rightarrow \text{int} \rightarrow \mu$.

Conventionally, the value $a(i)$ is called the ith *row* of the two-dimensional array a. Note that a row is a function $a(i) :$ int $\to \mu$ that is, a one-dimensional array. The transpose operator $'$ maps two-dimensional arrays to two-dimensional arrays, that is, $' : [\![\mu]\!] \to [\![\mu]\!]$ and is defined as

$$'(a)(i,j) = a(j,i) \tag{8.99}$$

The postfix notation $a'(i,j)$ is commonly used in lieu of the more cumbersome $'(a)$. A *column* of an array is a row of its transpose, that is, the jth column of a is $a'(j)$, which is also a one-dimensional array. Also note that in this formula I have used the notation $a(i,j)$ to indicate an element of the array instead of the more cumbersome (but formally more correct) $a(i)(j)$.

The macro null$(\alpha, n_1, \ldots, n_k)$ creates a k-dimensional rectangular array with the prescribed type and sizes, and filled with null elements. The null element is conventionally the neutral element of all the operations performed on the array. If the type α supports a multiplication, the macro ones$(\alpha, n_1, \ldots, n_k)$ build a similar array filled with the multiplication neutral value.

Element-wise operations on arrays can be defined as operations on the array functions. Then, for example, the element-wise sum and product of arrays are defined as

$$(a + b)(i,j) = a(i,j) + b(i,j) \tag{8.100}$$

and

$$(ab)(i,j) = a(i,j)b(i,j) \tag{8.101}$$

where it is assumed that the data type of the elements of the array supports a sum and a product, and that the arrays have the same size. The general function *apply* can be used to manipulate individual array members. Formally, apply is defined as

$$\text{apply} : (\mu \to \lambda) \to ([\![\mu]\!] \to [\![\lambda]\!]) \tag{8.102}$$

that is, if $\psi : \mu \to \lambda$, then

$$(\text{apply}(\psi)(a))(i,j) = \psi(a(i,j)) \tag{8.103}$$

Similarly, the general elementwise array combination operator is

$$\text{comb} : (\mu \to \lambda \to \zeta) \to ([\![\mu]\!] \to [\![\lambda]\!] \to [\![\zeta]\!]) \tag{8.104}$$

or, using functions on the Cartesian product instead of currying;

$$\text{comb} : (\mu \times \lambda \to \zeta) \to ([\![\mu]\!] \times [\![\lambda]\!] \to [\![\zeta]\!]) \tag{8.105}$$

The operator is defined as

$$(\text{comb}(\phi)(a,b))(i,j) = \phi(a(i,j), b(i,j)) \tag{8.106}$$

where $a : [\![\mu]\!]$, $b : [\![\lambda]\!]$, $\phi : \mu \times \lambda \to \zeta$, and the result is an array of type $[\![\zeta]\!]$. Note that the element-wise sum and product are special cases of comb.

As these operators are used quite often on arrays, I will use an abbreviated prefix notation for apply and an abbreviated infix notation for comb. Thus, if $\psi : \mu \to \lambda$, then

$$\psi \, a = \mathrm{apply}(\psi)(a) \qquad (8.107)$$

and if $\phi : \mu \times \lambda \to \zeta$, then

$$a \, \phi \, b = \mathrm{comb}(\phi)(a, b) \qquad (8.108)$$

Given an array $a : [\![\alpha]\!]^1$, the function $\mathrm{dom}(a) :$ int reports the upper limit of the domain of the array. The function $a :$ int $\to \alpha$ is defined in $[0, \mathrm{dom}(a) - 1]$. If the array is two-dimensional, the function $\mathrm{dom}(a)$ returns the domain of the curried function $a :$ int \to (int $\to \alpha$), that is, what is usually called the number of rows of the array.

A final operation on arrays that will be useful in the following is the tensor product \otimes. Given two one-dimensional arrays $a, b : [\![\alpha]\!]$ such that a product can be defined for the data type α, let $n = \mathrm{dom}(b)$; the tensor product $a \otimes b$ is the array

$$(a \otimes b)(i) = a(\lfloor i/n \rfloor) \cdot b(i \mod n) \qquad (8.109)$$

In case of multidimensional arrays, the tensor product is defined recursively on the curried functions. For instance, for two-dimensional arrays, it is

$$(a \otimes b)(i)(j) = (a(\lfloor i/n \rfloor) \otimes b(i \mod n))(j) \qquad (8.110)$$

In the case of two-dimensional arrays, it is easy to visualize the tensor product representing the arrays a and b as two matrices A and B. If

$$A = \begin{bmatrix} a_{11} & \cdots & a_{1p} \\ \vdots & & \vdots \\ a_{q1} & \cdots & a_{qp} \end{bmatrix} \quad B = \begin{bmatrix} b_{11} & \cdots & b_{1n} \\ \vdots & & \vdots \\ b_{m1} & \cdots & b_{mn} \end{bmatrix} \qquad (8.111)$$

then

$$A \otimes B = \begin{bmatrix} a_{11}B & \cdots & a_{1p}B \\ \vdots & & \vdots \\ a_{q1}B & \cdots & a_{qp}B \end{bmatrix} = \begin{bmatrix} a_{11}b_{11} & \cdots a_{11}b_{1n} & \cdots & a_{1p}b_{11} & \cdots & a_{1p}b_{1n} \\ \vdots & & & \vdots & & \vdots \\ a_{11}b_{m1} & \cdots a_{11}b_{mn} & \cdots & a_{1p}b_{m1} & \cdots & a_{1p}b_{mn} \\ \vdots & & & \vdots & & \vdots \\ a_{q1}b_{11} & \cdots a_{q1}b_{1n} & \cdots & a_{qp}b_{11} & \cdots & a_{qp}b_{1n} \\ \vdots & & & \vdots & & \vdots \\ a_{q1}b_{m1} & \cdots a_{q1}b_{mn} & \cdots & a_{qp}b_{m1} & \cdots & a_{qp}b_{mn} \end{bmatrix}$$

$$(8.112)$$

The tensor product generalizes similarly to higher-order arrays.

Complex datatypes can be constructed using the datatype construction operator \rhd. A datatype μ composed of a pair of values, the first of type τ, the second of type λ, is defined as

$$\mu \rhd x : \tau, y : \lambda \qquad (8.113)$$

The names x and y are used to access the two components of the type. For instance, the following fragment declares a type X to be a pair composed of an int and a list of real:

$$X \rhd n : \text{int}, l : [real] \qquad (8.114)$$

The following fragment will declare and initialize a variable of type X:

$$x : X \qquad (8.115)$$

$$x.n = 3 \qquad (8.116)$$

$$x.l = 1 \wr 2 \wr 3 \wr [] \qquad (8.117)$$

Data types can be defined recursively and have alternative definitions. A binary tree with integer values, for instance, can be defined as follows:

$$T \rhd \begin{cases} \epsilon : unit \\ v : \text{int}, l : T, r : T \end{cases} \qquad (8.118)$$

that is, a tree is either an empty value ϵ or an integer label with a right and a left subtree. An example of a binary tree is

$$(3, (3, \epsilon, (3, \epsilon, \epsilon)), (2, \epsilon, \epsilon)) \qquad (8.119)$$

Types can be parametrized with type variables. The data type of a generic binary tree can be expressed as

$$\alpha T \rhd \begin{cases} \epsilon : unit \\ v : \alpha, l : T, r : T \end{cases} \qquad (8.120)$$

The type can be specialized by instantiating the type variable α. For instance $X : real\ T$ defines a tree of real numbers.

A multigraph with nodes of types μ and edges of type λ is a function $\phi : \lambda \to \mu \times \mu$, which assigns to each edge e two nodes (called the nodes *connected* by that edge). If the function ϕ has a pseudo-inverse, in the sense that there exists a function $\psi = \phi^* : \mu \times \mu \to \lambda$ defined as

$$\psi(v_1, v_2) = \begin{cases} e : \lambda & \text{if } \exists e : \phi(e) = (v_1, v_2) \\ null & \text{otherwise} \end{cases} \qquad (8.121)$$

then the multigraph is simply called a *graph*. The existence of ϕ^* implies that every pair of nodes is connected by at most one edge. Also, as a consequence of the fact that ϕ is a function, ψ is an injection (one-to-one). The type definition of a graph is

$$\mu \lambda G \rhd \psi : \mu \times \mu \to \lambda \qquad (8.122)$$

Let $\psi : \mu \times \mu \to \lambda$ and $\xi : \mu' \times \mu' \to \lambda'$ be two graphs. The graphs are *isomorphic* if there are two isomorphisms $i : \mu \to \mu'$ and $j : \lambda \to \lambda'$ such that the following diagram commutes

$$
\begin{array}{ccc}
\mu \times \mu & \xrightarrow{\ \psi\ } & \lambda \\
{\scriptstyle i \times i}\downarrow & & \downarrow{\scriptstyle j} \\
\mu' \times \mu' & \xrightarrow{\ \xi\ } & \lambda'
\end{array}
\qquad (8.123)
$$

A graph ψ is *undirected* if for all v_1, v_2, $\psi(v_1, v_2) = \psi(v_2, v_1)$. A graph $\psi : \mu \times \mu \to \lambda$ is a *subgraph* of $\psi' : \mu \times \mu \to \lambda$ if $\psi(v_1, v_2) = e \Rightarrow \psi'(v_1, v_2) = e$.

Iterators on aggregated types. In addition to operations that act on aggregated data types (lists, sets, arrays, and graphs) as a whole, it is in general necessary to define operations that break down the aggregate types into their components, so that these components can be analyzed one by one. These operators are commonly called *iterators,* and their definition depends on the particular aggregated data type that is being analyzed.

Set iterator. The set iterator is the *forall* iterator, written forall $a \in A$. The forall iterator executes the block of operations that follows it, assigning every time to the variable a a different component of the set A. For instance, given a set of integers, the following operator computes their sum:

$$
\begin{aligned}
&A : \{\text{int}\}; \\
&s, a : \text{int}; \\
&A = \{1, 4, 5, 7, 10, 35\}; \\
&s = 0; \\
&\text{forall } a \in A \\
&\qquad \{s = s + a; \}
\end{aligned}
$$

List iterator. Iteration on a list is made with the help of three functions: The function head() : $[\alpha] \to \alpha$ returns the first element of a list; the function tail() : $[\alpha] \to [\alpha]$ returns the part of the list that follows the first element; and the function empty() : $[\alpha] \to$ Boolean determines whether a list is empty. The following code fragment computes the sum of integer numbers stored in a list:

$$
\begin{aligned}
&A, B : [\text{int}]; \\
&s : \text{int}; \\
&A = [1, 4, 5, 7, 10, 35]; \\
&s = 0; \\
&B = A; \\
&\text{while } \neg\text{empty}(B) \\
&\qquad \{s = s + \text{head}(B); B = \text{tail}(B); \}
\end{aligned}
$$

Array iterator. Array elements are accessed by using the index of the element as arguments to the array function. The iterator, therefore, takes the form of a "for" loop that iterates over the various indices. The function *dom*, defined as dom : $[\![\alpha]\!]$ → int returns the upper limit of the domain of an array.

As an array is a function, one is faced with the problem of how to assign values to a variable of type array. Assigning them as a function would entail something of the following sort:

```
function row1 (j : int) → int
    if j = 0 then 1
    else if j = 1 then 5
end

function row2 (j : int) → int
    if j = 0 then 7
    else if j = 1 then 9
end

function array(i : int) → (int → int)
    if i = 0 then row1
    else if i = 1 then row2
end

A : [[int]];
A = array
```

This is a formally correct but extremely complicated way of assigning values to a 2×2 array. I will use the following abbreviation:

$$A : [\![\text{int}]\!];$$
$$A = \{\{1, 5\}, \{0, 1\}\};$$

The sum example can be written as follows using a two-dimensional array:

$$A : [\![\text{int}]\!];$$
$$A = \{\{1, 4, 5\}, \{7, 10, 35\}\};$$
$$s : \text{int};$$
$$s = 0;$$
```
for i = 0,...,dom(A) − 1{
    for j = 0,...,dom(A(i)) − 1
        s = s + A(i)(j);
}
```

8.4.2 Image Features

An image is a two-dimensional array $I : [\![\mu]\!] = \text{int} \to \text{int} \to \mu$, where μ is the data type of the description of the individual pixels of the image. For instance, in a gray level image, $\mu = \text{int}$, while in a color image, $\mu = \text{int} \times \text{int} \times \text{int}$.

Several important operations can be defined on images, most of which are not relevant to a structural description of features like the one I am attempting here. Two of them, however, will be important in the following: *translation* and *scaling*. Given their importance, it is useful to define them in a rather general setting, as operations on generic n-dimensional arrays.

Translation. I will begin the simplest case: the translation of a one-dimensional array. Let $f : \text{int} \to \mu$ be an array of elements of type μ. A *translation* of $\text{int} \to \mu$ is a function of type $\theta^1 : \text{int} \to (\text{int} \to \mu) \to (\text{int} \to \mu)$. If $n : \text{int}$, $\theta^1(n)$ transforms a one-dimensional array f into another one-dimensional array $\theta^1(n)(f)$, defined as

$$\theta^1(n)(f)(m) = f(n - m) \tag{8.124}$$

The translation θ^1 can be automatically applied to multidimensional arrays. If, for example, $\mu = \text{int} \to \alpha$, then f is a two-dimensional array of type $f : \text{int} \to \text{int} \to \alpha$. In this case, according to the definition: $\theta^1(n)(f)(m, q) = \theta^1(n)(f)(m)(q) = f(n - m)(q)$. In other words, when applies to multidimensional arrays, the operator θ^1 causes a translation on the first index (hence the apex "1" in θ^1).

The following lemma shows that translations are a group with respect to function composition. The proof is an immediate application of the definition, and will be omitted.

LEMMA 8.3. *For all $n : \text{int}$, $m : \text{int}$, and $f : \text{int} \to \mu$, it is*

$$\theta^1(m)(\theta^1(n)(f)) = \theta^1(m + n)(f) \tag{8.125}$$

Translations on the other indices of a multidimensional array can be defined recursively. First, it is necessary to take care of a boundary condition that might occur when defining a multidimensional translation, namely the case in which a translation is required over an index that does not exist—for example, if a translation is required on the third index of a two-dimensional array. In these cases, the most sensible thing to do is to leave the array untouched. It is possible to reduce this boundary condition to that of the application of the function θ^1 to something that is not an array. The function θ^1 is, therefore, defined as

$$\theta^1(n)(f) = \begin{cases} m \mapsto f(m - n) & \text{if } f : \text{int} \to \alpha \\ f & \text{otherwise} \end{cases} \tag{8.126}$$

A translation on the ith parameter is then simply defined as

$$\theta^i(m)(f)(i) = \theta^{i-1}(m)(f(i)) \tag{8.127}$$

To see how the definition works, consider the application of a translation θ^2 (translation on the second index) to a two-dimensional array. In this case $f : \text{int} \to \text{int} \to \mu$. In addition, $f(i) : \text{int} \to \mu$. Therefore, $\theta^2(m)(f)(i) = \theta^1(m)(f(i))$. Now,

setting $f(i) = g$, g is a one-dimensional array, and so is $\theta^1(m)(g)$. Its value at an index j is $g(j - m)$. As $g = f(i)$, one obtains $\theta^2(f)(i)(j) = f(i)(j - m)$. The same principle applies to all other translations; the iteration "slides" all the indices of f inside the parenthesis, so that successive translations are applied to arrays of lower and lower dimension until, finally, one arrives to the point at which the translation θ^2 is applied to an $n - i + 1$-dimensional array.

Note that the same composition rule that holds for θ^1 also holds for all the θ^i:

$$\theta^i(m)(\theta^i(n)(f)) = \theta^i(m + n)(f) \tag{8.128}$$

This is true only if the apex i is the same for the two operators. The application of translation to two different indices is not reducible to a single translation, although it is easy to see that it is commutative:

$$\theta^j(m)(\theta^i(n)(f)) = \theta^i(n)(\theta^j(m)(f)) \tag{8.129}$$

In order to lighten the notation, I will often write θ^i_m in lieu of $\theta^i(m)$. As a final note, it would be possible to consider the index i as a further parameter, and define a general translation operator θ such that $\theta(i)(m) = \theta^i(m)$. This would, however, introduce some very complicated data types, and I will not pursue this generalization.

Scaling. A *scaling* σ is a datum of type

$$\sigma : \text{int} \rightarrow [\![\alpha]\!] \rightarrow [\![\alpha]\!] \tag{8.130}$$

defined as

$$\sigma(m)(f)(n)(r) = \sigma_m(f)(n) = f(2^m n)(2^m r) \tag{8.131}$$

Chapters 5 and 6 have introduced several features for describing images. All these features are, in a general sense, feature types, and, in the database, for each of these features the operations of data creation and similarity measurement are defined and a suitable data type of similarity measures is created. In order to specialize the operations that can be performed on an image feature, it is necessary to classify them more precisely. The features introduced in Chapters 5 and 6 can be divided into the following categories:

Field features are features defined at every point of the image and whose value depends on a neighborhood centered around the point at which they are evaluated. Typical examples are texture features and edge maps.

Multiresolution features and multiresolution transforms are field features repeated at different levels of resolution on the same image.

Summarization features represent the global characteristics of a certain field (or region field) features. Typical examples are histograms, statistical moments, and so on.

Region definition features describe the topology of a region regardless of its contents. These features are often associated to region field or summarization features which describe the contents of the region that these features describe.

Region features are like field or summarization features but, instead of being computed on the whole image, are restricted to a region, where the definition of the region is possibly data dependent.

Structural features describe the layout of regions in an image, and the relations between the regions. A typical example of a structural feature is the attribute relational graph of section 5.7.

All these features are syntactically represented as arrays, lists, or some derived datatype, such as graph. In order to establish a differentiation between them, it is necessary to analyze the properties of the process by which the features are computed from the image.

Field features. Let $\mathfrak{f} : [\![\alpha]\!] \to [\![\beta]\!]$ be a feature extractor, where α is the data type of a pixel in the image and β is the data type of an element in the feature array. The feature $f = \mathfrak{f}I$ is a field feature if the following diagram commutes for all images I and for all translations θ_n, θ_m:

$$
\begin{array}{ccc}
[\![\alpha]\!] & \xrightarrow{\theta_n\theta_m} & [\![\alpha]\!] \\
\mathfrak{f}\downarrow & & \downarrow\mathfrak{f} \\
[\![\beta]\!] & \xrightarrow{\theta_n\theta_m} & [\![\beta]\!]
\end{array}
\tag{8.132}
$$

If the diagram commutes, then translating the image along the two directions of the array will result in an equal translation of the feature field. The data type of a field feature composed of an array of elements of type β will be indicated as $\mathbb{F}[\beta]$.

Multiresolution features. Let $\mathfrak{f} : [\![\alpha]\!] \to [\![\beta]\!]$ be a feature extractor. The feature $f = \mathfrak{f}I$ is a *field at resolution m* if the following diagram commutes for all $m \geq 0$ and all images I

$$
\begin{array}{ccc}
[\![\alpha]\!] & \xrightarrow{\sigma_m\theta_i\theta_j} & [\![\alpha]\!] \\
\mathfrak{f}\downarrow & & \downarrow\mathfrak{f} \\
[\![\beta]\!] & \xrightarrow{\theta_i\theta_j} & [\![\beta]\!]
\end{array}
\tag{8.133}
$$

This definition captures the structural properties of lower resolution arrays: the fact that they are downsampled. In particular, a feature array has been downsampled k times if a translation by one pixel in the array is equivalent to a translation by 2^k pixels in the original image. Whether the feature is a bona fide lower resolution feature or not is something for the designer of the extractor \mathfrak{f} to ensure. The

data type of a field at resolution m with array element of type β will be indicated as $\mathbb{F}_m[\beta]$.

A *multiresolution field feature* is a list such that the kth element from the end of the list is a field at resolution k. If a list has k elements, the feature will be called an n-levels multiresolution field, and indicated as $\mathbb{M}_\beta[n]$. The definition of the datatype is as follows:

$$\frac{x : \mathbb{F}_1[\beta]}{[x] : \mathbb{M}_\beta[l]} \qquad \frac{x : \mathbb{F}_k[\beta] \quad [l] : \mathbb{M}_\beta[k-1]}{x \wr [l] : \mathbb{M}_\beta[k]} \tag{8.134}$$

Note that in this structural definition the fact that the images are downsampled when the resolution decreases is crucial. An operator that generates feature fields at different resolution but whose results are not downsampled will not give rise to multiresolution features, but simply to a list of field features.

Region definition features. In order to define region field features, it is necessary first to define mask functions. Intuitively, a mask is the indicator function of a connected set of pixels, where connectivity is assumed to be the 4-neighborhood (see Fig. 5.26). The mask operator takes as arguments a set $q \subset \mathbb{Z}^2$ and an array of type $[\![\alpha]\!]$. It gives as a result another array of type $[\![\alpha]\!]$ in such a way that

$$m_q(f)(i,\ j) = \begin{cases} f(i,j) & \text{if } i,j \in q \\ null & \text{otherwise} \end{cases} \tag{8.135}$$

where, if $f : [\![\alpha]\!]$, 0 is the null element of the data type α. As usual, in order to simplify the notation, I have written $m_q(f)$ in lieu of $m(q)(f)$. The mask operator is an operator of type

$$m : 2^{\mathbb{Z}^2} \to [\![\alpha]\!] \to [\![\alpha]\!] \tag{8.136}$$

The set of operators $m(q)$ can be given the structure of a poset (partially ordered set) induced by that of the sets q. It is possible to define a partial order \preceq as

$$m(q') \preceq m(q) \iff q' \subseteq q \tag{8.137}$$

The operator m_q is also called a *localized region* operator. The result of the application of this operator to an array a is called a *localized region* of a. Formally, a localized region is still an array with the same dimension as a and with elements of the same type. The application of the operator m_q to the unitary array $1 : [\![\alpha]\!]$ (of type α), is simply called the *region* q. Note that, given the element-wise multiplication between arrays, it is

$$m_q(a) = m_q(1) \cdot a \tag{8.138}$$

A (localized) region is also an array of type $[\![\alpha]\!]$, containing only 0's and 1's. The class of such arrays is the data type of regions, and is indicated with $\mathbb{RG}[\alpha]$. The operator $\rho(q) = m_q(1)$ is the constructor of this data type, and its type is $\rho : 2^{\mathbb{Z}^2} \to \mathbb{RG}[\alpha]$.

Note that a region $\rho(q)$ now has a type that is formally different from that of an array and, therefore, a multiplication such as for Eq. (8.138) requires a type conversion, and should be written as

$$m_q(a) = (\llbracket a \rrbracket)(\rho(1)) \cdot a \qquad (8.139)$$

In practice, of course, the type $\mathbb{RG}[\alpha]$ is compatible with $\llbracket \alpha \rrbracket$, because it is a subset of it, and the conversion operator can be omitted.

The definition of shapes as a feature requires a further step in which the shape of the region is abstracted from its location in the image.

DEFINITION 8.4. *Let $r_1 = \rho(q_1)$ and $r_2 = \rho(q_2)$ be two regions. The regions are called shape-equivalent, written $r_1 \overset{S}{\sim} r_2$ if there are two translations θ_i^1 and θ_j^2 such that $r_1 = \theta_j^2 \theta_i^1 r_2$.*

LEMMA 8.4. *The relation $\overset{S}{\sim}$ is an equivalence.*

The proof (which I will omit) is an immediate consequence of the group structure of translations[3]. The relation $\overset{S}{\sim}$ can then be used to define equivalence classes in the set of all localized regions.

DEFINITION 8.5. *A shape is an equivalence class of the relation $\overset{S}{\sim}$ in the set of all regions.*

All regions defined on a specific image are, of course, localized: The characterization of a region is possible only when the region is placed in a well-defined location. A square of side 10 pixels, for example, is a shape, but the characterization of, say, the percentage of red in the image can only be done for one specific square in one specific location of the image. In other words: The distinction between localized regions and shapes is purely algebraic, and does not imply any difference in the structure of the feature. Let $\mathbb{SH}[\alpha]$ be the data type of shapes on arrays of type $\llbracket \alpha \rrbracket$. The type conversion

$$(\tau : \mathbb{SH}[\alpha]) = (\mathbb{SH}[\alpha])(\rho(q)) \qquad (8.140)$$

transforms the region $\rho(q)$ into the shape τ. The "physical structure" of the region does not change in this transaction, but the algebraic operators that can be applied to it and their semantic do indeed change. The operations defined on the different data types will be present in the next section; for the moment the following example will suffice.

Let $q \subset \mathbb{Z}^2$, and $r_1, r_2, r_3 : \mathbb{RG}[\alpha]$ three region variables. Let $r_1 = \rho(q)$, $r_2 = \rho(q)$, and $r_3 = \theta_2^1 \rho(q)$. As regions, it is obvious that $r_1 = r_2$, while $r_1 \neq r_3$, because

[3] Note that this definition considers a rotated version of the same region as a different shape. The extension to provide invariance to rotations multiple of $\pi/2$ is quite easy, while an extension to general rotation invariance is extremely complicated because rotations will generally misalign the pixels.

r_3 is a translated version of r_1, and regions are always localized[4]. Let now s_1, s_2, s_3 : $\mathbb{SH}[\alpha]$ be three shape variables, and assign $s_1 = (\mathbb{SH}[\alpha])(r_1)$, $s_2 = (\mathbb{SH}[\alpha])(r_2)$, and $s_3 = (\mathbb{SH}[\alpha])(r_3)$. Although the region has not changed, this time it is both $s_1 = s_2$ and $s_1 = s_3$ because s_3 is a translation of s_1 and, thus, they are in the same equivalence class.

Summarization features. A summarization feature is (in general) a noninvertible function from a field transform of type $[\![\alpha]\!]$ to a generic type β. In many cases, the summarization feature can be represented as an n-dimensional array $[\![\beta]\!]^n$. This array, however, has in general no specific covariance properties and, in fact, is not bound to be a two-dimensional array or to have any relation with the topology of the image array.

Region features. A region feature is a description like a field or a summarization feature applied to a region of the image. There are several, slightly different ways in which the data type of a region feature can be defined; the one I will use is

$$\mathbb{FR}[\alpha | \beta] \triangleright r : \mathbb{RG}[\alpha], x : \beta \qquad (8.141)$$

where the generic type β can be a field feature $\mathbb{F}[\beta]$, a multiresolution feature $\mathbb{M}_\beta[k]$, or an array $[\![\beta]\!]$. In the first case the complete feature is also called a field-region feature, in the second case a multiresolution-region feature, and in the third a summarized-region feature.

The component x of a region feature is constrained to depend only on the data inside the region r. Let $\phi : 2^{\mathbb{Z}^2} \times [\![\alpha]\!] \to \mathbb{FR}[\alpha | \beta]$ be a function that constructs a region feature for a region \tilde{r}, and let $f_1, f_2 : [\![\alpha]\!]$ be two images. If the feature is regional, then

$$m_{\tilde{r}}(f_1) = m_{\tilde{r}}(f_2) \Rightarrow \phi(f_1) = \phi(f_2) \qquad (8.142)$$

or, in a more self-contained, albeit more complicated way:

$$(\phi(f_1).r = \phi(f_2).r \wedge m_{\phi(f_1).r}(f_1) = m_{\phi(f_2).r}(f_2)) \Rightarrow \phi(f_1).x = \phi(f_2).x \qquad (8.143)$$

that is, if the images are the same in the region that appears in the definition of the features, then their region features are equal.

In this definition, the location of the region is contained implicitly in the region r. A variation on the same theme is to use a shape, rather than a region, and store the location explicitly in the feature. This results in defining a region feature data type to be

$$r : \mathbb{SH}[\alpha], p : \text{int} \times \text{int}, x : \beta \qquad (8.144)$$

[4] Unless, of course, q defines a horizontal strip of infinite length, but I will assume that this is not the case.

This form is subsumed by the previous one, as the region data types define functions to extract the shape of the region and its location (see the following sections), and I will not use it in the following.

Structural features. In general terms, a structural feature is a directed graph with labeled edges. Nodes correspond to regions in the image, and the label on the edge joining two nodes encodes the spatial relation between them. The graph is directed, and the labels of the edge e going from node n_1 to node n_2 describes the relation in which n_2 stands to n_1. Thus, if the region corresponding to node n_2 is below the region corresponding to node n_1, the edge will be labeled "below" or some suitable encoding of it. As it is assumed that all relations are invertible, if one wants to know the relation in which node n_1 stands to node n_2, the edge e would be traversed backward, generating the relation "above."

The nodes of the graph are region features $\mathbb{FR}[\alpha\,|\,\beta]$ for some suitable data types α and β (remember that α is the type of the pixels of the image, and β is the type of the features that describe the contents of the region). I will assume that all the localized regions of the image are distinct and that, therefore, for a given image, all the nodes $n : \mathbb{FR}[\alpha\,|\,\beta]$ of the graph are different. This is a rather reasonable assumption because, in order to have the same feature representation, two regions should coincide in position and shape (and, therefore, content), which means, then that they are indistinguishable in all respects.

Any edge of the graph contains a specification of the relation between the two nodes attached to it. Let ω be the data type of such a specification, and depend on the specific representation that is being used for the spatial relation between two regions. To fix the ideas, I will represent an edge using a combination of three spatial relations: the relative position relation (see section 5.6.3); the distance relation (section 5.6.3); and the topological relations (section 5.6.3). The derivation of the data type of an edge under these conditions is somewhat peripheral to the current predicament, but it is a useful example of data type construction, so I will pursue it.

A relative position relation is determined by four numbers: the values of the functions $\mu_a, \mu_b, \mu_l, \mu_r$ of section 5.6.3; it can, therefore, be represented as a single dimensional array of real numbers: $[\![\text{real}]\!]^1$. The distance relation is characterized by two numbers: the values of μ_F and μ_N of section 5.6.3 but, as $\mu_N = 1 - \mu_F$ (see Eq. (5.196)), it will be sufficient to store one value, say μ_F. Finally, the topological relations are represented by an enumerated type:

$$\text{top} \triangleright \{\text{disjoint, meet, overlap, covered, equal, covers, contains, inside}\} \quad (8.145)$$

The data necessary to an edge in order to characterize the spatial relation between two nodes is of type $[\![\text{real}]\!]^1 \times \text{real} \times \text{top}$. There is, however, a further consideration. In the case of regions—that is, of nodes in the graph—I made the assumption that all regions were distinct. In the case of relations—that is, of edges in the graph—this assumption is no longer tenable—it might well happen that two different pairs of regions will be in the same spatial relation and, in this case, the

two edges joining them would be indistinguishable. To avoid this problem, I will add a unique identifier to the edge data type. The data type of an edge is therefore:

$$\text{edge} \triangleright r : [\![\text{real}]\!]^1, d : \text{real}, t : \text{top}, id : \text{int} \tag{8.146}$$

A structural feature is a graph, that is, a function:

$$\phi : \text{edge} \to \mathbb{FR}[\alpha|\beta] \times \mathbb{FR}[\alpha|\beta] \tag{8.147}$$

with a pseudo-inverse

$$\phi^* : \mathbb{FR}[\alpha|\beta] \times \mathbb{FR}[\alpha|\beta] \to \text{edge} \tag{8.148}$$

It is convenient to carry both definitions to the data type of the graph. Therefore, a structural feature for an image of type α, in which the regions are described by a feature of type β, has data type

$$\mathbb{S}[\alpha|\beta] \triangleright f : \text{edge} \to \mathbb{FR}[\alpha|\beta] \times \mathbb{FR}[\alpha|\beta],$$
$$g : \mathbb{FR}[\alpha|\beta] \times \mathbb{FR}[\alpha|\beta] \to \text{edge} \tag{8.149}$$

There are special cases in which structural features have a simpler representation. The most interesting and common one is that in which the images have been divided into a fixed group of regions, as was done in section 5.4.3 for histograms. In this case, the spatial relations between regions are fixed and known in advance, so that there is no need to represent them explicitly as edges of the graph. A common case is that in which the regions are rectangles placed in a regular grid, in which case the structural feature itself can be represented as an array

$$\mathbb{G}[\alpha|\beta] \triangleright [\![\mathbb{FR}[\alpha|\beta]]\!] \tag{8.150}$$

so that, if $\tau : \mathbb{G}[\alpha|\beta]$, then $\tau(i,j)$ is the representation of the region (i,j) of the grid, and the relation between regions can be determined simply by looking at the indices. Note also that in this case the shape and positions of the regions are known in advance, so that the use of a region feature to represent them is redundant, and the structural feature can be represented simply as

$$\mathbb{G}[\alpha|\beta] \triangleright [\![\beta]\!] \tag{8.151}$$

that is, as an array of features. This is exactly the representation that was used in section 5.4.3. In that case, β was an array containing a summarization feature—in the specific case, a histogram.

8.4.3 Feature Algebras

The characteristics of the feature data types introduced in the previous section can be used to define suitable algebras to manipulate the features in a database. In this section I will assume that all elementary types that concur in the formation of the feature data type have an associated algebra. In particular, for each elementary data type α there are two operations $+$ and \times, and two elements

$1_\alpha : \alpha$ and $0_\alpha : \alpha$ (the subscripts in 1_α and 0_α will be omitted when no possibility of confusion arises) such that for all $x : \alpha, y : \alpha, z : \alpha$,

$$
\begin{aligned}
&x + y : \alpha \qquad x \times y : \alpha \\
&x + y = y + x \qquad x \times y = y \times x \\
&x + (y + z) = (x + y) + z \qquad x \times (y \times z) = (x \times y) \times z \\
&z \times (x + y) = (z \times x) + (z \times y) \\
&\quad x + 0 = x \qquad x \times 1 = x \\
&\quad x \times 0 = 0
\end{aligned}
\tag{8.152}
$$

Operation on image data types depends both on the structural properties of the type (operations on an array are different from operations on a graph) and on the semantics of the extraction process, that is, on the covariance properties of the type (operations on a field data type will be different from operations in a summarization type, although both may be represented as an array). All feature types define a constructor (feature extraction) and a class of natural distances.

Field Features. Field features are arrays with a direct topological relationship with the pixels in the image. Informally, pixel (i, j) in a field feature f comes from "around" pixel (i, j) in the image I. Because of these characteristics, one does not usually intervene in the structure of a field relation. The most common operation that is done on a field feature is *selection*, either on the domain of the feature (i.e., selecting a specific region of the field and ignoring the rest) or on the co-domain (e.g., selecting only those components that satisfy a certain predicate). In addition to these two selections there are, of course, the basic operations of construction and distance computation.

Construction. Construction of a field feature is done by a feature extractor operator \mathfrak{f} which, given an image $I : [\![\alpha]\!]$, extracts a field feature of type α. The field feature constructor \mathbb{F} applies the operator to the image I to obtain a field feature. If $x : \mathbb{F}[\alpha]$ is a feature variable, then

$$
x = \mathbb{F}(\mathfrak{f})(I)
\tag{8.153}
$$

creates a field feature and assigns it to the variable x. Note that the field operator does not have a well-specified type because the objects on which it operates (the image I and the feature extractor \mathfrak{f}) are external to the algebra and, therefore, have no type. It can, however, be defined as

$$
\mathbb{F} : unit \times unit \to \mathbb{F}[\alpha]
\tag{8.154}
$$

leaving the type of its arguments unspecified.

Natural distance and similarity. The natural distance of field features of type $\mathbb{F}[\beta]$ is based on the natural distance of the basic type β, $d_\beta(x_1 : \beta, x_2 : \beta) : \mathbb{R}^+$. The natural distance between two field features is simply a monotonically increasing

function F of the sum of the distances between corresponding values that satisfies the hypotheses of Theorem 4.4:

$$d_{\mathbb{F}}(x_1 : \mathbb{F}[\beta], x_2 : \mathbb{F}[\beta]) = F\left(\sum_{ij} d_\beta(x_1(i,j), x_2(i,j))\right) \qquad (8.155)$$

The natural similarity is defined in the same way but, this time, function F is monotonically decreasing and satisfies the hypotheses of Theorem 4.5.

Distance functions can be created by combination of the distances d_β between elements of the field features using the distance algebra presented previously.

Array operations. A field feature is an array and, therefore, all array operations apply to field features. In particular, the apply and comb operators are defined for field features. Therefore, given $f : \mathbb{F}[\alpha], g : \mathbb{F}[\beta] \; \psi : \alpha \rightarrow \gamma$, and $\phi : \alpha \times \beta \rightarrow \gamma$, the field features $\psi f : \mathbb{F}[\gamma]$ and $f\phi g : \mathbb{F}[\gamma]$ are well defined.

Selection operator. The selection operator restricts all the operations on a field feature that take place on a given region. If $f : \mathbb{F}[\alpha]$ is a field feature, and $q : \mathbb{R}\mathbb{G}[\alpha]$ is a region, then the selection of region q over feature f is indicated as $^q f$. This selection indicates that the operations on feature f should only be limited to the region q, including operations in which the value of the feature is read. For instance, the assignment

$$h = g + {}^q f \qquad (8.156)$$

will assign to the field h the value g for all the elements outside the region q, and the value $g + f$ for all the elements in the region q. The assignments

$$h = g; \qquad (8.157)$$
$$h = {}^q f \qquad (8.158)$$

assign to the feature h the value g for all the elements outside of the region q, and the value f for all the elements inside the region q. The same effect can be obtained in a more compact way by defining the function $\phi(x, y) = y$. In this case it is

$$h = g\,\phi^q f \qquad (8.159)$$

Note that, although only the region q of the field feature f is considered in the operation, f is still a field feature, and not a region. In particular, if $g : \mathbb{R}\mathbb{G}[\alpha]$ is a region, in an assignment such as $g = \rho(q)f$ the values of f outside the region q are lost, while in the variable $^q f$ such values are still present; they are just not involved in the current operations.

Multiresolution Features. Multiresolution features are collections of field features taken at different resolution levels. The basic operations on multiresolution features are the same as those on field features, with the additional constraint

that selections must be scaled as one proceeds towards lower resolution arrays in order to take care of the downsampling that takes place at those resolutions. In addition, specific operators should be defined to manipulate the resolution levels.

Constructors. Multiresolution features are computed by extraction algorithms that usually are recursive, that is, given a multiresolution feature with k levels, they can operate on it and obtain a multiresolution feature with $k + 1$ levels. In general, multiresolution features are computed on the image data but they can, in principle, be computed based on any field feature.

Given $f : \mathbb{F}[\alpha]$, a multiresolution feature with one level (level 0) is simply a list containing the field feature f. Let \mathfrak{m} be the external algorithm that computes the multiresolution features, and I an image. Then $\mathbb{M}(\mathfrak{m})(I)$ is the zero level multiresolution feature, that is, a list containing a field feature of the image I extracted by \mathfrak{m}: $\mathbb{M}(\mathfrak{m})(I) : \mathbb{M}_\alpha[0] = [\![\alpha]\!]$. If $f : \mathbb{F}[\alpha]$, then the constructor $\mathbb{M}(f)$ builds a multiresolution feature at level 0 with the same content as f, that is $\mathbb{M}([\![\alpha]\!]) = [\![\alpha]\!]$. Given a multiresolution feature of level k, $g : \mathbb{M}_\alpha[k]$, the constructor $\mathbb{M}(\mathfrak{m})(g)$ builds a multiresolution feature of level $k + 1$: $\mathbb{M}(\mathfrak{m})(g) : \mathbb{M}_\alpha[k + 1]$. As for the case of the field constructor, the type of the multiresolution constructor is specified only in part, as some of its operands do not have a type. The constructor is in this case overloaded, as it has three signatures:

$$\mathbb{M} : \text{unit} \times \text{unit} \to \mathbb{M}_\alpha[0], \tag{8.160}$$

$$\mathbb{M} : \mathbb{F}[\alpha] \to \mathbb{M}_\alpha[0] \tag{8.161}$$

and

$$\mathbb{M} : \text{unit} \times \mathbb{M}_\alpha[k] \to \mathbb{M}_\alpha[k + 1] \tag{8.162}$$

The macro $\mathbb{M}^k(f)$, where $f : \mathbb{F}[\alpha]$ and $\mathbb{M}^k(\mathfrak{m})(g)$ build a k level multiresolution feature by successive application of the constructors.

Level operators. A multiresolution feature is a list of field features, each one at a coarser resolution than the previous, and each one obtained by downsampling the previous by a factor of two. Region operators allow one to extract these field features from the regions, and to use them as any other field feature. The following operators are defined:

nlev: The operator nlev(m) returns the number of levels of the multiresolution feature m.

level: The operator level(k, m) extracts the level k of the feature m and returns it as a field feature. Its signature is

$$\text{level} : \text{int} \times \mathbb{M}_\alpha[k] \to \mathbb{F}[\alpha] \tag{8.163}$$

This field feature is downsampled as required by the multiresolution scheme, that is, if along a given direction the field feature from which the

multiresolution feature m was derived has domain $[0, n]$, the result, the field feature level(k, m), will have domain $[0, n/(2^k)]$. Given the field feature $g = \mathbb{M}_\alpha[k]$, its domain can be increased using the tensor product. For example, the product

$$g \otimes \overbrace{\begin{bmatrix} 1 & 1 \\ 1 & 1 \end{bmatrix} \cdots \otimes \begin{bmatrix} 1 & 1 \\ 1 & 1 \end{bmatrix}}^{k \text{ times}} \tag{8.164}$$

will give a field feature of the same size as the original one. This operation is called *interpolation* of the feature at level k. This is usually not the best way of doing interpolation—algorithms outside the algebra can generally provide a numerically more accurate interpolation. The following operator takes advantage of this possibility.

ilevel: The operator ilevel(k, m, \mathfrak{m}) extracts the level k of the multiresolution feature m, just like the previous operator, but it returns a field feature of the same size as the field at the level 0 of the multiresolution feature, and directly comparable with this. If the feature extractor \mathfrak{m} offers an interpolation scheme, that scheme will be used, otherwise the feature at level zero will be obtained with a default method that is implementation dependent.

lrange: The operator lrange(k, m) extracts the first k resolution levels (i.e., the levels with the highest resolution) from the multiresolution feature m, and returns them as another multiresolution feature. If the number of levels of the multiresolution feature m is less than k, then m is returned. The signature of this operator is

$$\text{lrange} : \text{int} \times \mathbb{M}_\alpha[k'] \to \mathbb{M}_\alpha[k] \tag{8.165}$$

urange: The operator urange(k, m) extracts the last k resolution levels (i.e., the levels with the lowest resolution) from the multiresolution feature m, and returns them as another multiresolution feature. If the number of levels of the multiresolution feature m is less than k, then m is returned. The signature of this operator is

$$\text{lrange} : \text{int} \times \mathbb{M}_\alpha[k'] \to \mathbb{M}_\alpha[k] \tag{8.166}$$

Natural distance. The natural distance between multiresolution features is based on the natural distance between the field features that constitute their levels. More specifically, the natural distance between two multiresolution features is a function F of the sum of the distances between their levels, such that F satisfies the hypotheses of Theorem 4.4:

$$d_\mathbb{M}(m_1 : \mathbb{M}_\alpha[k], m_2 : \mathbb{M}_\alpha[k]) = F \left[\sum_{i=1}^{\text{lev}(m_1)-1} d_\mathbb{F}(\text{level}(i, m_1), \text{level}(i, m_2)) \right]$$

$$\tag{8.167}$$

The natural similarity is defined in the same way, but this time the function F is monotonically decreasing and satisfies the hypotheses of Theorem 4.5. As in the case of field features, other similarity functions can be defined by combining the distances between levels in different ways.

Array operators. Array operators are defined levelwise for the multiresolution features, and apply only to features of the same structure, that is, with field features at the level 0 of the same size, and the same number of levels.

Selection operators. Selection operators are defined analogously to their field feature counterparts but, in this case, the region used to make the selection is scaled down by a facor of two for every level of the feature. Thus, for every level, a region corresponding to the same physical portion of the image is selected. If the feature is complete, that is, the last level is composed of a single element, that element is never selected unless the whole image is selected. If $m : \mathbb{M}_\alpha[k]$ is a multiresolution feature, and $q : \mathbb{RG}[\alpha]$ is a region, then the selection of region q over feature m is indicated as $^q m$.

The semantic of the operator is the same as in the case of field features. Level operators maintain the selection, that is, if $f : \mathbb{F}[\alpha]$,

$$^q f = \mathrm{level}(0, {}^q \mathbb{M}(f)) \tag{8.168}$$

Region Definition Features. A region is a localized area of an image that is, a set of points in the image. The basic operations on regions are therefore based on set operations and geometric operations. Conventionally, constructors build regions as subsets of a grid consisting of a square of $N \times N$ points with N greater than the dimension of the images in the database. Suitable scaling operations are defined in order to apply the regions to images.

Constructors. A number of constructors are defined to build elementary regions that can then be combined together to build more complex regions:

rectangle: the function $\mathrm{rect}(p, l_1, l_2)$, with p : int \times int and l_1, l_2 : int creates a rectangle with center p and sides $2l_1$ and $2l_2$;

ellipse: the function $\mathrm{ellipse}(p, r_1, r_2)$, with p : int \times int and r : int creates a circle with center p and radii r_1 and r_2; and

set: the function $\mathrm{set}(q)$, where q : {int \times int} is a set of points, creates a region containing the points of the set q.

A second way of building regions is through a segmentation algorithm, which takes an image and divides it into more or less uniform regions. If \mathfrak{s} is a segmentation algorithm, the constructor $\mathbb{RG}(\mathfrak{s})(I)$ uses the algorithm \mathfrak{s} to process the image I, and returns a list of regions. As with all operators that work with external algorithms and data, \mathbb{RG} does not have a complete data type, but its

signature can be characterized as

$$\mathbb{RG} : \text{unit} \times \text{unit} \to [\mathbb{RG}[\alpha]] \qquad (8.169)$$

Note that this operator returns only the descriptions of the regions of the image. If a description of the interior is also needed, then one should use a constructor which constructs region features, that is, region definitions complete with their internal description.

Regions can also be constructed from shapes. The constructor $\mathbb{RG} : \mathbb{SH}[\alpha] \times \text{int} \times \text{int} \to \mathbb{RG}[\alpha]$ takes a shape and a point x, y, and builds a region with the given shape and such that its centroid is at a given point. That is, if $s : \mathbb{SH}[\alpha]$, the region $r = \mathbb{RG}(s, x, y)$ has the same shape as s, but its centroid is in x, y.

The constant constructor $r_\omega : \mathbb{RG}[\alpha]$ is the *universe*—a region that contains all points.

Geometric operators. These operators operate on the geometry of a region and retrieve information about it. The *shape* function, defined as shape : $\mathbb{RG}[\alpha] \to \mathbb{SH}[\alpha]$ produces a shape value containing the shape of the region (that is, it abstracts from the location of the region in the image). The shape function is, in reality, just a macro for the data type conversion $s = (\mathbb{SH}[\alpha])(r)$, where $s : \mathbb{SH}[\alpha]$ and $r : \mathbb{RG}[\alpha]$. Note that

$$\text{shape}(\mathbb{RG}(s, x, y)) = s \qquad (8.170)$$

The *center* function returns the centroid of a region. It signature is

$$\text{center} : \mathbb{RG}[\alpha] \to x : \text{int} \times y : \text{int} \qquad (8.171)$$

The *translate* operator creates a translated version of a region: $r_1 = \text{transl}(r, x, y)$ will create a region r_1 which is a copy of r translated by x points in the x direction and y points in the y direction. The signature of the function is

$$\text{transl} : \mathbb{RG}[\alpha] \times \text{int} \times \text{int} \to \mathbb{RG}[\alpha] \qquad (8.172)$$

The *rotate* operator rotates a region around a given point by multiples of $\pi/2$, the function is expressed as $r_1 = \text{rotate}(r, a, x, y)$, and its signature is

$$\text{rotate} : \mathbb{RG}[\alpha] \times \{0, 90, 180, 270\} \times \text{int} \times \text{int} \to \mathbb{RG}[\alpha] \qquad (8.173)$$

The parameters x and y can be omitted, in which case the region will be rotated around its centroid.

The operator scale scales a region up or down by integer factor: the call $r = \text{scale}(r_1, up, dwn)$ with $r_1, r : \mathbb{RG}[\alpha]$, $up, dwn : \text{int}$ returns a region with the same shape and the same centroid as s_1 scaled by a factor up/dwn. The signature of the operator is

$$\text{scale} : \mathbb{RG}[\alpha] \times \text{int} \times \text{int} \to \mathbb{RG}[\alpha] \qquad (8.174)$$

If any of the integer parameters is < 1, the operator reports an error. The operator scale is often used to apply an already defined region to a field feature. As

mentioned before, the constructors return by default a $N \times N$ array. Assume that one has a field feature f represented as a 128×128 array. In order to apply the region to the array, it is necessary to scale it down to an array of size 128×128. This can be done using scale as $\text{scale}(r, \text{dom}(f), N)$.

The operator scale does not deform the shape of the region array, that is, the array is always a square. The operators scalerow and scalecol allow this by scaling the region in the x direction only or the y direction only. Thus, given a region r of size 512×512, the operator $\text{scalecol}(r, 1, 2)$ will create a region of size 512×256, and the operator $\text{scalerow}(r, 1, 2)$ will create a region of size 256×512.

Combination. The following operators build regions by combining existing regions. The *union* of two regions $r_1 \cup r_2$ contains all the points that belong to either one of the regions, the *intersection* of two regions $r_1 \cap r_2$ contains the points that belong to both regions, and the *difference* $r_1 - r_2$ contains all the points that belong to region r_1 but not to region r_2. The complement of a region r is defined as $\neg r = r_\omega - r$.

Natural distance and similarity. The natural distance between two regions is given by the sum of the natural distance between their shapes (introduced in the next section), and the distance between their geometric centers:

$$d_{\mathbb{RG}}(r_1 : \mathbb{RG}[\alpha], r_2 : \mathbb{RG}[\alpha]) = F\left(d_{\mathbb{SH}}(\text{shape}(r_1), \text{shape}(r_2))\right.$$
$$\left. + \|\text{center}(r_1) - \text{center}(r_2)\|\right). \qquad (8.175)$$

As in the previous definitions, F satisfies the hypotheses of Theorem 4.4. The natural similarity is defined in the same way, but this time the function F is monotonically decreasing and satisfies the hypotheses of Theorem 4.5. Other similarity functions can be defined by combining the distances between levels in different ways.

Shape Features. Shape features are very much a derivation of region features, where the location has been removed. As shapes are not localized in space, it is not generally possible to combine them, the combination of regions depending on the mutual position of the regions.

Constructors. The most common way of building a shape is from a region, using either the region's "shape" function or using the data type conversion operator $\mathbb{SH}(r : \mathbb{RG}[\alpha])$, which gives a result of type $\mathbb{SH}[\alpha]$.

Elementary shapes can also be built using the following operators:

rectangle: the function $\mathbb{SH}\text{rect}(l_1, l_2)$, with $l_1, l_2 : \text{int}$ creates a rectangle with sides $2l_1$ and $2l_2$;

ellipse: the function $\mathbb{SH}\text{ellipse}(r_1, r_2)$, with $r : \text{int}$ creates a circle with radii r_1 and r_2;

set: the function $\mathbb{SH}set(q)$, where $q : \{\text{int} \times \text{int}\}$ is a set of points, creates a region of the same shape as the set q.

Modifier and conversion. The operator $\mathbb{SH}rotate$ rotates a shape around its centroid by multiples of $\pi/2$, the function has signature

$$\mathbb{SH}rotate : \mathbb{SH}[\alpha] \times \{0, 90, 180, 270\} \rightarrow \mathbb{RG}[\alpha] \qquad (8.176)$$

The operator $\mathbb{SH}scale$ scales a region up or down by integer factor: the call $s = \mathbb{SH}scale(s_1, up, dwn)$ with $s_1, s : \mathbb{SH}[\alpha]$, $up, dwn : \text{int}$ returns a feature with the same shape as s_1 scaled by a factor up/dwn.

The operator place creates a region from a shape by placing the centroid of the shape at a given point. The signature of the operator is

$$place : \mathbb{SH}[\alpha] \times \text{int} \times \text{int} \rightarrow \mathbb{RG}[\alpha] \qquad (8.177)$$

Natural distance. The natural distance of the shape feature is a primitive outside of the algebra, as it depends on the details of the representation of the shape, from which the shape feature is abstracted. If the shape is represented by Fourier coefficients, for instance, the natural distance can be defined as the Euclidean distance in the vector space of the coefficients. However, given the distance $d_{\mathbb{SH}}$, the algebra defines a natural similarity $s(s_1, s_2) = F(d_{\mathbb{SH}}(s_1, s_2))$, where F is a monotonically decreasing function that satisfies the hypotheses of Theorem 4.5. As in all the previous cases, other similarity functions can be defined by combining distance functions in different ways.

Summarization Features. Summarization features are global descriptions of an image (or a region of an image) stored in arrays. Typical examples of summarization features are histograms for the synthetic description of some field feature, or transforms generated from a group that does not have a subgroup that traverses the image plane, like the Fourier transform (transforms in which a subgroup traverses the image plane, such as wavelet transforms, are better described as field features, lists of field features, or multiresolution features).

Constructors. Summarization features are constructed in three ways: by the application of a feature extractor to an image; by the application of a feature extractor to a field feature (in which case the sumarization will be of that particular feature); or by the application of the feature extractor to region features with a description constituted by a field feature. If \mathfrak{h} is an algorithm to compute summarizations on a field of data, $f : \mathbb{F}[\alpha]$ a field feature, and $r : \mathbb{FR}[y \,|\, \alpha]$, the constructors are written as:

$$s = \mathbb{H}(\mathfrak{s})(I) \qquad (8.178)$$

$$s = \mathbb{H}(\mathfrak{s})(f) \qquad (8.179)$$

$$s = \mathbb{H}(\mathfrak{s})(r) \qquad (8.180)$$

The selector operator can be used to summarize field features in a region only. If $f : \mathbb{F}[\alpha]$, and $q : \mathbb{R}\mathbb{G}[\alpha]$, then $\mathbb{H}(\mathfrak{s})(^q f)$ will summarize the field feature f in the region q only. If $r : \mathbb{F}\mathbb{R}[\gamma\,|\,\alpha]$ and \mathfrak{s} is the feature extractor used to extract the feature $r.x$, then $\mathbb{H}(\mathfrak{s})(^{r.r}f)$ extracts the same feature as $r.x$.

Operators on congruent arrays. All the elementwise array operators apply to summarization features. In particular, the apply and comb operators are defined. In order to apply these operators, the features must be *congruent*, that is, they must be arrays of the same dimensionality and with the same number of elements in each dimension. Or, to put it in a more precise way, the two array functions muse be defined on the same domain.

A selection operator is also defined for summarization features. If $s : [\![\alpha]\!]^k$ is an array with a summarization feature, and $q \subset \mathbb{N}^k$, the array $^q s$ has all operations restricted to the set q just as with the analogous operator on field features.

Domain changing operators. The following operators change the dimensionality of arrays, or operate on arrays of different dimensionalities:

projection: the jth projection operator π_j takes a slice of an array, eliminating the jth dimension. The signature of the operator is

$$\pi_j : \text{int} \to [\![\alpha]\!]^n \to [\![\alpha]\!]^{n-1} \qquad (8.181)$$

and is defined as

$$(\pi_j(k)(s))(i_1,\ldots,i_{n-1}) = s(i_1,\ldots,i_{j-1},k,i_j,\ldots i_{n-1}) \qquad (8.182)$$

insertion: The insertion operator ι_j inserts an $n-1$ dimensional array as a "slice" into the jth dimension of an n-dimensional array. The signature of the operator is

$$\iota_j : \text{int} \to [\![\alpha]\!]^n \times [\![\alpha]\!]^{n-1} \to [\![\alpha]\!]^n \qquad (8.183)$$

and is defined as

$$(\iota_j(k)(s_1,s_2))(i_1,\ldots,i_n) = \begin{cases} s_1(i_1,\ldots,i_n) & \text{if } i_j \neq k \\ s_2(i_1,\ldots,i_{j-1},i_{j+1},\ldots,i_n) & \text{if } i_j = k \end{cases} \qquad (8.184)$$

Region Features. Region features are the union of a region and of a descriptor that can be either a field feature or a summarization feature.

Constructor. Strictly speaking, there is no constructor for a region feature, because the feature is simply created by putting together a region and a description of that region. The following macro is, however, defined, in which f is a field feature, \mathfrak{h} is a feature extractor of type $\mathbb{F}[\alpha] \to \beta$ (m can extract a summarization feature, another field feature, or simply leave f as it is, in which case it is the identity feature extractor), and $r : \mathbb{R}\mathbb{G}[\beta]$ is a region. Then the constructor $\mathbb{F}\mathbb{R}$ is defined as

$$\mathbb{FR}(r : \mathbb{RG}[\beta], \mathfrak{m} : \mathbb{F}[\alpha] \to \beta, f : \mathbb{F}[\alpha]) \to \mathbb{FR}[\alpha | \beta]$$
$$x : \beta;$$
$$a : \mathbb{FR}[\alpha | \beta];$$
$$x = \mathfrak{m}(^r f);$$
$$a = (r, x);$$
$$\text{return } a;$$

Natural distance. The natural distance between two region features is given by a function of the the sum of the natural distance between their regions, and the distance between their content descriptors:

$$d_{\mathbb{RG}}(f_1 : \mathbb{FR}[\alpha | \beta], f_2 : \mathbb{FR}[\alpha | \beta]) = F(d_{\mathbb{RG}}(f_1.r, f_2.r) + d_\beta(f_1.x, f_2.x)) \quad (8.185)$$

As in the previous definitions, F satisfies the hypotheses of Theorem 4.4. The natural similarity is defined in the same way, but this time the function F is monotonically decreasing and satisfies the hypotheses of Theorem 4.5. Other similarity functions can be defined by combining the distances between levels in different ways.

Structural Features. A structural feature is represented as a graph whose nodes are regions, and whose edges represent spatial relations between regions. Operations on the nodes and the edges of the graph are executed using the operators defined for the respective data types, while structural operations use graph-specific operators. The operators I will introduce in the following are a subset of those introduced in the AQUA data model [Subramanian *et al.*, 1993].

Constructors. The following operators are used to build a graph, and to modify its structure by adding or removing elements.

graph: the graph operator builds a graph with a single node and no edge. It signature is

$$\mathbb{S} : \mathbb{FR}[\alpha | \beta] \to \mathbb{S}[\alpha | \beta] \quad (8.186)$$

add node: The operator add_node(g, r) adds a region r to a graph g without connecting it to the other region of the graph, that is, the region node is left disconnected from the other nodes of the graph. The signature of the operator is

$$\text{add_node} : \mathbb{S}[\alpha | \beta] \times \mathbb{RG}[\alpha]\beta \to \mathbb{S}[\alpha | \beta] \quad (8.187)$$

connect: The operator connect(g, r_1, r_2, e) connects the regions r_1 and r_2 of the graph with the edge e. The signature of the operator is

$$\text{connect} : \mathbb{S}[\alpha | \beta] \times \mathbb{RG}[\alpha]\beta \times \mathbb{RG}[\alpha]\beta \times \text{edge} \to \mathbb{S}[\alpha | \beta] \quad (8.188)$$

union: The operator $g_1 \cup g_2$ creates a graph that is the union of two given graphs. The two graphs are left disconnected. The signature of the operator is

$$\cup : \mathbb{S}[\alpha\,|\,\beta] \times \mathbb{S}[\alpha\,|\,\beta] \to \mathbb{S}[\alpha\,|\,\beta] \qquad (8.189)$$

intersection: The operator $g_1 \cap g_2$ creates a graph containing the nodes and edges that the two graphs g_1 and g_2 have in common. The signature is identical to that of the union operator.

node deletion: The operator delete_node(g, r) removes the region r from the graph g, and all the edges connecting the region to the other regions. The signature of the operator is the same as that of the operator add_node.

edge deletion: The operator delete_edge(g, r_1, r_2) deletes the edge between the regions r_1 and r_2 of the graph. The signature of the operator is

$$\text{delete_edge} : \mathbb{S}[\alpha\,|\,\beta] \times \mathbb{RG}[\alpha]\beta \times \mathbb{RG}[\alpha]\beta \to \mathbb{S}[\alpha\,|\,\beta] \qquad (8.190)$$

access operators: These operators are used to access parts of the graph.

node access: The operator $\nu(g)$ returns the set of nodes of a graph. Its signature is

$$\nu : \mathbb{S}[\alpha\,|\,\beta] \to \{\mathbb{RG}[\alpha]\beta\} \qquad (8.191)$$

selection: The selection operator $\sigma(g, P)$, where P is a predicate on regions, returns the subgraph of g composed of the regions that satisfy P and the edges between them. The signature of the operator is

$$\sigma : \mathbb{S}[\alpha\,|\,\beta] \times (\mathbb{RG}[\alpha]\beta \to \text{boolean}) \to \mathbb{S}[\alpha\,|\,\beta] \qquad (8.192)$$

For the sake of convenience, the macro $\tilde{\sigma}$, which returns an unstructured set of nodes, is defined as $\tilde{\sigma}(g, P) = \nu(\sigma(g, P))$.

neighbors: The operator $N(r, g)$ returns the set of all the regions connected to the region r in the graph g. The signature of the operator is

$$N : \mathbb{RG}[\alpha]\beta \times \mathbb{S}[\alpha\,|\,\beta] \to \{\mathbb{RG}[\alpha]\beta\} \qquad (8.193)$$

edge: The operator $e(r_1, r_2, g)$ returns the edge between the regions r_1 and r_2. Its signature is

$$e : \mathbb{RG}[\alpha]\beta \times \mathbb{RG}[\alpha]\beta \times \mathbb{S}[\alpha\,|\,\beta] \to \{\text{edge}\} \qquad (8.194)$$

Natural distance. The natural distance between two graphs has three components: the similarity between regions; the similarity between their spatial relations; and the mismatch in the number of regions between two graphs. The natural distance $d_\mathbb{S}(s_1, s_2)$ is computed as defined in section 5.7. The natural similarity is obtained as $s_\mathbb{S}(s_1, s_2) = F(d_\mathbb{S}(s_1, s_2))$, where F is a function that satisfies the hypotheses of Theorem 4.5. As for all the other feature types, similarity

functions can be defined by combining the distances between levels in different ways.

8.5 Examples

This section presents some simple examples of use of the data model presented in this chapter. The database contains color images and, conventionally, I will indicate with $C \triangleright \text{int}^3$ the data type of a color pixel. An image is, therefore, an array $[\![C]\!]$. Assume that all images are scaled to a standard size of 256×256 before processing. Certain features are extracted from each image, and a database in normal form is built by creating the following tables:

$W(h : \text{int}, w : \mathbb{M}_C[8])$	This table contains an 8-level wavelet decomposition of the image.
$H(h : \text{int}, s : [\![\text{real}]\!]^3)$	This table contains a three-dimensional color histogram of the image.
$S(h : \text{int}, g : \mathbb{S}[C \mid \text{real}^{10}])$	This table contains a structural description in which each region is represented using an unspecified list of 10 values.
$X(h : \text{int}, u : (\text{word} \times \text{real})^M)$	This table contains text associated to images, determined and managed using the techniques of Chapter 7.

I will use this database for all of the following examples. Note that, although I will express some queries as "return images such that...," in reality all queries are similarity queries, and the actual answer is given by the k queries that best satisfy the criterion.

EXAMPLE 1. "return images with a general layout similar to h_1, but similar to h_2 in the details in the top-right portion of the image." The following code implements this query. Note that in the function s the type of the parameters is only partially specified due to the presence of the type variables k and α. When the function is called, these two parameters will be instantiated to the values of the actual parameters. On the other hand, the same two parameters are repeated in both arguments: This means that the function must be called with two multiresolution features with the same number of levels and base type. Once the two variables have been instantiated, they can be used inside the function to instantiate other variables.

```
1.    const λ : real = 0.1;
2.    ◊ : ⊐(𝕄_C[8]) × ⊐(𝕄_C[8]) → ⊐(𝕄_C[8]);

3.    function s₁  x₁ : 𝕄_α[k] → x₂ : 𝕄_α[k] → real
4.        u₁, u₂ : 𝕄_α[4];
5.        u₁ = urange(4, x₁);
```

```
6.        u_2 = urange(4, x_2);
7.        r : real = exp(-λd_M(u_1, u_2));
8.        return r;

9.    function s_2  x_1 : M_α[k] → x_2 : M_α[k] → real
10.       r : RG[α] = rectangle((450, 450), 162, 162);
11.       r = scale(r, 1, 2);
12.       f_1, f_2 : F[α];
13.       f_1 = level(0, x_1);
14.       f_2 = level(0, x_2);
15.       return d_F(^q f_1, ^q f_2);

16.    ◊ = Hamacher_product;
17.    ans = σ_k^#(Σ_W(s_1(W[h_1].a) ◊ s_2(W[h_2].x)))
```

The two function definitions implement the similarity according to the two criteria. The assignment of line 16 creates a scoring combination operator using the Hamacher product. In line 17, a function like $s_1(x)$ is a scoring function, assigning scores by distance with the feature vector x (this is a consequence of the fact that the two similarity functions are curried). The operator Σ_W assigns scores to the images in the database, and the operator $\sigma_k^\#$ retrieves the k images with the highest score.

EXAMPLE 2. "return images in which a region similar to region r_1 of image h_1 is on top of a region similar to region r_2 of image h_2." The following code answers this query.

```
1.    g : S[C|real^10];
2.    μ_a, μ_l, μ_b, μ_r : real;
3.    e : edge;
4.    r_1, r_2 : RG[C]real^10;
5.    r_1 = σ(H[h_l].s, x → x = r_1);
6.    g = S(r_1);
7.    r_2 = σ(H[h_2].s, x → x = r_2);
8.    g = add_node(g, r_2);
9.    μ_a = μ_l = μ_r = 0;
10.   μ_b = 1.0;
11.   e.r = (μ_a, μ_b, μ_l, μ_r);
12.   e.d = null;
13.   e.t = null;
14.   e.id = 0;
15.   g = connect(g, r_1, r_2, e);

16.   function s  x : S[C|real^10] → real
```

17. $\qquad a : \text{real} = \exp(-\lambda d_{\mathbb{S}}(x, g))$;

18. $\quad ans = \sigma_k^{\#}(\Sigma_S(s))$;

In this case, the rather long initialization (steps 1–15) is only needed to create a graph with which the graphs in the table S will be compared. The function s is not a similarity measure this time, but a self-contained scoring function.

EXAMPLE 3. "return images about cars which contain a lot of green." Assume that histograms are computed as three-dimensional histograms with $8 \times 8 \times 8$ bins. The greens are on the second axis.

1. $\quad r : [\![int]\!]^3 = \text{zeros}(8, 8, 8)$;
2. \quad for $i = 2 \ldots, 8$
3. $\qquad r(0, i, 0) = 1$;
4. $\quad r = (65536/6) \cdot r$;
5. \quad Txt \triangleright (word \times real)M;
5. $\quad \Diamond : \beth([\![int]\!]) \times \beth(\text{Txt}) \rightarrow \beth([\![int]\!] \times \text{Txt})$;

6. \quad function $s_1 \; h : [\![int]\!] \rightarrow \text{real}$
7. \qquad return $\exp(-\lambda d_H(h, r))$;

8. \quad function $s_2 \; w : \text{word} \times \text{real} \rightarrow \text{real}$
9. \qquad return $\exp(-\lambda d_T(w, (\text{"car"}, 1.0)))$;

10. $\quad \Diamond = \text{Hamacher_product}$;
11. $\quad ans = \sigma_k^{\#}(\Sigma_H(s_1) \underset{\Diamond}{\bowtie} \Sigma_X(s_2))$

Line 5 is a macro that defines the data type of the text feature; it is used only for ease of reference in the remainder of the query.

9

Where Is My Image?

There's gotta be a record of you someplace,
You've gotta be on somebody's books

Mark Knopfler, *On Every Street*

In the fictitious world of Douglas Adams's *Hitchhiker's Guide to the Galaxy* only very few things are manufactured. As Adams is kind enough to inform us, in fact, *in an infinitely large Universe such as, for instance, the one in which we live, most things one could possibly imagine and a lot of things one would rather not, grow somewhere.* To name but one example, mattresses live a peaceful, if uneventful life on the planet *Sqornshellous Zeta*.

Large image database are not unlike Adams's universe. Most image problems one has to solve (and many problems one would rather not solve) have a perfectly reasonable solution somewhere inside the database. The problem, in all large things (such as, for instance, a universe or a large image database) is how to get to the solution in a reasonable amount of time. While the inflexible and strictly enforced rules of relativity prevent Sunday mattress-harvesting trips to *Sqornshellous Zeta*, and force us to continue walking to the mattress store (driving, for those of you who live in Southern California), the equally inflexible drive of computer science induces researchers to do something about the speed of access to information.

It is rather useless to have a large amount of data if they cannot be accessed in time to do whatever the reason one was accessing them. Timely access to information is especially important in interactive systems in which the user "makes a move" and waits for the database to give the answers to her move before pondering what the successive move should be. This *modus operandi* will pose the indexing question for image databases in very different terms than in traditional

447

databases. Traditional databases work in a transaction-oriented mode. A transaction is composed of a query that the user sends to the database and an answer that the database returns to the user[1]. There is no interaction during the execution of the query. As a consequence, real-time retrieval is not terribly important (as long as, of course, the answer comes before the user starts tapping fingers nervously on desks and other horizontal surfaces), but one wants a correct answer. The situation in highly interactive image databases is quite the opposite. Here, a fast answer is more important than a completely correct one, as errors can be corrected in successive interactions, while too slow a response breaks the flow of interaction.

This difference has important repercussions in the design of indexing algorithms for image databases. It is worth accepting a certain probability of errors in exchange for a faster indexing. This consideration should be seen in the context of another issue in image databases, commonly referred as the *curse of dimensionality*. All methods devised so far for fast spatial indexing seem to break down when the dimensionality of the feature space grows. No method known today consistently outperforms linear search for databases of reasonable size when the dimensionality of the space grows beyond 10-15; some researchers even place that limit as low as five or six dimensions [Beyer *et al.*, 1999].

The curse of dimensionality, and its possible geometric causes, are analyzed in section 9.1. Problems in high-dimensional indexing, together with the consideration on the tolerability of approximate answers, led some reseachers to study ways to reduce the dimensionality of the feature space, introducing a certain error in the determination of the distance between images. These methods are introduced in section 9.2.

Sections 9.3 and 9.4 introduce the most common tree-like hierarchical structures introduced for a range queries in multidimensional spaces, while section 9.5 introduces multidimensional hashing and grid file techniques. Finally, section 9.6 shows how techniques for range query can be adapted to answer nearest-neighbor queries.

9.1 Who Cursed Dimensionality?

The expression "curse of dimensionality" refers to the set of circumstances by which the performace of logarithmic time $O(\log N)$ indexing methods, such as trees, degrades rapidly when the dimensionality of the space in which the search is performed increases. The phenomenon has been observed by most researchers in the area of indexing, and proved to be a formidable obstacle to the development of search algorithms for high-dimensional spaces.

[1] This is a simplification, of course. In reality a transaction is a much more complex activity that may include insertions, deletions, and modifications of records. For the purposes of a parallel with an image database, however, this simplified definition will suffice.

The degradation in the performance of indexing schemes is very likely an epiphenomenon deriving from the interaction of many causes, but many of them can be reduced to a phenomenon that occurs in most high-dimensional spaces, that is, the *concentration of measure* [Pestov, 1999]. The concentration of measure, in turn, generates another phenomenon, which is known as *query instability*, and which might be (there is no formal proof of this fact yet) the direct cause of the dimensionality curse. I will start by considering query instability, and then show how query instability is a consequence of the concentration of similarity. Before doing this, however, it is convenient to set up a framework in which these problems can be formalized.

9.1.1 Framework and Definitions

Access methods need to be evaluated in the context of a given *workload*, consisting of a finite set of points in a domain (that is, in a feature space) and a set of queries. The set of points is called the *database instance*. In order to make the method more general, the following definition will allow the set of queries to be infinite and to be described by a probability distribution of queries in the feature space.

DEFINITION 9.1. *A similarity workload is a quadruple* (Ω, d, μ, X), *where:*

1. Ω *is a (possibly infinite) set called the* domain *(i.e., the feature space);*

2. d *is a metric on* Ω *called the* dissimilarity measure *(i.e., (Ω, d) is a metric space);*

3. μ *is a probability measure on the metric space (Ω, d) (μ measures the distribution of query points in the domain); and*

4. X *is a finite subset of Ω called the* database instance, *and whose points are called the* data points.

The triple (Ω, d, μ) formed by a metric space (Ω, d) and a Borel probability measure μ is called a *probability metric space*. Similarity queries are of two major types:

range queries: a range query centered at $x^* \in \Omega$ and of radius ρ retrieves the set

$$A(x^*, \rho) = \{x \in X : d(x, x^*) \le \rho\} \tag{9.1}$$

nearest-neighbors queries: a *k-nearest-neighbors query* (*k*-NN) centered at $x^* \in \Omega$ and of *size k* retrieves the set $A(x^*, k) \subseteq X$ such that

$$x \in A(x^*, k), d(x^*, y) < d(x^*, x) \Rightarrow y \in A(x^*, k)$$
$$|A(x^*, k)| = k \tag{9.2}$$

The first condition implies that $A(x^*, k)$ contains the elements of X closest to the query point; the second condition implies that it contains k of them.

Given a point $x^* \in \Omega$, let $d_X(x^*)$ be the distance between x^* and its nearest neighbor in the instance X, that is,

$$d_X(x^*) = \min_{x \in X, x \neq x^*} d(x^*, x) \tag{9.3}$$

When the data are placed on a secondary storage device, they are always accessed by some *indexing scheme* [Hellerstein *et al.*, 1997]. Informally, an indexing scheme is a collection of blocks, each of which containing some fixed number of elements b (the block size). The union of these blocks contains all images in the instance X. The difference between the indexing methods that will be analyzed in the course of this chapter is in the order in which they will retrieve the blocks in which the answers to a query *might* be and, consequently, in the number of blocks that will be retrieved in order to answer the query. Some of these blocks will be retrieved unnecessarily (they will contain no record that answers the query) and will constitute the overhead of the indexing method.

More formally, an *indexing scheme* S is a collection of blocks: $S = \{B_1, \ldots, B_s\}$ such that

$$B \subseteq X$$
$$\bigcup_{i=1}^{s} B_i = X$$
$$\forall i \; |B_i| = b \tag{9.4}$$

Performance Measures. Note that in the definition of indexing scheme the condition $B_i \cap B_j = \varnothing$ does not appear. It can be possible to obtain a lower access time by allowing some redundancy in the index, that is, by storing some images multiple times. This possibility may result in a compromise between time (fast search) and space (low redundancy). The evaluation of an indexing scheme should consider both of these aspects.

The *storage redundancy* of an indexing scheme is the maximum number of blocks that contains the same element of X. The *average redundancy* of an indexing scheme is the average number of blocks that contains an element of X, that is:

$$r = \frac{sb}{|X|} \tag{9.5}$$

The *access cost* of an indexing scheme is the number of pages that the indexing scheme accesses to answer the query. This number depends on the number of results returned by the query. In order to have a more uniform measure of the access cost, it is possible to define the *access overhead* for an indexing scheme. Given a query Q that returns q results, an ideal indexing scheme would require accessing $\lceil q/b \rceil$ blocks. If, given an indexing scheme S, the query Q accesses $u(Q)$

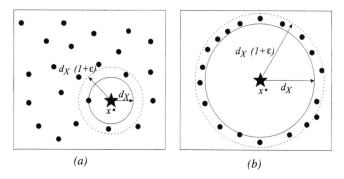

Figure 9.1. Instability in nearest-neighborhood search.

blocks, the access overhead is given by

$$v(Q) = \frac{u(Q)}{\lceil q/b \rceil} \tag{9.6}$$

9.1.2 Query Instability

Many problems in indexing high-dimensional feature spaces come from the fact that certain properties that make low-dimensional spaces "nice"—and that are so common for us that we assume them without a conscious effort—are no longer valid in high-dimensional spaces.

Consider an intuitive view of nearest-neighbor search. Figure. 9.1a is a typical case in which a number of points are placed more or less uniformly in the search space, and, given a query point (represented as a star), there is a well-defined nearest neighbor. In Fig. 9.1b, on the other hand, all points are at more or less the same distance from the query point. Although formally there still is a nearest-neighbor point, the distance between the query and the nearest neighbor is more or less the same as the distance between the query and the other points. This situation presents two problems:

- If there is some uncertainty in the computation of the distance between data points (e.g., resulting from uncertainty in the computation of the feature values), the determination of the nearest neighbor can become meaningless.

- Indexing is difficult because every partition that contains all points at a distance from the query slightly higher than the distance of the nearest point will contain most of the points of the database. Consequently, an indexing method that tries to iteratively restrict the search to an area at a distance $d_X(x^*)$ from the query point will have to examine most of the points in the data set.

If the search space has low dimensionality, the case of Fig. 9.1b is pathological and, in any case, incompatible with the hypothesis of uniform distribution of the points. It turns out, however, that in a high-dimensional space, the situation of

Fig. 9.1b is rather common and is a consequence of the properties of the distance function and not of any particular distribution of the points. Given a set of points X uniformly distributed in a high-dimensional space, the distribution of distances, seen from any point x^*, is similar that in Fig. 9.1b [Beyer *et al.*, 1998].

Because the phenomenon illustrated in Fig. 9.1b depends on the properties of the distance and not on the distribution of the points, it is not possible to use statistical methods to study it. The phenomenon can, however, be quantified starting from the following observation. In Fig. 9.1a, consider the sphere of radius $d_X(x^*)$ around the query point x^*, and increase its radius by a factor ϵ, bringing it to the value $(1 + \epsilon)d_X(x^*)$. The sphere of radius $d_X(x^*)$ contains only the nearest neighbor of the query point $x^{*\,2}$. In the situation of Fig. 9.1a, only a handful of points are contained in the sphere of radius $(1 + \epsilon)d_X(x^*)$, but in the case of Fig. 9.1b, that sphere contains most of the points in the dataset.

This behavior is at the root of most of the problems in indexing high-dimensional spaces, as it entails an explosion in the number of points that an indexing scheme has to consider as it analyzed a distance neighborhood of the nearest neighbor. The observation gives rise to the notion of ϵ-instability:

DEFINITION 9.2. *A nearest-neighbor query centered at $x^* \in \Omega$ is ϵ-unstable for an $\epsilon > 0$ if*

$$|\{x \in X : d(x^*, x) \le (1 + \epsilon)d_X(x^*)\}| > \frac{|X|}{2} \qquad (9.7)$$

The following section follows the argument in Beyer *et al.* (1998) to show that in many spaces of practical interest, and for fixed $\epsilon > 0$, the probability that a query will be ϵ-unstable converges to unity.

Probability of query instability. The following results from probability theory will be necessary to prove the main theorem of this section.

DEFINITION 9.3. *A sequence of random vectors x_1, x_2, \ldots, is said to* converge in probability *to a vector x if, for all $\epsilon > 0$, the probability of x_m being at a distance less than ϵ from x converges to unity as $m \to \infty$, that is,*

$$\forall \epsilon > 0 \quad \lim_{m \to \infty} P\{d(x_m, x) \le \epsilon\} = 1 \qquad (9.8)$$

Convergence in probability will be indicated as $x_n \overset{P}{\to} x$.

LEMMA 9.1. *If x_1, x_2, \ldots, is a sequence of random variables with finite variance $\lim_{n \to \infty} \mathbb{E}[x_n] = b$ and $\lim_{n \to \infty} \sigma^2(x_n) = 0$, then $x_n \overset{P}{\to} b$.*

THEOREM 9.1. *If x_1, x_2, \ldots, is a sequence of random variables, g is a continuous function, and $x_n \overset{P}{\to} x$, then $g(x_n) \overset{P}{\to} g(x)$.*

[2] The sphere can contain multiple points if two or more points are at the same distance from x^*. In the case of a uniform distribution of points, however, this will occur with zero probability.

COROLLARY 9.1. *If* $x_1, x_2, \ldots,$ *and* $y_1, y_2, \ldots,$ *are sequences of random variables such that* $x_n \xrightarrow{P} a$ *and* $y_n \xrightarrow{P} b \neq 0$, *then* $x_n / y_n \xrightarrow{P} a/b$.

The results of this section are probabilistic in nature, and aggregated over data sets and queries. Most of the results will be asymptotic in the dimensionality m of the feature space Ω, so that it will be necessary to consider a family of workloads. Let $(\Omega_m, d_m, \mu_m, X_m)$ be the workload for a feature space of dimensionality m, with $X_m = \{x_{m,1}, \ldots, x_{m,n}\}$, and where the $x_{m,i}$ are random points distributed according to a probability distribution P_m. The query points q_m are, as per definition, distributed according to μ_m. Moreover, define

$$d_m^- = \min\{d_m(x_{m,i}, q_m), i = 1, \ldots, n\}$$
$$d_m^+ = \max\{d_m(x_{m,i}, q_m), i = 1, \ldots, n\}$$

Then the following property holds:

THEOREM 9.2. *([Beyer et al., 1999]). If, for some* $p \geq 1$,

$$\lim_{m \to \infty} \sigma^2 \left(\frac{d_m(x_{m,1}, q_m)^p}{E[d_m(x_{m,1}, q_m)^p]} \right) = 0 \tag{9.9}$$

then for every $\epsilon > 0$,

$$\lim_{m \to \infty} P\{d_m^+ \leq (1 + \epsilon) d_m^-\} = 1 \tag{9.10}$$

(Note that the point $x_{m,1}$ *is used without loss of generality; the value of the variances and expectations is independent of the particular point used, as all the points are assumed to have the same distribution.)*

PROOF. Let $V_m = d_m(x_{m,1}, q_m)^p / E[d_m(x_{m,1}, q_m)^p]$; V_m is a random variable divided by its expectation. Therefore, $E[V_m] = 1$ and, trivially, $\lim_{m \to \infty} E[V_m] = 1$. Equation (9.9) states that $\lim_{m \to \infty} \sigma^2(V_m) = 0$. Therefore, by Lemma 9.1, $V_m \xrightarrow{P} 1$.

Consider now the vector

$$Z_m = \frac{1}{E[d_m(x_{m,1}, q_m)^p]} (d_m(x_{m,1}, q_m), \ldots, d_m(x_{m,1}, q_m))^T \tag{9.11}$$

Each component of Z_m is distributed as V_m. Therefore, $Z_m \xrightarrow{P} (1, \ldots, 1)^T$. From Theorem 9.1, and from the continuity of the function min and max, it follows that $\min(Z_m) \xrightarrow{P} 1$ and $\max(Z_m) \xrightarrow{P} 1$ and, from Corollary 9.1, that

$$\frac{\max(Z_m)}{\min(Z_m)} \xrightarrow{P} 1 \tag{9.12}$$

Note that $d_m^- = E[d_m(x_{m,1}, q_m)^p] \min(Z_m)$, and $d_m^+ = E[d_m(x_{m,1}, q_m)^p] \max(Z_m)$. Therefore,

$$\frac{d_m^+}{d_m^-} = \frac{E[d_m(x_{m,1}, q_m)^p] \max(Z_m)}{E[d_m(x_{m,1}, q_m)^p] \min(Z_m)} = \frac{\max(Z_m)}{\min(Z_m)} \tag{9.13}$$

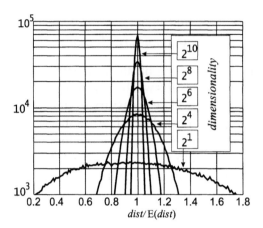

Figure 9.2.

so that $d_m^+/d_m^- \xrightarrow{P} 1$. By the definition of convergence in probability, for every $\epsilon > 0$,

$$\lim_{m \to \infty} P \left\{ \left| \frac{d_m^+}{d_m^-} - 1 \right| \le \epsilon \right\} = 1 \qquad (9.14)$$

and, because $d_m^+/d_m^- > 1$ by definition,

$$P\{d_m^+ \le (1 + \epsilon)d_m^-\} = P \left\{ \frac{d_m^+}{d_m^-} - 1 \le \epsilon \right\} = P \left\{ \left| \frac{d_m^+}{d_m^-} - 1 \right| \le \epsilon \right\} \qquad (9.15)$$

so that

$$\lim_{m \to \infty} P\{d_m^+ \le (1 + \epsilon)d_m^-\} = 1 \qquad (9.16)$$

\square

The theorem states that every data set for which condition equation (9.9) holds is "ill-behaved" in the sense that all points converge at the same distance from the query point.

How realistic are the conditions of Theorem 9.2? It is easy to see that if all the components of each data point (i.e., $x_{m,1}, \ldots, x_{m,m}$) are independent and identically distributed, the theorem holds (in this case, in fact, the condition $V_m \xrightarrow{P} 1$ is a consequence of the weak law of large numbers). This fact is exemplified in Fig. 9.2, which shows the sampled distribution of the distances between vectors in the case in which each component is independent and uniformly distributed in $[0, 1]$.

It is also possible to show that if all the components of the data vectors are deterministically dependent on a component, that is, $x_{m,j} = g_j(x_{m,1})$, then the hypotheses of the theorem are not satisfied. This result is expected because in this case all the points in the database would lie on a curve in the m-dimensional feature space and, therefore, the dimensionality of the problem is unity, independently of m.

9.1.3 Concentration of Measure

The wide variety of situations in which the phenomenon of ϵ-instability manifests itself lets one wonder whether such phenomenon might be an intrinsic property of the space Ω in which the data points are defined. A suggestion in this sense has been made by Pestov (1999), "incriminating" a property known as the *concentration of measure* in high-dimensional spaces. In informal terms, the expression "concentration of measure" refers to the following property: Take a set Ω equipped with a distance function and a probability measure, let A be a set containing at least half of all points in Ω, and define the ϵ-fattening of A as

$$A_\epsilon = \{\omega \in \Omega : d(\omega, A) < \epsilon\} \tag{9.17}$$

where

$$d(\omega, A) = \min_{a \in A} d(\omega, a) \tag{9.18}$$

and the function d that appears in the right-hand term of the equation is the distance function defined in Ω. The set Ω has the concentration of measure property if, for each such set A and $\epsilon > 0$, the set A_ϵ contains "almost all" the points in Ω, that is, A_ϵ contains all Ω except for a set of almost vanishing measure $\alpha(\epsilon)$.

This is a qualitative definition. A more precise formulation can be obtained by finding an upper bound for $\alpha(\epsilon)$ and showing that $\alpha(\epsilon)$ goes to zero very rapidly (e.g., exponentially) when ϵ increases.

More formally, define the *concentration function* of a probability metric space Ω with probability measure μ as

$$\alpha_\Omega(\epsilon) = 1 - \inf\left\{\mu(A_\epsilon) : A \subseteq \Omega, \mu(A) \geq \frac{1}{2}\right\} \tag{9.19}$$

The function α_Ω is decreasing in ϵ, and $\alpha_\Omega(0) = 1/2$. The following definition captures a class of spaces "ill-behaved" with respect to the concentration of measure.

DEFINITION 9.4. *A family* $(\Omega_n)_{n=1}^\infty$ *is a* Lévy family *if for each* $\epsilon > 0$, $\alpha_{\Omega_n}(\epsilon) \to 0$ *as* $n \to \infty$. *The family is called a* normal Lévy family *(with constants* C_1, C_2*) if, for all* n *and* $\epsilon > 0$,

$$\alpha_{\Omega_n}(\epsilon) \leq C_1 e^{-C_2 \epsilon^2 n} \tag{9.20}$$

The following spaces are examples of Lévy spaces [see Gromov and Milman (1983); Milman (1988)]:

- the n-dimensional unit sphere \mathbb{S}^n, equipped with the unique rotation-invariant probability measure and the geodesic distance;

- the same spheres with the Euclidean distance;

- the Hamming cubes $\{0, 1\}^n$, equipped with the normalized Hamming distance;

- the tori \mathbb{T}^n with the normalized geodesic distance and product measure; and

- the hypercubes $[0,1]^n$ with the normalized Euclidean distance.

Let $f : \Omega \to \mathbb{R}$ be a Lipschitz function:

$$\forall x, y \in \Omega \ \ |f(x) - f(y)| \le d(x,y) \tag{9.21}$$

The Lévy mean M of f is the number such that

$$\mu(\{x \in \Omega : f(x) \le M\}) = \mu(\{x \in \Omega : f(x) \ge M\}) \tag{9.22}$$

The following theorem from Pestov (1999) applies to f:

THEOREM 9.3. *For every $\epsilon > 0$,*

$$\mu(f^{-1}(M - \epsilon, M + \epsilon)) \ge 1 - 2\alpha(\epsilon) \tag{9.23}$$

The concentration of measures in high-dimensional spaces refers to the preceding situation, in which for almost all of its arguments the function f has almost the same value.

The following lemmas are necessary to prove the main result of this section; their proof is in Pestov (1999).

LEMMA 9.2. *Let $A \subseteq \Omega$, $\delta > 0$ and $\mu(A) > \alpha(\delta)$, then $\mu(A_\delta) > 1/2$.*

LEMMA 9.3. *Let $\delta > 0$, and let γ be a collection of subsets $A_y \subseteq \Omega$, such that for all γ, $\mu(A_y) \le \alpha(\delta)$, and such that $\mu(\bigcup_y A_y) \ge 1/2$. Then the 2δ-neighborhood of every point $x \in \Omega$, apart from a set of measures at most $(1/2)\alpha(\delta)^{1/2}$, meets at least $\lceil (1/2)\alpha(\delta)^{-1/2} \rceil$ elements of γ.*

Let (Ω, d, μ, X) be a similarity workload, and let α be the concentration function of Ω; define the function d_X as in Eq. (9.3), and let M be its median.

LEMMA 9.4. *Let $\delta > 0$. Then for all points $x^* \in \Omega$, except for a set of measures at most $2\alpha(\delta)$, the distance to the nearest neighbor in X is in the interval $(M - \delta, M + \delta)$.*

PROOF. Because the function $x^* \mapsto d_X(x^*)$ is Lipschitz, the result follows from Theorem 9.3. \square

DEFINITION 9.5. *Let (Ω, d, μ, X) be a similarity workload. For $x \in X$, let R_x be the maximal radius of an open ball centered in X of measure less than or equal $1/2$. Let $\epsilon > 0$; X is weakly ϵ-homogeneous in Ω if all such radii R_x, for $x \in X$ belong to an interval of length less than ε.*

The main result if this section is the following theorem [from Pestov (1999)]:

THEOREM 9.4. *Let (Ω, d, μ, X) be a similarity workload, and denote by M the median value of the distance from a query point in Ω to its nearest neighbor in X. Let $0 < \epsilon < 1$, and assume that the instance X is $(M\epsilon)$-homogeneous in Ω.*

Then for all points $x^ \in \Omega$ apart from a set of total mass at most $3\alpha(M\epsilon)$, the open ball of radius $(1 + \epsilon)d_X(x^*)$ centered at x^* contains at least*

$$\min\left\{|X|, \left\lceil \frac{1}{2\alpha\left(\frac{M\epsilon}{6}\right)^{1/2}} \right\rceil\right\} \tag{9.24}$$

elements of X.

PROOF. Let $R = \min_{x \in X} R_x$, and $\Delta = R - M$.

1. If $\Delta > M\epsilon$, then by Lemma 9.2, $\mu(B_M(x)) \leq \alpha(\Delta) \leq \alpha(M\epsilon)$. In fact, suppose it were $\mu(B_M(x)) \leq \alpha(\Delta)$. Then, by Lemma 9.2, and by considering that the ϵ-fattening of a ball of radius r is another ball of radius $r + \epsilon$, it would be

$$\mu(B_{M+\Delta}(x)) = \mu_R(x) > \frac{1}{2} \tag{9.25}$$

which contradicts the definition of R (see also Definition 9.5). In particular, it is $|X| \geq (1/2)\alpha(M\epsilon/6)^{-1}$. Applying Lemma 9.3 to the set of balls $\{B_M(x), x \in X\}$, with $\delta = M\epsilon/6$, yields the result that for all $x^* \in \Omega$, apart from a set of measure at most $(1/2)\alpha(M\epsilon/6)^{1/2}$, the $(M\epsilon)$-neighborhood of x^* meets at least $\lceil (1/2)\alpha(M\epsilon)^{-1/2} \rceil$ of such balls.

2. Assume now that $\Delta \leq M\epsilon/6$ (that is, from the previous point, $|X| < (1/2)\alpha(M\epsilon)^{-1/2} \leq (1/2)\alpha(M\epsilon)^{-1}$), then $R_x + M\epsilon \leq (1+\epsilon)$. Let X' be a subset of X such that

$$|X'| = \min\left\{|X|, \left\lceil \frac{1}{2\alpha\left(\frac{M\epsilon}{6}\right)^{1/2}} \right\rceil\right\} \tag{9.26}$$

Because the measure of every ball $B_{M(1+\epsilon/2)}(x)$ is at least $1 - \alpha(M\epsilon)$, for all $x^* \in \Omega$, apart from a set of measures at most $(1/2)\alpha(M\epsilon)^{1/2}$, the $(M\epsilon)$-neighborhood of x^* meets every ball $B_M(x)$, $x \in X'$.

As a consequence of Lemma 9.4, with $\delta = M\epsilon/4$, for all $x^* \in \Omega$, apart from a set of measures at most $2\alpha(M\epsilon/4)$, one has $|d_X(x^*) - M| < M\epsilon/4$ and therefore $M(1 + \epsilon/2) \leq d_X(x^*)(1 + \epsilon)$. The observation that

$$\frac{1}{2}\alpha\left(\frac{M\epsilon}{6}\right)^{1/2} + 2\alpha\left(\frac{M\epsilon}{4}\right) \leq 3\alpha\left(\frac{M\epsilon}{6}\right) \tag{9.27}$$

then proves the theorem. □

The significance of the theorem is better understood if it is cast into an *asymptotic theory* of indexed spaces, much as the complexity of an algorithm is easier to characterize if it expressed as a function of the size of the input and studied in the case in which such size goes to infinity. In the case of indexability, keeping in line with the framework of section 9.1.1, the dimensionality of the space plays the role of the input dimension.

Let $(\Omega_n, d_n, \mu_n, X_n)$ be a family of workloads, and let M_n be the median distance from points of Ω_n to their nearest neighbor in X. Also, assume that the query domains (Ω_n, d_n, μ_n) form a normal Lévy family, that the values M_n satisfy $M_n \geq M > 0$ for all n, and that, for an $\epsilon > 0$, the instances X_n are $(M_n\epsilon/6)$-homogeneous in Ω_n.

The following properties can then be proved [Pestov, 1999]:

COROLLARY 9.2. *For all query points* $x^* \in \Omega$, *apart from a set of measures*[3] $O(1)\exp(-O(1)M^2\epsilon^2 n)$, *the open ball of radius* $(1 + \epsilon)d_X(x^*)$ *centered at X contains either all the elements of X or else at least* $C_1 \exp(C_2 M^2\epsilon^2 n)$ *of them, for some constants* $C_1, C_2 > 0$.

COROLLARY 9.3. *For all query points* $x^* \in \Omega$, *apart from a set of measures* $O(1)\exp(-O(1)M^2\epsilon^2 n)$, *the ϵ-radius nearest-neighbor query centered at x^* is either unstable or takes an exponential time (in n) to answer.*

COROLLARY 9.4. *If, in addition to the previous hypotheses, the size of X_n grows subexponentially with n then for all query points* $x^* \in \Omega$, *apart from a set of measures $O(1)\exp(-O(1)M^2\epsilon^2 n)$, the similarity query centered at x^* is ϵ-unstable. All points of X are at a distance at most* $(1 + \epsilon)d_X(x^*)$ *from x^*.*

9.1.4 So, Now What?

These results cast a serious shadow on many attempts to find efficient indexing schemes in many feature spaces. Although the results are somewhat partial (it is not clear, for instance, exactly what spaces and data sets are weakly ϵ-homogeneous), there appears to be something structurally hard in searching data in high-dimensional spaces. The further characterization of this difficulty is one of the future goals of the newborn discipline of *indexability theory*. However, it is possible to learn some valuable lessons from these early results:

- It pays to try to reduce the dimensionality of the feature space. Although feature spaces of common use in image databases can have hundreds of dimensions, most of the images can be on or near a subspace of lower dimensionality. Dimensionality can be reduced in two ways: The individual features that are used to describe the image can be reduced in dimension using their specific properties [as is done, for instance, for color features in Flickner *et al.* (1995)] or the feature set can be statistically reduced to a

[3] As is customary in complexity theory, a symbol such as $O(n^a)$ denotes the family of functions $f(n)$ such that

$$\lim_{n \to \infty} \frac{f(n)}{n^a} = c$$

with $0 < c < \infty$. In particular, the symbol $O(1)$ is used to indicate any function of n that converges to a finite limit as $n \to \infty$. In this case the symbol is used, with slight impropriety, to indicate any function in the family.

lower-dimensional space using techniques such as singular-value decomposition [Press *et al.*, 1986] or multidimensional scaling [Beals *et al.*, 1968].

- The strategy of using imprecise and cheaper-to-compute distance measures as a preliminary filter to discard false hits, followed by a passage in which the elements that passed the first filter are analyzed one by one can be counter-productive if not used carefully. In the case of an instable query, an approximate distance measure will often return a significant portion of the instance X for analysis with the more precise distance, so that the benefits of having the imprecise filter are lost. The same considerations apply to approximate searches. If a query is ϵ-instable, an approximate index can fail to filter out a significant portion of the database.

- Finally, if the dimensionality of the space is such that sublinear indexing schemes fail, one should analyze the feasibility of linear ($O(N)$, where N is the number of images in the database) schemes. At high dimensionalities, a linear scheme that analyzes only a fraction of the database (i.e., a scheme that visits N/C elements, with C a constant) can be more effective than a sublinear (e.g., $O(\log N)$) scheme.

The next sections will introduce some popular indexing techniques for high-dimensional feature spaces. These techniques can be conveniently divided in four classes, namely, *space partitioning techniques*, *data partitioning techniques*, *distance-based techniques*, and *hashing techniques*. Before that, however, in the next section I will briefly introduce techniques that try to make indexing easier by reducing the dimensionality of the feature space.

9.2 Dimensionality Reduction

Because the dimensionality curse affects mostly spaces of high dimensionality, one is left with two roads to travel in search of an efficient indexing scheme: Either one tries to devise high-dimensional indexing schemes relatively immune to the curse, or one tries to reduce the dimensionality of the feature space as much as possible. The two classes of methods are, of course, complementary rather than contradictory, and one can usefully employ hybrid methods in which the dimensionality of the feature space is reduced as much as pragmatically feasible, and an efficient high-dimensional indexing method is used to take care of the residual dimensionality.

Reducing the dimensionality of the feature space entails an approximation and, therefore, an error in the measurement of distances. In the degenerate case in which *all* the dimensions were removed, the feature space would be zero-dimensional and, therefore, all images would coincide (the distance between any pair of images would be zero). From the complete feature space (in which the distances between images are the "true" distances or, at least, the best distance

one can have with the given feature extractors) to the degenerate case, the error
in measuring distances increases as one removes dimensions. On one hand, this
implies that every dimensionality reduction method will reach a compromise be-
tween richness of representation and ease of indexing. On the other hand, this
implies that one must select carefully which dimensions should be removed in
order to minimize the error for a given dimensionality of the indexed space.

9.2.1 Singular Value Decomposition

Singular value decomposition (SVD) was introduced in the definition of latent
semantics in section 7.2. Although applied to a different problem (and endowed
with a deeper semantic significance), SVD was used in latent semantics essentially
as a tool to reduce the dimensionality of a feature space and, as such, can also be
used in the present case.

Let $D = \{x^1, \ldots, x^N : x^i \in \mathbb{R}^n\}$ be a database containing N images, each one
represented as an n-dimensional feature vector. Build the matrix $A \in \mathbb{R}^{N \times n}$ as $A =
[x^1 | x^2 | \cdots | x^N]'$ and assume, as it is generally the case, that $N > n$. Singular value
decomposition ([Press $et\ al.$, 1986]; see also p. 17) decomposes the matrix A as

$$A = USV' \tag{9.28}$$

where U is an $N \times n$ orthogonal matrix, V is an $n \times n$ orthogonal matrix, and
$S = \mathrm{diag}(\lambda_1, \ldots, \lambda_n)$ is an $n \times n$ diagonal matrix containing the singular values
of the matrix A; most SVD decomposition algorithms will order the entries of
the matrix S in order of magnitude, that is, the decomposition will always be
such that $|\lambda_i| \geq |\lambda_{i+1}|$. The columns of V define a new orthonormal basis for the
feature space. The new basis can be used to obtain an approximate representation
of the feature vectors in a space of reduced dimensionality. As in section 7.2, for
a given matrix A, let $A_{r|s}$ be the matrix obtained taking the first r rows and the
first s columns of A. Considering the matrix $S_{k|k}$ one obtains an approximation
of the matrix A as

$$\hat{A} = U_{N|k} S_{k|k} V'_{n|k} \tag{9.29}$$

The columns of V form a basis of a k-dimensional subspace, which is the optimal
(in the least-square sense) representation of the original vectors of the matrix A
on a space of dimensionality k. Given a feature vector x^i, its approximate repre-
sentation is $V'_{n|k} x^i$. The dimension of the target feature space k must be chosen
as a compromise between representation and simplicity of indexing. The singu-
lar value decomposition algorithm is well known and widely available. However,
its use in image databases is limited by two disadvantages: 1) singular value de-
composition is based on the whole database (represented here as the matrix A)
and cannot be applied to dynamic situations in which the database is often up-
dated; and 2) singular value decomposition requires the original feature space to
be a vector space and cannot be applied to features that cannot be represented
as vectors.

9.2.2 Multidimensional Scaling

The dimensionality reduction technique of multidimensional scaling solves the second of the forementioned problems because it is based only on the distances between the elements of the database, without requiring them to be expressed as vectors in a vector space. The technique was first used for constructing models based on the results of psychological experiments [Torgerson, 1965; Shepard, 1962a; Carroll and Arabie, 1980], in which the only data available were dissimilarity measurements obtained from the subjects. Let $D = \{x^1, \dots, x^N : x^i \in X\}$ be a database, where X is a metric space, and let $\delta_{ij} = d(x^i, x^j)$ be the distance between x^i and x^j expressed using the metric of the space X. Multidimensional scaling builds a k-dimensional representation $y^i \in \mathbb{R}^k$ for each element of the database in such a way that distances between elements are maintained as well as possible. The *configuration* of the algorithm is given by the location of the points in the k-dimensional target space:

$$Y = \{y^i\} \tag{9.30}$$

The distance function in the target k-dimensional space is assumed to be the Euclidean distance, and, applied to the elements of a configuration Y, gives rise to the configuration distance matrix $\eta(Y)$:

$$\eta(Y)_{ij} = \left[\sum_{u=1}^{k} |y_u^i - y_u^j|^2 \right]^{1/2} \tag{9.31}$$

Multidimensional scaling minimizes a *stress* function, which is a function of the configuration defined as

$$\Psi(Y) = \sum_i \sum_j (\eta(Y)_{ij} - \delta_{ij})^2 \tag{9.32}$$

The minimization of the function is usually approximated through an iterative procedure, for example, using gradient descent, one derives

$$\frac{\partial \eta(Y)_{ij}}{\partial y_v^h} = \delta_{ih} \eta(Y)_{ij}^{-1} y_v^h (y_v^h - y_v^j) + \delta_{jh} \eta(Y)_{ij}^{-1} y_v^h (y_v^h - y_v^i) \tag{9.33}$$

and

$$\frac{\partial \Psi(Y)}{\partial y_v^k} = 4\Psi(Y) \sum_j \eta_{kj}(Y) \frac{\partial \eta_{kj}(Y)}{\partial y_v^k} \tag{9.34}$$

The components of the representations in the target space are then updated as

$$y_u^k \leftarrow \alpha y_u^k + (1 - \alpha) \frac{\partial \Psi(Y)}{\partial y_u^k} \tag{9.35}$$

In order to avoid biases, the iteration is usually initialized with the points placed at the vertices of a regular simplex, so that the distances $\eta(Y)_{ij}$ are all the same:

$$y^k_{2q-1} = \frac{\cos(2q(k-1)\pi/N)}{\sqrt{N}}$$

$$y^k_{2q} = \frac{\sin(2q(k-1)\pi/N)}{\sqrt{N}} \qquad (9.36)$$

with $q = 1, \ldots, \lceil (N-1)/2 \rceil$. If N is even, then the last coordinate is

$$y^k_{N-1} = \frac{(-1)^{k-1}}{\sqrt{2N}} \qquad (9.37)$$

Gradient descent is likely to get stuck in local minima, that is, in suboptimal representation. The numerical optimization literature offers the most sophisticated methods, which in some cases have been explicitly adapted to multidimensional scaling [Klock and Buhmann, 1997].

FastMap. FastMap is the name of an algorithm devised by Faloutsos and Lin (1995) to create vector representation of data given their distance matrix. The problem can be posed as follows.

Given n objects O_1, \ldots, O_n, a distance function d in the space in which the objects are defined, and a matrix δ such that $\delta_{ij} = d(O_i, O_j)$, find N points in a k-dimensional space $P_i = [x_{i1}, \ldots, x_{ik}]$ (where P_i is the "projection" of object O_i) such that, for a fixed distance function E defined on \mathbb{R}^k, and for every pair of indices i, j, it is $E(P_i, P_j) \approx d(O_j, O_j)$. The distance function E is usually assumed to be the Euclidean distance in \mathbb{R}^k.

For a more compact notation, just as $\delta_{ij} = d(O_i, O_j)$, it is convenient to define $\hat{\delta}_{ij} = E(P_i, P_j)$. The problem is quite similar to that already solved by multidimensional scaling in section 9.2. In that case the relation $E \approx d$ was translated in the minimization of the criterion

$$s^2 = \frac{\sum_{i,j} (\hat{\delta}_{ij} - \delta_{ij})^2}{\sum_{ij} \delta^2_{ij}} \qquad (9.38)$$

Multidimensional scaling can be used to solve the vector representation problem, but a couple of considerations discourage its use in image databases. In an image database setting, the vector representation is used on two occasions:

1. During the construction of the database, the optimal representation for the whole set of N images must be determined. Given the large size of current databases, the algorithm for doing so should be $O(N)$ or, at most, $O(N \log N)$.

2. Once the database is built, and the representation is fixed, there may be the need to represent new images. This is the case, for instance, if the user is doing Query by Example using an image not included in the database; then, the query image must be represented in the same vector space as the

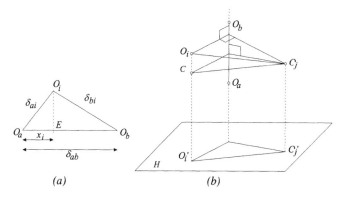

Figure 9.3. Illustration of the FastMap projection in two dimensions (a) and in three dimensions (b).

database (this is a much simpler operation, as the representation will not be changed); this operation should, ideally, require a time independent of the size of the database, that is, it should be $O(1)$.

Multidimensional scaling is typically a $O(N^2)$ algorithm, and insertion of a new element is an $O(N)$ operation; it is therefore too slow for some applications.

FastMap is not based on the explicit minimization of a functional, but on an heuristic criterion that is expected to give "good" results in most cases. As a consequence, the algorithm is fast: $O(N)$ for building the representation, and $O(1)$ for inserting a new element into an existing representation. The disadvantage is that the results will in general be suboptimal for a given dimensionality k.

The algorithm is based on the idea of projecting points on a suitably selected line. It is easier to explain how it works if one pretends that the objects are indeed described as points in an n-dimensional vector space, possibly with unknown n. It will be clear from the final algorithm that the dimension of this alleged vector space or the coordinates of the objects in it play no role on the final solution, which depends only on the distances between objects.

Consider first a one-dimensional problem (that is, with $k = 1$; Fig. 9.3a). Suppose that two *pivot* points O_a and O_b have been chosen. The one-dimensional problem can be solved by projecting all the points on the line through O_a and O_b. Given a third object O_i, its coordinate on this line (e.g., its distance from O_a, x_i) can be determined purely from distance information as

$$x_i = \frac{\delta_{ai}^2 + \delta_{ab}^2 - \delta_{bi}^2}{2\delta_{ab}} \tag{9.39}$$

This equation is an immediate consequence of the cosine law, which, if applied to the triangle $\triangle(O_a O_i O_b)$, states

$$\delta_{bi}^2 = \delta_{ai}^2 + \delta_{ab}^2 - 2x_i \delta_{ab} \tag{9.40}$$

The continuity of the projection preserves distances—at least partially—in the sense that, if the distance between two objects O_i and O_j (i.e., δ_{ij}) is small, then the distance between the two projections x_i, x_j is also small; the converse is not necessarily true, that is, two distant points can have very close (or even the same) projection.

Given the choice of the pivot points O_a and O_b, this projection solves the problem for $k = 1$. The question is whether the method can be extended to higher values of k. To see how this can be done, consider a generic n-dimensional example, represented schematically in Fig. 9.3b. The idea is to proceed iteratively as follows:

1. Determine two pivot objects O_a and O_b, and project all objects on the line joining them. The resulting value x_i (which is determined for every object O_i) will become the first coordinate of the representation of the object.

2. Project all the points on the $(n-1)$-dimensional hyperplane orthogonal to the line $\overline{O_a O_b}$ (plane H in Fig. 9.3b). The distance function δ will induce a new distance function δ' between pairs of projections.

3. The problem is now reduced to finding a $(k-1)$-dimensional representation for the $(n-1)$-dimensional space of projections. Repeat the procedure from step 1 with $k \leftarrow k - 1$ until $k = 0$.

Note that, again, I am using the assumption that the original objects are points in an n-dimensional vector space only for the ease of exposition; the final solution will be given only in terms of the distances between the objects and the coordinates x_i of the representation that is being built.

The projection step is illustrated in Fig. 9.3b. In the previous step, the pivot elements O_a and O_b were chosen, and all the objects were projected on the line $\overline{O_a O_b}$, determining the coordinates x_i. The points are now projected on the plane H, orthogonal to $\overline{O_a O_b}$. Point O_i is projected into point O_i', and point O_j is projected into point O_j'. In order to apply the algorithm to the projections on H, it is necessary to determine the distances $d'(O_i', O_j')$. Applying the Pythagorean theorem to the triangle $\triangle(O_i C O_j)$, these distance results are

$$d'(O_i', O_j')^2 = d(O_i, O_j)^2 - |x_i - x_j|^2 \qquad (9.41)$$

With this distance, the original k-dimensional problem is translated into a $(k-1)$-dimensional problem. Note that all one needs for going from the k-dimensional problem to the $(k-1)$-dimensional is the function d'. This function depends only on the original distance and on the coordinates of the representation found thus far, and not on the hypothesis that the original objects were elements of an n-dimensional vector space.

The only missing piece in the algorithm is the determination of the pivot objects O_a and O_b for each problem. I will leave the problem aside for a little longer and present the complete FastMap algorithm first. The pivot objects will be

determined by the as-yet unspecified function $\{O_a, O_b\} \leftarrow \text{getPivot}(\{O_1, \ldots, O_N\}, d)$. In addition, it is necessary to define a function that computes the function d'. The function q takes as inputs the original distance matrix δ, the number of dimensions currently assigned, and the matrix x of currently assigned coordinates:

$$q(i, j, \delta, m, x) = \sqrt{\delta_{ij}^2 - \sum_{s=1}^{m} |x_{is} - x_{js}|^2} \qquad (9.42)$$

The algorithm is as follows:

ALGORITHM 9.1. *The parameter k_0 is the desired dimensionality of the output space; the parameter k is a running value decremented at each iteration of the algorithm; when the algorithm is started, it should be $k = k_0$.*

$X \leftarrow \text{FastMap}(\delta, \{O_1, \ldots, O_N\}, k_0, k)$
1. if $k \leq 0$
2. return X
3. $c \leftarrow k_0 - k + 1$
4. $\{O_a, O_b\} \leftarrow \text{getPivot}(\{O_1, \ldots, O_N\}, q(\cdot, \cdot, \delta, c, X))$
5. if $\delta_{a,b} = 0$
6. for $i = 0, \ldots, N$
7. $X_{i,c} \leftarrow 0$
8. return
9. else
10. for $i = 0, \ldots, N$
11. $X_{i,c} \leftarrow \frac{q(a,i,\delta,c,X)^2 + q(a,b,\delta,c,X)^2 - q(b,i,\delta,c,X)^2}{2q(a,b,\delta,c,X)}$
12. $X \leftarrow [X | \text{FastMap}(\delta, \{O_1, \ldots, O_N\}, k_0, k - 1)]$

The last missing step of the algorithm is the determination of the pivot points O_a and O_b. This choice is also based on heuristic considerations, namely, that it is convenient to choose two points as far away as possible as pivots. Unfortunately, choosing the two points at maximal distance requires $O(N^2)$ distance computations, making the algorithm quadratic. The function getPivot makes an approximate determination as follows:

ALGORITHM 9.2.

$\{O_a, O_b\} \leftarrow \text{getPivot}(O, q)$
1. Let $O_b \in O$ be an arbitrary object.
2. $O_a \leftarrow \text{maxarg}_{x \in O} q(x, O_b)$
3. $O_b \leftarrow \text{maxarg}_{x \in O} q(x, O_a)$

Steps 2 and 3 can be repeated a constant number of times to improve the selection; Faloutsos and Lin (1995) report repeating the steps five times.

It is convenient to have the FastMap algorithm record the sequence of pivot objects used. If this is done, then the coordinates of a new object can be found by projecting it on the lines through the appropriate sequence of pivot points.

9.3 Space-Partitioning Techniques

Space-partitioning techniques organize the feature space as a tree. Each node of the tree stands for a region in the total feature space, and includes pointers to the data elements contained in that region. When the number of data points contained in the region exceeds a prescribed amount (corresponding to the number of data elements that can fit into a block, as defined in section 9.1.1), the space represented by the node is partitioned into subregions, whose representative nodes become the children of the original node.

9.3.1 The *K-d* Tree

The most widely used space-partitioning technique is the so-called *K-d* tree, introduced by Bentley (1975) and Friedman *et al.* (1977). The principles behind the *K-d* tree are best illustrated by a simple two-dimensional example. The query space and the data set are illustrated in Fig. 9.4a. The *K-d* tree is a binary tree

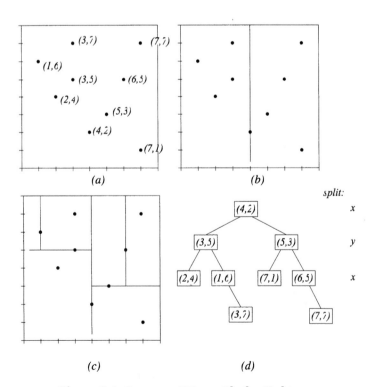

Figure 9.4. Space partition with the *K-d* tree.

whose root represents the whole space. The whole data set is, in general, too big
to be contained in a single node, therefore the root will *split*. At the first level, the
data set is divided along the x-axis. A *pivot* element is chosen (the details of this
choice will be given in the following), and two subtrees are created such that, if the
x-coordinate of the pivot is x_p, the left subtree contains all elements with $x \leq x_p$,
and the right subtree contains all the nodes with $x > x_p$. The root uses the point
$(4, 2)$ as pivot, therefore the left subtree will contain only points with $x \leq 4$, and
the right subtree will contain only points with $x > 4$, as shown in Fig. 9.4b. If the
nodes at the next level contain too many data elements, they also will split but
in this case they will split along the second dimension (y): Each node will select a
pivot point with the y-coordinate y_p, and put in the left subtree all data elements
with $y < y_p$, and in the right subtree all elements with $y > y_p$. In the data set of
Fig. 9.4, the left node uses the point $(3, 5)$ as pivot, and the right node uses the
point $(5, 3)$. In higher-dimensional spaces, this process is repeated at all levels,
so that, if the feature space has n dimensions, from x_0 to x_{n-1}, the ith level of the
tree will split along the dimension $i \mod n$ (the root is at level 0). In this case
there are only two dimensions, hence the third level will split again along the first
dimension (x). The final division of the space is represented in Fig. 9.4c, and the
resulting tree in Fig. 9.4d.

More formally, a *K-d* tree is represented as the following data type:

$$KT \triangleright \begin{cases} \text{empty} : unit \\ \text{node} : (x : \mathbb{R}^n \times n : \mathbb{N} \times l : KT \times r : KT) \end{cases} \tag{9.43}$$

The tree of Fig. 9.4 is then represented as

```
node([4,2], 0,
   node([3,5], 1,
      node([2, 4], 2, empty, empty)
      node([1, 6], 2, empty,
         node([3,7], 3, empty, empty)
      )
   ),
   node([5,3], 1,
      node([7,1], 2, empty, empty)
      node([6,5], 2, empty,
         node([7,7], 3, empty, empty)
      )
   )
)
```

The invariant of a *K-d* tree is that the subtrees originating at one node only
contain data elements on the right-hand side of the partitioning generated by
that node. If x is a data point, T a tree, and $x \in T$ has the obvious semantics, the

following predicate establishes such condition:

$$\text{legal}(empty) \tag{9.44}$$

$$\text{legal}(\text{node}(x, n, \text{empty}, \text{empty}))$$

$$\text{legal}(\text{node}(x, n, l, r)) \Leftrightarrow \forall y \in l \ y_n \le x_n \wedge \forall y \in r \ y_n > x_n \wedge$$

$$\text{legal}(l) \wedge \text{legal}(r)$$

The following insertion algorithm inserts a new data element in a K-d tree:

ALGORITHM 9.3. *Let d be the dimension of the feature space. The algorithm is recursive, and is called with the root of the tree as a parameter.*

```
Insert(x, N)
1.  if x[N.n] < N.x[N.n] then
2.        if x = N.x then return
3.        else if N.l = empty then
4.              N.l ← node(x, N.n + 1 mod d, empty, empty)
5.        else
6.              Insert(x, N.l)
7.  else
8.        if N.r = empty then
9.              N.r ← node(x, N.n + 1 mod d, empty, empty)
10.       else
11.             Insert(x, N.r)
```

The K-d trees are easy to build, as they are implemented as binary trees. They have two main disadvantages: First, K-d trees are not balanced, and their structure depends on the order of insertion of the data. Second, they are not designed for work with secondary storage devices (nodes will not fit in the blocks of the disk). Some modifications that deal with these problems will be discussed in the following.

The following algorithm uses the K-d tree to answer a range query. The query point is x^*, and the range of the query is ρ.

ALGORITHM 9.4. *The algorithm returns the set of points contained in the sphere of radius ρ, centered at the point x^*. The function d is the distance function defined in the feature space. The function intersect(p_1, p_2, x, ρ) returns true if the rectangle of extrema p_1 and p_2 intersects the sphere of radius ρ centered at x.*

```
RangeSearch(x*, ρ, T, p₁, p₂)
1.  S ← ∅
2.  if d(T.x, x*) < ρ
3.        S ← S ∪ {T.x}
4.  r₁ ← p₁
5.  r₁[T.n] ← T.x[T.n]
6.  r₂ ← p₂
```

 7. $r_2[T.n] \leftarrow T.x[T.n]$
 8. if intersect(p_1, r_2, x^*, ρ)
 9. $S \leftarrow S \cup$ RangeSearch$(x^*, \rho, T.l, p_1, r_2)$
 10. if intersect(r_1, p_2, x^*, ρ)
 11. $S \leftarrow S \cup$ RangeSearch$(x^*, \rho, T.r, r_1, p_2)$
 12. return S

The algorithm is recursive and, at every recursive call, it keeps track of the rectangle covered by the node it is analyzing in the parameters p_1 and p_2, which contain the opposite corners of such rectangle. When the algorithm is called, p_1 and p_2 are initialized to contain the extrema of the feature space. Before a node is split and its children are examined (steps 9 and 11), the extrema of the two rectangles enclosed in the two subtree are separated by splitting the rectangle of the current node along the split direction in correspondence of the $T.n$th coordinate of $T.x$. Consider again a two-dimensional example, and assume a particular step that a node is to be split along the first direction (x). The situation is the following:

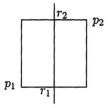

The point r_1 has all coordinates equal to p_1, except for the coordinate $T.n$, which is equal to $T.x$ (the value at which the rectangle is split). Similarly, r_2 has all coordinates equal to p_2 except for the coordinate number $T.n$.

A simple algorithm for nearest-neighbor queries can be implemented as a two-step procedure; first, given a query point x^*, find the node to which that point belongs, and take the split point for that node. The nearest neighbor is at most as distant from x^* as this point. Then, do a range query using the distance between the query point and this one as a parameter. The first operation is implemented by the following SearchLeaf algorithm:

ALGORITHM 9.5. *The algorithm returns the split point of the tree node that contains* x^*.

 SearchLeaf(x^*, T)
 1. if $(x^*[T.n] \leq T.x[T.n])$ then
 2. if $T.l =$ empty then return $T.x$
 3. else return SearchLeaf$(x^*, T.l)$
 4. else
 5. if $T.r =$ empty then return $T.x$
 6. else return SearchLeaf$(x^*, T.r)$

The list of candidate neighbors is then obtained as

$$\mathsf{RangeSearch}(x^*, d(x^*, \mathsf{SearchLeaf}(x^*, T)))$$

Static K-d trees. A serious disadvantage of the K-d tree is its dependence on the order in which the points are inserted. An unfavorable insertion sequence can give rise to a degenerate structure, much like the insertion of elements in alphabetical order in a binary tree. If the database is static, then all the data elements are known before their insertion into the structure. In this case, the insertion order and the sequence of split direction can be chosen in such a way to create a well-balanced structure. Several heuristics have been proposed to this end, but all use the same general algorithm (Algorithm 9.7). This algorithm depends on two functions, namely, splitDim and getPivot, which implement the particular heuristics used. The general semantics of the function is the following:

splitDim(S): given the data set S to be stored in a tree, determines the best direction along which the root should be split;

getPivot(S, q): given the data set S to be stored in a tree, and the direction q along which the root is split, determines the best element to be used as a pivot. Note that the pivot element is allowed to depend on the split dimension.

The general tree construction algorithm uses the following function to split a data set in two, given a dimension and a pivot element:

ALGORITHM 9.6.

$\{L, R\} \leftarrow \mathsf{split}(S, p, n)$
1. $L \leftarrow \emptyset$
2. $R \leftarrow \emptyset$
3. for all $x \in S$
4. if $x[n] \le p[n]$ then
5. $L \leftarrow L \cup \{x\}$
6. else
7. $R \leftarrow R \cup \{x\}$
8. return $\{L, R\}$

The build algorithm recursively creates the root of a tree, splits the dataset, and calls the same algorithm with the two subsets to build the subtrees:

ALGORITHM 9.7.

$T \leftarrow \mathsf{build}(S)$
1. if $S = \emptyset$ then
2. return empty
3. else if $S = \{x\}$ then
4. return $\mathsf{node}(x, -, \mathsf{empty}, \mathsf{empty})$

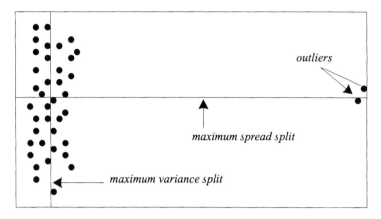

Figure 9.5. Example in which the maximum variance criterion offers a better split than the maximum spread.

5. else
6. $n \leftarrow \mathsf{splitDim}(S)$
7. $x \leftarrow \mathsf{getPivot}(S,n)$
8. $\{L,R\} \leftarrow \mathsf{split}(S,x,n)$
9. return $\mathsf{node}(x,n,\mathsf{build}(L),\mathsf{build}(R))$

The original optimized K-d tree [Friedman *et al.*, 1977] split along the direction of maximum spread, and used the median along that direction as a pivot. In terms of the functions defined in the preceding, one has

$$\mathsf{splitDim(S)} = \mathrm{maxarg}_n \max_{x,y,\in S} |x[n] - y[n]| \qquad (9.45)$$

and getPivot(S, n) is the point x such that

$$|\{y \in S : y[n] \le x[n]\}| = \frac{|S|}{2} \qquad (9.46)$$

A variant called the VAM K-d tree [White and Jain, 1996a] uses a slightly different strategy. The split direction is selected as the direction of maximum variance, as opposed to that of maximum spread. This solution should generate better splits in the presence of outliers (Fig. 9.5) The splitDim function is in this case

$$\mathsf{splitDim(S)} = \mathrm{maxarg}_n \sum_{x,y,\in S} (x[n] - y[n])^2 \qquad (9.47)$$

The original K-d algorithm splits the data set in two equal parts at every node. While this guarantees that the tree is balanced, the number of nodes in each subtree depends on the size of the dataset S. This can be an inconvenience in disk-based implementations, in which one tries to store "chunks" of trees in disk blocks. The VAM-split tree uses a rule more targeted towards disk applications. If S is the dataset for the current point, to be split between a "left" portion L and a "right" portion R, and if the size of a disk block is b, then the pivot is chosen in

such a way that

$$|L| = \begin{cases} \lfloor \frac{|S|}{2} \rfloor & \text{if } |S| < 2b \\ b\lfloor \frac{|S|}{2b} \rfloor & \text{otherwise} \end{cases} \qquad (9.48)$$

A variation of the K-d tree that deals with dynamic databases and pages secondary storage, the K-D-B tree, was proposed by Robinson (1981). The K-D-B tree, as the name suggests, is a hybrid between a K-d tree and a B-tree [Bayer and McCreight, 1972]. As a derivation of the K-d tree notwithstanding, the techniques used in the K-D-B trees are rather similar to those used in the R-trees and derived structures, in particular, to the R^*-trees, which will be introduced in the next section.

9.4 *R*-Trees Style Trees

Indexing structures derived from the K-d trees are based on the idea of partitioning the feature space in nonoverlapping regions. These structures offer a top-down view of the feature space. Start with the whole feature space, and divide it into smaller and smaller regions as they become too full. The R-trees [Guttman, 1984] are, in a sense, the opposite of K-d trees, as they take a bottom-up approach based on *minimum bounding rectangles*. Leaf nodes contain a number of data points, and are characterized by the coordinates of the minimal rectangle containing all the data points. Higher-level nodes contain other nodes, and are characterized by the minimal rectangle containing all the rectangles of their children. Unlike the basic K-d tree, R-trees are always balanced and well adapted to work with secondary storage devices.

An example of contruction of an R-tree is given in Fig. 9.6. The points in the feature space are in Fig. 9.6a. Assume that the *fan out* of the tree (the maximum number of children that a node can have) is four. In Fig. 9.6b, groups of four points are gathered together in nodes $R1, \ldots, R6$. Each node has an *extent*, which is the minimal bounding rectangle containing its children. The criterion used to group points into nodes will be discussed in the following but, for the moment, note that, unlike the K-d tree, the regions covered by different nodes of an R tree can overlap, that is, $R1$ overlaps with $R2$ and $R3$.

There are now six nodes and the procedure can be repeated by collecting them into groups. This time (Fig. 9.6c) they are collected into groups of three nodes and bounding rectangles $P1, P2$. These two groups are placed as children to the root of the tree. The resulting tree structure for this example is shown in Fig. 9.6d.

An R-tree is characterized by two numbers, namely, the maximum number of children that a node can have M, and the *minimum* number of children that a node (with the exception of the root) can have, $m \leq M/2$. This parameter plays a role similar to the one it plays in single-dimensional B-trees. If things are arranged so that the constraint that the number of children of a node must be at least m, and $m \geq 2$, the tree cannot degenerate in a list, that is, the height of the tree is

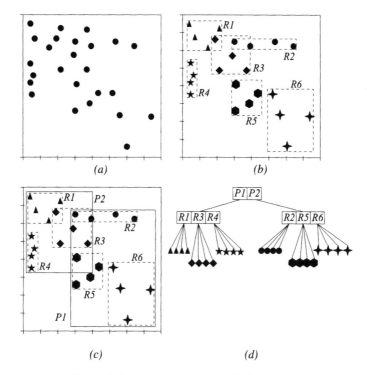

Figure 9.6. Data partition with the *R*-tree.

always logarithmic in the number of nodes; indeed, it is at most $|\log_m N + 1|$ for N entries. The condition $m \le M/2$ is necessary to ensure that the constraint can be satisfied, as will be evident in the following.

For a more formal definition of an *R*-tree, a distinction should be made between leaves and internal nodes. Leaves contain entries that point to the point data on the feature space. Each entry contains an identifier of the data point (which I will assume to be an integer), and its location in the n-dimensional feature space. An internal node contains the description of the minimal bounding rectangle containing all the points contained in its subtrees, and the subtrees. The *R*-tree is defined as the following data type:

$$(n, M)RT \; \triangleright \; \begin{cases} \text{leaf}(p : (id : int, x : \mathbb{R}^n)^M) \\ \text{node}(u : (t : (n, M)RT, r : \mathbb{R}^n)^M) \end{cases} \qquad (9.49)$$

The *R*-tree data type is parametrized by the dimension of the feature space that it indexes and by the maximum number of children that a node can have. In many cases these two values are clear from the context, thus the *R*-tree data type will simply be indicated as *RT*.

An *R*-tree is built and maintained in a way that ensures that the following conditions are always satisfied:

1. Every leaf contains betweem m and M data points, unless it is the root;

2. every nonleaf node has between m and M children, unless it is the root;

3. for each entry (t, r) in a nonleaf node, r is the smallest rectangle that contains all the rectangles in the R tree t;

4. the root has at least two children, unless it is a leaf; and

5. all leaves appear at the same level.

In order to formalize these conditions of validity, define first the following auxiliary function that expands a tree to a set containing all the data points of the tree:

$$\eta(leaf(p)) = \{p[i].x\}$$
$$\eta(node(u)) = \bigcup_i \eta(u[i].t)$$

and the following function that determines the validity of every node except the root:

$$nLegal(leaf(p)) \Leftrightarrow |p| \geq m \wedge |p| \leq M$$
$$nLegal(node(u)) \Leftrightarrow |u| \geq m \wedge |u| \leq M$$
$$\wedge \ \forall i \ \forall q \in \eta(u[i].t) \ q \in u[i].r$$
$$\wedge \ \forall i \ \forall r' \subset u[i].r \ \exists q \in \eta(u[i].t) : q \notin r'$$
$$\wedge \ \forall i \ nLegal(u[i].t). \tag{9.50}$$

The first definition of the function establishes that every leaf with the correct number of points is a legal subtree. In the second definition, the first two conditions enforce the limits on the number of children of a node; the third condition establishes that the rectangle associated with a subtree contains all the points in that subtree, and the last condition establishes that such a rectangle is minimal.

Finally, the following function determines the validity of a tree given its root, and enforces the special conditions that are valid for the root

$$legal(leaf(p)) \Leftrightarrow |p| \leq M$$
$$legal(node(u)) \Leftrightarrow |u| \geq 2 \wedge |u| \leq M$$
$$\wedge \forall i \ \forall q \in \eta(u[i].t) \ q \in u[i].r$$
$$\wedge \forall i \ \forall r' \subset u[i].r \ \exists q \in \eta(u[i].t) : q \notin r'$$
$$\wedge \forall i \ nLegal(u[i].t) \tag{9.51}$$

Range queries. The search algorithm descends the tree in a way similar to a search in a B-tree. However, because the regions covered by different nodes can overlap, several branches will have to be traversed in parallel. Every time the search sphere intersects the rectangle covered by a node, that node is traversed. The fact that the rectangles in the nodes cover a large amount of empty space in addition to the points will also cause the algorithm to needlessly explore some nodes. For instance, the range query in Fig. 9.7 will explore the nodes $P1$, $P2$, $R4$, $R5$, $R6$, although only the path $P1 \rightarrow R5$ will retrieve points. This example

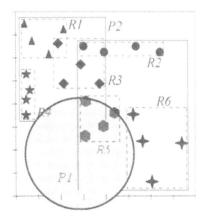

Figure 9.7. A range search that will explore several useless nodes.

illustrates the importance of keeping the rectangles as "tight" as possible, an observation that will have considerable importance in the following.

The range search algorithm for *R*-trees is the following.

ALGORITHM 9.8. *Returns a list of all the elements in the tree T at a distance at most r from the query element x*. The function intersect determines whether the minimal bounding rectangle of a node intersects a disk, given its center and radius. The function inside determines whether a point is contained within a sphere.*

$R \leftarrow$ search(x^*, r, T)
1. $R \leftarrow \varnothing$
2. if $T = node(u)$
3. for $i = 1, \dots, |u|$
4. if intersect$(x^*, r, u[i].r)$
5. $R \leftarrow R \cup$ search$(x^*, r, u[i].t)$
6. else if $T = leaf(p)$
7. for $i = 1, \dots, |p|$
8. if inside$(x^*, r, p[i].x)$
9. $R \leftarrow R \cup \{p[i].x\}$

Insertion in an *R*-tree is complicated by the fact that the structure must be kept balanced and all the nodes must contain at least *m* elements. The insertion algorithm is composed of the following three steps:

1. Given an element to be inserted in the structure, find the leaf where that element belongs;

2. if the leaf is not full (that is, if it has less than *M* elements in it), add the new point to it and exit. Otherwise, it is necessary to *split* the leaf. From a leaf *L* with *M* points and a new point that is to be inserted, create two new leaves L_1 and L_2, and divide the $M + 1$ points among them, assigning at least $\lfloor (M + 1) \rfloor$ to each node (in order to keep the tree legal, there must be at

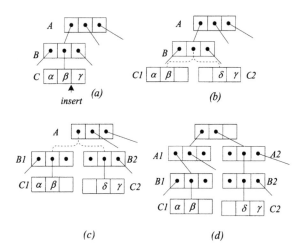

Figure 9.8. Insertion of a node in an R-tree.

least m elements in each leaf; this is the reason why it is necessary to have $m \le M/2$);

3. there are now two leaves (L_1 and L_2) to be attached to the tree where, previously, there was only one (L). If the parent of L has room (that is, if it has less than M children), it is possible to attach the new node to it, and the algorithm terminates. Otherwise, it is necessary to split the parent of L and assign the $M + 1$ children (the M it already had plus the newly created one) to it. This will create a new internal node. If the parent of this node does not have room to accommodate the new child, it is necessary to split it too, and so on until the root is reached. If the root is full, then it will be split into two, and a new root will be created with two children.

The structural process is illustrated in Fig. 9.8. The element δ is to be inserted into the R-tree of Fig. 9.8a, and the node in which the element should be inserted (C) has been identified using one of the heuristics that will be presented later in this section. The node, however, is full (in the example of Fig. 9.8, it is assumed that $M = 3$). The node is then *split* into the two nodes $C1$ and $C2$, and the $M + 1$ elements α, β, γ, and δ are distributed among these two nodes (this also is done using the heuristics presented later). Now the two nodes $C1$ and $C2$ have to be attached to the parent of C. The parent, however, is full. The split is then repeated generating the two nodes $B1$ and $B2$, and so on until one finds a node that can accommodate an extra child or (as in Fig. 9.8) the process is repeated all the way to the root. If the root is full, it will also be split (in $A1$ and $A2$ in the example) and a new root will be created with the two nodes as children. In addition to this structural process, every node whose children have been changed will need to update its bounding rectangle.

The insertion algorithm is divided in four parts, the fourth of which will be discussed in the next subsection. Algorithm 9.9 is the general insertion algorithm:

ALGORITHM 9.9. *Inserts a new data element into an R-tree and returns a new tree with the node inserted. This algorithm uses three functions:* ChooseLeaf, *which determines in which leaf the new element will be inserted,* Adjust, *which adjusts and balances the tree after insertion and updates the bounding rectangles of all the nodes, and* split, *which divides a node in two parts and distributes the children among them. Note that the function Adjust can be called with two distinct signatures, depending on whether or not the node with the new point has been split.*

$R \leftarrow$ Insert(E, T)
1. $L \leftarrow$ ChooseLeaf(E, T)
2. if $|L.p| < M$ then
3. $k \leftarrow |L.p| + 1$
4. $L.p[k].id \leftarrow E.id$
5. $L.p[k].x \leftarrow E.x$
6. return adjust(L, T)
7. else
8. $\{L_1, L_2\} \leftarrow$ split(L, E)
9. return adjust(L_1, L_2)

The following function returns the leaf in which the new point will be inserted

ALGORITHM 9.10. *The function envelope takes a set of rectangles and points and returns the minimum rectangle that contains them all. The operator $|\cdot|$ appled to a rectangle computes its area.*

$N \leftarrow$ ChooseLeaf(E, T)
1. if $N =$ leaf(p)
2. return N
3. else if $T =$ node(u)
4. $k = \text{minarg}_{i=1,\dots,|u|} |\text{envelope}(\{u[i].r, E.x\})| - |u[i].r|$
5. return ChooseLeaf$(u[k].t)$

The only step somewhat obscure in the algorithm is step 4. This step considers the rectangles included by the children of the current node one by one. For each one, compute the area that the rectangle would have if the point E would be added to that child ($|\text{envelope}(\{u[i].r, E.x\})|$) and, from this, the increment with respect to the current area. The algorithm chooses the nodes that require the smallest increase in area. Ties can be solved by choosing the entry with the rectangle of smallest area.

The function Adjust balances the tree once the new element is in place, and adjusts the bounding rectangles of all the nodes in the path of the newly introduced point.

ALGORITHM 9.11. *The function parent is used to access the parent of a node in the tree. It returns null if the node is the root. The function envelope returns the minimal bounding rectangle of a set of points and rectangles. The function is given*

with two different signatures, depending on whether or not there is a "dangling"
node (split but not yet attached).

$R \leftarrow \text{adjust}(N, T)$
1. if $\text{parent}(N, T) = \varnothing$ return N
2. $P \leftarrow \text{parent}(N, T)$
3. $j \leftarrow k : P.u[k].t = N$
4. $P.u[k].r = \text{envelope}(\{N.u[i].r : i = 1, \dots, |N.u|\})$
5. return $\text{adjust}(P)$

$R \leftarrow \text{adjust}(N_1, N_2, T)$
1. $r_1 \leftarrow \text{envelope}(\{N_1.u[i].r : i = 1, \dots, |N_1.u|\})$
2. $r_2 \leftarrow \text{envelope}(\{N_2.u[i].r : i = 1, \dots, |N_2.u|\})$
3. if $\text{parent}(N_1, T) = \varnothing$
4. $R \leftarrow \text{node}([(N_1, r_1), (N_2, r_2)])$
5. return R
6. else
7. $P \leftarrow \text{parent}(N_1, T)$
8. $j \leftarrow k : P.u[k].t = N$
9. $P.u[k].r = r_1$
10. if $|P.u| < M$
11. $k \leftarrow |P.u| + 1$
12. $P.u[k].t \leftarrow N_2$
13. $P.u[k].r \leftarrow r_2$
14. return $\text{adjust}(P)$
15. else
16. $\{L_1, L_2\} \leftarrow \text{splitnode}(P, N_2)$
17. return $\text{adjust}(L_1, L_2)$

Node split. Let N_1 be a node with M entries (for the moment, N_1 will be assumed
to be an internal node, but the same considerations apply to leaves as well), and
let L_1 be a new node to be added to N as a child. Because the node cannot ac-
commodate $M + 1$ entries, it is necessary to *split* it into two nodes N_1 and N_2, and
distribute the $M + 1$ children among them. Each one of these nodes has a bound-
ing rectangle, and the way children are assigned to N_1 and N_2 will determine the
shape and location of the bounding rectangles of N_1 and N_2.

Generally speaking, the way the $M + 1$ children are distributed among N_1 and
N_2 should minimize the probability that in a successive query both N_1 and N_2
will be examined. As the decision on whether or not to visit a node is based on
whether or not its minimum bounding rectangle intersects the query region, a
good heuristics is to distribute the children. Fig. 9.9 illustrates the point: The
split of Fig. 9.9b is a better split because the rectangles cover a smaller overall
area. The node split problem can be posed in the following general way: *Given*

Figure 9.9. Two ways of splitting four rectangles between two nodes.

$M + 1$ rectangles r_1, \ldots, r_{M+1}, divide the rectangles between two sets S_1 and S_2 in such a way that the total area of the minimal bounding rectangles of S_1 and S_2

$$envelope(\{r_i : r_i \in S_1\}) + envelope(\{r_i : r_i \in S_2\}) \qquad (9.52)$$

is minimized.

The problem subsumes both the problem of splitting internal nodes and that of splitting leaves. In the case of leaves, the rectangles r_i are degenerate, consisting of only one point.

A trivial solution to solve this problem is exhaustive search among all possible assignments of the nodes, choosing the one which results in the lowest overall area. Unfortunately, there are of the order of 2^{M-1} possible assignments and, because in practical applications M is of the order of 100, exhaustive search can take an intolerably long time to execute. Two alternative heuristic suboptimal algorithms are used in Guttman (1984), namely, one with complexity $O(M^2)$ and one with complexity $O(M)$.

The quadratic algorithm selects two of the $M + 1$ rectangles as the "seeds" of the two groups by choosing the pair that would waste the most area if they were placed in the same group (i.e., the area of the minimum bounding rectangle covering both minus the area of the two rectangles is greatest). Such an increase in area is the *cost* of adding the entry. At each following step, all the other rectangles are analyzed, and the cost of adding the entry to each group is computed. The entry for which the difference in cost between adding it to a group and adding it to the other is greatest, is added to the group for which the cost is lower. That is, define

$$C(S_i, r_j) = |envelope(S_i \cup \{r_j\})| - |envelope(S_i)| \qquad (9.53)$$

(remember that I assume that the operator $| \cdot |$ applied to a rectangle computes its area). The next element is picked so as to maximize $|C(S_1, r_j) - C(S_2, r_j)|$. This operation is performed by the following function, which takes the two sets S_1 and S_2, a set R of as yet unassigned rectangles, and returns the rectangle that maximizes the criterion:

ALGORITHM 9.12.

> $r \leftarrow \mathrm{pick}(S_1, S_2, R)$
> 1. $r \leftarrow \mathrm{minarg}_{r' \in R} |C(S_1, r') - C(S_2, r')|$
> 2. $R \leftarrow R - \{r\}$
> 3. return r

The following algorithm picks the two elements that will be used as seeds for the construction of the groups:

ALGORITHM 9.13.

> $\{r_1, r_2\} \leftarrow \mathrm{pickSeeds}(R)$
> 1. $m = -1$
> 2. for all $r_a, r_b \in R$
> 3. $m_1 = |\mathrm{envelope}(\{r_a\} \cup \{r_b\})| - |r_a| - |r_b|$
> 4. if $m_1 > m$
> 5. $m \leftarrow m_1$
> 6. $r_1 \leftarrow r_a$
> 7. $r_2 \leftarrow r_b$
> 8. $R \leftarrow R - (\{r_1\} \cup \{r_2\})$
> 9. return $\{r_1, r_2\}$

The quadratic split algorithm is as follows:

ALGORITHM 9.14.

> $\{S_1, S_2\} \leftarrow \mathrm{split}(R)$
> 1. $\{S_1, S_2\} \leftarrow \mathrm{pickSeeds}(R)$
> 2. while $R \neq \varnothing$
> 3. $r \leftarrow \mathrm{pick}(S_1, S_2, R)$
> 4. if $C(S_1, r) < C(S_2, r)$
> 5. $S_1 \leftarrow S_1 \cup \{r\}$
> 6. else
> 7. $S_2 \leftarrow S_2 \cup \{r\}$
> 8. if $|S_2| = M$ or $|S_1| + |R| = m$ then
> 9. $S_1 \leftarrow S_1 \cup R$
> 10. $R \leftarrow \varnothing$
> 11. if $|S_1| = M$ or $|S_2| + |R| = m$ then
> 12. $S_2 \leftarrow S_2 \cup R$
> 13. $R \leftarrow \varnothing$
> 14. return $\{S_1, S_2\}$

It is possible to devise many other heuristics for splitting nodes. The original paper by Guttman (1984) also proposed a linear time-separation algorithm, which was based on the quadratic algorithm, but replaced the function "pick" with a

random selection of a new rectangle, and the function "pickSeed" with a simpler, linear time version.

9.4.1 The R^*-Tree

The main algorithmic problem in an R-tree is the construction of sets of bounding rectangles, each one including between m and M nodes, in such a way that arbitrary retrieval operations performed on these nodes will be as efficient as possible. The problem is not solvable rigorously, and the R-tree relies on a heuristic derived from engineering common sense. The main idea behind the heuristic of the R-tree is that small rectangles are less likely to create problems than large ones. Based on this observation, the R-tree splits nodes trying to minimize the sum of the areas covered by the rectangles of the two new nodes. There are a number of parameters, in addition to the area of the rectangles, whose value affects the performance of the tree. The most obvious are [Beckman *et al.*, 1990]:

1. *The area covered by a minimal bounding rectangle.* This is the parameter optimized in the R-tree;

2. *the overlap between minimal bounding rectangles.* Whenever two rectangles intersect and their interstction overlaps the query area, the nodes containing both rectangles must be traversed. This effect can be minimized by minimizing the amount of overlap between rectangles;

3. *the surface of a minimal bounding rectangle.* This optimization tends to favor "regular" structures (square, cube, tesseract, ...) over irregular ones such as very oblong rectangles. This will also reduce the area of the rectangle; and

4. *storage utilization.* While the structure of the R-tree guarantees that no node will contain fewer than m entries, guaranteeing that storage is utilized to a fraction better than m/M is a matter for the split algorithm. Queries with large query surfaces are favored by high storage utilization.

Variants of the basic R-tree have played these optimization parameters in different ways [e.g., Greene, 1989]. The most famous and widely used variant is the R^*-tree, created by Beckmann, Kriegel, Schneider, and Seeger (1990) of the University of Bremen.

Structurally, the R^*-tree is identical to an R-tree, and differs from the latter only for the split and insertion criteria. In particular, the legality conditions equation (9.51) applies to the R^*-tree as well, and the search algorithm 9.8 and the skeleton of the insertion algorithm 9.9 are the same. The Chooseleaf algorithm 9.10 uses a different optimization criterion, based on rectangle area and rectangle overlap. Given a node N, the total overlap of the rectangle r with all the entries,

except for the kth is:

$$olp(r, N, k) = \sum_{i \neq k} |N.p[i].r \cap r| \qquad (9.54)$$

where, as usual, the operator $| \cdot |$ applied to rectangles computes their area. (The reason for the strange signature of the function olp should be clear after its usage in the following algorithm.)

The ChooseLeaf function for R^*-trees is as follows:

ALGORITHM 9.15. *The function min arg is assumed to return a set of elements that minimize its argument. If the minimum is unique, the set contains only one element.*

$N \leftarrow$ ChooseLeaf(E, T)
1. if $N = $ leaf(p)
2. return N
3. else if $T = $ node(u)
4. if $\forall i \in \{1, \dots, |u|\}$ $u[i].t = $ leaf(p)
5. $S \leftarrow \text{minarg}_{i=1,\dots,|u|}(\text{olp}(\text{envelope}(u[i].r, E.x), N, i)$
 $- \text{olp}(u[i].r, N, i))$
6. if $|S| > 1$
7. $k \leftarrow \text{minarg}_{i=1,\dots,|u|}|\text{envelope}(\{u[i].r, E.x\})| - |u[i].r|$
8. else
9. $k \leftarrow S[0]$
10. else
11. $k \leftarrow \text{minarg}_{i=1,\dots,|u|}|\text{envelope}(\{u[i].r, E.x\})| - |u[i].r|$
12. if $|S| > 1$
13. $k \leftarrow \text{minarg}_{i=1,\dots,|u|}|u[i].r|$
14. else
15. $k \leftarrow S[0]$
16. return ChooseLeaf$(u[k].t, E)$

Note that the algorithm uses two different strategies. If all the children of a node are leaves (step 4), then the algorithm chooses the child for which the addition of the new point results in the least increase of the overlap with the other nodes; ties are resolved choosing the node for which the increase in area is minimal; if the children of the node are not leaves, then the algorithm chooses the child for which the increase in area is minimal; ties are resolved using the child of minimal area. The choice of this double strategy was dictated by experimental findings in Beckmann *et al.* (1990).

The second difference between the R-tree and the R^*-tree is in the criterion used to split a node. The general problem is the same: Given a set of $M + 1$ nodes $Q = \{Q_1, \dots, Q_{M+1}\}$, create two nodes N_1 and N_2 that contain the $M+1$ entries and that minimize a given heuristic criterion. Given a division of Q into two groups R_1 and R_2, the heuristic criterion of the R^*-tree is a combination of the following three:

1. Minimize the total area of the bounding rectangles of the two groups:

$$C_a(R_1, R_2) = |\text{envelope}(R_1)| + |\text{envelope}(R_2)| \qquad (9.55)$$

2. Minimize the surface of the bounding boxes:

$$C_s(R_1, R_2) = |\partial \text{envelope}(R_1)| + |\partial \text{envelope}(R_2)| \qquad (9.56)$$

3. Minimize the overlap between the two groups:

$$C_o(R_1, R_2) = |\text{envelope}(R_1) \cap \text{envelope}(R_2)| \qquad (9.57)$$

The heuristic algorithm for the optimization proceeds in two steps: First, it chooses an *axis* along which the group will be split (this makes the R^*-trees quite similar to Robinson's K-D-B tree [Robinson, 1981]), and second it chooses a split value along this axis. Assume initially that the set of rectangles R is to be split and that an axis has been chosen. Say that it has been decided to split along direction h. First, the algorithm generates two sortings of the rectangles in Q, the first, Q^- is an array sorted by the lower value of the rectangles along the hth axis. Represent a rectangle Q_i as two arrays x_1 and x_2 containing the lower and upper value of Q_i along each dimension. Then Q^- is defined as

$$Q^- \leftarrow \text{sort } Q \text{ by } Q_i.x_1[h] \qquad (9.58)$$

Q^+ is built in a similar way, sorting on the *upper* value along the hth direction:

$$Q^+ \leftarrow \text{sort } Q \text{ by } Q_i.x_2[h] \qquad (9.59)$$

Consider now one of the two sortings, say, Q^-. The kth split of Q^- into two sets R_1 and R_2 is obtained by placing the first $(m-1)+k$ elements in R_1 and the remaining $M+1-k$ (Q contains $M+1$ elements) in R_2. This split is defined as:

$$\text{spt}(Q, k) = \{\{Q_i, i = 1 \ldots, k\}, \{Q_i, i = k+1, \ldots, |R|\}\} \qquad (9.60)$$

There are $M - 2(m-1)$ splits such that both R_1 and R_2 are legal R^*-tree nodes, that is, there are $M - 2(m-1)$ splits such that both sets contain at least m and at most M elements. The heuristics chooses among the $M - 2(m-1)$ splits of R^- and the $M - 2m + 2$ splits of R^+ the one that minimizes a combination of the three criteria C_a, C_s, C_o. This choice is repeated for all the axes, and the axes with the best split is selected.

In order to write down the algorithms more explicitly, I introduce first two functions that generate the kth lower split and the kth upper split, respectively:

ALGORITHM 9.16. *Generates the kth "lower"split, in which rectangles are sorted by the lower component along the hth axis. The value m is a design parameter.*

$\{L_1, L_2\} \leftarrow \text{splitL}(Q, k, h)$
1. $R^- \leftarrow \text{sort } Q \text{ by } Q_i.x_1[m]$
2. $L_1 = \{R_i^- : i = 1, \ldots, (m-1) + k\}$

3. $L_2 = \{R_i^- : i = m + k, \ldots, |R^-|\}$
4. return $\{L_1, L_2\}$

The function splitH is defined similarly, but in step 1 it sorts Q by $Q_i.x_2[m]$.

ALGORITHM 9.17. *Given the axis h along which the split is to be done, determines the k which gives rise to the minimal overlap value C_o. Resolves the ties using the minimal area value C_a.*

$\{S_1, S_2\} \leftarrow$ optSPlitIndex(Q, h)
1. $R^- \leftarrow$ sort Q by $Q_i.x_1[m]$
2. for $k = 1, \ldots, |Q| - 2(m - 1)$
3. $\{L_1[k], L_2[k]\} \leftarrow$ splitL(Q, k, h)
4. for $k = |Q| - 2(m - 1) + 1, \ldots, 2(|Q| - 2(m - 1))$
5. $\{L_1[k], L_2[k]\} \leftarrow$ splitH$(Q, k - (|Q| - 2(m - 1)), h)$
6. $S \leftarrow$ minarg$_{k=1,\ldots2(|Q|-2(m-1))} C_o(L_1[k], L_2[k])$
7. if $|S| > 1$
8. $k \leftarrow$ minarg$_{k=1,\ldots2(|Q|-2(m-1))} C_a(L_1[k], L_2[k])$
9. else
10. $k \leftarrow S[1]$
11. return $\{L_1[k], L_2[k]\}$

The following algorithm chooses the optimal axis to split:

ALGORITHM 9.18. *Chooses the optimal split axis by exhaustive search among all possibilities. The axis chosen is that for which the sum of the surface cost C_s for all the distributions is minimal. The dimension of the feature space is d.*

$\{S_1, S_2\} \leftarrow$ optSPlitAxis(Q)
1. for $h = 1, \ldots, d$
2. $R^- \leftarrow$ sort Q by $Q_i.x_1[m]$
3. for $k = 1, \ldots, |Q| - 2(m - 1)$
4. $\{L_1[k], L_2[k]\} \leftarrow$ splitL(Q, k, h)
5. for $k = |Q| - 2(m - 1) + 1, \ldots, 2(|Q| - 2(m - 1))$
6. $\{L_1[k], L_2[k]\} \leftarrow$ splitH$(Q, k - (|Q| - 2(m - 1)), h)$
7. $S[h] \leftarrow \sum_{k=1,\ldots2(|Q|-2(m-1))} C_s(L_1[k], L_2[k])$
8. $k \leftarrow$ minarg$_{h=1,\ldots d} S[h]$
9. return k

Finally, the following algorithm splits a node:

ALGORITHM 9.19.

$\{S_1, S_2\} \leftarrow$ split(Q)
1. $h \leftarrow$ optSPlitAxis(Q)
2. $\{S_1, S_2\} \leftarrow$ optSPlitIndex(Q, h)
3. return $\{S_1, S_2\}$

Table 9.1. Number of children of an R-tree node as a function of the dimensionality of the input space and the disk block size

Block Size	Dimensions						
	2	5	10	50	100	500	1000
512	25	11	6	1	0	0	0
1024	51	23	12	2	1	0	0
2048	102	46	24	5	2	0	0
4096	204	93	48	10	5	1	0
8192	409	186	97	20	10	2	1

In Beckmann *et al.* (1990), results with several distributions of two-dimensional rectangles are reported and show that the R-tree with the quadratic split insertion requires between 30 and 60% more page accesses per query with respect to the R^*-tree, depending on the distribution of the database. The largest performance difference is found in a database of 100,000 clustered rectangles (640 clusters), for which the R-tree requires two-thirds more page accesses than the R^* tree.

One of the most important factors determining the performance of any R-tree-like structure is the maximum number of children that a node can have, that is, M. In fact, the height of an R-tree will be

$$\log_M N \le h \le \log_{\lfloor M/2 \rfloor} N \tag{9.61}$$

where N is the number of elements in the database. The number M, in turn, is equal to the number of rectangle/pointer pairs that can fit in a node (called the *fan out* of the node). Assume that a pointer occupies 4 bytes, and that a coordinate value can also be specified by 4 bytes. Specifying a rectangle requires the specification of two points in the d-dimensional space, that is, of $2d$ coordinates, or $8d$ bytes. Each rectangle is attached to a pointer that needs 4 bytes. If B is the block size, the maximum number of children that a node can have is

$$M \le \left\lfloor \frac{B}{8d + 4} \right\rfloor \tag{9.62}$$

Table 9.1 shows the number of children that a node can have in an R-tree for several values of the block size and of the dimensionality of the feature space. When the number of children M equals unity, the tree degenerates in a linked list, and unless the database is small enough to be contained in a single node, the R-tree cannot be implemented (an R-tree with $M = 1$ will only have a single leaf). When $M = 0$, the R-tree cannot be built because it is not possible to fit even a single rectangle in a disk block. Table 9.2 shows the height of an R-tree for a database of 1,000,000 elements; the value ∞ indicates the degenerate cases.

The problem can be attenuated if the bounding regions at the nodes can be represented more compactly. In the R-tree such bounding regions are rectangles, which require $2d$ coordinates to be represented. A sphere, on the other hand,

Table 9.2. Height of an R-tree with 1,000,000 data points as a function of the dimensionality of the input space and the disk block size

Block Size	Dimensions						
	2	5	10	50	100	500	1000
512	5	6	8	∞	∞	∞	∞
1024	4	5	6	20	∞	∞	∞
2048	3	4	5	9	20	∞	∞
4096	3	4	4	6	9	∞	∞
8192	3	3	4	5	6	20	∞

requires only that its center (d coordinates) and its radius (1 real number) be specified, thus having the potential of increasing the value of M for an indexing tree. Based on this observation, White and Jain (1996b) proposed the SS-tree, that is, an indexing structure very similar to the R-tree but in which the bounding regions at every node are represented by spheres rather than rectangles. If the radius of the sphere requires 4 bytes, then a sphere requires only $4d + 4$ bytes to be described, and the limit for M is

$$M \le \left\lfloor \frac{B}{4d + 8} \right\rfloor \tag{9.63}$$

Table 9.3 shows the number of children that a node can have in an SS-tree, and Table 9.4 shows the tree height for a database of 1,000,000 elements. This advantage is canceled in part by the fact that, on average, spheres will have a much higher overlap than rectangles when covering the same set of points.

Along the same lines, performance has been further improved by the SR-tree [Katayama and Satoh, 1997], which uses the intersection of a minimum bounding sphere and a minimum bounding rectangle as the bounding region of a data element. The rationale behind this choice comes from the necessity to create a bounding region that, as the dimensionality of the space grows, has both a small volume (a property of the rectangle) and a small diameter (a property of the sphere).

Table 9.3. Number of children of an SS-tree node as a function of the dimensionality of the input space and the disk block size

Block Size	Dimensions						
	2	5	10	50	100	500	1000
512	32	18	10	2	1	0	0
1024	64	36	21	4	2	0	0
2048	128	73	42	9	5	1	0
4096	256	146	85	19	10	2	1
8192	512	292	170	39	20	4	2

Table 9.4. Height of an *SS*-tree with 1,000,000 data points as a function of the dimensionality of the input space and the disk block size

Block Size	Dimensions						
	2	5	10	50	100	500	1000
512	4	5	6	20	∞	∞	∞
1024	4	4	5	10	20	∞	∞
2048	3	4	4	7	9	∞	∞
4096	3	3	4	5	6	20	∞
8192	3	3	3	4	5	10	20

The efficiency of hierarchical data-partition techniques depends on two characteristics of the bounding regions of every node, that is, their *tightness* (a region is tight if reducing it will leave out some of the data points it contains), and the *overlap* between regions. The rectangles used in the *R*-tree are tight, but they present in general large overlaps. The *X*-tree [Berchtold *et al.*, 1996] uses rectangles as bounding regions, but uses an algorithm that minimizes their overlap during insertion. The performance of the *X*-tree is reported to be superior to the *R**-tree, but insertion is very costly.

9.4.2 The *TV*-Tree

All the examples of trees encountered so far used, at each level of the tree, bounding volumes of the same dimensionality as the feature space. The complexity of representing these volumes keeps the number of children of a node *M* small and decreases the performance of the tree. The idea behind the *TV-tree* of Lin *et al.* (1995) is to use a *variable* number of dimensions at each level of the tree. In all hierarchical structures, the nodes close to the root have a lower discriminatory power than the nodes closer to the leaves because near the root one is only concerned with dividing the space in large blocks containing many points, while near the leaves one must finely discriminate between relatively close points. In *R*-trees, this is reflected in the large size of the rectangles close to the root but, as it takes just as much space to represent a large rectangle than to represent a smaller one, the structure takes no advantage of this coarser resolution. In a *TV*-tree, nodes close to the root use only a few dimensions; as the nodes approach the leaves, they use more and more dimensions, thus becoming more discriminating. The feature vectors, therefore, contract and expand in a way that resembles a telescope; for this reasons, Lin *et al.* (1995) decided to call the structure a *Telescopic Vector* tree, or *TV*-tree.

Vectors can be reduced and enlarged by using a family of *telescopic functions*: Given a vector $x \in \mathbb{R}^n$, and a matrix $A_m \in \mathbb{R}^{m \times n}$, with $m \leq n$, the vector $y = A_m x$ is called an *m-contraction* of x. Families of telescopic functions are defined as follows:

DEFINITION 9.6. *A family of linear transformations A_1, \ldots, A_n, $A_m \in \mathbb{R}^{m \times n}$ is a telescopic family if, for all $1 < j \leq n$ and for all $x, y \in \mathbb{R}^n$,*

$$A_j x = A_j y \Rightarrow \forall k \leq j \ \ A_k x = A_k y \tag{9.64}$$

In informal terms, the definition means that reducing the dimensionality of the space we consider, one can only decrease the discriminating power: If two elements become indistinguishable when the dimensionality of the space is reduced from n to m, they will remain indistinguishable for all reductions to spaces of dimensionality less than m. An equivalent way of saying this is that, for every A_m, A_k, $k < m$, there is a martix $B_{k,m} \in \mathbb{R}^{k \times m}$ such that $A_k = B_{k,m} A_m$. A natural choice for telescopic functions is the truncation defined by $A_m = [I_m | 0]$. As usual, I will assume that the feature space \mathcal{F} that is being indexed is an n-dimensional vector space.

The *TV*-tree treats features asymmetrically, favoring the first, which are used in the root and in the nodes near the root, over the last ones, which are used only in nodes near the leaves. This asymmetry requires some kind of ordering of the features by importance, which can be obtained using one of the dimensionality reduction methods introduced in section 9.2, limited to the part of the methods that orders the components of the feature vectors by relevance. For instance, using the singular-value decomposition algorithm, the features are automatically ordered this way. In the following, I will assume that the feature components are ordered by importance, so that x_1 is the most discriminating component, x_2 the second most discriminating component, and so on.

The bounding regions in the *TV*-tree are derived from L_p balls, defined as

$$\mathcal{B}_p(x, r) = \left\{ y : \sum_i |y_i - x_i|^p \leq r^p \right\} \tag{9.65}$$

The nodes near the root do not contain the complete specification of a point in the feature space, but only the reduced description allowed by the few components that are stored there. In order to define minimal bounding regions for this case, the *TV*-tree uses telescopic L_p spheres:

DEFINITION 9.7. *A telescopic L_p sphere with center c, radius r, dimensionality d, and with α active dimension is the set of points y such that*

$$c_i = y_i \ \ i = 1, \ldots, d - \alpha \tag{9.66}$$

$$r^p \geq \sum_{i=d-\alpha+1}^{d} |c_i - y_i|^p$$

The dimensionality of the sphere determines how many "don't care" dimensions are present. If the feature space has dimensionality n, then there are $n - d$ dimensions (always the last $n - d$, according to the definition) along which the data point can have any value and still be in the sphere. The active dimensions are those along which the sphere radius is actually measured. For the first $d - \alpha$ dimensions, the definition requires that the feature vector and the center coincide.

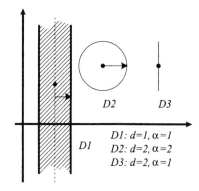

Figure 9.10. Examples of telescopic spheres in a two-dimensional feature space.

Figure. 9.10 shows some telescopic spheres in a two-dimensional vector space. The sphere $D1$ has dimensionality 1, and the second coordinate can assume any value because it is not used in the computation of the distance from the center. It also has $\alpha = 1$, so there are no coordinates ($d - \alpha = 0$) for which equality with the center is enforced. The sphere $D3$ has dimensionality 2, so that both coordinates are considered when computing the distance from the center, and $\alpha = 1$, so that the first coordinate equality with the center is enforced. Figure 9.11 shows some telescopic spheres in a three-dimensional vector space. The parameter α is usually a design parameter, and will be implicit in the rest of the discussion. The dimensionality of a sphere is given by the dimensionality of the telescopic vector that determines its center.

Formally, a telescopic vector is defined as

$$tv \triangleright n : \mathbb{N} \times x : \mathbb{R}^n \tag{9.67}$$

Because the dimensionality of the vector can vary, it is necessary to specify it explicitly as the component $tv.n$ of the data type. A telescopic sphere (α being

Figure 9.11. Examples of telescopic spheres in a three-dimensional feature space.

fixed in advance) is

$$ts \triangleright c : tv \times r : \mathbb{R}^+ \tag{9.68}$$

Finally, a *TV*-tree is defined in a way very similar to an *R*-tree, except that the bounding region is a telescopic sphere:

$$tvt \triangleright \begin{cases} \text{leaf}(p : (id : \mathbb{N} \times x : \mathbb{R}^n)^M \\ \text{node}(u : (r : ts \times t : tvt)^{M(u.r.c.n)} \end{cases} \tag{9.69}$$

Note that in the case of a node the number of entries depends on the dimensionality of the sphere (the number of elements in the specification of the center of each one of the telescopic spheres in u).

The search algorithm for the *TV*-tree is the same as that for the *R*-tree (Algorithm 9.8), with the exception that the intersection between the search sphere and the minimal bounding rectangles at each node are replaced by the intersection between the search region and the telescopic sphere at each node.

Insertion is also conceptually similar to that in an *R*-tree (Algorithm 9.9): First, the tree is descended looking for the "best" node to add the new element, then the tree is ascended again adjusting the bounding regions of the node and splitting the nodes that overflow. The "skeleton" of the algorithm is basically the same as in Algorithm 9.9 and, *mutatis mutandis*, the adjust procedure Algorithm 9.11 still applies.

The main differences between the *TV*-tree and the *R*-tree are that the adjustment in the bounding surfaces entail not only an adjustment in size, but may include changing their dimensionality, and the fact that a node can overflow not only because new elements were added, but also because the dimension of the telescopic vectors changed.

These differences impact the insertion and split criteria used in the *TV*-tree. The algorithm ChooseLeaf, for instance, is based on a recursion in which, at each step, one chooses the most promising branch in which the insertion of a new node will cause the least disruption. In the *R*-tree, at every step the branch was chosen for which the insertion of the new node caused the minimal increase in the area of the minimal bounding rectangle. The *TV*-tree uses the following criteria, in order of priority:

1. Minimize the number of overlapping regions; in Fig. 9.12a, the new point P is added to region $R1$, because adding it to either $R2$ or $R3$ will make $R2$ and $R3$ overlapping.

2. Minimize the decrease in the dimensionality of the telescopic spheres; in Fig 9.12b, the point P is attached to $R1$ because it can be done without changing the dimensionality of the sphere (simply by changing the radius), while attaching it to $R2$ requires reducing its dimensionality from 2 to 1.

3. Minimize the increase in the area of the region; in Fig. 9.12c, the point P will be added to region $R1$ because the total area of the resulting regions will be smaller than it would be had the point been added to $R2$.

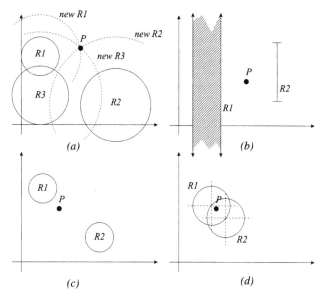

Figure 9.12. Criteria of choice to select the node where a new point will be inserted. In (a), $R1$ is selected because extending $R2$ or $R3$ will lead to a new pair of overlapping regions; in (b) $R1$ is selected because selecting $R2$ will increase its dimensionality; in (c), $R1$ is selected because selecting $R2$ would result in a region of larger area; in (d) $R1$ is selected because its center is closer to the point P.

4. Minimize the distance of the point from the center of the region; in Fig. 9.12d, this will cause $R1$ to be chosen over $R2$.

The function adjust is also basically the same as in the R-tree, with the exception that in the TV-tree, updating a minimal bounding region can entail reducing its dimensionality. The following function takes a telescopic sphere and adds a point to it:

ALGORITHM 9.20. *The notation $x[1,\dots,n]$ indicates an n-dimensional vector built using the first n components of x, and the notation last$\{i : P(i)\}$ returns the higher value i such that the property $P(i)$ holds and, for all $k < i$, the property $P(k)$ holds. As usual, α is a system-wide constant.*

$q \leftarrow$ enlarge$(s : ts, p : \mathbb{R}^m)$
1. if $(\forall i = 1, \dots, s.c.n - \alpha)$ $s.c.x[i] = p[i]$
2. $s.r \leftarrow \max\{s.r, \|s.c - p[1, \dots, s.c.n]\|\}$
3. return s;
4. else
5. $j \leftarrow$ last$\{i : s.c.x[i] = p[i]\}$
6. $s.c.n \leftarrow j$
7. $s.c.x \leftarrow [s.c.x[1], \dots, s.c.x[j]]$
8. $s.r \leftarrow \max_{x \in s}\{\|s.c - x[1, \dots, j]\|\}$
9. return s

The criterion for splitting a node also depends on the structure of the tele-scopic spheres. Lin *et al.* (1995) propose two splitting criteria, namely, *splitting by clustering* and *splitting by ordering*. Splitting by clustering bears some similarity to the split technique used in *R*-trees. Two seeds are picked by selecting the entries with the smallest common prefix in their center. These two seeds will be used to "grow" the two groups. Then, all the other nodes are inserted in either one of the two groups using the same criterion as in the ChooseNode function (that is, the criterion of Fig. 9.12).

In splitting by ordering, the entries that have to be distributed are ordered using some suitable criterion (lexicographically, or using space-filling curves through the centers, and so on). Then the best partition along the ordering is determined using the following criteria (in descending priority):

1. Minimum sum of the radii of the two bounding spheres; and

2. minimum difference between the sums of the radii minus the distance between the centers.

9.4.3 Indexing in Metric Spaces

The techniques introduced so far assume that the entries in the database are representable as points in a vector space, that is, the ith data point can be represented as $P_i = [x_{i,1}, \ldots, x_{i,n}]$, where n is the dimensionality of the feature space. However, this is not always the case. As Chapter 5 showed, in some cases images can be represented as graphs of objects and their spatial relations. While it is possible in this case to define a *distance* between two graphs, their representation as vectors is not immediate. In other words, certain representations of images form a metric space, but not a vector space.

Indexing methods for this class of features can be divided in two broad classes, specifically, methods that derive a vector representation from the metric characteristics of the space (and then use an indexing method for vector spaces), and methods that create special indexing structures that do not depend on the vector representation of the data. The first class includes methods already presented in section 9.2, for example, multidimensional scaling and the FastMap algorithm. The second class includes, for the most part, the so-called *vantage-point trees*. Similarly to the other tree-based techniques, vantage-point trees divide up the space but, lacking a suitable vector structure, this division is not absolute. Rather, each internal node contains a database point and a distance limit ρ. The subtrees centered at that node all contain elements at a distance at most ρ from the vantage point.

M-Trees: dividing up metric spaces. The second class of indexing techniques for metric spaces uses the properties of the metric space directly, without trying to represent the data into a vector space. I will consider in this section a representative of this class: the *M*-Tree, discovered by Ciaccia *et al.* (1997). The basic idea is

still to divide up the space so that each node of the tree includes a portion of the space, and the children of that node partition the space covered by their parent. In this case, however, lacking the reference system of the vector space, it is not possible to describe the covered region in absolute terms. Rather, each node contains a database object, and the region that the node covers is expressed as a sphere centered in that point. Containment in such a sphere can be expressed simply in terms of the distance from the point at its center, and therefore can be expressed in a metric space without needing a vector-space structure. The point relative to which the space is partitioned is sometimes called a *vantage-point*. The idea was first used in the *vantage-point tree* [Chiueh, 1994] and in the *MVP*-tree (*multiple vantage-points tree*) [Bozkaya and Ozsoyoglu, 1997]. Other methods, such as the GNAT design [Brin, 1995] use two reference points at each node, dividing the space indexed by the node into two depending upon which of the two references a point is closer to.

The *M*-tree is based on the same general principles, containing a vantage point for each node, and partitioning the space according to distance from the vantage points; furthermore, the *M*-tree tries to use the triangle inequality in order to reduce the number of distance computations necessary, a useful property if the computation of the distance is expensive.

The leaves of an *M*-tree store all database objects, as determined by a unique identifier and by their feature vector. Internal nodes store a fixed number of *routing objects*. Each routing object has an associated pointer to the root of a subtree called its *covering tree*, and a value r called its *covering radius*. All points in the covering tree of a routing object are at a distance at most r from it. Finally, each routing object has associated a distance δ from its parent node (this distance is not defined for entries in the root of the *M*-tree). The structure of an *M*-tree is therefore the following:

$$mt \triangleright \begin{cases} \text{leaf}(p : (id : \mathbb{N} \times O : \mu \times p : \mathbb{R}^+)^M \\ \text{node}(u : (O : \mu, t : mt \times r : \mathbb{R}^+ \times \delta : \mathbb{R}^+)^M \end{cases} \tag{9.70}$$

where μ is the unspecified type of the features in the database (which, it is worth remembering, is not in this case a vector in \mathbb{R}^n as in the tree examined so far).

The application of the triangle inequality for pruning parts of the tree during the search without actually computing distance is based on the following two lemmas [Ciaccia *et al.*, 1997]:

LEMMA 9.5. *Let Q be a query object, $r(Q)$ the radius of a range query, and $u[i]$ an entry in a node. If $d(u[i].O, q) > u[i].r + r(Q)$, then, for every entry $O_j \in u[i].t$, it is $d(O_j, Q) > r(Q)$.*

PROOF. By triangle inequality, $d(O_j, Q) \geq d(u[i].O, Q) - d(O_j, u[i].O)$; also, by definition of covering radius, $d(O_j, u[i], O) \leq u[i].r$. Therefore, it is $d(O_j, Q) \geq d(u[i].O, Q) - u[i].r$. By the hypothesis, it is $d(u[i].O, Q) - u[i].r > r(Q)$, from which the result follows. □

If, in the analysis of a node, the conditions of the lemma are met, it is possible to prune the whole tree $u[i].t$ because none of the elements contained there will be in the search radius. In order to apply this lemma, it is necessary to compute the distance $d(u[i].O, Q)$. This can be avoided in certain cases by taking advantage of the following result, which is a direct consequence of the triangle inequality

LEMMA 9.6. *Let $N.u[i]$ be a node, and $M.u[j]$ be the parent entry of N that is, the entry such that $M.u[j].t = N$. If $|d(M.u[j].O, Q) - d(N.u[i].O, M.u[j].O)| > r(Q) + N.u[i].r$, then $d(N.u[i].O, Q) > r(Q) + N.u[i].r$.*

The quantity $d(N.u[i].O, M.u[j].O)$ is stored in the entry $N.u[i]$ as the value $N.u[i].\delta$: $N.u[i].\delta = d(N.u[i].O, M.u[j].O)$, and the distance $d(M.u[j].O, Q)$ has already been computed as part of the analysis of $M.u[j]$ before analyzing node N. Therefore, if the conditions of this lemma are verified, it is possible to discard the whole tree $N.u[i].t$ without a single distance computation. In the following search algorithm, the distance between the parent of a node and the query is passed down from iteration to iteration. The first call to the algorithm has the value initialized to 0.

ALGORITHM 9.21. *The parameter N is the node of the tree that is being examined. The algorithm is first called with the root of the tree. The parameter d is the distance between the parent of the node N and the query. It is set to 0 in the initial call.*

$R \leftarrow$ search$(N : mt, Q : \mu, r : \mathbb{R}, \delta)$
1. if $N = leaf(p)$
2. for $i = 1, \ldots, |p|$
3. if $|\delta - p[i].\delta| \le r$
4. $q \leftarrow d(p[i].O, Q)$
5. if $q < r$
6. $R \leftarrow R \cup \{p[i].O\}$
7. return R
8. else if $N = node(u)$
9. for $i = 1, \ldots, |u|$
10 if $|\delta - u[i].\delta| \le r + u[i].r$
11. $q \leftarrow d(u[i].O, Q)$
12. if $q \le r + u[i].r$
13. $R \leftarrow R \cup$ search$(u[i].t, Q, R, q)$
14. return R

Steps 4 and 11 are the only steps that require the computation of the distance function. Step 10 checks the "pre-condition" of Lemma 9.6, while step 12 checks the condition of Lemma 9.5. If the first condition is false, there is no need to compute the distance between the node and the query. If both conditions are true, the child $u[i].t$ is traversed.

Insertion in the M-tree is rather similar to insertion in an R-tree. As in the case of R-trees, the insertion algorithm is composed of two steps. First, a top-down traversal of the tree determines the "best" (according to a pre-specified heuristic criterion) node in which the new data element can be inserted. Then, a bottom-up algorithm recursively updates the description of the area covered by each node and, if nodes are full, a second heuristic criterion is invoked in order to split them in two.

The first heuristic, that is, determining in which node should the new element be stored, is based on the following criteria:

1. If there is a node N for which the insertion of the new object O does not require increasing the covering radius, choose this one;

2. if there are multiple nodes that satisfy the previous criterion, choose the node for which the new object is closest to the center of the covering sphere; and

3. if there is no node for which the first criterion is satisfied, choose that for which the *increase* in the covering radius due to the insertion is minimized.

Splitting a node is also a two-step process. Let N be the node that needs splitting, P the parent node of N, and k the index such that $P.u[k].t = N$. Partitioning N entails the following:

1. Create a new node N'. Select two objects O, O' in N and *promote* them, that is, create two entries $u[k]$ and $u[k']$ in P that contain O and O' as their centers and that point to N and N'. (Note that the first entry will replace the existing entry $u[k]$, while the second is a new entry in the parent P. If P is full, this will require a recursive call to the splitting algorithm in order to wplit P.)

2. Partition the entry of N and the new entry that is to be inserted (for a total of $M+1$ entries) among N and N' so as to miniize some pre-specified criterion.

The original M-tree definition [Ciaccia *et al.*, 1997] offered a number of *split policies* (a split policy is determined by the conjunction of a promotion policy and a partition policy). Given a group of objects $\{O_1, \dots, O_{M+1}\}$ (the M objects in the node N that needs to be split, plus the new object that is being inserted), and the parent P of the node N, the "Promote" method chooses two objects O_{p_1}, O_{p_2} that will be placed as routing objects in P, and that will be used to address the two newly created nodes N and N'. Let k_1 and k_2 be the indices in P of the entries relative to the newly created nodes, that is, $P.u[k_1].t = N$ and $P.u[k_2].t = N'$. The choice of O_{p_1} and O_{p_2} implies that $P.u[k_1].O = O_{p_1}$ and $P.u[k_2].O = O_{p_2}$.

In any case, the semantics of the covering radius r and of the distance from the parent routing object δ has to be preserved. This means that, at the end of the splitting operations, the quantities $P.u[k_1].r$, $P.u[k_2].r$, $P.u[k_1].\delta$, $P.u[k_2].\delta$ will be recomputed.

The ideal split policy would promote two objects O_{p_1} and O_{p_2} and would divide the remaining points between N and N' in a way that minimizes the volume of the spheres needed to cover N and N_1 (that is, in a way that minimizes the values $P.u[k_1].r$ and $P.u[k_2].r$ as computed after the split) and the overlap between the two spheres. These criteria operate in the sense of reducing the *dead space* in the index.

Promotion policy. In Ciaccia *et al.* (1997), the following promotion policies are proposed:

Minimal sum of radii. This is the most computationally expensive of the proposed algorithms. Considers all pairs of objects O_i and O_j in the set of $M + 1$ objects. For each pair of objects, applies the split algorithm and computes he covering radii; then chooses the pair of objects for which the sum of the two covering radii is minimal.

Minimal maximum radius. Similar to the previous one, but minimizes the maximum of the two radii.

Maximum lower bound. This variant of the algorithm uses only the distances already stored in the structure. The first routing object remains the original parent of the node N (i.e., $P.u[k_1].O$ is unchanged), and the second routing object is choosen as the point O_j the farthest away from the first routing object, that is, the object such that

$$d(O_{p_2}, P.u[k_1].O) = \max_j d(O_j, P.u[k_1].O) \qquad (9.71)$$

For all the O_j such distance has already been computed and placed in the field δ of the entry corresponding to the object.

Random. Select the two objects randomly among the objects that need to be split.

Sampling. Take a sample of size s randomly among the $M + 1$ points, and apply the Minimal sum of radii or the Minimal maximum radius strategy to the sample.

Experimentally, the results confirm what one might with commonsense expect. Most expensive policies give the best results in terms of I/O cost of subsequent search operations.

Distribution policies. Two distribution policies are proposed in Ciaccia *et al.* (1997):

Generalized hyperplane. Assign each object O_j to the nearest routing object.

Balanced. Let $\mathcal{O} = \{O_1, \ldots, O_{M+1}\}$. The following algorithm builds two sets of objects N_1 and N_2 assigned to the two routing objects O_{p_1} and O_{p_2}

ALGORITHM 9.22.

$\{N_1, N_2\} \leftarrow \text{BalanceSplit}(O_{p_1}, O_{p_2}, \mathcal{O})$
1. while $\mathcal{O} \neq \varnothing$
2. $\qquad A \leftarrow \text{minarg}_{O_j \in \mathcal{O}} d(O_j, O_{p_1})$
3. $\qquad N_1 \leftarrow N_1 \cup A$
4. $\qquad \mathcal{O} \leftarrow \mathcal{O} - A$
5. \qquad if $\mathcal{O} \neq \varnothing$
6. $\qquad\qquad A \leftarrow \text{minarg}_{O_j \in \mathcal{O}} d(O_j, O_{p_2})$
7. $\qquad\qquad N_2 \leftarrow N_2 \cup A$
8. $\qquad\qquad \mathcal{O} \leftarrow \mathcal{O} - A$

Unlike the previous partitioning policy, this algorithm tries to create two new nodes of the same size.

Experimental results reported in Ciaccia *et al.* (1997) seem to indicate that the generalized hyperplane technique provides a better performance. It is intuitively clear that the balanced policy pays a price in terms of higher volume of the covering spheres in order to achieve balance. Experiments indicate that this price outweighs the benefit of having a balanced tree. This is especially true for indexing space of relatively small dimensionality. Given a fixed block size (typically 4KB), the number of entries in a block (M) varies with the dimensionality. For lower dimensionalities, M is rather large and it is statistically more probable that a generalized hyperplane assignment will generate a reasonably balanced split.

9.5 Hashing

In traditional (one-dimensional) indexing, hashing is a technique based on the idea of *computing* the number of the disk block in which a particular piece of data falls. If this can be accomplished, then the relevant disk block can be directly accessed and read, thereby obtaining an indexing structure with $O(1)$ disk accesses. Let Ω be a universe of records and, for the moment, assume that $\Omega = \mathbb{R}$. Also, let a *hashing table* composed of N disk blocks, numbered from 0 to $N - 1$, and containing B records each, be stored on disk. A function $h : \mathbb{R} \rightarrow [0, N-1]$, called *hashing function* is defined. In the ideal case, every record x will be stored in the disk-block number $h(x)$. Then the table would contain $N \cdot B$ records, and the function h would compute, for each record, the disk block where it is stored.

The major problems in using a hashing table come from the so-called *collisions*. Suppose that a set of records $X = \{x_1, \dots, x_M\}$, with $M \leq N \cdot B$ is given. The function h is also given in the form of a suitable algorithm *independent of the data set X*. The number of elements that will be stored in the jth bucket is $N_j = \{x \in X : h(x) = j\}$. There is no guarantee that this number will be less than or will equal the size of the bucket. In other words, when the elements of X are distributed in the buckets using the function h, it can easily happen that some buckets will be half empty, while others will be overfilled. In this case one speaks

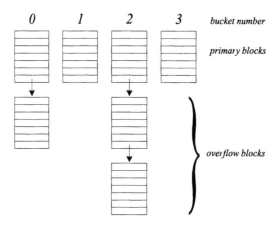

Figure 9.13. A hashing table with four buckets and three overflow blocks.

of a collision among the elements of X, as more than B elements try to share the B slots in the same bucket[4].

When more than B elements are stored in a bucket, storage is granted by using *overflow* blocks and linking them to the *primary* block. This situation is depicted in Fig. 9.13. Collisions and the need for overflow pages degrade the performance of the hashing scheme: In the worst scenario, all the entries x_i are mapped to the same bucket, requiring $\lceil M/B \rceil$ pages and, on average, $\lceil M/B \rceil$ accesses for a successful search. The performance of the hashing scheme, in this case, degrades to that of a linear search. This situation is very rare. Long overflow chains tend to appear only when the table is very full, that is, when $M \approx N \cdot B$. It is common practice to keep the occupancy of a hash table around 75-80%. In this situation, experimental studies show that, with a good choice of the hashing function, overflow chains are no longer than two or three pages. Loosely speaking, a "good" hashing function should be very irregular, and should resemble a random function as much as possible. If the entities x are real values, functions of the type $h(x) = \lfloor A \cdot x \rfloor$ (mod N), where A and N are co-prime integers, are often used.

Simple hashing is not very good for dynamic structures. In a dynamic situation, in which new data are added to the structure, as the number of elements approaches $N \cdot B$, the length of the overflow chains will grow, degrading the performance of the indexing scheme. In these cases it is necessary to add new primary pages, that is, to increase the number of buckets. The number of buckets N is usually used in the definition of the hashing function h, as can be seen in the previous

[4] The need for the independence of h on X derives from the fact that, in order to achieve $O(1)$ search time, the function h must be computable in $O(1)$ time. It is easy to devise functions that map the elements of X into the buckets without collision if h is allowed to depend on X; for instance, consider h such that

$$h(x) = j \text{ if } x_{jB} \leq x < x_{(j+1)B}$$

Computing this function, however, requires a time $O(m)$, thereby reducing the performance of hashing to that of linear access.

example. If this number is changed, the function h will also be changed (e.g., from $h(x) = \lfloor A \cdot x \rfloor \bmod N$ to $h(x) = \lfloor A \cdot x \rfloor \bmod (N + 1)$) and, consequently, the bucket number of all previously inserted data elements x_i will be changed. In this case, it is necessary to "rehash" the whole database, that is, to reassign to every element x_i a new bucket number, often a prohibitively expensive operation.

The *linear hashing* algorithm [Litwin, 1980] constitutes a solution in which, every time a new bucket is added, only the contents of one of the original buckets need to be rehashed. The algorithm is based on the definition of a family of hashing functions $h_i, i \geq 0$ such that:

1. For all x, $0 \leq h_i(x) \leq 2^i - 1$ *(range condition)*; and

2. for all x and for all i, it is either $h_{i+1}(x) = h_i(x)$ or $h_{i+1}(x) = h_i(x) + 2^i$ *(split condition)*.

If the record space is constituted of integer numbers (i.e., $\Omega = \mathbb{N}$), an example of such family is given by the following lemma:

LEMMA 9.7. *The family of functions $h_i : \mathbb{N} \to \mathbb{N}$ defined as $h_i(x) = x \bmod 2^i$ satisfies the range and the split conditions.*

PROOF. The range condition is obvious. In order to verify the split condition, take an arbitrary element x and write it as

$$x = q_1 2^i + r_1 = q_2 2^{i+1} + r_2 \tag{9.72}$$

with $0 \leq r_1 < 2^i$ and $0 \leq r_2 < 2^{i+1}$, which implies

$$2^{i+1} > r_2 - r_1 > -2^i \tag{9.73}$$

Note also that

$$(q_1 - 2q_2)2^i = r_2 - r_1 \tag{9.74}$$

so that $2 > q_1 - 2q_2 > -1$. This means that $q_1 - 2q_2$ is either zero or unity. In the first case, Eq. (9.74) implies $r_2 = r_1$, while in the second, Eq. (9.74) implies $r_2 = r_1 + 2^i$. Noting that $h_i(x) = r_1$ and $h_{i+1}(x) = r_2$ proves the lemma. \square

Given this family of functions, start with h_0 as hashing function. Because $h_0(x) = 0$ for all x, there will be only one bucket, that is, bucket number 0. As data are inserted, they will go in this bucket. When the bucket is full, add a new one (bucket number 1), use the function h_1 instead of h_0, and rehash all the elements in bucket 0. This time it is $0 \leq h_1(x) \leq 1$, so that the elements will be divided between bucket 0 and bucket 1. As new elements are inserted and the table gets full, it is necessary to split again. This time the algorithm creates a new bucket (bucket 2), and *splits* bucket 0, using the function h_2 to rehash its contents. For all the elements x in bucket 0, it was $h_1(x) = 0$. By the split condition, for all these elements it will be either $h_2(x) = 0$ or $h_2(x) = 2$; therefore, all the elements originally in bucket 0 will either remain there or be moved to the new bucket. The

rest of the table (which, in this case, is composed only of bucket 1) will not be touched. At this point, the situation is the following: Bucket 0 has been split, and the function h_2 has been used to decide which elements should stay there and which should go into bucket 2; bucket 1 is untouched, and contains the elements that had been directed there using function h_1.

The question at this point is: Given an element y to be searched, which function should be used to determine in which bucket one should look for y? In order to determine this, introduce a variable called *next*, which contains the number of the next bucket that will be split. In this case, *next* = 1. Consider the value y, and compute $h_1(y)$. If $h_1(y) = 1$, then y is in bucket 1, which has not been split after the elements have been assigned there using h_1. This is the simplest case: The algorithm will simply retrieve the bucket from the disk (complete with possible overflow blocks) where it will search y. Suppose now that $h_1(y) = 0$; because $h_1(y) < $ *next*, then the value corresponds to a bucket that has already been split, and one cannot be sure whether y is really in bucket 0 or has been placed in bucket 2. The decision is made by computing $h_2(y)$, which will give as a result either 0 or 2, indicating the bucket which really contains y.

More formally, the algorithm defines two variables, namely, *next*, and a *level* variable l. The value l indicates the number of times the whole set of buckets has been split. It also indicates that the number of bucket is $2^l \leq N < 2^{l+1}$. The variable l is initialized at 0; after the bucket is split, the level variable is set to 1, and the system contains two buckets. When both these buckets have been split, the variable l is set to 2 (and there are now four buckets), and so on. Note that, for a given value of l, the hashing function that is being used is h_l for the buckets that have not been split, and $h_{l+1}(x)$ for those that have already been split.

The access function returns the bucket number in which an element is held:

ALGORITHM 9.23. *The variables next and l are system-wide variables, initialized to 0.*

 $b \leftarrow$ access(x)
 1. $b \leftarrow h_l(x)$
 2. if $b < $ *next*
 3. $b \leftarrow h_{l+1}(x)$

The split algorithm splits the next bucket:

ALGORITHM 9.24. *The variables next and l are system-wide variables, initialized to 0; B_i is bucket number i, including the primary page and all the overflow pages. All the buckets are system-wide global variables.*

 split$()$
 1. $N \leftarrow N + 1$
 2. Create bucket B_{N+1}
 3. $T \leftarrow B_{next}$
 4. $B_{next} \leftarrow \varnothing$

5. for all $x \in T$
6. $b \leftarrow h_{l+1}(x)$
7. $B_b \leftarrow B_b \cup x$
8. $next = next + 1$
9. if $next = 2^l$
10. $l \leftarrow l + 1$
11. $next \leftarrow 0$

The derivation of an insertion algorithm from this split algorithm requires the definition of a criterion determining whether the next bucket should be split. Given this criterion, in fact, the insertion algorithm is as follows:

ALGORITHM 9.25. *The variables next and l are system-wide variables, initialized to 0; B_i is bucket number i, including the primary page and all the overflow pages. All the buckets are system-wide global variables.*

insert(x)
1. $b \leftarrow$ access(x)
2. $B_b \leftarrow B_b \cup x$
3. while criterion() = true
4. split()

This simple algorithm needs a few comments:

1. Step 2 can entail the creation or addition of overflow chains.

2. Splitting is done cyclically on the existing pages, independently of whether or not splitting the next page will help change the criterion. For instance, it might be that the next page to split is empty; in this case splitting the page may not change the criterion. This is why step 3 continues to split until the splitting criterion is false, as changing the criterion might require any number of splits. This could in theory require a complete rehash of the whole database, although in practice this is not likely to occur.

Criteria to split typically include keeping the average chain length or the storage utilization (M/NB) below a certain threshold.

Linear hashing solves the problem of dynamically growing tables, but still does not allow range query. Considering still the one-dimensional case, a range query is expressed as two numbers x_l, x_u, such that all the entries x with $x_l \le x \le x_u$ are answers to the query. The hashing scheme should return a set of bucket numbers $K = \{k_1, \ldots, k_u\}$ such that the following is true:

$$\forall x \in X : x_l \le x \le x_u \ \exists k \in K : x \in B_k \qquad (9.75)$$

that is, the hashing returns all the buckets, which might contain the points of interest. The answer can be trivially obtained by returning all the bucket numbers, that is, by returning $K = \{1, \ldots, N\}$, but this is of little help. Thus, one, in general,

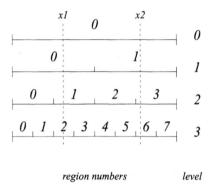

Figure 9.14. Region access for a range query.

requires that the answer be *tight* that is, removing any k_i from K, some of the points of interest will be left out. Note that the answer is tight only in terms of buckets: Some of the buckets can (and, in general, will) contain points out of the range of interest, as the queries are not, in general, aligned with bucket numbers. This is not considered a serious drawback because the determination of which points in each bucket belongs to the required range is done in main memory, and does not require additional I/O operations.

Grid files use hashing functions that permit an efficient treatment of range queries. In this section, I will present a particular technique for range query hashing: namely, Burkhard's *Interpolation-Based Index Maintenance* (IBIM) [Burkhard, 1983]. Consider still the one-dimensional case, and assume that the data space is limited, say, between a lower value *l* and an upper value *u*. Consider first a simple hashing function designed only to make range query simple, without any consideration for dynamic insertion of new elements. At level *i*, the key space is partitioned into 2^i *regions* of equal length[5], as in Fig. 9.14. In this case, it is very simple to determine which regions should be accessed for a range query, say, the range query with extrema x_1, x_2. In the case of Fig. 9.14, for instance, if the level is 2, region 1, 2, 3 will have to be accessed, while if the level is 3, regions 2, 3, 4, 5, 6 will have to be accessed. In general, if, at a given level, x_1 is in region b_1 and x_2 is in region b_2, all regions between b_1 and b_2 (incuding the extrema) will have to be accessed. The determination of the region numbers necessary to answer a range query is therefore reduced to two calls to the access function. The family of hashing functions between entries and region number Π_i is characterized by the following properties (which can easily be inferred from the figure):

1. for all x, $0 \leq \Pi_i(x) \leq 2^i - 1$;

2. for all x and i, either $\Pi_{i+1}(x) = 2\Pi_i(x)$, or $\Pi_{i+1}(x) = 2\Pi_i(x) + 1$.

[5] These regions are, in substance, the same thing as the buckets in the previous example. The reason why I use the word region now is that later on I will have to introduce another entity called buckets, and derive a mapping between region numbers and bucket numbers; using the word region now will avoid problems later on.

If the entries are real numbers between l and u, a family of such functions is given by

$$\Pi_i(x) = \begin{cases} \lfloor 2^i \frac{x-l}{u-l} \rfloor & \text{if } x \neq u \\ 2^i - 1 & \text{if } x = u \end{cases} \tag{9.76}$$

Answering a range query with these regions is very simple: Assume that the hashing scheme is at level i. The following algorithm returns a tight set of regions in which the answers to the query can be found:

ALGORITHM 9.26. *Return a set S of region numbers in which the answers to the query can be found.*

$S \leftarrow \text{range_search}(x_l, x_u)$
$k_l \leftarrow \Pi_i(x_l)$
$k_u \leftarrow \Pi_i(x_u)$
$S \leftarrow \{k_l, \ldots, k_u\}$

These hashing functions provide an immediate answer to the problem of answering range queries, but have none of the desirable properties of linear hashing. In particular, they do not allow the table to grow gradually: The only way to grow a table is to increase the level of the function by one, which entails doubling the number of buckets in the table and rehashing the whole table.

In order to have a dynamically adjustable table, it is necessary to store the regions identified by the region number into *buckets*, identified by a bucket number given by the linear hashing scheme. (In the remainder of this section, when talking about buckets, I will always consider that their number is assigned by the linear hashing algorithm.) In other words, it is necessary to devise a mapping between region numbers and bucket numbers. In order to do this, it is necessary to consider how the intervals in which the data space is divided are mapped into bucket numbers by the linear hashing algorithm. Consider first the case in which levels have been completely expanded. First (Fig. 9.15 first line), there is only one bucket, that is, bucket 0. When the bucket is split, the lower part of the interval stays in bucket 0, and the upper part goes to bucket 1 (Fig. 9.15 second line). When passing

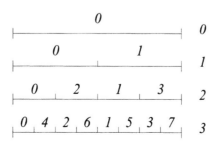

bucket numbers level

Figure 9.15. Mapping of intervals to bucket numbers by linear hashing.

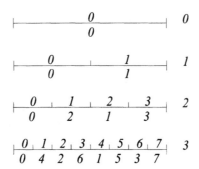

Figure 9.16. Correspondence between region numbers and bucket numbers.

to level 2, the first quarter of the interval is split between bucket 0 and bucket 2, and the second between bucket 1 and bucket 3, and so on. Figure 9.16 shows the correspondence between region numbers and bucket numbers. In order to be able to answer range queries, it is necessary to find a function ζ that maps the region number ω of a particular interval into its bucket number ψ. This function will also depend on the current level i, so that one should write: $\psi = \zeta(\omega, i)$. In order to determine the characteristics of the function ζ, consider a region with region number ω and bucket number ψ, which is being split into two regions— one with region number ω_1 and bucket number ψ_1 and one with region number ω_2 and bucket number ψ_2 (Fig. 9.17). The rules for assigning region numbers at the different levels state that $\omega_1 = 2\omega$ and $\omega_2 = 2\omega + 1$, while the rules for the assignment of bucket numbers state that $\psi_1 = \psi$ and $\psi_2 = \psi + 2^i$. The function ζ must therefore satisfy the following conditions:

$$\zeta(2\omega, i + 1) = \zeta(\omega, i)$$
$$\zeta(2\omega + 1, i + 1) = \zeta(\omega, i) + 2^i \qquad (9.77)$$

If the region and bucket numbers are integers expressed using the binary system, then a simple function property is the *i-bits bit reversal function* $b(i, x)$, which takes the "mirror image" of the bit representation of a number considered as an i bits representation (the number will be padded with zeros on the left if it is represented using fewer i bits). For instance:

$$b(3, 011) = 110 \qquad (9.78)$$
$$b(4, 0011) = 1100 \qquad (9.79)$$

Figure 9.17. Splitting a region with region number ω and bucket number ψ.

The statement derives from the following property of the bit reversal function [Burkhard, 1983]:

$$b(i + 1, n) = \begin{cases} b(i, n/2) & \text{if } n \text{ is even} \\ b(i, \lfloor n/2 \rfloor) + 2^i & \text{if } n \text{ is odd} \end{cases} \qquad (9.80)$$

To sum things up—and still in the situation in which the system is at a level i, which is completely split—given a datum x, one first computes the *region* in which the datum lies as $\omega = \Pi_i(x)$; then one computes the *bucket* in which the datum lies as $\psi = b(i, \omega)$. This corresponds to using a linear hashing scheme with hashing function

$$h_i(x) = b(i, \Pi_i(x)) \qquad (9.81)$$

The previous considerations show that this is indeed a hashing function that satisfies the requirement for linear hashing and, consequently, it is possible to apply the linear hashing algorithm as is to this function.

The advantage of using this function h_i (instead of, say, the family defined by Lemma 9.7) is that it gives one the possibility of dealing with range queries. The region numbers are consecutive, therefore, once the region numbers of the extrema of the range query have been determined, it is easy to analyze all the regions included in the range (and, by applying the bit-reversal function, all the buckets). The outline of an algorithm for answering range queries is as follows:

1. Given the extrema of the range query x_1, x_2, and the current level l, compute the region numbers $\omega_1 = \Pi_l(x_1)$ and $\omega_2 = \Pi_l(x_2)$.

2. For all ω such that $\omega_1 \leq \omega \leq \omega_2$ compute $\psi = b(i, \omega)$, and visit the bucket ψ.

In addition to this, one must consider that many times the algorithm is "between levels," that is, some buckets have been split l times, and some $l + 1$ times. The region numbers change only when the level number changes but between levels the buckets are progressively split. A complete algorithm for range queries is therefore as follows.

ALGORITHM 9.27. *The variables next and l are system-wide variables, initialized to 0; B_i is bucket number i, including the primary page and all the overflow pages. All the buckets are system-wide global variables.*

$\Omega \leftarrow \text{range}(x_1, x_2)$
1. $\omega_1 \leftarrow \Pi_l(x_1)$
2. $\omega_2 \leftarrow \Pi_l(x_2)$
3. $\Omega = \emptyset$
4. for all $\omega : \omega_1 \leq \omega \leq \omega_2$
5. $\psi \leftarrow b(i, \omega)$
6. if $\psi < next$
7. $\Omega \leftarrow \Omega \cup \{\psi, \psi + 2^l\}$

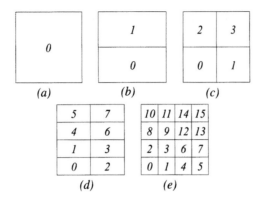

Figure 9.18. Assignment of region numbers in a two-dimensional search space.

8. else
9. $\Omega \leftarrow \Omega \cup \{\psi\}$

The final step is to extend the scheme to multidimensional data spaces. The idea in this case is to split regions and buckets along one dimension at a time. Start as a regular IBIM, splitting along the first dimension and continue with the same algorithm with the difference that, every time the level number is incremented, the index of the dimension along which one splits is also incremented. Consider the two-dimensional example of Fig. 9.18, in which region numbers are represented. At first, as usual, the whole space belongs to region 0. As new data are inserted, the region is split along the first direction (the vertical, in this case), creating regions 0 and 1. Now the level is incremented, therefore successive splits will be along the horizontal direction. As new data are inserted, the regions are split, giving rise to the situation in Fig. 9.18c. At this point, the split direction returns to be the vertical one, and the whole procedure is repeated. In this process, buckets are also split, creating the numbering of Fig. 9.19. Given a range query $l_i < x_i < u_i$, the problem is once more to determine the buckets in which the extrema of the

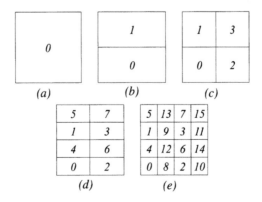

Figure 9.19. Assignment of bucket numbers in a two-dimensional search space.

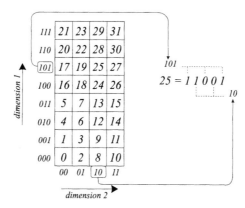

Figure 9.20. Relation between coordinates and region numbers.

query fall, and all the buckets in between. As in the one-dimensional case, for each point one determines first the region number, and then the bucket number. The relation between region number and bucket number is exactly the same as in the one-dimensional case, that is, at level i, region number ω is contained in bucket number $b(i, \omega)$[6]. The question therefore is: How can one determine the region number corresponding to a given point (x, y)?

The key observation is illustrated in Fig. 9.20. If the rows and the columns are numbered and the numbers are represented using the binary system, then the region number is obtained by interleaving the digits of the rows and column numbers of the regions. Therefore, in general, consider a d-dimensional cube with 2^{l+1} cells on the directions from 1 to q, and 2^l cells in the directions from $q + 1$ to d. Represent the "cell coordinates" of a region in binary notation

$$
\begin{aligned}
c_1 &= b_{0,1} b_{0,2} \cdots b_{0,l} \\
c_2 &= b_{1,1} b_{1,2} \cdots b_{1,l} \\
&\vdots \\
c_q &= b_{q,1} b_{q,2} \cdots b_{q,l} \\
c_{q+1} &= b_{q+1,1} b_{q+1,2} \cdots b_{q+1,l-1} \\
&\vdots \\
c_d &= b_{d,1} b_{d,2} \cdots b_{d,l-1}
\end{aligned}
\tag{9.82}
$$

where $b_{ij} \in \{0, 1\}$. The region number corresponding to this point is

$$
r = b_{1,1} b_{2,1} \ldots b_{d,1} \cdots b_{1,l-1} b_{2,l-1} \ldots b_{d,l-1} \cdots b_{1,l} b_{2,l} \ldots b_{q,l}
\tag{9.83}
$$

Formally, this "scramble" operation will be written as $r = S_{l,q}(c_1, \ldots, c_d)$.

In order to apply this result to the determination of bucket numbers, let l be the current level number. In this case, $q = l \bmod d$ dimensions will have

[6] Region numbers still form a one-dimensional sequence, so that the relation between region numbers and bucket numbers is completely independent of the dimensionality of the data space.

been split $\lceil d/l \rceil$ times, while the remaining $d - q$ dimensions will have been split $\lceil d/l \rceil - 1$ times. Let u_j be the number of times direction j has been split. For a point $x = (x_1, \ldots, x_d)$, define

$$c_i = (\Pi_{u_i}(x_i))_{u_i} \qquad (9.84)$$

This operation simply computes the cell number along each direction using the functions Π_l defined previously and represents it with the suitable number of bytes. If a direction has been split u times, u bytes will be necessary to represent its cell numbers. At this point, the scramble function S can be used to derive the region number, and the bit-reverse function to derive the bucket number, which is therefore given by:

$$\psi = b(i, S((\Pi_{u_1}(x))_{u_1}, \ldots, (\Pi_{u_d}(x))_{u_d})) \qquad (9.85)$$

For a range query $a_i \leq x \leq b_i$, $i = 1, \ldots, d$, one will first determine the cell numbers along the d directions for both a and b:

$$\begin{aligned} c_i^a &= (\Pi_{u_i}(a_i))_{u_i} \\ c_i^b &= (\Pi_{u_i}(b_i))_{u_i} \end{aligned} \qquad (9.86)$$

Then, for all groups of cell numbers $c = (c_1, \ldots, c_d)$ with $c_i^a \leq c_i \leq c_i^b$, the region and bucket number are computed, and the bucket is accessed.

This method is very efficient, and allows an easy growth of the index as new elements are inserted in the database. It suffers (as most grid file methods) from a serious problem, that is, the number of regions (and therefore of buckets) grows exponentially with the number of dimensions, regardless of whether these buckets will be occupied. As long as reasonable uniformity conditions are satisfied, all buckets will be occupied but for high-dimensional spaces, it will be impossible to split all dimensions even once. A 40-dimensional space will generate 2^{40} buckets if all dimensions are split once! One of the dimensionality reduction methods introduced in section 9.2 should be employed in order to bring the dimensionality of the space down to a more manageable size.

A modification of the method [Burkhard, 1984] alleviates the problems of high dimensionality by maintaining a running estimate of the probability distribution of the data in the database, and splitting the bins not in half, but in positions dependent on the data distribution. In this case, the partition of the data space resembles somewhat that done in KD-trees, with the exception that, as the structure is dynamic, the partitions are determined by the estimate of the data distribution at the time in which the partition is made rather than by the overall data distribution. This also requires maintaining a history of the probability distribution estimates based on which the partitions were made.

The hashing method presented here is only one of the many variations on the idea of *calculating* the position of a data point on disk rather than obtaining it following the pointers of a data structure. Many of these methods are variations of the *grid file* technique [Nievergelt *et al.*, 1984], with provisions for balancing

[Freeston, 1987], better space partition [Hutflesz *et al.*, 1998], or with a hybrid approach between trees and hashing tables [Otoo, 1986]

9.6 Nearest-Neighbor Search

The indexing methods introduced so far are designed to answer *range queries*, that is, their "search" procedure always considers a point in the query space and a maximum distance from that point, and returns all the points in the dataset that are within the given distance from the query point. None of the indexing methods presented so far explicitly addresses k-nearest-neighbor queries, in which the k data points closest to the query are requested independently of their distance from it. A k-nearest-neighbors query is usually answered by some algorithm that uses the space indexing schemes to access in succession the areas of the search space in which the next neighbor is most likely to be found.

This section introduces a cost model for nearest-neighbor queries originally developed by Berchtold *et al.* (1997). The model is based on a nearest-neighbor algorithm originally devised by Hjaltason and Samet (1995), and which is optimal in the following sense:

DEFINITION 9.8. *Let $x^* \in \Omega$ be a point, and define $S_N(x^*)$ as the sphere of center x^* and radius $d_X(x^*)$. An algorithm for nearest-neighbor search is optimal if every page it retrieves intersects $S_N(x^*)$.*

Given a query point q, Hjaltason and Samet's algorithm visits the nodes of a tree-like space partition structure in order of their value *mindist*, defined as the minimal distance from the query point q to any of the points in the partition:

$$mindist(P, q) = \min_{x \in P} d(q, x) \qquad (9.87)$$

The following is a slight generalization of the Hjaltason and Samet algorithm.

ALGORITHM 9.28. *Assume that a spatial index structure organized as a tree is available; N is the current node of the index structure, and $N.sub$ is a list of all the partitions of the space directly under N in the tree; L is a list of data points still waiting to be analyzed. The procedure prune(L, x) removes from the list L all points whose distance from the query point is greater than x. The point q is the query point. The nearest neighbor is returned in the variable nn.*

1. set $L \leftarrow N.sub$
2. sort the partitions in L by their mindist value.
3. while $L \neq \emptyset$
4. if isLeaf($L.top$)
5. $n_t \leftarrow$ nearest point to the query in $L.top$
6. if $d(q, n_t) < d(q, nn)$
7. prune(L, n_t)
8. $nn \leftarrow n_t$

9. else
10. remove(L, n_t)
11. $L = L \cup n_t.sub$
12. sort the partitions in L by their mindist value.

The following lemma shows that Algorithm 9.28 is optimal in the sense of Definition 9.8:

LEMMA 9.8. *Algorithm 9.28 is optimal in the sense of Definition 9.8, that is, it only accesses pages that intersect the sphere $S_N(x^*)$.*

PROOF. The proof of the correctness of the algorithm is the same as that of Hjaltason and Samet (1995). Assume, by contradiction, that the algorithm accesses a page A, which does not intersect the sphere $S_N(x^*)$. If r is the radius of $S_N(x^*)$, this implies that $mindist(A, x^*) > r$. Let P_0 be the data page containing the nearest neighborhood of x^*, P_1 the page containing P_0, and so on, with P_k being the partition in the root page containing P_{k-1}. Thus

$$r \geq mindist(P_0) \geq \ldots \geq mindist(P_k) \tag{9.88}$$

consequently,

$$mindist(A) \geq r \geq mindist(P_0) \geq \ldots \geq mindist(P_k) \tag{9.89}$$

P_k is in the root page and, at some time early in the algorithm, will be in the queue. It will then be replaced by P_{k-1}, P_{k-2}, and so on, until P_0 is placed in the queue (these pages will have to be loaded because P_0 contains the nearest neighbor and the algorithm is correct). If the algorithm accesses A, then at some point during the search, A must be on top of the partition list. Because $mindist(A)$ is greater than the mindist of all the P_k, A cannot be loaded until all the P_k, including P_0, have been visited and removed from the queue. However, once P_0 is loaded, all the partitions that have *mindist* greater than r will be pruned, including A. Therefore, A is not accessed. □

9.6.1 A Cost Model

A cost model of a nearest-neighborhood query should give a bound to the number of pages that will be retrieved by a given nearest-neighborhood query. Because of the properties of the optimal algorithm, this number is at most the number of pages that intersect the sphere $S_N(x^*)$. The estimation of this value is made more complicated by *boundary effects*. Because the feature space is bounded, in many cases, the sphere $S_N(x^*)$ will be partially out of the feature space. The parts of $S_N(x^*)$ that fall out of the feature space will obviously intercept no pages and, therefore, a simple argument based on the ratio between the volume of $S_N(x^*)$ and the volume of the portion of space included in the average page will overestimate the number of pages accessed. Sproull (1991) estimated that boundary effects

play a significant role unless the following condition holds:

$$N \gg C_p \left(\left[\frac{1}{C_p V_s^d \left(\frac{1}{2} \right)} \right]^{1/d} + 1 \right)^d \tag{9.90}$$

where N is the number of elements in the database, d is the dimensionality of the feature space, C_p is the average number of data points per page, and $V_s^d(r)$ is the volume of a d-dimensional sphere of radius r, $S^d(x, r)$, given by

$$V_s^d(r) = \frac{\pi^{d/2}}{\Gamma \left(\frac{d}{2} + 1 \right)} r^d \tag{9.91}$$

with

$$\Gamma \left(\frac{1}{2} \right) = \sqrt{\pi}$$
$$\Gamma(1) = 1$$
$$\Gamma(x + 1) = x \cdot \Gamma(x)$$

In order for the condition to be true, the number of elements in the database should grow exponentially with the dimensionality of the space. The condition is therefore seldom verified for high-dimensional spaces, so that boundary effects play an important role in many cases of practical interest. In the remainder of the section, I will follow closely the method used by Berchtold *et al.* (1997). As in that paper, I will consider the feature space to be the d-dimensional unit cube $\Omega = [0, 1]^d$.

As a first step, consider a data point $x = (x_1, \ldots, x_d)$ and a query point $q = (q_1, \ldots, q_d)$. If both points are uniformly distributed in $[0, 1]^d$, what is the probability distribution of the distance between them? The distance between them is less than r if the point q is within a sphere of radius r centered at x. If the sphere is completely contained within the feature space, the uniformity assumption implies that this probability is equal to the ratio between the volume of the sphere and the volume of the feature space, that is, because the feature space has unit volume, equal to the volume of the sphere. However, if the point x is close to the boundary of the feature space, that is, if $B_r(x)$ is true with

$$B_r(x) = \exists i \in \{1, \ldots, d\} : r > x_i \vee x_i > 1 - r \tag{9.92}$$

then the probability is equal to the volume of the portion of the hypersphere included within the feature space Ω. In order to compute this volume, define the indicator function of the sphere centered at x as

$$u_{x,r}(y) = \begin{cases} 1 & \text{if } \sum_{j=1}^{d} |x_1 - y_i|^2 \leq r^2 \\ 0 & \text{otherwise} \end{cases} \tag{9.93}$$

The volume of the intersection between the sphere and the feature space is then

(a) *(b)*

Figure 9.21. Transformation of a range query in a point query using the Minkoswki sum.

given by

$$V(S^d(x, r) \cap \Omega) = \int_\Omega u_{x,r}(y) \, dy \qquad (9.94)$$

If the point x is uniformly distributed in Ω, then the average value of the volume is

$$\overline{V}^d(r) = \int_\Omega V(S^d(x, r) \cap \Omega) \, dx \qquad (9.95)$$

Consider now the problem of finding the expected distance between a query point and its nearest neighbor in a database of N points. The probability that this distance is at most r can also be described in the reverse, specifically, as one minus the probability that none of the N data points is in the sphere of radius r, that is, the probability that the nearest neighbor will be at most at a distance r from the query is

$$P(r) = 1 - (1 - \overline{V}^d(r))^N \qquad (9.96)$$

The corresponding density function is

$$p(r) = \frac{d}{dr} P(r) = N \frac{d\overline{V}^d(r)}{dr} (1 - \overline{V}^d(r))^{N-1} \qquad (9.97)$$

From this, the expected nearest-neighbor distance is obtained as

$$\rho^* = \int_0^\infty r p(r) \, dr \qquad (9.98)$$

The next step is to determine the number of pages that intersect a sphere with a given radius r. In order to this, it is useful to first transform the range query into a point query, which can be done using the *Minkowski sum*. The idea of the Minkowski sum is shown in Fig. 9.21. The circle in Fig. 9.21a is the range query, and the rectangles are the partitions of the feature space. In Fig. 9.21b, the partitions are "fattened" by considering the surface that results from moving the center of the query sphere along the border of the region. The Minkowski sum

Figure 9.22. The volume of an enlarged square in two dimensions.

is the volume of this region. It is clear that, if the query sphere touches a given region, then the "fattened" region contains the center of the sphere, that is, the query point. The calculation of the volume of a two-dimensional square "fattened" with a circle of radius r is shown in Fig. 9.22. In general, if the indexing page is a d-dimensional cube of side a, the Minkowski sum is given by

$$M^d(r) = \sum_{i=0}^{d} \binom{d}{i} a^{d-i} V_s^i(r) \tag{9.99}$$

This is the expected value of the volume of the bounding boxes of the data pages that are intersected by a range query of radius r. If boundary effects are not taken into account, the expected value of the number of data pages intersected is given simply by

$$\theta = \frac{M_d(r)}{a^d} \tag{9.100}$$

In most high-dimensional spaces, however, boundary effects need to be considered. Let B be a partition in the data space; the indicator function of the "fattening" of the partition is

$$\phi_B(x, r) = \begin{cases} 1 & \text{if } mindist(x, B) \le r \\ 0 & \text{otherwise} \end{cases} \tag{9.101}$$

The volume of the intersection of the Minkowski volume around B and the feature space is

$$M_B^d(r) = \int_\Omega \phi_B(x, r)\, dx \tag{9.102}$$

If B is a rectangular box with lower corner $[l_1, \ldots, l_d]$ and upper corner $[u_1, \ldots, u_d]$, then the function $mindist$ is given by

$$mindist(x, B)^2 = \sum_{i=1}^{d} \begin{cases} 0 & \text{if } l_i \le x_i \le u_i \\ (l_i - x_i)^2 & \text{if } x_i \le l_i \\ (u_i - x_i)^2 & \text{otherwise} \end{cases} \tag{9.103}$$

In order to determine the Minkowski sum using this formula, one would need a probabilistic model of the behavior of the extrema of the pages u_i and l_i of the index pages. In practice, as noted by Berchtold *et al.* (1997), in high-dimensional spaces, the number of splits per dimension is very limited. In, say,

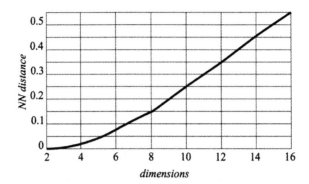

Figure 9.23. Expected distance between a query and its nearest neighbor as a function of the dimensionality of the feature space.

a 30-dimensional space, one split per dimension would create $2^{30} \approx 10^9$ cells. Therefore, in most cases, some dimensions will only be split once and other dimensions will not be split at all. Let d', the number of dimensions that will be split at position s_i in dimension i, be given by

$$d' = \left\lceil \log\left(\frac{N}{C_p}\right) \right\rceil \tag{9.104}$$

The Minkowski sum over all pages (which also corresponds to the number of pages intersected, by virtue of the unit volume of the feature space) is then

$$\theta(r) = \sum_{k=0}^{d'} \sum_{(i_1,\ldots,i_k)\in P(d')} V(S^d([s_{i_1},\ldots,s_{i_k}],r)\cap\Omega) \tag{9.105}$$

For uniformly distributed data, the splits always takes place in the middle of the corresponding dimension, that is, $s_i = 1/2$. In this case the number of intersected pages is given by

$$\theta(r) = \sum_{k=0}^{d'} \sum_{(i_1,\ldots,i_k)\in P(d')} V\left(S^d\left(\left[\frac{1}{2}\ldots,\frac{1}{2}\right],r\right)\cap\Omega\right) \tag{9.106}$$

which can be simplified to

$$\theta(r) = \sum_{k=0}^{d'} \binom{d'}{k} V\left(S^d\left(\left[\frac{1}{2}\ldots,\frac{1}{2}\right],r\right)\cap\Omega\right) \tag{9.107}$$

This value gives the number of pages intersected by a range query of radius r. In order to obtain the average number of pages intersected by a nearest-neighborhood query, it is necessary to weight this number with the probability density $p(r)$ of Eq. (9.97). The average number of pages intersected by a nearest-neighborhood query in a d-dimensional space is therefore given by

$$\bar{\theta} = \int_0^\infty \theta(r)p(r)\,dr \tag{9.108}$$

Figure 9.24. Expected number of pages accessed as a function of the size of the database for a 16-dimensional space.

Some examples of model predictions are shown in Figs. 9.23 and 9.24. Figure 9.23 shows the expected distance between the query and the nearest neighbor. As expected, for high dimensionalities, the distance grows roughly linearly with the number of dimensions. Figure 9.24 shows the expected number of pages accessed as a function of the size of the database for a 16-dimensional space. Experiments in Berchtold *et al.* (1997) showed the estimate to agree with the experimental data within a few percent. The highest prediction errors occur with structures such as the *X*-tree with special provisions to avoid dead space [Berchtold *et al.*, 1996], provisions that are not included in the cost model.

10

Of Mice and Men

...il Macintosh è cattolico controriformista, e risente della "ratio studiorum" dei gesuiti. È festoso, amichevole, conciliante, dice al fedele come deve procedere passo per passo per raggiungere—se non il regno dei cieli—il momento della stampa finale del documento. È catechismo, l'essenza della rivelazione è risolta in formule comprensibili e in icone sontuose. Tutti hanno diritto alla salvezza.

Il Dos è protestante, addirittura calvinista. Prevede una libera interpretazione delle scritture, chiede decisioni personali e sofferte, impone una ermeneutica sottile, dà per scontato che la salvezza non è alla portata di tutti.

Umberto Eco, *La Bustina di Minerva*

During my first visit to the United States, I had to adapt to do many things differently than ever before in my life. For one thing, I had to speak a different language, and it took considerable effort to come to terms with the idea that the people I was talking to used English as their primary language rather than—as it happens often in Europe—as a backup when your knowledge of the language of whatever country you are visiting fails you miserably right after being stopped for speeding.

I was ready, eager, and well equipped for whatever challenge *Merriam & Webster* would throw my way, but not even with a considerable dose of wicked imagination would I ever have expected to have problems with *doors*. Alas, I did. You see, in Europe all external doors open inward (there are exceptions for rooms destined to contain large crowds, for security reasons, but let us not quibble about details not worth quibbling about). That is, in order to enter a building, you have to push. In the United States it is exactly the opposite—external doors open *outwards*. Thus, in order to enter a building you have to *pull*. It might appear as a rather minor difference, well into the list of things not worth quibbling about, but

it is not. I crashed into more doors and provoked more laughter than I care to remember before I acquired the right reflex.

My initial driving experience also contained its fair share of problems. Apart from the fact that the number of people trying to kill you on the road is lower here than in Italian urban centers, a fair share of the cars I happened to drive in America (rented, borrowed, and bought) had automatic transmission, while, of course, every good, decent, and hot-blooded Italian would rather be caught dead (or worst, putting pepperoni on a pizza) than renouncing the clutch-shift-clutch ritual that always accompanies a well-done change of gear. You might be led to think that the switch is immediate, yet it is all but that. My left foot did not stop looking for that damn clutch, and when it did not find it, I started experiencing a very uneasy sensation, the world was not quite the way it was supposed to be.

The moral of these examples is (apart from "beware of doors when you cross the ocean") that a natural and habit-forming interface between us and the devices that surround us is important and, although computer scientists appropriated the term, they certainly did not invent the concept. It was done by the first caveman who decided to shape a stone to make a better weapon. We are just trying to improve it.

The term interface is another word on semantic loan from other disciplines. Strictly speaking, an interface is the surface that is formed at the common boundary between two different substances. By analogy, computer science uses it to indicate the conceptual area in which man and machine meet. It is common these days to use the term "interface" to refer to the sequence of screen layouts that a program presents to the user in order to display information and to receive commands, but this is a rather limited use of the term. By and large, I will call interface the whole set of operations involved in the communication between a user or a group of users and the database.

The communication between the user and a computer system can be considered from different points of view. Most of the approaches to user-system interaction have been cognitive, trying to represent and model the exchange of information that takes place during the interaction. The theoretical basis for such approaches is in cognitive psychology, particularly in the study of such activities as planning and goal-reaching [Card *et al.*, 1983]. This model, however, makes it difficult to model phenomena out of the simple user-computer loop, such as group interaction.

A different perspective is the semiotic. Here, computers are *media* in the same way as books, cinema, or theater are, and their function is to represent and communicate messages. The computer is in this case an agent of communication within the community of which the user is part, and the interface is a representation of the sign system used to communicate between them.

Souza (1993) considers an interface as a set of messages sent from the designer to the user. With this interpretation in mind, the interface has two roles: 1) it communicates the application functionality and the interaction model; and 2) it

facilitates the exchange of messages between the user and the application. This approach evidences the necessity for the user and the designer to share enough common background to make this communication possible, a case which does not happen as often as one would like.

A shared background is particularly important when an interface is designed as a *metaphor*, which, in the parlance of computer science, indicates an interface in which the user actions structurally replicate those that the user would undertake in a more familiar domain. Such interfaces are considered iconic[1]. These interfaces, although, in general, useful, are subject to the limits of imperfect metaphors.

Most modern general-purpose interfaces derived more or less directly from those of the Xerox *Alto* and *Star* workstations, via the mediation of the Apple Macintosh personal computer. Here, the computer screen represents a desktop, the disk files and programs are represented as documents that can be manipulated, and logical disk divisions (e.g., directories) as folders in which the documents are placed. Certain operations on the desktop are chosen to represent the corresponding operations in the computer, so it is possible to move documents around, delete them by throwing them in a wastebasket, and so on.

The "desktop & documents" metaphor, however, breaks down in several occasions and in two different ways, namely, by introducing additional symbolic actions with no iconic counterpart and—with far more disruptive effects—by breaking down the structure preservation of the iconic actions. Symbolic actions, which break the metaphor in the first sense, are usually clearly marked and recognizable; for example, in most offices one uses a photocopier in order to make copies of a document, but in most computer interfaces a distinct "copy" command is used instead. Similarly, a double click with the mouse usually means "open a document," an action that has no counterpart on a real desktop and is therefore symbolic. More serious (and closer to a metaphor break of the second class) is the fact that if the element on the screen-desktop is not a document but a program, the same double-click operation will result in the execution of the program.

Unannounced breaks in the metaphor are more disruptive. At this moment on my desk (the real desk, that is) there are several piles of documents and folders. In order to create one pile, I (who, will blissfully admit, am not the tidiest person in the world) simply started placing documents and folders on top of each other. However, if I try to do the same on my computer desktop, the result will be that documents will be inserted *inside* the folder. Even worst, on the Microsoft Windows desktop, if the folder is on the same disk as the original document, the consequence of this action will be to *move* the document inside the desktop.

[1] In the semiotic, not in the pictorial term; the common use of the term *icon* to indicate small pictorial representations on the computer screen is quite unfortunate, and might cause some confusion in the following.

However, if the document is on a different disk (e.g., a floppy), the same action will make a *copy* of the document and place it in the folder. The desktop metaphor is breaking down without warning. The most (in)famous example of this breakdown is probably the Apple Macintosh desktop in which, in order to extract the floppy disk, it is necessary to drag its representation onto that of the wastebasket. I do not know anybody who can do that without a mute prayer and a shiver down the spine.

All in all, metaphors are useful if used with caution, and only when the operations that one executes in the interface have an obvious counterpart in some area of experience with which the user is very familiar. However, trying to force the desktop metaphor in applications that do not naturally deal with documents or to people who have never worked on a real desk with real documents is just plain silly.

An alternative to viewing the interface as a metaphor is to regard it as a collection of sign systems through which the various components of the database (either algorithmic or human) communicate. Each component of the database "explains" its status using a sign system and a shared context, and listens to a description of the state it should have (which comes from other components of the database) using other sign systems and other contexts. All these sign systems should be expressive, that is, they should allow a "natural" encoding of the state of the component they represent. Natural, in this case, means that the sign system should represent all the relevant structure of a component without adding spurious structure.

These observations are rather generic and qualitative. In order to make them more precise, it is important to define with a certain precision the notion of *sign system* and that of *semiotic morphism* between sign systems. Most of this formalization has been developed in the user-interface literature. In particular, this section will follow Goguen's approach, which he calls *algebraic semiotics* [Goguen, 1998].

10.1 Sign Systems

Sign systems are composed of signs of different *types*[2] that can be combined following certain rules to obtain signs of other types. The most immediate example is that of written language, in which signs of type "character" can be combined to form signs of type "word," which, in turn, can be combined to form signs of type "sentence." The rules that create signs of a certain type from other signs are called *constructors*. Constructors can have *priority*, for example a first-order

[2] Goguen (1998) prefers the term *sort* to the more familiar *type* on grounds of overuse of the latter term. I prefer to risk confusion in order to be able to highlight some parallels between data types and sign sorts that I believe are important. Both concepts are used to describe the structure of an underlying system.

constructor has higher priority than a second-order constructor which, in turn, has higher priority than a third-order constructor, and so on. Priorities create a partial order of constructors.

Rather than considering a sign system as a set of signs grouped into types, Goguen (1998) prefers to model it as a *theory*.

DEFINITION 10.1. *A sign system \mathfrak{S} is a 7-tuple*

$$\mathfrak{S} = (T, V, \leq_T, \leq_V, C, F, A) \qquad (10.1)$$

where

- T *is a set of* data types;

- V *is a set of* parameter types;

- \leq_T *is a partial ordering relation on T, called the* subtype *relation;*

- \leq_V *is a partial ordering relation on $T \uplus V$ called the* level *relation such that:*
 - $\forall v \in V, t \in T \ v \leq_V t$
 - $\exists! t_s : \forall t \in T \ t \leq_V t_s; \ t_s$ *is called the* top type;

- $C = \{(C_n, \leq_n)\}$ *is a collection of partially ordered sets of* constructors; C_n *is the set of constructors for signs at level n. A constructor in C_n is written as* $r : s_1 \cdots s_k d_1 \cdots d_l \rightarrow s$, *indicating that the ith argument must have type* s_j, *its jth parameter type d_j, and its result has type s. Constructors can only be used to build "upwards" in the hierarchy of signs, that is, for none of the arguments s_i it is the case that $s \leq_V s_i$. The set C_n is (partially) ordered by the priority relation \leq_n. Constants are indicated as $c \rightarrow s$;*

- *a set F of functions and relations on signs; and*

- *a set A of logic sentences called* axioms.

The parameter types are used to store ancillary data about the signs, such as positions, colors, and similar information. This formalization tries to capture as many aspects as possible of a semiotic sign system (subject to the caveat and limitations expressed in Chapter 2) but, for most of my purposes in this chapter, it is too complex and cumbersome. In particular, I will generally not need to use parameters, and I will implicitly assume that all the constructors necessary to build the relevant data types are present. Therefore, in this chapter I will mainly use the following simplified representation:

$$\mathfrak{S} = (T, \leq_T, F, A) \qquad (10.2)$$

Sign systems are partially ordered by inclusion: $\mathfrak{S} \subseteq \mathfrak{T}$ if $\mathfrak{S}.T \subseteq \mathfrak{T}.T$, $(\mathfrak{S}. \leq_T) \subseteq (\mathfrak{T}. \leq_T)$, $\mathfrak{S}.F \subseteq \mathfrak{T}.F$, and $\mathfrak{S}.A \subseteq \mathfrak{T}.A$. Given a sign system \mathfrak{S}, the systems $\mathfrak{S}^{(i)}$ will

indicate a family of sign systems such that

$$\mathfrak{S}^{(i+1)} \subseteq \mathfrak{S}^{(i)}, \quad \mathfrak{S}^{(0)} = \mathfrak{S} \tag{10.3}$$

Sometimes a sign system can be augmented by adding something that is not a sign system. For instance, one can take a sign system

$$\mathfrak{S} = (T, \leq_T, F, A) \tag{10.4}$$

add to it more types, relations, functions, and axioms, to obtain a larger sign system

$$\mathfrak{S}' = (T \cup T', \leq_T \cup \leq'_T, F \cup F', A \cup A') \tag{10.5}$$

The fact that \mathfrak{S}' is a sign system does not imply that the added portion

$$Q = (T', \leq'_T, F', A') \tag{10.6}$$

is also a sign system. For instance, the set of axioms A' may contain some axioms relative to data types in T while the axioms of a sign system are supposed to refer only to the elements of that sign system (in this case, A' should only contain type axioms relative to the types in T'). This operation is therefore not the combination of two sign systems, but a more generic *augmentation* of a sign system \mathfrak{S} with a tuple Q which, in general, will depend on \mathfrak{S}. I will use the notation $\mathfrak{S} \uplus Q$ to indicate this operation. If Q is an independent sign system \mathfrak{Q}, then \mathfrak{S}' is the *direct sum* of \mathfrak{S} and \mathfrak{Q}, and the operation will be indicated as $\mathfrak{S}' = \mathfrak{S} \oplus \mathfrak{Q}$.

As an example, consider the output panel of the interface for a query-by-example system that displays a grid of 3×3 images, representing the images most similar to the query (see Fig. 10.3 in the following for an illustration). This sign system consists of two types: img (for "image") and gp (for "group"). In this example it is not necessary to analyze the composition of an image any further, thus it can be taken as a primitive sign:

$$\text{img} \triangleright \text{unit} \tag{10.7}$$

A group is a set of three rows of three images each:

$$\text{gp} \triangleright [i_{hk} : \text{img } h, k = 1, \ldots, 3] \tag{10.8}$$

The only ordering relation between sorts is $img \leq gp$; the images are built by a constructor $r_i : (n : \mathbb{N}) \rightarrow$ img, which takes as a parameter the identifier of the image, and the group is built by a constructor that takes nine images. Functions defined on the sign system include the following:

- pimg : gp $\times \mathbb{N}^2 \rightarrow$ img which, given a group and a position in it, returns the image in that position.

- ngb : $\mathbb{N}^2 \times \mathbb{N}^2 \rightarrow$ Boolean, which, given two positions (i, j) and (i', j') in a group, determines if they are neighbors.

- nxt : $\mathbb{N}^2 \to \mathbb{N}^2 \cup$ null, which, given a position, returns the "next" position in the natral order of the group (left to right and top to bottom) or null if the position is the last in the group.

- id : img $\to \mathbb{N}$, which returns the identifier of a given image.

- s : img $\to [0, 1]$, which returns the score of a given image.

Axioms on this system include, among others, the following:

- group structural axioms, such as ngb$((1,1),(1,2))$, ngb$((1,1),(2,1))$, nxt$(1,1) = (1,2)$, nxt$(2,3) = 3,1$, and so on, the symmetry axioms for the neighborhood relation ngb$(a,b) \Leftrightarrow$ ngb(b,a), and the anti-symmetry of the next relation: nxt$(a) = b \Rightarrow$ nxt$(b) \neq a$;

- unicity axioms, such as

$$\forall u, v, h, k, \ u \neq h \vee v \neq k \Rightarrow \mathrm{id}(\mathrm{pimg}(gp, u, v)) \neq \mathrm{id}(\mathrm{pimg}(gp, h, k)) \quad (10.9)$$

which states that every image is represented in the interface at most one;

- scoring axioms, such as

$$\mathrm{nxt}(i, j) = (u, v) \Rightarrow s(\mathrm{pimg}(g, i, j)) \geq s(\mathrm{pimg}(g, u, v)) \quad (10.10)$$

which states that images are ordered by scores, and

$$\forall im' : \mathrm{img}, (\exists u, v : s(im') > s(\mathrm{pimg}(g, u, v))) \Rightarrow \exists i, j : \mathrm{pimg}(g, i, j) = im' \quad (10.11)$$

which states that all the images with the highest scores are contained in the interface.

A more complete description of the query-by-example interface sign system will be given in section 10.2.2.

10.1.1 Semiotic Morphisms

A semiotic morphism is mapping $M : S_1 \to S_2$, where S_1 and S_2 are sign systems. A morphism should preserve as much structure as possible of the sign system, although preserving the whole structure may not be possible; many morphisms are partial maps.

DEFINITION 10.2. *Given two sign systems S_1 and S_2, a semiotic morphism $M : S_1 \to S_2$ is a collection of partial functions (all denoted by the same symbol M) consisting of:*

1. *types$(S_1) \to$ types(S_2),*

2. *constructors$(S_1) \to$ constructors(S_2),*

3. *predicates*(S_1) → *predicates*(S_2),

4. *functions*(S_1) → *functions*(S_2),

such that

1. if $s \leq s'$ then $M(s) \leq M(s')$,

2. if $c : s_1 \cdots s_k \rightarrow s$ is a constructor and $M(c)$ is defined the $M(c) : M(s_1) \cdots M(s_k) \rightarrow M(s)$,

3. if $p : s_1 \cdots s_k$ is a predicate of S_1 and $M(p)$ is defined, then $M(p) : M(s_1) \cdots M(s_k)$.

As an example, consider a sign system similar to the query-by-example interface. It also contains two types img' and gp', but, in this case, the group of images is defined as

$$gp' \triangleright [i_k : \text{img}' \, k = 1, \ldots, 9] \tag{10.12}$$

In words, this means that the images are presented in a single row rather than as a matrix of 3×3 images. The functions id' : img' → \mathbb{N} and s' : img' → $[0, 1]$ are defined as in the previous case; the function pimg' has in this case signature pimg' : \mathbb{N} → img'; the function ngb' has signature ngb' : $\mathbb{N} \times \mathbb{N}$ → Boolean, and the function nxt' has signature nxt' : \mathbb{N} → $\mathbb{N} \cup$ null.

The morphsm between these two systems transforms, for example:

$$M(\text{img}) = \text{img}'$$
$$M(\text{gp}) = \text{gp}'$$
$$M(s) = s'$$
$$M(\text{id}) = \text{id}'$$
$$M(\text{nxt}) = \text{nxt}'$$
$$M(\text{ngb}) = \text{ngb}'$$
$$M(\text{pimg}) = \text{pimg}'$$

but only some of the axioms of the first system are transformed into axioms of the second system. For instance:

$$M(\text{nxt}((1,1),(1,2))) = \text{nxt}'(1,2)$$
$$M(\text{nxt}((2,1),(2,2))) = \text{nxt}'(5,6) \tag{10.13}$$

The axiom of symmetry is also transformed in an axiom of symmetry. On the other hand, an axiom such as nxt$((1,1),(2,1))$ has no corresponding axiom in the second system. Conversely, the axiom nxt'$(3,4)$ has no corresponding axiom in the first system; the morphism between the two systems preserves only part of the structure.

Quality of morphisms. In very general terms, a morphism should provide a high-quality mapping of a sign system into another. In the case of an interface, this means that, for instance, the screen display should provide a faithful representation of the relevant internal structure of the database. However, exactly what does that mean? What is *high quality*? The concept is related to the preservation of the structure of a sign system. In particular, as a morphism $M : S_1 \rightarrow S_2$ is partial, some of the signs, data types, functions, or axioms of S_1 may be lost in the transformation. Quality is not, however, simply the preservation of structure: If the structure of S_1 is too complicated, it may be desirable to remove some of it. Goguen (1998) presents an example in which S_1 is the English language. If S_2 is the bracket notation and S_3 the linear notation for sentences, then a morphism $M_2 : S_1 \rightarrow S_2$ would retain more of the structure of S_1 than a morphism $M : S_1 \rightarrow S_3$. Yet, a representation in S_2 such as

$$[[[[the]_{Det}[light]_N]_{NP}[[on]_{Prep}[[the]_{Det}[left]_N]_{NP}]_{PP}]_{PP}[[comes]_V[on]_{Part}]_{VP}]_{Sent}$$

is worse for most practical uses than the structurally poorer linear representation

<div align="center">the light on the left comes on</div>

Any attempt to tie the concept of quality to that of structure preservation should first consider counterexamples such as this one. Before attempting to do so, I will one again appeal to the semiformalist program launched in Chapter 2. Any attempt to fully formalize experience will fall into a reductionist trap, while any attempt to fully avoid such a trap is condemned to inconclusiveness. The position I have taken in this book is to formalize freely, keeping an open mind to the limits of such formalization. The considerations on the quality of semiotic morphisms that will follow should be placed in this semiformalist light; for one thing, all considerations here are limited to the particular universe of image databases, and make no claims of universality; for another, even in the image database domain, they should be taken as a partial systematization of more complex phenomena rather than as a complete explanation.

In the example of the English sentence in the preceding, it is possible to formalize the problem as one of interpretation. The actual chain is composed of two morphisms that act on the original system:

$$S_1 \xrightarrow{\;M\;} S_3 \xrightarrow{\;I_L\;} O \tag{10.14}$$

The first morphism translates the English sentence into the representation S_2 (the bracketed representation). This is the sign system that the reader is supposed to interpret. The second part of the diagram is a different rewriting of the Peircean triangle in which the system S_2 constitutes the representamen, and is interpreted through the user's linguistic competence (which is, in this case, the interpretant I_L). Most people are well equipped with a morphism to interpret normally written English language into a semantic field. In other words, the morphism I_L will be invoked every time some message is recognized to have a linguistic structure. In the first message in the preceding, however, the sentence is placed in a hidden

structure that is not interpreted (after you read the first sentence, you do not build a mental picture of its grammatical structure, but only of its meaning as a sentence, the same meaning you would derive from the second sentence). The actual process in the first case is therefore the following:

$$S_1 \xrightarrow{M} S_2 \xrightarrow{I_S} S_3 \xrightarrow{I_L} O \tag{10.15}$$

The interpretation I_S strips the message from the structure that the reader does not want or need to interpret[3], but she must go through the extra work of removing in order to reach the system S_3. In other words, S_2 (the bracketed notation) is a very uncommon system that people are not used to but within that, there is a system $S_2 \subset S_3$ (the linear notation) that is very common and for which an interpretant is readily available. The reader, therefore, when presented with S_3 will not know what to do with the additional structure, and will go through the additional work of stripping it away, thereby returning to the more familiar linear structure. That is, the additional structure—which is an unusual addendum to a very common structure—did more harm than good. I will translate this idea into my own personal Santini's razor: *structurae non sunt multiplicanda sine necessitate.*

Subject to this caveat—which will have to be checked in the different applications—I will assume that, as a general principle, a good morphism should preserve as much structure as possible of the original sign system. Before defining formally the properties of quality preservation, I will have to give a preliminary technical definition:

DEFINITION 10.3. *A selector for a sign system \mathfrak{S} is a function $f : s \to d$, where s is a data type and d a parameter type such that there is a set of axioms A' such that adding f and A' to \mathfrak{S} is consistent and defines a unique value $f(x)$ for each sign x of type s.*

The definition is a bit convoluted but, essentially, a selector is a function that attaches a value to each sign of a particular type and such that its definition (which is encoded in the axioms A') does not conflict with other definitions in the system. For example, in the case of the query-by-example interface, it is possible to define a selector for the grid type that returns an array with the similarity between the query and the nine images displayed in the interface.

[3] This simple formalization should not be taken as an accurate account of the process of interpretation in the two cases. It leaves out several important points of interpretation—including the problem of how is the first sentence recognized as a sentence, how is the determination done that the parentheses are somehow additional scaffolding and can be ignored for the purposes of signification, and the question of whether the sentence that is interpreted (without parentheses) is really the same as that with parentheses. The model is also incredibly naive in compressing the process of signification into a single morphism into an interpretation space O. The model is drawn simply to illustrate the point that the structure should not be made more complicated than it needs to be. In particular, the system O should not be taken as some form of structure language or "mentalese."

DEFINITION 10.4. *Let* $\mathfrak{S}_1 = (T_1, V_1, \leq_{T_1}, \leq_{V_1}, C_1, F_1, A_1)$ *and* $\mathfrak{S}_2 = (T_2, V_2, \leq_{T_2}, \leq_{V_2}, C_2, F_2, A_2)$ *be two sign systems, and* $M : \mathfrak{S}_1 \rightarrow \mathfrak{S}_2$ *a semiotic morphism.*

1. *M is* level preserving *if, for every* $t, t' \in T_1$, $t \leq_{V_1} t' \Rightarrow M(t) \leq_{V_2} M(t')$;

2. *M is* priority preserving *if, for every* $c, c' \in C_1$, $c \leq_n c' \Rightarrow M(c) \leq_n M(c')$;

3. *M is* axiom preserving *if for each axiom* $a \in A_1$, *M(a) is either an axiom in* A_2 *or a logical consequence of axioms in* A_2;

4. *M preserves a selector* f *of* \mathfrak{S}_1 *if there is a selector* f_2 *of* \mathfrak{S}_2 *such that for every sign of* \mathfrak{S}_1 *where M is defined it is* $f_2(M(x)) = f_1(x)$.

The following definition allows the comparison of the structure preserved by two different morphisms:

DEFINITION 10.5. *Let* $\mathfrak{S}_1 = (T_1, V_1, \leq_{T_1}, \leq_{V_1}, C_1, F_1, A_1)$ *and* $\mathfrak{S}_2 = (T_2, V_2, \leq_{T_2}, \leq_{V_2}, C_2, F_2, A_2)$ *be two sign systems,* $M : \mathfrak{S}_1 \rightarrow \mathfrak{S}_2$ *and* $M' : \mathfrak{S}_1 \rightarrow \mathfrak{S}_2$ *two semiotic morphisms.*

1. *M' is* at least as defined as *M, written* $M \leq_d M'$ *if for each constructor* $c \in \mathfrak{S}_1$, *M'(c) is defined whenever M(c) is defined;*

2. *M'* preserves at least as many axioms *as M, written* $M \leq_a M'$ *if for every axiom* $a \in A_1$, *if M preserves a, then M' preserves a.*

3. *M' is* at least as inclusive *as M, written* $M \leq_i M'$ *if for each sign x of* \mathfrak{S}_1, *M(x) = x implies M'(x) = x.*

4. *M'* preserves at least as much content *as M, written* $M \leq_c M'$ *if M' is as defined as M, and if M preserves a selector f on* \mathfrak{S}_1, *so does M'.*

The intuition behind the definition of content preservation is that if the sign system \mathfrak{S}_1 has a way to retrieve some data value from its signs (through a suitable selector f), then this possibility should be preserved when the sign system is transformed by the morphism M. The second definition induces a partial ordering in the set of morphisms, where $M \preceq M'$ if $M \leq_d M'$, $M \leq_a M'$, $M \leq_i M'$, and $M \leq_c M'$. This ordering is, in a sense, *natural*, stating that a morphism should preserve as much structure as possible between two sign systems. Other orderings than that defined in the preceding could be useful for special applications. In the aforementioned linguistic example, for example, the desirable properties of a morphism would be to preserve as much as possible the structure of the system S_1 while at the same time adding as little as possible to the structure of the system O. Consider the following diagram:

$$\mathfrak{S} \xrightarrow{\;\;M\;\;} \mathfrak{T} \xrightarrow{\;\;I(M)\;\;} \mathsf{0} \qquad\qquad (10.16)$$

In this case the structure of the system 0 is fixed, and any additional structure present in \mathfrak{T} is removed by the interpretation process $I(M)$, which depends on

the morphism M. Given then two morphisms $M, M' : \mathfrak{S} \to \mathfrak{T}$, one might define $M \preceq M'$ if

$$M \leq_d M' \qquad M \leq_a M' \qquad M \leq_i M'$$

$$M \leq_c M'$$

$$I(M) \leq_d I(M') \quad I(M) \leq_a I(M') \quad I(M) \leq_i I(M')$$

$$I(M) \leq_c I(M')$$

Semiotic morphisms can be composed. That is, given semiotic morphisms $M : \mathfrak{S}_1 \to \mathfrak{S}_2$ and $M' : \mathfrak{S}_2 \to \mathfrak{S}_3$, their composition[4] $M; M' : \mathfrak{S}_1 \to \mathfrak{S}_3$ is defined by the composition of the functions that form the morphism M. It is easy to see that $M; M'$ is still a semiotic morphism. Also, given $M'' : \mathfrak{S}_3 \to \mathfrak{S}_4$, it is possible to prove that

$$(M; M'); M'' = M; (M'; M'') \tag{10.17}$$

that is, composition is associative. For every sign system there is an identity morphism $1_\mathfrak{S} : \mathfrak{S} \to \mathfrak{S}$ such that for any morphism $M : \mathfrak{S}_1 \to \mathfrak{S}_2$ it is

$$1_{\mathfrak{S}_1}; M = M$$
$$M; 1_{\mathfrak{S}_2} = M \tag{10.18}$$

An *isomorphism* $I : \mathfrak{S}_1 \to \mathfrak{S}_2$ is a morphism such that there exist another morphism $I^{-1} : \mathfrak{S}_2 \to \mathfrak{S}_1$ such that

$$I; I^{-1} = 1_{\mathfrak{S}_1} \tag{10.19}$$

and

$$I^{-1}; I = 1_{\mathfrak{S}_2} \tag{10.20}$$

The morphism I^{-1} is called the *inverse* of I.

THEOREM 10.1. *If defined, the inverse of a morphism M is unique.*

PROOF. Assume that there are two distinct inverses M' and M''. Then

$$
\begin{aligned}
M'' &= M''; 1_{\mathfrak{S}_1} && \text{by (10.18)} \\
&= M''; (M; M') && \text{by (10.19)} \\
&= (M''; M); M' && \text{by associativity} \\
&= 1_{\mathfrak{S}_2}; M' && \text{by (10.20)} \\
&= M' && \text{by (10.18)}
\end{aligned}
\tag{10.21}
$$

contradicting the hypothesis that the two inverses were distinct. \square

[4] I follow Goguen (1998) in using the symbol ";" for composition to indicate an order opposite that of the usual symbol "∘"; the symbol $f; g$ means that f is applied first, and then g (as is done in a programming language. This is the reason for the choice of ";" as a symbol), while $f \circ g$ means that g is applied first.

THEOREM 10.2. *The composition of two isomorphisms* $M : \mathfrak{S}_1 \to \mathfrak{S}_2$ *and* $N : \mathfrak{S}_2 \to \mathfrak{S}_3$ *is also an isomorphism, and* $(M; N)^{-1} = N^{-1}; M^{-1}$.

PROOF. The composition of two morphisms is a semiotic morphism. Therefore, all that is necessary to prove is that the composition has an inverse and that the inverse is the one indicated. To this end, consider:

$$
\begin{aligned}
(M; N); (N^{-1}; M^{-1}) &= (M; (N; N^{-1})); M^{-1} \\
&= (M; 1_{\mathfrak{S}_2}); M^{-1} \\
&= M; M^{-1} \\
&= 1_{\mathfrak{S}_1}
\end{aligned}
\tag{10.22}
$$

Similarly, it is possible to prove that $(N^{-1}; M^{-1}); (M; N) = 1_{\mathfrak{S}_3}$; ergo, the inverse exists and is equal to $N^{-1}; M^{-1}$. □

The presence of isomorphisms confers structure to the set of sign systems.

DEFINITION 10.6. *Two sign systems* \mathfrak{S}_1 *and* \mathfrak{S}_2 *are isomorphic (written* $\mathfrak{S}_1 \cong \mathfrak{S}_2$) *if there exists an isomorphism* $I : \mathfrak{S}_1 \to \mathfrak{S}_2$.

THEOREM 10.3. *The isomorphy relation is reflexive, symmetric, and transitive, that is,* \cong *is an equivalence relation.*

PROOF. The proof entails proving reflexivity, symmetry, and transitivity of the relation:

- to prove reflexivity, simply note that $1_{\mathfrak{S}}$ is trivially an isomorphism between \mathfrak{S} and itself;

- if $\mathfrak{S}_1 \cong \mathfrak{S}_2$, then there is an isomorphism $I : \mathfrak{S}_1 \to \mathfrak{S}_2$. Its inverse $I^{-1} : \mathfrak{S}_2 \to \mathfrak{S}_1$ is also an isomorphism (I is its inverse), which proves that it is also $\mathfrak{S}_2 \cong \mathfrak{S}_1$;

- let $\mathfrak{S}_1 \cong \mathfrak{S}_2$ and $\mathfrak{S}_2 \cong \mathfrak{S}_3$, which means that there are isomorphisms $I_1 : \mathfrak{S}_1 \to \mathfrak{S}_2$ and $I_2 : \mathfrak{S}_2 \to \mathfrak{S}_3$. By Theorem 10.2, $I_1; I_2 : \mathfrak{S}_1 \to \mathfrak{S}_3$ is also an isomorphism and, therefore, $\mathfrak{S}_1 \cong \mathfrak{S}_3$.

□

Sign systems and semiotic morphisms provide the tools necessary to study the process of communications between parts of a community. In the remainder of this chapter, these concepts will be applied to the community composed of the subsystems of an image database and of the database users.

10.2 Interface Spaces and Sign Systems

In a highly interactive system, the interface cannot be described as a completely separate piece. It is intimately connected to the rest of the database, to the user,

and to the user's social environment. To some extent, therefore, modeling the user-database interaction requires modeling the whole database. This should be done at a suitable level of abstraction to avoid needlessly complicating things with problems one could avoid. In this chapter, I will represent the database as a collection of *spaces* that send messages one to another using certain sign systems. The spaces are essentially explicative devices. Because their structure is inaccessible and, therefore, irrelevant, the only thing that matters is the "view" on the internal structure of the space that is afforded by the sign system with which the space communicates. Because of this, I will be rather liberal with my notation, and use the same symbol to indicate the space and the sign system that describes its configuration.

Feature space. The feature space F is the space in which the data elements of the database are described. In many image databases, this is one of the feature spaces described in Chapters 5 and 6, but the sense in which the term feature is used here is larger. A feature is everything that serves to identify and describe an element in the database for the purposes of storage and querying. In this sense, in a relational database, a row of the table resulting from joining all the tables is the feature of the element represented by that row.

Output space. The output space O is the space resulting from the action of a query on a feature space. The nature of this space depends on the nature of the database. In the case of a relational database, for instance, the output space is the subset of the feature space that contains only the elements that satisfy the query. Independently of the nature of the database, the output space always depends on the query, that is, different queries on the same feature space will generate different output spaces.

Display space. The display space D is the space in which the data are presented to the user. This should not be confused with the two-dimensional surface of the screen in which the data are physically presented. The display space is a more abstract space with structure. This space, however, is subject to the requirement of being isomorphic to a suitable set of screen representations.

Composition space. This is a space of configurations and commands that the user can give to interact with the database. The composition space can be either an independent space or a space of operators on the display space (see the examples in the following).

Query space. The query space Q is the space of the query operators that modify the feature space. In some cases the query space can be indistinguishable from the configuration space because the user explicitly determines the query. This happens rarely in image databases because the query space is typically a space of distance functions and reference points and, while the user can explicitly select a reference point, she usually acts indirectly on the distance function.

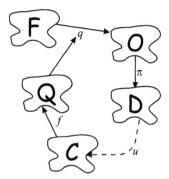

Figure 10.1. Illustration of the spaces and operators of a database and its interface.

At any time during the interaction, each space will contain a certain number of elements in a certain configuration. For instance, the feature space will contain N elements (the features of the images in the database) with certain values and in certain positions of the space. Once a query is made, the output space will contain a number of elements (still images in the database) with certain attributes (e.g., the similarity between each image and the query). That is, each space is at any time in a given *configuration*.

Associated with each space, I will assume the presence of a sign system of enough power with describe all the configurations of the underlying space. In other words, the sign system associated with each space allows one to write a "text" that describes completely the current configuration of the associated space.

A number of operators are defined between these spaces (Fig. 10.1). The *query operator q* takes a database in a feature space F and transforms it into a configuration in the output space O. This operation takes a different form in the different database models. In a relational database, the operator q isolates from the database the elements that satisfy the query; in a query-by-example database, it orders the database elements by their similarity with the query as measured by the current similarity measure, and so on. The *projection operator π* transforms the representation in the space O, which is still abstract and multidimensional, in a configuration that can be displayed. The user intervention u derives from the data in the display space enough information to create a new configuration in the configuration space C (see examples in what follows). This configuration, in turn, will operate on the query space through the operator f and will create a new query operator q with which the cycle will start again.

I will try to elucidate the ideas behind these spaces and operators with two fairly well-known examples: a relational database, and a query-by-example image database. A more complete interface model for query-by-example will be introduced later in this chapter but, for the moment, the account given in section 1.2 will be sufficient.

10.2.1 Relational Databases

Consider a relational database of a bookseller that is composed of two tables: a *Book* table and an *Author* table. The book table is the following:

Book_ID	Author_ID	Title	Publisher	Year	Pages
01	01	Un Viejo Que Leía Novelas de Amor	TusQuets	1989	137
02	02	Dictionary of the Khazars	Knopf	1988	338
03	01	La Frontera Extraviada	Guanda	1996	140
04	03	La Vie, Mode d'Emploi	Hachette	1978	570
05	04	La Tregua	Einaudi	1963	272
06	02	Landscape Painted with Tea	Knopf	1990	338
07	03	La Disparition	Denoël	1969	283

while the author table is the following:

Author_ID	Name	Nationality
01	Luis Sepúlveda	Chile
02	Milorad Pavić	Serbia
03	Georges Perec	France
04	Primo Levi	Italy

The user expresses queries through the screen of Fig. 10.2, in which she fills some of the fields, and the database returns a list of books in the format:

Author	Title	Year	Country

Note that not all the fields in the database are returned (for instance, this particular interface does not return the publisher and the number of pages of a book). In this database, the configuration space is the set of all legal

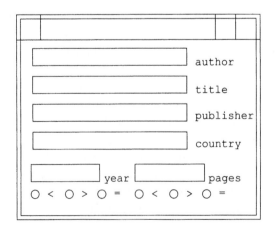

Figure 10.2. Input screen for the toy book database example.

inputs of the screen. Ignoring, for the sake of simplicity, the conditions of validity, the composition space is a set of elements of the following data type:

$$C \triangleright \text{author} : (\mathbb{N} \cup \text{null}) \times \text{title} : (\text{string} \cup \text{null})$$
$$\times \text{pub} : (\text{string} \cup \text{null}) \times \text{country} : (\text{string} \cup \text{null})$$
$$\times \text{year} : (\mathbb{N} \cup \text{null}) \times \text{ycond} : \{<, =, >, \text{null}\}$$
$$\times \text{pag} : (\mathbb{N} \cup \text{null}) \times \text{pcond} : \{<, =, >, \text{null}\} \tag{10.23}$$

An example of legal input is the configuration

null	null	null	chile	1980	>	null	null

which requests all books published by a Chilean author after 1980. The configuration operator f will translate this external representation into an internal query drawn from the query space. If the database uses the SQL query language, this query will appear, for example, as

```
SELECT *
FROM Author A, Book B
WHERE A.Author_ID = B.Author_ID AND A.Country = 'Chile'
      AND B.Year > 1980
```

The SELECT portion of the query is left blank for now; I will return to it in a moment. This is the query operator q that acts on the feature space to create the output space.

The feature space in this case is the space of whatever abstract representation is used to represent the two tables. It can be considered as composed of two sets, that is, *Books* and *Authors*. The first set contains tuples of type:

$$B \triangleright \text{aid} : \mathbb{N} \times \text{pid} : \mathbb{N} \times \text{title} : \text{string} \times \text{pub} : \text{string} \times \text{year} : \mathbb{N} \times \text{pag} : \mathbb{N} \tag{10.24}$$

while the second set contains elements of the type

$$A \triangleright \text{pid} : \mathbb{N} \times \text{name} : \text{string} \times \text{country} : \text{string} \tag{10.25}$$

The output of the query is in this case simply a subset of the feature space, containing the following entries:

Book_ID	Author_ID	Title	Publisher	Year	Pages
01	01	Un Viejo Que Leía Novelas de Amor	TusQuets	1989	137
03	01	La Frontera Extraviada	Guanda	1996	140

and

Author_ID	Name	Nationality
01	Luis Sepúlveda	Chile

The relation between the feature space and the output space is not always this simple, not even in the case of a relational database. In the case of a relational database without aggregation functions, the output space has the same structure as the feature space, and its elements are subsets of the tables that compose the feature space. In many cases, however, relational databases include aggregation operators such as GROUP-BY and SORT. These operators give additional structure to the output space. For instance, the presence of the SORT operator makes the output space contain not only subsets of the table in the feature space but also *ordered* sets of entries, an additional structure not present in the feature space but created by the query into the output space.

The projection operator π operates on these results to produce the version that will be displayed on the screen. In the case of SQL queries, the projection operators are mixed with the query specification so that the complete query should appear, for example, as

```
SELECT A.name, B.title, B.year, A.country
FROM Author A, Book B
WHERE A.Author_ID = B.Author_ID AND A.Country = ''Chile''
     AND B.Year > 1980
```

The SELECT statement at the beginning of the query is in reality a projection operator into the display space[5], which takes all the data in the output space and creates a format that can be displayed on the screen.

The operation of this system can be schematically represented as follows:

$$\begin{array}{c} F \\ \quad \searrow^{q} \; O \xrightarrow{\pi} D \\ \cdots \xrightarrow{u} C \xrightarrow{f} Q \end{array} \qquad (10.26)$$

10.2.2 Query-by-Example

Query-by-example is arguably the most popular interface and query model in image databases, and there are a number of slightly different flavors of it. The example in this section is modeled after one of the oldest, which is found, for example, in the Virage search engine [Gupta, 1995]. The database interface is organized as in Fig. 10.3. In the upper portion, the user is presented with a sample of images from the database; in the lower portion, three knobs allow the user to select a similarity criterion as a combination of color, shape, and texture. Clicking on one of the nine images will return the images most similar to it according to the similarity criterion established by the control knobs.

[5] The symbol π that I am using here for the projection operator derives from the symbol used in relational algebras. The SQL SELECT function is actually implementing an operator that in relational algebra is called projection. While in this chapter I will consider projection as an interface operator, and keep it separated from the query operations, there are practical advantages in mixing the two, especially when dealing with query optimization.

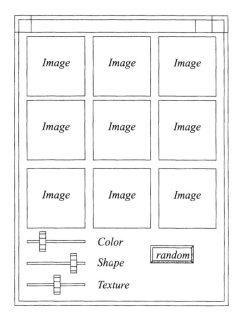

Figure 10.3. Interface panel for a query-by-example engine.

Every image is described by a handle and a feature value. For the sake of simplicity, assume that image features are vectors in \mathbb{R}^n. The feature space is a space of elements of type

$$F \rhd \mathrm{id} : \mathbb{N} \times x : \mathbb{R}^n \qquad (10.27)$$

If a distance function d is defined between image representations, then the feature data type F also has a metric.

A *configuration* in the composition space contains an image id (the image that the user has chosen as a referent) and four values in the interval $[0, 1]$ (the weights that the user selects for the three similarity criteria). A configuration is therefore a datum of type

$$C \rhd \mathrm{id} : \mathbb{N} \times w : [0, 1]^3 \qquad (10.28)$$

The configuration selects a query operator from the query space Q. In this case, the query space Q is a space of scoring functions, that is, of functions of type $s : \mathrm{F} \to [0, 1]$. The scoring functions depend on the parameters of the composition configuration and, in general, are defined based on a family of distance functions on the feature space F. The operator f transforms a configuration in C into a scoring function s, that is, f is an operator of type

$$f : C \to (F \to [0, 1]) \qquad (10.29)$$

defined as

$$f(c : C)(u : F) = g(d(\hat{c}.x, u.x; c.w)) \qquad (10.30)$$

where $\hat{c} = q \in F : q.id = c.id$ (the element is unique because there are no duplicate identifiers), $g : \mathbb{R} \to [0, 1]$ is a monotonically decreasing function, and $d(\cdot, \cdot; w)$ is a parametrized distance function. For the sake of the example, assume that there are three distance functions d_c, d_s, d_t that measure the distance with respect to color, shape, and texture, respectively. In this case the operator f could be defined as

$$f(c : C)(u : F) = g \left(\frac{c.w_1 \cdot d_c(\hat{c}.x, u.x) + c.w_2 \cdot d_s(\hat{c}.x, u.x) + c.w_3 \cdot d_t(\hat{c}.x, u.x)}{c.w_1 + c.w_2 + c.w_3} \right)$$

$$(10.31)$$

The query operator q then applies the scoring function $f(c)$ to all elements of the database expressed in the feature space, and obtains an output space in which every image is represented by its id and its score. The output space in this case has elements of type

$$O \triangleright \text{id} : \mathbb{N} \times score : [0, 1] \qquad (10.32)$$

Note that according to this definition the output space ᴏ contains the whole database, but the feature values of the images are replaced by the score values given by the query. This is in accordance with the observation made in the preceding that the values stored in the feature space F are independent of the query, but the values of the output space ᴏ depend on the query.

The projection operator π projects the elements in a space isomorphic to the representation on the screen. It performs two operations, that is, out of all the elements in the output space, the projection operator selects the nine with the highest score and assigns to every element a position from $(1, 1)$ to $(3, 3)$ determining the position that the element will have in the interface.

In this case the display space is a set of nine elements of type id : $\mathbb{N} \times$ pos : $\{(1, 1), \ldots, (3, 3)\}$. This space can be completely represented on the screen.

A diagram of the interaction involved in a query-by-example database is the following:

$$(10.33)$$

This diagram is very different from that in diagram equation (10.26) in that it contains a closed loop, while the diagram in diagram equation (10.26) is open. This means that the interaction in a query-by-example database is continuous; the result of a query can be used to start another query. For instance, one of the results returned by the database during an interaction can be considered a rather close example of what the user wanted, although not yet a satisfactory solution. The user can select that image and use it as the example of the next iteration of the query. The cyclical form of the diagram implies that the query process is ideally endless. Thus, no matter what the answer, the user

always has the possibility of starting a new iteration and improving on the results.

10.2.3 Interaction Diagrams

I call objects such as those in diagram equations (10.26) and (10.33) *interaction diagrams.* An interaction diagram shows the structure of the operators that the database defines between the spaces introduced in the previous section and the possible sequences in which they are used; they are diagrams of the conversation between the user and the database. Structural properties of the diagram and of the spaces it contains reflect certain properties of the interaction model of the database.

The first structural property is evident from the two diagram equations (10.26) and (10.34). *Open* diagrams describe batch-style or one-shot interactions in which the user poses a query, the database answers, and the process ends:

$$-\overset{u}{\dashrightarrow} C \overset{f}{\longrightarrow} Q' \overset{F}{\underset{q}{\searrow}} \overset{q}{\longrightarrow} O \overset{\pi}{\longrightarrow} D \qquad (10.34)$$

This is a common occurrence in traditional databases in which the query is exact, that is, satisfaction of a query is a well-defined concept, and the database reports all the elements that satisfy the query posed by the user (and only those). In most of these cases, the display space D has the structure of a set or an ordered set, without metric properties. Note that, conventionally, the user actions are represented by dashed lines.

In image databases, most query situations are iterative, that is, the results of a query are used to formulate a new query whose results will be used to formulate another query, and so on. The basic diagram of this interaction is the following:

$$\begin{array}{c} F \searrow q \\ Q' \overset{\curvearrowright}{\longrightarrow} O \\ f \uparrow \ (context) \ \downarrow \pi \\ C \overset{u}{\dashleftarrow} D \end{array} \qquad (10.35)$$

The loop in the diagram generates a *context*. Every new iteration is started in the context of the previous answer. The names of the operators are often superfluous, and will be omitted unless specifically necessary.

The first query is usually made out of any context and, at a certain point, the user will decide that the answer is good enough and will disengage the conversation. The basic interaction diagram therefore becomes the following:

$$\begin{array}{c} \overset{start}{\dashrightarrow} C \longrightarrow Q' \overset{F}{\underset{context}{\curvearrowright}} O \\ \uparrow \downarrow \\ C \overset{continue}{\dashleftarrow} D \overset{accept}{\dashrightarrow} \end{array} \qquad (10.36)$$

The diagram can be extended to encompass other options. For instance, at a certain point the database can communicate to the user that, under the given circumstances, the query cannot be answered (e.g. the last n iterations resulted in the same query that did not change the display, or some condition on the last input prevented the database from forming a valid query). At this point, the user can decide to disengage from the interaction, to continue in the same context no matter what (if possible), or to start a new context

(10.37)

All these possibilities correspond to alternative paths that the designer of the interface must consider.

More complicated situations arise when the user operates on different contexts at the same time, exchanging data between the two and using both contexts to create queries:

(10.38)

It may be useful sometimes to represent the same space in different places of the same diagram. In this case, the identity of the two representations of the same space will be marked either by using connectors, or by joining the symbols with a double line. The following diagram is therefore equivalent to the previous one:

(10.39)

10.2.4 Representation

The projection operator π represents the output space o on the display space D. In rather generic terms, a good projection should preserve the important structure of the space o. Unfortunately, in all but the simplest (and least interesting) cases, the spaces o and D are not isomorphic, so that part of the structure of o will inevitably be lost in the projection; in these cases the quality of a projection is represented by what it preserves. In terms of interface, the output of the operator π is a sign system, which represents the current status of the database, in terms that are written in the display space using the display sign system. Because of the crucial relation between structure and semiosis outlined in Chapter 2, a good representation should preserve, more than the nature of individual signs, the relation between signs.

The representation of the configuration of the output space is one of the most widely studied problems in complex human computer interfaces, and will be considered more in detail in section 10.4.

10.2.5 User Response

The composition space c is that of the possible user responses, and the map $u : \text{D} \to \text{c}$ represents the action of the user. The interesting issue here is the characterization of the relation between the display D and the composition system c. Ultimately, user interaction aims at reaching a configuration in the display space that satisfies the user, in particular, a configuration containing images that the user considers useful for the task at hand. One way of doing this would be for the user to intervene directly on the display, and to change its configuration in a way that better reflects her ideas. This requires that the space c coincide, at least in part, with the space D. I call the case in which c = D a *direct manipulation* interface.

In general, there will be a certain relation between c and D, but it will be weaker than complete coincidence. In the example of the query-by-example in the preceding, the three knobs for the selection of the distance measure are completely independent of the display space. The selection of the example image is a partial connection between the two, although such a connection is rather weak because the composition space does not share the most important structural characteristic of the display space, that is, containing a set of images ordered by score.

The situation can be described as follows:

$$
\begin{array}{ccc}
O & & Q \\
\big\lfloor & \overset{u^2}{\diagdown} & \big\rfloor \\
\text{D}^1 & & \text{C} \\
\underset{\text{D}^2}{\overset{\uplus}{}} \;\overset{u^1}{=\!=\!=}\; \underset{\text{D}^2}{\overset{\oplus}{}}
\end{array}
\tag{10.40}
$$

Here, part of the display (the sign system D^2) can be directly manipulated, and constitutes part of the composition space. A different component (D^1) is only displayed, and the user cannot manipulate it. Finally, part of the composition space

is disconnected from the display space altogether. In this interaction, the user action has been divided, for the sake of simplicity, into two parts—a direct manipulation u^2, and a user input u^1. The directness of the interaction is represented by the double line, indicating that part of the composition space is the same as part of the display space (the two D^2 symbols).

The question in this case is that of the mapping of the *structure* of the display. The display is a sign system that describes, to a certain degree, the configuration of the output space O. That is, a sign in $D = D^1 \uplus D^2$ is a translation, more or less faithful, and more or less abridged, of the configuration in O. A direct manipulation operation maps the structure of the subsystem D^2 into a component of the composition space C. In a situation such as that of the previous diagram, three things happen:

1. The structure of the subsystem D^1 is not mapped to any structure of the composition system;

2. the structure of the subsystem D^2 is preserved and mapped into the subsystem D^2 of the composition system; and

3. the structure of the subsystem C of the composition space is imposed by the user.

A good interface should maximize the second situation, and reduce the occurrence of the other two. The first situation represents a displayed structure that cannot be immediately transformed into action, while the third represents action that, in a sense, "floats" on the interface without being supported by an adequate displayed representation.

10.2.6 Querying

The result of user interaction is a configuration taken from the composition space. In the query-by-example interface, the configuration is the 4-tuple (id, w_c, w_s, w_t), where id is the unique identifier of the selected image, and w_c, w_s, w_t are the weights selected for the three query criteria. The query operator q uses the output of the selection to create a query drawn from the query space, which will be an expression in the query algebra of the database.

This translation might result in structural loss. Consider again the output of the query-by-example interface, and a database based on the Virage search engine, which was designed specifically to accommodate the kind of interface that I have been using as an example. In this case, the database query language is exactly the same as the composition space, that is, the set of 4-tuples (id, w_c, w_s, w_t). In this case, the configuration selected by the user can be translated into a query without any loss of structure.

However, consider now a hypothetical database with the following characteristics:

- Each image is described as a set of regions, each one described by its border, internal color histogram, and texture descriptor;

- similarity measures are defined separately for each of these features and for spatial relations, and they can be combined using a suitable similarity algebra such as that of section 8.2; and

- a query can be composed by an arbitrary set of images, and the similarity between a database entry and the query images can also be composed using similarity algebra operations.

In this database the configuration selected by the user cannot be immediately translated into a query, that is, some adaptation will be necessary. If the query algebra of the database permits the definition of weighted operators, the solution in this case could be to translate the weight selection in a weighted "and," defined using a weighting scheme such as that of section 8.2.5 (p. 407), and to use the selected image as the only query referent. In this case, the structure of the composition space would be maintained. The structural mismatch, however, would be in the other direction—the query language has considerably more structure (more operators, the possibility of defining a query using multiple referent images) than the composition space can use. From the point of view of the interface, this is not a serious functional problem, but rather a missed opportunity. The composition space could have been much richer in structure.

The situation is different if the query algebra does not permit the use of weighted operators. In this case an important structural component of the composition space (the weights, the associated data type, and the corresponding axioms) cannot be mapped to the structure of the database and will be lost. A certain part of this structure can be recovered using the properties of the query algebra. For instance, if the three weights that the user can manipulate are in the range $[0, 1]$, a limited amount of structure can be retained by translating the configuration in an *and* of all the criteria whose weight is above a certain value τ, discarding the other criteria.

10.2.7 Other Forms of User Dialog

The search for information is embodied in a prolonged interaction between the user and the database that can take different forms, generating dialogs of different complexity. The simple form of dialog that gives results sufficient for more traditional database application (which always includes two steps, that is, the user asks a question, and the database answers it) is woefully inadequate for the complex and imprecise queries proper of image (and, in general, multimedia) databases.

The dialog between an image database and a user consists in a multiplicity of actions, each one expressed in a specific sign system. These actions are not limited to the context-generation cycle of display and refinement, but can comprise a

multitude of types of act. A glimpse of the potential complexity of this dialog is given by diagram equation (10.37).

The overall dialog will consist of acts of different nature [Winograd and Flores, 1987] including, for instance:

- offers of the database to restart the interaction along other lines if the current context is leading nowhere;

- withdrawal from the interaction by the user;

- counteroffers by the database of alternative lines along which the search could be made;

- promise, by the database, that, even if the current line of search appears to be leading nowhere, there could be new developments in a few interactions; and

- offer by the database to bring in results obtained by other people.

All these modes of interaction should go under the control of a *dialog manager*, which would have at its disposal a number of *media* with which the conversation with the user can be carried on. Such media can include:

- context cycles, composed of a display and a way for the user to change the status of the display;

- tools to analyze the state of the interaction, and natural language generation tools to communicate this state to the user;

- ready-to-use explicative tools, for example, in the form of images or videos; and

- graphic animations generated online, for instance, and animation showing the evolution of the display up to a certain point.

The use of conversational techniques in human-computer interaction is a well-established discipline, and the subject will be touched on here only in passing. More information can be found in the literature [see, for instance, Stein and Thiel (1993)].

10.3 Query-by-Example

I have used the typical query-by-example interface in the previous sections as a matter of exemplification; in this section, I will put together the observations I have already made with some new ones in order to conduct a more complete analysis of the interface. I will make reference specifically to that as a prototypical example. Although the kind of interface that I am considering here has had many

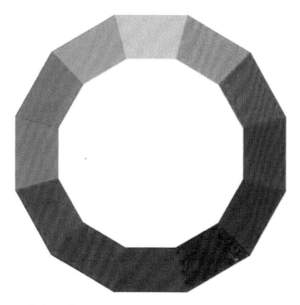

Color plate 1. The Runge-Itten color circle.

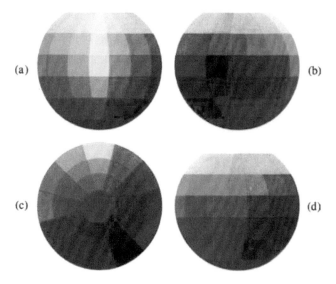

Color plate 2. The Itten color sphere; (a) and (b) are views of the surface of the sphere; (c) is a horizontal section at the equator. Each of the concentric circles is a Runge-Itten circle of different saturation; (d) is a vertical section of the sphere with a plane through the z-axis, cutting the sphere from the red-orange to the blue-green sector. J. Itten, *The Art of Color*, 1961 and reprinted by permission of John Wiley & Sons, Inc.

Color plate 3. Image database interface.

Color plate 4. Image database interface with selection by dimming.

Color plate 5. Image database interface with selection by size increase.

Color plate 6. Image database interface with fish-eye display.

Color plate 7. Image database interface with fish-eye display.

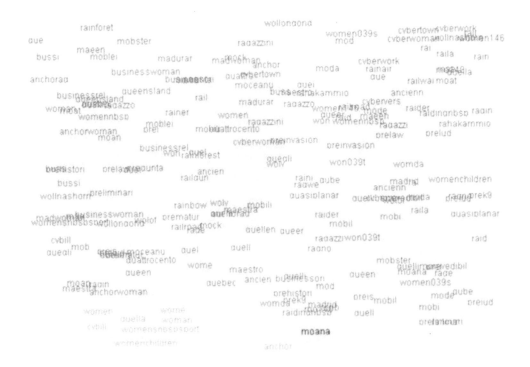

Color plate 8. Image database text interface.

more or less complex embodiments in the past, the basic principles appear to be the same.

The general diagram of this interface is that typical of an iterative interface:

$$(10.41)$$

In order to analyze its functions, I will begin by following the structure of the relevant sign systems that, from the point of view of this analysis, are the output system O, the display system D, and the composition system C.

The output system is

$$O = \{T_0, \leq_0, F_0, A_0\} \qquad (10.42)$$

where

$$T_0 = \{\text{id} \triangleright \mathbb{N}, \text{ord} \triangleright \mathbb{N}, \rho \triangleright [0,1], \Sigma : \text{id} \times \text{ord} \times \rho, \chi : \{\Sigma\}\} \qquad (10.43)$$

The first data type is that of image identifiers, the second data type is that of the image order, and the third is that of the image scores. The data type Σ is that of a single image in the output configuration, while χ is the data type of a *configuration* of images. The ordering relations between the data types are the following:

$$\begin{aligned} \text{id} &\leq_0 \Sigma \\ \text{ord} &\leq_0 \Sigma \\ \rho &\leq_0 \Sigma \\ \Sigma &\leq_0 \chi \end{aligned} \qquad (10.44)$$

The set F_0 contains the following functions:

$$f_i : \Sigma \to \text{id} \qquad (10.45)$$

which assigns an identifier to each image sign;

$$f_o : \Sigma \to \text{ord} \qquad (10.46)$$

which assigns an *order position* to image sign;

$$f_\rho : \Sigma \to \rho \qquad (10.47)$$

which assigns a score to each image sign. The set A_0 contains the following axioms:

$$\begin{aligned} &\forall \sigma_1 : \Sigma, \sigma_2 \in \Sigma, \sigma_1, \sigma_2 \in \chi \\ &a_1 : \sigma_1 \neq \sigma_2 \Rightarrow f_i(\sigma_1) \neq f_i(\sigma_2) \\ &a_2 : \sigma_1 \neq \sigma_2 \Rightarrow f_o(\sigma_1) \neq f_o(\sigma_2) \\ &a_3 : f_\rho(\sigma_1) > f_\rho(\sigma_2) \Rightarrow f_o(\sigma_1) < f_o(\sigma_2) \end{aligned} \qquad (10.48)$$

and

$$a_4 : \ \forall n \ (\exists \sigma \in \chi : f_o(\sigma) = n \Rightarrow \forall n' < n \ \exists \sigma' \in \chi : f_o(\sigma') = n') \qquad (10.49)$$

Axiom a_1 states that different images have different identifiers, that is, each image of the database is represented at most once in the interface; a_2 states that different images have different ordering numbers; a_3 states that images with lower ordering numbers have higher scores (a_2 and a_3 together assert that the ordering numbers sort the images by a score); a_4 states that the ordering is without "holes," that is, all the positions up to a certain maximum value are filled with an image.

The display system D of a query-by-example database is composed of a browser with a number of images (9, in the example that I used earlier in this chapter) and three cursors to determine the relative weights of three similarity criteria. The three weights do not really tell anything about the output space o, and I will leave them aside for the moment. I will return to them later while discussing the configuration space. The display sign system can therefore be modeled as follows:

$$D = \{T_D, \leq_D, F_D, A_D\}. \qquad (10.50)$$

The types set T_D is defined as

$$T_D = \{\text{img} \triangleright \textit{unit}, \text{id} \triangleright \mathbb{N}, \text{ord} \triangleright \{(1,1) \ldots, (3,3)\},$$
$$\text{s} \triangleright \textit{si} : \text{img} \times \textit{sid} : \text{id} \times \textit{sr} : \text{ord}, \mathfrak{g} \triangleright [q_{ij} : \text{s}, i, j = 1, 2, 3]\} \qquad (10.51)$$

(The symbol s is a short for "slot"—identifying a slot in the interface—and \mathfrak{g} is a short for "group"—identifying the group of images that form the top-level type of the interface, and from which the signs that are proposed to the user are drawn.) The set \leq_D contains the following ordering relations:

$$\text{id} \leq_0 \text{s}$$
$$\text{ord} \leq_0 \text{s} \qquad (10.52)$$
$$\text{s} \leq_0 \mathfrak{g}$$

The function set F_D contains the following functions:

1. The selectors of the slot data type s that, given a slot, return the image in that slot, its identifier, and its order number. Following a convention common in computer science, I will use the "dot" notation to indicate selectors; if $a : \text{s}$, then its selectors and the relative data types are $a.id$: id, $a.img$: ing, $a.ord$: ord;

2. the selectors of the group sign; if $g : \mathfrak{g}$, then $g.[i,j] : \text{s}$; and

3. the structure functions for the grid (see p. 522)

$$\text{ngb} : \mathbb{N}^2 \times \mathbb{N}^2 \rightarrow \text{Boolean} \qquad (10.53)$$

and

$$\text{nxt} : \mathbb{N}^2 \to \mathbb{N}^2 \tag{10.54}$$

that determine if two locations in the grid of the browser are neighbors and the location of the next image, in left-to-right, top-to-bottom order.

The axioms for this system are:

a_1: for all i, j, h, k, $\text{ngb}((i,j),(h,k))$ iff

$$(i = h \land |j - k| = 1) \lor (|i - h| = 1 \land j = k) \lor \tag{10.55}$$

$$(i = h + 1 \land j = 1 \land k = 3) \lor (i = h - 1 \land j = 3 \land k = 1) \tag{10.56}$$

a_2: $\text{nxt}(i,j) = \left(i + \langle \frac{j+1}{3} \rangle, j + 1 \pmod 3\right)$

a_3: $g.[u,v].id = g.[h,k].id \Rightarrow u = h \land v = k$

a_4: $\text{nxt}(i,j) = (u,v) \Rightarrow f_\rho(g.[i,j].img) \geq f_\rho(g.[u,v].img)$

a_5: $\forall im' : img\, (\exists u, v : f_\rho(im') > f_\rho(g.[u,v].img)) \Rightarrow \exists i, j : im' = g.[i,j].img$.

Note that axioms a_3 and a_4 contain the function f_ρ defined for the output system. They represent the structure-preserving properties of the interface. A more formal way to define these properties would have been to define an independent score function for the display system, say, f_ρ', and then to impose on the morphism $M : \text{O} \to \text{D}$ the property $M(f_\rho) = g \circ f_\rho'$, where g is a monotonically increasing function.

In order to determine the relation between the display and the composition system, it is useful to divide the display into two sign systems—a system D^2 containing sets of nine images, and a system D^1 of possible orderings of nine elements.

The component D^1 is not directly translated into a composition. The component D^2 is *partially* translated into the composition—the composition space, in fact, contains *one* image (the referent) drawn from D^2. The direct manipulation interface is not, in this case $\text{D}^2 \longrightarrow \text{D}^2$, but $\text{D}^2 \longrightarrow \text{C}^2 \subset \text{D}^2$ (C^2 is isomorphic to the subspace of D^2 composed of sets in which all the images are the same). The remaining part of the composition space is $[0, 1]^3$, that is, the set of all possible positions of the three knobs. The interaction component of the query-by-example interface can be represented as

$$\tag{10.57}$$

This diagram is a bit misleading in that it indicates that the user input u^2 is completely uncorrelated with the content of the display space. This is certainly not true—some kind of *cognitive mapping* between the contents of the display space

and the necessary input to the composition space takes place. The diagram tries to convey the message that this mapping is not as direct as a simple manipulation of the display space, or constrained to certain activities determined by the display space, as the selection of one of the images displayed. A cognitive connection such as u^2 is often very indirect, and can require special training or a rather deep knowledge of the working of the database system (as does the decision regarding which of the available similarity criteria should be modified in order to bring the results closer to the desired response).

The semiotic morphism between the display system D and the composition system C preserves very little of the structure of the display. The only component that is transferred from one to the other is a single image (the image that the user selects as the next example) that is, a sign of type img. The types s and g are lost, and so are the functions on these types and the axioms a_1, a_2, and a_5. Axiom a_3 (unicity) is trivially true, as now the system contains a single image. Axiom a_4 is preserved in the weaker axiom of the C system

$$|\{i \in 0 : s(i) > s(i^*)\}| \leq 8 \tag{10.58}$$

where i^* is the selected image. This axiom states that, given a selected image, there are at most eight images closer to the current query than that image.

The other component of the composition space C contains two types: val \triangleright unit and weights \triangleright val^3, with val \leq weights. Its axioms state that each val is between 0 and 1.

The main problem of this type of interface derives from this structural mismatch. Much of the structure of the display space does not automatically translate into a corresponding structure of the composition space. Additionally, a significant portion of the structure of the composition space has to come from the user.

10.4 Representation Techniques

From the query-by-example interface of the previous section, it is clear that an interface rests primarily on two semiotic morphisms—that between the outputs system and the display system ($M : 0 \rightarrow$ D), and that between the display system and the composition system ($M' : $ D \rightarrow C). The first one is a "reading" of the output space, while the second is a "speech" to the configuration space describing the desires of the user. In this section I will consider techniques for the representation of the output space.

Before doing this, it is important to realize that the structure of the display system will depend, at least in part, on that of the output space. An output space extremely poor in structure cannot be used as the starting point of a highly structured display space. For instance, if the output space contains (as is the case with relational databases) simply an undifferentiated set of results, the best thing that the display space can do is to show the elements of this set, possibly with a no-

tation that reveals something of the internal structure of the elements (which is also part of the output space, of course).

In image databases, the structure of the output space is richer, including, for example, the distance between images. Its seems reasonable to include part of this geometric structure in the display. In the output space, these geometric characteristics are encoded into the distance between pairs of images—two images very close to each other will be very similar for the current query, while two images far away from each other will be very dissimilar. This kind of information is richer than the ordered set of relevant images returned by the browser in the interface of the previous section. It should give the user not only the possibility to see what images the database is considering as relevant but, to a certain degree, *why* (that is, on the basis of which interpretation of similarity) are such images considered similar.

The usefulness of placing images into a metric space comes from the possibility of defining clusters, and from the *cluster hypothesis* (van Rijsbergen (1979); see also Chapter 7): "Closely associated documents tend to be relevant to the same requests." The association of images in the output space should satisfy a "query cluster" hypothesis of the same nature but slightly more specialized. In information retrieval the association is a priori, in this output space it is given by the query (that is, it is *a posteriori*); the association in the output space indicates similar relevance for the current query and for queries similar to the present one. The latter is what makes clustering in the output space important for interactive applications. When a query is iteratively modified, the changes from one iteration to the next are generally very small, so that the cluster structure of the output space at one given time provides indications on the relevance of the images to the next iterations of the process. In other words, clustering can provide indications on the best way to modify the query.

More formally, the output space will be in this case a system

$$\mathbb{O} = \{\mathbf{T}_0, \leq_0, \mathbf{F}_0, \mathbf{A}_0\} \tag{10.59}$$

where

$$T_0 = \{\mathrm{id} \rhd \mathbb{N}, \mathrm{ord} \rhd \mathbb{N}, \Lambda \rhd \{l_i\}, \Sigma \rhd n : \mathrm{id} \times \lambda : \Lambda \times r : \mathrm{ord},$$
$$D \rhd \Sigma \times \Sigma \to \mathbb{R}^+, \chi \rhd s : \{\Sigma\} \times f : D\} \tag{10.60}$$

The data types id, ord, and Σ are the same as the data types of the output system equation (10.42); Λ is a finite set of cluster labels, and the λ component of an image type keeps track of the cluster to which it belongs. The data type D is that of the distance functions between images. The configuration χ is composed of a set of images and a distance function between them.

The ordering relations between the data types are the following:

$$\mathrm{id} \leq_0 \Sigma, \ \mathrm{id} \leq_0 D, \ \mathrm{ord} \leq_0 \Sigma, \ \rho \leq_0 \Sigma \tag{10.61}$$

$$\Sigma \leq_0 D, \ \Sigma \leq_0 \chi, \ D \leq_0 \chi \tag{10.62}$$

The set F_0 contains the selectors on img: $i.id$, $i.r$, and $i.\lambda$ (which assign to an image its identifier, order number, and cluster number) and the function dst, which computes the distance between two images according to the current distance function:

$$\text{dst}(i_1 : \Sigma, i_2 : \Sigma, c : \chi) = c.f(i_1, i_2) \qquad (10.63)$$

Most of the projection techniques presented in the following require that the output space be a vector space while the sign system o only has a metric structure (the configuration element $\chi.f : D$). The metrics of the output space, however, can be used to embed it in a vector space, at least approximately, using techniques presented in the previous chapters, for example, multidimensional scaling or FastMap. To this end, I will add another function to the set, the function

$$\eta : \Sigma \to \mathbb{R}^n \qquad (10.64)$$

which will embed the output space in a vector space \mathbb{R}^n, for some suitable dimension n.

The axioms include the usual unicity and ordering axioms, as well as the axioms typical of the distance function. In addition, there are clustering axioms, which state that images belonging to the same cluster are "closer" to each other than images in different clusters. These axioms are not easy to express because clustering itself is an imprecise operation. The following set is not necessarily exhaustive or even optimal, but it will suffice for the following discussion.

Before writing the axioms, I will define a few auxiliary functions. Given a label $l_i \in \Lambda$, let $I(l_i, C)$ be the set of images in a configuration C whose cluster label is equal to l_i, that is,

$$I(l_i, C) = \{s : \Sigma \in C : \chi | s.\lambda = l_i\} \qquad (10.65)$$

The function d_i computes the average intracluster distance between the images of the configuration C that belong to the cluster l_i:

$$d_i(l_i, C) = \frac{1}{|I(l_i, C)|^2} \sum_{s \in I(l_i,C)} \sum_{s' \in I(l_i,C)} C.f(s.id, s'.id) \qquad (10.66)$$

The function d_e computes the average intercluster distance between images in the cluster l_i and images in the cluster l_j:

$$d_e(l_i, l_j, C) = \frac{1}{|I(l_i, C)||I(l_j, C)|} \sum_{s \in I(l_i,C)} \sum_{s' \in I(l_j,C)} C.f(s.id, s'.id) \qquad (10.67)$$

The following axiom states that for each cluster l_i, the average intercluster distance is less than the average distance between that cluster and any other cluster:

$$a_1 : \quad \forall l_i \in \Lambda \ \ \forall l_j \in \Lambda \ \ d_i(l_i, C) < d_e(l_i, l_j, C) \qquad (10.68)$$

A good display o should represent the structure of the output space. In particular, it should represent the distance function f and the cluster structure given by the labels λ.

The idea, therefore, is to display a *configuration* of images on the screen in such a way that the distance between images will reflect their distance in the output space. The display in this case must allow the representation of distances, for example, by using the physical distance between the representation of images on the surface of the screen. This solution will allow not only the images that better satisfy the query to be shown but, at the same time, the relations between them and thus to place them in context.

Because the screen is a flat two-dimensional surface, a two-dimensional display is a rather natural solution that allows one to map distances in the output space directly to distances on the screen (to the extent that this is possible, as will be discussed shortly).

In some cases, one might decide to devise different mappings. For instance, a "three-dimensional" display maps distances between points in the output space to distances between points in a three-dimensional space, and then projects this configuration on the two-dimensional screen. Note that the final display is, of course, still two-dimensional (as this is the physical dimensionality of the output device). The display is called three-dimensional because the second transformation—the projection—is fixed and independent of the data so that the "real" semiotic morphism is between the output space and the three-dimensional display. I will consider, for the moment, "pure" two-dimensional displays.

A two-dimensional *configuration display* can be defined as

$$D = \{T_D, \leq_D, F_D, A_D\} \tag{10.69}$$

The types set T_D is defined as

$$T_D = \{img \triangleright unit, id \triangleright \mathbb{N}, pos : \mathbb{R}^2,$$
$$\mathfrak{s} \triangleright i : img \times n : id \times x : pos, \mathfrak{g} \triangleright w : \{\mathfrak{s}_i : i = 1, \dots N_D\}\} \tag{10.70}$$

The configuration in this case is composed of N_D images which, in general, correspond to the first N_D images of the output space sorted by order value. The set F_D contains the selectors that assign to an image its identifier and the function that computes the physical distance between the representations of two images on the screen, using their position:

$$d(a : \mathfrak{s}, b : \mathfrak{s}) = \left[(a.x_1 - b.x_1)^2 + (a.x_2 - b.x_2)^2\right]^{1/2} \tag{10.71}$$

Note that in this display there is no *physical* indication of clustering (such as a color or a mark that indicates, for each image, to which clusters it belongs). There can, of course, be some *induced* representation of clustering, in the sense that the representation can be such that clusters in the output space translate into clusters in the display space.

The semiotic morphism between output and display transforms the χ-configuration of the output space into the \mathfrak{g}-configuration of the display space. The operations of this semiotic morphism are quite obvious, with one exception: the transformation $M(dst) = d$ is that which preserves the crucial information

about the output space. This transformation determines the $x : pos$ component of images. In other words, images are placed in the interfaces in such a way that their distance should reflect as well as possible the distance of the corresponding images in the output space.

10.4.1 Spring Embedding

The most immediate solutions involve determining the position of the representations on the screen in such a way that the distances resulting from the current configuration of the output space will be optimally approximated in a functional sense. The *current distances* in the output space are given by the matrix

$$D_{ij}^{\chi} = \mathrm{dst}(i_1, i_2, \chi) \quad i_1, i_2 \in \chi.s \tag{10.72}$$

The semiotic morphism $M(\Sigma) = \mathfrak{s}$ generates a transformation of an image i_k into a screen representation $\mathfrak{i}_k = M(i_k)$ whose position is set in a way that, together with all the images in the configuration, will minimize the discrepancy between the distances D_{ij}^{χ} and the distance between screen representation. That is, the positions are set so as to minimize a suitable p-norm:

$$E_p(\chi) = \left[\sum_{hk} (D_{hk}^{\chi} - d(\mathfrak{i}_h.x, \mathfrak{i}_k.x))^p \right]^{1/p} \tag{10.73}$$

The most common case is that in which $p = 2$, which is also known as *spring embedder* [Leouski and Allan, 1998] because it simulates an hypothetical physical situation in which the representations \mathfrak{i}_h and \mathfrak{i}_k are joined by a spring with rest length D_{hk}^{χ}, and the system is left to relax to the configuration of minimal energy.

This solution is optimal from the mathematical point of view, but not necessarily from the structural point of view. Perceptually, in fact, the clustering structure of a space appears more important than the pure mathematical optimization. It is generally more informative to have a mathematically less precise display that preserves more of the clustering structure of the output space rather than a mathematically more precise display in which such structure is lost. The question then is how well does this form of mathematical optimization map the cluster structure (if any is present) of the output space? Consider a hypothetical case of a four-dimensional feature space in which data are divided into a certain number of clusters. Figure 10.4 shows three displays obtained minimizing Eq. (10.73). The output space has four dimensions, and the data are distributed in 4, 8 and 16 clusters placed at the corners of the unit cube in \mathbb{R}^4. It is evident from the figures that, as the number of clusters increases, the representation is no longer adequate to display them. Already in the case of eight clusters, not all the clusters are clearly individuated in the display; in the case of 16 clusters very little of the structure of the output space is preserved in the display.

 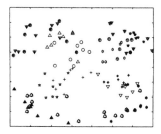

Figure 10.4. Projection from a four-dimensional space to a two-dimensional space using spring embedder. The clusters are placed at the corners of the unit cube in \mathbb{R}^4.

The spring embedder optimization also has the drawback of being a rather slow iterative process, a considerable problem in interactive applications in which responsiveness is of paramount importance.

One possibility to reduce the computational cost of spring embedding is to reduce the number of springs. This is possible based on the observation that what one really needs in an interface is to maintain the "short distance" relation between elements, which is responsible for much of the cluster structure of the output space. The relative positioning of images far away from each other is relatively unimportant. It is therefore convenient to attach the springs only between those pairs of elements that in the output space are closer than a certain threshold t, usually expressed as a fraction of the maximum distance between two elements. Let $\overline{D}^\chi = \max D_{hk}^\chi$ be the maximal distance between two elements of the configuration χ, and define the set

$$Q(t) = \{(h, k) : D_{hk}^\chi \le t \cdot \overline{D}^\chi\} \tag{10.74}$$

The optimization problem equation (10.75) then becomes:

$$E_p(\chi) = \left[\sum_{hk \in Q(t)} \left(D_{hk}^\chi - d(i_h.x, {}_{ik}.x)\right)^p \right]^{1/p} \tag{10.75}$$

In addition to being computationally more efficient, this "partial spring embedding" method often creates better displays in which the cluster structure of the output space is more evident. Intuitively, one can say that, not having to be concerned with maintaining the distance between faraway clusters or images, the optimizer has a greater freedom to place the elements in such a way that neighboring clusters will be well separated on the screen. Figure 10.5 shows a two-dimensional representation of the same data as Fig. 10.4 using partial spring embedding with thresholds $t = 0.1$ and $t = 0.01$. Of course, it can happen that two faraway clusters, whose relative position is not constrained in the cost function, will end up very close to each other, or even one on top of the other. In practice, this problem is less evident than the loss of structure caused by the presence of all the strings, and can be minimized by a good choice of the threshold t, which is the real *punctum dolens* of the whole procedure.

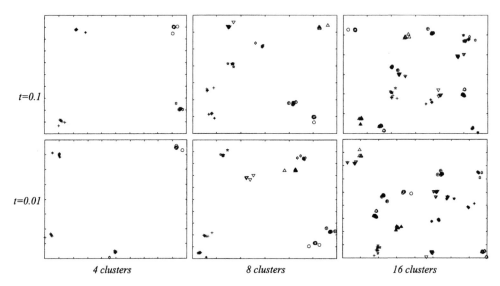

t=0.1

t=0.01

| 4 clusters | 8 clusters | 16 clusters |

Figure 10.5. Projection from a four-dimensional space to a two-dimensional space using partial spring embedding. The first row uses a threshold $t = 0.1$, the second row uses $t = 0.01$. The clusters are placed at the corners of the unit cube in \mathbb{R}^4.

Measuring the structure. One would like to select the threshold t in such a way that the display will have "structure." This generates the following problem: How is one to measure the structure of a display? Or, equivalently, how is one to measure the amount of structure that the projection operator ($\pi : 0 \to D$) preserves?

This issue is very general, and its importance goes well beyond the selection of a threshold for spring embedding. I will introduce some general principles in the context of spring embedding, and later expand on these principles and define structure-measuring functionals for other applications.

Consider a two-dimensional output space with points distributed as in Fig. 10.6, and assume that the display space is one-dimensional. The question is: What is the one-dimensional space that preserves most of the structure of the two-dimensional output space?

There are essentially two possibilities, namely, a projection on the horizontal axis or a projection on the vertical axis. The projection on the horizontal axis

Figure 10.6. Toy example of a two-dimensional output space.

(a) maximum variance

(b) maximum nonuniformity

Figure 10.7. Two possibilities for the one-dimensional projection and the resulting displays.

(Fig. 10.7) maximizes the *variance* of the resulting display, that is, it gives the most information on the location of the points. This is the optimization criteria used by dimension-reduction methods such as singular-value decomposition that I have used several times in the previous chapters. The display of Fig. 10.7a minimizes the error that one commits by ignoring the additional dimension, but the resulting display is uniform, while the two-dimensional display is not. The vertical projection (Fig. 10.7b) gives a much worse representation of the positions of the individual images, but it captures an essential element of the two-dimensional space—the fact that the points are divided into two groups. Among all the one-dimensional projections of the original points, this is the one that differs the most from a uniform distribution. In other words, the vertical projection is obtained by *maximizing nonuniformity*. A criterion that maximizes nonuniformity, therefore, would favor the most structured vertical projection over the less structured horizontal. Other criteria, that I will introduce in the following, will not maximize nonuniformity, but *nonnormality*, that is, they will favor the configuration that deviates the most from a normal distribution.

A first measure of the spatial nonuniformity of data can be derived from the theory of point processes [Stoyan and Stoyan, 1994] Consider a configuration of points in an n-dimensional metric space, with a distance function d. Let λ be the average number of points per unit volume (the *intensity* of the point field), and $N(h)$ be the number of points within a distance h of a randomly chosen point. Bartlett's K function [Bartlett, 1964] is defined as

$$K(h) = \lambda^{-1}E(N(h)) \tag{10.76}$$

The function $K(h)$ measures the local concentration of points at a distance h from a certain point. It can be shown that the function K has properties that make it an effective measure of the spatial dependencies of a point field [Ripley, 1977]; in a word, of its structure. If $K(h)$ is high, there are more points close to an arbitrary point than the average intensity of the field would make one think, that is, there are clumps or clusters of points in the field. On the other hand, if the value of $K(h)$ is low, there are fewer points close to an arbitrary point that the average intensity would call for. In this case there are holes, or gaps, in the field.

The function K can be used to measure the difference in structure between two point fields. In order to transform it in an absolute measure, it is necessary to choose a reference distribution so that the function K of an arbitrary distribution will be compared with that of the chosen distribution. A good choice for the completely unstructured point field is the Poisson field, in which a point has equal probability of being in any location of the display space, subject to the constraint that no two points can be in the same location. The function K for a Poisson field is given by

$$K_P(h) = \frac{\pi^{n/2}}{\Gamma(1 + \frac{n}{2})} h^n \qquad (10.77)$$

where n is the dimensionality of the space, and Γ is Euler's function. For ease of comparison, it is also customary to use the following function of K, rather than K itself:

$$L(h) = \sqrt{n} \frac{\Gamma(1 + \frac{n}{2})}{\pi^{n/2}} K(h) \qquad (10.78)$$

which, for the Poisson distribution, gives $L_P(h) = h$. When, for a given distribution, $L(h) > h$, there are clusters, while when $L(h) < h$ there are gaps. The test variable

$$\tau = \max_{h < h_0} \frac{|L(h) - h|}{h} \qquad (10.79)$$

is used to test the amount of structure in the display, where h_0 is the maximal interpoint distance. The definition of $K(h)$ given in Eq. (10.76) applies to a continuous distribution. If, as it is usually the case, the display is given as a finite set of points, the expectation in Eq. (10.76) should be replaced by the sample average, and the intensity λ with the estimator $\hat{\lambda} = N/v$, where v is the volume of the display. Defining the function $I(x)$ as 1 if x is true, and 0 if x is false, the estimator for K can be expressed as

$$\hat{K}(h) = \frac{v}{N} \sum_{i=1}^{N} \sum_{\substack{j=1 \\ j \neq i}}^{N} \frac{1}{N} I(d(s_i, s_j) < h) \qquad (10.80)$$

Figure 10.8 shows the behavior of the value τ for the output space and for the display space as a function of the number of clusters for the examples shown previously. The structure in the output space remains more or less the same, while the structure in the display degrades sensibly as the number of clusters increases. Figure 10.9 shows the shape of the function $L(h)$ as a function of h for the three cases of 4, 8, and 16 clusters. When thresholding is added to spring embedding, things improve considerably. Figure 10.10 shows the behavior of the value function τ for spring embedding with thresholds $t = 0.1$ and $t = 0.01$. Note that, in this case, the display space maintains the structure even with a higher number of clusters.

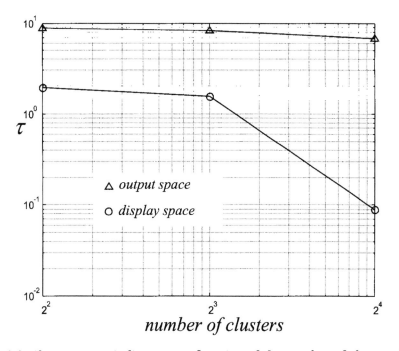

Figure 10.8. The structure indicator as a function of the number of clusters for the case of spring embedding without threshold.

10.4.2 Projection Pursuit

It is possible to obtain more efficient methods for projecting the output space into the display by restricting the family of allowed projections. A simple and powerful family of projections is given by *linear* projection. If the output space is an n-dimensional vector space, and the display space is two-dimensional, then a linear projection is defined as a $2 \times n$ matrix Π, and the projection of the point $x \in \mathbb{R}^n$ is the two-dimensional vector Πx.

Much like the positions of the points in spring embedding, a linear transform is sought that maximizes some suitable objective function. Let X be the set of

Figure 10.9. The behavior of the function $L(h)$ for the case of 4, 8, and 16 clusters.

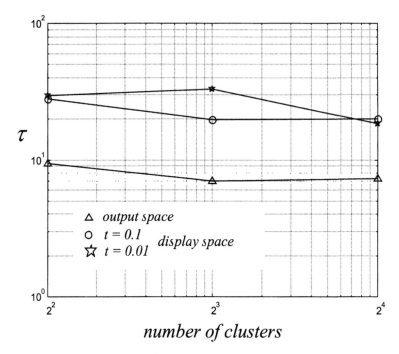

number of clusters

Figure 10.10. The structure indicator as a function of the number of clusters for the case of spring embedding with thresholds $t = 0.1$ and $t = 0.01$.

points in a suitable vector representation of the output space, that is,

$$X = \{\eta(q) : q \in \chi.s\} \subset \mathbb{R}^n \tag{10.81}$$

and let ΠX be their projection on the display space. The projection matrix Π is determined in a way that maximizes a *projection index* $Q(\Pi X)$. Projection indices can be of various types, generating different kinds of projections. For instance, if $Q(\Pi X)$ is the variance of the distribution on the display space, the resulting projection Π coincides with that determined using singular value decomposition. The inconvenience of maximizing the variance for display projections was outlined briefly in the previous section. In this section, I will consider a different technique, called *projection pursuit*, in which the cost functional Q is chosen so as to maximize the *nonnormality* of the resulting distribution [Huber, 1985].

Projection indices. As in [Huber, 1985], I will consider three classes of projection indices, classified by their covariance and invariance properties.

Class I: location and scale covariance. This class contains functions for which it is

$$Q_I(sX + t) = sQ_I(X) + t \tag{10.82}$$

Class II: location invariance, scale covariance:

$$Q_{II}(sX + t) = sQ_{II}(X) \tag{10.83}$$

Class III: affine invariance:

$$Q_{III}(sX + t) = Q_{III}(X) \tag{10.84}$$

Note that the absolute difference of two class I functions is a class II function:

$$|Q_I(X) - Q_I'(X)| = Q_{II}(X) \tag{10.85}$$

and the quotient of two class II functions is a class III function:

$$\frac{Q_{II}(X)}{Q_{II}'(X)} = Q_{III}(X) \tag{10.86}$$

Class I functions are location estimators, and are of little interest in this context. Principal components analysis and singular value decomposition are typical examples resulting from the application of Class II functions. In particular, the functional $Q(\Pi X) = Cov(\Pi X)$ is maximized by projecting on the directions of the principal eigenvectors of the covariance matrix of X.

Projection pursuit is based on Class III functions based in part on the intuitive notion that a visually interesting display is so, independently of the scale at which it is seen and therefore whatever property it is that makes a display interesting, it should possess affine invariance. The heuristics on which projection pursuit is based is that a projection is less interesting the more normal it is; the central limit theorem says that the convolution of two distributions is "more normal" (and therefore less interesting) than the less normal among the two distribution. Therefore, it is desirable that the projection index Q satisfies the following condition:

DEFINITION 10.7. *The projection index Q is a nonnormality measure if, given two independent random variables X and Y with finite variance, it is*

$$Q(X + Y) \leq \max(Q(X), Q(Y)) \tag{10.87}$$

All examples of functionals Q reported in Huber (1985) are of the form

$$Q(X) = h\left(\frac{S_1(X)}{S_2(X)}\right) \tag{10.88}$$

where h is a monotonically increasing function, and S_1, S_2 are Class II functions satisfying

$$S_1^2(X + Y) \leq S_1^2(X) + S_1^2(Y) \tag{10.89}$$

and

$$S_2^2(X + Y) \geq S_2^2(X) + S_2^2(Y) \tag{10.90}$$

From these relations and from the inequality

$$\frac{a + c}{b + d} \leq \max\left(\frac{a}{b}, \frac{c}{d}\right) \tag{10.91}$$

valid for positive real numbers, the property of Definition 10.7 follows easily.

A number of functionals satisfy these conditions. It will be easier to introduce them if the output and the display spaces are considered for a moment as continuous probability distributions. Assume that the elements X in the output space are a sample from an underlying probability distribution F_0. A linear projection A will transform these points into the display configuration $Y = AX$ and, correspondingly, will transform the probability distribution F_0 in a probability distribution F_D of which Y is a sample. Let f_0 and f_D be the corresponding probability densities. The projection indices can then be expressed as functionals on the probability density f_D, that is, as functionals that try to maximize the structure in f_D.

The most widely used projection index is the *Shannon entropy*, defined as

$$\mathcal{I}(f) = \int_{-\infty}^{\infty} f(x) \log f(x)\, dx \tag{10.92}$$

It can be shown that, for a given mean and variance of the data, this functional is minimized by the normal distribution. Most projection pursuit algorithms define $Q(f_D) = \mathcal{I}(f_D)$.

Huber (1985) studied a number of such functionals, among them the standardized Fisher information

$$Q(f) = \int f(x) \left(\frac{f'(x)}{f(x)} \right)^2 dx \tag{10.93}$$

but, in the following, I will only consider Shannon entropy. The functional depends on the probability density in the display space f_D, but one usually has only the projected points. If there are N points in the output space, in the display space these are represented by the projected matrix $Y = AX$, which is an $N \times 2$ matrix. The density of the underlying distribution can be approximated with the help of a kernel K as

$$\hat{f}_D(x) = \frac{1}{Nh} \sum_{i=1}^{N} K\left(\frac{x - Y_{i,\cdot}}{h} \right) \tag{10.94}$$

where $Y_{i,\cdot}$ is the ith row of the matrix Y (that is, the coordinates of the ith point). The kernel K can be any positive function localized around zero. I use the exponential kernel

$$K(x) = \exp(-\|x\|^2) \tag{10.95}$$

The sum in \hat{f}_D accumulates the values of $K(x)$ in the areas dense with points, while it accumulates much less in the areas in which the points are more sparse. With this approximation of the probability density, it is possible to evaluate the function $Q(\hat{f}_Y)$ for the configuration of points resulting from a given projection matrix A, and write the projection index function

$$C(A) = Q(\hat{f}_{AX}) = \int \hat{f}_{AX}(u) \log \hat{f}_{AX}(u)\, du \tag{10.96}$$

The resulting optimization problem can be solved by any known method (see Press *et. al.* (1986) for examples). The most expensive part of the resulting algorithm

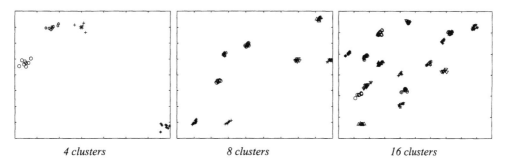

4 clusters	*8 clusters*	*16 clusters*

Figure 10.11. Projection from a four-dimensional space to a two-dimensional space using projection pursuit.

is the computation of the integral in Eq. (10.96). In practice, the integral can be replaced with a summation taken over a suitable set of points x_i without too much degradation in the quality of the display[6], resulting in the optimization problem

$$\hat{C}(A) = \sum_{u_i=1}^{M} \hat{f}_{AX}(u_i) \log \hat{f}_{AX}(u_i) \tag{10.97}$$

Figure 10.11 shows displays obtained using projection pursuit and the same data used for Figs. 10.4 and 10.5. The τ function for projection pursuit is shown in Fig. 10.12. As in the case of partial spring embedding, the structure in the output space is fairly constant, independently of the number of clusters.

10.4.3 Clustering in the Output Space

The previous techniques considered the set of elements in the output space as an undifferentiated set, that is, they made no use of the cluster label λ. The figures presented in the previous section did show different symbols for elements belonging to different clusters, but this was done only in order to show how the clusters were preserved in the display; the algorithms themselves made no reference to the cluster label of the data in the output space. If the data are clustered in the output space, however, it is possible to use the clustering information to create a *cluster-based* projection.

Consider a clustered output space in which an image $q : \Sigma$ has cluster number $q.\lambda$ and position $\eta(q)$. Let

$$S(a) = \{q : q.\lambda = a\} \tag{10.98}$$

[6] There may be, of course, some degradation in the quality of the display as a consequence of this approximation. The designer, however, should always weigh this against the gain in the responsiveness of the system, keeping in mind that, as usual, in a reactive system a short response time can be more important than a better quality display.

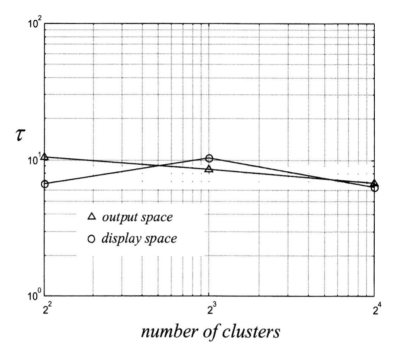

τ

Figure 10.12. The structure indicator as a function of the number of clusters for projection pursuit.

be the set of images in the cluster a. The center of the cluster is given by

$$c(a) = \frac{1}{|S(a)|} \sum_{q \in S(a)} \eta(q) \tag{10.99}$$

The centers of the clusters can be considered as the elements of a "cluster space," and the projection techniques presented in the previous section can be applied to the configuration composed of the cluster centers.

Spring embedding. Spring embedding does not determine a global transformation from the output space to the display space, but it does determine the positions of the images one by one. Therefore, in order to apply it to clustered output spaces, it is necessary to resort to a two-step process. First, a spring-embedding cost function is minimized to find the optimal placement of the centers of the clusters in the display space. If $\Delta_{a,b} = d(c(a), c(b))$, that is, the distance between the centers of the clusters $S(a)$ and $S(b)$ in the output space, then the positions of the centers of the clusters $\pi(a)$ in the display space are chosen to minimize

$$C(\pi) = \left[\sum_{a,b} (\Delta_{ab} - d(\pi(a), \pi(b)))^2 \right]^{1/2} \tag{10.100}$$

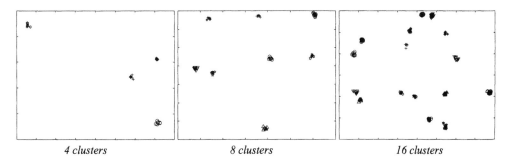

| 4 clusters | 8 clusters | 16 clusters |

Figure 10.13. Projection from a four-dimensional space to a two-dimensional space using spring embedding on a preclustersd output space.

Then, for each cluster, a spring-embedding problem is solved for the elements of the output space that belong to that cluster. For cluster $S(a)$ this entails the minimization of the function

$$E(x) = \left[\sum_{h,k:i_h,i_k \in S(a)} (D^x_{hk} - d(x_k, x_h))^2 \right]^{1/2} \qquad (10.101)$$

The position on the display of image i_h belonging to cluster $S(a)$ is given by $i_h = \pi(a) + x_h$. Figure 10.13 shows the displays obtained this method employing the same output space as in the preceding examples.

Note that spring embedding is typically an $O(N^2)$ procedure. If the space has M clusters with K images each, then the complexity of the total problem is now $O(M^2) + O(MK^2)$; if $M = K = \sqrt{N}$, the complexity of the problem is $O(N\sqrt{N})$. Therefore, the availability of clustering information in the output space results in a faster determination of the display.

Projection pursuit. Projection pursuit determines a global linear projection that, once determined, can be applied to all the points in the space. Application of projection pursuit to the clustered case is very simple: Take the set of cluster centers and apply projection pursuit to them in order to determine a transformation that preserves the distance between the centers. Then, apply the linear transformation so obtained to all the points. Figure 10.14 shows the results of this procedure to the familiar clustered output space.

Finally, Fig. 10.15 shows the τ function for these displays obtained using cluster-based spring embedding and projection pursuit of cluster centers.

10.4.4 Other Visualization Techniques

The techniques developed so far aim at determining a faithful representation of the structure of the output space. This gives the best global representation of such a structure and, in a sense, are optimal for a "bird's-eye" view of the display. In some cases, however, the user is engaged in an active exploration of the space,

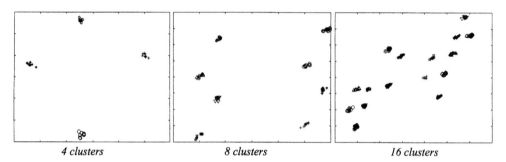

4 clusters *8 clusters* *16 clusters*

Figure 10.14. Projection from a four-dimensional space to a two-dimensional space using projection pursuit on a preclustersd output space.

making full use of attentional mechanisms. For example, a user might want, at a given point, to analyze one of the clusters more in detail, where "detail" could signify a better representation of the details of an element. Every element, in fact, will, in general, have several possible representations at different "resolutions" on the screen, and the user might want to switch from one representation to another depending on whether she wants to have a broad structural view of a set of elements, or to analyze each element more closely.

The previous sections have considered the elements of the output space as points in the display, that is, as elements without internal structure. In most cases,

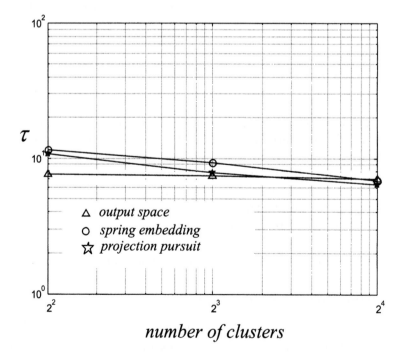

number of clusters

Figure 10.15. The structure indicator as a function of the number of clusters for spring embedding and projection pursuit on a preclustered output space.

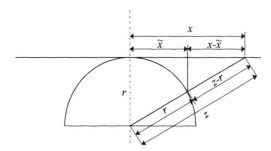

Figure 10.16. The geometry of the one-dimensional fish-eye display.

however, this is not true. Everything that is represented in the display space has an internal structure that needs to be displayed. In interfaces for image databases, the "things" that are displayed in an interface are typically images or words. I will consider, for the time being, the display of images.

When the displayed elements are images, a display such as those introduced in the previous section will closely resemble those in Color plate 3. If the display is well clustered, the configuration is good enough to give qualitative information about the *global* characteristics of the output space (how many clusters are there, how widely separated they are, how tight,...), but does not focus the attention of the user on any particular image or group of images. One possibility to achieve this focus of attention is to alter the representation of the single images so that the images on which the user wants to concentrate (e.g., the images that the user is selecting as examples for a following interaction) will be more evident. If the interesting images are concentrated in a separated area of the display, this can be done very simply by *dimming* the other images, as in Color plate 4. This solution does not work well if the selected images are isolated and scattered around the interface. In this case, a better solution is to increase the size of the selected images, as in Color plate 5.

Attention-based mechanisms can be used also to browse the display in search of interesting images. One of the best-known techniques is the *fish-eye display*. The geometry of a one-dimensional fish-eye display is shown in Fig. 10.16. Let the horizontal line be the display space. In this one-dimensional display, the position of an element is characterized by its coordinate x. Draw a half-circle of radius r under the origin of coordinate system (the construction can be generalized to half-circles placed anywhere under the line by translating the origin by a suitable amount). Given a point with coordinate x, draw the line between that point and the center of the circle and project vertically the point of intersection between this line and the circumference. The result is a new point \tilde{x}, which is called the *fish-eye projection* (or radius r) of the point x. A little algebra, and the similitude of the two triangles $\triangle(r, z, x)$ and $\triangle(\pi, z - r, x - \tilde{x})$ will prove that the coordinate x of the point and its fish-eye projection \tilde{x} are related by

$$\frac{1}{\tilde{x}^2} = \frac{1}{x^2} + \frac{1}{r^2} \qquad (10.102)$$

Figure 10.17. The geometry of the two-dimensional fish-eye display.

The point at coordinate x will therefore be mapped into the point

$$\tilde{x} = \frac{1}{\sqrt{\frac{1}{r^2} + \frac{1}{x^2}}}$$

(10.103)

The two-dimensional projection is obtained with the help of a half-sphere, as illustrated in Fig. 17. Let (x, y) be the display space coordinates of an element, to be mapped on the fish-eye display, and let (x_0, y_0) be the coordinates of the center of the sphere. Then the point is at a distance

$$\rho^2 = (x - x_0)^2 + (y - y_0)^2$$

(10.104)

from the center of the sphere, and will be mapped in a point at a distance

$$\tilde{\rho}^2 = \frac{1}{\frac{1}{r^2} + \frac{1}{\rho^2}}$$

(10.105)

from the center of the fish-eye. Its coordinates will therefore be

$$\tilde{x} = \frac{\tilde{\rho}}{\rho}(x - x_0)$$

(10.106)

and

$$\tilde{y} = \frac{\tilde{\rho}}{\rho}(y - y_0)$$

(10.107)

An example of fish-eye display is shown in Color plate 6. In general, one browses through the display by moving the center of the semisphere around in the positions in which potentially interesting images can be found. Color plate 7 shows the same display in Color plate 6 with the center of the semisphere moved to analyze a different cluster.

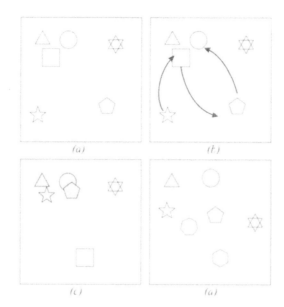

Figure 10.18. Schematic description of an interaction using direct manipulation.

10.5 User Response

The general model of the user response to the database representation is given by the following diagram:

$$
\text{(10.108)}
$$

According to this diagram, the user responds to the system using two alternatives—either changing the configuration of the display space in a way that better reflects his desires, or updating the query through some external means, independent of the state of the display.

10.5.1 Direct Manipulation

Direct manipulation can formally be described as the action of suitable operators on the display space. Informally, a user interaction using direct manipulation is shown schematically in Fig. 10.18. In Fig. 10.18a, the database proposes a certain distribution of images (represented schematically as simple shapes) to the user. The distribution of the images reflects the current similarity interpretation of the database. For instance, the triangle, the square, and the circle are considered very similar to each other, while the pentagon, the star, and the hexagonal star are rather different. In Fig. 10.18b the user moves some images around to reflect his own interpretation of the relevant similarities, and marks some images as

"relevant." The result is shown in Fig. 10.18c. According to the user, the triangle, pentagon, star, and circle, are quite similar to each other, while the square is rather different from them.

As a result of the user assessment, the database will create a new similarity measure, and reorder the images, yielding the configuration of Fig. 10.18d. The four marked figures are in this case rather similar (although they were moved from their intended position). Note that the result is not a simple rearrangement of the images in the interface. For practical reasons, an interface cannot present more than a small fraction of the images in the database. Typically, one displays the 100-300 images most relevant to the query. The reorganization following the user interaction involves the whole database. Some images will disappear from the display (the square), and some will appear (the eptagon and the hexagon).

In order to describe the interaction more formally, it will be necessary to change the sign system of the display slightly. In particular, in the type set T_D defined in Eq. (10.70), the type \mathfrak{s} will change to

$$\mathfrak{s} \triangleright si : \mathrm{img} \times sid : \mathrm{id} \times x : \mathrm{pos} \times m : \mathrm{Boolean} \qquad (10.109)$$

where the component $s.m$ is true if the image has been "marked" by the user. By default, the projection operator produces a configuration in which all the images are unmarked, that is, in which $s.m$ = false for all images.

The interaction model can be described as a set of operators that transform a configuration in the display system into another[7]. that is, a set of operators

$$\mu : \mathfrak{g} \times \theta \to \mathfrak{g} \qquad (10.110)$$

where θ are parameters that depend on the operator. In particular, the following basic operators can be defined.

Move image: Takes an image s in the display and moves it to a different location z in the same display:

$$\mathrm{mv}(g : \mathfrak{g}, s : \mathfrak{s}, z : \mathrm{pos}) = g - \{s\} \cup \{\mathfrak{s}(s.si, s.sid, z, s.m)\} \qquad (10.111)$$

Flip mark: Changes the value of the mark of an image

$$\mathrm{mk}(g : \mathfrak{g}, s : \mathfrak{s}) = g - \{s\} \cup \{\mathfrak{s}(s.si, s.sid, s.x, \neg s.m)\} \qquad (10.112)$$

Insert image: Inserts an image in a display in a given location

$$\mathrm{ii}(g : \mathfrak{g}, s : \mathfrak{s}, z : \mathrm{pos}) = g \cup \{\mathfrak{s}(s.si, s.sid, z, s.m)\} \qquad (10.113)$$

[7] These operators should not be confused with semiotic morphisms. In the case of direct manipulation, the display system and the configuration system coincide, therefore, the semiotic morphism $M : \mathrm{D} \to \mathrm{C}$ is the identity.

Insert set: An extension of the previous operator, where a number of images are inserted in the same position:

$$\text{ii}(g : \mathfrak{g}, S = \{s : \mathfrak{s}\}, z : \text{pos}) = g \cup \{\mathfrak{s}(s.si, s.sid, z, s.m) : s \in S\} \quad (10.114)$$

The latter operator allows the creation of *visual concepts*—sets of images with a specific meaning that the user can collect in a single unit. Groups of images can be taken from the interface at any stage of the interaction and collected into a visual concept library. Elements from the visual concept library can then be introduced in the interface at any stage using the insert set operator.

It is interesting to note that the distinction between the role of the user and the role of the database is blurred in this model. In very general terms, the role of the database is to *focus* the attention of the user on certain relations that, given the current interpretation of meaning in the database, are deemed relevant. The database does this by displaying a subset of relevant images and their relations in the similarity criterion that is used to define the meaning.

The role of the user is exactly the same. By displacing images in the interface plane, the user focuses the attention on the database on certain relations between images that, given the user interpretation of the meaning of the displayed images, are relevant. Both systems, the database and the user, will adjust their similarity measure based on the response of the other system. The fact that we expect more flexibility from the database rather than from the user (i.e., the database should adapt its similarity measure, while the user has a relatively stable idea of what he/she wants) makes the difference between the two a matter of power relations rather than a categorical distinction.

10.5.2 Linguistic Features

Linguistic terms are often associated with images in a database. The simpler form to use linguistic terms is to start a visual query. The method is basically that of the visual dictionary, illustrated in section 7.6.1. The scheme of interaction in this case is the following:

$$(10.115)$$

the interaction is started as a textual query in a linguistic feature space (the terms associated with the document), and the result of this query, which is a configuration of images, is used to start the visual context.

A more interesting interface can be obtained by considering the relations be-
tween images and words. A similarity between words can be defined as in Eq.
(7.80) (see section 7.6.2 p. 39). It is therefore possible to create a configuration
of words along the same lines as the creation of a configuration of images. An
example of such a configuration is given in Color plate 8.

The text interface is the exact dual of the image interface of the last section.
In particular, the same operators apply. In this interaction model, a user is shown
two configurations—a text configuration and an image configuration. The two
are connected, as the similarity between words and the lexical similarity between
images depend on each other through the term weight matrix A. (In the case of
images, the visual similarity should also be taken into account; this will be done
in the next section on query formation.) The user will act on either display, using
the operators introduced previously (move, mark, ...). The result of the interaction
will be a query that will alter both the relation between images and that between
terms, that is, acting on one of the two displays will reconfigure both. The general
scheme of this interaction is the following:

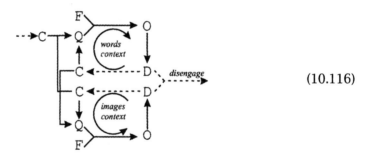

$$(10.116)$$

10.5.3 Additional interaction

While direct manipulation is a convenient interaction modality in some circum-
stances, sometimes other modalities are preferable. In particular, this happens
in two cases—when the query *desiderata* are expressable as a linguistic syntactic
description of the images, and in those that I call the "but" queries.

Syntactic linguistic description. Syntactic linguistic descriptions should not be
confused with the linguistic description of images considered in the previous
section. In that case, in fact, the discourse associated with an image was related
to its semantics, that is, it defined what the image was about or how it should
be interpreted, while the linguistic description that I am considering here is a
description of the *appearance* of the image. To use a rather trivial example: A
description like "image of a ferrari" is a semantic description, while "image with
an oblong red region in the middle" is a syntactic description.

Syntactic descriptions can be generated essentially in two ways—either by let-
ting the user "draw" an example, and treating it as any other image in the database,
or by directly manipulating the feature algebra of the feature space.

In the first case, the user is given a drawing tool[8] that can be used to put together a rough sketch of the desired image. This sketch is stored in an image and analyzed using the same feature extractor used for the images in the database. The sketch is now another element of the feature space F, and can be treated exactly like every other image. I will consider here mainly drawing tools of the "paint" type that is, drawing tools whose basic operation is to paint a finite region in the image of a given color. Other tools work by creating line drawings [Del Bimbo and Pala, 1997], which can be directly transformed into edge images. The choice between these two types of drawing tools depends in part on the type of features that the database employs.

The use of this newly created image in the ongoing interaction also generates two possibilities. On one hand, the drawing can be inserted into the current context, that is, it can be entered into the current image configuration (e.g., it can be placed in an arbitrary position in the interface of Fig. A3 and used to generate the next iteration of the current context. Schematically, the situation is the following:

$$\text{(10.117)}$$

in which G is the unspecified interface to the drawing tool. Alternatively, the output of the drawing tool can be used to start or to restart a context, as in the following diagram:

$$\text{(10.118)}$$

The two initial arrows indicate that, in this particular case, a context can be started either by entering some text that describes the semantics of an image or by creating a drawing and using it to start a query.

[8] This drawing tool is usually rather coarse, giving the user only the possibility of generating very rough shapes (for instance, assemblying large blocks), and selecting their color from among a rather limited pallette. There is, strictly speaking, no reason why the drawing tools associated with databases should not be more sophisticated, but image databases are often not able to search based on the minutiae of a drawing, but only on its general lines. Based on this limitation, two considerations suggest limiting the power of the drawing tool: (1) a more sophisticated drawing tool is harder to use, and there is no reason why the user should have to learn a more complicated tool to interact with a system that cannot use all the power of the tool; and (2) interfaces generate expectations and, if a powerful tool is used, the natural expectation is that the capabilities of the database will be similar to those of the drawing tool. The realization that this is not the case can be disappointing.

Things change, of course, if the database itself is but an accessory of a drawing tool; in this case the power of the tool has an independent justification.

In the previous example, the drawing and all the subsequent processing resulted, ultimately, in the creation of a feature value with which the rest of the database was compared. Any way to create such a value will constitute a valid interaction modality. A few possibilities (but this is by no means an exhaustive list) are the following.

Direct creation from the drawing tool. From the point of view of the user, this modality is indistinguishable from the previous one but, from an implementation point of view, it qualifies as a direct interaction with the feature algebra. Instead of using the drawing tool to create an image and then analyze it employing the feature extraction algorithm used for the database images, it is possible to associate the various components of the drawing tool directly with the feature types. In order to make an example, assume the following (very, very simplified) scenario:

- The drawing tool only allows one to draw two types of shapes—rectangles and spheres;

- the shapes can be colored one of four colors—black, red, green, or blue;

- features are structure graphs; the edges of a graph contain four numbers specifying the relative positions between the nodes attached to that edge (that is, the values μ_a, μ_b, μ_l, μ_r of section 5.6.3), and nodes contain a color histogram for the color and the area of the region.

Formally, the features are defined as the following data types:

$$n \triangleright a : \text{int} \times h : \mathcal{H} \times x : \text{int}^2 \qquad (10.119)$$

$$e \triangleright p : \text{real}^4 \qquad (10.120)$$

$$f : \mathbb{S}[e \,|\, n] \qquad (10.121)$$

where \mathcal{H} is the data type of color histograms (e.g., this can be an array with nine elements containing the statistical description of the histogram).

The interface is defined as a set of operators over a set of regions (representing the image that the user is building). The output of the interface is a set of region features that, at the time in which the image is submitted to the database, will be transformed in a single image feature value. Let F be the set of features that the drawing tool is building. Also, four predefined histograms h_k, h_r, h_g, h_b are defined, which contains the histograms of a region of area 1 in the four admissible colors. Some examples of operators are the folliwing

Place region: $p(F, R)$. If the region R is placed, then the operator transforms F as follows:

$$F, R, x \mapsto F \cup \{(\text{area}(R), \text{area}(R) \cdot h_k, x)\} \qquad (10.122)$$

Note that the default color of a region R is black.

Assign color: the operator $c(F, R, c)$ assigns color $c \in \{k, r, g, b\}$ to region R, and
 is defined as

$$F, R, c \mapsto F - \{R\} \cup \{(R.a, h_c, R.x)\} \qquad (10.123)$$

Other operators can of course be defined along the following lines. At the end
of the interaction, the set of features F is transformed into a feature graph by
merging all the overlapping regions with the same color, joining all the feature
values with edges, and assigning to the edges the suitable relative position values
computed from the x values of the regions.

Definition through a formal language. A formal language can be defined on top
of the feature algebra selected for a particular application and used to describe
the image required. The specification of an image in the formal language can be
transformed into a suitable feature value by a very simple compiler. This solu-
tion is in general very user-unfriendly but, depending on the definition of the
language, can be very powerful. Consider, as an example, the following simple
language. As in the previous tool, the language draws two shapes—ellipses and
rectangles. There is a *current color*, which is set by the command `color`, and a
current position of a cursor, which is set using the commands in what follows. The
command

```
rectangle <lx> <ly>
```

draws a rectangle of sides `<lx>` (on the x-axis) and `<ly>` (on the y-axis). At the be-
ginning of the drawing, the horizontal axis is x and the vertical axis is y. Similarly,
the command

```
ellipse <dx> <dy>
```

draws an ellipse of diameters dx and dy. The command

```
color {red | green | blue | black}
```

sets the current color. The cursor can be moved by four commands:

```
down  <y>
up    <y>
left  <x>
right <x>
```

Finally, the whole coordinate system can be rotated using the command

```
rotate <angle>
```

For instance, the following sequence uses several combinations of commands
to draw four squares on the image plane:

```
up    100
left 100
color red
rectangle 50 50
down 200
rectangle 50 50
left 200
rectangle 50 50
rotate 90
left 200
rectangle 50 50
```

The specification language is completed by the possibility of defining functions like

```
defun f
  color red
  rectangle 50 50
  down 200
  rectangle 50 50
  left 200
  rectangle 50 50
  rotate 90
  left 200
  rectangle 50 50
end
```

and by the possibility of recursive calls to functions. Finally, the command query will send the complete image to the query engine, and the command clear will erase the drawing board.

This toy example of a picture definition language should, of course, be enriched and expanded, but it should be enough to give an idea of how such a specification can be translated in a feature value and used as a query sample.

Natural language description. Another possibility is to use a natural language processing module that takes a description of the image that the user wants to use as a prototype and transforms it into a suitable feature value. The basic mechanism is quite simple because in this case the context of the conversation is very restricted (the user and the database are only describing the appearance of images to one another), and full language understanding is not required. The detection of small fragments of sentences containing the specification of regions, colors, and their location, will, in general, be sufficient to create a good description of the image.

The "but" query. I call this the "but" query because its prototypical example is the query "I want something like this, but with this difference." Truth be told, the most interesting part of this query is not the conjunction "but" (which, logically, is just an "and"), but the shifter "this," which makes the query refer to the current context. Of course, all direct manipulation queries are contextual in this sense (I want a configuration like this, but...), but contextual queries come up naturally in other types of interactions, in particular, when descriptions are made using natural language.

I am not aware of any work in this area of linguistic analysis directly dedicated to work with image databases and, at this point, all that I can offer are a few very generic observations:

- It is reasonable to assume that most of the queries of this class will have a structure similar to the sentence "show me something similar to the images on the screen, but with the following changes:...";

- the sentence that follows the "following changes" in the preceding is, *mutatis mutandis*, a linguistic statement about syntactic properties of the image that can be analyzed using the same techniques used for the analysis of self-contained natural language description except, of course, for the presence of comparatives (more, less than, just like,...);

- the referent of the comparatives is to be found in the current configuration. The solutions for this specification are rather diverse—a designer may require the user to specifically designate an image or a group of images in the current configuration as the referent, or can take the set of images closer to the query as a referent, or the computed center of the cluster that is more prominent on the screen at the time in which the request is made, and so on; and

- a similar problem exists in the case in which the user uses names of objects in his specification rather than resorting to a fully syntactic specification. An example could be a query such as "an image like this one (where "this one" is clearly indicated) but where the car is bigger." Again, the problem is to determine which regions of the image is the user designating as "car" and should therefore be bigger.

Finally, "but" queries can be composed visually by creating a drawing tool in which the user can take an image from the configuration and modify it according to her desires. This is, from an interface point of view, the same case as the drawing tool of the previous section, with the exception that this time rather complex existing images are edited and direct creation of features appears infeasible. It is a lot easier to use the drawing tool to create an image and determine its feature values employing the same feature extraction tools used for the creation of the database.

10.6 Query Creation

The query operator transforms the input of the user (in particular, the configuration selected by the user) into a query that the database can answer. This process usually entails two activities—first, a suitable similarity measure is built starting from the "marked" images in the composition space, then a suitable query is composed using such a similarity measure.

The details of this process are very database-specific depending, among other things, on the type of the interface, the number and nature of the feature tables defined in the database, and the nature of the scoring function algebra that supports the creation of similarity functions.

The easiest case to consider is that in which the database has a single ordered relation with a feature type that supports general similarity measures (e.g., a "general ontology" feature such as those introduced in Chapter 6), and a family of similarity measures that can be adapted by setting the values of a parameter vector.

Let χ be the configuration in the direct manipulation composition space, and let $\mathcal{M}(\chi)$ be the set of marked images:

$$\mathcal{M}(\chi) = \{q \in \chi : q.m\} \tag{10.124}$$

Also, assume that the database contains a single table

$$T(id : \text{int}, \phi : \alpha) \tag{10.125}$$

where α is the data type of the features in the table. The natural similarity measure of the table is $T.v$. A family of similarity functions $s(x : \alpha, y : \alpha; \theta : \mathbb{R}^n)$, depending on the parameters θ is also defined for the feature type α.

Given the configuration χ, the first part of the query creation process is to determine what similarity function should be used. This can be done by adapting the parameters θ in such a way that the distances between the marked elements in the feature space will correspond, as much as possible, to the distances between them selected by the user. This would lead to an optimization problem of the type

$$\min_{\theta} E(\theta) = \min_{\theta} \left[\sum_{s_1, s_2 \in \mathcal{M}(\chi)} (s(T[s_1.id].\phi, T[s_2.id].\phi; \theta) - g(d_e(s_1.x, s_2.x))t)^2 \right]$$
$$\tag{10.126}$$

The expression $T[s_1.id].\phi$ retrieves from the database the feature vector of an image given the id that the image carries with itself on the display space and, consequently, on the composition space. The function $s(T[s_1.id].\phi, T[s_2.id].\phi; \theta)$ determines the similarity between the feature representations of two images in the composition space. The function d_e represents the Euclidean distance between the display representation of two images, and the function g, as usual, transforms this distance into a similarity measure.

This optimization procedure should be amended in two ways. First, the actual values of the distances in the composition space are immaterial. What one requires is that the ratio between the various distances be preserved. This scale invariance can be enforced by inserting an additional unknown scale parameter λ. Second, the optimization problem is usually underconstrained (the vector θ could have more components than the number of distance constraints), and it should be regularized. This can be done by weighting in the displacement between the similarity measure $s(x, y; \theta)$ and the natural distance of the table. The optimization problem therefore becomes:

$$\theta_0 = \text{minarg}_\theta E(\theta) \tag{10.127}$$

$$= \text{minarg}_{\theta,\lambda} \sum_{s_1,s_2 \in M(\chi)} (s(T[s_1.id].\phi, T[s_2.id].\phi; \theta) - \lambda g(d_e(s_1.x, s_2.x)))^2$$

$$+ w \sum_{s_1,s_2 \in M(\chi)} (s(T[s_1.id].\phi, T[s_2.id].\phi; \theta) - T.v((T[s_1.id].\phi, T[s_2.id].\phi))^2$$

Let \Diamond be a scoring composition operator. Given the optimizing vector θ_0, the score of a distance with respect to the set of selected samples is given by the scoring function $s_{\theta_0} : \phi \to [0, 1]$ defined as

$$s_\theta(\phi) = \underset{s \in M}{\Diamond} s(\phi, T[s.id].\phi; \theta) \tag{10.128}$$

Given this function, the query derived from the configuration of the composition space is expressable as

$$\sigma_k^\# [\Sigma_T(s_{\theta_0})] = \sigma_k^\# \left[\Sigma_T \left(\underset{s \in M}{\Diamond} s(T[s.id].\phi; \theta_0) \right) \right] \tag{10.129}$$

where k is the number of images that will be placed in the output space, that is, the number of images that will appear in the interface during the following iteration.

10.6.1 Image-text Integration

In the linguistic model presented in Chapter 7, words are expressed in terms of images and images in terms of words. The similarity between terms $\langle T_\mu, T_u \rangle$ is given by

$$s_w(T_t, T_u; A) = \langle T_t, T_u \rangle = \sum_{k=1}^{N} \alpha_{t,k} \alpha_{u,k} \tag{10.130}$$

and the lexical similarity between images $\langle I_k, I_h \rangle$ is given by

$$s_l(I_k, I_h) = \langle I_k, I_h \rangle = \sum_{t=1}^{M} \alpha_{t,k} \alpha_{t,h} \tag{10.131}$$

That is, if $A = \{\alpha_{t,k}\}$ is the matrix of the terms weights, then the similarity between I_k and I_h is the element (k, h) of the $N \times N$ matrix AA', while the similarity between terms T_t and T_u is the (t, u) element of the $M \times M$ matrix $A'A$.

The linguistic similarity between two images can be encoded as a second ordered relation

$$L(id : \text{int}, t : [\![(\text{tv} \triangleright w : \text{int} \times p : rmreal)]\!]^1) \tag{10.132}$$

where t is the terms vector composed of an array of elements of type tv (for "terms vector"), where each element of type tv contains the id of a word (in the word table in what follows) and its associate weight.

Similarly, words are collected into an ordered relation

$$W(wid : \text{int}, \text{txt} : \text{word}, q : [\![(\text{iv} \triangleright id : \text{int} \times p : rmreal)]\!]^1) \tag{10.133}$$

A word is represented by an identifier, its textual representation, and an array of elements of type "iv" (for "images vector"), each containing the identifier of an image and the weight of that image in the word.

Given a combination operator \diamond for similarity measures, the total image similarity is defined as the similarity function on the \diamond-join of the tables T and L. If the table I is defined as

$$I = T \underset{\diamond}{\bowtie} L \tag{10.134}$$

then the *total image similarity* is

$$I.v = T.v \diamond L.nu \tag{10.135}$$

that is,

$$s_t(I_h, I_k; \theta, A) = s_v(I_k, I_h; \theta) \vee (AA')_{hk} \tag{10.136}$$

where s_v is the visual similarity defined for the table T^9.

The matrix A is changed by interaction as discussed in section 7.6.2. A change in the matrix A then results in two queries—one on the table I, expressed as

$$\sigma_k^{\#}\Big[\Sigma_T\Big(\underset{s \in M}{\diamond} s_t(T[s.id].\phi; \theta_0, A)\Big)\Big] \tag{10.137}$$

which is used to generate the image display window (as in Fig. A.6), and a query on the table W expressed as

$$\sigma_k^{\#}\Big[\Sigma_W\Big(\underset{t \in T}{\diamond} s_w(W[t.wid].t; A)\Big)\Big] \tag{10.138}$$

where T is the set of terms that the user has selected in the text window.

10.7 What Else?

The peculiar nature of the process of signification in images creates the need for innovative approaches to human-computer interfaces. This area of research is

[9] Note that, if text is used in conjunction with images, the total similarity should be used to generate the output space and the display, rather than the visual similarity.

still in its infancy, and this chapter contained but a few preliminary ideas on how interfaces for image database could be framed and developed. If the experience of the past is any lesson, five years from now half of the ideas presented in this chapter will seem obvious and the other half will have turned out to be completely wrong.

Lack of time and expertise forced me to avoid some themes that will undoubtedly be very relevant in the future. For instance, all the interfaces presented here considered the interaction between a single user and an image database. Yet, in many applications, the users of a database are part of an organization or, at least, of a community. Organizations tend to impose a certain structure on information repositories, and communities develop trends, habits, and quirks that their members take for granted but that are not captured in the simple one-on-one interaction that has been considered here. Some ideas, such as recommendation systems and collaborative filtering, already exist although, to the best of my knowledge, few attempts have been made to incorporate these techniques into image search [the only example that I know of is Tatemura *et. al.* (1999)].

These ideas will develop quickly and, if the muses of publishing are benign, you will probably find a lot about them in the second edition of this book.... .

A

Traveling the World Wide Web

Images are captured from web pages together with the accompanying text. A web traversal program (sometimes known as "web crawler" or "web spider") iteratively visits a page and all the pages linked to it in a random fashion. The crawler maintains a list of pending pages to visit, and a list of visited pages. The high-level description of the crawler operation is as follows.

ALGORITHM A1. *Let P be the set of pending sites, V the set of pending sites, each one represented by its URL h. The algorithm starts with V = ∅ and P = {h₀}, where h₀ is the starting site. The algorithm visits at most N_{MAX} sites. Also, rnd(P) is a random element taken from P*

$while$ $P \neq \emptyset$ and $visits < N_{MAX}$
 $h \leftarrow rnd(P); P = P - \{h\}$
 $V = V \cup \{h\}$
 if $h \notin V$
 for all $links$ h_i in the $page$ h
 if $h_i \notin V$
 $P \leftarrow P \cup \{h_i\}$
 $Q[v].t \leftarrow Text(h)$
 $Q[v].n \leftarrow Title(h)$
 $Q[v].k \leftarrow Keywords(h)$
 for $each$ $image$ I_k in the $page$ h
 $Q[v].I[k].n \leftarrow URL(I_k)$
 $Q[v].I[k].i \leftarrow IndexOf(I_k, h, T[v])$
 $Q[v].I[k].a \leftarrow AltText(I_k)$

The functions *Text* returns an array with all the words in the text portion of the page (that is, excluding text that is included in the header of tags). The function *IndexOf* takes an image, the URL of a page, and the text of the same page. It returns the position in the text array at which the image I_k occurs. The function *Keywords* returns the list of words that are included in the META, KEYWORDS tag. The function *AltText* returns the text included in the *tt ALT* argument of the IMG tag of I_k. The output of the crawler is, for each page, a structure Q containing the title, text, and keywords of the page, and an array of structures I, one for each image. Each structure I contains the URL, index, and text associated with the image.

Note that the next page to visit is chosen randomly from the set of images still to visit. This should minimize the number of consecutive and rapid hits to the same server.

The structure of a web crawler is very easily implemented in a language such as Java, which comes with standard libraries that allow the programmer to open a connection to a web page, check the nature of the link (typically only links of class http will be traversed), and load the text of a page. The PERL scripting language also has a library (perlwww) that contains the basic operations necessary to implement a web crawler.

Web crawlers are great information-gathering tools, but they can be a great burden on servers because, unlike regular users, they tend to request many pages in rapid sequence from the same site. Retrieving the next page randomly from the waiting set helps attenuate the problem, but it does not completely eliminate it. For this reason, an informal—but of rather wide acceptance—protocol for crawler exclusion has been established. The protocol is "honor based," in the sense that the manager of the server has no way to enforce it, but must rely on the urbanity of the robot designer.

Also, before indexing, images are subject to a simple filtering operation. In order to be accepted as valid, images need to satisfy the following criteria:

1. The image must be contained in a jpeg file.

2. The image must be at least of size 100×100.

3. The width-to-height ratio must be between one-third and 3.

4. There must be some text between the image and the beginning of the page.

The first rule tries to eliminate troublesome images such as animated GIFs, or images of no direct interest to this specific database, such as cartoons[1]. The second and third criteria try to eliminate small images, such as buttons, and very skewed images such as separation lines. This and the following criterion are also used to reduce the number of advertising banners in the database.

[1] I am also very uncomfortable with proprietary standards, which I feel are rather contrary to the spirit of the Internet.

Bibliography

Aczel, J. (X). (1966). *Lectures on Functional Equations and Applications.* New York: Academic Press.

Ali, S. T., Antoine, J. P., and Gazeau, J. P. (1991). Square-integrability of group representations in homogeneous spaces I. Reproducing triples and frames. *Annales de L'Instut Henri Poincarè, Physique thèorique* **55**:829–856.

Allan, J. (1996). Incremental relevance feedback for information filtering, in *Proc. SIGIR '96, August 1996, Zurich, Switzerland.*

Allen, J. F. (1983). Maintaining knowledge about temporal intervals, *Communications of the ACM* **26**(11):832–843.

Amitay, E. (1998). Using common hypertext links to identify the best phrasal description of target web documents, in *Proceedings of the 21st ACM SIGIR Conference on Research and Development in Information Retrieval, Melbourne, Australia.*

Apostol, T. M. (1997). *Linear Algebra: A First Course, with Applications to Differential Equations.* New York: John Wiley & Sons.

Armitage, L. and Enser, P. G. (1997). Analysis of user needs in image archives, *Jour. Information Science* **23**(4):287–299.

Ashby, F. G. and Perrin, N. A. (1988). Toward a unified theory of similarity and recognition, *Psychological Review* **95**(1):124–150.

Attneave, F. (1950). Dimensions of similarity, *Americal Jour. Psychology* **63**:516–556.

Bach, J., Paul, S., and Jain, R. (1993). A visual information management system for the interactive retrieval of faces, *IEEE Trans. Knowledge and Data Engineering* **5**(4):619–628.

Barthes, R. (1980). *Camera Lucida: Reflections on Photography.* London: Cape.

583

Bartlett, M. S. (1964). The spectral analysis of two-dimensional point processes, *Biometrika* **51**:299-311.

Bates, M. J. (1986). Subject access in online catalogs: a design model, *JASIS* **37**(6):357-376.

Bayer, R. and McCreight, E. (1972). Organization and maintenance of large ordered indexes. *Acta Informatica* **1**(3):173-189.

Beals, R., Krantz, D. H., and Tversky, A. (1968). The foundations of multidimensional scaling, *Psychological Review* **75**:127-142.

Beckmann, N., Kriegel, H. P., Schneider, R., and Seeger, B. (1990). The R*-tree: an efficient and robust access method for points and rectangles, in *Proc. ACM SIGMOD, International Conference on Management of Data, Atlantic City, NJ*, pp. 322-331.

Bellman, R. E. and Giertz, M. (1973). On the analytic formalism of the theory of fuzzy sets, *Information Science* **5**:149-156.

Bennet, J. G. (1974). Depiction and convention, *The Monist* **58**:255-268.

Bentley, J. (1975). Multidimensional binary search trees used for associative searching, *Communications of the ACM* **18**(9):509-517.

Berchtold, S., Böhm, C., Keim, D. A., and Kriegel, H.-P. (1997). A cost model for nearest neighbor search in high dimensional data space, in *Proc. ACM International Conference on Principles of Database Systems, PODS '97, Tucson, USA*.

Berchtold, S., Keim, D., and Kriegel, H.-P. (1996). The X-tree: An index structure for high dimensional data, in *Proc. 22nd VLDB Conference*.

Beyer, K., Goldstein, J., Ramakrishnan, R., and Shaft, U. (1998). When is "nearest neighbor" meaningful? Technical Report TR1377, Computer Science Department, University of Wisconsin at Madison.

Borges, J. L. (1964). *Other Inquisitions, 1937-1952*. Austin, TX: University of Texas Press.

Boynton, R. M. (1979). *Human Color Vision*. New York: Holt, Rinehart, and Winston.

Bozkaya, T. and Ozsoyoglu, M. (1997). Distance-based indexing for high dimensional metric spaces, in *Proc. ACM SIGMOD, International Conference on Management of Data*, pp. 357-368.

Brin, S. (1995). Near neighbor search in large metric spaces, in *Proc. 21st VLDB Conference, Zurich, Switzerland*.

Bruce, V. and Green, P. (1985). *Visual Perception: Physiology, Psychology, and Ecology.* New Jersey: Lawrence Erlbaum Associates.

Burke, L. I. (1991). Clustering characterization of adaptive resonance, *Neural Networks* 4:485–491.

Burkhard, W. (1983). Interpolation-based index maintenance, in *Proc. ACM SIGMOD, International Conference on Management of Data,* pp. 76–89.

Burkhard, W. (1984). Index maintenance for non-uniform record distributions, in *Proc. ACM SIGMOD, International Conference on Management of Data,* pp. 173–179.

Campbell, D. and Stanley, J. (1963). *Experimental and Quasi-Experimental Designs for Research.* Chicago: Rand McNally College Publishing Company.

Card, S. K., Moran, T. P., and Newell, A. (1983). *The Psychology of Human-Computer Interaction.* Hillsdale, NJ: Lawrence Erlbaum Associates.

Carpenter, G. A. and Grossberg, S. (1987). ART 2: Selforganization of stable category recognition codes for analog input patterns, *Applied Optics* 26:4919–4930.

Carroll, J. D. and Arabie, P. (1980). Multidimensional scaling, *Annual Review of Psychology* 31:607–649.

Carson, C., Thomas, M., Belongie, S., Hellerstein, J. M., and Malik, J. (1999). Blobworld: A system for region-based image indexing and retrieval, in *Proc. Visual '99, the International Conference on Visual Information Systems.*

Chevreul, M. E. (1987). *The Principles of Harmony and Contrast of Colors and Their Applications to the Arts.* West Chester, Pennsylvania Shiffer Publishing Ltd.

Chakrabarti, S., Dom, B., Gibson, D., Kleinberg, J., Kumar, R., Raghavan, P., Rajagopalan, S., and Tomkins, A. (1999). Mining the link structure of the world wide web, *IEEE Computer* 32(8).

Chakrabarti, S., Dom, B., Raghavan, P., Rajagopalan, S., Gibson, D., and Kleinberg, J. (1998). Automatic resource compilation by analyzing hyperlink structure and associated text, in *Proc. Seventh International World Wide Web Conference, Brisbane, Australia.*

Chang, S. F. and Smith, J. R. (1995). Extracting multidimensional signal features for content-based visual query, in *SPIE Symposium on Communications and Signal Processing.*

Chiueh, T. (1994). Content-based image indexing, in *Proc. 20th VLDB Conference, Santiago, Chile.*

Christie, A. (1992). *Mrs. McGinty's Dead.* New York: Harper Mass Market Paperbacks.

Ciaccia, P., Patella, M., and Zezula, P. (1997). M-tree: An efficient access method for similarity search in metric spaces, *in Proc. 23th VLDB Conference, Athens, Greece.*

Cilliers, P. (1998). *Complexity and Postmodernism : Understanding Complex Systems.* New York: Routledge.

Cleverdon, C. W., Mills, J., and Keen, M. (1966). *Factors Determining the Performace of Indexing Systems.* Cranfield: ASLIB Cranfield Project.

Cobley, P. and Jansz, L. (1997). *Introducting Semiotics.* New York: Totem Books.

Cooper, W. S. (1968). Expected search length: A single measure of retrieval effectiveness based on weak ordering action of retrieval systems, *Jour. American Society for Information Science* **19**:30–41.

Cootes, T. F., Cooper, D. H., Taylor, C. J., and Graham, J. (1992). Trainable method of parametric shape description, *Image and Vision Computing* **10**(5).

Copson, E. T. (1968). *Metric Spaces.* Cambridge: Cambridge University Press.

Corridoni, J., Del Bimbo, A., and De Magistris, S. (1996). Querying and retrieving pictorial data using semantics induced by colour quality and arrangement, in *Proc. Third IEEE International Conference on Multimedia Computing and Systems, Hiroshima, Japan.*

Crow, E., Davis, F. A., and Maxfield, M. W. (1960). *Statistics Manual.* New York: Dover.

Daubechies, I. (1992). *Ten Lectures on Wavelets.* Philadelphia: Society for Industrial and Applied Mathematics.

Davison, B. (2000). Topical locality in the web, in *Proc. SIGIR 2000, International Conference on Research and Development in Information Retrieval, Athens, Greece.*

Deacon, T. (1997). *The Symbolic Species: The Co-Evolution of Language and the Brain.* New York: W. W. Norton & Company.

Debreu, G. (1960). Topological methods in cardinal utility theory, in *Mathematical Models in the Social Sciences.* K. Arrow, S. Karlin, and P. Suppes, eds., Palo Alto: Stanford University Press.

Deerwester, S., Dumais, S., and Harshman, R. (1990). Indexing by latent semantic analysis, *Jour. American Society for Information Science,* **41**:391–407.

Del Bimbo, A. and Pala, P. (1997). Visual image retrieval by elastic matching of user sketches, *IEEE Trans. Pattern Analysis and Machine Intelligence* **19**(2).

Del Bimbo, A. and Pala, P. (1999). Shape indexing by multiscale representation, *Image and Vision Computing* **17**:245-261.

Dempster, A., Laird, N., and Rubin, D. (1977). Maximum likelihood from incomplete data via the EM algorithm, *Jour. Royal Statistical Society B*, **39**(1):1-38.

Dennett, D. (1984). Cognitive wheels: the frame problem of AI, in *Minds, Machines, and Evolution.* C. Hookway, ed., Philosophical Studies, Cambridge: Cambridge University Press, pp. 129-152.

Derrida, J. (ed.), G. G., and (Translator), S. W. (1988). *Limited, Inc.* Champaign-Urbana: Northwestern University Press.

Desai Narasimhalu, A., Kankanhalli, M. S., and Wu, J. (1997). Benchmarking multimedia databases. *Multimedia Tools and Applications* **4**(3):333-355.

Dreyfus, H. (1992). *What Computers Still Can't Do: a Critique of Artificial Reason.* Cambridge, MA: MIT Press.

Dubois, D. (1983). *Modéle mathématiques de l'imprécis at de l'incertain, en vue d'applications aux techniques d'aide á la décision.* Thése d'etat, Université de Grenoble.

Dubois, D. and Prade, H. (1980a). *Fuzzy Sets and Systems: Theory and Applications.* New York: Academic Press.

Dubois, D. and Prade, H. (1980b). New results about properties and semantics of fuzzy set-theoretic operators, in *Fuzzy Sets: Theory and Applications to Policy Analysis and Information Systems,* P. Wang and S. Chang, eds., New York: Plenum, pp. 59-75.

Dubois, D. and Prade, H. (1984). Criteria aggregation and ranking of alternatives in the framework of fuzzy set theory, in *Fuzzy Sets and Decision Analysis.* vol. 20, H. J., Zimmerman, L. A., Zadeh, and B., Gaines, eds., TIMS Studies in the Management Sciences, pp. 209-240.

Dubois, D. and Prade, H. (1985). A review of fuzzy set aggregation connectives, *Information Sciences* **36**:85-121.

Duflo, M. and Moore, C. C. (1976). On the regular representation of nonunimodular locally compact groups, *Jour. Functional Analysis* **21**:209-243.

Dujmovic, J. J. (1976). Evaluation, comparison, and optimization of hybrid computers using the theory of complex criteria, in *Simulation of Systems,* L. Dekker, ed., Amsterdam: North Holland.

Durbin, J. (1973). *Distribution Theory for Tests Based on the Sample Distribution Function.* Philadelphia, PA: Society for Industrial and Applied Mathematics.

Dyckhoff, H. and Pedrycz, W. (1984). Generalized means as model of compensatory connectives, *Fuzzy Sets and Systems* **14**:143–154.

Eakins, J. P., Boardman, J. M., and Graham, M. E. (1998). Similarity retrieval of trademark images, *IEEE Multimedia* **5**(2).

Eco, U. (1976). *A Theory of Semiotics.* Bloomington: Indiana University Press.

Eco, U. (2000). La bustina di Minerva, *Bompiani Overlook,* pp. 165.

Egenhofer, M. (1991). Reasoning about binary topological relations, in *Proc. Second Symposium on the Design and Implementation of Large Spatial Databases.* Berlin: Springer-Verlag, LNCS.

Ennis, D. M. and Johnson, N. L. (1993). Thurstone-Shepard similarity models as special cases of moment generating functions, *Jour. Mathematical Psychology* **37**:104–110.

Ennis, D. M., Palen, J. J., and Mullen, K. (1988). A multidimensional stochastic theory of similarity, *Jour. Mathematical Psychology* **32**:449–465.

Enser, P. and McGregor, C. G. (1992). Analysis of visual information retrieval queries, British Library Research and Development Report 6104, British Library.

Excalibur Technologies. Visual Retrievalware. http://www.excalib.com/products/vrw.

Fagin, R. (1996). Combining fuzzy information from multiple systems, in *Proc. 15th ACM Symposium on Principles of Database Systems, Montreal,* pp. 216–226.

Fagin, R. and Wimmers, E. (1997). Incorporating user preferences in multimedia queries, in *Proc. 1997 International Conference on Database Theory,* pp. 247–261.

Faloutsos, C., Barber, R., Flickner, M., Hafner, J., Niblack, W., Petkovic, D., and Equitz, W. (1994). Efficient and effective querying by image content, *Jour. Intelligent Information Systems: Integrating Artificial Intelligence and Database Technologies* **3**(3-4):231–262.

Faloutsos, C. and Lin, K.-I. (1995). *FastMap:* A fast algorithm for indexing, data-mining and visualization of traditional and multimedia datasets, in *Proc. ACM SIGMOD, International Conference on Management of Data, San Jose, CA,* pp. 163–174.

Fidel, R. (1985). Individual variability in online searching behavior, *ASIS '85:*

Proceedings of the ASIS 48th Annual Meeting, in C. A., Parkhurst, ed., vol. 22, pp. 69–72.

Flickner, M., Sawhney, H., Niblack, W., Ashley, J., Huang, Q., Dom, B., Gorkani, M., Hafner, J., Lee, D., Petkovic, D., Steele, D., and Yanker, P. (1995). Query by image and video content: the QBIC system, *IEEE Computer.*

Florack, L. M. J., Salden, A. H., ter Haar Romeny, B. M., Koenderink, J. J., and Viergever, M. A. (1995). Nonlinear scale-space, *Image and Vision Computing* **13**(4):279–294.

Fodor, J. (1981). Imagistic representation, in *Imagery,* N., Block, ed., Cambridge: MIT Press, pp. 63–86.

Freeston, M. (1987). The BANG file: a new kind of grid file, in *Proceedings of the ACM SIGMOD, International Conference on Management of Data,* pp. 260–269.

Friedman, J. H., Bentley, J. L., and Finkel, R. A. (1977). An algorithm for finding best matches in logarithmic expected time, *ACM Trans. Mathermatical Software* **3**(3):209–226.

Fu, K. S. (1974). *Syntactic Methods in Pattern Recognition.* New York: Academic Press.

Furnas, G. W., Landauer, T. K., and Dumais, S. T. (1983). Statistical semantics: Analysis of the potential performance of key-word information systems, *Bell System Technical J.* **62**(6):1753–1806.

Garner, W. R. (1962). *Uncertainty and Structure as Psychological Concepts.* New York: Wiley.

Garner, W. R. (1966). To perceive is to know, *American Psychologist* **21**:11–19.

Gevers, T. and Smeulders, A. (1996). A comparative study of several color models for color image invariant retreival, in *Proc. 1st Int. Workshop on Image Databases and Multimedia Search, Amsterdam, Netherlands.*

Ginzberg, M. (ed.). (1987). *Readings in Nonmonotonic Reasoning.* Los Altos, CA: Morgan-Kaufmann.

Gnedenko, B. V. and Korolyuk, V. S. (1961). On the maximum discrepancy between two empirical distributions, *Select. Transl. Math. Statist. and Probability* **1**:13–15 (Providence) Inst. Math. Statist. and Amer. Math. Soc.

Goguen, J. (1998). An introduction to algebraic semiotics, with applications to user interface design, in *Computation for Metaphors, Analogy, and Agents,* C., Nehaniv, ed., University of Aizu. Aizu-Wakamatsu, Japan.

Goldstein, E. B. (1989). *Sensation and Perception.* Belmont CA: Wadsworth.

Gombrich, E. H. (1965). *Art and Illusion. A Study in the Psychology of Pictorial Representation.* New York: Pantheon Books.

Gravetter, F. and Lockhead, G. R. (1973). Criterial range as a frame of reference for stimulus judgment, *Psychological Review* **80**:203–216.

Greene, D. (1989). An implementation and performance analysis of spatial data access methods, in *Proc. 5th International Conference on Data Engineering*, pp. 606–615.

Grigni, M., Papadias, D., and Papadimitriou, C. (1995). Topological inference, in *Proc. 14th International Joint Conference of Artificial Intelligence.*

Gromov, M. and Milman, V. D. (1983). A topological application of the isoperimetric inequality, *American Jour. Mathematics* **105**:843–854.

Grossman, A., Morlet, J., and Paul, T. (1985). Transforms associated with square integrable group representations, *Jour. Mathematical Physics* **27**.

Gupta, A. (1995). Visual information retrieval technology: A virage perspective. Technical Report, San Mateo, CA: Virage, Inc.

Guttman, A. (1984). R-trees: a dynamic index structure for spatial searching, in *Proc. ACM SIGMOD, International Conference on Management of Data*, pp. 47–57.

Hamacher, H. (1978). Über logische verknupfungen unscharfer aussagen und deren zugehörige bewertungs-funcktionen, in *Progress in Cybernetics and System Research,* R., Trappl, G., Klir, and L., Ricciardi, eds., New York: Hemisphere, pp. 276–287.

Harmandas, V., Sanderson, M., and Dunlop, M. (1997). Image retrieval by hypertext links, in *Proc. 20th ACM SIGIR Conference on Research and Development in Information Retrieval.*

Harshman, R. A. and Lundy, M. (1984). The PARFAC model for three-way factor analysis and multi-dimensional scaling. in *Research Methods for Multimode Data Analysis.* H. G., Law, C. W., Snyder Jr., J., Hattie, and R., McDonald, eds., New York: Præger.

Harter, S. P. (1975). A probabilistic approach to automatic keyword indexing, part 1: on the distribution of specialty words in technical literature, *Jour. American Society for Information Sciences* **26**:197–206.

Hastings, S. K. (1995). Query categories in a study of intellectual access to digitized art images, in *ASIS '95: Proceedings of the 58th ASIS Annual Meeting*, vol. 32, pp. 3–8.

Heidegger, M. (1962). *Being and Time.* New York: Harper & Row.

Hellerstein, J., Koutsoupias, E., and Papadimitriou, C. (1997). On the analysis of indexing schemes, in Proc. ACM PODS, International Conference on Principles of Database Systems, pp. 249–256.

Hjaltason, G. R. and Samet, H. (1995). Ranking in spatial databases, in *Proc. 4th International Symposium on Large Spatial Databases, Portland, ME, USA.*

Hjelmslev, L. (1961). *Prolegomena to a Theory of Language.* Madison: University of Wisconsin at Madison.

Huang, J., Kumar, S., Mitra, M., Zhu, W., and Zabih, R. (1997). Image indexing using color correlograms, in *Proc. IEEE Computer Socciety Conference on Computer Vision and Pattern Recognition.*

Huber, P. J. (1985). Projection pursuit, *Annals of Statistics* **13**(2):435–475.

Hutflesz, A., Six, H.-W., and Widmayer, P. (1988). Twin grid files: space optimizing access schemes, in *Proc. ACM SIGMOD, International Conference on Management of Data,* pp. 183–190.

Ide, E. (1971). New experiments in relevance feedback, in *The SMART Retrieval System,* G., Salton, ed., Englewood Cliffs: Prentice-Hall. pp. 337–354.

Itten, J. (1961). *The Art of Color.* New York: Reinhold Pub. Corp. John Wiley & Sons.

Itten, J. (1970). *The Elements of Color.* New York: Van Nostrand Reinhold.

Jacobs, C. E., Finkelstein, A., and Salesin, S. H. (1995). Fast multiresolution image querying, in *Proc. SIGGRAPH 95, Los Angeles, CA.* New York: ACM SIGGRAPH.

Jain, A. and Dubes, R. (1988). *Algorithms for Clustering Data.* Englewood Cliffs: Prentice-Hall.

Jain, A. K. (1989). *Fundamental of Digital Image Processing.* Information and System Sciences Series. Englewood Cliffs, NJ: Prentice-Hall.

Jain, R., Kasturi, R., and Shunk, B. (1995). *Machine Vision.* New York: McGraw-Hill.

James, W. (1890). *The Principles of Psychology.* New York: H. Holt and Company.

Julesz, B. (1975). Experiments in the visual perception of texture, *Scientific American* **232**:34–43.

Kalisa, C. and Torrésani, B. (1993). N-dimensional affine Weyl-Heisenberg wavelets, *Annales de L'Instut Henri Poincarè, Physique thèorique* **59**(2):201–236.

Kappel, G. (1991). *Design and Analysis—A Researcher's Handbook.* Englewood Cliffs, NJ: Prentice-Hall.

Katayama, N. and Satoh, S. (1997). The SR-tree: an index structure for high-dimensional nearest neighbor queries. in *Proc. ACM SIGMOD, International Conference on Management of Data,* pp. 369–380.

Kato, T. (1992). Database architecture for content-based image retrieval, in *Proceedings of SPIE, vol. 1662 Image Storage and Retrieval Systems,* A. A., Jambardino and W., Niblack, eds., pp. 112–123.

Kayser, D. (1979). Vers une modélisation du raisonnement approximatif. in *Représentation des Connaisances at Raisonnement dans the Sciences de l'Homme,* M., Borillo, ed., pp. 440–457. INRIA, Le Chesnay.

Kirillov, A. A. (1976). *Elements of the Theory of Representations.* New York: Springer Verlag. English version of Elementy teorii Predstavlenii, Nauka, Moskow, 1972.

Klock, H. and Buhmann, J. (1997). Multidimensional scaling by deterministic annealing, in *Proceedings EMMCVPR'97, Lecture Notes In Computer Science,* M., Pellilo and E. R., Hancock, eds., Berlin: Springer Verlag.

Kohonen, T. (1990). The self-organizing map, *Proc. IEEE* **78**(9):1464–1480.

Krumhansl, C. L. (1978). Concerning the applicability of geometric models to similarity data: The interrelationship between similarity and spatial density, *Psychological Review* **85**:445–463.

Kruskal, J. B. (1978). Factor analysis and principal components: Bilinear methods, in *International Encyclopedia of Statistics.* H. Kruskal, and J. Tanur, eds., New York: Free Press.

Laine, A. and Fan, J. (1993). Texture classification by wavelet packet signature, *IEEE Trans. Pattern Analysis and Machine Intelligence* **15**(11):1186–1191.

Lammens, J. (1994). *A Computational Model of Color Perception and Color Naming.* PhD thesis, SUNY, Buffalo, NY.

LeBon, G. (1895). *Psychologie der Massen.* Stuggart: Kroner.

Leouski, A. and Allan, J. (1998). Evaluating a visual navigation system for a digital library, in *Proceedings of the Second European Conference on Research and Technology for Digital Libraries,* pp. 535–554.

Leung, T. and Malik, J. (1996). Detecting, localizing, and grouping repeated scene elements from an image, in *Proceedings of the European Conference on Computer Vision,* pp. 546–555.

Lin, K.-I., Jagadish, H. V., and Faloutsos, C. (1995). The TV-tree: An index structure for high dimensional data, *VLDB Journal* **3**:517–542.

Link, S. W. (1992). *The Wave Theory of Difference and Similarity.* Scientific Psychology Series. New Jersey: Lawrence Erlbaum Associates.

Litwin, W. (1980). Linear hashing: a new tool for file and table addressing, in *Proceedings of the 6th VLDB Conference.*

Liu, Y., Rothfus, W. E., and Kanade, T. (1998). Content-based 3D neuroradiologic image retrieval: preliminary results, in *IEEE International Workshop on Content-based Access of Image and Video Databases (CAIDV '98), Mumbai, India,* pp. 91, 100.

Lovins, B. J. (1971). Error evaluation of stemming algorithms as clustering algorithms, *Jour. American Society for Information Sciences* 22:28-40.

Luhn, H. P. (1958). The automatic creation of literature abstracts, *IBM Jour. Research and Development* 2:159-165.

Ma, W. Y. and Manjunath, B. S. (1997). Edge flow: A framework of boundary detection and image segmentation, in *Proceedings of CVPR '97 the IEEE International Conference on Computer Vision and Pattern Recognition.*

Makayama, M., Norita, T., and Ralescu, A. (1993). A fuzzy logic based qualitative modeling of image data, in *Uncertainty in Intelligent Systems,* B. Bouchon-Meunier, R. Yager, and L. Zadeh eds., New York: Elsevier Science, pp. 309-318.

Malik, J. and Perona, P. (1990). Preattentive texture discrimi-nation with early vision mechanisms, *Jour. Optical Society of America A* 7(5).

Mallat, S. (1989). A theory for multiresolution signal decomposition: The wavelet representation, *IEEE Trans. Pattern Analysis and Machine Intelligence* 11(7):674-693.

Mandel, J. (1964). *The Statistical Analysis of Experimental Data.* New York: Interscience Publishers (republished in 1984 by Dover, Mineola, NY).

Manjunath, B. S. and Ma, W. Y. (1996). Texture features for browsing and retrieval of image data. *IEEE Trans. Pattern Analysis and Machine Intelligence* 18(8):837-842.

Markkula, M. and Sormounen, E. (1998). Searching for photo-journalists practices in pictorial IR, in *The Challenge of Image Retrieval. Papers Presented at a Workshop on Image Retrieval. University of Northumbria at Newcastle.*

McCarthy, J. (1996). *Defending AI Research.* Number 49 in CSLI Lecture Notes. Stanford, CA CSLI Publications.

McCarthy, J. and Hayes, P. (1969). Some philosophical problems from the standpoint of artificial intelligence, in *Machine Intelligence,* B. Meltzer and D., Michie, eds., vol. 4, pp. 463-502. New York, Halsted Press.

McCarty, G. (1988). *Topology: An Introduction with Applications to Topological Groups.* New York: Dover.

Merrel, F. (1995). *Semiosis in the Postmodern Age.* Lafayette, IN: Purdue University Press.

Meseguer, P. (1989). Constraint satisfaction problems: an overview, *AICOM* 2(1):3-17.

Milman, V. D. (1988). The heritage of P. Lévy in geometric functional analysis, *Astérique* **157-158**:273-301.

Miyajima, K. and Ralescu, A. (1993). Modeling of natural objects including fuzziness and application to image understanding, in *Proceedings of the Second IEEE International Conference on Fuzzy Systems,* pp. 1049-1054.

Muckenhaupt, M. (1986). *Text und Bild.* Tugingen: Narr.

Murofushi, T. and Sugeno, M. (1989). An interpretation of fuzzy measures and the choquet integral as an integral with respect to a fuzzy measure, *Fuzzy Sets and Systems* **29**(2):201-227.

Nes, N. and Kersten, M. (1998). The acoi algebra: A query algebra for image retrieval systems, in *Proceedings of the 16th British National Conference on Databases, BNCOD 16, Cardiff, Wales, UK,* vol. 1405 of *Lecture Notes in Computer Science,* Berlin: Springer-Verlag, pp. 77-89.

Nievergelt, J., Hinterberger, J., and Sevcik, K. C. (1984). The grid file: an adaptable, symmetric multikey file structure, *ACM Trans. Database Systems* 9(1): 38-71.

Nöth, W. (1998). SRB insights: Can pictures lie? *The Semiotic Review of Books* 6(2).

Okubo, T. (1987). *Differential Geometry.* Monographs and Textbooks in pure and applied mathematics. New York: Marcel Dekker, Inc.

Olson, R. R. and Attneave, F. (1970). What variables produce similarity grouping? *American Jour. Psychology* **83**:1-21.

Ornager, S. (1997). Image retrieval: theoretical and empirical user studies on accessing information in images, in *ASIS '97: Proceedings of the 60th ASIS Annual Meeting,* vol. 34, pp. 202-211.

Otoo, E. J. (1986). Balanced multidimensional extendible hash tree, in *Proceedings of the 5th ACM SIGACT/SIGMOD Symposium on Principles of Database Systems,* pp. 100-113.

Paek, S. and Smith, J. (1998). Detecting image purpose in worldwide web documents, in *IS&T/SPIE Symposium on Electronic Imaging: Science and Technology—Document Recognition.*

Papadias, D., Theodoridis, Y., Sellis, T., and Egenhofer, M. J. (1995). Topological relations in the world of minimum bounding rectangles: A study with R-trees, in *Proceedings of ACM SIGMOD Conference, San Jose, USA.*

Papoulis, A. (1991). *Probability, Random Variables, and Stochastic Processes.* New York: McGraw-Hill.

Parducci, A. (1965). Category judgment: a range-frequency model, *Psychological Review* **72**:407-48.

Peirce, C. S. (1931-58). *Collected Papers.* Cambridge, MA: Harvard University Press.

Pestov, V. (1999). On the geometry of similarity search: dimensionality curse and the concentration of measure. Technical Report RP-99-01, School of Mathematics and Computer Science, Victoria University of Wellington, New Zealand.

Petrakis, E. and Faloutsos, C. (1997). Similarity searching in medical image databases, *IEEE Trans. Knowledge and Data Engineering* **9**(3):435-447.

Porkaew, K., Mehrotra, S., Ortega, M., and Chakrabarti, K. (1999). Similarity search using multiple examples in MARS, in *Proceedings of the International Conference on Visual Information Systems.*

Powell, J. (1989). *Postmodernism for Beginners.* New York: Writers and Readers.

Press, W. H., Flannery, B. P., Teulolsky, S. A., and Vetterling, W. T. (1986). *Numerical Recipes, The Art of Scientific Computing,* Cambridge: Cambridge University Press.

Ralescu, D. and Adams, G. (1980). The fuzzy integral, *Jour. Mathematical Analysis and Applications* **75**:562-570.

Riddler, T. W. and Calvard, S. (1978). Picture thresholding using an iterative selection method, *IEEE Trans. Systems, Man and Cybernetics* **8**(8):630-632.

Riesz, F. and Sz.-Nagy, B. (1990). *Functional Analysis.* New York: Dover. Translation of *Leçon d'analyse functionelle.*

Ripley, B. D. (1977). Modelling spatial patterns, *Jour. Royal Statistical Society* **39**:172-192.

Rissanen, J. (1978). Modeling by shortest data description, *Automatica* **14**:465-471.

Rissanen, J. (1989). *Stochastic Complexity in Statistical Inquiry.* Singapore: World Scientific.

Ritter, H. (1991). Asymptotic level density for a class of vector quantization processes, *IEEE Trans. Neural Networks* **2**(1):173-175.

Ritter, H. and Schulten, K. (1988). Convergence properties of Kohonen's topology preserving maps: Fluctuations, stability and dimension selection, *Biological Cybernetics* **60**:59–71.

Robinson, J. (1981). The K-D-B-tree: A search structure for large multidimensional dynamic indexes, in *Proceedings of the ACM SIGMOD, International Conference on Management of Data,* pp. 10–18.

Rocchio, J. J. (1971). Relevance feedback in information retrieval, in G. Salton, ed., *The SMART Retrieval System,* Englewood Cliffs: Prentice-Hall, pp. 313–323.

Rose, J. E. and Woosley, C. N. (1949). Organization of the mammalian thalamus and its relationships to the cerebral cortex, *Encephalography and Clinical Neurophysiology* **1**:391–404.

Rosenfeld, A. and De La Torre, P. (1983). Histogram concavity analysis as an aid to threshold selection, *IEEE Trans. Systems, Man and Cybernetics* **13**(3):231–235.

Rosh, E. (1975). Cognitive reference points, *Cognitive Psychology* **7**:532–547.

Rothkopf, E. Z. (1957). A measure of stimulus similarity and errors in some paired-associate learning tasks, *Jour. Experimental Psychology* **53**:94–101.

Roussopoulos, N., Kelley, F., and Vincent, F. (1995). Nearest neighborhood queries, in *Proceedings of ACM SIGMOD Conference.*

Russell, B. (1967). *A History of Western Philosophy.* New York: Simon and Shuster.

Salton, G. (1988). *Automatic Text Processing.* Reading, MA: Addison-Wesley.

Salton, G. and Buckley, C. (1990). Improving retrieval performance by relevance feedback, *Jour. American Society for Information Science* **41**(4):288–297.

Saussure, F. D. (1960). *Cours de linguistique generale.* Paris: Payot.

Sayood, K. (1996). *Introduction to Data Compression.* San Francisco: Morgan Kaufman.

Schwartz, G. (1978). Estimating the dimension of a model, *Annals of Statistics* **6**:461–464.

Schweizer, B. and Siklar, A. (1961). Associative functions and statistical triangle inequalities, *Publ. Math. Debrecen* **8**:169–186.

Shepard, R. N. (1957). Stimulus and response generalization: A stochastic model relating generalization to distance in psychological space, *Psychometrika* **22**:325–245.

Shepard, R. N. (1962a). The analysis of proximities: Multidimensional scaling with unknown distance function. Part I, *Psychometrika* **27**:125–140.

Shepard, R. N. (1962b). The analysis of proximities: Multidimensional scaling with unknown distance function. Part II, *Psychometrika* **27**:219–246.

Shepard, R. N. (1987). Toward a universal law of generalization for physical science, *Science* **237**:1317–1323.

Shridhar, M. and Badreldin, A. (1984). High accuracy character recognition algorithm using Fourier and topological descriptors, *Pattern Recognition* **17**(5):515–524.

Sjoberg, L. (1972). A cognitive theory of similarity, *Goteborg Psychological Reports* **2**(10).

Smith, J. and Chang, S. F. (1997). Safe: A general framework for integrated spatial and feature image search, in *IEEE 1997 Workshop on Multimedia Signal Processing*.

Smith, J. R. and Chang, S. F. (1995). Single color extraction and image query, in *Proceedings of the International Conference on Image Processing (ICIP-95)*.

Smith, S. and Jain, A. (1982). Chord distribution for shape matching, *Computer Vision, Graphics and Image Processing* **20**:259–265.

Sonesson, G. (1994). Sémiotique visuelle et écologie sémiotique, *RSSI* **14**(1-2):31–48.

Sonesson, G. (1997). The ecological foundations of iconicity, in *Semiotics Around the World: Synthesis in Diversity. Proceedings of the Fifth International Congress of the IASS, Berkeley,* I. Rauch and G. Garr, eds., Berlin and New York: Mouton de Gruyter, pp. 739–742.

Sonesson, G. (1998). Iconicity in the ecology of semiosis. World wide web document, University of Lund. http://www.arthist.lu.se/kultsem/sonesson/LifeworldIconicity1/html.

Sonka, M., Hlavac, V., and Boyle, R. (1999). *Image Processing, Analysis, and Machine Vision.* Pacific Grove: PWS Publishing.

Souza, C. S. (1993). The semiotic engineering of user interface languages, *International Journal of Man-Machine Studies* **39**:753–773.

Sproull, R. F. (1991). Refinements to nearest neighbor searching in *k*-dimensional trees, *Algorithmica*, pp. 579–589.

Stein, A. and Thiel, U. (1993). A conversation model of multimedia interaction, in *Proceedings of the 11th National Conference on Artificial Intelligence (AAAI '93), Washington, DC, USA.*

Stockton, W. (1980). Creating computers to think like humans. *New York Times Magazine.*

Stoyan, D. and Stoyan, H. (1994). *Fractals, Random Shapes, and Point Fields.* New York: John Wiley & Sons.

Stricker, M. (1994). Bounds for the discrimination power of color indexing techniques, in *Proc. SPIE,* vol. 2185, *Storage and Retrieval for Still Image and Video Databases II.*

Stricker, M. and Orengo, M. (1995). Similarity of color images, in *Proc. SPIE,* vol. 2420, *Storage and Retrieval of Image and Video Databases III, San Jose, USA,* pp. 381–392.

Subramanian, B., Zdonik, S. B., Leung, T. W., and Vandenberg, S. L. (1993). Ordered types in the AQUA data model, in *Proceedings of the 4th International Workshop on Database Programming Languages.*

Sugeno, M. (1977). Fuzzy measures and fuzzy integrals: a survey, in *Fuzzy Automata and Decision Processes,* M. Gupta, G. N., Saridis, and B. R., Gaines, eds., Amsterdam: North-Holland, pp. 89–102.

Swain, M. and Ballard, D. (1991). Color indexing, *International Journal of Computer Vision* 7(1):11–32.

Tatemura, J., Santini, S., and Jain, R. (1999). Social and content-based approach for visual recommendation of web graphics, in *Proceedings of the International Conference on Visual Languages.*

Thurstone, L. L. (1927). A law of comparative judgement, *Psychological Review* 34:273–286.

Tihonov, A. N. (1963). Regularization of incorrectly posed problems, *Soviet Mathematical Doklady* 4:1624–1627.

Tomita, F., Shirai, Y., and Tsuji, S. (1982). Description of textures by a structural analysis, *IEEE Trans. Pattern Analysis and Machine Intelligence* 4(2):183–191.

Torgerson, W. S. (1965). Multidimensional scaling of similarity, *Psychometrika* 30:379–393.

Torrésani, B. (1994). Some remarks on wavelet representations and geometric aspects, in *Wavelets: Theory, Algorithms, and Applications,* C. C., Chui, L., Montefusco, and L., Puccio, eds., New York: Academic Press, pp. 91–115.

Tversky, A. (1977). Features of similarity, *Psychological Review* 84(4):327–352.

Tversky, A. and Gati, I. (1982). Similarity, separability, and the triangle inequality, *Psychological Review* 89:123–154.

Tversky, A. and Krantz, D. H. (1970). The dimensional representation and the metric structure of similarity data, *Jour. Mathematical Psychology* **7**:572-597.

Ullman, J. (1982). *Principles of Database Systems,* 2nd ed., Rockville: Computer Science Press.

Ullman, J. (1994). *Elements of ML Programming.* Englewood Cliffs: Prentice-Hall.

Van De Wouwer, G., Scheunders, P., and Van Dyck, D. (1999). Statistical texture characterization from discrete wavelet representations, *IEEE Trans. Image Processing* **8**(4):592-599.

van den Boomgaard, R. and Smeulders, A. (1995). The morphological structure of images: The differential equations of morphological scale-space, *IEEE Trans. Pattern Analysis and Machine Intelligence* **16**(11).

van Rijsbergen, C. J. (1979). *Information Retrieval.* London: Butterworths.

von Goethe, J. W. (1970). *Theory of Colours.* Cambridge: MIT Press.

Wang, Z. and Klir, G. J. (1992). *Fuzzy Measure Theory.* New York: Plenum Press.

White, D. and Jain, R. (1996a). Similarity indexing: algorithms and performance, in *Proc. SPIE,* vol. 2670, *Storage and Retrieval for Still Image and Video Databases IV,* pp. 62-73.

White, D. A. and Jain, R. (1996b). Similarity indexing with the SS-tree, in *Proceedings of the 12th IEEE International Conference on Data Engineering, New Orleans, Louisiana, USA.*

Winograd, T. and Flores, F. (1987). *Understanding Computers and Cognition.* Reading, MA: Addison-Wesley.

Wu, J. K., Lam, C.-P., Mehtre, B. M., Gao, Y. J., and Desai Narasimhalu, A. (1996). Content based retrieval for trademark registration, *Multimedia Tools and Applications* **3**:245-267.

Wyszecki, G. and Stiles, W. S. (1967). *Color Science; Concepts and Methods, Quantitative Data and Formulas.* New York: John Wiley & Sons.

Yeo, C. H. (1979). The anatomy of the vertebrate nervous system: an evolutionary and developmental perspective, in *Brain, Behaviour, and Evolution,* D. A., Oakley and H. C., Plotkin, eds., London: Methuen, pp. 28-51.

Zipf, H. P. (1949). *Human Behaviour and the Principle of Least Effort.* Cambridge, MA: Addison-Wesley.

Index

Printed and bound by CPI Group (UK) Ltd, Croydon, CR0 4YY

03/10/2024

01040321-0010